Robin Gibson

FLOWER
PAINTING

PHAIDON
Oxford

E.P. DUTTON
New York

The author and publishers would like to thank all those museum authorities and private owners who have kindly allowed works in their possession to be reproduced. The photograph for Plate 46 has been kindly lent by Sotheby & Co., London.

Phaidon Press Limited, Littlegate House, St Ebbe's Street, Oxford
Published in the United States of America by E. P. Dutton & Co., Inc.

First published 1976

© *1976 Elsevier Publishing Projects SA, Lausanne/Smeets Illustrated Projects, Weert*

ISBN 0 7148 1692 2
Library of Congress Catalog Card Number: 76-344

Printed in The Netherlands

FLOWER PAINTING

The origins of flower painting in European art

Representations of plants have been found by archaeologists in most early civilizations. In ancient Greece the acanthus leaf ornamented the capitals of Corinthian columns and has survived until comparatively recently as one of the most popular of all architectural motifs. Paintings of flowers are known to have been produced in Greece, and flowering plants and still lifes appear in the frescoes and mosaics of Pompeii. The first still lifes of the Italian Renaissance may well have been derived from a knowledge of Roman decoration.

It is difficult to appreciate today the importance placed by man in earlier centuries on even the commonest of plants. They were at once his medicine-cupboard and a symbol of the forces of nature against which he battled or which he relied on for his living. Endowed with healing or magical powers, they became associated with cults and religions and it is as much for this as for purely decorative reasons that flowers make their first appearance in the religious paintings and manuscripts of the Middle Ages. Even so, their symbolic message, which could be read by the scholar and illiterate peasant alike, often had its origins in pre-Christian mythology. The lily was associated with Isis and the rose with Venus long before their qualities were transferred to the Virgin Mary (Plate 1), whose perfect purity and love they came to symbolize. It would be foolish to maintain that every single flower beneath the feet of the saints of fifteenth-century Flemish religious pictures or even those in Botticelli's *Primavera* had a specific purpose in the painting's 'message'. It is quite clear that with the increasingly rationalistic thought of the Renaissance in the South, and of the Reformation in the North, flowers in paintings came to be admired more for their decorative values than their associations.

With the one exception of Memling's *Vase of Flowers* (Plate 2), no significant oil paintings of flowers alone have survived from before 1600. During the sixteenth century, with its great advances in scientific study and the technology of printing, herbals and florilegia took over the function of illustrating flowers from medieval illuminated manuscripts and Books of Hours. The accurate drawing of plants required by herbals for both botanical and aesthetic reasons was greatly influenced by the magnificent studies of Leonardo da Vinci and Albrecht Dürer (Plate 3). It was only a matter of time before the idea of painting an arrangement of attractive flowers as an end in itself would become feasible, and there is evidence that one or two such paintings were produced in the Low Countries in the 1580s and '90s. Both the northern and southern provinces of the Netherlands were climatically ideally suited to the cultivation of flowers and it is no coincidence that the genre of the flowerpiece was developed and found its greatest expression there.

The formal flowerpiece, 1600–1800

The rise in popularity of specific genres of painting such as landscape, portraits and historical subjects coincided with the new, broadly painted and often theatrical, baroque style, which did not allow for the exact and minute depiction of small objects such as flowers. In Catholic Antwerp, Rubens carried the achievements

of the early baroque to new heights and it was from there also that the first and greatest flower painters came. Jan Brueghel the Elder (1568–1625) is perhaps the best known of them among Rubens's contemporaries. His detailed and vividly coloured bouquets show the combination of close botanical study with an almost primitive symmetrical composition, characteristic of their work. The new genre was highly valued by contemporary collectors. The technique of *trompe-l'oeil* – deceiving the eye into thinking the painted flowers are real – was much admired, and enthusiasts delighted in pictures of prized blooms which, unlike the short-lived flowers, were always with them. For this reason, flowers were drawn while in season and each incorporated later into an arrangement which ignored the laws of nature. The inclusion of exotic shells, birds and insects in most of these early flowerpieces underlines the element of illusionism and shows the appeal of these paintings as documentation of beautiful and rare species in natural history collections.

Under Charles de Lécluse (1526–1609), the botanical gardens at Leyden had made Holland an important centre of horticulture. It was there that Lécluse grew the first tulips and the crown imperial fritillary, both of which play a large part in the still lifes of the seventeenth century. It is well known that vast prices were paid for tulips, but similar values were also placed on paintings of flowers. Jacques de Gheyn (1565–1629), an Antwerp refugee and friend of Lécluse, received 1,000 guilders for a flowerpiece presented to Marie des Médicis. Savery and the Bosschaert family, also protestant refugees from Belgium, established a flourishing centre of flower painting at Utrecht. It was perhaps due to this influx of Flemish painters that Holland superseded Belgium as the centre of Northern flower painting after the death of Seghers, Brueghel's chief pupil, in 1661 (Plate 13).

The flower painters of the Netherlands were not the sole initiators of the genre, but there is no doubt that their influence on its development in Italy, France and Germany was very great. Cardinal Borromeo's collection of Brueghels at Milan and Seghers's visit to Rome in the 1620s were crucial in creating both a style and a demand for pictures by artists such as Mario de' Fiori (1603–73). The still life paintings of Caravaggio (1573–1610) helped establish a strong school of still life painting at Naples while his innovations in chiaroscuro were in their turn important in the development of Dutch flower painting. The Neapolitan school, with its large canvases of dramatically lit and untidy baroque bouquets, set the example for decorative work throughout Europe and was influential in France on artists such as Jean-Baptiste Monnoyer (Plate 22).

By the 1650s a noticeable change was taking place in Dutch flowerpieces. The great era of Dutch painting under Rembrandt, Hals and Vermeer, with its emphasis on naturalism and chiaroscuro, was passing, and the flower and still life painters seem to have waited to learn from their example. The works of de Heem (Plate 14), Mignon (Plate 17) and Walscapelle (Plate 20) show a greater unification in the various components of the painting, increasing use of light and shade, and a move towards asymmetry of design.

The more specific symbolism of particular flowers in fifteenth- and early sixteenth-century religious paintings was no longer valid when new species and varieties were being introduced yearly, but flowers themselves could be seen as emblems of transience. The evergreen ivy supplied a picturesque metaphor for immortality and the delicate ear of wheat bearing the seeds of rebirth stood for resurrection. Most of these visual metaphors had gone out of use by the eighteenth century, but man's urge to associate himself with nature is strong. The Victorians created

a new 'Language of Flowers' to incorporate all the new species and even today florists' advertisements remind us that red roses are for love.

The last Dutch painter of international repute before Van Gogh was, appropriately, a flower painter. Jan van Huysum (Plates 25, 26) refined the style of the seventeenth century to a pitch of visual exactness with a technique which continues to amaze. His major innovation however was an overall lightening of colour, often with a bluish tinge, and the introduction of a woodland background which heightened the artificial impression of his elaborate arrangements. This style, so much admired at the time, was carried on into the nineteenth century by Jan van Os (1744–1808) and Gérard van Spaendonck (1746–1822), the teacher of the famous botanical artist, Redouté. Significantly, van Spaendonck and several other Dutch flower painters worked in Paris, now established under Louis XIV as the leading centre of painting in Europe. The influence of Flemish painters was strong in the eighteenth century, both on artists such as Watteau, and on that master of the still life, Chardin (Plate 27). Flower painting by native French artists was largely confined to decorations for tapestries and porcelain, but blossoms fill the works of the great rococo painters Boucher and Fragonard.

Flower painting after 1800

The decline of the formal flowerpiece in the second half of the eighteenth century was due partly to the fact that the genre had worked itself out and partly to the competition presented by the advances in printing techniques made during the century. This meant that the drawings of botanical artists such as Redouté (1759–1841) could be reproduced with great accuracy, and made available to a far wider circle of connoisseurs. The publication of horticultural material increased enormously in the late eighteenth and early nineteenth centuries as did the number of plants being introduced from abroad.

It was the later French Romantics who rediscovered flowers for art. Delacroix (Plate 32) looked to the past for his compositions but painted flowers with a *bravura* that opened up new possibilities of technique which Manet was to develop (Plate 40). Courbet (Plate 33) in his search for realism found that flowers provided an opportunity for contrasting different depths of colour, untrammelled by subject-matter, and could be painted in his broad manner. His influence on the young group of artists later to be called the Impressionists was profound, and he recommended painting flowers as an ideal method of developing their use of colour. Renoir (Plate 36), Monet (Plate 39) and Fantin-Latour (Plates 37, 38) all painted flowerpieces on Courbet's advice in 1863–4. Although still executed on a dark or red ground, these flowerpieces of the early 1860s played an important part in the creation of the Impressionist style.

Unlike Fantin, whose work remained firmly rooted in the still lifes of the past and whose detailed approach perhaps owed more to the new art of photography, Monet and Renoir went on to produce dazzlingly coloured and informally arranged bouquets of flowers with pure Impressionist technique. The opening of Japan to foreigners in the middle of the nineteenth century made way for the introduction of a wealth of new plants and coincided with the importation of Japanese *objets d'art* and the highly coveted prints and watercolours. The mania for *Japonaiserie* in the 1870s and '80s can be felt in the flowerpieces of the Impressionists, both in their composition and in their choice of flowers such as chrysanthemums; but it was only

fully absorbed by the younger generation of artists, including Van Gogh (Plate 42) and Gauguin (Plate 41). The movement away from a realistic and three-dimensional representation of life did not preclude painting flowers, whose vivid colours and decorative contours provided the subjects for some of their greatest works. Other post-Impressionist artists, such as Redon (Plate 46), Matisse and the German Expressionists (Plates 44, 48), painted flowers, inspired both by their colour and their associations with the joyful and affirmative side of life.

The Plates

Plate 1. MARTIN SCHONGAUER (1453–91): *The Madonna of the Rose Garden.* 1473. Panel, 201 × 112 cm. Colmar, Church of St. Martin.

The tradition of showing the Madonna and Child in an enclosed garden was well established by the time Schongauer painted his masterpiece and only documented work. Essentially a mystical concept borrowed from the Old Testament 'Song of Solomon', the garden setting allowed artists great freedom in the choice of flowers with which to emphasize the attributes of the Virgin. Here, the magnificent peony reflects her role in Paradise as the 'rose without thorns'.

Plate 2. HANS MEMLING (d.1494): *Vase of Flowers in a Niche.* About 1490. Panel, 28·7 × 21·5 cm. Lugano, Thyssen Collection.

The earliest known still life of flowers is painted on the back of a portrait of a man in the attitude of a donor and has obvious affinities with the vases of madonna lilies and other flowers known to us from many 'Annunciations'. Memling emphasizes the symbolic flowers, which would have been seen when the diptych was closed, by painting three open blossoms of each for the Trinity and placing them in a vessel bearing the sacred monogram of Christ.

Plate 3. ALBRECHT DÜRER (1471–1528): *An Iris.* Inscribed. About 1495. Watercolour, 77 × 31 cm. Bremen, Kunsthalle.

Dürer's drawings of plants and animals, like those of his older Italian contemporary Leonardo da Vinci, are indicative of the lively scientific interest in all aspects of the natural world which was a by-product of the Renaissance. In no case does either artist seem to have used any of his surviving drawings of plants as preliminary studies for paintings although this one was clearly known to the artist of the *Madonna of the Iris*, which is in the National Gallery.

Plate 4. MATTHIAS GRÜNEWALD (*c.*1470/5–1528): *Vase of Lilies and Roses* (detail from the *Stuppach Madonna*). 1517–19. Panel, 187 × 146 cm. Stuppach, Parish Church.

Although painted less than thirty years after Memling's emblematic vase of flowers (Plate 2), Grünewald's seems to belong to another age. The asymmetrical arrangement and vigorous brushwork might suggest part of a baroque altarpiece of 150 years later, were it not for the intensity of the artist's observation. Every image in Grünewald's few known paintings seems to bear the stamp of the artist's hard-won spiritual experience. In a picture already bristling with symbols, the prominently situated flowers become a vivid metaphor in this late medieval vision of Mary as the Mother of God and the Church.

Plate 5. ROELANDT SAVERY (1576–1639): *Flowers in a Niche with Lizards and Insects.* Signed and dated 1604. Copper, 29 × 19 cm. Utrecht, Central Museum.

Savery, like Bosschaert, was a Flemish refugee who settled in Holland. He was in the service of the great collector, Emperor Rudolf II, from 1604 to 1619 and was able to study in the imperial collections the animals, birds and insects which fill his landscapes and flowerpieces. Although the magical and surreal quality of his landscapes is often carried to the point of eccentricity, Savery's early flower paintings are distinguished from those of his contemporaries by their depth and realism.

Plate 6. JAN BRUEGHEL THE ELDER (1568–1625): *Large Bouquet of Flowers in a Tub.* About 1610? Panel, 124·5 × 96·2 cm. Munich, Alte Pinakothek.

Jan, nicknamed 'Velvet' and 'Flower', Brueghel, has remained the best known of the early flower painters. The size and top-heaviness of this famous bouquet with its mixture of flowers of all seasons shows that it is not meant to be taken as a literal representation of a vase of flowers. Perhaps, like his other allegorical works, it should be interpreted rather as a homage to the Kingdom of Flora. The modest earthenware tub can be seen as the Earth, bearing the whole range of flowers popular at the time, reigned over by the much revered crown imperial.

Plate 7. OSIAS BEERT THE ELDER (*c.*1580–1624): *Large Flowerpiece.* About 1615? Panel, 180 × 140 cm. Brussels, Musées Royaux des Beaux-Arts.

Little is known of Osias Beert and it is only recently that his work as a flower painter has been re-identified. As might be surmised from this large panel, he was a contemporary of Brueghel at Antwerp, but the effect of his paintings is more primitive, rather like a tapestry. There are pleasingly incongruous touches of realism in this bouquet such as the bunch of small flowers tucked in at the bottom and the petals scattered over the cloth as if it had just been arranged.

Plate 8. AMBROSIUS BOSSCHAERT THE ELDER (1573–1621): *Flowers in a Window Niche with Landscape.* Signed. About 1619. Panel, 63·5 × 46 cm. The Hague, Mauritshuis.

Bosschaert's work has much in common with Savery's but only Bosschaert took the imaginative step of setting his flowers against a distant landscape of the sort Savery painted. The device automatically gives a greater sense of depth and airiness to the bouquet and enables the artist to create a lively visual pattern with the silhouetted leaves. Some of the same flowers are to be found in his other paintings and clearly derive from a sketch-book.

Plate 9. PETER BINOIT (1590/3–1632): *Bouquet of Flowers in a Gold-Mounted Vase with Garland and Parakeets.* Signed and dated 1620. Panel, 110 × 87 cm. Darmstadt, Hessisches Landesmuseum.

Frankfurt's position as an old-established commercial and horticultural centre is reflected in this flowerpiece by the German painter Binoit. The valuable vase, exotic parakeets and the wide range of flowers are all items which would have appealed to the collector. The artist must clearly have seen a Brueghel flower painting, although his own flowers have a distinctive spiky vitality and stiffness.

Plate 10. JACQUES LINARD (*c.*1600–45): *Vase of Lilies, Roses and Poppies on a Wooden Box.* Signed. About 1630? Canvas, 57 × 42 cm. Karlsruhe, Staatliche Kunsthalle.

The life of Linard, the first major French still life painter, is obscure but it seems likely that his style may have been influenced by the colony of Flemish painters working in Paris in the early seventeenth century. His flower paintings are nevertheless of great originality and, by comparison, more restrained in colour and composition. There is an air of mystery about this painting. Is it, as in some of Linard's allegorical still lifes, symbolical? Is there something in the box, or is it simply the container for the flowers now in the vase?

Plate 11. AMBROSIUS BOSSCHAERT THE YOUNGER (1610?–45): *Flowers in a Bronze Vase.* Signed. About 1640? Panel, 50 × 40 cm. Cambridge, Fitzwilliam Museum.

Ambrosius was only twelve when his father died but must have made use of his drawings. Their choice of such flowers as the large and vividly striped tulips is similar, but this late example of the son's work is far more modern in feeling. The open composition with the S-line of the iris leaves looks forward to the flower painters of the 1660s and '70s, while the pale background with the cast shadow of the flowers seems to be unique for its period.

Plate 12. JAN BRUEGHEL THE ELDER (1568–1625) and SIR PETER PAUL RUBENS (1577–1640): *Madonna and Child in a Garland of Flowers*. Before 1617. Canvas, 85 × 65 cm. Paris, Musée du Louvre.

As personal friends, it was perhaps inevitable that Brueghel and Rubens should each attempt to complement the other's apparently incompatible style. Brueghel wrote to his patron, Cardinal Borromeo (5 September 1621): 'The most beautiful and rare thing I have ever done in my life. Mr Rubens has also done his best in the central picture which contains a very beautiful madonna.' The genre of the Virgin in a garland was a logical development, in the baroque age, of the medieval 'Madonna in a Garden', and was taken up with enthusiasm in Flanders and Italy. The gesture of the little angel crowning Rubens's Queen of Heaven with a wreath of flowers is subtly repeated by Brueghel in the painted image.

Plate 13. DANIEL SEGHERS (1590–1661) and FRANS(?) DENYS (*fl.* 1650): *Garland of Flowers with the Holy Family*. Signed. About 1650? Canvas, 128 × 97 cm. Antwerp, Musée Royal des Beaux-Arts.

Although Brueghel originated the idea of a floral surround for religious subjects, it was his most important pupil, Seghers, who gave it its definitive baroque form. Educated in Holland as a protestant, Seghers returned to his native Antwerp in 1610. He was converted by Brueghel to Catholicism, and devoted his life to the Jesuits, painting flowers in their service. He was not permitted to sell his works and they became prized gifts for official and religious dignitaries throughout Europe, including the exiled Charles II of England.

Plate 14. JAN DAVIDSZ. DE HEEM (1606–83/4): *'Vanitas' Still Life with Flowers*. Signed. About 1660. Canvas, 102 × 84 cm. Munich, Alte Pinakothek.

Born in Holland, de Heem spent much of his working life in Antwerp. His style combines the best traits of both schools: the richness and robustness of Dutch painting and the bright colours and delicate textures of Seghers. The asymmetrically placed flowers occupy most of the composition, but the key to the 'vanitas' allegory lies in the crucifix and the inscription on the paper: 'But the most beautiful flower of all one does not heed.' The ephemeral flowers are contrasted with the Christian faith, its promise of resurrection and eternal life symbolized by the ears of wheat and the ivy-entwined skull.

Plate 15. DIRCK DE BRAY (*fl.* 1651–78): *Still Life with Flowers*. Signed and dated 1665. Panel, 55·8 × 47·7 cm. Private Collection.

A son of Salomon de Bray, painter of portraits and historical subjects, Dirck spent his known working life in Haarlem, where he was a member of the Guild of Painters. He produced hunting scenes and pictures of game, and his flower subjects are rare. He also worked as a book-illustrator, engraving fish, poultry and birds as well as flowers.

Plate 16. NICOLAES VAN VERENDAEL (1640–90): *Flowers round a Classical Bust*. Signed. About 1680? Canvas, 38 × 46·5 cm. Brussels, Musées Royaux des Beaux Arts.

The most accomplished of all Seghers's followers in Antwerp, Verendael also owes

much to de Heem in his compositions and predilection for symbolism. In this unusual flowerpiece, the relic of a dead civilization is compared to the ephemeral flowers and contrasted with the enduring message of Christianity. Butterflies (souls) settle on thistles (reminiscent of the crown of thorns and the crucifixion) and on an ear of wheat (for resurrection).

Plate 17. ABRAHAM MIGNON (1640–79): *Flowers, Birds, Insects and Reptiles in a Cave.* About 1675? Canvas, 78·7 × 99 cm. Darmstadt, Hessisches Landesmuseum.

The German-born Mignon's vases of flowers are very similar to those of his teacher, de Heem, and he seems also to have borrowed from him the strange genre of outdoor plant and animal-life. While artists such as the appropriately named van Schriek specialized in dramatic scenes of unhealthy life in the hedgerows, Mignon has placed an arrangement of garden flowers into his busy cave. The surrealist note is heightened by the vivid effect of the lighting and the detail and accuracy with which everything is depicted. ·

Plate 18. HIERONYMUS GALLE (1626–after 1679): *Pink and White Flowers in a Glass Vase.* Signed. About 1665? Panel, 46·7 × 34·7 cm. Maestricht, Bonnefanten Museum.

This painting by a little-known follower of Seghers in Antwerp is characterized throughout by great calligraphic mastery of the brush, even to the elaborate signature. The elegance and transparency of the paint is matched by the subtle and subdued range of colours. Where Seghers would have used sprigs of orange blossom, Galle, with a perverse stroke of inspiration, takes twigs bearing young, undeveloped fruit to crown his composition.

Plate 19. SIMON PIETERSZ. VERELST (1644–*c.*1721): *Tulip, Roses and Ranunculus.* About 1670? Canvas, 42·2 × 36·4 cm. Cambridge, Fitzwilliam Museum.

Simon Verelst is the most distinguished member of a family of painters from The Hague who settled in England. Samuel Pepys came across him in 1669 and recorded in his diary: 'One Evarelst [sic] . . . did show us a little flowerpot of his doing, the finest thing that ever, I think, I saw in my life, the drops of dew hanging on the leaves so as I was forced, again and again, to put my finger to it, to feel whether my eyes were deceived or no. He do ask £70 for it. . .' Verelst received considerable patronage from the Restoration court and later turned to portraits.

Plate 20. JACOB WALSCAPELLE (1644–1727): *Flowers in a Vase on a Ledge.* Signed. About 1680? Panel 38 × 30 cm. Brussels, Musées Royaux des Beaux-Arts.

Born in Dordrecht, Walscapelle gave up painting in the late 1680s and devoted himself to several municipal offices in Amsterdam. His style, both in technique and composition, is clearly modelled on de Heem's, and he shares with him a fondness for one or two particular flowers, like the attractive yellow Austrian briar here. Unlike the larger and showier paintings of the de Heem school, the jewel-like effect of this small bouquet does not overwhelm the viewer with an excess of magnificence and colour.

Plate 21. RACHEL RUYSCH (1664–1750): *Hollyhocks and Other Flowers on a Ledge with Peaches.* Signed and dated 1701. Canvas, 76·2 × 63·5 cm. Cambridge, Fitzwilliam Museum.

Rachel Ruysch is probably the most distinguished of all women painters and is second to no one in her own field. She had ten children by her marriage to a minor portrait-painter and she was also Court Painter at Düsseldorf from 1708 until 1713. She produced a steady flow of impeccable canvases until she was eighty.

Her work combines all that is best in Dutch flower painting at the end of the seventeenth century with a softness and delicacy of colour and texture and a rococo liveliness of design.

Plate 22. JEAN-BAPTISTE MONNOYER (1636–99): *Two Putti with Flowers*. About 1670? Canvas, 88 × 123 cm. Rouen, Musée des Beaux-Arts.

The unprecedented building programme of Louis XIV created an enormous demand for decorative paintings for the French royal residences. With the friendship of the dictatorial *premier peintre*, Lebrun, Monnoyer obtained a virtual monopoly on commissions for floral work and executed some sixty flower paintings for Versailles and other palaces. He also produced designs for tapestries and in 1690 came to England to work for the Duke of Montagu. The low view-point and frivolous *putti* of this composition suggest an overmantel in a salon decorated on a mythological theme.

Plate 23. ALEXANDRE FRANÇOIS DESPORTES (1661–1743): *A Dog with Flowers and Dead Game*. Signed. 1715? Canvas, 131 × 164 cm. London, Wallace Collection.

A practising portrait-painter, Desportes is better known for his still lifes with dead game and studies of animals. Born in Paris, his apprenticeship to an obscure Flemish artist seems to have determined the direction of his style away from the rather Italianate decorations of artists such as Monnoyer. He also visited England, and his paintings were much in demand for palaces and country houses throughout Europe. Most of his game pictures show one or two flowering plants in typical bluish rococo shades.

Plate 24. RACHEL RUYSCH (1664–1750): *Roses, Marigolds, Hyacinth and Other Flowers on a Marble Ledge*. Signed and dated 1723. Canvas, 38·1 × 30·5 cm. Glasgow, Art Gallery and Museum.

Painted more than twenty years later than Plate 21, this small canvas, with its diagonally-based composition of luxuriant cabbage roses and double flowers, shows how Rachel Ruysch's art had moved with the times, both stylistically and in her choice of blooms. She nevertheless retains the dark backgrounds of the seventeenth century and avoids the often artificial colouring and settings of her contemporary, van Huysum.

Plate 25. JAN VAN HUYSUM (1682–1749): *Flowers on a Ledge in a Landscape*. Signed and dated 1726. Panel, 80 × 60 cm. London, Wallace Collection.

This Amsterdam painter was known in his day as the 'Phoenix of Flower Painters' and many still regard him as such. Van Huysum's miraculous technique and finish are always breathtaking; brushstrokes are invisible and the urge to wipe the dew drops off the surface of the painting is irresistible. His conscientiousness, so evident from his technique, is also demonstrated in a letter explaining he had been unable to finish a commission that year for lack of a particular rose. Hence the fact that several of his paintings are dated twice.

Plate 26. JAN VAN HUYSUM (1682–1749): *Study of Flowers in an Urn*. Signed. Inscribed 1730. Pen, ink and watercolour, 39·6 × 30·8 cm. Cambridge, Fitzwilliam Museum.

Preparatory studies for flower paintings are not common, although Monnoyer had also produced drawings much prized by collectors. It might seem surprising that the most meticulous of flower painters should have produced such freely executed masterpieces of rococo draughtsmanship, but van Huysum clearly liked to create

each composition afresh, using his drawing as a guide, before embarking on the laborious task of painting each flower into its allotted place. His drawing technique, with its pale watercolour washes, may have played a part in lightening his palette, one of his principal innovations.

Plate 27. JEAN-BAPTISTE-SIMEON CHARDIN (1699–1779): *Flowers in a Blue and White Vase*. About 1760–3. Canvas, 43·8 × 36·2 cm. Edinburgh, National Gallery of Scotland.

Three paintings of flowers by Chardin were recorded in his lifetime, but this magical canvas is the only one to survive. As in his other still lifes, Chardin's aim here is prophetically close to that of the Impressionists; with crumbly paint he evokes the fall of gentle light on the simplest of subjects and depicts colour and structure with a rare depth. Vague as they seem, these flowers exhale an almost fragrant freshness compared with the garish ostentation of so much rococo flower painting.

Plate 28. HENRI-HORACE ROLAND DE LA PORTE (c.1724–93): *Little Orange Tree*. Exhibited 1763. Canvas, 60 × 49·5 cm. Karlsruhe, Staatliche Kunsthalle.

Roland de la Porte was probably a pupil of the still life and animal painter. J.-B. Oudry although, significantly, this and several other paintings by him were for a long time attributed to Chardin. We can see today that Roland de la Porte's work is more precise, less grainily atmospheric than the older master's, but he shares with him a fondness for gentle light and a profound respect for the simple things of life.

Plate 29. ANNE VALLAYER-COSTER (1744–1818): *Roses, Ranunculus and Other Flowers in a Blue Vase*. Signed. About 1775–80. Canvas, 40 × 32 cm. Nancy, Musée des Beaux-Arts.

Anne Vallayer-Coster, who later became painter to Marie-Antoinette, suffered in her early career from Diderot's criticism that she, like Roland de la Porte, was a 'victim' of Chardin. In fact, her softly painted flowers in warm colours, although owing much to the master, are an example of the late rococo flowerpiece at its best. Fragonard's name seems a more appropriate comparison for the rounded fullness of her roses and delicious textures of the smaller-petalled flowers.

Plate 30. JOHN CONSTABLE (1776–1837): *Autumn Berries and Flowers in a Brown Pot*. About 1814? Canvas, 45·7 × 30·5 cm. National Trust, Knightshayes Court, Devon, Heathcoat-Amory Collection.

Although Constable made drawings and ocasionally paintings of growing wild plants as Gainsborough, Crome and other British landscape-painters had done before him, he also painted one or two arrangements of flowers in vases. This modest bouquet is like a breath of fresh autumn air in comparison with the stilted compositions of hot-house blooms produced by the professional flower-painters of the day. Constable's spontaneous approach to nature paved the way for the Impressionists half a century later.

Plate 31. JOHN FREDERICK LEWIS (1805–76): *In the Bey's Garden*. Signed and dated 1865. Canvas, 106·7 × 68·6 cm. Preston, Harris Museum and Art Gallery.

Subjects from the harem are frequent in Lewis's Middle-Eastern paintings and caused a sensation when they were first exhibited at the Royal Academy. In order to dispel any moral doubts about her status, the lady holds a madonna lily, an emblem which even in the Victorian 'Language of Flowers' stood for 'purity'. Lewis thus creates a nineteenth-century secular equivalent of the Madonna in the garden – a sunlit escape from the drabness and frustrations of mid-Victorian life.

Plate 32. EUGÈNE DELACROIX (1798–1863): *Basket of Flowers in a Park*. 1848. Canvas, 105 × 140 cm. New York, Metropolitan Museum of Art.

Both the great enthusiasm and respect for the art of the past with which this most romantic of all painters tackled every possible subject are evident even in this painting of flowers. Delacroix undertook several large-scale decorations in the manner of the seventeenth-century baroque and it is perhaps not unexpected that he should have attempted a decorative flower painting in the same vein. What is new is the immediacy and vigour of the paint, and the impression of movement in his emotive confusion of vivid colours.

Plate 33. ANSELM FEUERBACH (1829–80): *Roses*. Signed and dated 1871. Canvas, 56 × 78 cm. Karlsruhe, Staatliche Kunsthalle.

These lusciously painted roses are unfortunately an exception in Feuerbach's *œuvre*. The most considerable of the German academic painters in the second half of the nineteenth century, he is better known for his enormous and rather chilly neo-Greek subjects, whose marbled perfection belies the warmth and spontaneity of execution found here. The sensuousness of these larger-than-life flowers suggests a happy impulse in the artist's otherwise rather troubled life.

Plate 34. GUSTAVE COURBET (1819–77): *The Trellis*. Signed. 1863. Canvas, 109·9 × 135·2 cm. Toledo, Ohio, Toledo Museum of Art.

Although the arch-realist Courbet would have rejected the idea that his art was in any way dependent on that of the past, we can see that his exuberant and broadly-painted arrangement of flowers owes much to the same decorative pictures of the Italian and French baroque which Delacroix admired. The abundance of mixed flowers growing against the trellis is no more realistic than the gesture of the pretty girl arranging them.

Plate 35. EDGAR DEGAS (1843–1917): *Woman with Chrysanthemums*. Signed and dated 1865. Paper on canvas, 73·7 × 92·1 cm. New York, Metropolitan Museum of Art (Bequest of Mrs H. O. Havermeyer).

It was perhaps as a result of seeing Courbet's *The Trellis* of two years earlier (Plate 34) that Degas was inspired to experiment with this unusual composition. He captures his sitter (Mme Hertel) in a moment of reverie, almost losing her again in the overflowing bouquet, whose flowers may have raised some train of associations in her mind. The painting's light colours and decorative effect mark the beginnings of Degas's movement towards the technical innovations of the Impressionists.

Plate 36. PIERRE AUGUSTE RENOIR (1841–1919): *Spring Bouquet*. Signed and dated 1866. Canvas, 105·4 × 80 cm. Cambridge, Massachusetts, Fogg Art Museum.

Renoir began his artistic training painting floral decorations on porcelain, and throughout his life continued to be fascinated with the play of light and colour which painting flowers afforded him. This, one of the finest of his early works, shows that he had learnt much from Courbet in freedom of technique and creating light and colour over a dark ground. The muted pinks and lilacs of his richly dishevelled bouquet are, however, already washed and blurred by brilliant morning sunlight.

Plate 37. HENRI FANTIN-LATOUR (1836–1904): *Still Life with Vase of Hydrangeas and Ranunculus*. Signed and dated 1866. Canvas, 73 × 59·6 cm. Toledo, Ohio, Toledo Museum of Art.

Although Fantin-Latour is now remembered chiefly as one of the greatest exponents of flower painting in the nineteenth century, he would probably have considered that his fame should rest on his many small symbolical paintings of mysterious

and hazily draped nymphs, inspired by his love of music and of Wagner in particular. The Toledo painting is one of the most exquisite of his early still lifes and was painted in the same year as Renoir's *Spring Bouquet* (Plate 36). Fantin's neutral backgrounds, static interior light and meticulous technique show how little he was affected by the revolutionary ideas of the circle he moved in, and his style did not alter appreciably throughout his long career.

Plate 38. HENRI FANTIN-LATOUR (1836–1904): *Nasturtiums*. Signed and dated 1880. Canvas, 62·8 × 42·5 cm. London, Victoria and Albert Museum.

If Fantin's earlier *Still Life* (Plate 37) looks back to Chardin and his followers in the mid-eighteenth century, this masterly and objective study of climbing nasturtiums might suggest the botanical drawings of Redouté in the late eighteenth and early nineteenth centuries. It is also possible to discern in its narrow format the influence of the fashionable Japanese decorative panel. Simple studies of flowering plants are not common in Fantin's *oeuvre* but, like those of Dürer, are worthy of a place among the masterpieces of the genre.

Plate 39. CLAUDE MONET (1840–1926): *Mallow Flowers in a Vase*. Signed. About 1882. Canvas, 100·3 × 81·3 cm. London University, Courtauld Institute Galleries.

Gardens are a frequent subject of Monet's paintings, and in his later years he devoted himself almost exclusively to building up the elaborate garden he had created at Giverny. In the late 1870s and early 1880s he produced a number of flower paintings which all exhibit that infectious joy in the immediate sensation of light and colour that made him the most faithful and celebrated of the Impressionists. Chrysanthemums, with their oriental associations, are a favourite subject, but they are no match for the amazing dance of light he creates with the fragile blossoms of these pink and white mallows.

Plate 40. EDOUARD MANET (1832–83): *Roses and a Tulip in a Glass Vase*. Signed. About 1882. Canvas, 56 × 36 cm. Zürich, Bührle Collection.

By the time Manet painted this exquisite still life he was suffering from the paralysis from which he died, and passed his time painting the flowers brought by visiting friends. Although light is of supreme importance in suggesting the strong contrast of colours and background and the luminous delicacy of the stems seen through the crystal vase with its shimmering golden decoration, he uses it in a different way from the Impressionists. The effect is timeless and static, as with Chardin, and his technique looks back to the painterly values of Hals and Velazquez.

Plate 41. PAUL GAUGUIN (1848–1903): *Mandolin and Flowers*. Signed and dated 1885. Canvas, 64 × 53 cm. Paris, Musée du Louvre.

In 1885, Gauguin had already mastered the Impressionist use of colour and freedom of technique, but his expressive contours enclosing flatter areas of colour in an overtly decorative design all reflect a general movement in which he, Cézanne and Seurat were laying the foundations of twentieth-century painting. Gauguin painted many pictures of flowers at all stages of his career. Whether those of a Parisian florist or of a Tahitian jungle, they are seldom easy to identify. Gauguin's primary interest was in their form, colour and associations.

Plate 42. VINCENT VAN GOGH (1853–90): *Sunflowers*. Signed. 1888. Canvas, 92·4 × 65·1 cm. Philadelphia Museum of Art (Mr and Mrs Carroll S. Tyson Collection).

In the spring of 1888, Van Gogh moved to Arles, in Provence, where he spent

some of the happiest months of his disturbed life. In his letters to his brother Theo, he describes the excitement of his latest projects: 'I am hard at it, painting with the enthusiasm of a Marseillais eating bouillabaisse . . . some great sunflowers.' The flowers were to be a decorative scheme of twelve canvases for a studio to be shared with Gauguin. As a great enthusiast for Japanese prints, it is not surprising that Van Gogh should intend his sunflowers as decorations and paint them with such boldness and simplicity. That, with these intentions, he should have produced a series of masterpieces remains one of the mysteries behind the creation of a great painting.

Plate 43. HENRI-JULIEN ('LE DOUANIER') ROUSSEAU (1844–1910): *Flowers in a Vase.* Signed and dated 1909. Canvas, 45·4 × 32·7 cm. Buffalo, New York, Albright-Knox Art Gallery.

Rousseau was a genuinely naïve man, who believed himself to be a great realist artist. Fortunately for posterity, his instinctive genius and powerful imagination survived any attempts by himself or teachers to make a successful academic painter out of him and he developed an original and poetic style of his own. In this late still life, he seems to be trying to create a flowerpiece in the best academic traditions, even, in the branch of ivy, looking back to the seventeenth century. The individual components of the picture, taken from the *petit bourgeois* surroundings of Rousseau's world, are transfigured by his eye into an image of timeless poetry.

Plate 44. AUGUST MACKE (1887–1914): *Clivias.* Signed. 1911. Canvas, 90 × 71·5 cm. Munich, Städtische Galerie im Lenbachhaus.

Of all the young artists in Munich who associated themselves with the Expressionist movement, *Der Blaue Reiter*, Macke was the least complex and the one whose work exhibits that quality not normally associated with German painting, *joie de vivre*. 'Working really means to me being totally immersed in enjoying nature, sunshine, trees, shrubs, people, animals, flowers and pots and pans, tables, chairs, mountains . . .' he wrote. These brilliant greenhouse flowers recreate the exuberance and well-being of summer warmth and colour in a similar way to Van Gogh's sunflowers. Macke's death in action at the beginning of the First World War was an incalculable loss to European painting.

Plate 45. SIR MATTHEW SMITH (1879–1959): *Lilies in a Vase.* Signed. About 1914–15. Canvas, 76·2 × 55·9 cm. Leeds, City Art Gallery.

Smith's brief attendance in Paris at the school run by Henri Matisse, the leader of the 'Fauve' movement, made a profound impression on him and this canvas was one of the first he painted on his return to England. It apparently took him about a year to complete to his satisfaction, and in it we can see him trying to come to terms with many different aspects of the new styles. The juxtaposition of brilliant primary colours for an arrangement of near-white flowers shows how completely he had mastered Fauvist principles. The painting's linear and decorative qualities, if not yet as free as in his later works, create a profoundly satisfying composition.

Plate 46. ODILON REDON (1840–1916): *Vase of Flowers with Branches of Spring Blossom.* About 1905–6. Canvas, 130 × 68 cm. Private Collection.

At about the turn of the century, the tormented visions of Redon's symbolist paintings and sinister lithographs seem to have given way to a brighter and more optimistic view of life, in which flowers played a prominent role. The change to pale, evanescent colours was partly due to his absorption of the Impressionist palette and partly

to his discovery of pastel as an appropriate medium for the serene creations of his old age. He himself described these pictures as '. . . flowers that have come to the confluence of two streams, that of representation and that of memory'.

Plate 47. MARC CHAGALL (b. 1889): *Lovers in the Lilacs*. Signed and dated 1930. Canvas, 128 × 87 cm. New York, Collection Richard S. Zeisler.

Poetry, music and a deep devotion to his wife Bella seem to be the inspiration for most of the Russian-born Chagall's more tranquil paintings, and flowers are often a point of departure for a stream of associations. The scent of heavy-flowered lilacs evokes for him a night of love and moonlight reflected in a murmuring river under the bridge of a distant town. If it is possible to create a 'nocturne' in paint, then Chagall has surely given it its most magical expression.

Plate 48. EMIL NOLDE (1867–1956): *Irises and Poppies*. Watercolour, 35 × 47·5 cm. Seebüll, Ada und Emil Nolde Foundation.

From his early years, the North German Expressionist Emil Nolde had already attained a unique mastery in the volatile medium of rapid watercolour paintings (they are never drawn). Whether landscapes, figures or flowers, they probably constitute the greatest achievement in a neglected medium this century. The glowing blotches of translucent paint seem to express the inner spirit of the flowers, although the violent juxtaposition of clashing colours reminds us of the element of tension to be found throughout his work. 'I loved the flowers for their fate; springing up, blooming, glowing, making people happy, drooping, wilting, finally ending up discarded in a ditch. Human life is not always so logical or beautiful.'

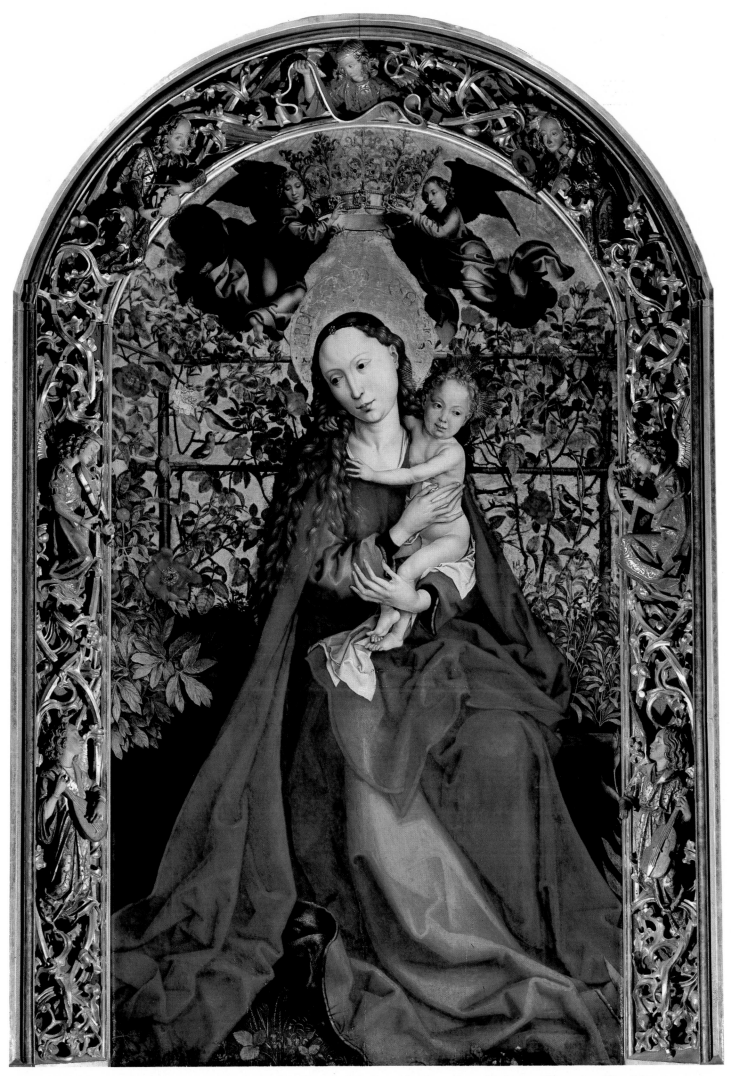

1. MARTIN SCHONGAUER (1453–91): *The Madonna of the Rose Garden*. 1743. Colmar, Church of St. Martin

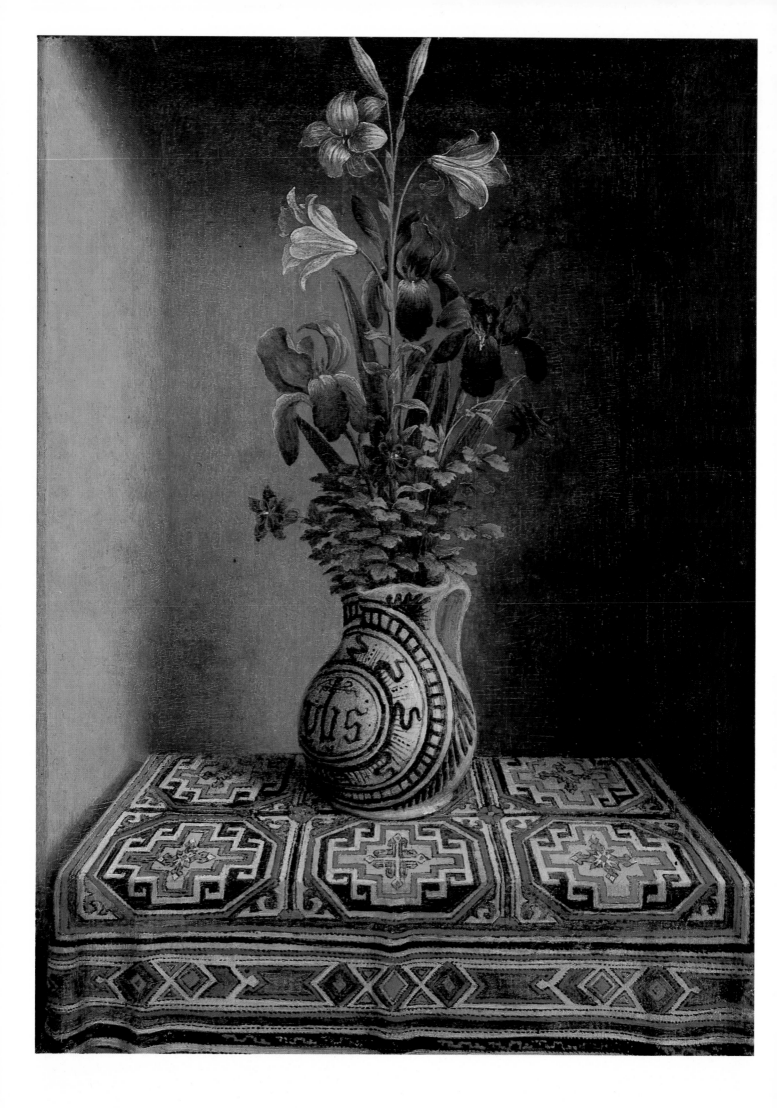

HANS MEMLING (d. 1494): *Vase of Flowers in a Niche*. About 1490. Lugano, Thyssen Collection

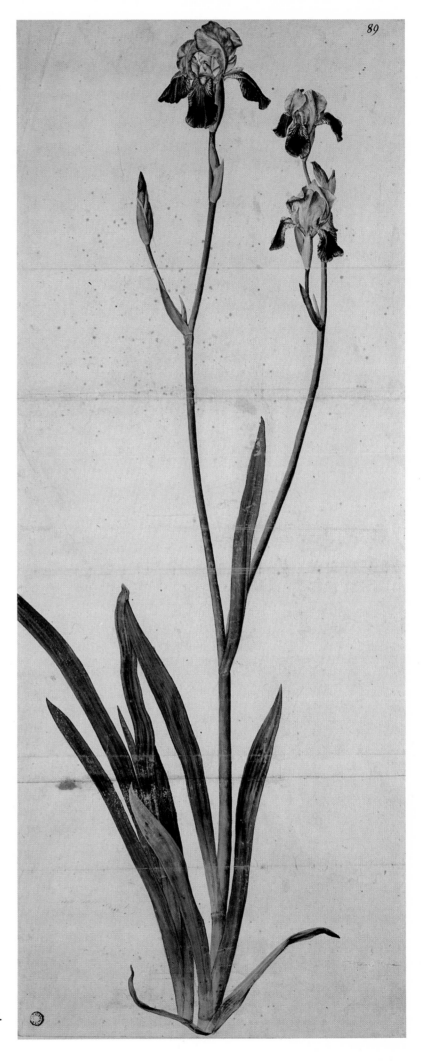

3. ALBRECHT DÜRER (1471–1528): *An Iris*. About 1495. Bremen, Kunsthalle

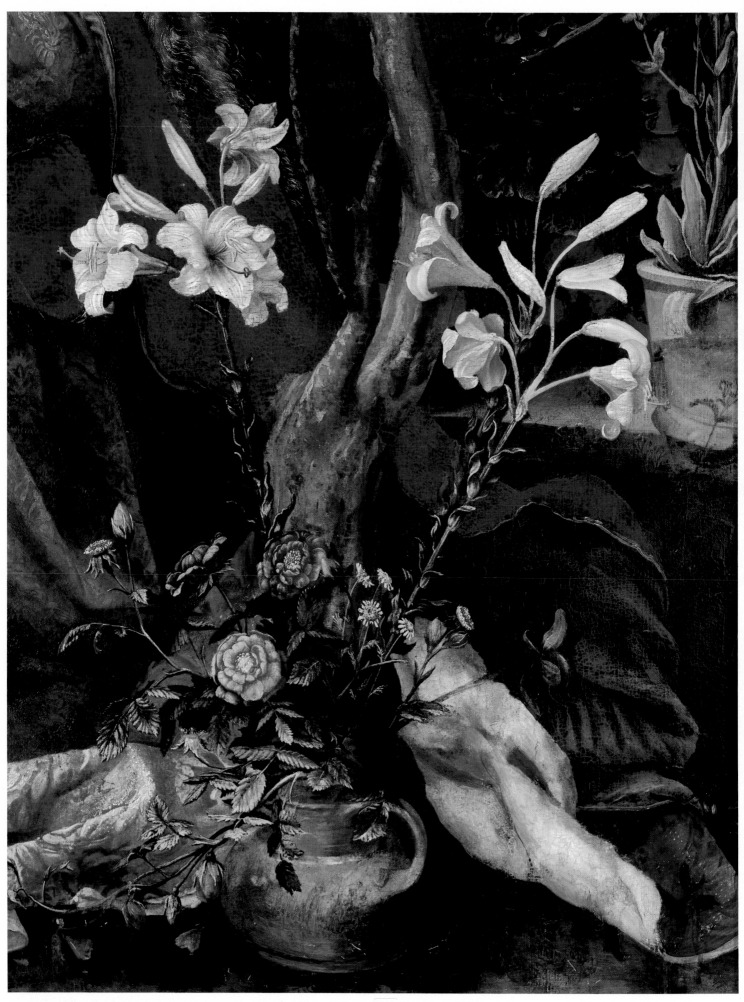

4. MATTHIAS GRÜNEWALD (*c.*1470/5–1528): Detail from the *Stuppach Madonna.* 1517–19. Stuppach, Parish Church

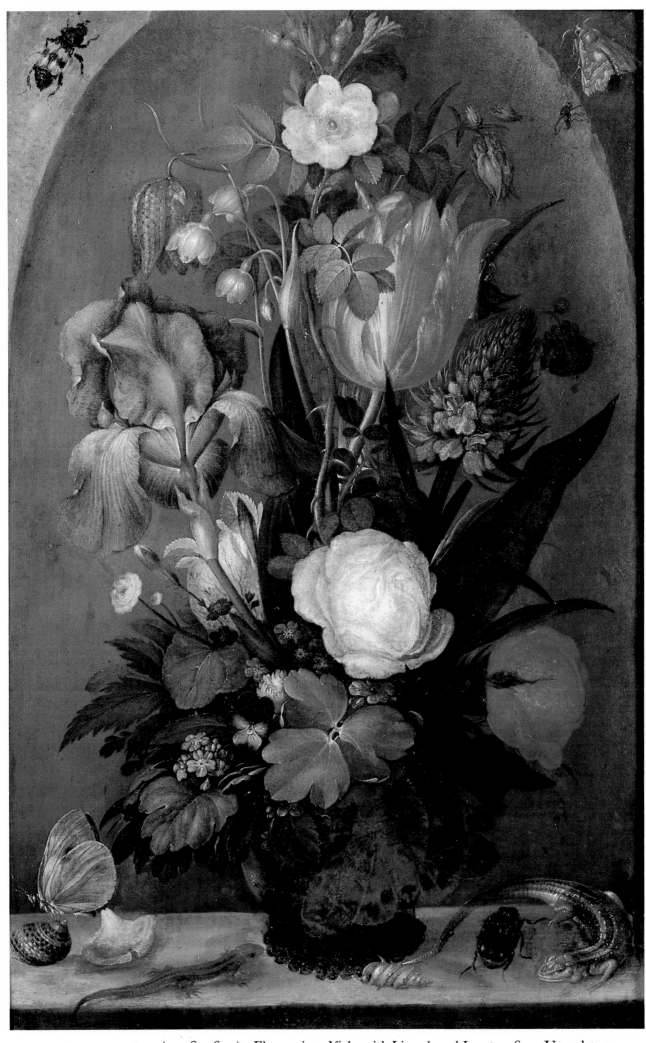

5. ROELANDT SAVERY (1576–1639): *Flowers in a Niche with Lizards and Insects.* 1604. Utrecht, Central Museum

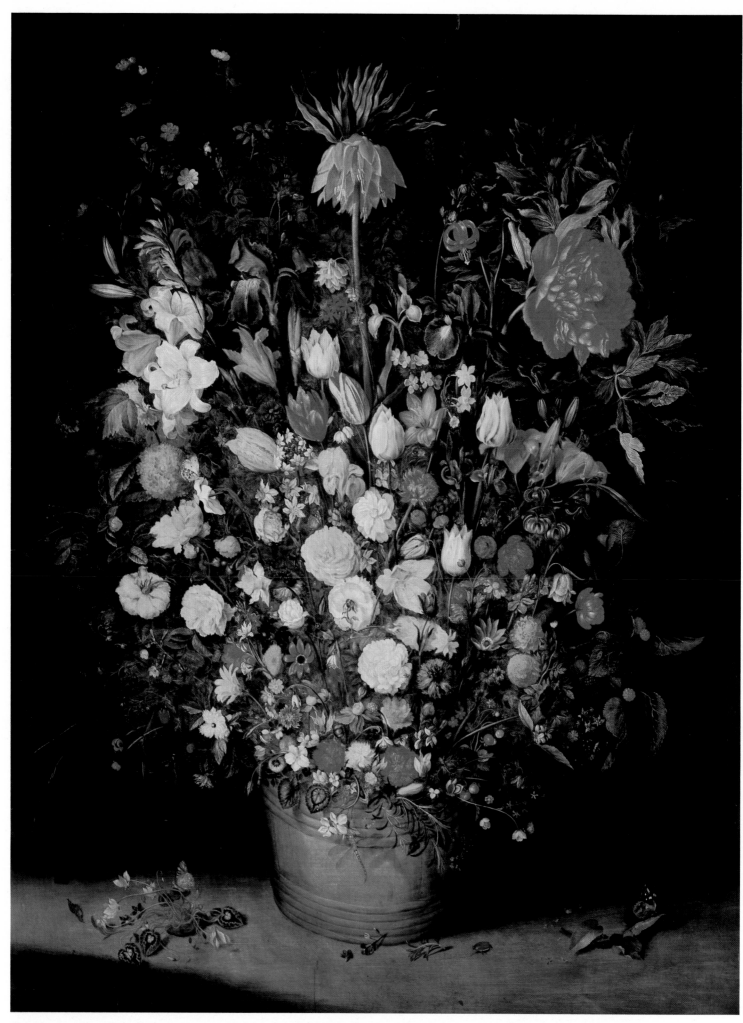

6. JAN BRUEGHEL THE ELDER (1568–1625): *Large Bouquet of Flowers in a Tub*. About 1610? Munich, Alte Pinakothek

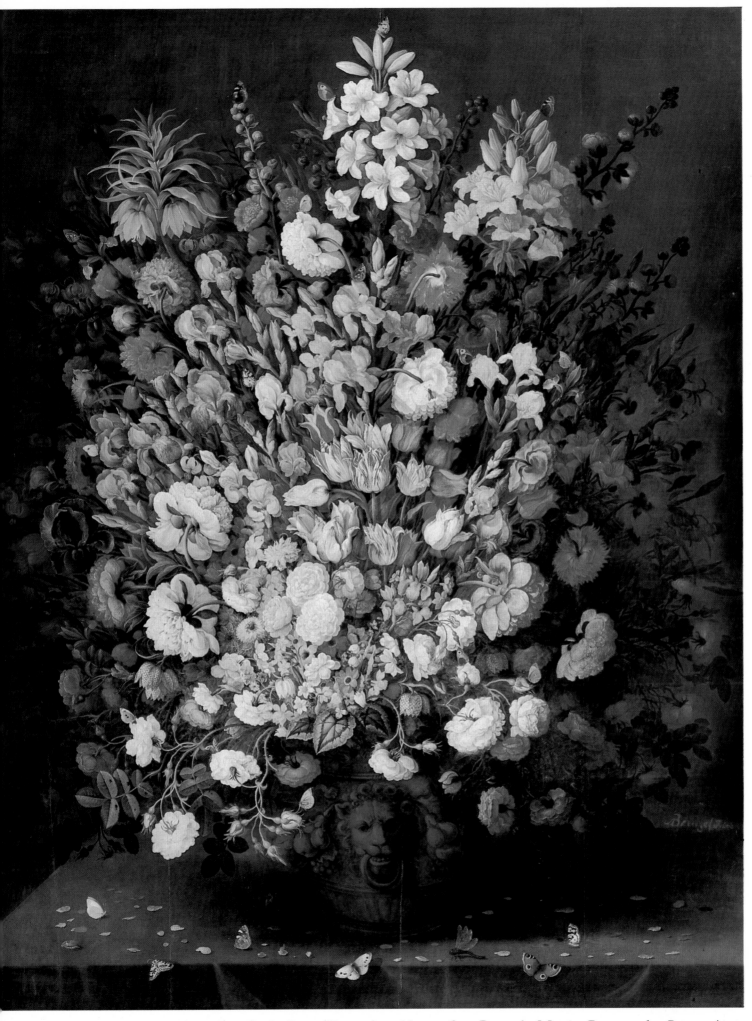

7. OSIAS BEERT THE ELDER (*c.* 1580–1624): *Large Flowerpiece*. About 1615. Brussels, Musées Royaux des Beaux-Arts

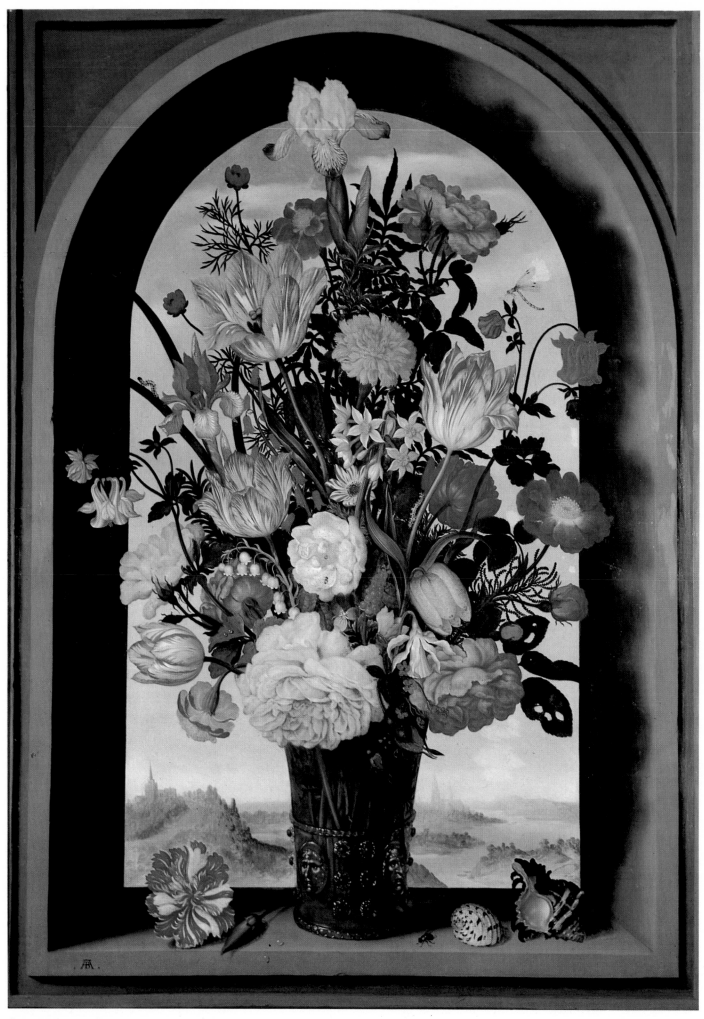

8. AMBROSIUS BOSSCHAERT THE ELDER (1573–1621): *Flowers in a Window Niche with Landscape*. About 1619. The Hague, Mauritshuis

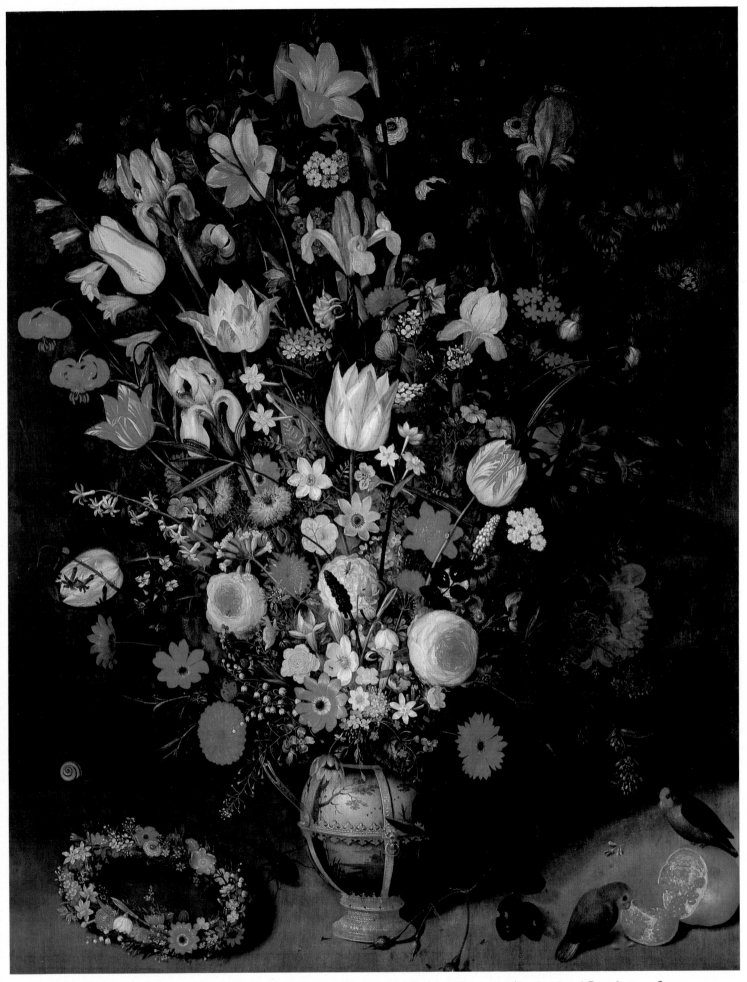

9. PETER BINOIT (1590/3–1632): *Bouquet of Flowers in a Gold-Mounted Vase with Garland and Parakeets.* 1620.
Darmstadt, Hessisches Landesmuseum

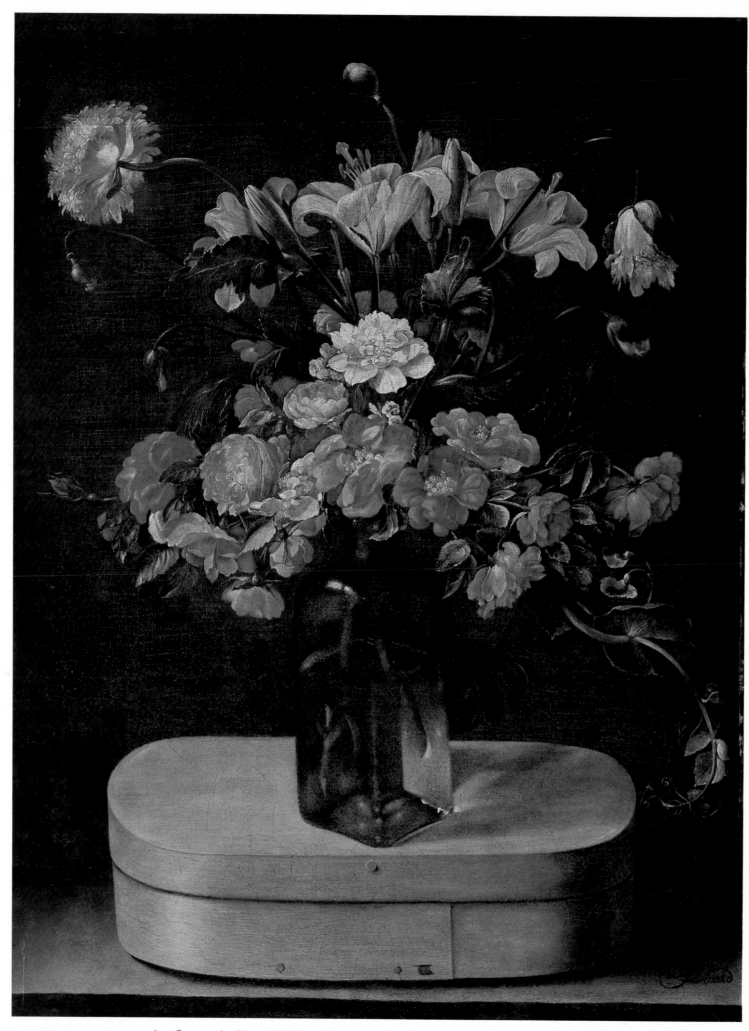

10. JACQUES LINARD (*c*.1600–45): *Vase of Lilies, Roses, and Poppies on a Wooden Box*. About 1630? Karlsruhe, Staatliche Kunsthalle

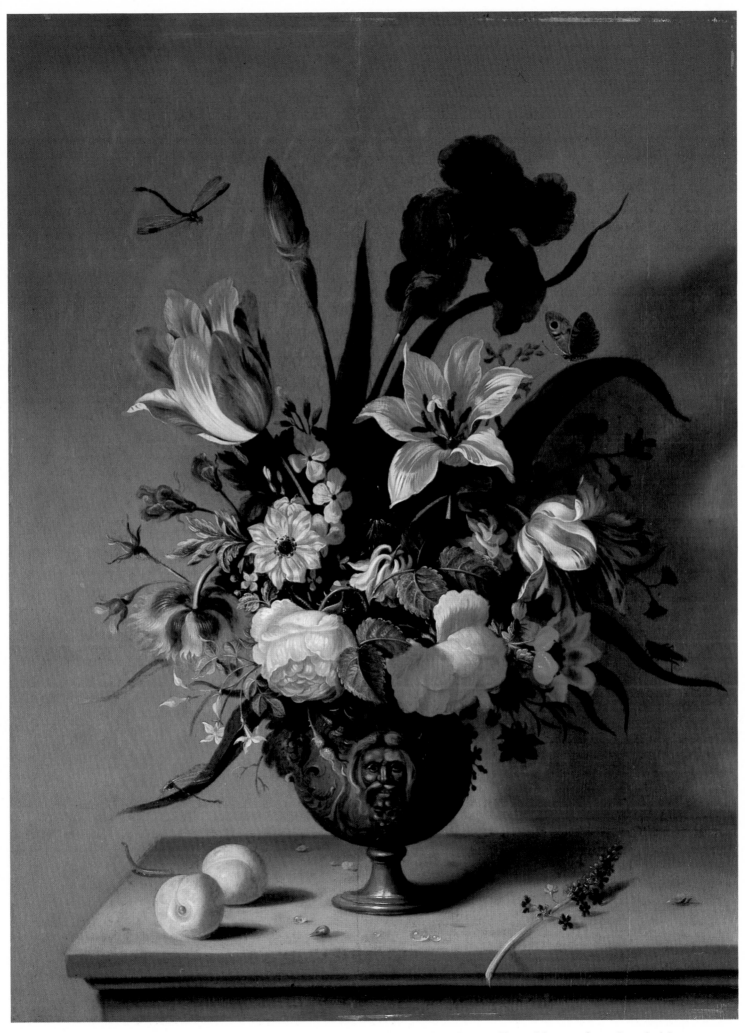

11. AMBROSIUS BOSSCHAERT THE YOUNGER (1610?–45): *Flowers in a Bronze Vase*. About 1640. Cambridge, Fitzwilliam Museum

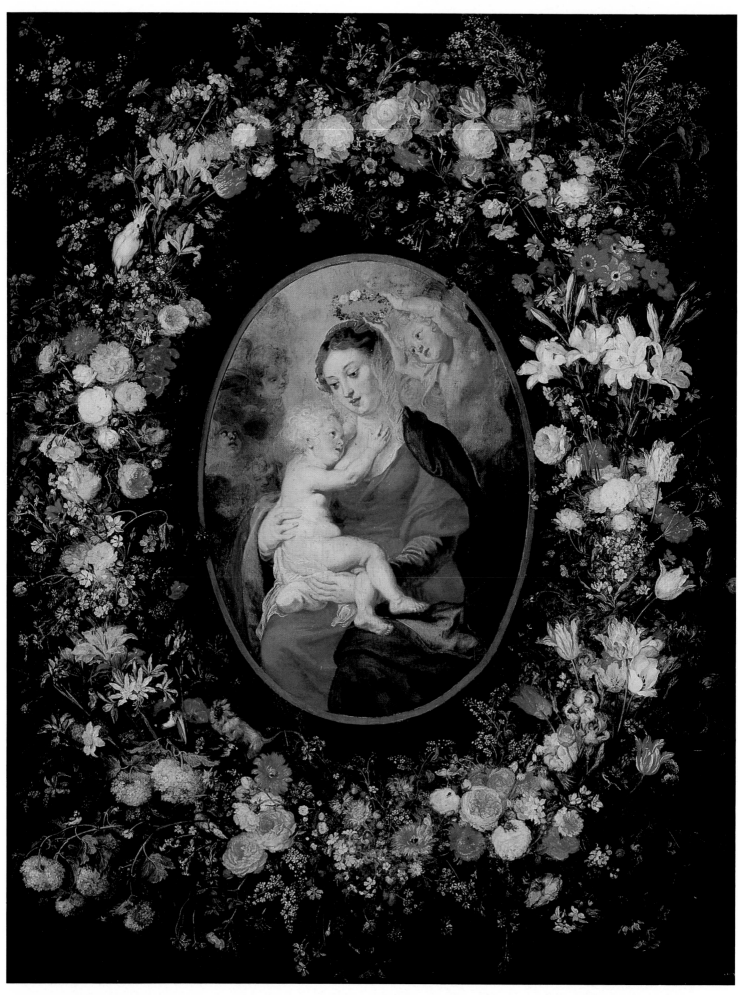

12. JAN BRUEGHEL THE ELDER (1568–1625) and SIR PETER PAUL RUBENS (1577–1640): *Madonna and Child in a Garland of Flowers*. Before 1617. Paris, Musée du Louvre

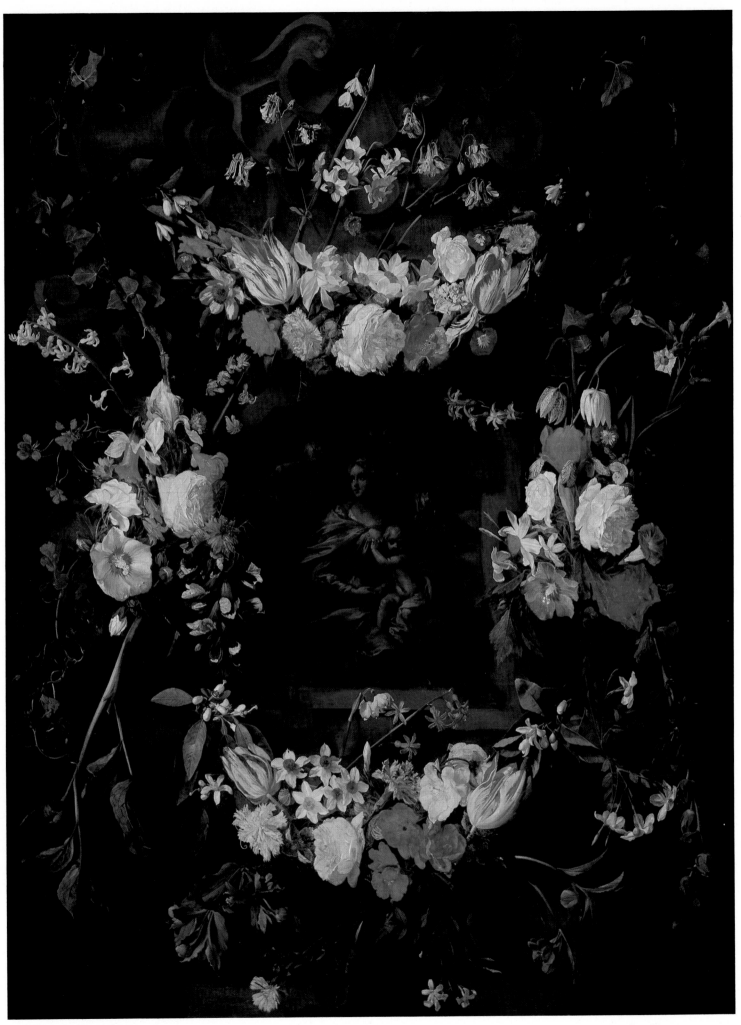

13. DANIEL SEGHERS (1590–1661) and FRANS(?) DENYS (*fl.* 1650): *Garland of Flowers with the Holy Family.*
About 1650? Antwerp, Musée Royal des Beaux-Arts

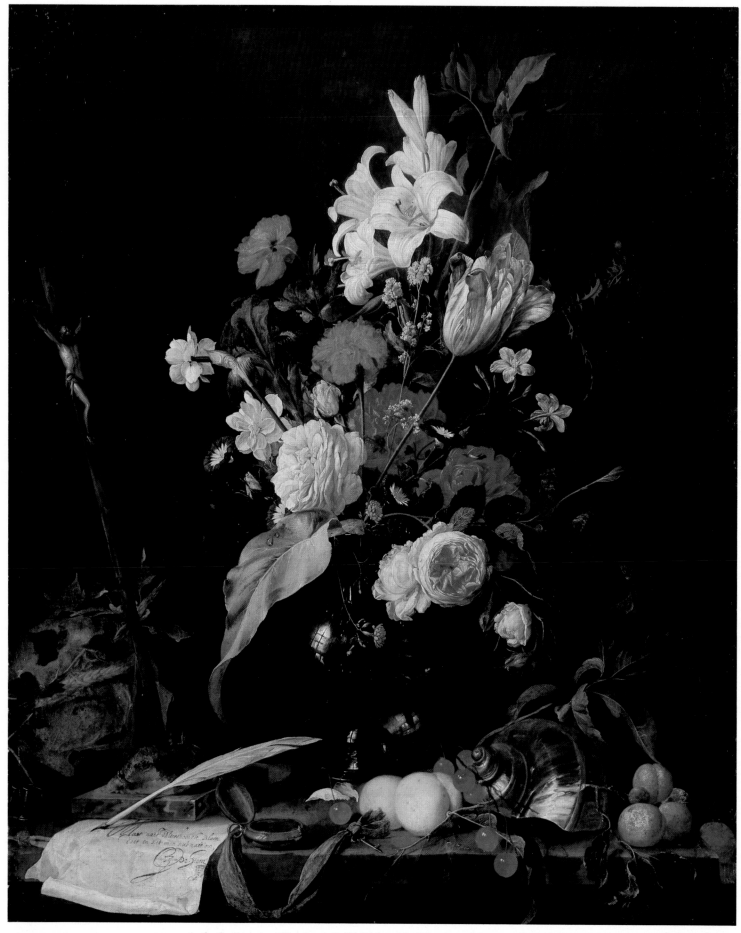

14. JAN DAVIDSZ. DE HEEM (1606–83/4): *'Vanitas' Still Life with Flowers*. About 1660. Munich, Alte Pinakothek

15. DIRCK DE BRAY (*fl.* 1651–78): *Still Life with Flowers*. Signed and dated 1665. Private Collection

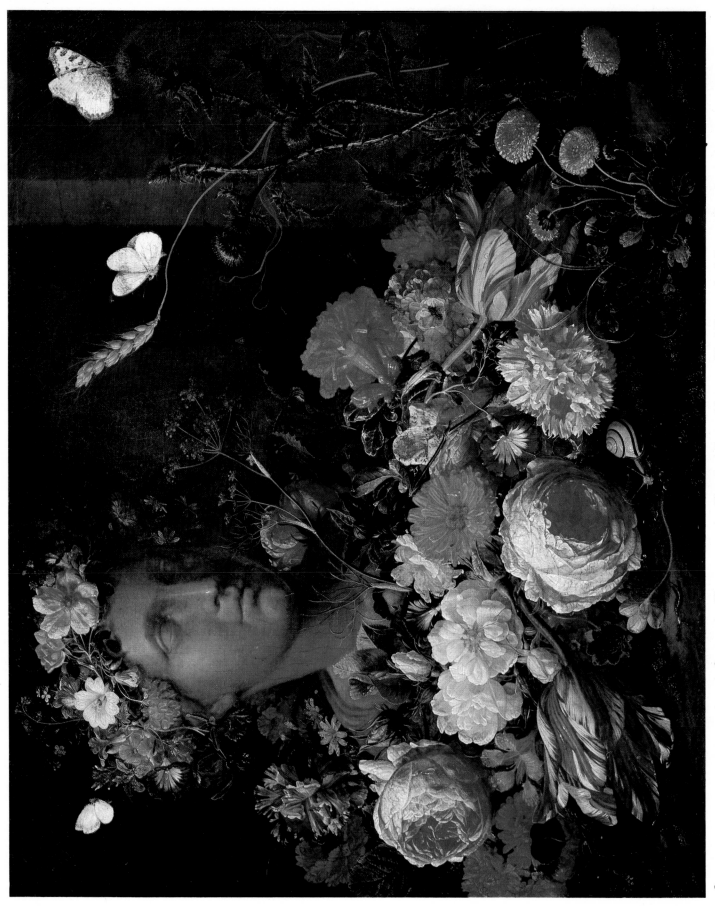

16. NICOLAES VAN VERENDAEL (1640–90) : *Flowers round a Classical Bust*. About 1680? Brussels, Musées Royaux des Beaux-Arts

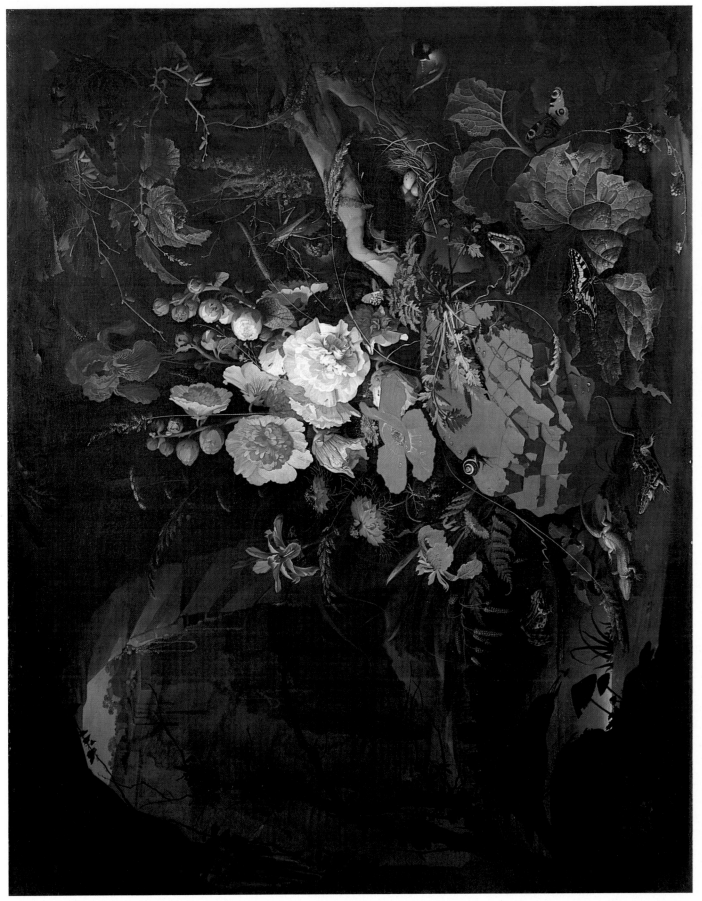

17. ABRAHAM MIGNON (1640–79) : *Flowers, Birds, Insects and Reptiles in a Cave.* About 1675.? Darmstadt, Hessisches Landesmuseum

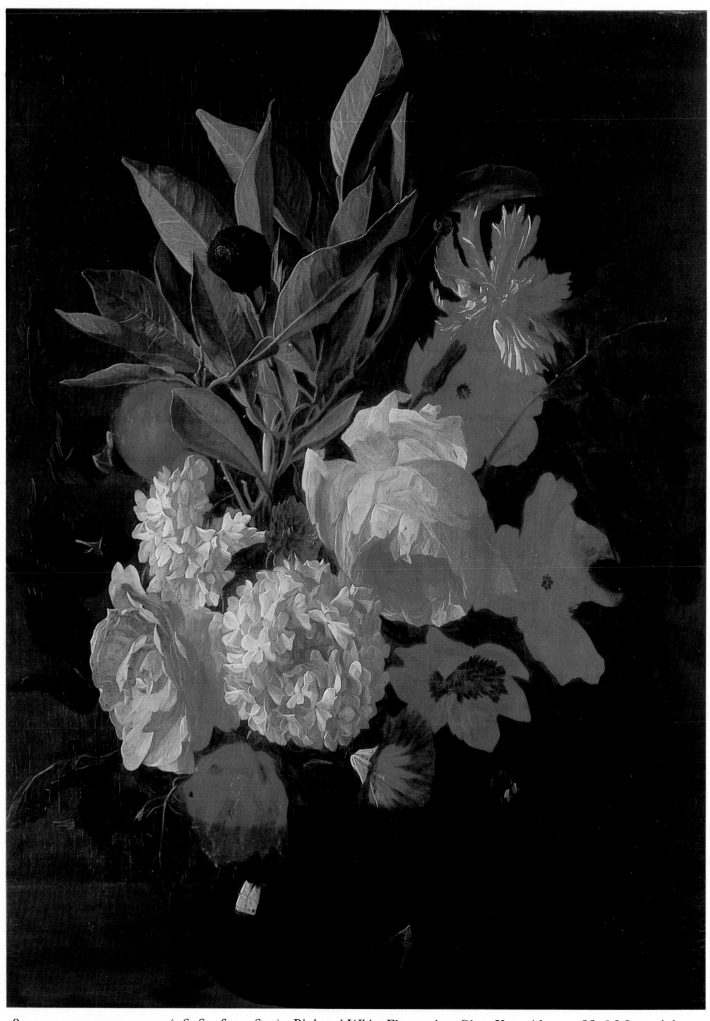

18. HIERONYMUS GALLE (1626–after 1679): *Pink and White Flowers in a Glass Vase*. About 1665? Maestricht, Bonnefanten Museum

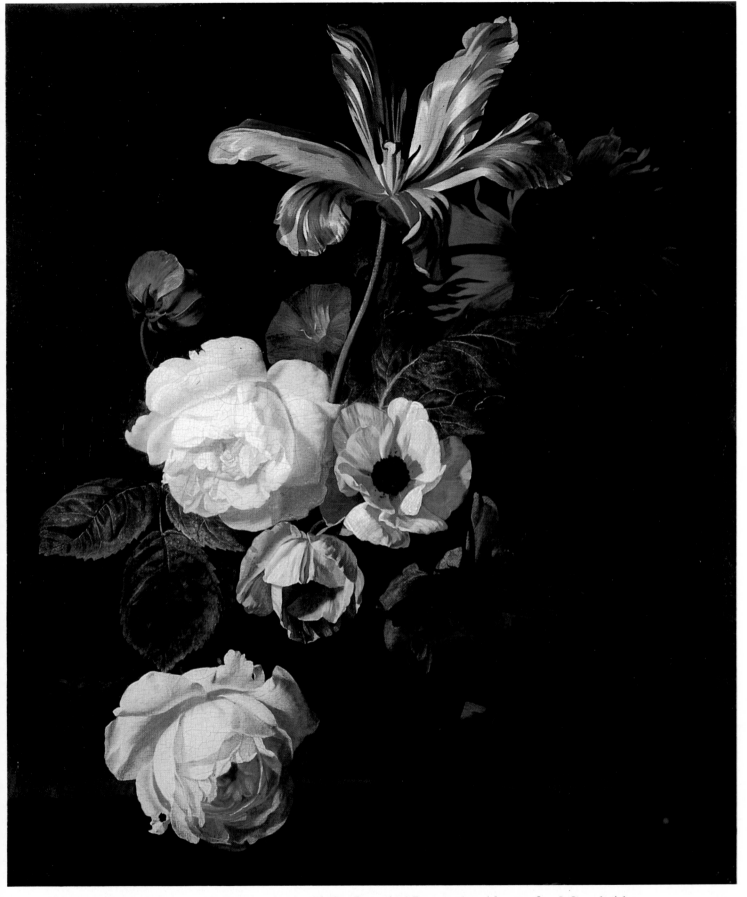

19. SIMON PIETERSZ. VERELST (1644–*c*.1721): *Tulip, Roses and Ranunculus*. About 1670? Cambridge,
Fitzwilliam Museum

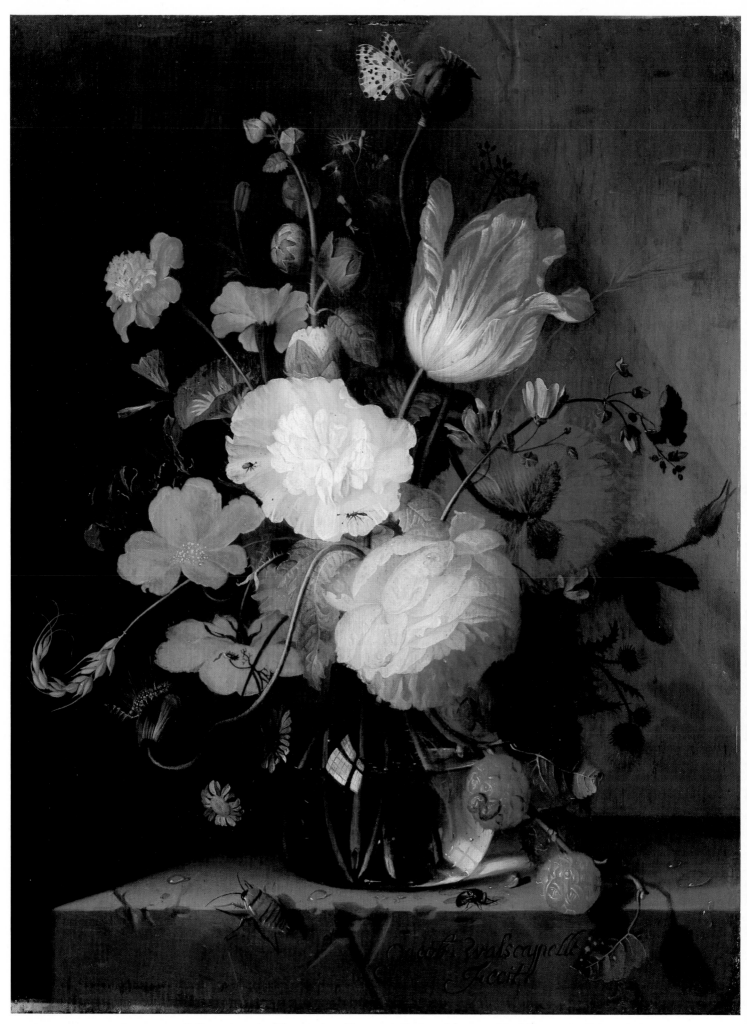

20. JACOB WALSCAPELLE (1644–1727): *Flowers in a Vase on a Ledge*. About 1680? Brussels, Musées Royaux des Beaux-Arts

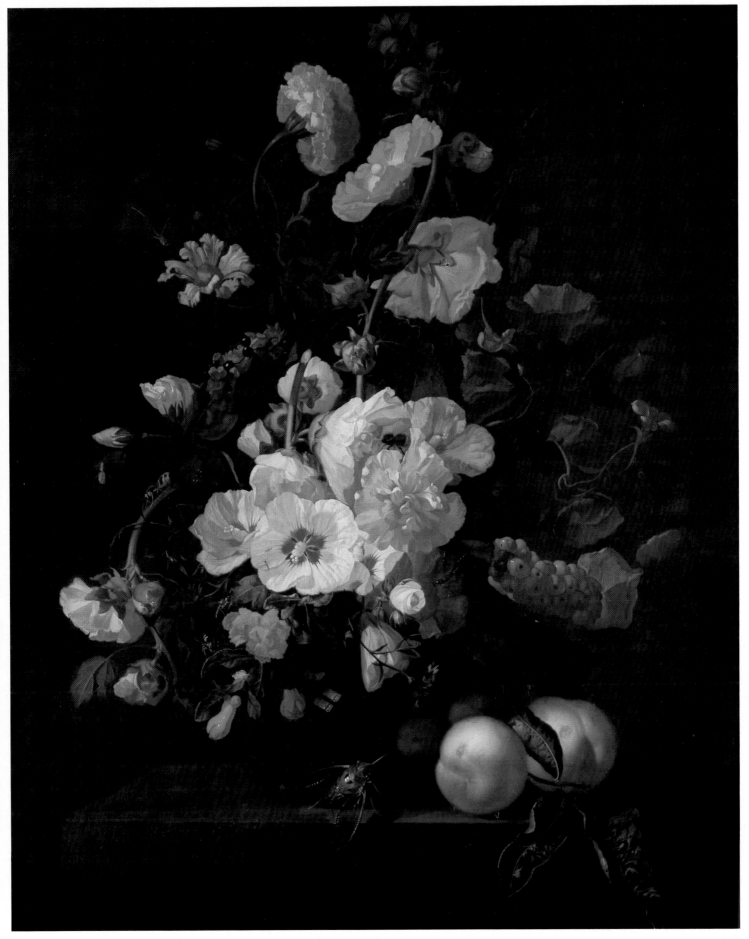

21. RACHEL RUYSCH (1664–1750): *Hollyhocks and Other Flowers on a Ledge with Peaches.* 1701. Cambridge, Fitzwilliam Museum

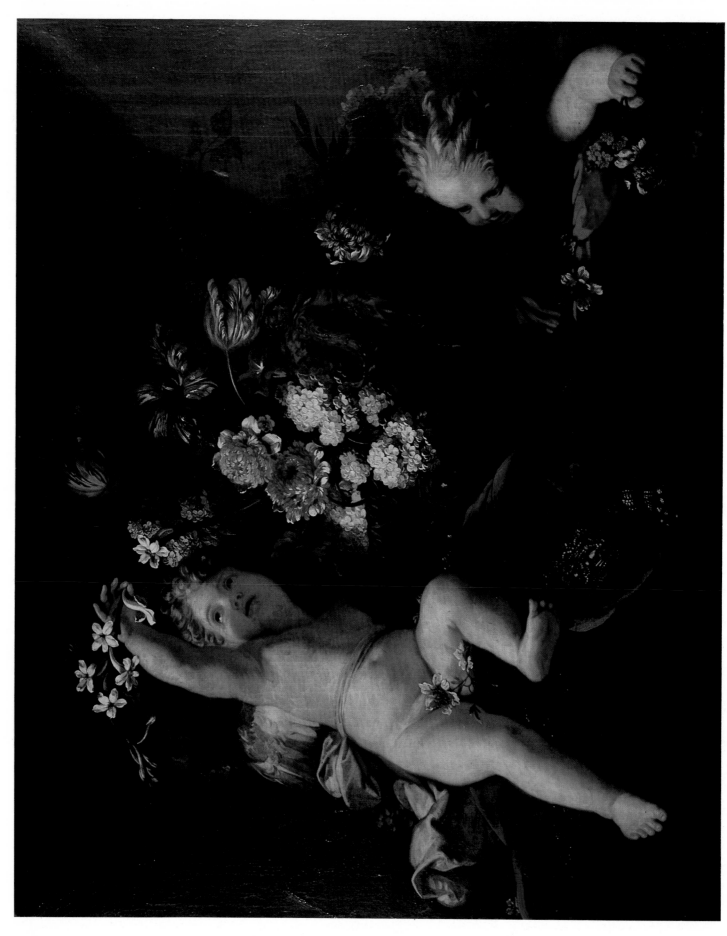

22. JEAN-BAPTISTE MONNOYER (1636–99) : *Two Putti with Flowers.* About 1670? Rouen, Musée des Beaux-Arts

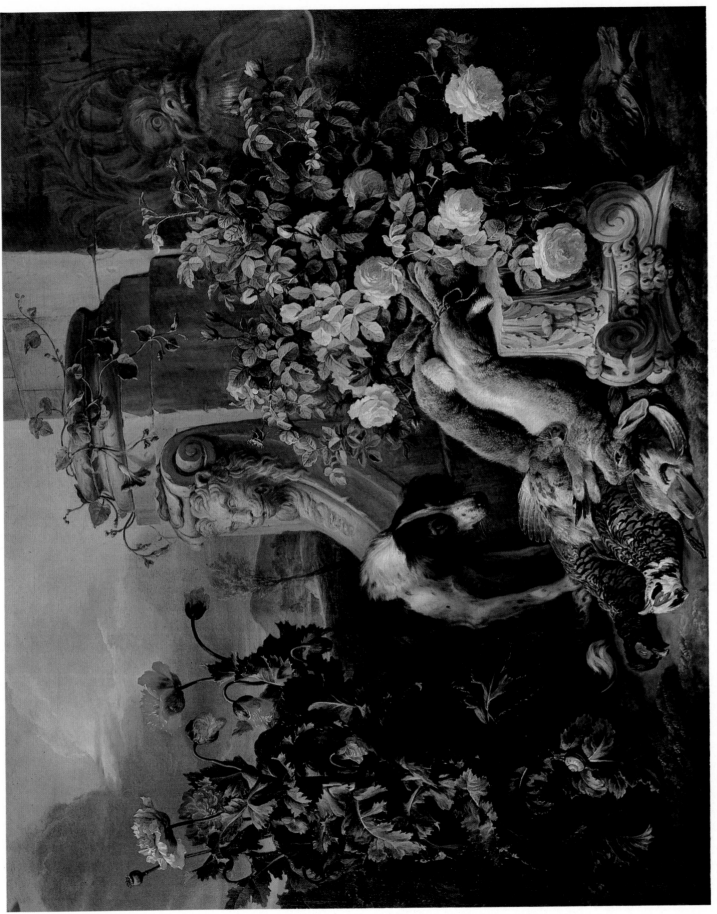

23. ALEXANDRE FRANÇOIS DESPORTES (1661–1743) : *A Dog with Flowers and Dead Game*. 1715? London, Wallace Collection

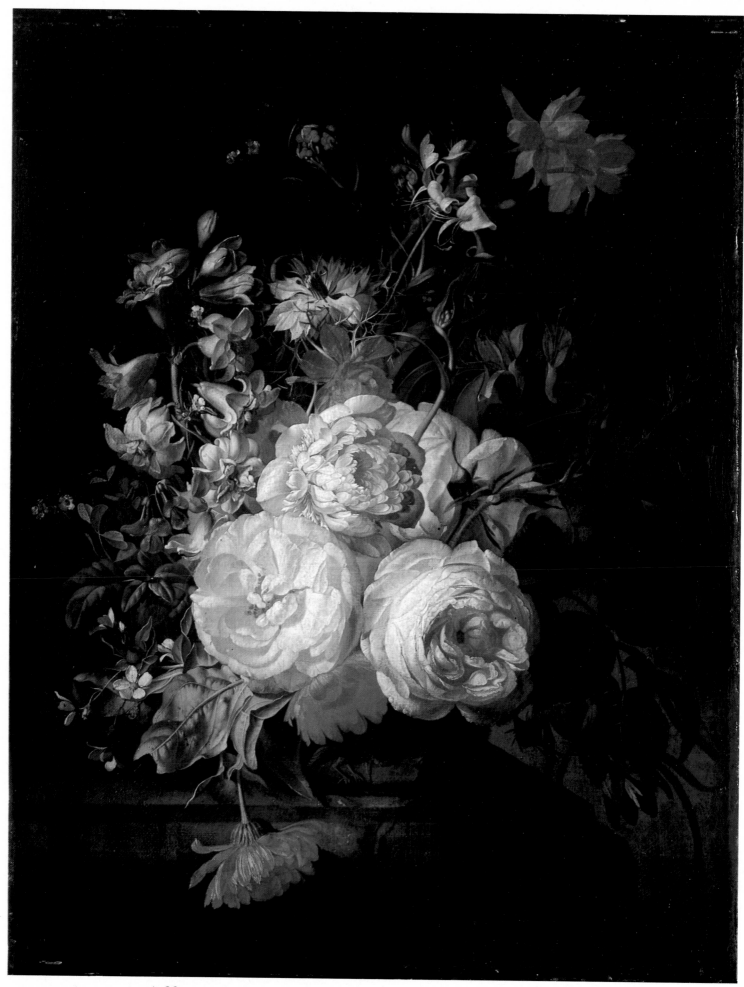

24. RACHEL RUYSCH (1664–1750): *Roses, Marigolds, Hyacinth and Other Flowers on a Marble Ledge.* 1723.
Glasgow, Art Gallery and Museum

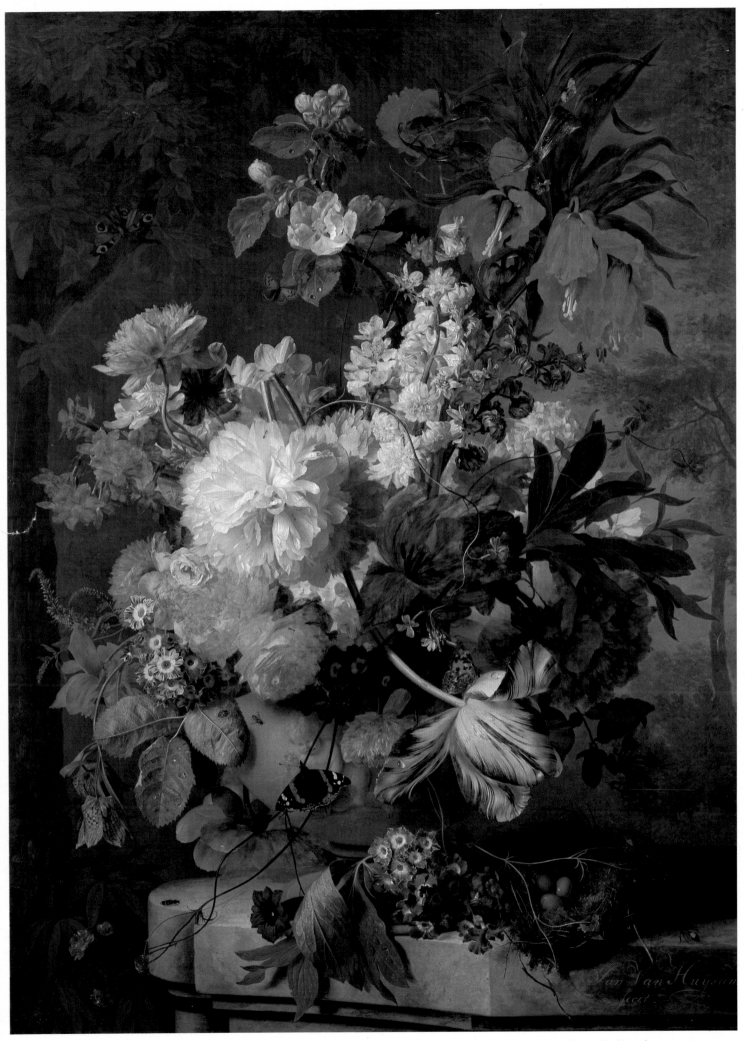

25. JAN VAN HUYSUM (1682–1749): *Flowers on a Ledge in a Landscape.* 1726. London, Wallace Collection

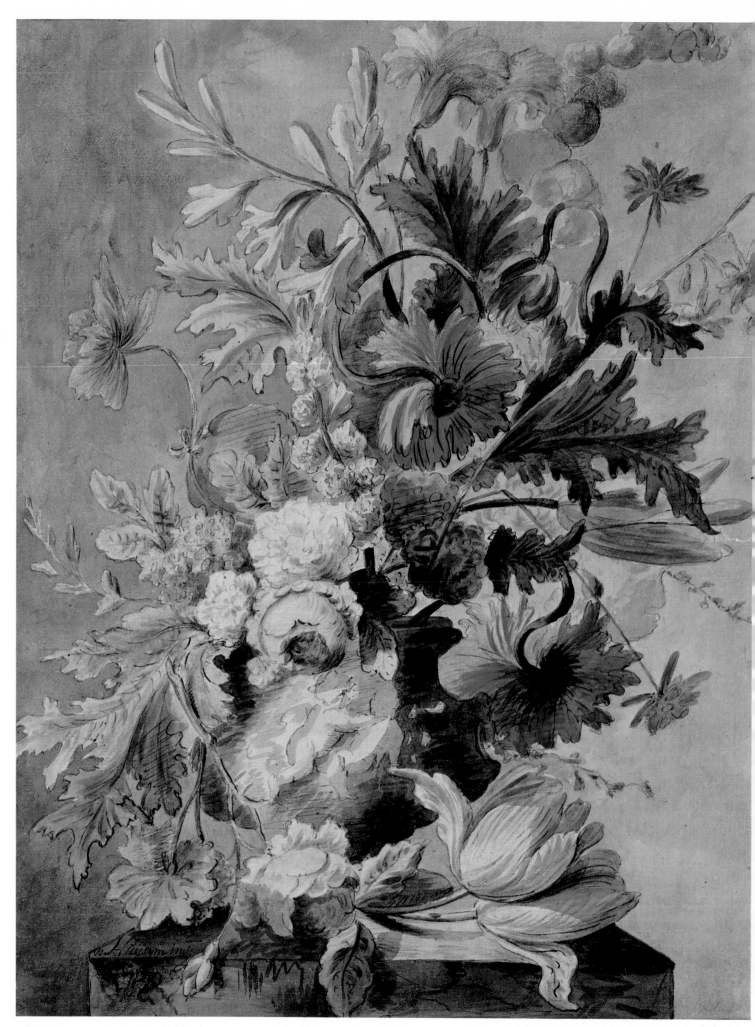

26. JAN VAN HUYSUM (1682–1749): *Study of Flowers in an Urn.* 1730. Cambridge, Fitzwilliam Museum

27. JEAN-BAPTISTE-SIMEON CHARDIN (1699–1779): *Flowers in a Blue and White Vase*. About 1760–3. Edinburgh, National Gallery of Scotland

28. HENRI-HORACE ROLAND DE LA PORTE (*c.*1724–93): *Little Orange Tree.* Exhibited 1763. Karlsruhe, Staatliche Kunsthalle

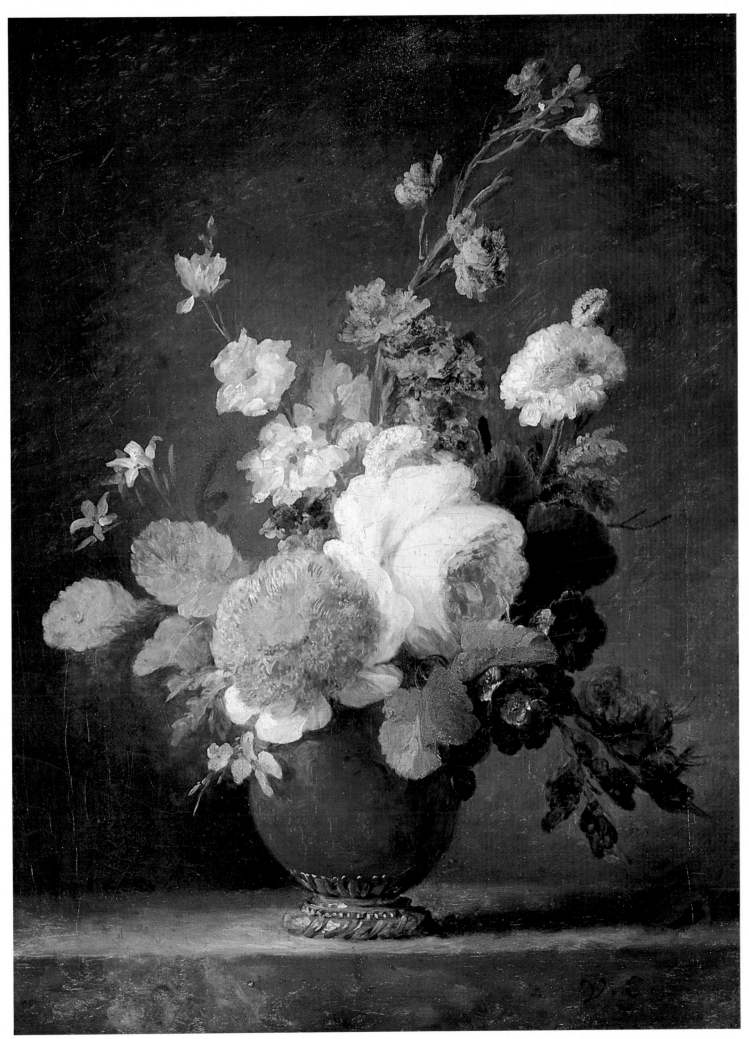

29. ANNE VALLAYER-COSTER (1744–1818): *Roses, Ranunculus and Other Flowers in a Blue Vase*. About 1775–80. Nancy, Musée des Beaux-Arts

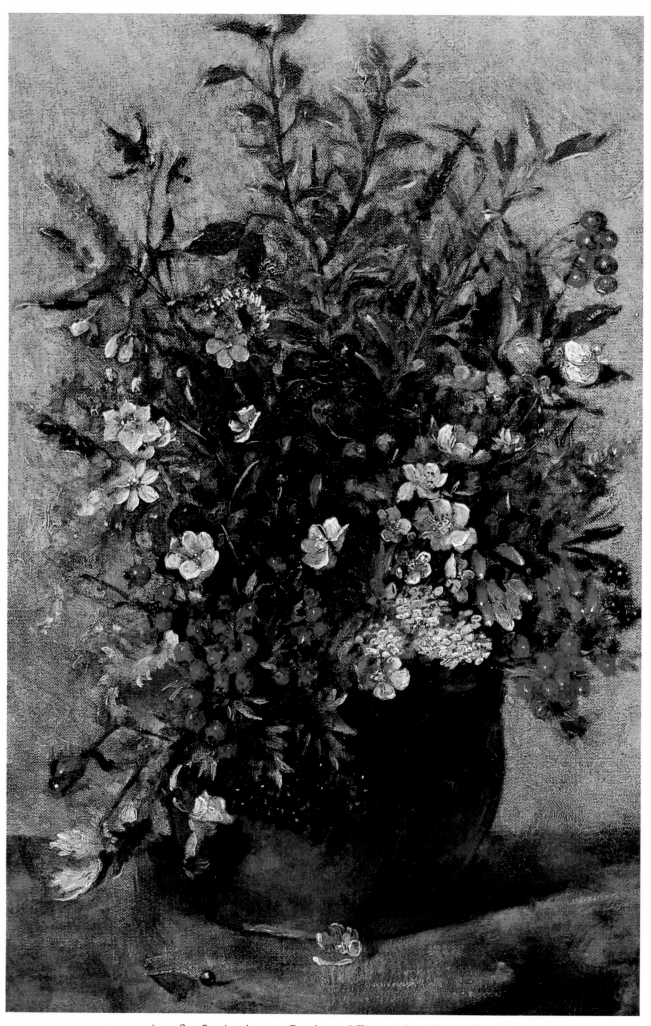

30. JOHN CONSTABLE (1776–1837): *Autumn Berries and Flowers in a Brown Pot*. About 1814?
National Trust, Knightshayes Court, Devon, Heathcoat-Amory Collection

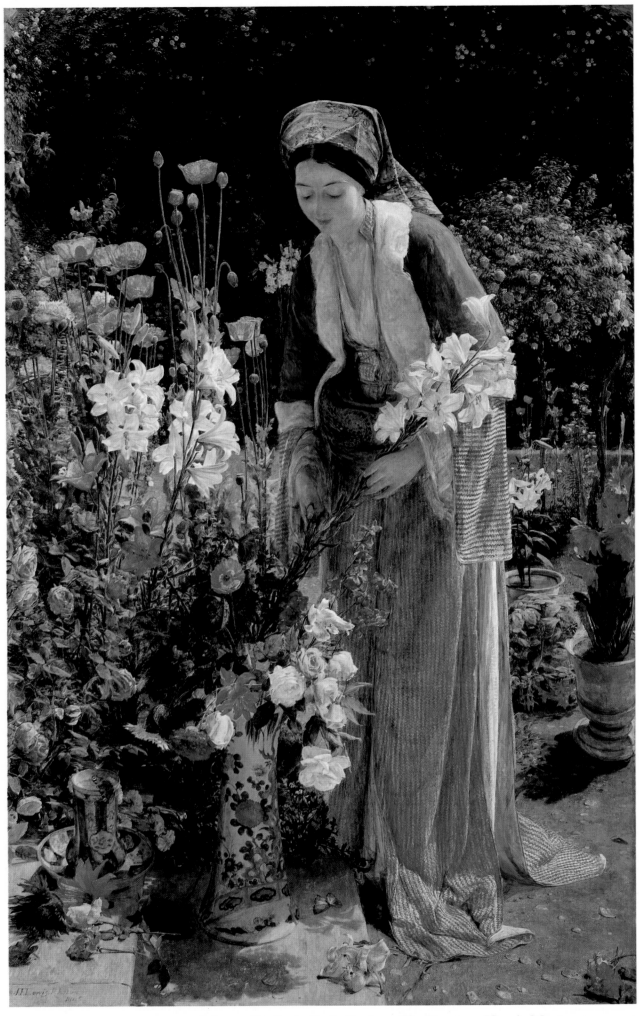

31. JOHN FREDERICK LEWIS (1805–76): *In the Bey's Garden*. 1865. Preston, Harris Museum and Art Gallery

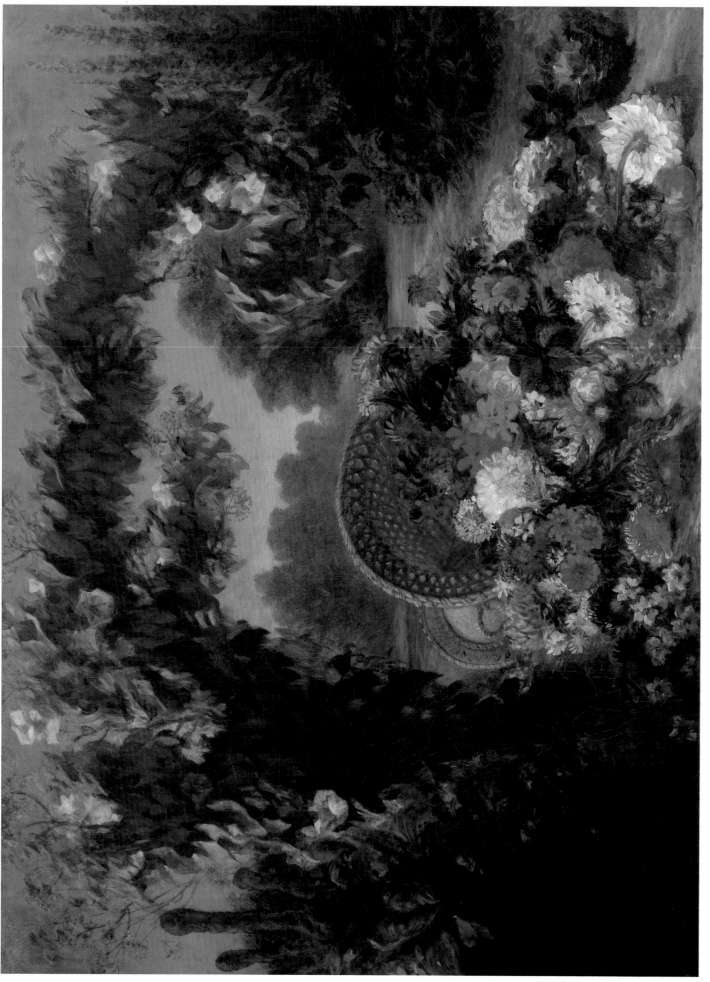

32. EUGÈNE DELACROIX (1798–1863) : *Basket of Flowers in a Park*. 1848. New York, Metropolitan Museum of Art

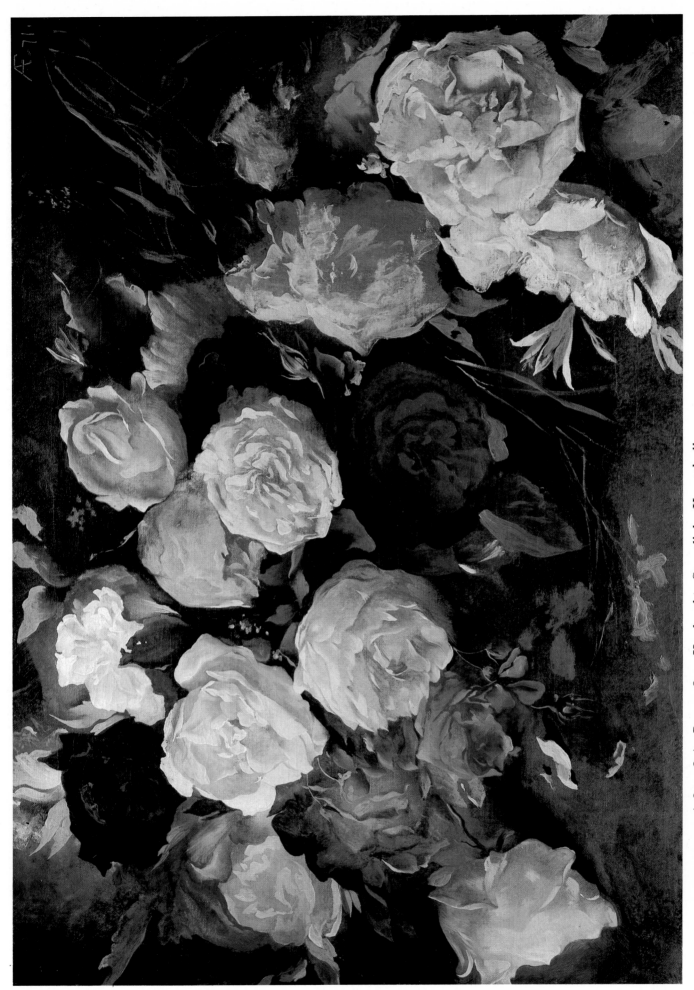

33. ANSELM FEUERBACH (1829–80) : *Roses*. 1871. Karlsruhe, Staatliche Kunsthalle

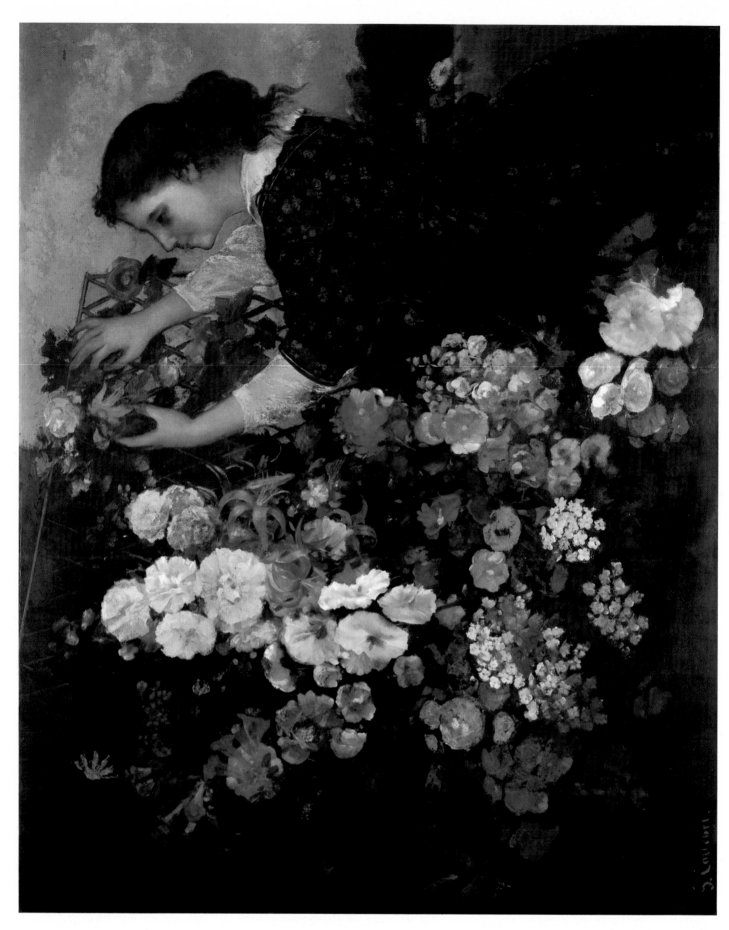

34. GUSTAVE COURBET (1819–77): *The Trellis*. 1863. Toledo, Ohio, Toledo Museum of Art

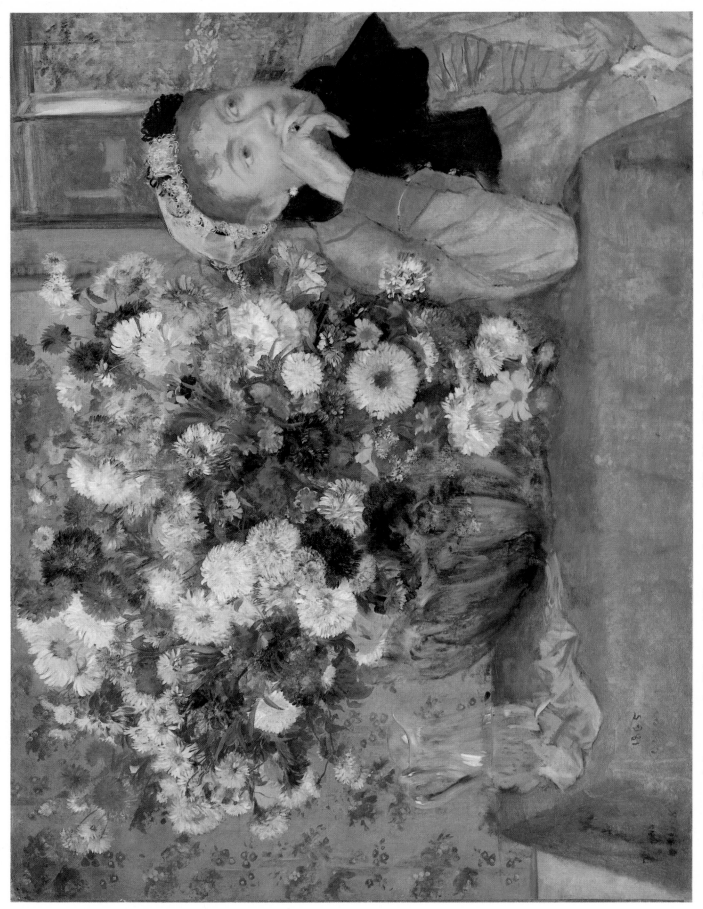

35. EDGAR DEGAS (1843–1917) : *Woman with Chrysanthemums*. 1865. New York, Metropolitan Museum of Art (Bequest of Mrs H. O. Havemeyer)

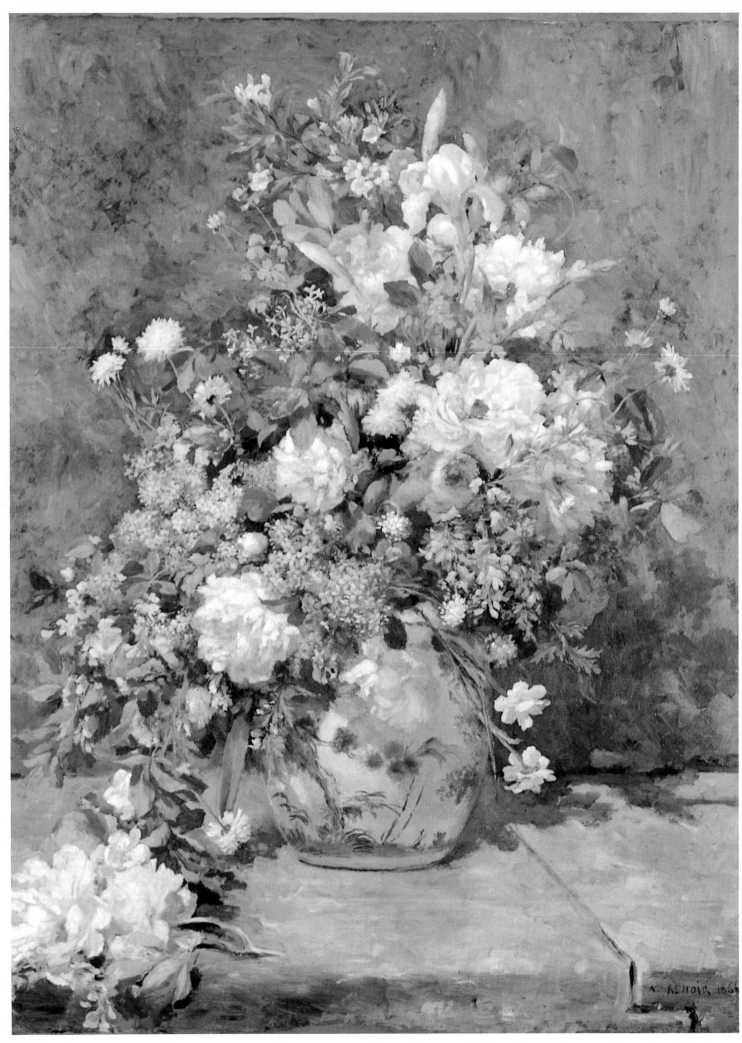

36. PIERRE AUGUSTE RENOIR (1841–1919): *Spring Bouquet*. 1866. Cambridge, Massachusetts, Fogg Art Museum

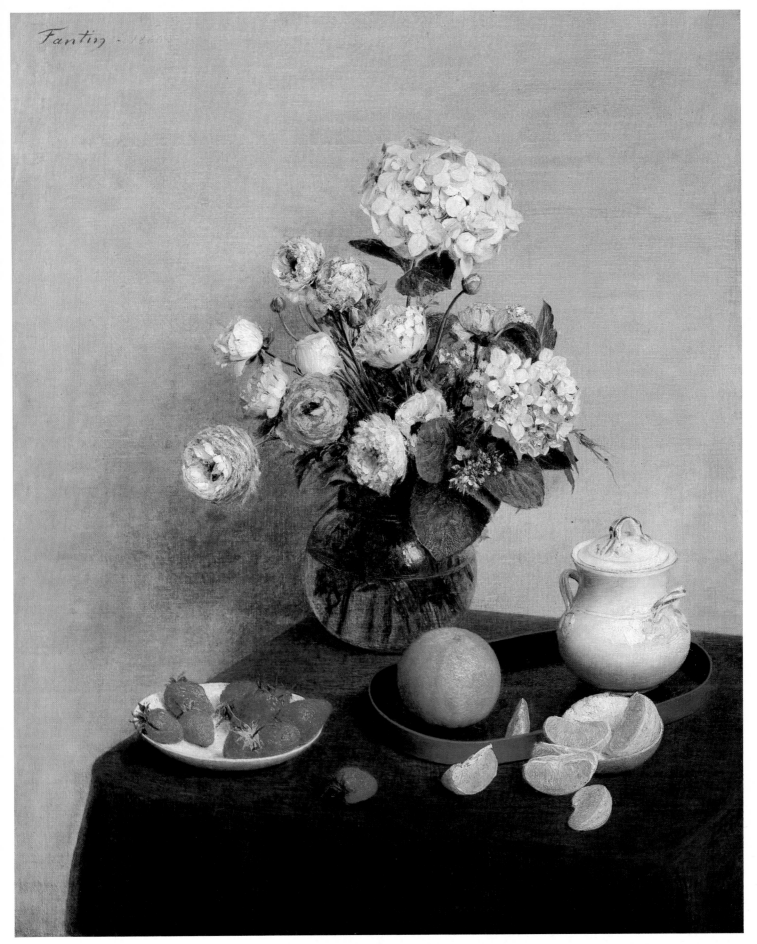

37. HENRI FANTIN-LATOUR (1836–1904): *Still Life with Vase of Hydrangeas and Ranunculus*. 1866. Toledo, Ohio, Toledo Museum of Art

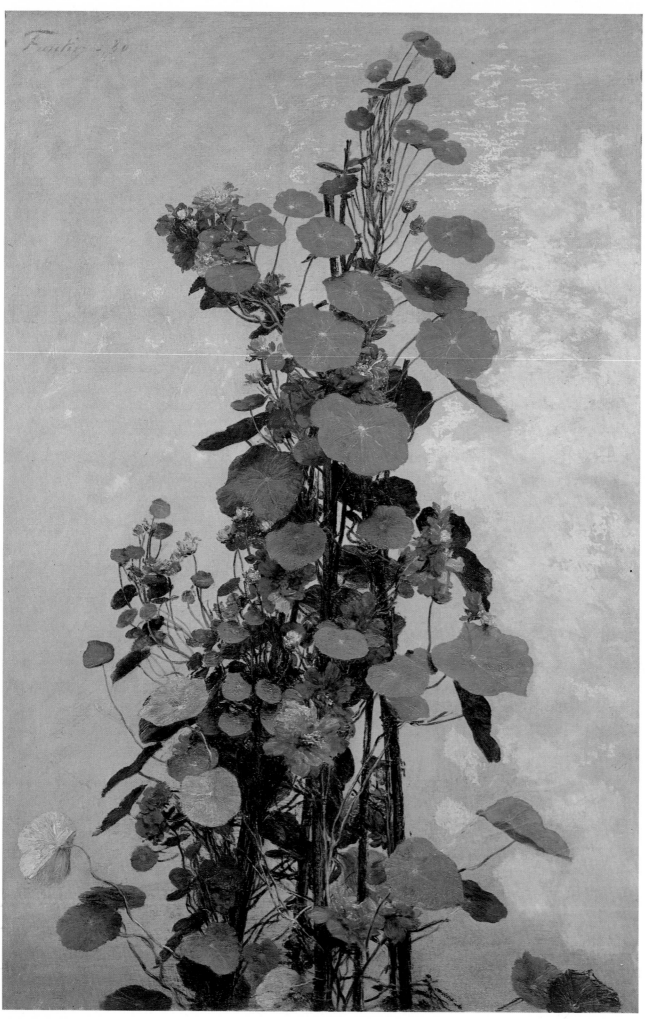

38. HENRI FANTIN-LATOUR (1836–1904): *Nasturtiums*. 1880. London, Victoria and Albert Museum

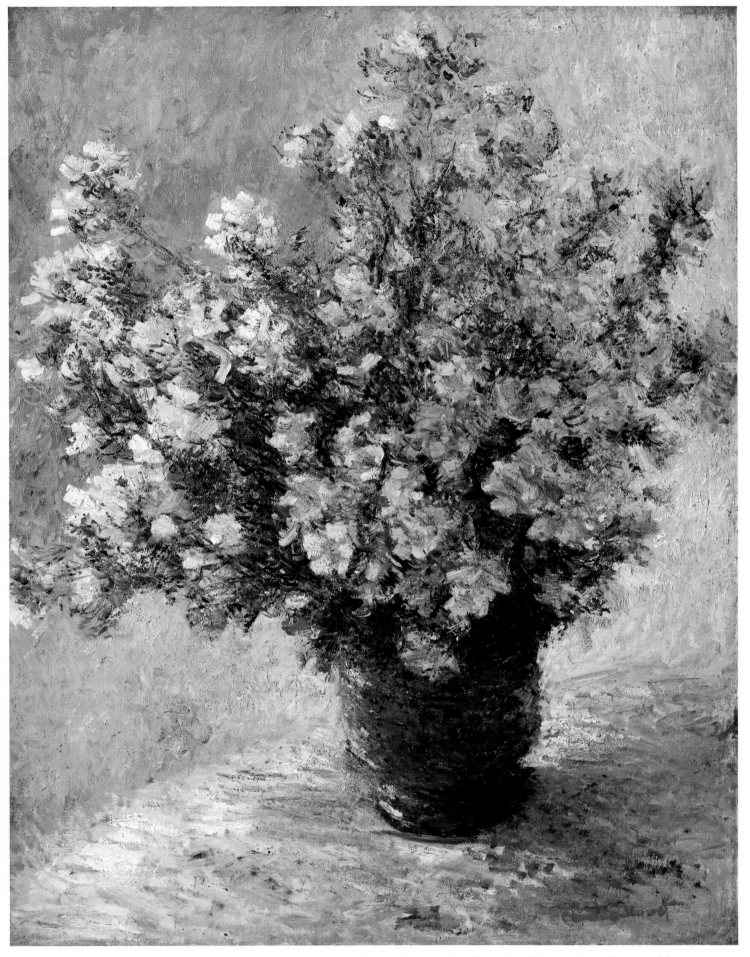

39. CLAUDE MONET (1840–1926): *Mallow Flowers in a Vase*. About 1882. London University, Courtauld
Institute Galleries

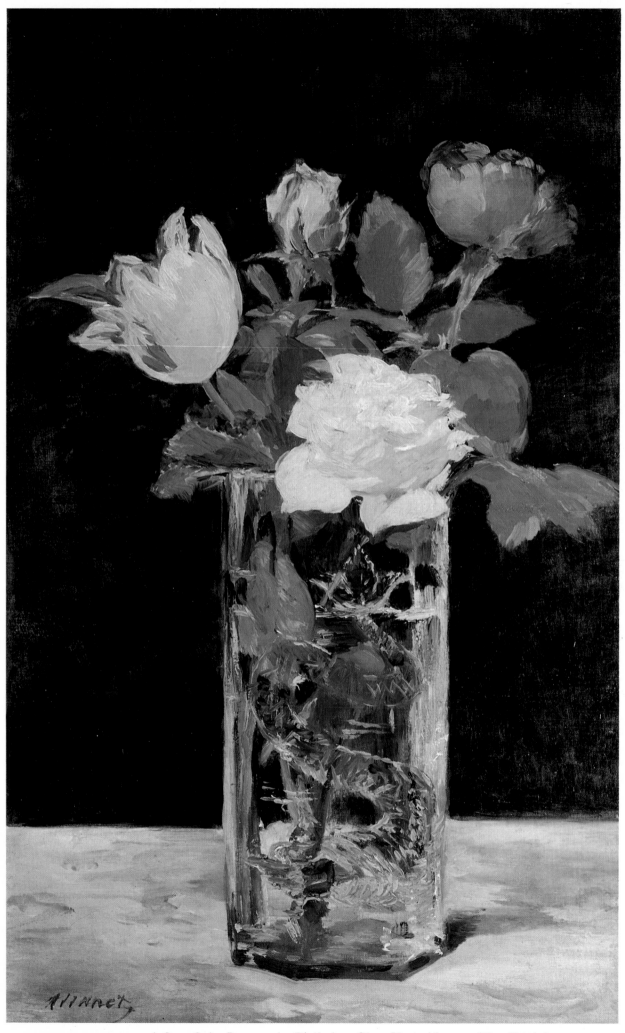

40. EDOUARD MANET (1832–83): *Roses and a Tulip in a Glass Vase*. About 1882. Zürich,
Bührle Collection

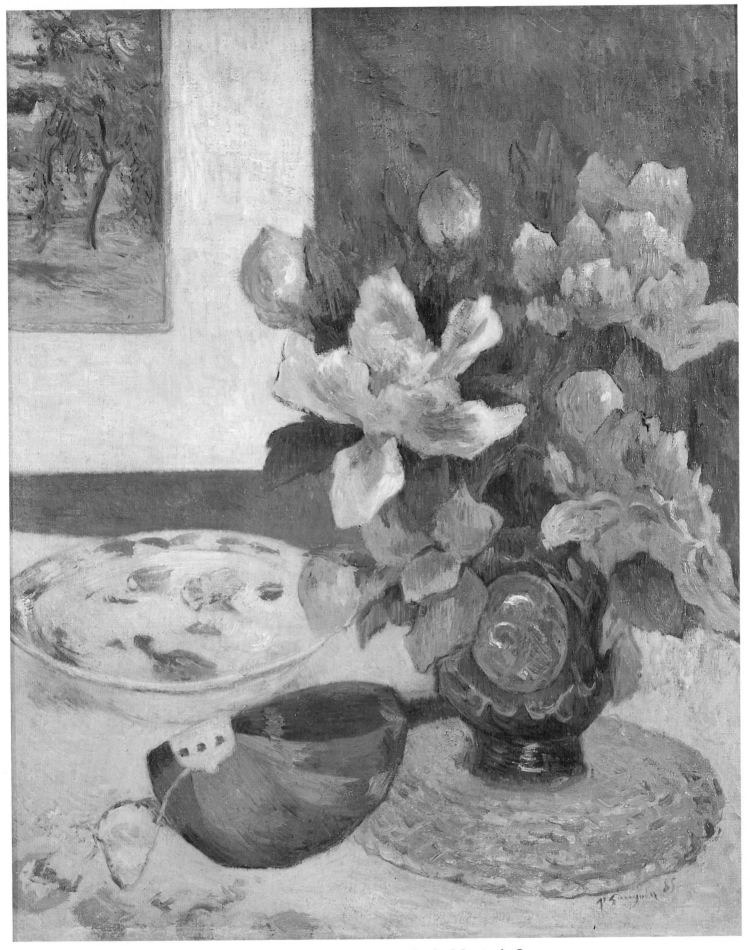

41. PAUL GAUGUIN (1848–1903): *Mandolin and Flowers*. 1885. Paris, Musée du Louvre

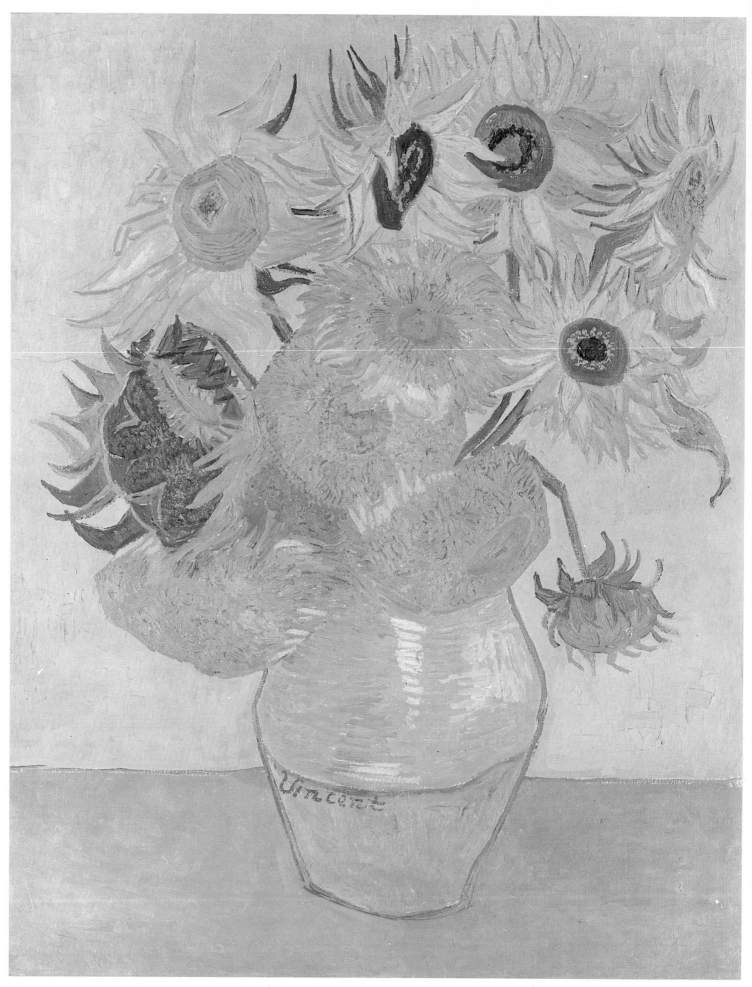

42. VINCENT VAN GOGH (1853–90): *Sunflowers*. Philadelphia Museum of Art (Mr and Mrs Carroll S. Tyson Collection)

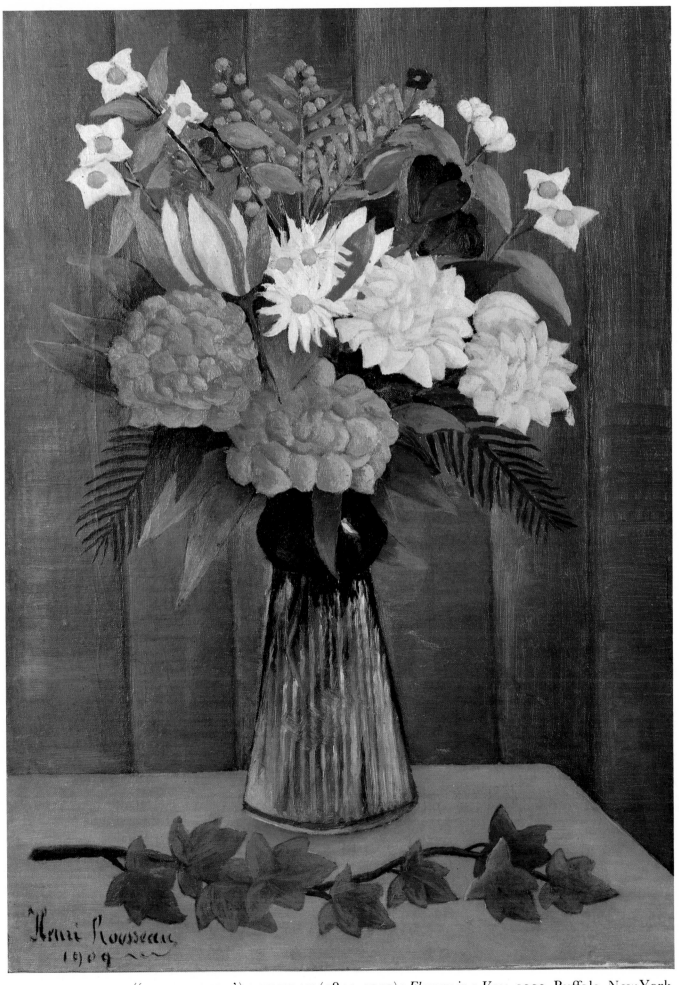

43. HENRI JULIEN ('LE DOUANIER') ROUSSEAU (1844–1910): *Flowers in a Vase*. 1909. Buffalo, New York, Albright-Knox Art Gallery

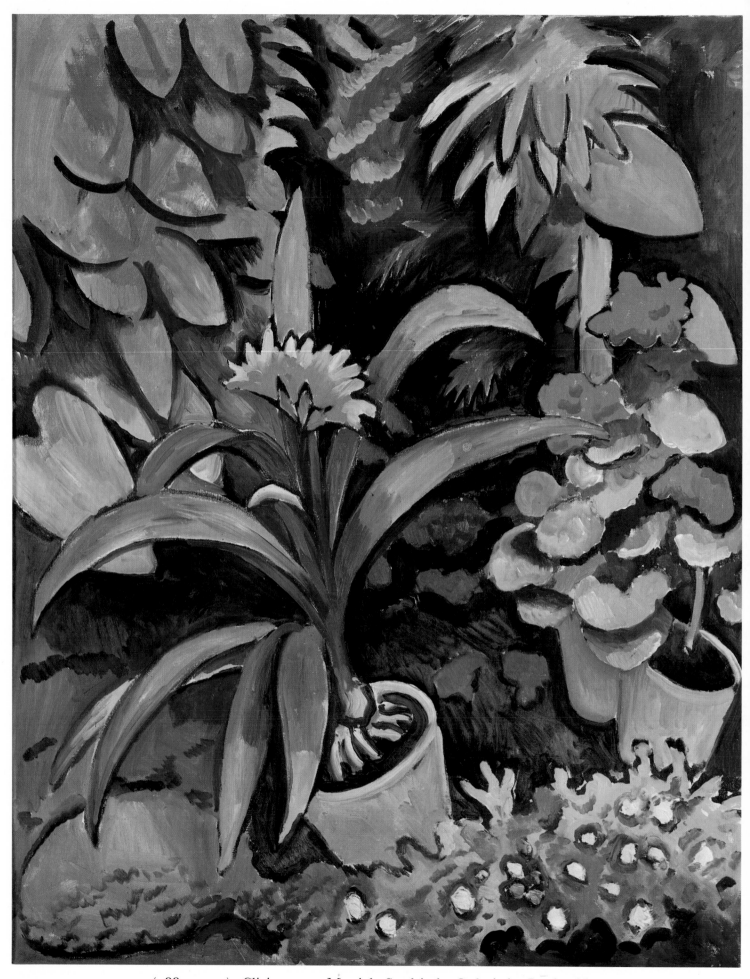

44. AUGUSTE MACKE (1887–1914): *Clivias*. 1911. Munich, Städtische Galerie im Lenbachhaus

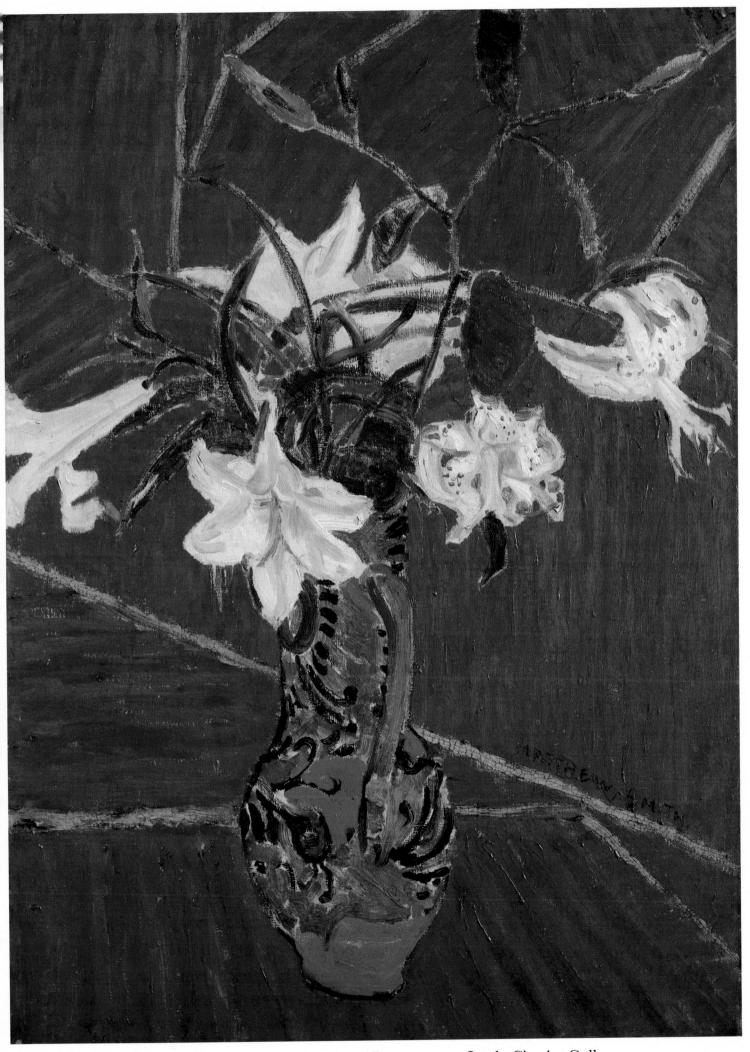

45. SIR MATTHEW SMITH (1879–1959): *Lilies in a Vase*. About 1914–15. Leeds, City Art Gallery

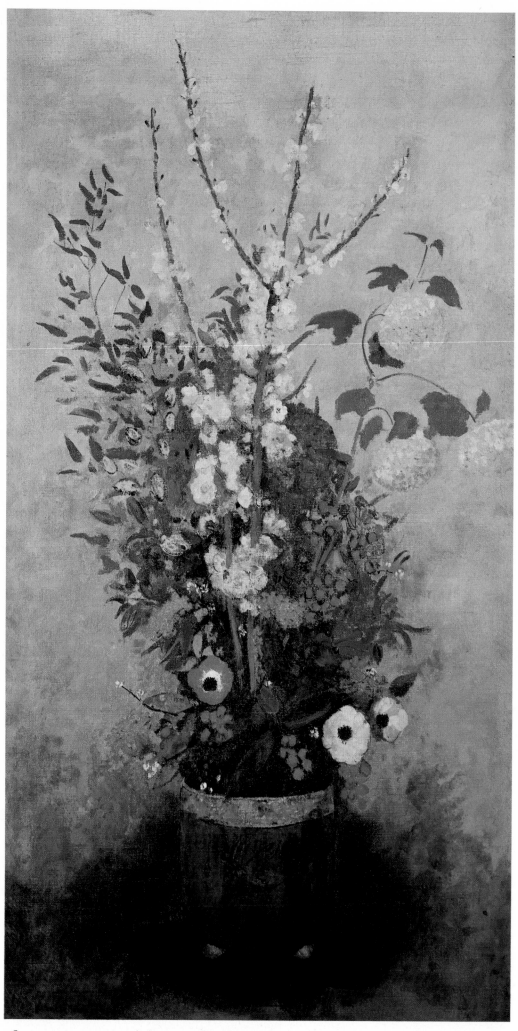

46. ODILON REDON (1840–1916): *Vase of Flowers with Branches of Spring Blossom.*
About 1905–6. Private Collection

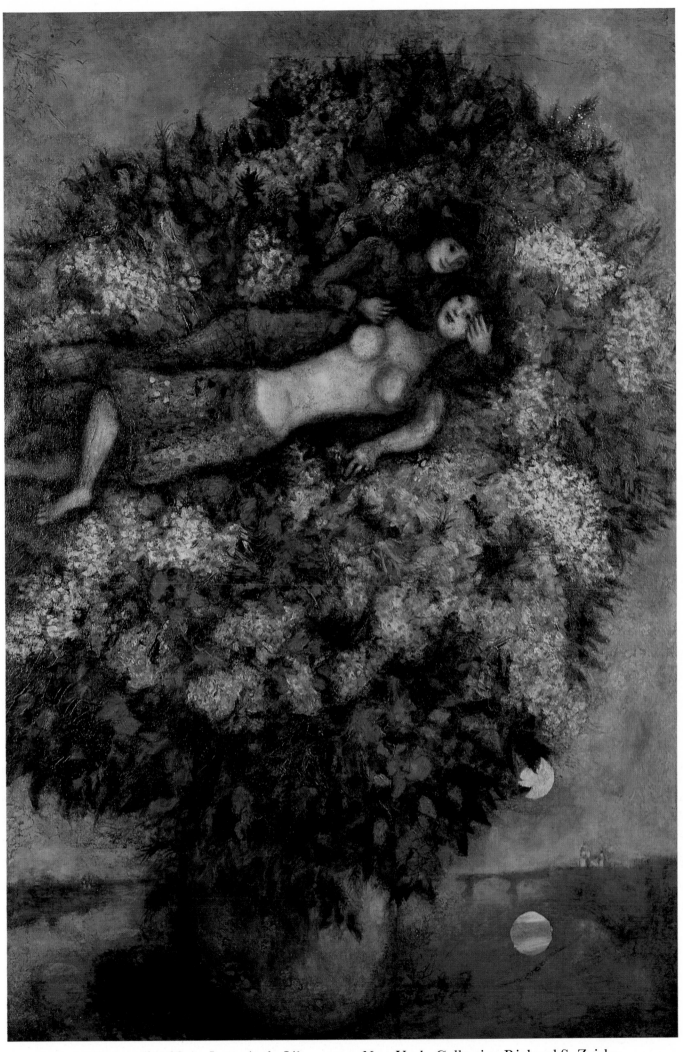

47. MARC CHAGALL (b.1889): *Lovers in the Lilacs*. 1930. New York, Collection Richard S. Zeisler

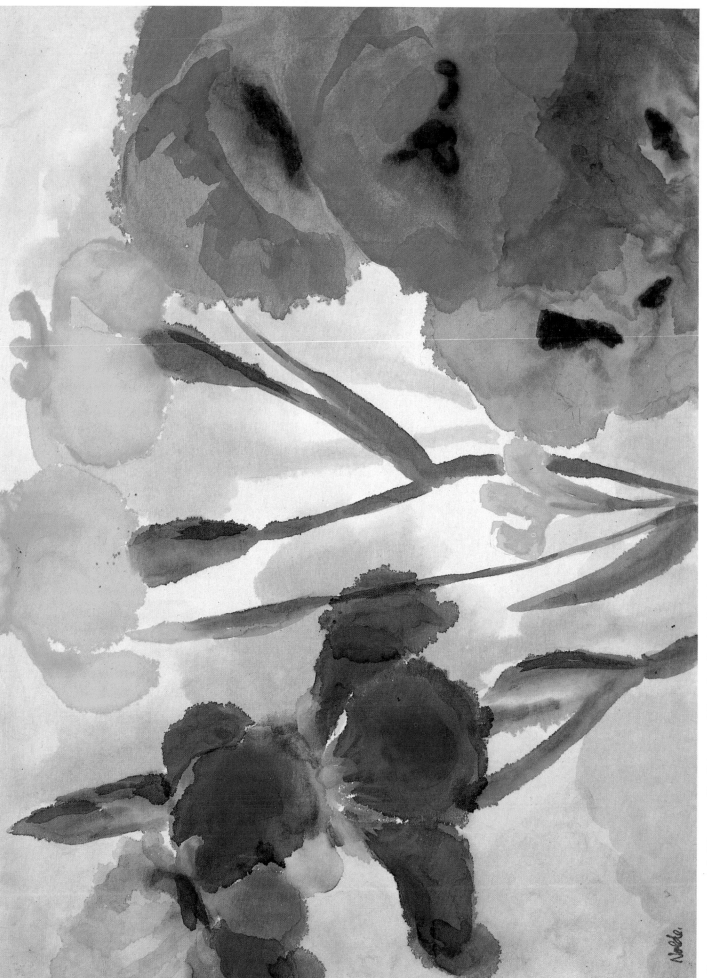

48. EMIL NOLDE (1867–1956): *Irises and Poppies*. Seebüll, Ada und Emil Nolde Foundation

THE
73RD
ART DIRECTORS
ANNUAL
AND THE
8TH
INTERNATIONAL
EXHIBITION

THE
73RD
ART DIRECTORS
ANNUAL
AND THE
8TH
INTERNATIONAL
EXHIBITION

Anistatia R Miller
EDITOR-IN-CHIEF

Martin Solomon
ART DIRECTOR/DESIGNER

PDR/Royal
TYPOGRAPHY & COMPUTER GENERATED ART

Alexa Nosal
TYPOGRAPHIC COORDINATOR

Jim Wasserman, Studio 31
MECHANICAL & PAGE LAYOUT

Robert K. Watkins
Jared M. Brown
COPYEDITING/PRODUCTION

Myrna Davis
EXECUTIVE DIRECTOR, THE ART DIRECTORS CLUB, INC.

Henry Artis
EXHIBITION DIRECTOR

**PUBLISHED IN 1994 BY
ROTOVISION SA
ROUTE DE SUISSE 9, CH-1295 MIES/VD, SWITZERLAND**

THE ART DIRECTORS CLUB, INC.
250 PARK AVENUE SOUTH, NEW YORK NY 10003-1402 USA

ISSN: 0735-2026
RotoVision SA ISBN: 2-88046-218-5
Watson-Guptill ISBN: 0-8230-6373-9

Distributed to the trade in the United States and Canada by
Watson-Guptill Publications
1515 Broadway, New York NY 10036 USA

International Distribution by
ROTOVISION SA
Route de Suisse 9, CH-1295 MIES/VD, SWITZERLAND

Printed in Singapore

ADC HALL OF FAME

1972
M.F. Agha
Lester Beall
Alexy Brodovitch
René Clark
A.M. Cassandre
Robert Gage
William Golden
Paul Rand

1973
Charles Coiner
Paul Smith
Jack Tinker

1974
Will Burtin
Leo Lionni

1975
Gordon Aymar
Herbert Bayer
Cipe Pineles Burtin
Heyworth Campbell
Alexander Liberman
L. Moholy-Nagy

1976
E. McKnight Kauffer
Herbert Matter

1977
Saul Bass
Herb Lubalin
Bradbury Thompson

1978
Thomas M. Cleland
Lou Dorfsman
Allen Hurlbert
George Lois

1979
W.A. Dwiggins
George Giusti
Milton Glaser
Helmut Krone
Willem Sandberg
Ladislav Sutnar
Jan Tschichold

1980
Gene Federico
Otto Storch
Henry Wolf

1981
Lucian Bernhard
Ivan Chermayeff
Gyorgy Kepes
George Krikorian
William Taubin

1982
Richard Avedon
Amil Gargano
Jerome Snyder
Massimo Vignelli

1983
Aaron Burns
Seymour Chwast
Steve Frankfurt

1984
Charles Eames
Wallace Elton
Sam Scali
Louis Silverstein

1985
Art Kane
Len Sirowitz
Charles Tudor

1986
Walt Disney
Roy Grace
Alvin Lustig
Arthur Paul

1987
Willy Fleckhaus
Shigeo Fukuda
Steve Horn
Tony Palladino

1988
Ben Shahn
Bert Steinhauser
Mike Tesch

1989
Rudolph de Harak
Raymond Lowey

1990
Lee Clow
Reba Sochis
Frank Zachary

1991
Bea Feitler
Bob Gill
Bob Giraldi
Richard Hess

1992
Eiko Ishioka
Rick Levine
Onofrio Paccione
Gordon Parks

1993
Leo Brunett
Yusaku Kamekura
Robert Wilvers
Howard Zieff

1994
Alan Fletcher
Norman Rockwell
Ikko Tanaka
Rochelle Udell
Andy Warhol

Carl Fischer
Selection Chairman

Bill Buckley
Paul Davis
Lou Dorfsman
Gene Federico
Walter Kaprielian
Andy Kner
Eileen Hedy Schultz
Richard Wilde

 Ever since museums were invented in the eighteenth century, every craftsman has wanted to be called an artist. But what we now have come to call art was done before there were museums, before there were critics; done by people who had unexceptional jobs as scribes and illustrators. It was very much like what we now call, reproachfully, commercial art.

 By saving notable work each year in this book, and by identifying in our Hall of Fame people whose lifetime effort thrills us, we are probably preserving some of the best of whatever it is we do — this changeable and ill-defined form.

 It is a worthwhile enterprise, for if, as Linciln said, "We cannot escape history," we might as well save and study the work, before it is thrown away.

— Carl Fischer
Chairman
Hall of Fame Committee

Alan Fletcher drew pictures as a kid. When it came time to choose a career, life in post-war Britain only offered him three options: go to university, join the army, or work for a bank. None of these was very appealing to him, enough that went after and got a scholarship to attend illustration courses at Hammersmith Art College. The next year—after he found out that there were other choices—he transferred to Central Art School. It was a livelier place, and as it happens, his future partner Colin Forbes was also taking classes there.

Fletcher found himself part of a new generation of young designers whose evangelical mission was to design. Unlike the egotistical and sentimental 1940s commercial poster artists, this new breed was training to become a group of passionate problem solvers.

When he graduated from London's Royal College of Art, 1950s Britain was "a very grey, boring place. And America—from what I could see in the movies—was bright lights, Manhattan, Cary Grant and Audrey Hepburn." Fletcher received a scholarship to Yale University's School of Architecture and Design. Paul Rand, one of his instructors, gave Fletcher a few IBM freelance jobs and Alvin Eisenman introduced him to other potential clients such as the Container Corporation.

Then Fletcher took a trip to Los Angeles. Standing with his portfolio in a public phone booth, broke, he cold-called Saul Bass for an interview. Again, he just seemed to be at the right place at the right time. Bass liked his work and gave him some freelence work to do.

But New York then was considered to be the world capital of graphic design, and Swiss Modern all the rage. So Fletcher returned to the East in 1958, landing his first salaried job at Fortune magazine.

It wasn't that Fletcher knew exactly where he wanted to go in his career, he had the necessary ambition to design: "I couldn't actually do anything else. I always thought I could design well as a student, but then I would find someone who could do it better. But it wasn't far off, it wasn't unattainable, it was just difficult. So I was driven by my own inadequacy, probably. You've got to have an ego to be a designer. It's a stupid job to have unless you've got that, undressing very day in front of some client who doesn't necessarily share your enthusiasm."

INSTITUTE OF DIRECTORS

When he returned to London in 1959, most designers were still doing the same thing: one-color jobs in 8-point type. (If there was a second color it was always red or blue.) Fletcher's portfolio filled with imaginative four-color jobs stood out.

He had been back for only six months when Bob Gill rang him up. Aaron Burns had suggested that the two of them should meet when Gill moved to London. They went to supper and in 1962 later they opened Fletcher/Forbes/Gill along with Colin Forbes.

They didn't get any work in their first month of business. Then some Penguin book jackets came in. They went to a café with a few design briefs and did them over coffee—sharing the project "like a bone." Others clients followed—Pirelli, Cunard, Olivetti.

Fletcher and Forbes formed a new partnership with Theo Crosby three years after Gill departed. They aded two more partners, Mervyn Kurlansky and Kenneth Grange, which eventually resulted in the 1972 formation of Pentagram.

While at Pentagram, Fletcher created design programs for Reuters, The Mandarin Oriental Hotel Group, The Victoria & Albert Museum, Lloyd's of London, Daimler Benz, Arthur Andersen & Co and ABB. Within the atmosphere of mutual idea exchange and individual interpretation, Fletcher managed to achieve the best of both worlds, working on large, complex corporate projects while also enjoying the freedom to work on his own ideas "which are invariably the ones that don't pay."

Today Alan Fletcher works on his own. He retired from Pentagram in 1992 to devote more time to his personal projects, but ironically is busier than ever solving communication problems as the design consultant for Phaidon Press and Domus Magazine, and producing a corporate identity for The Institute of Directors.

When Alan Fletcher received the honor of Senior Fellow of the Royal College of Art, he was toasted as a "design magician." A partial reference to the fact that he found the name Pentagram in a book on witchcraft. Visual wit, paradox, and irony are ingredients contained in all of Fletcher's work. He blends his Swiss-oriented, less-is-more, form-follows-function training with a very personal vision. To Fletcher, problem solving is not the problem, it's "adding value, investing solutions with visual surprise and above all with wit." He often misquotes a familiar axiom to define his design philosophy: One smile is worth a thousand pictures.

Fletcher bases his design work on the search for the idea. "The rest of it is just layout. I'm quite broad about ideas; putting certain colors together could be an idea. But every job has to have an idea. Otherwise it would be like a novelist trying to write a book about something without really saying anything."

He carries this theory to the extreme at times. He has been known to challenge the basic design brief supplied by a client, becoming a participant in conceptualization as well as the craftman of its realization. "I try to solve their problems, but in solving their problems take an opportunity to find that extra twist that adds the magic." The art posters he did for IBM are a good exmple. IBM asked him to design a placard for their new Paris headquarters, which said a painting would shortly arrive for the space on the wall occupied by the placard. In response he did a series of posters interpreting the word "art" as defined by an author or artist, and put the line about the paintings in 6 point along the bottom. "If I had answered the brief, they would have got a straightforward placard," he said.

Fletcher's client roster includes some of modern design's most progressive patrons embodies a rich volume of material: calendars, magazines, brochures, books,

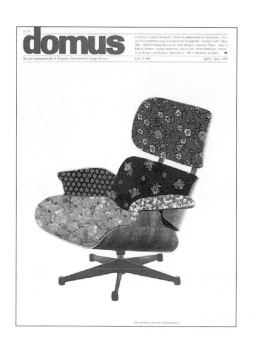

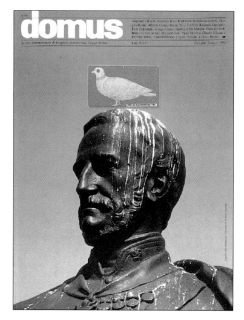

FLAGSHIP PORTSMOUTH

100TH ANNIVERSARY OF THE AUTOMOBILE

identities, sign systems, desktop products and posters. In his work for these and other clients, it is obvious that he takes the business of humor very seriously. Each piece progressively carries progressively less inhibition about how images are made and demonstrates unfailing confidence in his own drawing ability.

He believes that designers have both the opportunity and the obligation to provide connectivity between "the objects we use, and the human gift for artful extremes." Form may follow function, but designers—as the artists of modern society—must "provide the spice as well as the nutrition."

Fletcher has co-authored numerous books on design in which he displays many of these sentiments, including: Identity Kits—A Pictorial Survey of Visual Signs; Graphic Design: Visual Comparisons; and A Sign Systems Manual. He has also co-authored four books of Pentgram work: Pentagram: The Work of Five Designers; Living by Design; Ideas on Design, and The Compendium.

How does Alan Fletcher perceive his career at this point? "There is no career structure for what I do and I'll be working in the same sort of way at the end as I was at the beginning, I like visual ideas, so that's no problem. If I wasn't paid for it, I'd still carry on. Perhaps your work won't be as good when you're seventy or eighty as when you were younger, but as I'll be doing it for myself, not anyone else, that won't really matter."

Fletcher's working philosophy has earned him gold awards from the British Designers & Art Directors Association and the One Show. In 1977 he shared the D&AD Association President's Award for outstanding contributions to design with Pentgram partner Colin Forbes. In 1982 the Society of Industrial Artists and Designers awarded him the Annual Medal for outstanding achivement in design. He served as President of the D&AD in 1973 and as President of Alliance Graphique Internationale from 1982 to 1985. He is a Royal Designer for Industry, a Fellow of the Chartered Society of Designers, Senior Fellow of the Royal College of Art. In 1993 he was awarded The Prince Phillip Prize for the Designer of the Year.
—Anistatia R. Miller

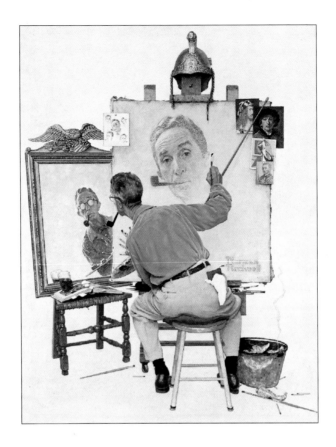

Shortly after the turn of the century, three young art students swore an oath: they signed their names in blood, swearing never to prostitute their art, never to do advertising jobs, and never to make more than fifty dollars a week. One of these blood brothers dismally failed to keep his allegiance. His name was Norman Rockwell.

To the millions of Americans whose lives were touched by his work, he is the best known and best loved illustrator of the twentieth century. For nearly seven decades, Norman Rockwell chronicled on canvas the heart and soul of America. In many of his best-known works he visually idealized the clean, simple country life of his childhood. In others he introduced middle America to the products of progressive urban life: the telephone, radio, electrical lighting, television, airplane travel, and the space program. Later in life, he devoted himself to more serious subjects: civil rights, the war on poverty, and the Peace Corps.

Norman Rockwell was born in New York City on February 3, 1894. As a child, he was drawn to country life: delighting in the summers his family spent on an upstate New York farm and their eventual move to Mamaroneck, New York.

He discovered that he had a natural talent for drawing. Since he wasn't built for athletics, he decided to work toward the goal of becoming an illustrator. In 1909 he left high school and enrolled full time in the National Academy of Design. Soon after, he switched to the Art Students League, which was the most progressive school of that time. There he studied under George Bridgeman who tutored him in the rigorous technical skills he relied on throughout his career.

Unlike most illustrators, Rockwell didn't have to face the usual hardships. His work always sold. At fifteen, he painted and sold four Christmas cards. He began a successful freelance career illustrating. He did ads for Heinz Baked Beans, two books for the Boy Scouts of America, and

numerous magazine illustrations. Three years later, he was hired as an illustrator for Boy's Life. Within a few months, he was promoted to art director. He only held the position for a few years, but the relationship he established with the Boy Scouts lasted for the rest of his life.

Rockwell established his own studio in 1915 with cartoonist Clyde Forsythe. From this New Rochelle studio, he worked for popular magazines of the day: Country Gentleman, Literary Digest and St. Nicholas. The next year, he painted his first of 321 covers for the Saturday Evening Post—Boy with Baby Carriage. Rockwell used one model for all three boys featured in the illustration. It best displayed his talent to create a variety of characters from the same subject.

He joined the navy during World War I and served as the art editor for Afloat and Ashore the house publication for the Charleston, South Carolina Naval Reserve Base. His other duty in the service was being the naval officers' portrait painter. He was still

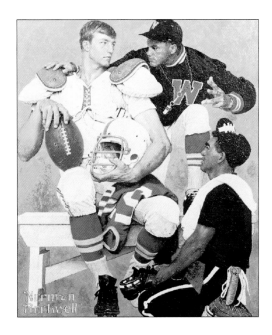

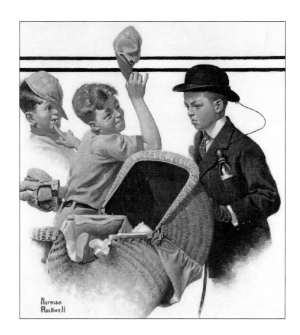

permitted to do civilian work: his covers still appeared on the *Post*. A cover commission for *Life* magazine, "Over There" was later used on the cover of the sheet music for the song of the same name.

During a 1923 trip to Paris, Rockwell became enamored with the modernist movement. He proposed a number of works with modern influences to the *Saturday Evening Post*; they were horrified. Despite their reaction, traces of Picasso, Van Gogh, Pollack, Rembrandt, Sargent, and Dürer occasionally appeared in his work.

In the 1920s, Rockwell's client list grew from leading publications to product advertising—illustrating everything from automobiles to Jell-O. In 1925, the first of fifty annual Boy Scout calendars featuring Rockwell's work was published.

Though he had been quite successful and productive in the twenties, his popularity hit its all-time peak in the forties. After he moved his second wife and three children to Arlington, Vermont, he set to work on his contributions to the war effort. As America came together to support our troops in World War II, he turned his talent toward producing among other works, a series based on an Franklin Delano Roosevelt speech, "The Four Freedoms." The paintings became the

main attraction of a nationwide fund drive that helped sell over $132 million in war bonds. At that time, Rockwell's *Post* covers depicted life on the home front, or the adventures of Willis Gillis, his characterization of G.I. "everyman."

Another memorable character Rockwell created was "Rosie the Riveter," the symbol of women involved in wartime production. Familiar images like "Rosie" and "The Recruit" were based, according to Rockwell, on works by Michelangelo. Rockwell sought to transpose the master's figures onto his models and transform them into modern middle-American icons. (Perhaps as an acknowledgment of the source of his inspiration, Rockwell placed a pale

Renaissance halo over the head of his lady riveter.)

In the fifties Rockwell moved to Stockbridge, Massachusetts. There he was commissioned to do the first of two decades' worth of presidential candidates' portraits. He also produced a series of Hallmark Christmas cards, began a series of *Four Seasons* calendars for Brown & Bigelow, and a series of ads for Massachusetts Mutual Life Insurance Company. At the same time continued his long-running relationship with the *Saturday Evening Post*. The *Post* had gone through many redesigns in forty-five years, and in 1961, Rockwell depicted all of its changes as they lay strewn around Herb Lubalin's drawing table.

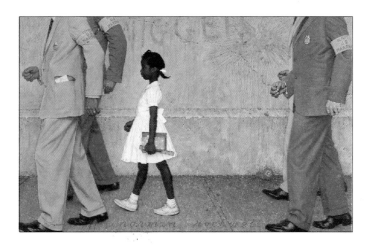

America had lost its veil of innocence. In the notes for a speech, Rockwell reflected: "There was a change in the thought climate in America brought on by scientific advance, the atom bomb, two world wars, and Mr. Freud and psychology...Now I am wildly excited about painting contemporary subjects...pictures about civil rights, astronauts, Peace Corps, poverty programmes. It is wonderful."

As a result of this new consciousness, Rockwell severed his long-standing relationship with the ultra-conservative *Saturday Evening Post*. In one instance, the magazine rejected his cover depicting Yugoslavian premier Marshal Tito as the only hope to unite the Serbs, Bosnians and Croats in Yugoslavia because it portrayed a communist leader in a favorable light. Rockwell's last *Post* cover was published in December 14, 1963. It was a reprint of his famous 1960 John F. Kennedy cover portrait with an added caption, "in memoriam."

Rockwell then accepted a number of Look magazine commissions. His first cover for them "The Problem We All Live With" focused on the Civil Rights movement and specifically school desegregation. Another, "Southern Justice," condemned violence against blacks and civil rights workers. A stark image of three men being murdered by a group of shadows was executed in tones of brown and grey except for a flow of red blood on one man's shoulder. This was a radical departure for a man who for nearly five decades had been depicting wholesome folk in classic scenarios. Interestingly, Look opted not to publish the finished painting of "Southern Justice." Instead, they ran his more impressionistic color study.

Rockwell never referred to himself as an artist—always as an illustrator or commercial artist. Artists, he felt, were people who painted what they wanted, not what they were paid to paint. Would he have believed it if someone told him that his works would soon fetch $150,000 to $300,000 at auction?

Detractors who take the time to study his work are surprised to find that it doesn't lack in inspirational depth, despite its accessibility, yet, his work is not included along with another twentieth-century illustrator, Andrew Wyeth, in most art history textbooks. He is not hailed for his contribution to the visual history of America as are Remington and Sargent. There are signs, however, that he will eventually be counted amongst the great twentieth-century American artists. There is a diverse group of Rockwell collectors, the Metropolitan Museum of Art, The Smithsonian, The National Portrait Gallery, the Corcoran Gallery and Steven Spielberg.

The Norman Rockwell Museum opened in 1993 in Stockbridge, Massachusetts—one of the few American museums to grow out of popular demand for a single artist's work. The museum became a necessity after Rockwell agreed to lend some of his works to the Stockbridge Historical Society in 1969 for a permanent exhibition. Word spread that his works were on display and attendance swelled from 5,000 people up to the current 160,000 annually.

Compared with his achievements, to mention the awards and honors he received would seem anti-climatic, except for two. In 1977, President Gerald Ford presented

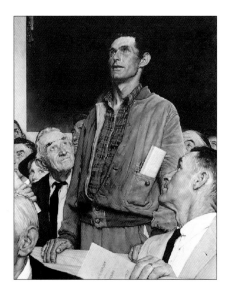

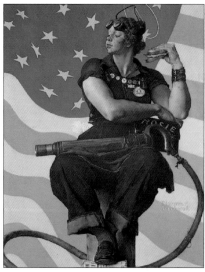

Norman Rockwell with the Presidential Medal of Freedom for his "vivid and affectionate portraits of our country." And on July 1, 1994, Norman Rockwell took his place next to Elvis and other American icons when the United States Postal Service issued a commemorative series of five Rockwell works including "Triple Self Portrait" and "The Four Freedoms."

The simple eloquence of his familiar style belies his painstaking creative process. Each painting began by carefully setting up the scene and photographing it or sketching it from life. After a series of black-and-white pencil sketches, he would do color studies. The final oil painting would invariably include the excruciatingly minute details that make his work nearly impossible to forge.

Robert Campbell of the Boston Globe commented: "The mistake most of us make is to think of Rockwell as a realist. He wasn't, really. For starters, his people usually don't even cast shadows. They don't seem to have any weight or mass. They touch the ground but don't exert pressure on it. Often the ground itself is vague and white, like a cloud. Rockwell's people aren't so much flesh and blood as they are likeable everyday gods and goddesses, inhabiting American mythological heaven."

In "Triple Self Portrait," Rockwell composed three images of himself placed in some illustrious company—Van Gogh, Picasso, Rembrandt and Dürer—which he included as reference studies tacked on one corner of his canvas. He admitted

to being influenced by both classic and modern fine arts masters.

And like other masters, Rockwell had a unique talent for uncovering the everyday, human side of even his most famous subjects. He preferred common faces. He compared the excitement he felt painting the face of a successful person to a slab of warm butter. He readily admitted that the America he depicted was the country he hoped it could be, and considered his pre-1960s work to be more escapist than realist. There are few artists who better exemplify the dichotomy between high and popular art in the twentieth century than the man who gave Americans an endearing and enduring vision of themselves.
—Anistatia R Miller

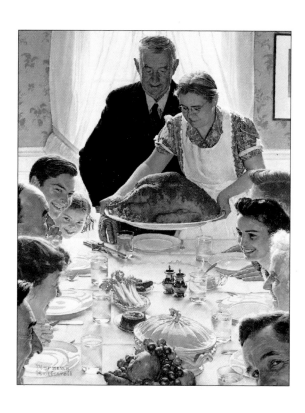

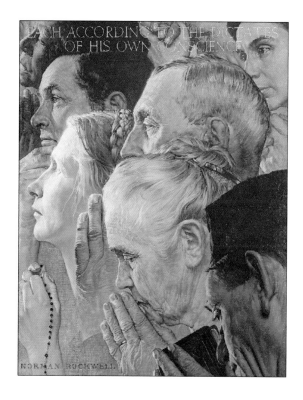

Strong, clean, and impactful are the best descriptives you could use to describe Ikko Tanaka's work. They are universal images, honed with a fastidious eye: finding the natural flow of photographs in a book spread, steadying the central point of a corporate symbol so the mind retains every detail, and enriching the typographic and illustrative forces of a poster into a pure, homogeneous form.

Tanaka has been honored by the Tokyo Art Directors Club, the Mainchi Industrial Design Award, the Yugoslavia-based International Exhibition of Graphic Design, Japan's Ministry of Education, the Japan Cultural Award, and the Warsaw International Poster Biennale, amongst many others.

Since establishing the Tokyo-based Ikko Tanaka Design Studio in 1963, he has created the display design for the Oceanic Cultural Museum at the Ocean EXPO '75 in Okinawa, designed the symbols for EXPO '85 in Tsukuba and World City Expo Tokyo '96. He has worked for such illustrious clients as the Seibu Saison Group, The

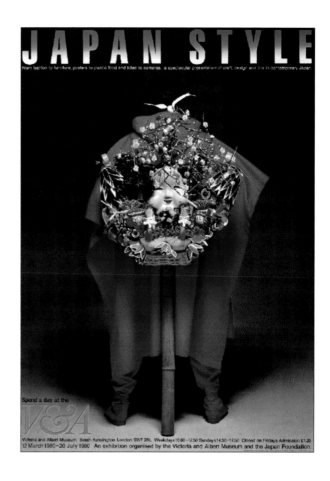

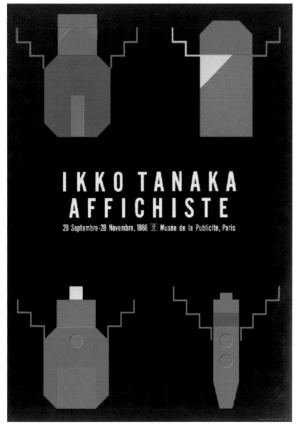

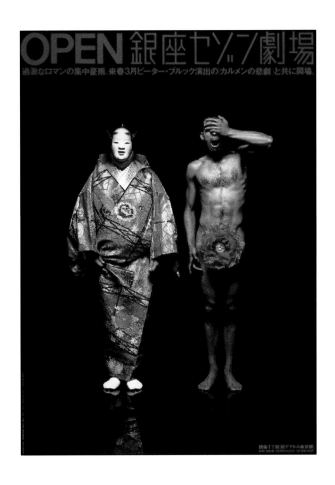

International Garden and Greenery Exposition, Hanae Mori, Issey Miyake, and the Mazda Corporation.

Tanaka has exhibited and lectured throughout the world: at the A.G.I. Conference Kröller Müller Museum and Gerrit Rietveld Academy in Amsterdam; Cooper Union in New York; the Pompidou Center in Paris; the Museum of Modern Art in New York; The School of Design Altos de Chavon in Dominica, and the Museum für Gestaltung in Zürich.

He has curated and designed exhibitions for the Victoria and Albert Museum in London, a Japanese design exhibition in pre-Glasnost Moscow, and throughout Japan.

As a result of his commitment to design, his influence can be seen in the work of a generation of young designers, many of whom don't speak Japanese. But the strong, easily accessible images he creates transcend language; carrying their messages far beyond the limitations of the written word.

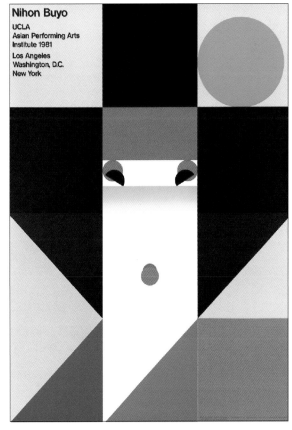

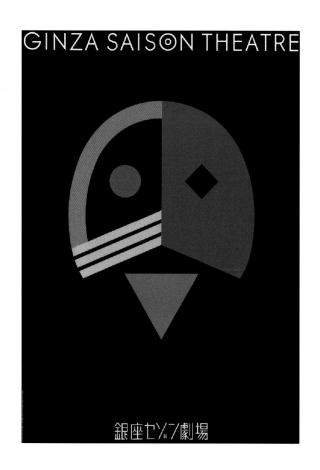

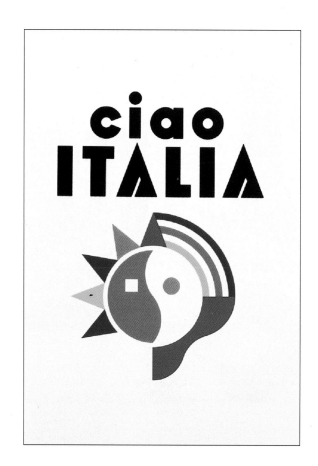

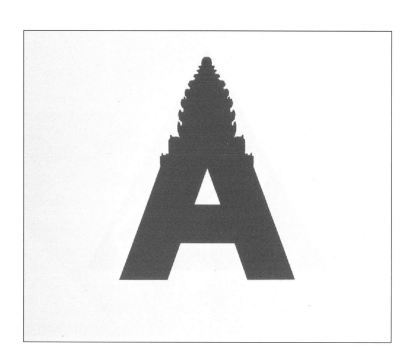

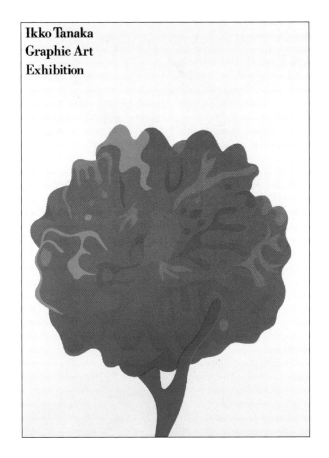

Ikko Tanaka
Graphic Art
Exhibition

HANAE
MORI

Rochelle Udell got her Bachelor's degree from Brooklyn College and her Masters from Pratt Institute in the sixties, but that's as conventional as she's ever been in her career. This baker's daughter has been a high school art teacher, a magazine art director, advertising creative director, mother, and associate editorial director. Most recently, she has become vice-president of creative marketing specializing in new media for Condé Nast Publications.

A loaf of bread complete with braided handle, kneaded by hand in her father's Brooklyn bakery, was her presentation for a school packaging assignment—her instructor was Milton Glaser. Her solution and his opinion eventually led to her jobs as Assistant Art Director of *New York Magazine* and founding designer of *Ms.* magazine.

She worked as the art director of *Harper's Bazaar*, *Vogue*, and *Esquire* and design director of *House & Garden* and *Self*.

"A magazine," she passionately explains, "a good magazine that is, steps in where society steps out, provoking questions and helping shape a reader's lifelong values, ideas and goals. These are a few of the convictions and hopes which propelled me from early days of sewing props for the cover of *New York Magazine*, to later life living inside the pages of *Esquire Fortnightly* (it died quickly), *Harper's Bazaar* (where I died quickly), *GQ*, *Vogue*, *House & Garden*, *The New Yorker* et al."

While she was at *Vogue*, she began doing advertising projects for Calvin Klein. By 1981, she was opening his in-house agency as its president and creative director.

She returned to magazines for a short time as the design director of *GQ* before advertising lured her once again into the position of Senior Vice-President and Creative Director of Della Femina, Travisano & Partners.

Her philosophical attitude about advertising is that good advertising "is the product and the expression of that experience. That keen pursuit of both truth and dreams. As such, it continues to fascinate, repel, challenge, enthrall, and every once in a while, even infuriate me."

In 1992, Udell returned to Condé Nast as the Vice-President of Creative Marketing. Last year, she was appointed Vice-President-Creative Marketing/New Media for Condé Nast Publications, advising individual magazines and corporate departments on the feasibility of new media proposals and developing her own ideas regarding the incorporation of computer on-line services, multimedia CD-ROM, interactive TV, and other non-traditional communications media. According to chairman S.I. Newhouse, "I'm delighted to have as a guide an executive who combines an all-around background in magazines with an established interest in emerging communication technologies."

She was also the driving force behind a number of marketing and promotion projects including the GQ Japan partnership. At the end of September 1994, Udell expanded her responsibilities by joining The Condé Nast Group, a newly expanded corporate sales and marketing division.

"It's ironic," Udell admits. "I've spent literally years in publishing. Yet I have never believed in working 'by the book.' This is probably because, as a baker's daughter, I spent my youth helping out in a family business. In a small family business the essential things are innately understood. There is no need for the so-called 'book' to explain or enforce executive rules and roles.

"As for the titles attached to my name, I consider them important only in as much as they help the outside world understand who I am and what I do. My fear is that, like 'the book,' they often do more to confine rather than define one's creative possibilities.

As Udell herself admits, "Fortunately, I've been privileged and lucky enough in my professional life to have encountered others who believe as I do. Namely, that the structure behind every good business organization should first encourage those possibilities. For me personally, that means identifying with and making that vital connection with the human being who is the reader or consumer. Only then can one hope to successfully serve the creative spirit and develop a product powerful and imaginative enough to contain the future."

Calvin Klein Jeans

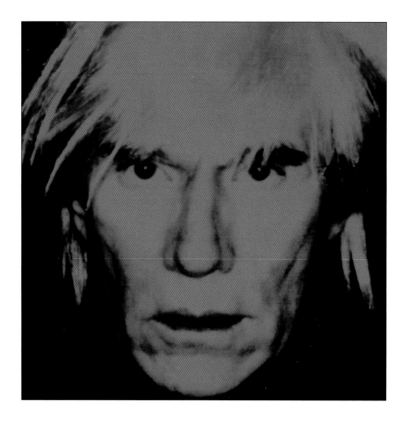

Andy Warhol painted a series of Coca-Cola paintings in 1960. He worked in a succession of approaches, starting with Abstract Expressionist and ending with a clean, graphic style that looked more like an illustration than a painting. He showed the series to four friends from the art world. They all preferred the final approach. The rest is pop culture history.

Artist, illustrator, filmmaker, entrepreneur Andy Warhol became an icon just like the subjects of his paintings—Marilyn Monroe, Elvis Presley, Mao Zhe Dong—before his death. But his earlier connection to the New York advertising and design community bears recognition for the immense body of work he contributed to the industry as well as its direct affect on his later work.

Forties America was psychologically grim. The country had just recovered from the Depression. The Second World War had brought the cruel outside world to the hearts and minds of isolationist-minded Americans. The average man worried about protecting his at-home interests—money, property and manners—from Fascists,

Communists, and atomic bombs. Compromise was his best psychological defense; keeping up with the Joneses' was the standing rule. In this atmosphere of conformity, Warhol enrolled in the Pictorial Design program at Pittsburgh's Carnegie-Mellon Institute of Technology's Department of Painting and Design.

Twice a year, he and fellow art student Philip Pearlstein went museum and gallery hopping in New York. When they graduated in 1949, Pearlstein and his wife Dorothy Kantor moved with Warhol to join the burgeoning Manhattan art world. The Beat movement was there, slamming the mentally lethargic, decadent attitude of the middle class. Artists and writers were out to alter the public consciousness. New York was also the home of breakthrough creativity in the commercial arts industry. Madison Avenue was the advertising and editorial hub of the world. It was the perfect place for an illustrator to make a living.

Another of Warhol's classmates had also moved to New York. But his aspirations directed him to mid-

town. George Klauber went to work as a special assistant to Will Burtin at Fortune magazine. He helped establish Warhol's illustration career by giving him some of his first commissions.

As Pearlstein recounted: "Well, Andy was immediately employable. I was a very uncertain thing—my portfolio was one of those elaborately worked out, intellectualized things about the US Constitution (2B), and unfortunately, I hit New York in the beginning of the McCarthy era, and as soon as I walked in and somebody saw it, they immediately assumed I was some sort of political kook...Andy went right to the heart of the matter, he knew—that's what I mean by he was immediately employable; he was only interested in illustration, and they were very direct!"

Warhol's work may have been highly accessible, but his experiences were no different from other aspiring New York arrivals. He gained street-smarts quickly. "I got one job, and then I would have to do it at night and then spend all day looking," he recalled. "You carry your portfolio and after do-

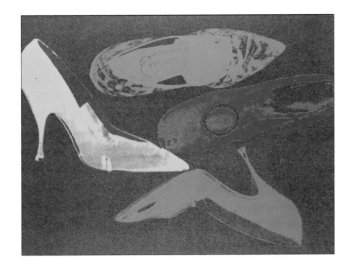

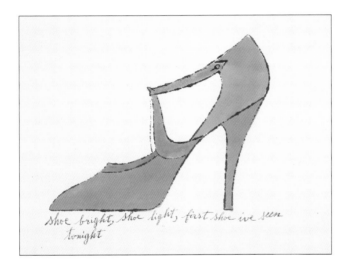

shoe bright, shoe light, first shoe ive seen tonight

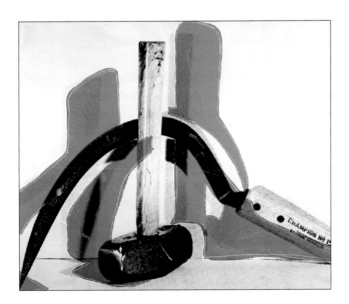

ing it for a couple of years you learn that if you come five minutes before twelve o'clock, that was the best time to come. Because if they tell you to get there at nine, you would just sit around until five minutes to twelve and they wouldn't see you. So the best time was always—well, most of the people ate in the art department—usually at lunch time, so you could always see them at twelve o'clock."

Glamour magazine's Tina Fredericks hired Warhol to illustrate an article entitled "Success is a Job in New York." It was coming true for Warhol. His drawings appeared on record covers, books, Christmas cards, ads, and TV work for CBS's Lou Dorfsman. In 1951, he won his first ADC Award for a CBS record illustration.

The next year, his mother moved in with him. She contributed her distinctive handwriting to his illustrations and drawings. (Mrs. Warhola received ADC certificate in 1958 inscribed "toAndy Warhol's Mother" for her calligraphic style.) His client roster grew to include NBC, *Harper's Bazaar* and Dobeckmun. Ironically, he was also commissioned to illustrate the *Amy Vanderbilt Complete Book of Etiquette* that year. Warhol also had his first New York exhibition—a series of drawings based on the writings of Truman Capote at the Hugo Gallery. He began a series of drawing portfolios and artist's books between commercial assignments, including *Love Is A Pink Cake* and *25 Cats Named Sam and One Blue Pussy* with text contributed by Ralph T. Ward.

In 1955, I. Miller decided to recreate their image. The plan was to use repetition in order to drive home the visual message. Fashion editor Geraldine Stutz, advertising director Marvin Davis, and art director Peter Palazzo concentrated the placement of their strategy by running it only in national fashion magazines, the Sunday Times and the Herald Tribune. They hired Warhol because of the distinctive nature of his drawings and his ability to create repetitive themes. Palazzo noted: "I would draw it out the way I would think it would be a decent composition, or I'd crop it and he'd finish it...he went home with the shoes and that was

totally his own. I would not tell him
how to draw there, because he usually
did something nice on his own...Andy
was very easy in that sense; he just felt
it was his bread and butter."

Shoes also appeared in his
fine art work, especially in *A la
Recherche du Shoe Perdu*, a 1955 portfo-
lio with verses by Ralph Pomeroy.

Warhol travelled to Japan,
Southeast Asia, Italy and Holland in
1956 and had two exhibitions at the
Bodley Gallery. The work for I. Miller,
Harper's Bazaar, and Noonday Press
won him additional ADC awards. His il-
lustration business had grown so large
that he formed Andy Warhol
Enterprises, Inc. in 1957, and hired a
few assistants.

He started making use of rub-
ber stamps and other reproductive de-
vices specifically to speed up produc-
tion. Then iconographic images began
infiltrating his work. A 1959 Tiffany as-
signment was a glimpse into his future:
the illustration included a Coca-Cola
bottle.

In 1975, Warhol said: "What's
great about this country is that America
started the tradition where the richest
consumers buy essentially the same
things as the poorest. You can be
watching TV and see Coca-Cola, and
you can know that the President drinks
Coke, Liz Taylor drinks Coke, and just
think, you can drink Coke, too. A Coke
is a Coke and no amount of money can
get you a better Coke than the one the
bum on the corner is drinking. All the
Cokes are good. Liz Taylor knows it,
the President knows it, the bum
knows it.'

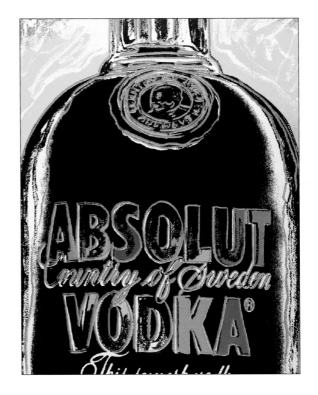

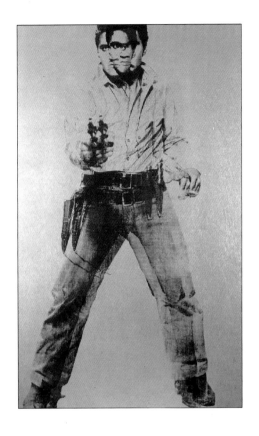

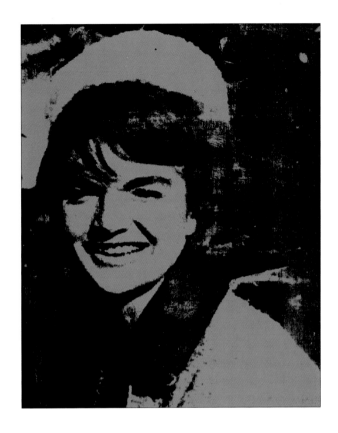

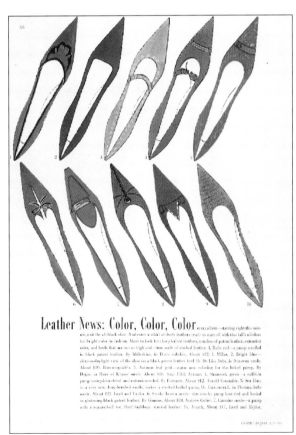

56

Leather News: Color, Color, Color everywhere—starting right this minute, exit the all-black shoe. And enter a whirl of lively leathers ready to start off with this fall's sideline for bright color in fashion. More to look for: long-looked leathers, touches of patent leather, extension soles, and heels that are not so high and often made of stacked leather. 1, Ruby red—a pump scrolled in black patent leather. By Miller&son, in Davis suka-kin. About $22. 1, Miller. 2, Bright blue—clear-as-daylight view of the shoe on a black patent leather heel. By De Liso Debs, in Donovan suede. About $20. Bloomingdale's. 3, Autumn leaf gold—warm new coloring for the heeled pump. By Degas, in Hans of Krause suede. About $16. Saks Fifth Avenue. 4, Shamrock green—a calfskin pump in step-bracelet and extension-soled. By Fortunet. About $42. Arnold Constable. 5, Sea blue, in a very new, lomp-brushed suede, makes a stacked-heeled pump. By Customcraft, in Fleming-Joffe suede. About $23. Lord and Taylor. 6, Smoky brown suede—the smoky pump lace-tied and laced in glistening black patent leather. By Gamins. About $20. Andrew Geller. 7, Carmine smoke—a pump with a squared-off toe. Heel build-up: stacked leather. By Amalfi. About $17. Lord and Taylor.

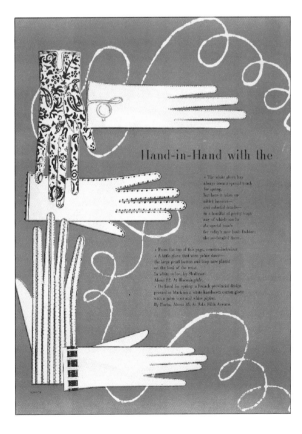

Hand-in-Hand with the

• The white glove has always been a special touch for spring.
but here it takes on added luster—
and colorful details—
in a handful of pretty ways
one of which can be
the special touch
for today's new look: fashion;
the wee-detailed sleeve.

• From the top of this page, counterclockwise:
• A little glove that wins prize shows—
the large pearl button and loop now placed
on the back of the wrist.
In white or blue, by Shalimar.
About $2. At Bloomingdale's.
• On hand for spring: a French provincial design
printed in black on a white handsewn cotton glove
with a palm vent and white poplin.
By Fuchs. About $5. 6, Saks Fifth Avenue.

MEDALISTS

NATIONAL & INTERNATIONAL JUDGES

NATIONAL JUDGES

Sal DeVito
ADVERTISING CHAIRPERSON

Paul Scher
GRAPHIC DESIGN CHAIRPERSON

Gail Anderson

Tony Angotti
ANGOTTI THOMAS HEDGE

Abby Aron [check if this should delete per their request]
Dave Berger
Amy Borlowsky
LOWE SMS

Doris Caesar
ANGOTTI THOMAS HEDGE

Rob Carducci [check if this should delete per their request]

Nick Cohen
MAD DOGS & ENGLISHMEN

Peter Cohen
LOWE SMS

Paul Davis
PAUL DAVIS STUDIO

Bill Drentell
DRENTELL DOYLE PARTNERS INC.

Neil Drossman
RYAN & PARTNERS

Janet Froelich
NEW YORK TIMES MAGAZINE

Stephan Geissbuhler
CHERMAYEFF & GEISMAR INC.

Carin Goldberg
DK Holland
Chip Kidd
Gary Koepke
KOEPKE INTERNATIONAL LTD.

Don Miller
Lowe SMS

Ty Montague
LOWE SMS

Steve Montgomery
MESSNER VETERE BERGER MCNAMEE SCHMETTERE

Steve Penchina
KETCHUM ADVERTISING

Jim Perretti
PERRETTI PRODUCTIONS

Robert Reitzfeld
ALTCHILLER REITZFELD

Dean Stefanides
HOUSTON EFFLER HAMPEL & STEFANIDES INC.

Leslie Sweet

Mike Tesch
AMIL GARGANO & PARTNERS

Mike Vitello
BBDO

Ed Wolper

INTERNATIONAL JUDGES

Harvey Hoffenberg
CHAIRPERSON

Neil Calet

Cathie Campbell
OGILVY & MATHER

Don Easdon
HEATER/EASDON

Bob Gill

Dabni Harvey
SAATCHI & SAATCHI

Kiki Kendrick
KIRSCHENBAUM & BOND

Steve Mitsch
ALTSCHILLER REITZFELD

John Morrison
SAATCHI & SAATCHI

B. Martin Pedersen
GRAPHIS

Steve Penchina
KETCHUM ADVERTISING

Sherry Pollack
OGILVY & MATHER

Meg Rogers
SAATCHI & SAATCHI

Bob Schriver
PEPSICO

Jaime Seltzer

Dean Stefanides
HOUSTON EFFLER HAMPEL & STEFANIDES INC.

Mike Tesch
AMIL GARGANO & PARTNERS

Rodney Underwood
CASTLE/UNDERWOOD

Bill Yamada
SAATCHI & SAATCHI

To the judges:

Thanks for saying "yes" when I asked you to judge the show.

Thanks for actually showing up to judge it.

Thanks for judging the radio.

Thanks for looking at over 14,000 ads.

Thanks for killing the 12,917 of them that should've been killed in the first place.

Thanks for judging the radio.

Thanks for limiting your lunch hour to two hours.

Thanks to Mike Tesch for staying late Thursday night and missing *Baywatch*.

Thanks to everyone for staying past midnight on Friday even though I swore on a stack of annuals we'd be out of there by nine.

Thanks for judging the radio.

Thanks for being the tough, jaded, cynical bastards I knew you'd be.

— Sal Devito
Chairman
Advertising Judging Committee

The designs selected by the jury of the Graphic Design section of the Art Directors Club national and international exhibitions are all of high quality and were the best work entered in their respective categories. The selection process was easy. It is easy to identify good work. What is difficult is to create levels of distinction among good work. Therefore, the judging of the show was smooth, quick and uncontroversial. But the selection of medals was noisy, contentious and much more interesting.

How good is a gold medal? What's the difference between silver and gold? What is "distinctive merit?" There is no assigned criteria for any of these awards other than "graphic excellence." Mostly, medals are those pieces that stand out because 6 to 8 people thought they were "really, really, really good" (gold) as opposed to "really, really good" (silver) and plain old "really good" (distinctive merit).

After a great deal of discussion the judges arrived at a criteria for judging medals. We agreed that gold would be awarded only when it elevated a form of work. An example of this is Mirko Ilic's op-ed page design, where typography becomes the illustration. This is revolutionary for *The New York Times*. The design expanded the expectation of the form (and it's beautiful to boot).

Since we set the criteria for gold at a very high level, we awarded very few of them. Silver medals were awarded based on the content of the piece coupled with design. Those pieces that were awarded silver medals reflected the highest intelligence in design without necessarily expanding the form. Those pieces that were awarded distinctive merit were simply plain old-fashioned "really good."

Were each juror to award the medals in a vacuum, I do not believe the choices would be as succinct. The good work exhibited here is as good as any other show. The medals are better.

— Paula Scher
Chairman
Graphic Design Committee

It was the heaviest thing of its size I had ever held in my hand, I remember — all gold and shiny, the first Art Directors award I had been lucky to win. The names of those who also won that year were unknown to me, but I did know the names of the legends that came before us. We all did.

I was honored to chair the ADC's 8th International Exhibition, and can't imagine that those who managed to take home awards this year feel any less proud. They were judged the best by an extraordinarily talented group of peers who gave generously of their time and judgment to make sure that each winning piece was truly worthy of an ADC International award and what it represents. The striking work somehow always jumps out at you, no matter what the barriers. I thank the international judges for catching that work and coming up with a show of which we can be proud.

Now get on with it. Turn the page and see.

— Harvey Hoffenberg
International Committee Chair

ADVERTISING

ITALIAN FEAST
1 / 82
SILVER
ART DIRECTION
John Leu,
Donna Weinheim
CREATIVE DIRECTION
Cliff Freeman,
Donna Weinheim
COPYWRITING
Jeff Watzman
PRODUCTION
Anne Kurtzman
DIRECTION
Simon West
STUDIO
Pilot Pictures
AGENCY
Cliff Freeman and
Partners
CLIENT
Little Caesars
Enterprises
ENTRANT LOCATION
New York, NY

NIP
1 / 663
SILVER
ART DIRECTION
Susan Kruskopf
COPYWRITING
Jarl Olsen
PRODUCTION
Dublin Productions
DIRECTION
Jarl Olsen
MUSIC
Asche & Spencer
AGENCY
Kruskopf Olson
CLIENT
Pet Food Warehouse
ENTRANT LOCATION
Minneapolis, MN

GRANDMA DOBERMAN
1 / 757
SILVER
ART DIRECTION
John Vitro
COPYWRITING
John Robertson
PRODUCTION
Ilene Schneider
DIRECTION
Jon Francis
MUSIC
Piece of Cake
Music, Inc
AGENCY
Suissa Miller
Advertising, Inc
CLIENT
Schlage Lock Company
ENTRANT LOCATION
Santa Monica, CA

SAN FRANCISCO JAZZ
FESTIVAL
1 / 239
DISTINCTIVE MERIT
ART DIRECTION
John Butler, Mike Shine
COPYWRITING
Mike Shine, John Butler
PRODUCTION
Shelley Predovich
DIRECTION
Tom DeCerchio
MUSIC
Ad Music
AGENCY
Butler, Shine & Stern
CLIENT
San Francisco Jazz
Festival
ENTRANT LOCATION
Sausalito, CA

AIRPLANE
1 / 274
DISTINCTIVE MERIT
ART DIRECTION
Donna Weinheim
CREATIVE DIRECTION
Donna Weinheim,
Cliff Freeman
COPYWRITING
Cliff Freeman
PRODUCTION
Melanie Klein
DIRECTION
Simon West
STUDIO
Pilot Pictures
AGENCY
Cliff Freeman and
Partners
CLIENT
Little Caesars
Enterprises
ENTRANT LOCATION
New York, NY

EASY CARE
1 / 576
DISTINCTIVE MERIT
ART DIRECTION
Margaret McGovern
COPYWRITING
Paul Silverman
PRODUCTION
Amy Mizner,
Sarah Rueppel
DIRECTION
Paul Giraud
MUSIC
Muddy Waters
STUDIO
HSI Productions
AGENCY
Mullen
CLIENT
The Timberland
Company
ENTRANT LOCATION
Wenham, MA

BIG BAD WOLF
1 / 12
ART DIRECTION
Harvey Marco
COPYWRITING
David Smith
PRODUCTION
Jack McWalters
AGENCY
Ammirati & Puris Inc
CLIENT
Aetna Life
& Casualty Co.
ENTRANT LOCATION
New York, NY

RESTAURANT
1 / 27
ART DIRECTION
Mike Campbell
COPYWRITING
Chris Wall,
Steve Hyden
PRODUCTION
Barbara Mullins
DIRECTION
Joe Pytka
AGENCY
BBDO
CLIENT
Apple Computer
ENTRANT LOCATION
New York, NY

AIRPORT
1 / 33
ART DIRECTION
Mike Mazza
COPYWRITING
Steve Silver,
Chuck McBride
AGENCY PRODUCTION
Karen Smith
DIRECTION
Allan Van Rijn
MUSIC
Machine Head
STUDIO
BFCS, Inc
AGENCY
Team One
CLIENT
Lexus
ENTRANT LOCATION
El Segundo, CA

41

MONSTER TRUCK
1 / 34
ART DIRECTION
Kevin Donovan
CREATIVE DIRECTION
Arthur Bijur,
Cliff Freeman
COPYWRITING
Cliff Freeman,
Rick LeMoine
PRODUCTION
Mary Ellen Duggan
DIRECTION
Simon West
STUDIO
Pilot Pictures
AGENCY
Cliff Freeman and
Partners
CLIENT
Little Caesars
Enterprises
ENTRANT LOCATION
New York, NY

MEETING
1 / 37
ART DIRECTION
Mike Campbell
COPYWRITING
Chris Wall,
Steve Hyden
PRODUCTION
Barbara Mullins
DIRECTION
Joe Pytka
AGENCY
BBDO
CLIENT
Apple Computer
ENTRANT LOCATION
New York, NY

DOG PSYCHOLOGIST
1 / 39
ART DIRECTION
Donna Weinheim
CREATIVE DIRECTION
Donna Weinheim,
Arthur Bijur
COPYWRITING
Cliff Freeman,
Arthur Bijur
PRODUCTION
Melanie Klein
DIRECTION
Mark Story
STUDIO
Crossroads Films
AGENCY
Cliff Freeman and
Partners
CLIENT
Little Caesars
Enterprises
ENTRANT LOCATION
New York, NY

BIG LAWYER ROUND UP
1 / 58
ART DIRECTION
Terry Baker
COPYWRITING
Dan Heagy
PRODUCTION
Dave Musial,
Dave Beller
DIRECTION
Michael Bay
MUSIC
Steve Shafer Music
AGENCY
Leo Burnett Company
CLIENT
Miller Brewing
Company
ENTRANT LOCATION
Chicago, IL

STARES
1 / 59
ART DIRECTION
Larry Jarvis
COPYWRITING
Rob McPherson
PRODUCTION
Carrie Zeizer
DIRECTION
Neil Abramson,
Gore Verbinski
AGENCY
Angotti, Thomas
Hedge, Inc.
CLIENT
Saab Cars USA, Inc.
ENTRANT LOCATION
New York, NY

ROOSTER
1 / 67
ART DIRECTION
Tom McConnaughy
COPYWRITING
Scott Eirinberg
PRODUCTION
Jon Wyville
DIRECTION
Berl Cattell
AGENCY
McConnaughy Stein
Schmidt Brown
CLIENT
Walgreen Company
ENTRANT LOCATION
Chicago, IL

APPLAUSE
1 / 79
ART DIRECTION
Mike Campbell
COPYWRITING
Janet Lyons,
Dennis Berger
PRODUCTION
Bob Emerson
DIRECTION
Jim Gartner
AGENCY
BBDO
CLIENT
Federal Express
ENTRANT LOCATION
New York, NY

HEART RATE
1 / 99
ART DIRECTION
Sal DeVito
COPYWRITING
Don Miller
PRODUCTION
Deb Labick,
Pat Quaglino
DIRECTION
Bob Giraldi
AGENCY
DeVito / Verdi
CLIENT
Lucille Roberts
ENTRANT LOCATION
New York, NY

GUPPY
1 / 114
ART DIRECTION
Tony Angotti
COPYWRITING
Dion Hughes
PRODUCTION
Barbara Beatty
DIRECTION
Jim Peretti,
stock footage
MUSIC
stock
AGENCY
Angotti, Thomas
Hedge, Inc.
CLIENT
Molson Breweries, Inc.
ENTRANT LOCATION
New York, NY

GUPPY

LIFE FLASH
1 / 117
ART DIRECTION
Dean Stefanides
COPYWRITING
Larry Hampel
CREATIVE DIRECTION
Sam Scali
PRODUCTION
Gary Grossman
DIRECTION
Henry Sandbank
AGENCY
Lowe & Partners / SMS
CLIENT
Mercedes - Benz
ENTRANT LOCATION
New York, NY

NAUTILUS
1 / 121
ART DIRECTION
Sal DeVito
COPYWRITING
Sal DeVito, Abi Aron
PRODUCTION
Deb Labick,
Pat Quaglino
DIRECTION
Bob Giraldi
AGENCY
DeVito / Verdi
CREATIVE DIRECTION
Sal DeVito
CLIENT
Lucille Roberts
ENTRANT LOCATION
New York, NY

LONELY PEOPLE
1 / 125
ART DIRECTION
Hal Curtis
COPYWRITING
Paul Keye
PRODUCTION
Beth Hagen
DIRECTION
Joe Pytka
MUSIC
Brian Banks
AGENCY
Livingston + Company
CLIENT
California Department
of Health Services
ENTRANT LOCATION
Venice, CA

STAY YOUNG
1 / 129
ART DIRECTION
Steve Fong
COPYWRITING
Bill Bruce
PRODUCTION
Vicki Halliday
DIRECTION
Joe Pytka
AGENCY
BBDO
CLIENT
Campbell's Soup Co.
ENTRANT LOCATION
New York, NY

WEDDING
1 / 134
ART DIRECTION
Gail San Filippo
COPYWRITING
Julie Curtis
PRODUCTION
Jennifer Golub
DIRECTION
Tony Kaye
MUSIC
John Trivers
AGENCY
Chiat / Day inc.
CLIENT
Home Savings
of America
ENTRANT LOCATION
Venice, CA

THE ROCKER
1 / 140
ART DIRECTION
Harvey Marco
COPYWRITING
David Smith
PRODUCTION
Jack McWalters
DIRECTION
Jake Scott
AGENCY
Ammirati & Puris Inc
CLIENT
Thomson Consumer
Electronics
ENTRANT LOCATION
New York, NY

SMARTER
1 / 168
ART DIRECTION
David Page,
Brent Boucher
COPYWRITING
Adam Goldstein
PRODUCTION
Susan Shipman
DIRECTION
Mark Coppos
MUSIC
Elias
AGENCY
Ammirati & Puris Inc
CLIENT
MasterCard
ENTRANT LOCATION
New York, NY

GOTCHA
1 / 171
ART DIRECTION
Mike Campbell
COPYWRITING
Dennis Berger,
Janet Lyons
PRODUCTION
Bob Emerson
DIRECTION
Jim Gartner
AGENCY
BBDO
CLIENT
Federal Express
ENTRANT LOCATION
New York, NY

MAGNET
1 / 181
ART DIRECTION
Craig Tanimoto
COPYWRITING
Eric Grunbaum,
Scott Vincent
PRODUCTION
Linda Arett
DIRECTION
Michael Werk
AGENCY
Chiat / Day inc.
CLIENT
Nissan Motor Corp
ENTRANT LOCATION
Venice, CA

CRABBER
I / 200
ART DIRECTION
Sherry Charles
COPYWRITING
Paul Cuneo
CREATIVE DIRECTION
Jon Hyde,
Jim Sanderson
PRODUCTION
Craig Allen,
Therese Vreeland
DIRECTION
Gary Weis
STUDIO
I - 33 Productions
AGENCY
J. Walter Thompson
CLIENT
Supercuts
ENTRANT LOCATION
San Francisco, CA

GUITAR
I / 210
ART DIRECTION
Mike Mazza
COPYWRITING
Steve Silver,
Rich Anderman
CREATIVE DIRECTION
Tom Cordner
PRODUCTION
Johns + Gorman Films
AGENCY PRODUCTION
Kelly Waltos
DIRECTION
Jeff Gorman
EDITING
Tom Schacte /
Straight Cut
MUSIC
Manuel Barrueco
& Machine Head
Sound Design
AGENCY
Team One
CLIENT
Lexus
ENTRANT LOCATION
El Segundo, CA

MANUEL BARRUECO
Asturias in E minor

TRAIN
I / 223
ART DIRECTION
Steve Sweitzer
COPYWRITING
Bob Rice
PRODUCTION
Jack Harrower
DIRECTION
Allan Van Rijn
AGENCY
Chiat / Day inc.
CLIENT
Reebok
ENTRANT LOCATION
Venice, CA

JAZZ MUSICIAN
1 / 227
ART DIRECTION
Susan Westre
COPYWRITING
Chris Wall
PRODUCTION
Barbara Mullins
DIRECTION
Joe Pytka
MUSIC
stock
AGENCY
BBDO
CLIENT
Apple Computer
ENTRANT LOCATION
New York, NY

SUPERMARKET
1 / 234
ART DIRECTION
David Page,
Brent Boucher
COPYWRITING
Adam Goldstein,
Scott Zacaroli
PRODUCTION
Susan Shipman
DIRECTION
Mark Coppos
AGENCY
Ammirati & Puris Inc
CLIENT
MasterCard
ENTRANT LOCATION
New York, NY

DRIVE TO WORK
1 / 241
ART DIRECTION
Mike Mazza,
Tom Rosenfield
CREATIVE DIRECTION
Tom Cordner
COPYWRITING
Steve Silver,
Chuck McBride
PRODUCTION
BFCS, Inc
AGENCY PRODUCTION
Karen Smith
DIRECTION
Allan Van Rijn
EDITING
Tom Schacte /
Straight Cut
MUSIC
Machine Head
AGENCY
Team One
CLIENT
Lexus
ENTRANT LOCATION
El Segundo, CA

STAND UP COMIC
1 / 257
ART DIRECTION
Susan Westre
COPYWRITING
Chris Wall
PRODUCTION
Barbara Mullins
DIRECTION
Joe Pytka
MUSIC
Music Kitchen,
Los Angeles, CA
AGENCY
BBDO
CLIENT
Apple Computer
ENTRANT LOCATION
New York, NY

STRIPPER
1 / 280
ART DIRECTION
Dean Stefanides
COPYWRITING
Larry Hampel
CREATIVE DIRECTION
Sam Scali
PRODUCTION
Chris Coccaro
DIRECTION
Elbert Budin
AGENCY
Lowe & Partners / SMS
CLIENT
Purdue Farms, Inc.
ENTRANT LOCATION
New York, NY

DRACULA
1 / 299
ART DIRECTION
John Leu
CREATIVE DIRECTION
Arthur Bijur
COPYWRITING
Arthur Bijur,
Jeff Watzman
PRODUCTION
Anne Kurtzman
DIRECTION
Charles Wittenmaier
STUDIO
Harmony Pictures
AGENCY
Cliff Freeman and
Partners
CLIENT
Sony Imagesoft
ENTRANT LOCATION
New York, NY

BRAIN FREEZE
1 / 304
ART DIRECTION
Matt Canzano
CREATIVE DIRECTION
Nina DiSesa,
Matt Canzano,
Rita Winters,
Steve Romanenghi
PRODUCTION
Ed Maroney
DIRECTION
Tenney Fairchild
MUSIC
Chicago Music Works
AGENCY
J. Walter Thompson /
Chicago
CLIENT
Southland / 7 - Eleven
ENTRANT LOCATION
Chicago, IL

TALK
1 / 319
ART DIRECTION
David Page
COPYWRITING
Brent Bouchez
PHOTOGRAPHY
Peter Brown, DP
PRODUCTION
Ozzie Spenningsby
DIRECTION
Mark Coppos
PRODUCTION COMPANY
Coppos Films
AGENCY
Ammirati & Puris,
New York
CLIENT
Compaq
ENTRANT LOCATION
Los Angeles, CA

ACT NOW
1 / 348
ART DIRECTION
Tom Routson
DESIGN
Tom Routson
COPYWRITING
Scott Aal
PRODUCTION
Betsy Flynn
DIRECTION
Danny Boyle
AGENCY
Goodby Berlin
& Silverman
CLIENT
Sega of America
ENTRANT LOCATION
San Francisco, CA

STROBE
1 / 365
ART DIRECTION
Jeff Henson
COPYWRITING
Brian Toogood
PRODUCTION
Susan Poor
DIRECTION
Jeff Henson,
Brian Toogood
AGENCY
Houston Effler &
Partners
CLIENT
Boston Museum of
Science
ENTRANT LOCATION
Boston, MA

CAN OPENER
1 / 391
ART DIRECTION
Tony Angotti
COPYWRITING
Dion Hughes
PRODUCTION
Barbara Beatty
DIRECTION
Jim Peretti
MUSIC
stock
AGENCY
Angotti, Thomas
Hedge, Inc.
CLIENT
Molson Breweries,
U.S.A. Inc.
ENTRANT LOCATION
New York, NY

COW
1 / 399
ART DIRECTION
Scott Bailey
COPYWRITING
Mikal Reich
PHOTOGRAPHY
stock
PRODUCTION
Amy Alkon
AGENCY
Mad Dogs &
Englishmen
CLIENT
Kenneth Cole
ENTRANT LOCATION
New York, NY

KICK / FARMER
1 / 411
ART DIRECTION
David Page
COPYWRITING
Ty Montague
PHOTOGRAPHY
Peter Brown, DP
PRODUCTION
Roxanne Karsche
DIRECTION
Mark Coppos
PRODUCTION COMPANY
Coppos Films
AGENCY
Chiat / Day New York
CLIENT
Reebok
ENTRANT LOCATION
Los Angeles, CA

YOUR JOB
1 / 412
ART DIRECTION
Sal DeVito
COPYWRITING
Tom Gianfagna
PRODUCTION
Deb Labick,
Pat Quaglino
DIRECTION
Bob Giraldi
AGENCY
DeVito / Verdi
CLIENT
Lucille Roberts
ENTRANT LOCATION
New York, NY

X - RAY
1 / 439
ART DIRECTION
Robert Shaw West
DESIGN
Robert Shaw West
COPYWRITING
Philip Wilson
EDITING
Ed Kisberg,
Horn Eisenberg
PRODUCTION
Joe Mosca
DIRECTION
Robert Shaw West
MUSIC
Jimi Hendrix
STUDIO
Earle Palmer Brown /
Phila.
AGENCY
Earle Palmer Brown /
Phila.
CLIENT
WMMR 93.3 FM
ENTRANT LOCATION
Philadelphia, PA

GRAVEYARD
1 / 445
ART DIRECTION
Robert Shaw West
DESIGN
Robert Shaw West
COPYWRITING
Kelly Simmons
EDITING
Ed Kisberg,
Horn Eisenberg
PRODUCTION
Joe Mosca
DIRECTION
Robert Shaw West
PRODUCTION COMPANY
Earle Palmer Brown /
Phila.
MUSIC
Nirvana
AGENCY
Earle Palmer Brown /
Phila.
CLIENT
WMMR 93.3 FM
ENTRANT LOCATION
Philadelphia, PA

CONGLOMCO
1 / 459
ART DIRECTION
Chuck Finkle
COPYWRITING
Dean Hacohen
PRODUCTION
Pat Quaglino
DIRECTION
Henry Sandbank
AGENCY
Goldsmith / Jeffrey
CLIENT
NYNEX BTB Directory
ENTRANT LOCATION
New York, NY

PSYCH-O-DELIC
1 / 484
ART DIRECTION
Robert Shaw West
DESIGN
Robert Shaw West
COPYWRITING
Ken Cills
EDITING
Billy Woods,
Modern Video
PRODUCTION
Joe Mosca
DIRECTION
Robert Shaw West
PRODUCTION COMPANY
Earle Palmer Brown /
Phila.
MUSIC
Jefferson Airplane
AGENCY
Earle Palmer Brown /
Phila.
CLIENT
WMMR 93.3 FM
ENTRANT LOCATION
Philadelphia, PA

POKER
1 / 499
ART DIRECTION
Noam Murro
COPYWRITING
Eddie Van Bloem
EDITING
Avi Aron
DIRECTION
Tim Bieber
AGENCY
Goldsmith / Jeffrey
CLIENT
Lumex Healthcare
ENTRANT LOCATION
New York, NY

GLOBAL MAPMAKERS
1 / 514
ART DIRECTION
Chuck Finkle
COPYWRITING
Dean Hacohen
PRODUCTION
Patricia Quaglino
DIRECTION
Henry Sandbank
AGENCY
Goldsmith / Jeffrey
CLIENT
NYNEX BTB Directory
ENTRANT LOCATION
New York, NY

SCHOOL YARD
1 / 516
ART DIRECTION
Kitty Thorne
COPYWRITING
Katie Hennicke
PRODUCTION
Jim Bogner
DIRECTION
Robert Lieberman
STUDIO
Harmony Pictures,
Los Angeles, CA
AGENCY
FCB / Leber Katz
Partners
CLIENT
Nabisco Bisquit
Company
ENTRANT LOCATION
New York, NY

BRUSH / GARGLE
1 / 534
ART DIRECTION
Miguel Nogueras
COPYWRITING
Kim Christian Olson
PRODUCTION
Herb Miller
DIRECTION
Brent Thomas /
Coppos Films,
Los Angeles, CA
AGENCY
FCB / Leber Katz
Partners
CLIENT
Nabisco Food
Company
ENTRANT LOCATION
New York, NY

DINER
1 / 568
ART DIRECTION
Bob Cockrell,
Susan Westre
COPYWRITING
Greg Ketchum,
Chris Wall
PRODUCTION
Barbara Mullins
DIRECTION
Joe Pytka
STUDIO
Pytka
MUSIC
Music Forever
AGENCY
BBDO
CLIENT
Apple Computer
ENTRANT LOCATION
Los Angeles, CA

HOWL-O-WEEN
1 / 632
ART DIRECTION
Susan Kruskopf
COPYWRITING
Jarl Olsen
PRODUCTION
Dublin Productions
DIRECTION
Jarl Olsen
MUSIC
Asche & Spencer
AGENCY
Kruskopf Olson
CLIENT
Pet Food Warehouse
ENTRANT LOCATION
Minneapolis, MN

ROCKY
1 / 751
ART DIRECTION
Brien Spanier
COPYWRITING
Charlie Callahan
PRODUCTION
Jane Jacobsen
DIRECTION
Buck Holzemer
STUDIO
Wilson Griak
MUSIC
John Trivers
AGENCY
Kauffman Stewart
CLIENT
Blockbuster Video
ENTRANT LOCATION
Minneapolis, MN

MEGATHERIUM
1 / 1
SILVER
ART DIRECTION
Susumu Miyazaki,
Takuya Onuki
DESIGN
Kazuhiro Suda,
Keisuke Tadokoro
COPYWRITING
Masahiko Ishii,
Tomomi Maeda
PHOTOGRAPHY
Satoshi Seno
PRODUCTION
Seiichiro Horii,
Kazuyuki Machida
DIRECTION
Shinya Nakajima
STUDIO
Chioda Bros. Studio
(LA)
CLIENT
Nissin Food Products
Co., Ltd.
ENTRANT LOCATION
Tokyo, Japan

QUETZALCOATLUS
1 / 7
SILVER
ART DIRECTION
Susumu Miyazaki,
Takuya Onuki
DESIGN
Kazuhiro Suda,
Keisuke Tadokoro
COPYWRITING
Masahiko Ishii,
Tomomi Maeda,
Kouji Ando,
Mitsuaki Imura,
Kotaro Yoshioka
PHOTOGRAPHY
Satoshi Seno
PRODUCTION
Seiichiro Horii,
Kazuyuki Machida
DIRECTION
Shinya Nakajima
STUDIO
Chioda Bros. Studio
(LA)
CLIENT
Nissin Food Products
Co., Ltd.
ENTRANT LOCATION
Tokyo, Japan

OPEN AIR BATH
1 / 9
SILVER
ART DIRECTION
Takashi Kitazawa
COPYWRITING
Yoshinobu Yokoo,
Mayuko Kamo
PHOTOGRAPHY
Eiichiro Sakata
PRODUCTION
Masahiro Taniguchi,
Nobuko Nogami,
Hitoshi Kodama
DIRECTION
Kikuhide Sekiguchi
MUSIC
Shinichiro Akita
STUDIO
Engine Film Inc.
AGENCY
Dentsu Inc., Tokyo
CLIENT
Sanyo Electric Co., Ltd
ENTRANT LOCATION
Tokyo, Japan

GLASS DOOR
1 / 10
SILVER
ART DIRECTION
Else Haavik
COPYWRITING
Tom Sozbauken
PHOTOGRAPHY
Erik Poppe
PRODUCTION
Ragnhild Winje
DIRECTION
Erik Poppe
AGENCY
Publicis FCB
CLIENT
Norwegian Opticians
Associates
ENTRANT LOCATION
Oslo, Norway

**ENCOUNTER
WITH A LION**
1 / 2
ART DIRECTION
Jun-ichiro Akiyoshi,
Tetsuo Hashimoto
COPYWRITING
Tetsuo Higuma,
Shinji Takahashi
PHOTOGRAPHY
Aiji Fujiwara
PRODUCTION
Hiroshi Yoshida
DIRECTION
Masatake Satomi
MUSIC
Hiroaki Kondo
AGENCY
Hakuhodo
Incorporated
CLIENT
Matsushita Electric
Industrial Co., Ltd.
ENTRANT LOCATION
Tokyo, Japan

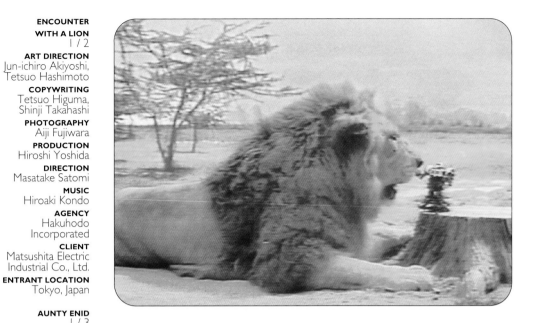

AUNTY ENID
1 / 3
ART DIRECTION
Rodger Williams
COPYWRITING
Chips Hardy
PRODUCTION
Barry Stephenson
DIRECTION
Rodger Woodburn
STUDIO
Park Village
AGENCY
BSB Dorland
CLIENT
Woolworths Plc
ENTRANT LOCATION
London, England

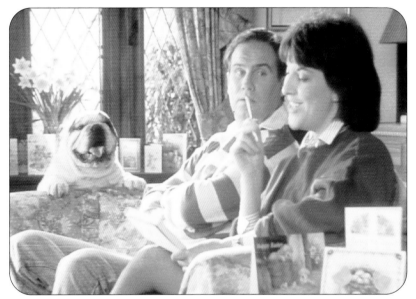

**SUMITOMO 3M (SOCCER
VERSION)**
1 / 4
ART DIRECTION
Akira Kagami
DESIGN
Shiroh Takasugi
COPYWRITING
Shiroh Takasugi,
Asako Hashida,
Hanako Suzuki,
Sumiko Sato
PHOTOGRAPHY
Nobuo Hoshimoto
ILLUSTRATION
Mario Mariotti
PRODUCTION
Hisako Kuniyasu
DIRECTION
Hideyo Hashimoto
MUSIC
Sting Tone
STUDIO
Kuni & Associates, Inc.
& Dentsu Prox, Inc.
AGENCY
Dentsu Inc., Tokyo
CLIENT
Sumitomo 3M Ltd.
ENTRANT LOCATION
Los Angeles, CA

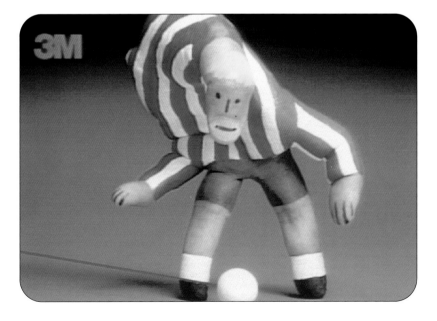

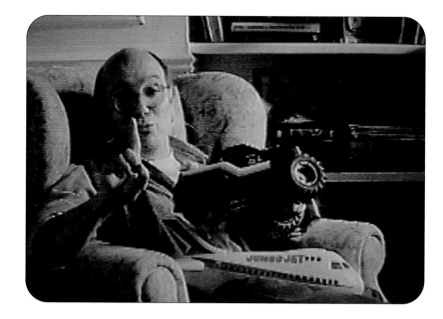

PRICES
1 / 5
ART DIRECTION
Roberto Cipolla
COPYWRITING
Nizan Guanaes
Luiz Toledo
PRODUCTION
Side by Side
DIRECTION
Renato Assad
AGENCY
DM9 Publicidade
CLIENT
Lego
MUSIC
Cardan
ENTRANT LOCATION
Sao Paulo, Brazil

TENNIS BALL
1 / 6
ART DIRECTION
Haruyo Arai
DESIGN
Akira Kurita
COPYWRITING
Noboru Inoue,
Toshiya Kohno
PHOTOGRAPHY
Mitsuaki Ishikawa
PRODUCTION
Shigeru Yoshioka
DIRECTION
Toshiro Takahashi
STUDIO
Polio Tennis Studio
AGENCY
Hakuhodo
Incorporated
CLIENT
Toagosei Chemical
Industries Co., Ltd.
ENTRANT LOCATION
Tokyo, Japan

REGEN
1 / 8
ART DIRECTION
Kai Zastrow
COPYWRITING
Hartwig Keuntje
PRODUCTION
Take Five Film
Production GmbH
DIRECTION
Hartwig Keuntje
AGENCY
Jung V. Matt
CLIENT
Oldesloer -August
Ernst GmbH & Co.
ENTRANT LOCATION
Hamburg, Germany

If you go to law school,
it will cost **$70,000.**

POOR ETC
2 / 129
GOLD
ART DIRECTION
Steve Whittier
COPYWRITING
Ted Nelson
PRODUCTION
Win Peniston
DIRECTION
Win Peniston
AGENCY
The Joey Reiman
Agency
CLIENT
Rocky Mountain
College of Art
ENTRANT LOCATION
Atlanta, GA

You won't be poor until after graduation.

AIRPLANE / ITALIAN FEAST / MONKEY
2 / 73

DISTINCTIVE MERIT

ART DIRECTION
Donna Weinheim,
John Leu, Bruce Hurwit

CREATIVE DIRECTION
Donna Weinheim,
Cliff Freeman

COPYWRITING
Cliff Freeman,
Jeff Watzman,
Don Austen

PRODUCTION
Melanie Klein,
Anne Kurtzman

DIRECTION
Simon West, Jon
Francis

STUDIO
Pilot Pictures,
Steifel & Company

AGENCY
Cliff Freeman and
Partners

CLIENT
Little Caesars
Enterprises

ENTRANT LOCATION
New York, NY

NIP / BED / HOWL-O-WEEN
2 / 156
DISTINCTIVE MERIT
ART DIRECTION
Susan Kruskopf
COPYWRITING
Jarl Olsen
PRODUCTION
Dublin Productions
DIRECTION
Jarl Olsen
MUSIC
Asche & Spencer
AGENCY
Kruskopf Olson
CLIENT
Pet Food Warehouse
ENTRANT LOCATION
Minneapolis, MN

MUDDY / EASY CARE / FASHION
2 / 8

ART DIRECTION
Margaret McGovern

COPYWRITING
Paul Silverman

PRODUCTION
Amy Mizner,
Sarah Rueppel

DIRECTION
Paul Giraud

MUSIC
Muddy Waters

STUDIO
HSI Productions

AGENCY
Mullen

CLIENT
The Timberland
Company

ENTRANT LOCATION
Wenham, MA

GLOBAL MAPMAKERS /
SMITHIES AUCTION / E-Z
WEIGHT LOSS
2 / 13

ART DIRECTION
Chuck Finkle

COPYWRITING
Dean Hacohen

PRODUCTION
Patricia Quaglino

DIRECTION
Henry Sandbank

AGENCY
Goldsmith / Jeffrey

CLIENT
NYNEX BTB Directory

ENTRANT LOCATION
New York, NY

**J. MUSICIAN / CATERER /
COMIC**
2 / 14
ART DIRECTION
Susan Westre
COPYWRITING
Chris Wall
PRODUCTION
Barbara Mullins
DIRECTION
Joe Pytka
MUSIC
Ear to Ear,
Los Angeles, CA
AGENCY
BBDO
CLIENT
Apple Computer
ENTRANT LOCATION
New York, NY

BOOK / MOVIE / TOLL
2 / 25
ART DIRECTION
Nick Scordato
COPYWRITING
Gordon Hasse
PRODUCTION
Gaston Braun
MUSIC
Elias Associates
AGENCY
Ayer Advertising
CLIENT
AT & T Corp.
ENTRANT LOCATION
New York, NY

OLD GIRLFRIEND / DOG BREATH / LEECHES
2 / 30
ART DIRECTION
Cabell Harris
COPYWRITING
Tom Camp
CREATIVE DIRECTION
Cabell Harris
PRODUCTION
Beth Hagen
DIRECTION
Mark Story
AGENCY
Livingston + Company
CLIENT
California Department
of Health Services
ENTRANT LOCATION
Venice, CA

WHERE IS NEWTON / REST / MEETING
2 / 38
ART DIRECTION
Mike Campbell,
Susan Westre
COPYWRITING
Chris Wall
PRODUCTION
Barbara Mullins
DIRECTION
Joe Pytka
MUSIC
Music Forever,
Los Angeles, CA
AGENCY
BBDO
CLIENT
Apple Computer
ENTRANT LOCATION
New York, NY

SPOONS / WATERFALL / CHROMOSOMES
2 / 46
ART DIRECTION
Joe Stuart
COPYWRITING
Ryan Ebner
AGENCY
McConnaughy Stein
Schmidt Brown
CLIENT
True Value Hardware
ENTRANT LOCATION
Chicago, IL

PIG / FROG / MOSQUITO
2 / 110
ART DIRECTION
Hal Tench
COPYWRITING
Joe Alexander
PRODUCTION
Randy Shreve
STUDIO
Henninger Video
AGENCY
The Martin Agency
CLIENT
Barnett Banks, Inc.
ENTRANT LOCATION
Richmond, VA

DOG / BUGS / ACT NOW
2 / 115
ART DIRECTION
Tom Routson
DESIGN
Tom Routson
COPYWRITING
Taylor Heyman,
Scott Aal
PRODUCTION
Shelly Predovich,
Betsy Flynn
DIRECTION
Tom Routson,
Mark Pellington,
Danny Boyle
MUSIC
Earwax
AGENCY
Goodby Berlin &
Silverman
CLIENT
Sega of America
ENTRANT LOCATION
San Francisco, CA

GRAVEYARD / X - RAY /
PSYCHO-O-DELIC
2 / 117
ART DIRECTION
Robert Shaw West
DESIGN
Robert Shaw West
COPYWRITING
Kelly Simmons,
Ken Cills, Philip Wilson
EDITING
Ed Kisberg,
Horn Eisenberg,
Billy Woods,
Modern Video
PRODUCTION
Joe Mosca
DIRECTION
Robert Shaw West
PRODUCTION COMPANY
Earle Palmer Brown /
Phila.
MUSIC
Nirvana, Jimi Hendrix,
Jefferson Airplane
AGENCY
Earle Palmer Brown /
Phila.
CLIENT
WMMR 93.3 FM
ENTRANT LOCATION
Philadelphia, PA

AUNTY ENID / SOFA /
DOG'S DINNER / MALLET /
RUCKSACK
2 / 2
DISTINCTIVE MERIT
ART DIRECTION
Rodger Williams,
Nick Simons,
Russell Waldron
COPYWRITING
Chips Hardy,
David Prideaux,
Jon Canning
PRODUCTION
Barry Stephenson,
Bruce Macrae
DIRECTION
Rodger Woodburn,
Peter Webb
STUDIO
Park Village
AGENCY
BSB Dorland
CLIENT
Woolworths Plc
ENTRANT LOCATION
London, England

OPEN AIR BATH /
PROMISES / SKI
2 / 4
DISTINCTIVE MERIT
ART DIRECTION
Takashi Kitazawa
COPYWRITING
Yoshinobu Yokoo,
Mayuko Kamo
PHOTOGRAPHY
Eiichiro Sakata
PRODUCTION
Masahiro Taniguchi,
Nobuko Nogami,
Hitoshi Kodama
DIRECTION
Kikuhide Sekiguchi
STUDIO
Engine Film Inc.
AGENCY
Dentsu Inc.
CLIENT
Sanyo Electric Co., Ltd.
ENTRANT LOCATION
Tokyo, Japan

OLD LADIES / BOOTS / SERVICE CHIEF / TERRACE
2 / 1
ART DIRECTION
Antoine Barthuel
COPYWRITING
Bruno Lacoste
PRODUCTION
Premiere Heure
DIRECTION
Valerie Lemercier
AGENCY
B.D.D.P.
CLIENT
La Francaise Des Jeux
ENTRANT LOCATION
Boulogne, France

BONAFONT (PURIFIED WATER) / THOSE WHO KNOW IT PREFER IT
2 / 3
ART DIRECTION
Carlos Quintana
DESIGN
Carlos Quintana,
Franco Garuti
COPYWRITING
Gustavo Blanquel,
Sofia Aguilar
PHOTOGRAPHY
Eduardo Martinez
Solares
PRODUCTION
GB Producciones
DIRECTION
Simon Bross
AGENCY
Noble DMB & B
CLIENT
Bonafont (Purified
Water)
ENTRANT LOCATION
Mexico City, Mexico

THERAPIST
3 / 22
DISTINCTIVE MERIT
ART DIRECTION
Steve Luker
COPYWRITING
Steven Johnston
PRODUCTION
Sam Walsh
DIRECTION
Sam Stevens
AGENCY
Cole and Weber
CLIENT
S . I . F . F
ENTRANT LOCATION
Seattle, WA

SHOWDOWN
3 / 26
DISTINCTIVE MERIT
ART DIRECTION
Bob Shallcross
COPYWRITING
Jim Ferguson
PRODUCTION
Glant Cohen
DIRECTION
Joe Pytka
MUSIC
Intuition / Chicago
AGENCY
Leo Burnett Company
CLIENT
McDonald's
Corporation
ENTRANT LOCATION
Chicago, IL

NAMES
3 / 11

ART DIRECTION
Tom Tieche

COPYWRITING
Steven Johnston

PRODUCTION
Shirley Radebaugh

MUSIC
Don Piestrup

AGENCY
Cole and Weber

CLIENT
Boeing Defense and
Space

ENTRANT LOCATION
Seattle, WA

LEGENDS
3 / 19

ART DIRECTION
Kathy Delaney

COPYWRITING
Charles Hall

PHOTOGRAPHY
Guy Furner, DP

PRODUCTION
Amy Saunders

DIRECTION
Brenton Thomas

PRODUCTION COMPANY
Coppos Films

AGENCY
Chiat / Day New York

CLIENT
Reebok

ENTRANT LOCATION
Los Angeles, CA

DINER
3 / 42

ART DIRECTION
Bob Cockrell,
Susan Westre

COPYWRITING
Greg Ketchum,
Chris Wall

PRODUCTION
Barbara Mullins

DIRECTION
Joe Pytka

MUSIC
Music Forever

STUDIO
Pytka

AGENCY
BBDO

CLIENT
Apple Computer

ENTRANT LOCATION
Los Angeles, CA

I'M EMMITT
3 / 60
ART DIRECTION
Steve Sweitzer
COPYWRITING
Bob Rice
PRODUCTION
Jack Harrower
DIRECTION
Allan Van Rijn
MUSIC
Enterprise Burbank, CA
STUDIO
BFCS Phoenix, Arizona
AGENCY
Chiat / Day New York
CLIENT
Reebok
ENTRANT LOCATION
New York, NY

GRAVES
3 / 67
ART DIRECTION
Noam Murro
COPYWRITING
Gary Goldsmith
EDITIN G
Avi Oron
DIRECTION
Yaariv Gaber
MUSIC
Stock
AGENCY
Goldsmith / Jeffrey
CLIENT
Goldsmith / Jeffrey
ENTRANT LOCATION
New York, NY

MASTERMIND
3 / 84
ART DIRECTION
Chris Hooper
COPYWRITING
Scott Vincent
PRODUCTION
Helen Erb
DIRECTION
Frank Oz
AGENCY
Chiat / Day inc.
CLIENT
Eveready Batteries
MUSIC
Jonathan Elias
ENTRANT LOCATION
Venice, CA

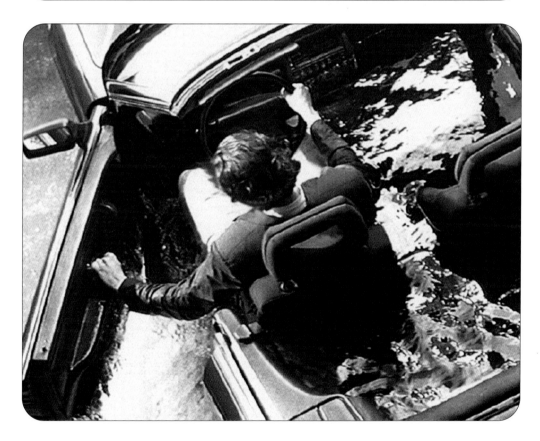

CUCKOO
3 / 3
SILVER
ART DIRECTION
Johan Gulbranson,
Morten Varhaug
COPYWRITING
Dagfinn Blaafjell
PHOTOGRAPHY
Thomas Boman
PRODUCTION
Knut E. Jensen,
Anna Sohlman
DIRECTION
Johan Gulbranson
AGENCY
Leo Burnettt AS
CLIENT
Looc - Olympic Coins
(Winter Olympics,
1994)
ENTRANT LOCATION
Oslo, Norway

CONVERTIBLE
3 / 1
DISTINCTIVE MERIT
ART DIRECTION
Pieter van Velsen
COPYWRITING
Wim Ubachs
PRODUCTION
Edwin Wagenaar
DIRECTION
Will v.d. Vlugt
MUSIC
Jan Akkerman
AGENCY
Saatchi & Saatchi
Advertising
CLIENT
Audi / Pon's
Automobielhandel
ENTRANT LOCATION
Amstelveen, Holland

VAMPIRE
3 / 2
ART DIRECTION
Detlef Wildermuth
COPYWRITING
Detlef Wildermuth
PRODUCTION
Detlef Wildermuth
DIRECTION
Nikolai Karo
MUSIC
P.O.V. München
STUDIO
German Answer
Production
AGENCY
Ayer Frankfurt
CLIENT
Brewery Gotha
ENTRANT LOCATION
Frankfurt, Germany

DRESDEN/AMERIKA
3 / 4
COPYWRITING
Joachim Schoepfer,
Sebastian Turner
PHOTOGRAPHY
Andreas Josimovics
PRODUCTION
Martin Hagemann,
Zak Berlin
DIRECTION
Ronald Eichhorn
MUSIC
Arpad Bondy
AGENCY
Sholz & Friends Berlin
CLIENT
Saechsische Zeitung
ENTRANT LOCATION
Berlin , Germany

THE KILLING SUN
3 / 5
ART DIRECTION
Johan Gulbranson,
Morten Saether
COPYWRITING
Oistein Borge
PHOTOGRAPHY
Thomas Boman
PRODUCTION
Knut E. Jensen
DIRECTION
Johan Gulbranson
MUSIC
Bohren & Aaserud
AGENCY
Leo Burnett AS
CLIENT
Norwegian
Cancer Association
(Kreftforeningen)
ENTRANT LOCATION
Oslo, Norway

L'ATTAQUE DU FRIGO
3 / 6
ART DIRECTION
Harley Jesup
CREATIVE DIRECTION
Bernard Bureau
PHOTO DIRECTION
Pat Turner
ANIMATION
Doug Smythe,
Joe Pasquale,
Tom Bertino,
Wade Howie,
Ellen Poon
PRODUCTION
Clint Goldsman / ILM,
Patrice Haddad /
Premiere Heure
DIRECTION
Ken Ralston
MUSIC
Scott Chandler /
Skywalker Sound
North
STUDIO
Industrial Light & Magic
AGENCY
Ogilvy & Mather/Paris
(through Premiere
Heure/Paris)
CLIENT
Perrier
ENTRANT LOCATION
San Rafael , CA

He:

...or - God help me -
as a Tampax.
That would be marvelous!

HE/SHE
3 / 7
COPYWRITING
Nizan Guanaes
PRODUCTION
Casablanca
DIRECTION
Mauricio Guimaraes
MUSIC
VU
AGENCY
DM9 Publicidade
CLIENT
Presidencialist Brazilian
Party
ENTRANT LOCATION
Sao Paulo, Brazil

PRONTO LIGHT BENCH
3 / 8
ART DIRECTION
Stefano Longoni,
Roxanne Bianco
COPYWRITING
Lorenzo De Rita
CREATIVE DIRECTION
Gianfranco Marabelli,
Enrico Bonomini
PRODUCTION
Federica Camurri
DIRECTION
Gian Abrile
MUSIC
Lovin' Spoonful
AGENCY
Verba DDB Needham
CLIENT
SC-Johnson Wax
ENTRANT LOCATION
Milan, Italy

MASTERMIND ETC.
4 / 14, 15
ART DIRECTION
Chris Hooper,
Craig Tanimoto
COPYWRITING
Scott Vincent,
Hillary Jordan
PRODUCTION
Richard O'Neill,
Helen Erb
DIRECTION
Frank Oz,
Danny Kleinman
MUSIC
Jonathan Elias
AGENCY
Chiat / Day inc.
CLIENT
Eveready Batteries
ENTRANT LOCATION
Venice, CA

TAP DANCER / ICE SKATER / FOOTBALLER
4 / 1
GOLD
ART DIRECTION
Erik Voser
COPYWRITING
Matthias Freuler
PRODUCTION
Stefan Zurcher,
Linda Peryer
DIRECTION
Bill Marshall
MUSIC
David Dundas
AGENCY
Advico Young &
Rubicam
CLIENT
ZVSM
ENTRANT LOCATION
Zurich, Switzerland

OLD GIRLFRIEND
5 / 302
GOLD
ART DIRECTION
Cabell Harris
COPYWRITING
Tom Camp,
Tom DeCerchio
PRODUCTION
Beth Hagen
DIRECTION
Mark Story
AGENCY
Livingston + Company
CLIENT
California Department
of Health Services
ENTRANT LOCATION
Venice, CA

I'LL BE HOME FOR CHRISTMAS
5 / 58

ART DIRECTION
Kevin Kearns

CREATIVE DIRECTION
Fred Bertino

COPYWRITING
Jay Williams

PRODUCTION COMPANY
Cucoloris Films

PRODUCTION
Diane Carlin

DIRECTION
Dan Ducovny

AGENCY
Hill, Holliday, Connors, Cosmopulos, Inc.

CLIENT
Pine Street Inn

ENTRANT LOCATION
Boston, MA

MATISSE
5 / 70

ART DIRECTION
Doug Trapp

COPYWRITING
Christopher Wilson

PROP
Minnefex Inc.

PRODUCTION
Lisa Thotland

DIRECTION
Greg Winter

STUDIO
Wilson Griak

MUSIC
Tom Lecher / Echo Buys

AGENCY
Martin / Williams

CLIENT
Target Stores / Minneapolis Institute of the Arts

ENTRANT LOCATION
Minneapolis, MN

NUNNAY'S STORY
5 / 3
SILVER
ART DIRECTION
Tony Osborne
COPYWRITING
Steve Brown
MUSIC
Dave Upson /
Creating Waves
AGENCY
Ad. Link DDB
Needham
CLIENT
World Vision
ENTRANT LOCATION
Perth, W. Australia

CAMPING
5 / 1
ART DIRECTION
Nico van Scherpenzeel
COPYWRITING
Jaap van Haastrecht
PRODUCTION
Peter Burger
DIRECTION
Michael Steenmeijer
MUSIC
Alfred Klaassen
AGENCY
N&W / Leo Burnett
CLIENT
Ministry of
Environment
ENTRANT LOCATION
Amsterdam,
Netherlands

SELF HELP
5 / 2
ART DIRECTION
Jarl Olsen
COPYWRITING
Jarl Olsen
DIRECTION
Jarl Olsen
STUDIO
Dublin Productions
CLIENT
Ministry of Information
ENTRANT LOCATION
Minneapolis, MN

CAN'T UNDERSTAND /
DON'T KNOW / BORING.
6 / 7
GOLD
ART DIRECTION
Aleta Taylor
COPYWRITING
Dory Toft
PHOTOGRAPHY
Susan Marie Anderson
PRODUCTION
Joyce Schmidtbauer
EDITING
Kathy Medak
AGENCY
Livingston + Company
CLIENT
Seattle Opera
ENTRANT LOCATION
Seattle, WA

SERVIZIO UTENZA RESIDENZIALE
6 / 1

ART DIRECTION
Mauro Mortaroli

DESIGN
Manuele Mariani,
Alessandro Brunetti,
Giuseppe Mangano

COPYWRITING
Mauro Mortaroli,
Erminio Perocco

PHOTOGRAPHY
Giuseppe Lanci

DIRECTION
Alessandro D'Alatri

MUSIC
Gabriele Ducros

STUDIO
Film Master

AGENCY
Armando Testa S.p.A.

PUBLICATION
Testimonial: Massimo
Lopez

CLIENT
SIP/Italian Telephone
Company

ENTRANT LOCATION
Rome, Italy

PARENTS
7 / 55
SILVER
ART DIRECTION
Steve Whittier
COPYWRITING
Ted Nelson
PRODUCTION
Win Peniston
DIRECTION
Win Peniston
AGENCY
The Joey Reiman
Agency
CLIENT
Rocky Mountain
College of Art
ENTRANT LOCATION
Atlanta, GA

SPOONS
7 / 25
ART DIRECTION
Joe Stuart
COPYWRITING
Ryan Ebner
DIRECTION
Berl Cattell
AGENCY
McConnaughy Stein
Schmidt Brown
CLIENT
True Value Hardware
ENTRANT LOCATION
Chicago, IL

THE BOOT
7 / 1
ART DIRECTION
Benjamin Vendramin
COPYWRITING
Robert McDougall
PRODUCTION
Waveform
DIRECTION
Robert McDougall,
Benjamin Vendramin
MUSIC
Doug Riley
(Einstein Bros.)
STUDIO
Waveform
AGENCY
Stay Hungry
Advertising
CLIENT
Aurora Importing and
Distributing Ltd.
ENTRANT LOCATION
Toronto, Canada

GRAVES
8 / 5
ART DIRECTION
Noam Murro
COPYWRITING
Gary Goldsmith
EDITING
Avi Oron
DIRECTION
Yaariv Gaber
MUSIC
stock
AGENCY
Goldsmith / Jeffrey
CLIENT
Goldsmith / Jeffrey
ENTRANT LOCATION
New York, NY

DINER
8 / 7
ART DIRECTION
Bob Cockrell,
Susan Westre
COPYWRITING
Greg Ketchum,
Chris Wall
PRODUCTION
Barbara Mullins
DIRECTION
Joe Pytka
STUDIO
Pytka
MUSIC
Music Forever
AGENCY
BBDO
CLIENT
Apple Computer
ENTRANT LOCATION
Los Angeles, CA

DEUX
9 / 3
SILVER
ART DIRECTION
Jack Mariucci
COPYWRITING
Bob Mackall
PRODUCTION
Lora Nelson
DIRECTION
Peter Smillie
MUSIC
Michael Kamen
AGENCY
DDB Needham
Worldwide
CLIENT
Martell Cognac
ENTRANT LOCATION
New York, NY

ALGEBRA
9 / 12
ART DIRECTION
Len McCarron
COPYWRITING
Michael Patti
PRODUCTION
Hyatt Choate
DIRECTION
Steve Chase
AGENCY
BBDO
CLIENT
Pepsi International
ENTRANT LOCATION
New York, NY

DEUX
12 / 11
GOLD
ART DIRECTION
Jack Mariucci
COPYWRITING
Bob Mackall
PRODUCTION
Lora Nelson
DIRECTION
Peter Smillie
MUSIC
Michael Kamen
AGENCY
DDB Needham
Worldwide
CLIENT
Martell Cognac
ENTRANT LOCATION
New York, NY

WEDDING
12 / 2
ART DIRECTION
Gail San Filippo
COPYWRITING
Julie Curtis
PRODUCTION
Jennifer Golub
DIRECTION
Tony Kaye
MUSIC
John Trivers
AGENCY
Chiat / Day inc.
CLIENT
Home Savings of
America
ENTRANT LOCATION
Venice, CA

HAVE YOUR DAY IN THE SUN
12 / 8
ART DIRECTION
Denise O'Bleness
COPYWRITING
Graham Button
PRODUCTION
Mary Cheney
AGENCY
Grey
CLIENT
Bausch & Lomb
ENTRANT LOCATION
New York, NY

EMMITT
12 / 10
ART DIRECTION
Steve Sweitzer
COPYWRITING
Bob Rice
PRODUCTION
Jack Harrower
DIRECTION
Allan Van Rijn
AGENCY
Chiat / Day inc.
CLIENT
Reebok
ENTRANT LOCATION
Venice, CA

MAGICIAN
12 / 1
ART DIRECTION
Stephan Pfeiffer
COPYWRITING
Hermann Vaske
CREATIVE DIRECTION
Hermann Vaske
PRODUCTION
Alexandra Repp
DIRECTION
Paul Arden
MUSIC
MDR Sinfonieorchester
AGENCY
FCB Hamburg
CLIENT
MDR Mitteldeutscher
Rundfunk
ENTRANT LOCATION
Hamburg, Germany

SHORT STORIES
13 / 32
SILVER
COPYWRITING
Jack Low
PRODUCTION
Sonny Dufault
DIRECTION
Jack Low
STUDIO
Soundtrack, Boston
AGENCY
McMann & Tate
CLIENT
New England Electric
ENTRANT LOCATION
Weehawken, NJ

ANNOUNCER: Some very short stories from New England Electric.
SFX: Fairy tale music, under.
ANNOUNCER: This is a story about a boy who climbed a tree near electrical wires.
SFX: Music ends abruptly
SFX: Electrical shock
ANNOUNCER: This is a story about a man who put his ladder too close to a power line.
SFX: Music ends abruptly
SFX: Electrical shock
ANNOUNCER: The End.
ANNOUNCER: New England Electric. Please, play it safe.

ITALIAN FEAST
13 / 5
COPYWRITING
Jeff Watzman, John Leu
CREATIVE DIRECTION
Arthur Bijur,
Donna Weinheim
PRODUCTION
Deed Meyer
STUDIO
Clacks Recording
MUSIC
Michael Carroll
AGENCY
Cliff Freeman and
Partners
CLIENT
Little Caesars
Enterprises
ENTRANT LOCATION
New York, NY

ANNOUNCER: Once a year when Spring winds its way to the village of Florenta, Italy.
SFX: Beautiful mandolin Music throughout
ANNOUNCER: Antonio cooks his famous family feast.
ANNOUNCER: He uses the finest ingredients...
ANNOUNCER: Preparing them for hours, until it's perfect.
ANNOUNCER: And when the family gathers and...
ANNOUNCER: Antonio brings his masterpiece to the table, everyone agrees, it's the worst thing they've
ever tasted.
SFX: Sound of a bubble rising
SFX: Sound of a burp, baby crying, and dog groaning
SFX: Gagging
SFX: Sounds of a fly bussing, screeching halt, bullet ricochet as flay leaves frame.
ANNOUNCER: Fortunately there's Little Caesar's Italian "Picnic Picnic," two pizzas, two sides of spaghetti,
two soft drinks, for $9.99
LITTLE CAESAR: Pizza! Pizza!

MARS OBSERVER
13 / 19
COPYWRITING
Dean Hacohen
STUDIO
Soundtracks
VOICE OVER
Nik Schatzki
AGENCY
Goldsmith / Jeffrey
CLIENT
Crain's New York
Business
ENTRANT LOCATION
New York, NY

ANNOUNCER: Over the course of the past year, the Mars Observer Space Probe was hurled 400 million
miles into space at a cost of one billion dollars. For some unknown reason, the satellite was
unable to complete its task. The entire mission is now a bust. Oh, boy. In the future, if NASA
would like to be able to probe hard-to-reach places, extract information and report it back
successfully, the reporters at Crain's New York Business would be more than happy to provide
some tips. Just don't ask us to go.

SFX: Theme music under Announcer
ANNOUNCER: Welcome to "Crazy Meals," sponsored by Little Caesar's. Crazy! Crazy!
SFX: Clink of Silverware and dishes.
BILL: (eating) This Little Caesar's Crazy Crazy is dandy-tasting, Ma.
CHRIS: (eating) Yeah, it's a great big meal.
MOM: (eating) It's a good value.
CHRIS: (eating) I'm taking the last slice.
BILL: Over my dead body.
CHRIS: Eat lead, buddy...
SFX: Sudden gunfire, dishes breaking
MOM: (calling over the noise) Could we have one meal without gunplay?!?
BILL: He started it.
SFX: Theme music returns
ANNOUNCER: Little Caesar's Crazy! Crazy!—two pizzas with any topping, two free Crazy Breads, and two free soft drinks for only $7.98
LITTLE CAESAR: Pizza! Pizza!

CRAZY MEAL
13 / 24
COPYWRITING
Don Austen
CREATIVE DIRECTION
Arthur Bijur
PRODUCTION
Deed Meyer
STUDIO
Clacks Recording
AGENCY
Cliff Freeman and Partners
CLIENT
Little Caesars Enterprises
ENTRANT LOCATION
New York, NY

CIA II / 99 BOTTLES / MARS OBSERVER
14 / 4
COPYWRITING
Dean Hacohen
STUDIO
Soundtracks
VOICE OVER
Nik Schatzki
AGENCY
Goldsmith / Jeffrey
CLIENT
Crain's New York Business
ENTRANT LOCATION
New York, NY

ANNOUNCER: (half-singing) 99 bottles of beer on the wall, 99 bottles of beer. You take one down and pass it around— 98 bottles of beer on the wall. 98 bottles of beer on the wall, 98...

ANNOUNCER: (he stops and speaks) If you miss the stories in this week's *Crain's New York Business*, chances are you'll have to wait a while until they appear in other papers. We just thought we'd give you something to do in the meantime.

ANNOUNCER: (he resumes tune) 97 bottles of beer on the wall, 97 bottles of beer...

ANNOUNCER: Over the course of the past year, the Mars Observer Space Probe was hurled 400 million miles into space at a cost of one billion dollars. For some unknown reason, the satellite was unable to complete its task. The entire mission is now a bust. Oh, boy. In the future, if NASA would like to be able to probe hard-to-reach places, extract information and report it back successfully, the reporters at *Crain's New York Business* would be more than happy to provide some tips. Just don't ask us to go.

STEPHEN KING: The rats seemed to pour out of the pipe and run down the alley.
PETER THOMAS: Stephen King, author of *Carrie*, *The Shining*, and *Pet Sematary*.
STEPHEN KING: His legs were too bad to let him move with any speed. He shifted frantically, trying to get up as he watched them come in a seemingly endless wave, past the dumpsters and the barrels. But he couldn't move. And so he sat, against the bags of trash, his face frozen in horror, as they race toward him, past him, around him, over him and finally settled on him—diving into his pockets, shredding the bags behind him, ripping at the shopping bag he had, nipping at the exposed skin at his ankles and his wrists. The squealing seemed to fill the sky...(pause) The most horrifying part of this story, is that I didn't write it. It's the true account of what happened to a homeless man in an alley in Boston's Back Bay. Please. Support The Pine Street Inn. You can't imagine what the homeless go through. Even I can't.
PETER THOMAS: The Pine Street Inn. 444 Harrison Avenue. 482-4944.

STEPHEN KING
15 / 101
GOLD
COPYWRITING
Jay Williams,
Bill Murphy
CREATIVE DIRECTION
Fred Bertino
PRODUCTION
Scott Doggett
PRODUCTION COMPANY
Soundtrack
AGENCY
Hill, Holliday, Connors,
Cosmopoulos, Inc.
CLIENT
Pine Street Inn
ENTRANT LOCATION
Boston, MA

TERRY ANDERSON: The physical part is bad, but it's the loneliness that's the hardest thing...
PETER THOMAS: Terry Anderson, journalist and eight-year Lebanon hostage.
TERRY ANDERSON: ...you're completely cut off. There isn't even the slightest bit of human warmth in your day. You may hear the news in staticky snippets from a passing radio. You might see a newspaper from time to time, but only a piece—you don't know what it all means. A phone call is something you remember vaguely, from your previous life. And a letter, well, you don't expect you'll ever hold a letter in your hands again for as long as you live. (pause) Unfortunately, this isn't my account of my captivity in Lebanon. This is a homeless man's account of life on the street in Boston. Please. Support The Pine Street Inn. You can't imagine what it's like to be homeless. Even I can't.
PETER THOMAS: The Pine Street Inn. 444 Harrison Avenue. 482-4944.

TERRY ANDERSON
15 / 1
SILVER
COPYWRITING
Jay Williams,
Bill Murphy,
Jamie Mambro
CREATIVE DIRECTION
Fred Bertino
PRODUCTION COMPANY
Soundtrack
PRODUCTION
Kelly Pauling
AGENCY
Hill, Holliday, Connors,
Cosmopoulos, Inc.
CLIENT
Pine Street Inn
ENTRANT LOCATION
Boston, MA

SUSAN BUTCHER: No matter how many times you're out there, you never get used to the cold...
PETER THOMAS: Susan Butcher, four-time winner of Alaska's Iditarod Dogsled Race.
SUSAN BUTCHER: ...you're always thinking of a way to get out of it. It's what keeps you going, out there all alone. You think about what it would be like to be warm for even just a few minutes. You daydream about what it would be like to feel the chill start to melt out of your hands and feet—to feel your face start to soften out of its cold, stiff expression. You keep telling yourself that you're going to make it. Sometimes even out loud. It's like you're in another world. (pause) Unfortunately, this is not a description of what it's like to race the Iditarod. It's a homeless woman's description of what it's like to walk the streets of Boston. Please. Support The Pine Street Inn. You can't imagine what the homeless go through. Even I can't.
PETER THOMAS: The Pine Street Inn. 444 Harrison Avenue. 482-4944.

SUSAN BUTCHER
15 / 105
SILVER
COPYWRITING
Jay Williams,
Bill Murphy
CREATIVE DIRECTION
Fred Bertino
PRODUCTION
Kelly Pauling,
Diane Carlin
PRODUCTION COMPANY
Soundtrack
AGENCY
Hill, Holliday, Connors,
Cosmopoulos, Inc.
CLIENT
Pine Street Inn
ENTRANT LOCATION
Boston, MA

FEELINGS
15 / 37
COPYWRITING
Steven Johnson
PRODUCTION
Sam Walsh
AGENCY
Cole and Weber
CLIENT
Nike i.e
ENTRANT LOCATION
Seattle, WA

ANNOUNCER: Feelings. Nothing more than feelings. Trying to forget my feelings of love.
Feelings. For all my life I'll feel it. I wish I'd never met you girl. You'll never come again.
Feelings. Wo, wo, wo, feelings. Wo, wo, wo, feelings. Wo, wo, wo, wo.
Second verse.
Feelings. Nothing more than feelings. You should try the feelings of i.e. shoes with Nike Air.
Teardrops. Rolling down on your face. Vanish with the feelings of i.e. shoes with Nike Air.
Wo, wo.
Feelings. Try them on for thirty days. If don't love the feelings, just bring them back to the store.
ANNOUNCER: i.e. shoes with Nike Air Cushioning. The second best feeling in the world. Wo, wo.

I AM THE WALRUS.
15 / 40
COPYWRITING
David Marks
PRODUCTION
Craig Wiese
STUDIO
Cookhouse
AGENCY
Muller + Company
CLIENT
The Des Moines
Register
ENTRANT LOCATION
Kansas City, MO

GUY: Ooh, it's eleven o'clock.
SFX: Click of radio being turned on
RADIO DJ: I-i-it's Prizetime! And that one million dollar jackpot is yours if we call you, and you say "I am the walrus."
GUY: Wow! A million bucks!
SFX: Telephone rings
GUY: I am the walrus! Golf clubs? Oh, yeah, the ad in the register classifieds to sell my clubs. Yeah, come on by.
SFX: Hangs up phone
RADIO DJ: No winner yet, so we're gonna keep calling.
GUY: Oh, boy!
SFX: Telephone rings
GUY: I am the walrus! Yeah, head covers. Sure, stop by any time.
SFX: Hangs up phone
RADIO DJ: We're still calling...
GUY: Well, you never know.
SFX: Telephone rings
GUY: (tentatively) I am the walrus? (sighs) Yes. Irons, driver, bag, the whole deal. Bye now. Geez!
SFX: Hangs up phone
GUY: (very frustrated) Geez!
ANNOUNCER: Not only is it inexpensive to take out an ad in the Des Moines Register Classifieds —three lines for three days starting at just four-fifty—it's also very effective.
SFX: Telephone rings
GUY: I am the golf club—Wait!!!
RADIO DJ: Oooh, sorry Pal. That was really close.
SFX: Radio DJ hangs up
ANNOUNCER: Whatever you're selling, you can kiss it goodbye in the Des Moines Register Classifieds. 284-8141.
GUY: (disgustedly) I am the Bozo! I am so dumb—

RABBITS
15 / 52
ART DIRECTION
Fred Bertino
COPYWRITING
Al Lowe
PRODUCTION
Scott Doggett
PRODUCTION COMPANY
Soundtrack
AGENCY
Hill, Holliday, Connors,
Cosmopoulos, Inc.
CLIENT
Massachusetts State
Lottery
ENTRANT LOCATION
Boston, MA

RABBIT: Hi, I'm a rabbit. You know, usually I don't say much. But this has been building up inside of me. I mean, all my life I've been hunted...hounded, forced to live underground. In real holes. Why? This foot thing. I mean, come on...do you really think rubbin' a rabbit's foot is lucky? For who? Not rabbits. I'll tell you what...You wanna rub a foot? Take off your shoes. You want lucky? Knock on wood. Try a four-leaf clover. Get a horseshoe. I mean, hey...you take a horse's shoe...at least the horse still has feet. Better yet, forget about altogether and use your head. Yeah, that's right. Play Mass Cash. The game that gives you the best chance to win a hundred grand. No kiddin'. Over six hundred people have won a hundred thousand bucks playin' Mass Cash already. With a game like that, how much luck do you need? So there ya go. Play Mass Cash. But leave my feet out of it, all right? I mean, really, how would you feel if you were in my shoes? Nervous, that's how. Besides, if I develop foot problems, who's gonna deliver Easter eggs, heh? Never thought of that, did ya? Heh, heh, heh.

TOM: Visiting friends and relatives is one thing, but staying with 'em is quite another. Hi, I'm Tom Bodett with some simple truths. Well whoever said "It's a nice place to visit, but I wouldn't wanna live there," Must have been talking about a trip to visit friends and relatives. It's always nice to see 'em, but they just do things differently. Like your friend from high school with the blinking barricade light collection he keeps in the spare bedroom where you're supposed to sleep. Or that nice aunt of yours who means well, but with all those fuzzy covers she puts on the stuff in the bathroom, you can never get the toilet lid to stay up by itself. A better idea would be to stay at Motel 6. You'll get a clean, comfortable room and a good night's sleep for the lowest prices of any national chain. And your kids can stay with you free. There's more than 750 locations all around the country, and not a one of 'em has fuzzy toilet covers. I'm Tom Bodett for Motel 6, and we'll leave the lid up for you.

FUZZY TOILET COVERS
15 / 53
COPYWRITING
Mike Renfro
PRODUCTION
Harvey Lewis
STUDIO
Real to Real
AGENCY
The Richards Group
CLIENT
Motel 6
ENTRANT LOCATION
Dallas, TX

ANNOUNCER: It's the classic story. Boy meets girl. Boys falls for girl. Boy loses girl. boy finds new girl. Boy resolves never to lose girl again. Boy kidnaps girl. Boy ties girl up.. Boy hides girl in his basement. Boy plays Nancy Sinatra over and over on the stereo. Boy listens to girl's complaints. Boy accuses girl of trickery and deception. Boy gets hungry. Boy eats girl's leg. Boy ignores girl's screams. Boy shows girl extensive butterfly collection. Boy passes out. Boy awakes and sees an empty chair. Boy panics. Boy runs to the stairs. Boy finds his one-legged girl trying to open a locked door. Boy leads girl back to the basement. Boy puts a tape in VCR. Boy and girl watch *It's a Wonderful Life*. See classic stories. See not so classic stories. See what you want to see. The nineteenth Seattle International Film Festival begins May fourteenth. See how people act.

CLASSIC STORY
15 / 54
COPYWRITING
Steven Johnson
PRODUCTION
Sam Walsh
DIRECTION
Sam Stevens
AGENCY
Cole and Weber
CLIENT
S.I.F.F.
ENTRANT LOCATION
Seattle, WA

MATCHMAKER: Jack?
JACK: Yeah.
MATCHMAKER: I've got Jill on the other line. How tall are you?
JACK: Um...5'6"...and 1/2.
MATCHMAKER: Hold on.
SFX: Click
MATCHMAKER: Jill?
JILL: Yeah.
MATCHMAKER: I've got Jack on the other line. How tall are you?
Jill: 5'9".
MATCHMAKER: Perfect. He's 5'9"-ish. How'd your hair turnout?
JILL: The blonde sorta came out...yellow.
MATCHMAKER: Hold on.
SFX: Click
MATCHMAKER: Jack, what color hair do you like?
JACK: Um...blondes.
MATCHMAKER: Perfect. She's...real blonde. Do you still have a beard?
JACK: I shaved the mustache. But I kept the beard part.
MATCHMAKER: Hold on.
SFX: Click
MATCHMAKER: Jill, he's...got a beard.
JILL: He sounds perfect.
MATCHMAKER: You guys are...perfect.
ANNOUNCER: Being a matchmaker can be fun. All you need is the new game from the Virginia Lottery, $10,000 Cash Match. You could get five matches on one ticket. And like the name says, you could win up to $10,000.
SFX: Click.
MATCHMAKER: Jill, you're my friend. This guy's a loser. You don't want to go out with him.
JACK: This is Jack.
ANNOUNCER: $10,000 Cash Match. It's the perfect companion for just about anybody. Chances of winning $10,000 are 1 in 978,000.

VA LOTTERY RADIO
BLIND DATE
15 / 55
COPYWRITING
Rob Schapiro
PRODUCTION
Frank Soukup
AGENCY
Earle Palmer Brown /
Richmond
CLIENT
Virginia State Lottery
ENTRANT LOCATION
Richmond, VA

TRUST
15 / 60
COPYWRITING
Dean Saling
CREATIVE DIRECTION
Pat LeBaron
PRODUCTION
Hoyt's Greater Radio
Community
DIRECTION
Jeff Hoyt
STUDIO
Bad Animals, Seattle
AGENCY
Jacobson Ray
McLaughlin Fillips
CLIENT
Pierce County Medical
ENTRANT LOCATION
Tacoma, WA

ANNOUNCER: (rapidly) And now, a list of things you can trust. You can trust your mother, Mother Theresa, and TV mother Barbara Billingsley. You can trust your cold to Contact. You can trust George Washington, Abe Lincoln, and Abe Vigoda. You can trust me, I know what I'm doing. You can trust Eddie Rickenbacker, Orville Redenbacher, and Red Auerbach. You can trust that I can't say that five times fast. You can trust Walter Cronkite, four out of five dentists, and guys who aren't a doctor but play one on TV. You can trust your car to the man who wears the star. You can trust that right now, someone, somewhere is watching a rerun of *Gilligan's Island*, drinking Yoo-Hoo, and eating barbecued pork rinds. You can trust the uncanny predictive power of the Magic Eight-Ball. You can trust the Pope, Popeye, Ron Popeil, and Pierce County Medical. Pierce County Medical, you ask? Sure, I answer, cleverly segueing into a brief commercial message. After all, more people trust Pierce County Medical that any other health plan in Pierce County. And for good reason. They've been providing local coverage and service for 75 years. They're based here. So you can trust Pierce County Medical to be right here for you. Just like you can trust that that little light goes out when you close the refrigerator door, that that stuff on cheese doodles isn't really cheese, and that this commercial will end with a catchy slogan.
ANNOUNCER 2: Pierce County Medical. We're right here when you need us.

WHAT'S NEW.
15 / 64
COPYWRITING
Arthur Bijur,
Don Austen
CREATIVE DIRECTION
Arthur Bijur
PRODUCTION
Deed Meyer
STUDIO
Clacks Recording
AGENCY
Cliff Freeman and
Partners
CLIENT
Little Caesars
Enterprises
ENTRANT LOCATION
New York, NY

SFX: Musical Theme
ANNOUNCER: Now it's time for What's New? And here's Roger...!!
SFX: Audience applause
ROGER: (cheerfully) Okay, first let's ask our panel, "What's new with you?"
BILL: (beat of silence) ...nothin'.
MARSHALL: (wasn't listening) What?
PAT: (crankily) Let's just start.
ROGER: Okay, let's start our game.
SFX: Ticking clock
ROGER: (dramatically reading a card) There's something totally new at Little Caesar's
BILL: Roger!
SFX: Ding
ROGER: Yes.
BILL: It is two pizzas for one low price?
ROGER: No, they've always had that.
BILL: Roger!
SFX: Ding
ROGER: (irritated) Yes.
BILL: So it' something new?
ROGER: (getting curt) First clue...(reading) It's a long thin food from Italy.
MARSHALL: Hmmm...
PAT: Long and thin?

DEFICIT REDUCTION
15 / 68
COPYWRITING
Mike Renfro
PRODUCTION
Harvey Lewis
STUDIO
Real to Real
AGENCY
The Richards Group
CLIENT
Motel 6
ENTRANT LOCATION
Dallas, TX

TOM: Hi, Tom Bodett for Motel 6 with an open letter to the president. Well sir, you asked us to all contribute to helping shrink up the deficit. And since what's good for the goose is good for the gander, I've got a painless way for you to contribute along with the rest of us—Motel 6. Instead of staying at those big fancy places when you go out on business, you could stay at the Six. You'd get a clean, comfortable room for the lowest prices of any national chain and a good night's sleep to go along with it. Those guys in the suits and dark glasses that follow you around could stay in the room with you for just a few extra dollars. Heck, maybe you could all watch a free in-room movie or make a few free local phone calls or something. It'd be a blast. Oh sure, you'd have to do without a shower cap and that fancy guava-gel conditioning shampoo, but all in all, Mr. President, I'd say you've probably already spent enough money on your hair, anyway. I'm Tom Bodett for Motel 6, and we'll leave the light on for you, sir.

SFX: Ambient bathtub noises. Clearly a man and woman. Low whispers and giggles.
ANNOUNCER: If the preceding sounds were only vaguely familiar to you, you're married.
Loews Coronado Bay Resort. Bathtubs for two and terry cloth robes if you ever get out.
Call 1-800-81-LOEWS. Loews Coronado Bay. You need it. You both need it.

BATHTUB
15 / 78
ART DIRECTION
Jordin Mendelsohn
COPYWRITING
Claudia Caplan
PRODUCTION
Nancy Koch
AGENCY
Mendelsohn / Zien
Advertising
CLIENT
Loews Coronado Bay
Resort
ENTRANT LOCATION
Los Angeles, CA

ANNOUNCER: Jiffy Lube presents the way things are, Part 3
SFX: Phone rings.
VOICE 1: Hello, trademark office.
VOICE 2: Hi, I'd like to get a trademark on the name of my new quick lube business.
VOICE 1: What's the name?
VOICE 2: Groove Lube. Great, huh?
VOICE 1: It's taken.
VOICE 2: What?
VOICE 1: It's taken.
VOICE 2: Wait, there's already a quick lube place called Groove Lube?
VOICE 1: Yeah.
VOICE 2: Okay. All right. How about Groovy Luby?
VOICE 1: That's taken, too.
VOICE 2: C'mon.
VOICE 1: Hey, there's a new quick lube place every day, pal.
VOICE 2: Okay, how about Groovin' and Lubin'?
VOICE 1: Uh, that's taken.
VOICE 2: The Groovy Lubster.
VOICE 1: Taken.
VOICE 2: El Groovo Lubo.
VOICE 1: Oh, come. Oh, show some originality, will ya... (continues under announcer)
ANNOUNCER: With quick lube places being thorn up on every corner, and everybody from car dealers to
tire stores jumping into the oil change business, isn't it nice to know there's a place you can be
sure of to get your car's oil changed, get complete 14-point service in just minutes, at a low price
with a guarantee by professionals who know what they're doing and are actually polite? Jiffy Lube.
A job well done in minutes. There's still hope.
VOICE 2: Grooverama Luberama.
VOICE 1: Gone.
VOICE 2: Oh, geez!
VOICE 1: That, you can use.
VOICE 2: Grooverama Luberama?
VOICE 1: No. Oh, geez.

NAMES
15 / 80
COPYWRITING
Jeff Millman
PRODUCTION
John Noble
AGENCY
Gray Kirk / VanSant
CLIENT
Jiffy Lube
ENTRANT LOCATION
Baltimore, MD

MAN: One day my son tells me he's got a virus. So I ask the standard questions every good parent asks.
Does your stomach hurt? Do you have a fever? Do you have to keep breathing on me that way?
And he says, dad, I've got a computer virus. And I said, really? I didn't know you could get viruses
from a computer. What have you been doing with that thing? And he says, "Look, *I'm* not sick.
My computer has the virus." And I said, oh, what does it have? A cold? The Flu? I hop it's not the
chicken pox. You know your sister hasn't had those yet. And he says, "Just take me to Computer
City." And I said, they got a good medical center there? And he says, "No, Computer City has
computers, modems, scanners, plus an expert staff to help him choose from their huge selection
of anti-virus software." And I said, oh, they've got medicines. Do you think they'd have something
for my acid indigestion? Computer City. Best brands, super selection, guaranteed great prices,
every day.

VIRUS
15 / 96
COPYWRITING
David Morring
PRODUCTION
Karen Junkins
STUDIO
Hollywood Recording
AGENCY
The Richards Group
CLIENT
Computer City
Supercenters
ENTRANT LOCATION
Dallas, TX

DO IT YOURSELF JINGLE
15 / 184
COPYWRITING
Mike Renfro
PRODUCTION
Harvey Lewis
STUDIO
Real to Real
AGENCY
The Richards Group
CLIENT
Motel 6
ENTRANT LOCATION
Dallas, TX

TOM: Hi, Tom Bodett for Motel 6 with a reply. You know a lot of people've been writing in asking, "Hey, Tom, how come Motel 6 doesn't have a fancy singing jingle like a lot of places?" Well, hard as it may be to believe, we don't spend a whole lot of money on advertising stuff so we can save you money. But we do like to keep everybody happy. So if you really want a singing jingle, so be it. Here, I'll shut up a minute and you can come up with your own words and sing along to the music.

Say something here about clean, comfortable rooms.

Don't forget, "Lowest prices of any national chain."

You're doin' fine.

Okay, big finale here. Maybe a line about free local calls and free in-room movies.

Oh, yeah, you're a natural. Don't quit your day job just yet, though. I'm Tom Bodett for Motel 6, thanks for helping out, and we'll leave the light on for you.

STEPHEN KING: The rats seemed to pour out of the pipe and run down the alley.

PETER THOMAS: Stephen King, author of *Carrie*, *The Shining*, and *Pet Semetary*.

STEPHEN KING: His legs were too bad to let him move with any speed. He shifted frantically, trying to get up as he watched them come in a seemingly endless wave, past the dumpsters and the barrels. But he couldn't move. And so he sat, against the bags of trash, his face frozen in horror, as they race toward him, past him, around him, over him and finally settled on him—diving into his pockets, shredding the bags behind him, ripping at the shopping bag he had, nipping at the exposed skin at his ankles and his wrists. The squealing seemed to fill the sky...(pause) The most horrifying part of this story, is that I didn't write it. It's the true account of what happened to a homeless man in an alley in Boston's Back Bay. Please. Support The Pine Street Inn. You can't imagine what the homeless go through. Even I can't.

PETER THOMAS: The Pine Street Inn. 444 Harrison Avenue. 482-4944.

**SUSAN BUTCHER /
STEPHEN KING / TERRY
ANDERSON**
16 / 51
GOLD
COPYWRITING
Jay Williams,
Bill Murphy,
Jamie Mambro
CREATIVE DIRECTION
Fred Bertino
PRODUCTION
Kelly Pauling,
Diane Carlin
PRODUCTION COMPANY
Soundtrack
AGENCY
Hill, Holliday, Connors,
Cosmopulos, Inc.
CLIENT
Pine Street Inn
ENTRANT LOCATION
Boston, MA

TERRY ANDERSON: The physical part is bad, but it's the loneliness that's the hardest thing...

PETER THOMAS: Terry Anderson, journalist and eight-year Lebanon hostage.

TERRY ANDERSON: ...you're completely cut off. There isn't even the slightest bit of human warmth in your day. You may hear the news in staticky snippets from a passing radio. You might see a newspaper from time to time, but only a piece—you don't know what it all means. A phone call is something you remember vaguely, from your previous life. And a letter, well, you don't expect you'll ever hold a letter in your hands again for as long as you live. (pause) Unfortunately, this isn't my account of my captivity in Lebanon. This is a homeless man's account of life on the street in Boston. Please. Support The Pine Street Inn. You can't imagine what it's like to be homeless. Even I can't.

PETER THOMAS: The Pine Street Inn. 444 Harrison Avenue. 482-4944.

SUSAN BUTCHER: No matter how many times you're out there, you never get used to the cold...

PETER THOMAS: Susan Butcher, four-time winner of Alaska's Iditarod Dogsled Race.

SUSAN BUTCHER: ...you're always thinking of a way to get out of it. It's what keeps you going, out there all alone. You think about what it would be like to be warm for even just a few minutes. You daydream about what it would be like to feel the chill start to melt out of your hands and feet— to feel your face start to soften out of its cold, stiff expression. You keep telling yourself that you're going to make it. Sometimes even out loud. It's like you're in another world. (pause) Unfortunately, this is not a description of what it's like to race the Iditarod. It's a homeless woman's description of what it's like to walk the streets of Boston. Please. Support The Pine Street Inn. You can't imagine what the homeless go through. Even I can't.

PETER THOMAS: The Pine Street Inn. 444 Harrison Avenue. 482-4944.

LOEWS CAMPAIGN
16 / 4
SILVER
COPYWRITING
Claudia Caplan
CREATIVE DIRECTION
Jordin Mendelsohn
PRODUCTION
Nancy Koch
AGENCY
Mendelsohn / Zien
Advertising
CLIENT
Loews Coronado Bay
Resort
ENTRANT LOCATION
Los Angeles, CA

SFX: Ambient bathtub noises. Clearly a man and woman. Low whispers and giggles.
ANNOUNCER: If the preceding sounds were only vaguely familiar to you, you're married.
Loews Coronado Bay Resort. Bathtubs for two and terry cloth robes if you ever get out.
Call 1-800-81-LOEWS. Loews Coronado Bay. You need it. You both need it.

WIFE: Honey?
HUSBAND: Uhmm?
WIFE: Do I look fat in this dress?
HUSBAND: Ah, no. You look fine.
WIFE: I'm just fine? So, so you think I should lose five pounds?
HUSBAND: If you want to.
WIFE: Great. Because I'm fat.
HUSBAND: Look, you're not going to get me to say that you're fat.
WIFE: Well, you don't have to. You think I am.
HUSBAND: I'm not saying anything.
WIFE: Maybe I should wear the black dress.
HUSBAND: Just do what you want.
WIFE: These are your friends. I mean, don't you care what I wear?
HUSBAND: Honey, you look fine.
WIFE: Fine?
HUSBAND: Look, all your stuff is nice. Wear what you want.
WIFE: Should I wear the blue dress?
HUSBAND: Yeah, I like that one.
WIFE: I don't have a blue dress.
ANNOUNCER: If the preceding sounds were extremely familiar to you, you're married. Loews Coronado
Bay Resort on Coronado Island. 1-800-81-LOEWS. You need it. You both need it.

WIFE: Uhmm, no.
HUSBAND: What's happened?
WIFE: Nothing.
HUSBAND: Nothing what? What?
WIFE: I, well, why can't we just do something romantic for a change?
HUSBAND: That's fine. Call and make reservations somewhere and we'll go out. It'll be romantic, what?
WIFE: No, if I call it isn't romantic.
HUSBAND: Well, does the dog gonna...Well, I'll call.
WIFE: Funny.
HUSBAND: Well, well what do you want to do?
WIFE: No, forget it, forget it, forget it, forget it.
HUSBAND: Alright, I'll call. What's the big deal? What's the problem? What's the...
WIFE: There's no problem, no big deal, OK.
HUSBAND: But you're upset about something and I don't even know...
WIFE: No. No, I'm not, I'm not. I'm fine.
HUSBAND: You're fine.
WIFE: Uhmm.
HUSBAND: Oh yeah, we're fine again.
ANNOUNCER: If the preceding sounds were familiar to you, you're married. Loews Coronado Bay Resort
on Coronado Island. 1-800-81-LOEWS. You need it. You both need it.

ANNOUNCER: It's the classic story. Boy meets girl. Boys falls for girl. Boy loses girl. boy finds new girl. Boy resolves never to lose girl again. Boy kidnaps girl. Boy ties girl up.. Boy hides girl in his basement. Boy plays Nancy Sinatra over and over on the stereo. Boy listens to girl's complaints. Boy accuses girl of trickery and deception. Boy gets hungry. Boy eats girl's leg. Boy ignores girl's screams. Boy shows girl extensive butterfly collection. Boy passes out. Boy awakes and sees an empty chair. Boy panics. Boy runs to the stairs. Boy finds his one-legged girl trying to open a locked door. Boy leads girl back to the basement. Boy puts a tape in VCR. Boy and girl watch *It's a Wonderful Life*. See classic stories. See not so classic stories. See what you want to see. The nineteenth Seattle International Film Festival begins May fourteenth. See how people act.

**CLASSIC STORY / LINES # 1
/ LINES # 2**
16 / 52
DISTINCTIVE MERIT
COPYWRITING
Steven Johnson
PRODUCTION
Sam Walsh
DIRECTION
Sam Stevens
AGENCY
Cole and Weber
CLIENT
S.I.F.F.
ENTRANT LOCATION
Seattle, WA

ANNOUNCER: Well, OK, then. My name is Inigo Montoya. You killed my father. Prepare to die. When you're slapped, you'll take it and like it. He passed away two weeks ago. He bought the land a week ago. That's unusual. Serpentine, Shel. Serpentine. Wallace Beery. Wrestling picture. Whaddya need, a roadmap? Whenever Mrs. Kissel breaks wind, we beat the dog. I don't wanna make anything bought, sold or processed. I don't wanna sell anything made or processed, or bought. Well, which is it gonna be, young fella? Cuz ffen I freeze, I can't get rightly drop, and iffen I drop, I'm a-gonna be in motion. Wake up. It's time to die. You're not too smart, are you? I like that in a man. Come on, Charley. You wanna do it? Let's do it, right here on the Oriental. Lines are now forming for the nineteenth Seattle International Film Festival, beginning May fourteenth. See how people act.

ANNOUNCER: From now on, you will speak only when spoken to, and the first and last words out of your filthy sewers will be sir! Do you maggots understand that? What are you kiddin' me? We got us a family unit here. Little brains. That's what we call you people. I believe in the soul, the small of a woman's back, the hanging curve ball, high fiber, good scotch, long foreplay, show tunes. We're on a mission from God. Unfortunately, there's one thing that stands between me and that property, and that's the rightful owners. She tried to sit on my lap when I was standing up. Joey, have you ever seen a grown man naked? Well, this one goes to eleven. She drove me to drink. That's the one thing I'm indebted to her for. Now all you have to do is hold the chicken, bring me the toast, and give me a check for the chicken salad sandwich.
Liens are now forming for the nineteenth Seattle International Film Festival, beginning May fourteenth. See how people act.

DEFICIT REDUCTION, DO
IT YOURSELF, FUZZY
TOILET
16 / 32
COPYWRITING
Mike Renfro
PRODUCTION
Harvey Lewis
STUDIO
Real to Real
AGENCY
The Richards Group
CLIENT
Motel 6
ENTRANT LOCATION
Dallas, TX

TOM: Hi, Tom Bodett for Motel 6 with an open letter to the president. Well sir, you asked us to all contribute to helping shrink up the deficit. And since what's good for the goose is good for the gander, I've got a painless way for you to contribute along with the rest of us—Motel 6. Instead of staying at those big fancy places when you go out on business, you could stay at the Six. You'd get a clean, comfortable room for the lowest prices of any national chain and a good night's sleep to go along with it. Those guys in the suits and dark glasses that follow you around could stay in the room with you for just a few extra dollars. Heck, maybe you could all watch a free in-room movie or make a few free local phone calls or something. It'd be a blast. Oh sure, you'd have to do without a shower cap and that fancy guava-gel conditioning shampoo, but all in all, Mr. President, I'd say you've probably already spent enough money on your hair, anyway. I'm Tom Bodett for Motel 6, and we'll leave the light on for you, sir.

TOM: Hi, Tom Bodett for Motel 6 with a reply. You know a lot of people've been writing in asking, "Hey, Tom, how come Motel 6 doesn't have a fancy singing jingle like a lot of places?" Well, hard as it may be to believe, we don't spend a whole lot of money on advertising stuff so we can save you money. But we do like to keep everybody happy. So if you really want a singing jingle, so be it. Here, I'll shut up a minute and you can come up with your own words and sing along to the music.
Say something here about clean, comfortable rooms.
Don't forget, "Lowest prices of any national chain."
You're doin' fine.
Okay, big finale here. Maybe a line about free local calls and free in-room movies.
Oh, yeah, you're a natural. Don't quit your day job just yet, though. I'm Tom Bodett for Motel 6, thanks for helping out, and we'll leave the light on for you.

TOM: Visiting friends and relatives is one thing, but staying with 'em is quite another. Hi, I'm Tom Bodett with some simple truths. Well whoever said "It's a nice place to visit, but I wouldn't wanna live there," Must have been talking about a trip to visit friends and relatives. It's always nice to see 'em, but they just do things differently. Like your friend from high school with the blinking barricade light collection he keeps in the spare bedroom where you're supposed to sleep. Or that nice aunt of yours who means well, but with all those fuzzy covers she puts on the stuff in the bathroom, you can never get the toilet lid to stay up by itself. A better idea would be to stay at Motel 6. You'll get a clean, comfortable room and a good night's sleep for the lowest prices of any national chain. And your kids can stay with you free. There's more than 750 locations all around the country, and not a one of 'em has fuzzy toilet covers. I'm Tom Bodett for Motel 6, and we'll leave the lid up for you.

ANNOUNCER: On any given Sunday, someone looks for a three-letter word for "snake." A man follows a story about the conflict in the Middle East. And a 6-year-old sits down on the front step an looks for Garfield.

On any given Sunday, a woman reads a travel story to her husband. Today, it's about a whitewashed town on a Greek Island. And a young boy checks to make sure his favorite team is still one game up.

On any given Sunday, people all over read the Sunday *Dallas Morning News*. For sports, business, the arts, comics, coupons and—news.

It's one paper. But everybody finds something special in it. Something they're sure we put in, just for them.

The Sunday *Dallas Morning News*. It's more than a newspaper. It's the story of all of us.

**ANY GIVEN SUNDAY /
SHOPPING / SATURDAY**
16 / 42
COPYWRITING
Pat Mendelson,
Diane Seimetz
CREATIVE DIRECTION
David Fowler,
Diane Seimetz
PRODUCTION
Marianne Newton
MUSIC
Elder Forest Music,
Scott Harper
STUDIO
TLA Studios, Criterion,
Real to Reel
AGENCY
Tracy - Locke / DDB
Needham
CLIENT
The Dallas Morning
News
ENTRANT LOCATION
Dallas, TX

ANNOUNCER: On any given Sunday, someone sits in a favorite chair and shops for a car.

A couple circles a house, then underlines it.

And for his parents' listening pleasure, a twelve-year-old fins a great deal on a set of drums.

On any given Sunday, a college student is sprawled out on the floor, looking through the classifieds for a couch.

A man spots a job opportunity, so he turns the page and finds a sale on suits.

And everyone discovers the value of coupons.

On any given Sunday, people all over buy, sell., browse and shop in the Sunday *Dallas Morning News*.

Something they're sure is in there just for them.

The Sunday *Dallas Morning News*. It's more than a newspaper. It's the story of all of us.

ANNOUNCER: On any given Saturday, a teenager is the first to call on a classified ad for a '66 Mustang.

One owner, no engine.

A kid brother has the entire weekend to enjoy the Sunday comics.

And a young woman has an extra day to look for her first apartment.

On any given Saturday, you can pick up the early edition of the Sunday *Dallas Morning News*.

It gives you all weekend to enjoy sports, business, shopping, opinions and news.

So you can read about a movie before you take the family.

Collect your coupons for the week, or spend a few more exasperating hours working *The New York Times* Sunday Crossword.

The early edition of the Sunday *Dallas Morning News*. It's available at noon at grocery and convenience stores on any given Saturday. And it's more than a newspaper. It's the story of all of us.

MAYOR / NICKNAMES /
VIRUS
16 / 43
COPYWRITING
David Morring
PRODUCTION
Karen Junkins
STUDIO
Hollywood Recording
AGENCY
The Richards Group
CLIENT
Computer City
Supercenters
ENTRANT LOCATION
Dallas, TX

MAN: One day I walked into this place called Computer City. So I said to the first person I see, I want to speak to the mayor. And he said, we don't have a mayor. And I said, you don't have a mayor? Every city has a mayor. But he says, we're not that type of city. And I said, well then what type of city are you? And he said, well, Computer City's a store. And I said, then why do you call yourself a city if you're really a store, Mr. Smart Guy? And he said, well, Computer City has everything you'd find if you drove all over the city. Software, hardware, accessories, even furniture at super low prices every day. So I said, it's called Computer City because it's like having a city all in one store. And he says, exactly. And I said, so do you have a store manager? And he said, of course. And I said, well shouldn't that be the city manager? I mean if you don't have a mayor, you should at least have a city manager. Computer City. Best brands, super selection, guaranteed great prices, every day.

MAN: One day I walked into this place called Computer City and I said to this guy, why doesn't Computer City have a nickname? And he said, a nickname? And I said, yeah a nickname. Every city has to have a nickname. I mean if I say Big D, you immediately think of Davenport, Iowa, and if I mention the City of Brotherly Love you know I'm talking about San Francisco. And he said, well, maybe we could start calling Computer City, "The City of Friendly Assistance" or "The City of Super Selections" or "The City of Great Prices." But I said I didn't think any of those were catchy enough. Then he said, well, we have other Computer Cities all over the country completely identical to this one. So maybe people will start calling us the Twin Cities. And I said, don't you know anything? Wayne and Payne, Oklahoma already have that one. Computer City. Best brands, super selection, guaranteed great prices, every day.

MAN: One day my son tells me he's got a virus. So I ask the standard questions every good parent asks. Does your stomach hurt? Do you have a fever? Do you have to keep breathing on me that way? And he says, dad, I've got a computer virus. And I said, really? I didn't know you could get viruses from a computer. What have you been doing with that thing? And he says, "Look, I'm not sick. My computer has the virus." And I said, oh, what does it have? A cold? The Flu? I hop it's not the chicken pox. You know your sister hasn't had those yet. And he says, "Just take me to Computer City." And I said, they got a good medical center there? And he says, "No, Computer City has computers, modems, scanners, plus an expert staff to help him choose from their huge selection of anti-virus software." And I said, oh, they've got medicines. Do you think they'd have something for my acid indigestion? Computer City. Best brands, super selection, guaranteed great prices, every day.

FLOOD RELIEF CAMPAIGN
21 / 11
COPYWRITING
Tom Townsend
CREATIVE DIRECTION
Tom Townsend,
Jim Fortune
PRODUCTION
John Seaton,
Don Greifenkamp
STUDIO
Innervision
AGENCY
DMB&B / St. Louis
CLIENT
The Salvation Army
ENTRANT LOCATION
St. Louis, MO

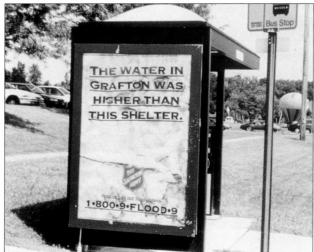

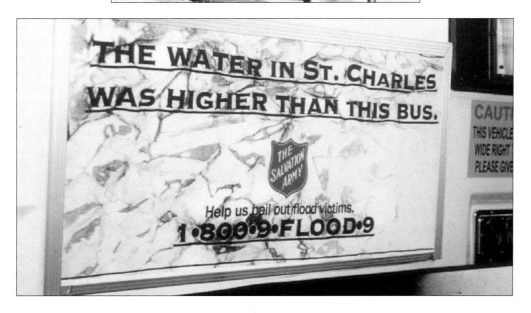

SUGGESTION
22 / 2
SILVER
ART DIRECTION
Sal DeVito
COPYWRITING
David Bromberg,
Audrey DeVries
PHOTOGRAPHY
Cailor / Resnick
CREATIVE DIRECTION
Sal DeVito
AGENCY
DeVito / Verdi
CLIENT
Daffy's
ENTRANT LOCATION
New York, NY

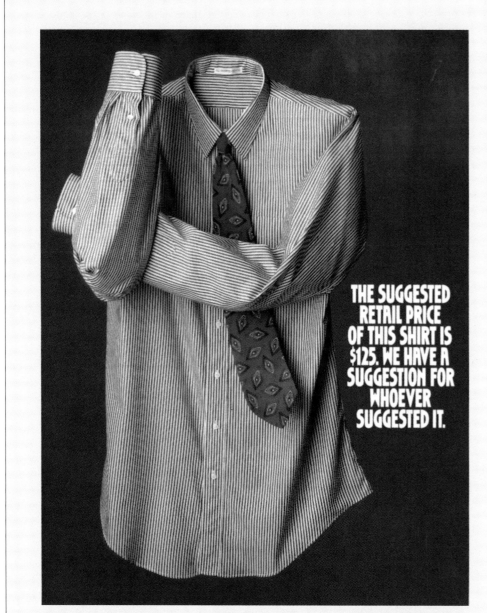

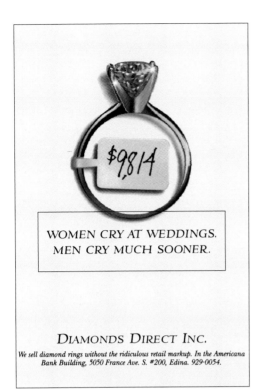

WOMEN CRY AT WEDDINGS.
MEN CRY MUCH SOONER.

DIAMONDS DIRECT INC.

*We sell diamond rings without the ridiculous retail markup. In the Americana
Bank Building, 5050 France Ave. S. #200, Edina. 929-0054.*

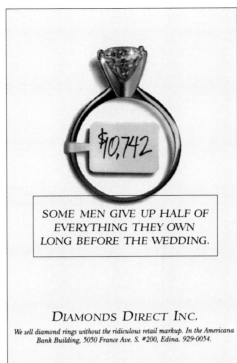

SOME MEN GIVE UP HALF OF
EVERYTHING THEY OWN
LONG BEFORE THE WEDDING.

DIAMONDS DIRECT INC.

*We sell diamond rings without the ridiculous retail markup. In the Americana
Bank Building, 5050 France Ave. S. #200, Edina. 929-0054.*

IT'S
FLUE
SEASON
AGAIN.

CHIMNEY DOCTORS
CHIMNEY SWEEPS
1.617.446.0367

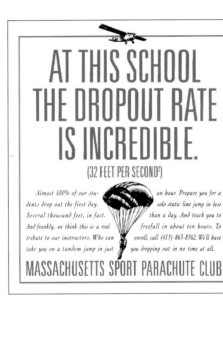

AT THIS SCHOOL
THE DROPOUT RATE
IS INCREDIBLE.
(32 FEET PER SECOND²)

Almost 100% of our stu-
dents drop out the first day.
Several thousand feet, in fact.
And frankly, we think this is a real
tribute to our instructors. Who can
take you on a tandem jump in just

an hour. Prepare you for a
solo static line jump in less
than a day. And teach you to
freefall in about ten hours. To
enroll, call (413) 863-8362. We'll have
you dropping out in no time at all.

MASSACHUSETTS SPORT PARACHUTE CLUB

WOMEN CRY AT
WEDDINGS
22 / 1
ART DIRECTION
Christopher Cole
COPYWRITING
Mark Wegworth
PHOTOGRAPHY
Earl Kendall
ILLUSTRATION
Lee Stokes Retouching
AGENCY
Chuck Ruhr Advertising
CLIENT
Diamonds Direct
ENTRANT LOCATION
Minneapolis, MN

SOME MEN GIVE UP HALF..
22 / 3
ART DIRECTION
Christopher Cole
COPYWRITING
Mark Wegwerth
PHOTOGRAPHY
Earl Kendall
ILLUSTRATION
Lee Stokes Retouching
AGENCY
Chuck Ruhr Advertising
CLIENT
Diamonds Direct
ENTRANT LOCATION
Minneapolis, MN

IT'S FLUE SEASON AGAIN
22 / 4
ART DIRECTION
Karen MacDonald
Lynch
COPYWRITING
Peter Pappas
AGENCY
Mullen
CLIENT
Chimney Doctors
ENTRANT LOCATION
Wenham, MA

AT THIS SCHOOL THE
DROPOUT RATE IS
INCREDIBLE
22 / 5
ART DIRECTION
Brian Fandetti
DESIGN
Brian Fandetti
COPYWRITING
Al Lowe
ILLUSTRATION
John Burgoyne
CLIENT
Massachusetts Sport
Parachute Club
ENTRANT LOCATION
Boston, MA

RELIVE THE MOVIE
22 / 6
ART DIRECTION
Sakol Mongkolkasetarin,
Wade Koniakowsky
COPYWRITING
Kirt Gentry, Jim Real
PHOTOGRAPHY
Product: Tom Hollar,
Dinosaurs: Universal
City Studios, Inc.
AGENCY
Acme Advertising
CLIENT
Pacific Snax Corp.
ENTRANT LOCATION
Santa Ana, CA

VERTICAL HOLD
22 / 7
ART DIRECTION
Marcus Woolcott
COPYWRITING
Marcus Woolcott
AGENCY
Alecto / Megaera
CLIENT
Apex TV Repair
ENTRANT LOCATION
New York, NY

LOOK, UP IN THE SKY
22 / 8
ART DIRECTION
Brian Fandetti
DESIGN
Brian Fandetti
COPYWRITING
Al Lowe
ILLUSTRATION
John Burgoyne
CLIENT
Massachusetts Sport
Parachute Club
ENTRANT LOCATION
Boston, MA

**HOW HARD CAN
SKYDIVING BE?**
22 / 9
ART DIRECTION
Brian Fandetti
DESIGN
Brian Fandetti
COPYWRITING
Al Lowe
ILLUSTRATION
John Burgoyne
CLIENT
Massachusetts Sport
Parachute Club
ENTRANT LOCATION
Boston, MA

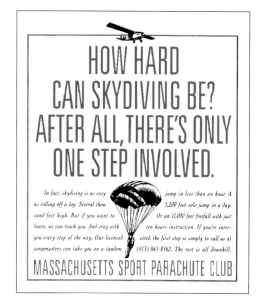

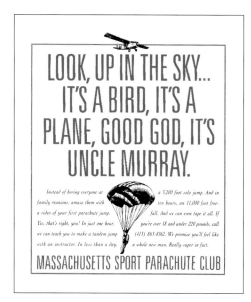

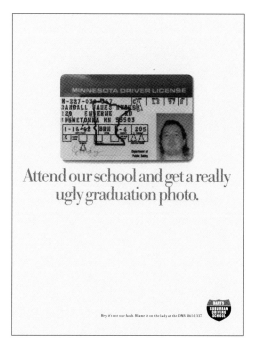

Attend our school and get a really ugly graduation photo.

Hey it's not our fault. Blame it on the lady at the DMV. 861-1337.

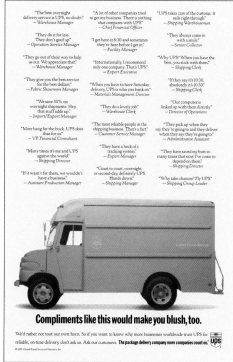

Compliments like this would make you blush, too.

We'd rather not toot our own horn. So if you want to know why more businesses worldwide trust UPS for reliable, on-time delivery, don't ask us. Ask our customers. **The package delivery company more companies count on.**

Live burials.
Dismemberment.
Insanity.
The perfect
museum
for the entire
family.

The Poe Museum
1914 East Main Street. 648-5523.

If you're
faint
of heart,
there's
always The
Stephen King
Festival.

The Poe Festival.
October 15-17.
1914 East Main Street. 648-5523.

GRAND PHOTO
22 / 10
ART DIRECTION
Randy Hughes
COPYWRITING
Bill Johnson
PHOTOGRAPHY
Curtis Johnson,
Arndt Photography
PRODUCTION
Randy Hughes
STUDIO
ColorHouse
AGENCY
Clarity Coverdale Rueff
CLIENT
Bart's Suburban Driving
School
ENTRANT LOCATION
Minneapolis, MN

**COMPLIMENTS LIKE THIS
WOULD MAKE YOU
BLUSH, TOO**
22 / 11
ART DIRECTION
David Burger
COPYWRITING
David Wojdyla
PHOTOGRAPHY
Lamb & Hall
AGENCY
Ammirati & Puris
CLIENT
UPS
ENTRANT LOCATION
Ridgewood, NJ

LIVE BURIALS
22 / 12
ART DIRECTION
Cliff Sorah
COPYWRITING
Raymond McKinney
AGENCY
The Martin Agency
CLIENT
The Edgar Allan Poe
Museum
ENTRANT LOCATION
Richmond, VA

**IF YOU'RE FAINT OF
HEART**
22 / 13
ART DIRECTION
Cliff Sorah
COPYWRITING
Raymond McKinney
AGENCY
The Martin Agency
CLIENT
The Edgar Allan Poe
Museum
ENTRANT LOCATION
Richmond, VA

WE USED TO BE CLOSED
22 / 14
ART DIRECTION
Cliff Sorah
COPYWRITING
Raymond McKinney
AGENCY
The Martin Agency
CLIENT
The Edgar Allan Poe
Museum
ENTRANT LOCATION
Richmond, VA

LION, HYENA AND
JACKALS
22 / 15
ART DIRECTION
Gerard Vaglio
COPYWRITING
Neal Hughlett
PHOTOGRAPHY
Jerry Cailor
AGENCY
Grace & Rothschild
CLIENT
Land Rover
North America, Inc
ENTRANT LOCATION
New York, NY

WOMEN HAVE
22 / 16
ART DIRECTION
Steve St. Clair
COPYWRITING
Steve St. Clair,
Stephenie Crippen
CREATIVE DIRECTION
Mark Hughes
AGENCY
Lord, Dentsu
& Partners
CLIENT
Outward Bound
ENTRANT LOCATION
New York, NY

REMEMBER TO BRUSH,
FREE INTERNAL EXAMS,
FLU SEASON
22 / 17
ART DIRECTION
Eric Revels
COPYWRITING
Corinne Mitchell
ILLUSTRATION
Eric Revels
AGENCY
Revels, Mitchell & Mac
CLIENT
St. Peters
Chimney Sweep
ENTRANT LOCATION
St. Peters, MO

We used to be closed from November until March. Nevermore.

The Poe Museum
1914 East Main Street. 648-5523.

Women
have balls
too.

The Outward Bound Expeditions
1 800 268-7329 or in Toronto 787-1721.

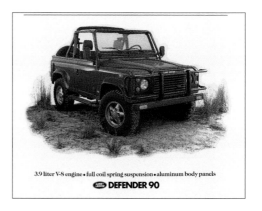

3.9 liter V-8 engine • full coil spring suspension • aluminum body panels
DEFENDER 90

Remember to brush
twice yearly.

Regular brushing by a professional removes creosote and soot buildup from your chimney.
Preventing a dangerous fire hazard. Call 314-928-9394 today for an appointment.

St. Peters Chimney Sweep

Now offering free
internal exams.

Every time you light up, creosote and soot build up inside your chimney. Undetected,
they create a dangerous fire hazard. So call 314-928-9394 and schedule a free checkup.

St. Peters Chimney Sweep

Flue season
is here.

Creosote and soot buildup inside your chimney causes dangerous congestion and even fires.
Call 314-928-9394 today to schedule a professional cleaning. Because prevention is the best cure.

St. Peters Chimney Sweep

WE PUT THE NAME ON
THE BACK
22 / 18

ART DIRECTION
Denise Crandall

COPYWRITING
Ken Lewis

PHOTOGRAPHY
Michael Rausch

PRODUCTION
Michelle Anderson

AGENCY
Team One Advertising

CLIENT
Lexus Dealer
Association

ENTRANT LOCATION
El Segundo, CA

CALL MERCEDES-BENZ AT
11 P.M.
22 / 19

ART DIRECTION
Cliff Sorah

COPYWRITING
Kerry Feuerman

PRINT PRODUCTION
Linda Locks

AGENCY
The Martin Agency

CLIENT
Mercedes-Benz of
North America

ENTRANT LOCATION
Richmond, VA

BEHIND THE
REFRIGERATOR
22 / 20

ART DIRECTION
Penny Redfern

COPYWRITING
Jerry Confino

AGENCY
Lord, Dentsu
& Partners

CLIENT
AT & T Universal Card

ENTRANT LOCATION
New York, NY

USELESS JUNK...ANTIQUES
22 / 21

ART DIRECTION
Randy Hughes

COPYWRITING
Josh Denberg

PHOTOGRAPHY
Shawn Michienzi

PRODUCTION
Jan Miller

AGENCY
Clarity Coverdale Rueff

CLIENT
St. Paul Pioneer Press

ENTRANT LOCATION
Minneapolis, MN

MAYBE IT'S THE FORMULA
22 / 22
ART DIRECTION
Barney Goldberg
COPYWRITING
David Neale
PHOTOGRAPHY
Tony Sylvestro
PRINT PRODUCTION
Jenny Schoenherr
AGENCY
The Martin Agency
CLIENT
Nature Food Centres
ENTRANT LOCATION
Richmond, VA

BROOKS HERS
22 / 23
ART DIRECTION
Walt Connelly
DESIGN
Walt Connelly
COPYWRITING
Bruce Richter
ILLUSTRATION
Walt Connelly
AGENCY
Ogilvy & Mather NY
CLIENT
Brooks Brother
ENTRANT LOCATION
New York, NY

KILL YOU
22 / 24
ART DIRECTION
Eric Tilford
COPYWRITING
Todd Tilford
AGENCY
The Richards Group
CLIENT
The Spy Factory
ENTRANT LOCATION
Dallas, TX

WHEN YOU DON'T HAVE
TIME TO SEE THE MOVIE
22 / 25
ART DIRECTION
Sean Riley
COPYWRITING
Raymond McKinney
PHOTOGRAPHY
Tom Layman
AGENCY
The Martin Agency
CLIENT
Carriage House Book
Shop
ENTRANT LOCATION
Richmond, VA

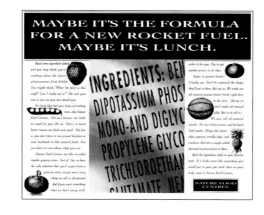

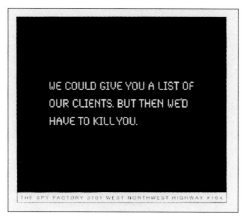

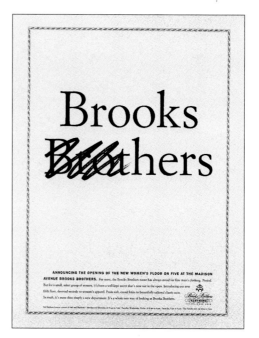

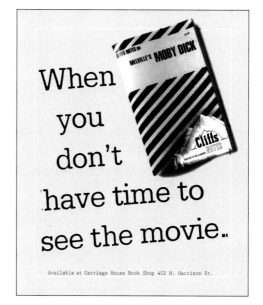

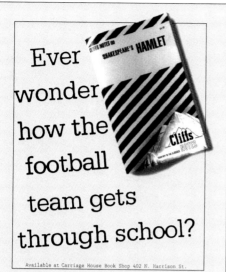

Ever wonder how the football team gets through school?

Available at Carriage House Book Shop 402 N. Harrison St.

All in favor of preventing premature births, raise your hands. Three-fourths of all infant deaths result from premature births, many of which could have been prevented. That's why, at MedCenters Health Plan, we're taking steps to lower the number of preterm births. It's part of our 10-year program we call "Dedicated To Better Health." Our goal: to reduce preventible health problems in the Twin Cities. We have developed a special book that emphasizes the importance of early and ongoing prenatal care. It outlines the normal changes of pregnancy, preterm labor warning signs, and the harmful effects of smoking, drugs and alcohol on pregnancy. We also offer free classes on early pregnancy care, preterm birth prevention, and smoking cessation. In this way, we hope to minimize the incidence and costs of premature births. And when you take a look at the hand on this page, you realize the reasons are far too small to ignore. **MedCenters** *dedicated* TO BETTER HEALTH

Hold this page up to the light.

A made in Canada story with no mention of hockey, toques or back bacon?

CHRYSLER
Reinventing the Automobile
1-800-361-3700

EVER WONDER HOW THE FOOTBALL TEAM GETS THROUGH SCHOOL?
22 / 26
ART DIRECTION
Sean Riley
COPYWRITING
Raymond McKinney
PHOTOGRAPHY
Tom Layman
AGENCY
The Martin Agency
CLIENT
Carriage House Book Shop
ENTRANT LOCATION
Richmond, VA

RAISE YOUR HAND
22 / 27
ART DIRECTION
Chris Lincoln
COPYWRITING
Bruce Hannum
PHOTOGRAPHY
Parallel Production / Tom Berthiaume
CLIENT
Med Centers
ENTRANT LOCATION
Minneapolis, MN

HOLD THIS PAGE UP TO THE LIGHT
22 / 1
ART DIRECTION
Jamie Way
DESIGN
Jamie Way
COPYWRITING
Brent Peterson
PHOTOGRAPHY
Richard Picton
PRODUCTION
Margaret Freitas
AGENCY
Harrod & Mirlin
CLIENT
Moosehead Breweries
ENTRANT LOCATION
Toronto, Canada

HOCKEY / TOQUES / BACK BACON
22 / 2
ART DIRECTION
Rich Buceta
CREATIVE DIRECTION
Larry Tolpin, Richard Williams
DESIGN
Rich Buceta
COPYWRITING
Zak Mroueh
ILLUSTRATION
Clancy Gibson
AGENCY
BBDO Canada
CLIENT
Chrysler Canada Ltd.
ENTRANT LOCATION
Toronto, Canada

ROAD SAFETY / CUSHION /
BODIES / FLOORS
22 / 7, 6, 5, 4
ART DIRECTION
Neil French
DESIGN
Neil French
COPYWRITING
Neil French
PHOTOGRAPHY
Han Chew
PUBLICATION
Straits Times Group
CLIENT
Singapore Press
Holdings
ENTRANT LOCATION
Singapore

FACES / POLICEMAN /
FINGER / THIS WAY UP
22 / 11, 10, 9, 8
ART DIRECTION
Neil French
DESIGN
Neil French
COPYWRITING
Neil French
PHOTOGRAPHY
Han Chew
PUBLICATION
Straits Times Group
CLIENT
Singapore Press
Holdings
ENTRANT LOCATION
Singapore

FEET / WEST SAND / MUG
ON SIDE
22 / 14, 13, 12
ART DIRECTION
Neil French
DESIGN
Neil French
COPYWRITING
Neil French
PHOTOGRAPHY
Han Chew
PUBLICATION
Straits Times
CLIENT
Singapore Press
Holdings
ENTRANT LOCATION
Singapore

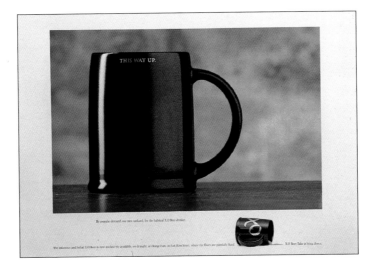

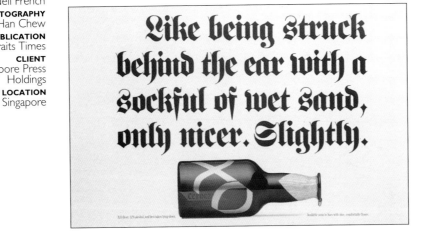

Sadomasochist, drug addict, manic depressive, pervert, egomaniac, alcoholic? When did Poe find time to write?

All of Poe's stories were inspired by bizarre opium hallucinations. Once Poe got drunk in New York and was found several days later running like a wild man through the New Jersey woods. He was hopelessly insane.

Whoa! Listen to all the sordid rumors and stories circulating around Edgar Allan Poe and you'd think that he was quite a scoundrel. The fact of the matter is, most frank and trustworthy accounts of the day paint the picture of a basically gentle comrade, a conscientious editor and an attentive husband.

So where did this *National Enquirer* version of his life come from? The primary culprit is one Rufus Griswold. In the early 1830's, Griswold and Poe engaged in a series of brutal literary battles. Among other things that we don't want to print in a family newspaper, Poe claimed that Griswold had "a miserable want of talent."

Poe went on in later years, thinking the feud had been put to rest, to appoint Griswold as executor of his estate.

Griswold took advantage of this trust, after Poe had passed away, to slander the poor man, forging some letters, manipulating others and creating a body of myths and untruths that live with us today. For example, Poe was not a drug addict. We have his doctor's word on that. He was not an alcoholic. True, he had a problem when he did drink. He simply couldn't hold his liquor. From what we know today, his trouble looks suspiciously like diabetes or an enzyme defect.

Of course, we're not trying to say Poe was perfect. He did behave erratically at times. But can you name a genius who didn't? We're just saying, maybe he wasn't that bad of a guy. Why don't you come down to the Poe Museum and make up your own mind? We're at 1914 East Main Street here in Richmond. With one of the largest Poe collections in the world, you'll find out something really startling about Poe's life. The truth. **The Poe Museum**

The Edgar Allan Poe Museum, 1914 East Main Street, Richmond, Virginia 23223. Open 7 Days A Week. Admission $5.00. Call (804)648-5523.

SADOMASOCHIST, DRUG ADDICT, MANIC DEPRESSIVE, PERVERT, EGOMANIAC, ALCOHOLIC?
23 / 7
DISTINCTIVE MERIT
ART DIRECTION
Cliff Sorah
COPYWRITING
Raymond McKinney
PHOTOGRAPHY
Jon Hood
AGENCY
The Martin Agency
CLIENT
The Edgar Allan Poe Museum
ENTRANT LOCATION
Richmond, VA

MOSES
23 / 14
DISTINCTIVE MERIT
ART DIRECTION
Sal DeVito
COPYWRITING
Abi Aron,
Rob Carducci
CREATIVE DIRECTION
Sal DeVito
AGENCY
DeVito / Verdi
CLIENT
Empire Kosher Poultry
ENTRANT LOCATION
New York, NY

What Kind Of Job Would You Do If The Boss Was Always Looking Over Your Shoulder?

At Empire, we have to please someone who's even more demanding than our customers. That's why we use a slower, all natural process to produce a better

tasting chicken. And why no chicken goes through more inspections than an Empire Kosher chicken. So it's not surprising that four out of five people who took part in a recently conducted, independent test preferred the taste of our chicken over Perdue, Cookin'Good, Tyson and Bell & Evans. And it's also no surprise that in a separate tenderness test, Empire Kosher chicken was again preferred over Perdue, Cookin'Good, Tyson and Bell & Evans. Apparently, it's not just somebody up there who likes us.

Pick up an Empire chicken at your nearby supermarket or butcher shop. And start enjoying the product of a strict religious upbringing.

EMPIRE KOSHER CHICKEN
You should have a chicken so good.

BOSS
23 / 19
DISTINCTIVE MERIT
ART DIRECTION
Abi Aron,
Rob Carducci
COPYWRITING
Rob Carducci,
Abi Aron
CREATIVE DIRECTION
Sal DeVito
AGENCY
DeVito / Verdi
CLIENT
Empire Kosher Poultry
ENTRANT LOCATION
New York, NY

ELECTRIC MAN - PSI
ENERGY
23 / 2
ART DIRECTION
Hal Tench
COPYWRITING
Steve Bassett
ILLUSTRATION
Paul Bernarth
PRINT PRODUCTION
Karen Smith
AGENCY
The Martin Agency
CLIENT
PSI Energy
ENTRANT LOCATION
Richmond, VA

EARLY AMERICANS
CALLED POE A HACK
23 / 3
ART DIRECTION
Cliff Sorah
COPYWRITING
Raymond McKinney
AGENCY
The Martin Agency
CLIENT
The Edgar Allan Poe
Museum
ENTRANT LOCATION
Richmond, VA

WISHBONE
23 / 4
ART DIRECTION
Paul Blade
COPYWRITING
Albert Kelly
CREATIVE DIRECTION
Sam Scali
PHOTOGRAPHY
Robert Ammirati
AGENCY
Lowe & Partners/SMS
CLIENT
Perdue Farms Inc
ENTRANT LOCATION
New York, NY

POE CREATED THE
DETECTIVE STORY BACK
IN THE 1841
23 / 5
ART DIRECTION
Cliff Sorah
COPYWRITING
Raymond McKinney
PHOTOGRAPHY
Jon Hood
AGENCY
The Martin Agency
CLIENT
The Edgar Allan Poe
Museum
ENTRANT LOCATION
Richmond, VA

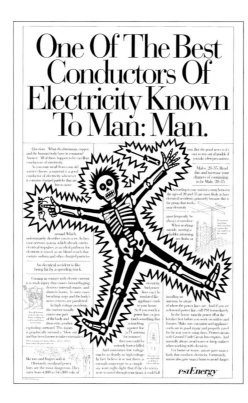

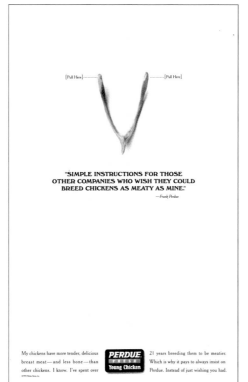

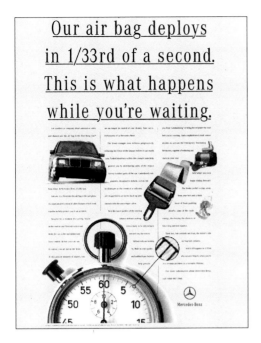

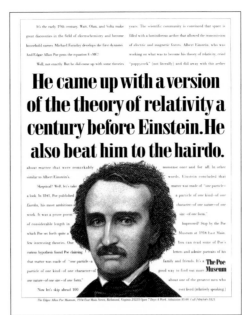

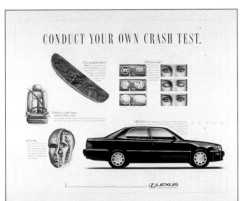

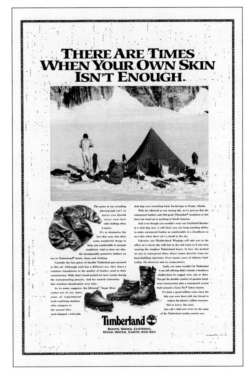

1/33RD OF A SECOND
23 / 6
ART DIRECTION
Paul Blade
COPYWRITING
Debbie Kasher
CREATIVE DIRECTION
Sam Scali
PHOTOGRAPHY
Cailor / Resnick,
David Lebon,
Jim Galante
AGENCY
Lowe & Partners/SMS
CLIENT
Mercedes - Benz
ENTRANT LOCATION
New York, NY

**HE CAME UP WITH A
VERSION OF THE THEORY
OF RELATIVITY A
CENTURY BEFORE
EINSTEIN.**
23 / 8
ART DIRECTION
Cliff Sorah
COPYWRITING
Raymond McKinney
PHOTOGRAPHY
Jon Hood
AGENCY
The Martin Agency
CLIENT
The Edgar Allan Poe
Museum
ENTRANT LOCATION
Richmond, VA

**CONDUCT YOUR OWN
CRASH TEST**
23 / 9
ART DIRECTION
John Boone
COPYWRITING
Ron Huey
CREATIVE DIRECTION
Tom Cordner
PHOTOGRAPHY
Michael Ruppert
ILLUSTRATION
Antar Dayal
PRODUCTION
Pam Jones,
Kristi Nelson
AGENCY
Team One Advertising
CLIENT
Lexus
ENTRANT LOCATION
El Segundo, CA

**BOOTS, SHOES, CLOTHES,
WIND, WATER, EARTH
AND SKY**
23 / 10
ART DIRECTION
Margaret McGovern
COPYWRITING
Paul Silverman
PHOTOGRAPHY
John Krakauer,
Product: John Holt
Studio
AGENCY
Mullen
CLIENT
The Timberland
Company
ENTRANT LOCATION
Wenham, MA

THIS CAN STILL KICK THE YOU - KNOW - WHAT OUT OF ANY BOOT MADE
23 / 11
ART DIRECTION
Margaret McGovern
COPYWRITING
Paul Silverman
PHOTOGRAPHY
John Holt Studio
AGENCY
Mullen
CLIENT
The Timberland
Company
ENTRANT LOCATION
Wenham, MA

HOW TO SURVIVE A MELTDOWN
23 / 12
ART DIRECTION
Margaret McGovern
COPYWRITING
Paul Silverman
PHOTOGRAPHY
David Muenda/
Product:
John Holt Studio
AGENCY
Mullen
CLIENT
The Timberland
Company
ENTRANT LOCATION
Wenham, MA

FASHION POLICE
23 / 1
ART DIRECTION
Dennis Walker
DESIGN
Dennis Walker
COPYWRITING
Kevin Swisher
PHOTOGRAPHY
Geof Kern
HANDWRITING
Dennis Walker,
Diane Ambrico
AGENCY
The Richards Group
CLIENT
Neiman Marcus
ENTRANT LOCATION
Dallas, TX

BREASTS, THIGHS AND LEGS
23 / 13
ART DIRECTION
Carolyn Tye McGeorge
COPYWRITING
Raymond McKinney
PRODUCTION
Jenny Schoenherr
AGENCY
Newt & Partners
CLIENT
Deja Vu Night Clubs
ENTRANT LOCATION
Richmond, VA

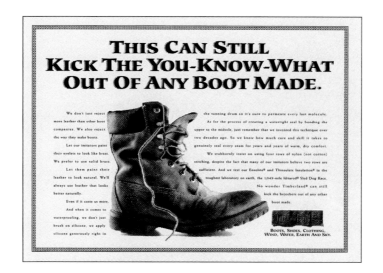

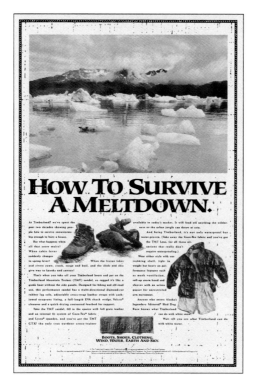

Be Thankful The IRS Uses Their Own Inspectors. Not Ours.

At Empire, after a chicken passes government inspections, it still has to pass our kosher inspections. Which means no chicken goes through more inspections than an Empire kosher chicken. For more details, call 1-800-EMPIRE-4. And consider yourself lucky we're working on your dinner, not your taxes.

EMPIRE KOSHER CHICKEN

THE CORPORATE RAT RACE NOW HAS A PACE CAR.

Besides Mercedes S-Class luxury, our 600 SEL offers the invigorating performance of a V-12 engine. Just the thing for drivers who want to separate themselves from the pack. Let us arrange a test drive today.

PREVENT HOSTILE TAKEOVERS ON THE INTERSTATE.

The V-8 powered 500 SEC and V-12 powered 600 SEC coupes from Mercedes-Benz. Their slippery contours and breathtaking performance make them the cars everyone will try to overtake. Take a test drive today.

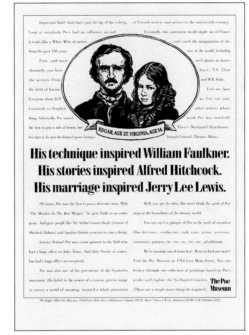

His technique inspired William Faulkner.
His stories inspired Alfred Hitchcock.
His marriage inspired Jerry Lee Lewis.

EDGAR, AGE 27. VIRGINIA, AGE 14.

The Poe Museum

IRS
23 / 15
ART DIRECTION
Leslie Sweet,
Stephanie Arnold
COPYWRITING
Stephanie Arnold,
Leslie Sweet
CREATIVE DIRECTION
Sal DeVito
AGENCY
DeVito / Verdi
CLIENT
Empire Kosher Poultry
ENTRANT LOCATION
New York, NY

RAT RACE
23 / 16
ART DIRECTION
Mark Fuller
COPYWRITING
Ken Hines
PRINT PRODUCTION
Kay Franz
AGENCY
The Martin Agency
CLIENT
Mercedes-Benz of
North America
ENTRANT LOCATION
Richmond, VA

TAKE A TEST DRIVE
TODAY
23 / 17
ART DIRECTION
Mark Fuller
COPYWRITING
Ken Hines
PRINT PRODUCTION
Kay Franz
AGENCY
The Martin Agency
CLIENT
Mercedes-Benz of
North America
ENTRANT LOCATION
Richmond, VA

HIS TECHNIQUE INSPIRED
WILLIAM FAULKNER.
23 / 18
ART DIRECTION
Cliff Sorah
COPYWRITING
Raymond McKinney
ILLUSTRATION
Paul Bernath
AGENCY
The Martin Agency
CLIENT
The Edgar Allan Poe
Museum
ENTRANT LOCATION
Richmond, VA

NATURE PROTECTION
23 / 1
ART DIRECTION
Norito Shinmura
DESIGN
Hironobu Kuribayashi
Noviaki Kaneda
COPYWRITING
Motoharu Sakata
PHOTOGRAPHY
Teiichi Ogata
AGENCY
I & S Corporation
CLIENT
The Mainichi
Newspapers
ENTRANT LOCATION
Tokyo, Japan

(UNTITLED)
23 / 2
ART DIRECTION
Urs Schwerzmann
COPYWRITING
Urs Schwerzmann
PHOTOGRAPHY
Dietmar Henneka
AGENCY
Urs V. Schwerzmann
CLIENT
Begum's Fashion
Stuttgart
ENTRANT LOCATION
Stuttgart, Germany

INTRODUCTION
23 / 3
ART DIRECTION
Kins Lee
DESIGN
Kins Lee
COPYWRITING
Janet Lee
CREATIVE DIRECTION
Neil French
ILLUSTRATION
Hau Theng Hui,
Patrick Fong
PRODUCTION
David Lee
STUDIO
Spider
ACCOUNT DIRECTION
TL Yeap, Peter Gan
CLIENT
Filmaco Sdn Bhd
ENTRANT LOCATION
Kuala Lumpur, Malaysia

FACE
23 / 4
ART DIRECTION
Gladys Lam,
Darren Spiller
COPYWRITING
Ruth Lee,
David Alberts
CREATIVE DIRECTION
Christen Monge,
David Alberts,
Darren Spiller
AGENCY
DDB Needham
Worldwide Ltd.
CLIENT
Metro Broadcast Corp
Ltd.
ENTRANT LOCATION
Wanchai, Hong Kong

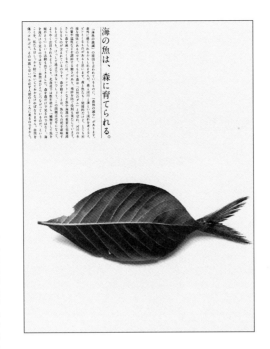

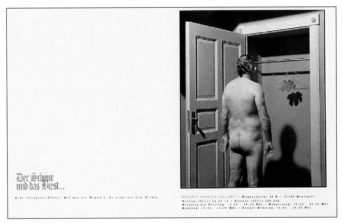
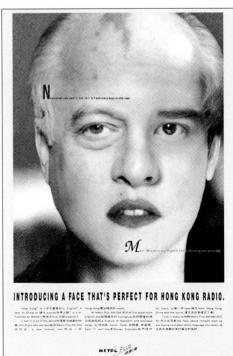

AS YOU CAN SEE, THE NEW GE WHITE-ON-WHITE FRIDGE LOOKS ELEGANT FROM ANY ANGLE.

BRUT. THE ESSENCE OF MAN.

BRUT. THE ESSENCE OF MAN.

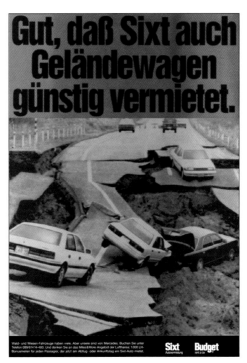

COLOURS
23 / 6
ART DIRECTION
Kins Lee
DESIGN
Kins Lee
COPYWRITING
Janet Lee
CREATIVE DIRECTION
Neil French
ILLUSTRATION
Hau Theng Hui,
Patrick Fong
PRODUCTION
David Lee
STUDIO
Spider
ACCOUNT DIRECTION
TL Yeap, Peter Gan
CLIENT
Filmaco Sdn Bhd
ENTRANT LOCATION
Kuala Lumpur, Malaysia

SLEEPLESS NIGHTS
23 / 7
ART DIRECTION
Sarah Goh
COPYWRITING
Ted Lim
PHOTOGRAPHY
Pashe Studio
AGENCY
Naga DDB Needham
CLIENT
Diethelm (M) SDN
BHD
ENTRANT LOCATION
Selangor, Malaysia

RAPID HEARTBEAT
23 / 8
ART DIRECTION
Sarah Goh
COPYWRITING
Ted Lim
PHOTOGRAPHY
Pashe Studio
AGENCY
Naga DDB Needham
CLIENT
Diethelm (M) SDN
BHD
ENTRANT LOCATION
Selangor, Malaysia

GELANDEWAGEN
23 / 9
ART DIRECTION
Deneke Von Weltzien
DESIGN
Christoph Rabanus
COPYWRITING
Oliver Krippahl
PHOTOGRAPHY
archive
AGENCY
Jung v. Matt
CLIENT
Sixt Autovermietung
ENTRANT LOCATION
Hamburg, Germany

THIS AD'S ON A DIET TOO
23 / 10
ART DIRECTION
Taihei Ohkur
CREATIVE DIRECTION
Etsufumi Umeda,
Kenichi Yatani
DESIGN
Takanobu Nakui,
Taihei Ohkura
COPYWRITING
Yuriko Gotoh
PHOTOGRAPHY
Tadayoshi Yoshida
PRODUCTION
Jun Nakagawa
AGENCY
Dentsu Inc., Tokyo
CLIENT
Ajinomoto Co., Inc.
ENTRANT LOCATION
Tokyo, Japan

DIFFERENT VIEWS
23 / 5
ART DIRECTION
Kins Lee
DESIGN
Kins Lee
COPYWRITING
Janet Lee
CREATIVE DIRECTION
Neil French
PRODUCTION
David Lee
STUDIO
Spider
ACCOUNT DIRECTION
TL Yeap, Peter Gan
CLIENT
Filmaco Sdn Bhd
ENTRANT LOCATION
Kuala Lumpur, Malaysia

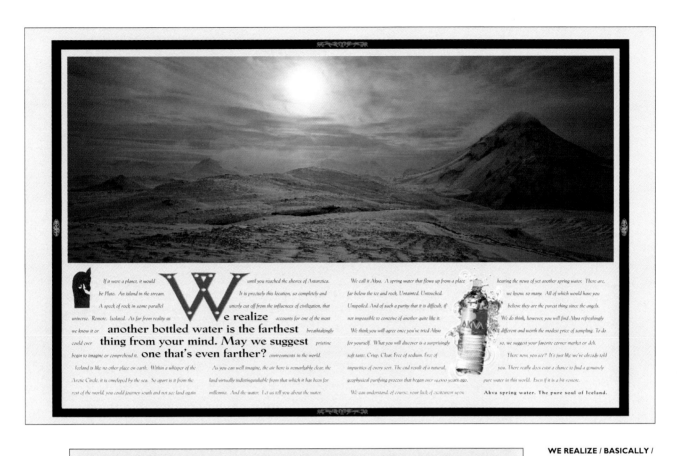

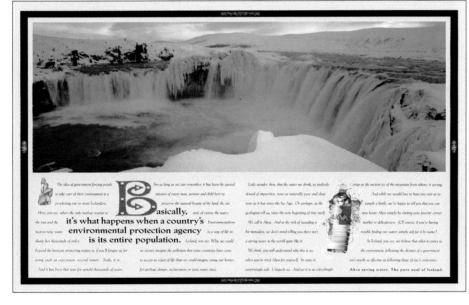

**WE REALIZE / BASICALLY /
THE VIKING**
24 / 8
DISTINCTIVE MERIT
ART DIRECTION
John Doyle
DESIGN
John Doyle,
Charles Bischof
COPYWRITING
Ernie Schenck
PHOTOGRAPHY
Sigurgeir Sigurjónsson /
Hashi
ILLUSTRATION
Peter Hall
AGENCY
Doyle Advertising and
Design Group
CLIENT
AKVA Spring Water
ENTRANT LOCATION
Boston, MA

(continued on next page)

(continued from
previous page)

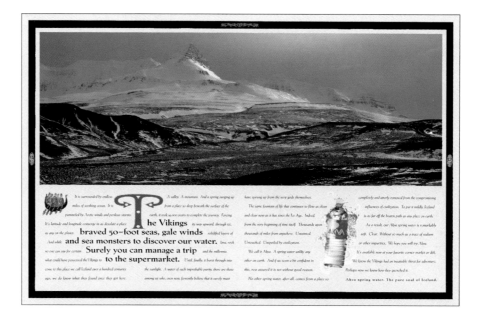

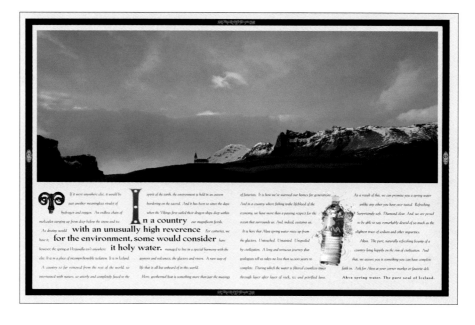

IMPORTED ALL THE WAY FROM UPSTAIRS.

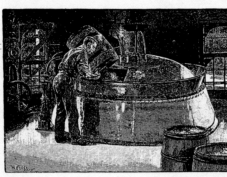

Welcome beer lover.

Thank you for joining us for a short biography of our ales. If you were in the vicinity of one of our hospitable bartenders, he'd pour you one, and you wouldn't have to read any further to appreciate the taste of our beer. Unfortunately, all you have is this paper and it's probably too early to come down to 42 Thompson Street anyway. (Or is it?) While words hardly do justice to the taste of our beer, they'll at least give you an idea of how we achieve it.

How does Mr. Garrett Oliver, our resident brewmaster, create these fine tasting ales?

(You're probably thinking, "Hey, do I really have to learn about your beer-making process? I'm sure it's great, so let's leave well enough alone." Well, my friend, it will be well worth your while to understand why anybody who cares about beer should care about our beer. Ready?)

Garrett uses only the costliest malts (a result of his British apprenticeship) to create the 'wort', a mixture of crushed malt and hot water, which he decocts painstakingly through two brewing-kettles (like that huge, copper thing that sticks out of the front of our building). Then he mixes combinations of select hops from England that most brewers would give an arm for and adds them as seasoning to different batches of wort. Differences in seasoning results in different ales. (We have five for you to try.) Finally, he ferments each ale by adding a top layer of yeast. This requires two stages – a primary layer followed by a secondary one. (Conventional brewers take short-cuts by fermenting their beer only once.) After aging and filtering, the beer is siphoned into a holding tank. From there it goes into kegs and eventually, (here comes the best part) into your thirsty mouth.

Is that accurate enough Garrett? "So, so," he says. For those of you who need a more detailed breakdown of the process, he'd be proud to show you around upstairs.

As for the rest of us, quit drooling, guys. It won't be long before the day is over.

IMPORTED FROM UPSTAIRS.

42 Thompson Street New York City 925-1515

MANHATTAN BREWING CO.

IMPORTED / CHEERS / FOOD / WAITING
24 / 13
DISTINCTIVE MERIT
ART DIRECTION
Greg Nations - Powell
DESIGN
Greg Nations - Powell
COPYWRITING
Arun K. Nemali
ILLUSTRATION
Dover Publications
AGENCY
Louise Vidya & Sons
CLIENT
Manhattan Brewing Company
ENTRANT LOCATION
New York, NY

(continued on next page)

(continued from previous page)

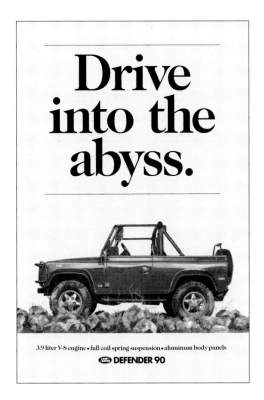

Drive into the abyss.

3.9 liter V-8 engine • full coil spring suspension • aluminum body panels

DEFENDER 90

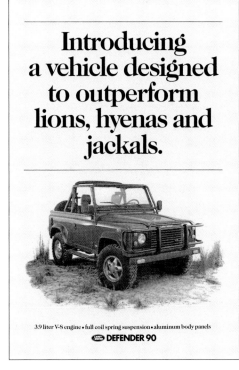

Introducing a vehicle designed to outperform lions, hyenas and jackals.

3.9 liter V-8 engine • full coil spring suspension • aluminum body panels

DEFENDER 90

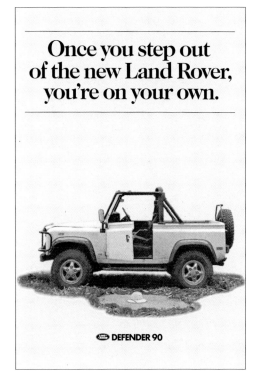

Once you step out of the new Land Rover, you're on your own.

DEFENDER 90

**PITH HELMET/ LION,
HYENA, JACKALS / DRIVE
INTO THE ABYSS**
24 / 1
ART DIRECTION
Allen Richardson,
Gerard Vaglio
COPYWRITING
Gary Cohen,
Neal Hughlett
PHOTOGRAPHY
Jerry Cailor, Vic Huber
AGENCY
Grace & Rothschild
CLIENT
Land Rover
North America, Inc
ENTRANT LOCATION
New York, NY

HE WAS AN EARLY / POE
CREATED / HIS
TECHNIQUE INSPIRED
24 / 2

ART DIRECTION
Cliff Sorah

COPYWRITING
Raymond McKinney

PHOTOGRAPHY
Jon Hood

ILLUSTRATION
Paul Bernath

AGENCY
The Martin Agency

CLIENT
The Edgar Allan Poe
Museum

ENTRANT LOCATION
Richmond, VA

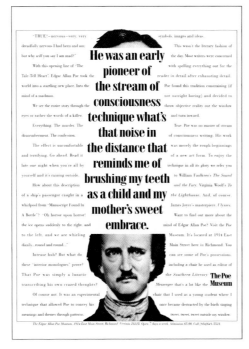

He came up with a version of the theory of relativity a century before Einstein. He also beat him to the hairdo.

Sadomasochist, drug addict, manic depressive, pervert, egomaniac, alcoholic? When did Poe find time to write?

Early Americans called Poe a hack. The French loved him. (Does this mean we'll be opening a Jerry Lewis museum one day?)

**EARLY AMERICANS /
SADOMASOCHIST / HE
CAME UP**
24 / 3
ART DIRECTION
Cliff Sorah
COPYWRITING
Raymond McKinney
PHOTOGRAPHY
Jon Hood
AGENCY
The Martin Agency
CLIENT
The Edgar Allan Poe
Museum
ENTRANT LOCATION
Richmond, VA

THERE'S NOTHING TO
FEAR BUT FEAR ITSELF /
OVER THE RIVER AND
THROUGH THE WOODS /
THROUGH RAIN, SNOW,
SLEET, AND HAIL / ONE
WEEK OF HELL CAN CURE
A YEAR OF IT / WOMEN
HAVE BALLS TOO
24 / 4, 5, 6, 7, 12
ART DIRECTION
Steve St. Clair
COPYWRITING
Stephanie Crippen,
Steve St. Clair
CREATIVE DIRECTION
Mark Hughes
AGENCY
Lord, Dentsu &
Partners
CLIENT
Outward Bound
ENTRANT LOCATION
New York, NY

**SOCIETY / REQUEST /
BREAKTHROUGH**
24 / 9

ART DIRECTION
Graham Clifford

DESIGN
Graham Clifford

COPYWRITING
Dion Hughes

PRODUCTION
Bobby Lamb

AGENCY
Chiat / Day New York

CLIENT
William Grant -
Grant's Scotch

ENTRANT LOCATION
New York, NY

PIRANHA / TYPE A / READ /
MACHETE
24 / 10
ART DIRECTION
Miles Turpin, Denise
Crandall, Lisa Gargano
COPYWRITING
Melissa Huffman,
Ken Lewis,
Betsy Hamilton
PHOTOGRAPHY
Vic Huber,
David LeBon,
Michael Rausch
Production Artist
Michelle Anderson
AGENCY
Team One Advertising
CLIENT
Lexus Dealer
Association
ENTRANT LOCATION
El Segundo, CA

South American peasants work all day in the hot sun to bring us our special beans.

Like them, our coffee boasts a strong aroma.

CafFEINDS
A coffee bar and roastery. 3095 Peachtree Road, N.E., Atlanta Tel. 262-7774

Political discussions, good music and a mood-altering substance.

If we allowed nudity, it would be just like Woodstock.

CafFEINDS
A coffee bar and roastery. 3095 Peachtree Road, N.E., Atlanta Tel. 262-7774

Assassinations. Violent revolution. Political unrest.

Perhaps the Colombians should try our decaf.

CafFEINDS
A coffee bar and roastery. 3095 Peachtree Road, N.E., Atlanta Tel. 262-7774

SOUTH AMERICA /
POLITICAL DISCUSSIONS /
ASSASINATIONS
24 / 11
ART DIRECTION
Dan Scarlotto
COPYWRITING
David Garzotto
AGENCY
BBDO South
CLIENT
CafFeinds
ENTRANT LOCATION
Atlanta, GA

MANNEQUIN / MOLDS ARE
FOR JELLO / WIND SOCK
24 / 14
ART DIRECTION
Dennis Walker
DESIGN
Dennis Walker
COPYWRITING
Kevin Swisher
PHOTOGRAPHY
Geof Kern
HANDWRITING
Dennis Walker,
Diane Ambrico
AGENCY
The Richards Group
CLIENT
Neiman Marcus
ENTRANT LOCATION
Dallas, TX

Live burials.
Dismemberment.
Insanity.
The perfect
museum
for the entire
family.

The Poe Museum
1914 East Main Street. 648-5523.

The Edgar
Allan Poe
Museum.
Conveniently
located
near the
Church Hill
cemetery.

The Poe Museum
1914 East Main Street. 648-5523.

Who
invented
the
detective
story?
Mr. Poe.
In the
parlor.
With the
quill.

The Poe Museum
1914 East Main Street. 648-5523.

**THE EDGAR ALLEN / WHO
INVENTED THE
DETECTIVE STORY / LIVE
BURIALS**
24 / 15
ART DIRECTION
Cliff Sorah
COPYWRITING
Raymond McKinney
AGENCY
The Martin Agency
CLIENT
The Edgar Allan Poe
Museum
ENTRANT LOCATION
Richmond, VA

WE USED TO BE CLOSED /
HIS UNCANNY ABILITY /
POE WAS ONE OF THE
MOST MERCILESS
24 / 16
ART DIRECTION
Cliff Sorah
COPYWRITING
Raymond McKinney
AGENCY
The Martin Agency
CLIENT
The Edgar Allan Poe
Museum
ENTRANT LOCATION
Richmond, VA

His uncanny
ability to
write about
the future made
him a pioneer
of science fiction.
(Wonder if he
foresaw this ad?)

The Poe Museum
1914 East Main Street. 648-5523.

We used
to be
closed
from
November
until
March.
Nevermore.

The Poe Museum
1914 East Main Street. 648-5523.

Poe was one
of the most
merciless critics
in history. For
example, he
would have
thought this
headline was
sophomoric,
boring and
much too long.

The Poe Museum
1914 East Main Street. 648-5523.

TILL DEATH DO US PART /
EXPENSIVE CHINA /
DIVORCE RATE
24 / 17
ART DIRECTION
Perry Hack
DESIGN
Perry Hack
COPYWRITING
David Bromberg
AGENCY
Dolphin Friendly
Advertising
CLIENT
Meltzer and Kanzer
ENTRANT LOCATION
New York, NY

NOT TOO POPULAR /
1, 2, 3, 4 HOURS /
SMALL APARTMENT
24 / 18
ART DIRECTION
Angelo Juliano,
Kevin Samuels
COPYWRITING
Terry Congrove
PHOTOGRAPHY
Beth Canzano /
Chicago
AGENCY
DDB Needham
Chicago
CLIENT
Anheuser Busch /
Bud Light
ENTRANT LOCATION
Chicago, IL

Small Apartment?

You'll find that the eight-ounce can of Bud Light is very versatile.
It doesn't just fit any size living space. It fits any occasion as well.

Just how long would you like your friends to stick around?

☐ 1 Hour ☐ 2 Hours

☐ 3 Hours ☐ 4 Hours

You'd better make sure you have the right amount of Bud Light
at your next party. Because once it runs out, so will your guests.

When you're having a party.

When you're having a party but aren't too popular.

Get a Bud Light Draft Ball for your next small get-together.
But don't be surprised if it turns into a large get-together.

For the hand that's not operating the remote control.

Tonight, sit down with an ice cold can of Bud Light. It goes perfectly with a few hundred of your favorite TV stations.

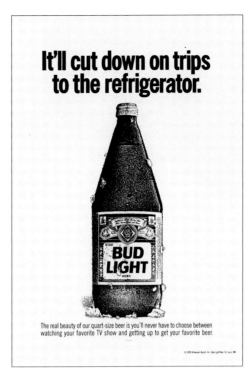

It'll cut down on trips to the refrigerator.

The real beauty of our quart-size beer is you'll never have to choose between watching your favorite TV show and getting up to get your favorite beer.

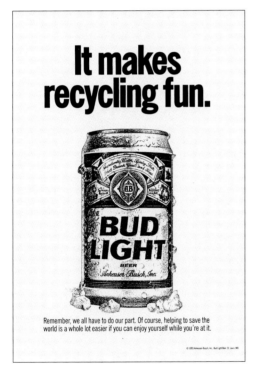

It makes recycling fun.

Remember, we all have to do our part. Of course, helping to save the world is a whole lot easier if you can enjoy yourself while you're at it.

RECYCLING FUN / TRIPS TO THE FRIDGE / REMOTE CONTROL
24 / 19

ART DIRECTION
Angelo Juliano,
Kevin Samuels

COPYWRITING
Ted Xistris,
Anne Coyle,
Terry Cosgrole

PHOTOGRAPHY
Beth Canzano

AGENCY
DDB Needham
Chicago

CLIENT
Anheuser Busch /
Bud Light

ENTRANT LOCATION
Chicago, IL

143

ALL CARS. NOW $29.95./
ALL COMPUTERS. NOW
$29.95./ALL BOATS. NOW
$29.95
24 / 20
ART DIRECTION
David Swartz,
Alex Bogusky
COPYWRITING
Kim Genkinger,
Chuck Porter
PHOTOGRAPHY
Philip - Jon
AGENCY
Crispin & Porter
CLIENT
The Miami Herald
ENTRANT LOCATION
Miami, FL

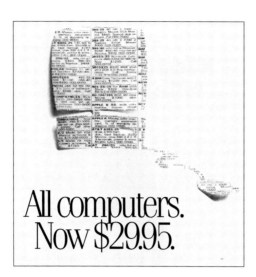

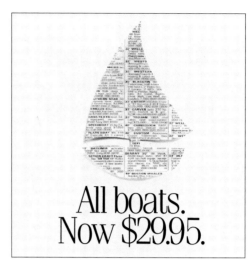

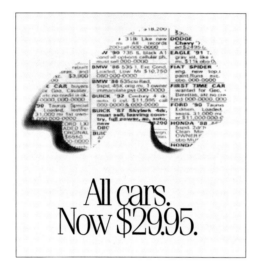

BOOM!

And that's all folks, everything goes bye-bye, and you're talking about me subscribing for a year? As if we'll be around NEXT WEEK. You think it's just, Clinton's in...Peace On Earth? Don't you read your own headlines? On the surface, sure, everything's sweet, but two hundred feet below ground there's some kid named Kevin trying to figure out the nuclear disarmament instructions, "Was it cut the red wire, twist the black or was it twist the red..." Face it, it's out with Cold War, in with the planet where half wolf/half human children roam the land. I mean, I don't want to bum anybody out or anything, but, whoa.

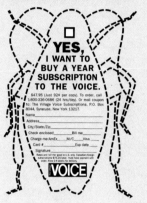

☐ **YES,**
I WANT TO
BUY A YEAR
SUBSCRIPTION
TO THE VOICE.

$47.95 (just 92¢ per copy). To order, call 1-800-336-0686 (24 hrs/day). Or mail coupon to: The Village Voice Subscriptions, P.O. Box 8044, Syracuse, New York 13217.

Name_____
Address_____
City/State/Zip_____
Check enclosed_____Bill me_____
Charge me:AmEx____M/C___Visa
Card #_____Exp date____
Signature_____
Rates and 'toll me' good in U.S. only. Canadian/foreign subscriptions $79.20/year, must have payment with order. Allow 2-4 weeks for delivery.

VOICE

(GULP)

You want me to commit to you for an entire year? I mean, we're talking big "S" subscription here. I don't understand why we can't just keep things the way they are. If I'm in a "Voice" mood, I pick up an issue. Why do you want to start complicating things, don't you trust me? This is a very serious step, I don't think we should just rush into it. I mean, I just got out of a really long subscription with National Geographic and it's been really hard for me. Maybe I just need a little space, a little time to myself, not tied down to any one paper. I just want what's best for both of us. Look, why don't we just stay really, really good friends?

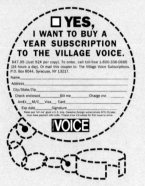

☐**YES,**
I WANT TO BUY A
YEAR SUBSCRIPTION
TO THE VILLAGE VOICE.

$47.95 (Just 92¢ per copy). To order, call toll-free 1-800-336-0686 (24 hours a day). Or mail this coupon to: The Village Voice Subscriptions, P.O. Box 8044, Syracuse, NY 13217.

Name_____
Address_____
City/State/Zip____
Check enclosed_____Bill me_____Charge me___
AmEx___M/C___Visa __ Card___
Exp date_____Signature_____
Rates and toll me' good in U.S. only. Canadian/foreign subscriptions $79.30/year, must have payment with order. Please allow 2-4 weeks for first issue to arrive.

VOICE

#31070

subscription holder, reporting for duty! Is that what you want, for me to become another faceless entity that you can anonymously slip your paper to? Maybe I'm an antique, but I don't mind going down to a real newsstand, paying with real money, flashing a real smile, and heck, maybe even slipping in a "Thanks, 'preciate it." What human contact do we have left? Computo-bank tellers, TV diplomas, "Personalized" bulk mail, blow-up dolls, push "1" for this - push "2" for that. How 'bout I come down there, push "3" and blow your whole operation to bits? Listen here, you... you...personality leeches, I'm a real person! I have a name. I am not, I repeat, NOT, a credit card number!

☐ **YES,** I WANT TO BUY
A ONE YEAR SUBSCRIPTION
TO THE VILLAGE VOICE.

$47.95 (92¢ per copy). To order, call 1-800-336-0686 (24 hrs/day). Or mail coupon to: The Village Voice Subscriptions, P.O. Box 8044, Syracuse, NY 13217.

Name_____
Address_____
City/State/Zip_____
Check enclosed_____Bill me_____Charge me_____
AmEx___M/C___Visa __ Card #_____Exp date_____
Signature_____
Rates and 'toll me' good in U.S. only. Canadian/foreign subscriptions $79.20/year, must have payment with order. Allow 2-4 weeks for delivery.

VOICE

0 17805 66604 2

Puleez!

I subscribe and I might as well come tap dancing out of the closet wearing leather chaps and a fuzzy, hot-pink jock-strap! Hullo...Earth to Voice...my parents know I don't care about politics, they know I'm not an animal rights activist, and they darn well know I couldn't give a flying nun about urban infra-structure. Do you think they'll just assume I read your paper for that silly sports page? NO, I AM NOT BEING PARANOID! Look, I pick up an occasional copy and the old man figures, "Eh, the kid's going to the movies or some music crapola." (What he doesn't know won't hurt me.) But c'mon, fifty-two copies a year, hand-delivered to my house, my name branded across the cover? Pardon me, while I take this moment to measure up my parents for matching beds in the cardiac ward. Oh great, now I've really done it. You're hurt, aren't you?

☐
YES,
I WANT TO
BUY A YEAR
SUBSCRIPTION.

$47.95 (Just 92¢ /copy). Call 1-800-336-0686 (24 hours a day). Or mail this coupon to: The Village Voice Subscriptions, P.O.Box 8044, Syracuse, NY 13217.
Name_____City/State/Zip_____
Address_____
Check enclosed__Bill me__Charge me__AmEx__M/C__Visa
Card_____Exp date_____
Signature_____

VOICE

GULP / #31070 / BOOM! /
PULEZZ
24 / 21
ART DIRECTION
Scott Bailey
COPYWRITING
Mikal Reich
AGENCY
Mad Dogs &
Englishmen
CLIENT
Village Voice
ENTRANT LOCATION
New York, NY

DEJA VU NIGHT CLUBS -
NUDE SHOWGIRLS
24 / 22
ART DIRECTION
Carolyn Tye McGeorge
COPYWRITING
Raymond McKinney
PRODUCTION
Jenny Schoenherr
AGENCY
Newt & Partners
CLIENT
Deja Vu Night Clubs
ENTRANT LOCATION
Richmond, VA

Some People
Were Born
With A
Silver Spoon.
I Got A Fork.

Ron DePuy
Piano Tuning and Repair
619·225·1841

Six Months
Of Practice
And No
Improvement.
Maybe
It's Not You.

Ron DePuy
Piano Tuning and Repair
619·225·1841

If You Haven't
Had Your
Piano Tuned
In 6 Months,
You Have
Two Choices.

1.

2.

Ron DePuy
Piano Tuning and Repair
619·225·1841

I'll Do
Anything
For A
Grand.

Ron DePuy
Piano Tuning and Repair
619·225·1841

**I'LL DO ANYTHING / IF
YOU HAVEN'T / SOME
PEOPLE / SIX MONTHS**
24 / 23
ART DIRECTION
Jillian Stern
COPYWRITING
Kirt Gentry
AGENCY
Salvati Montgomery
Sakoda
CLIENT
Ron DePuy
Piano Tuning
ENTRANT LOCATION
Costa Mesa, CA

MD-11
24 / 19, 17, 18
SILVER
ART DIRECTION
Hiromasa Kisso
DESIGN
Norihiko Miyamoto,
Eiji Tsukamoto
COPYWRITING
Atsushi Hamada
PHOTOGRAPHY
Hideki Sato
AGENCY
Crosscom, Inc.
CLIENT
Swiss Air Transport
Co., Ltd.
ENTRANT LOCATION
Tokyo, Japan

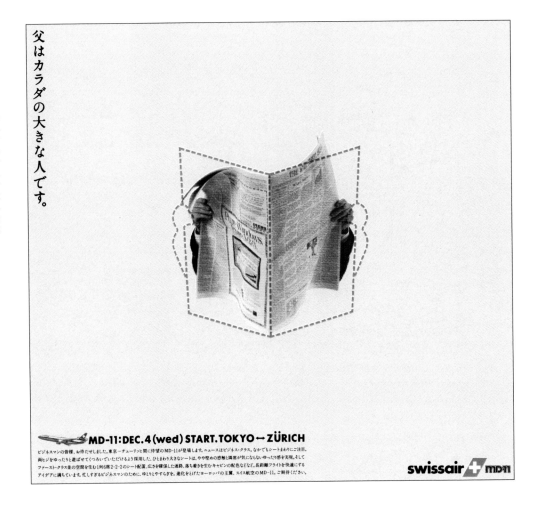

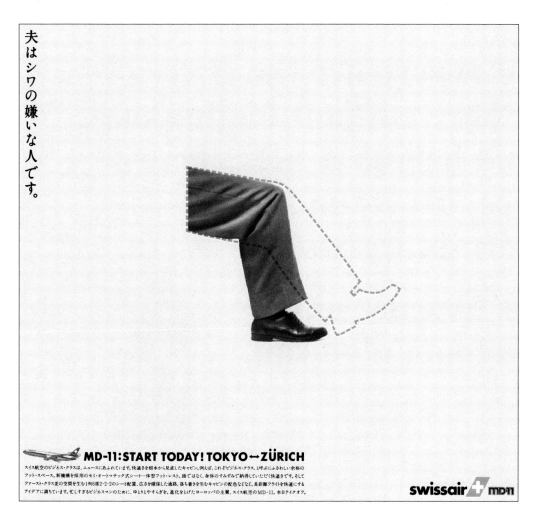

夫はシワの嫌いな人です。

MD-11: START TODAY! TOKYO↔ZÜRICH

swissair ✈ MD-11

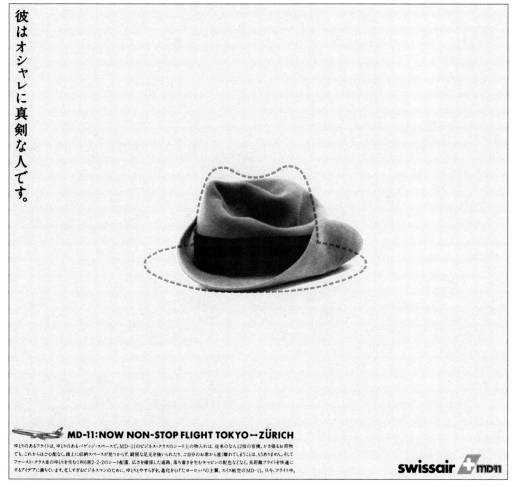

彼はオシャレに真剣な人です。

MD-11: NOW NON-STOP FLIGHT TOKYO↔ZÜRICH

swissair ✈ MD-11

To experience the effect of our beer without buying one, stand behind a policeman's horse, lift its tail, and insert an ice-cube.

In absence of horse, policeman also can.

12% alcohol, and available soon in selected bars with nice comfortable floors. X.O. Beer. Take it lying down.

POLICEMAN / ROAD
SAFETY / WET SAND
24 / 34
SILVER
ART DIRECTION
Neil French
DESIGN
Neil French
COPYWRITING
Neil French
PHOTOGRAPHY
Han Chew
PUBLICATION
Straits Times Group
CLIENT
Singapore Press
Holdings
ENTRANT LOCATION
Singapore

As our contribution to road safety, may we point out that drinkers of our beer will never drink and drive, because after three nobody ever remembers where they parked the car.

12% alcohol, and available soon in selected bars with nice comfortable floors. X.O Beer. Take it lying down.

Like being struck behind the ear with a sockful of wet sand, only nicer. Slightly.

X.O Beer. 12% alcohol, and best taken lying down. Available soon in bars with nice, comfortable floors.

COOKING SEMINAR FOR
KIDS
24 / 1
ART DIRECTION
Kazuta Sakurai
DESIGN
Hiroe Shimizu
COPYWRITING
Sachiko Soh
PHOTOGRAPHY
Seiya Higuchi
PRODUCTION
Takaaki Matsuoka
AGENCY
I & S Corporation
PUBLICATION
Newspaper
CLIENT
Q.P. Corporation
ENTRANT LOCATION
Tokyo, Japan

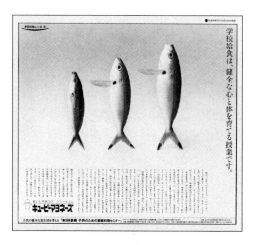

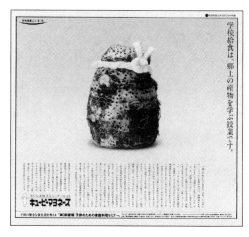

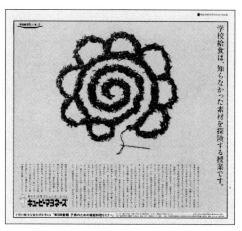

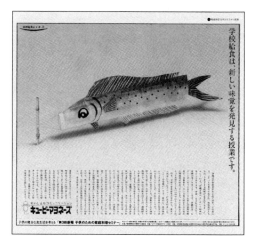

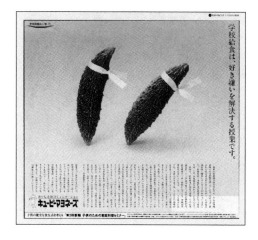

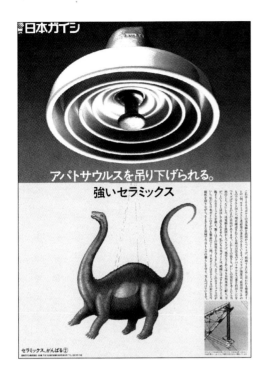

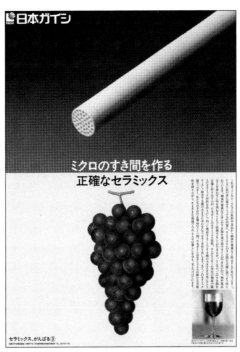

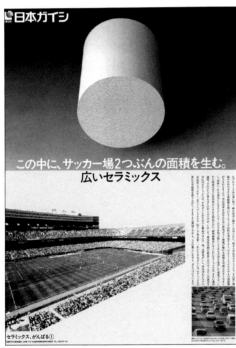

(UNTITLED)
24 / 2, 3, 4
ART DIRECTION
Iwao Matsuura
DESIGN
Koji Seino
COPYWRITING
Yoshihiro Iwanaga,
Soushiro Nishiyama,
Takuya T. Fujimura
CREATIVE DIRECTION
Yoshihiro Iwanaga
PHOTOGRAPHY
Hiromichi Ide
ILLUSTRATION
Nobuyoshi Matsui
AGENCY
Nikkei Advertising Co.
Ltd.
CLIENT
NGK Insulators, Ltd.
ENTRANT LOCATION
Tokyo, Japan

SPICES
24 / 10
ART DIRECTION
Ng Heok Seong
COPYWRITING
Ted Lim
PHOTOGRAPHY
Pashe Studio
AGENCY
Naga DDB Needham
CLIENT
Concorde Hotel,
Kuala Lumpur
ENTRANT LOCATION
Selangor, Malaysia

"AN ASIAN RESTAURANT SO DIFFERENT, DINNER BEGINS WITH ANTIQUE CLOCKS, DUTCH LAMPS AND A RICKSHAW." Rare objets d'art collected from around the region. Or what we call, "food for the imagination." The kind you feast your eyes on before you feed your appetite. And a most appropriate prelude, we might add, to the fine selection of authentic Asian cuisine that is to follow.

"A PLACE WHERE PEOPLE IN GUCCIS AND ARMANIS CAN EAT OUT OF A CAN AND NOT FEEL OUT OF PLACE." Unconventional as it may sound, it is quite common to see the well-heeled do the uncommon at Spices. Like having lunch out of a tiffin carrier - the way the sahibs used to do in India. Maybe it's the authentic Asian food. Or the classic 1920's ambience. Or both. For how else could you explain the way people in haute couture take to our hot cuisine?

"PRINCES, AMBASSADORS, STATESMEN, DIPLOMATS. SOME DAYS, IT'S LIKE THE UNITED NATIONS." They would come in their expensive cars and chauffeur-driven limousines. Some to enjoy the fine Asian cuisine. Others, the classic 1920's ambience. Yet, there are those who come to see. And to be seen. But whatever the reason, these days, anybody who is anybody is meeting up with somebody at Spices.

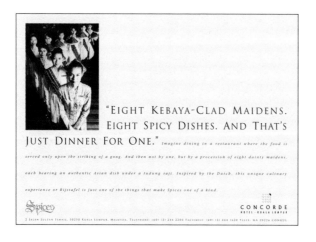

"EIGHT KEBAYA-CLAD MAIDENS. EIGHT SPICY DISHES. AND THAT'S JUST DINNER FOR ONE." Imagine dining in a restaurant where the food is served only upon the striking of a gong. And then not by one, but by a procession of eight dainty maidens, each bearing an authentic Asian dish under a tudung saji. Inspired by the Dutch, this unique culinary experience or Rijstafel is just one of the things that make Spices one of a kind.

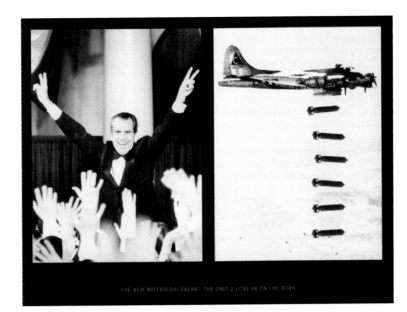

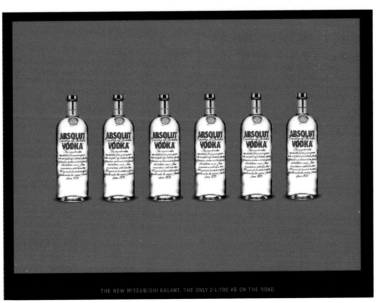

THE NEW MITSUBISHI GALANT / VIVVVVIAN / ABSOLUT VODKA / CLOCKS / RABBIT
24 / 5, 6, 7, 8, 9
ART DIRECTION
Theseus Chan
COPYWRITING
Jim Aitchison
PHOTOGRAPHY
Archive Photo, New York
ILLUSTATION
Theseus Chan
AGENCY
Euro RSCG Ball Partnership
CLIENT
Cycle & Carriage/ Mitsubishi
ENTRANT LOCATION
Singapore

155

PENFOLDS
24 / 11
ART DIRECTION
Tony Wong-Hee
COPYWRITING
Tony Wong-Hee
ILLUSTRATION
Tony Wong-Hee
AGENCY
DDB Needham Sydney
CLIENT
Penfolds Wine Group
ENTRANT LOCATION
North Sydney, Australia

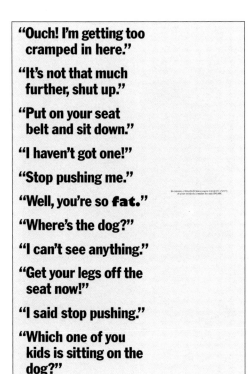

"Ouch! I'm getting too
cramped in here."

"It's not that much
further, shut up."

"Put on your seat
belt and sit down."

"I haven't got one!"

"Stop pushing me."

"Well, you're so **fat**."

"Where's the dog?"

"I can't see anything."

"Get your legs off the
seat now!"

"I said stop pushing."

"Which one of you
kids is sitting on the
dog?"

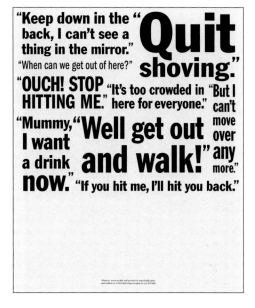

QUIT SHOVING / AI YAH /
FAT
24 / 12
ART DIRECTION
Jim Aitchison,
Grover Tham,
Andy Clarke
COPYWRITING
Jim Aitchison
AGENCY
Euro RSCG Ball
Partnership
CLIENT
Cycle & Carriage/
Mitsubishi
ENTRANT LOCATION
Singapore

A CAMPAIGN FOR THE
RESTYLED...
24 / 14, 13, 15, 16
ART DIRECTION
Lars Nordh
COPYWRITING
Goran Rahm,
Stefan Lindholm
PHOTOGRAPHY
Suzanna Lackman
AGENCY
Arnek Annonsbyra
CLIENT
Ostgota
Correspondenten
ENTRANT LOCATION
Linkoping, Sweden

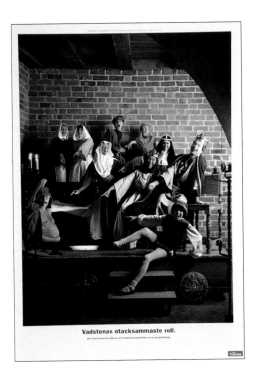

Vadstenas otacksammaste roll.

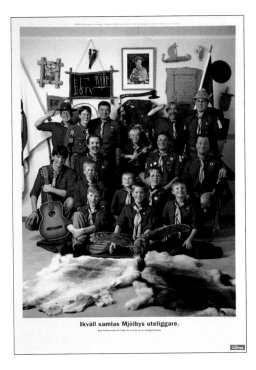

Ikväll samlas Mjölbys uteliggare.

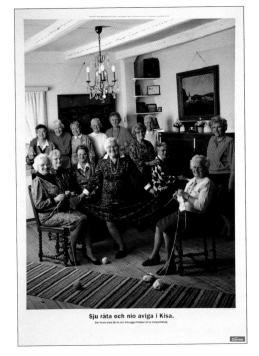

Sju räta och nio aviga i Kisa.

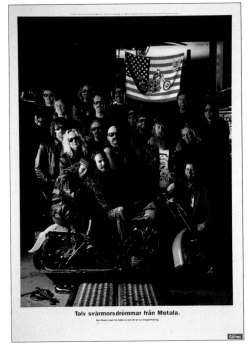

Tolv svärmorsdrömmar från Motala.

AS YOU CAN SEE, THE NEW GE WHITE-ON-WHITE FRIDGE LOOKS ELEGANT FROM ANY ANGLE.

INTRODUCING THE NEW RANGE OF GE WHITE-ON-WHITE FRIDGES.

THE NEW GE WHITE-ON-WHITE FRIDGES
ARE AVAILABLE IN THE RANGE OF COLOURS SHOWN BELOW.

**AS YOU CAN SEE /
INTRODUCING / THE NEW
GE**
24 / 20, 21, 22
ART DIRECTION
Kins Lee
DESIGN
Kins Lee
COPYWRITING
Janet Lee
CREATIVE DIRECTION
Neil French
ILLUSTRATION
Hau Theng Hui,
Patrick Fong
PRODUCTION
David Lee
STUDIO
Spider
ACCOUNT DIRECTION
TL Yeap, Peter Gan
CLIENT
Fimaco Sdn Bhd
ENTRANT LOCATION
Kuala Lumpur, Malaysia

VIP DESIGNER
24 / 23
ART DIRECTION
Ravi Deshpande,
Abhijit Gune
DESIGN
Abhijit Gune
COPYWRITING
Raj Kaushal
CREATIVE DIRECTION
Ravi Deshpande
PHOTOGRAPHY
Ashok Salian
AGENCY
Contract Advertising
(India) Limited
CLIENT
Maxwell Apparel
Industries Ltd.
ENTRANT LOCATION
Bombay, India

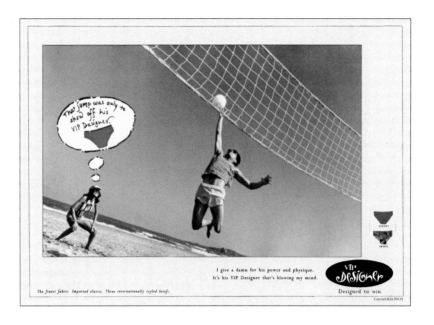

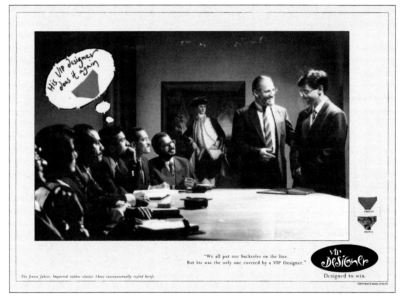

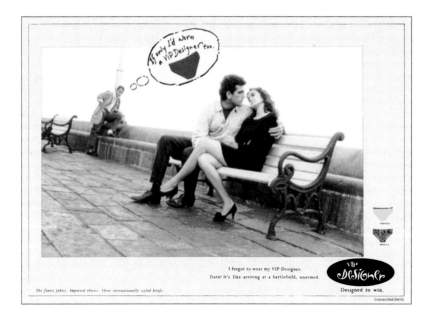

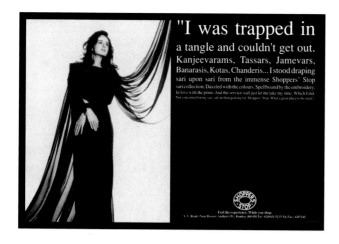

"I was trapped in a tangle and couldn't get out. Kanjeevarams, Tassars, Jamevars, Banarasis, Kotas, Chanderis... I stood draping sari upon sari from the immense Shoppers' Stop sari collection. Dazzled with the colours. Spellbound by the embroidery. In love with the prints. And the service staff just let me take my time. Which I did. Not concerned for my car, safe in their parking lot. Shoppers' Stop. What a great place to be stuck!"

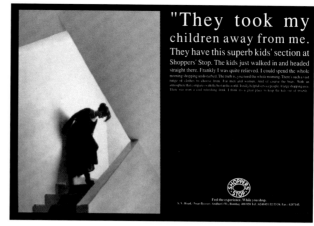

"They took my children away from me. They have this superb kids' section at Shoppers' Stop. The kids just walked in and headed straight there. Frankly I was quite relieved. I could spend the whole morning shopping undisturbed. The truth is, you need the whole morning. There's such a vast range of clothes to choose from. For men and women. And of course the bags. With an atmosphere that conjures a childhood in the world. Totally helpful service people. A large shopping area. There was even a cool refreshing drink. I think it's a great place to keep the kids out of trouble.

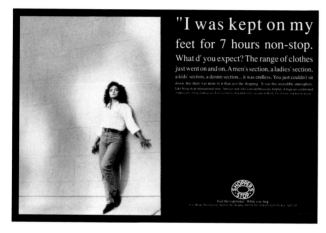

"I was kept on my feet for 7 hours non-stop. What d' you expect? The range of clothes just went on and on. A men's section, a ladies' section, a kids' section, a denim section... it was endless. You just couldn't sit down. But there was more to it than just the shopping. It was this incredible atmosphere. Like being in an international store. Service staff who were unobtrusively helpful. A huge air-conditioned shopping area. Ample parking space. I can understand why this place is so chic. Really, I wish every shop was as chic!"

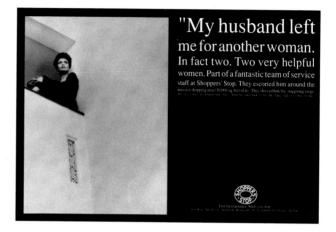

"My husband left me for another woman. In fact two. Two very helpful women. Part of a fantastic team of service staff at Shoppers' Stop. They escorted him around the massive shopping area (30,000 sq. feet of it). They showed him the staggering range. But by the time he was back in my life, baby, I was hooked. Now you know the rest of the story."

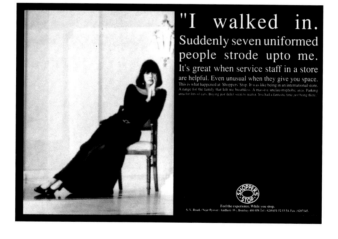

"I walked in. Suddenly seven uniformed people strode upto me. It's great when service staff in a store are helpful. Even unusual when they give you space. This is what happened at Shoppers' Stop. It was like being in an international store. A range for the family that left me breathless. A massive unclaustrophobic area. Parking area for lots of cars. Buying just didn't seem to matter. You had a fantastic time just being there.

SHOPPERS' STOP
24 / 24

ART DIRECTION
Prashant Godbole

DESIGN
Prashant Godbole

COPYWRITING
Rahul Da Cunha,
Shibani Bathija

PHOTOGRAPHY
Rafique Sayed

AGENCY
Contract Advertising
(India) Limited

CLIENT
Shopper's Stop

ENTRANT LOCATION
Bombay, India

161

CLASS C MERCEDES-BENZ
24 / 25, 26, 27, 28, 29
ART DIRECTION
Giorgio Bramante
COPYWRITING
Licia Sideri
DIRECTION
Dirk May
AGENCY
Lintas
CLIENT
Mercedes-Benz
SPA C Class
ENTRANT LOCATION
Milan, Italy

Ti ricordi
il giorno in cui
ti sei stufato
delle
promesse?

Classe C Mercedes-Benz,
dal 18 Giugno.
Un giorno da ricordare.

Ti ricordi
il giorno in cui
hai capito
che eri nato
per volare?

Classe C Mercedes-Benz,
dal 18 Giugno.
Un giorno da ricordare.

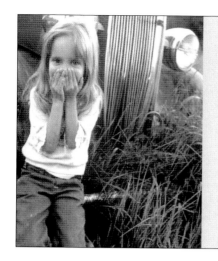

Ti ricordi
il giorno in cui
hai scoperto
come le rane
fanno l'amore?

Classe C Mercedes-Benz,
dal 18 Giugno.
Un giorno da ricordare.

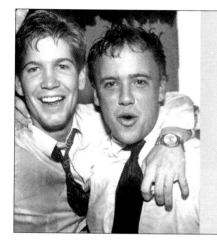

Ti ricordi
il giorno in cui
hai imparato che
dovevi avere
più cura
dei tuoi soldi?

Classe C Mercedes-Benz,
dal 18 Giugno.
Un giorno da ricordare.

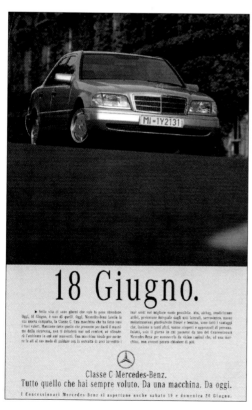

18 Giugno.

Classe C Mercedes-Benz.
Tutto quello che hai sempre voluto. Da una macchina. Da oggi.

THIS WAY UP / MUG ON
SIDE / BODIES
24 / 30
ART DIRECTION
Neil French
DESIGN
Neil French
COPYWRITING
Neil French
PHOTOGRAPHY
Han Chew
CLIENT
Singapore Press
Holdings
ENTRANT LOCATION
Singapore

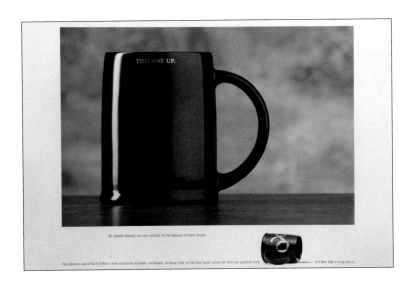

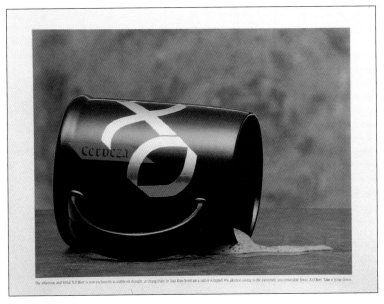

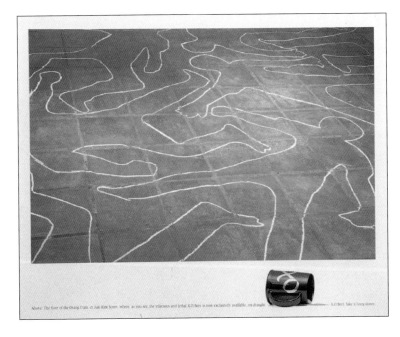

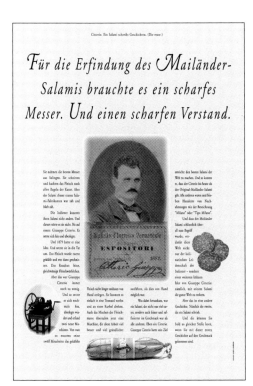

Citterio. Ein Salami schreibt Geschichten. (Die erste.)

Für die Erfindung des Mailänder-Salamis brauchte es ein scharfes Messer. Und einen scharfen Verstand.

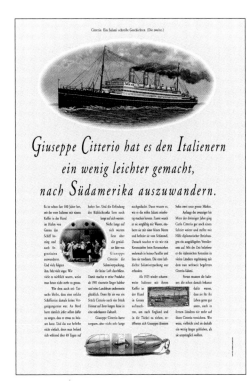

Citterio. Ein Salami schreibt Geschichten. (Die zweite.)

Giuseppe Citterio hat es den Italienern ein wenig leichter gemacht, nach Südamerika auszuwandern.

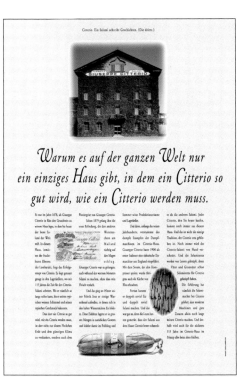

Citterio. Ein Salami schreibt Geschichten. (Die dritte.)

Warum es auf der ganzen Welt nur ein einziges Haus gibt, in dem ein Citterio so gut wird, wie ein Citterio werden muss.

WARUM ES AUF DER GANZEN ...
24 / 35
ART DIRECTION
Alvaro Maggini
COPYWRITING
John Leuppi
AGENCY
Advico Young & Rubicam
CLIENT
Giuseppe Citterio S.p.A
ENTRANT LOCATION
Zurich, Switzerland

FEET / FINGER / FACES /
FLOORS / CUSHION
24 / 33
ART DIRECTION
Neil French
DESIGN
Neil French
COPYWRITING
Neil French
PHOTOGRAPHY
Han Chew
CLIENT
Singapore Press
Holdings
ENTRANT LOCATION
Singapore

COMPLIMENTS LIKE THIS
WOULD MAKE YOU
BLUSH, TOO
25 / 1
ART DIRECTION
David Burger
COPYWRITING
David Wojdyla
PHOTOGRAPHY
Lamb & Hall
AGENCY
Ammirati & Puris
CLIENT
UPS
ENTRANT LOCATION
Ridgewood, NJ

BARKING UP WRONG TREE / SPILT MILK / DON'T COUN'T YOUR / BURN YOUR BRIDGES / LOOK BEFORE YOU LEAP
25 / 1
ART DIRECTION
Theseus Chan
COPYWRITING
Jim Aitchison
ILLUSTRATION
Francis Tan
AGENCY
Euro RSCG Ball Partnership
CLIENT
Hong Kong Bank
ENTRANT LOCATION
Singapore

FRIHETEN HANDLE NAR
DET PASSER DE
26 / I
ART DIRECTION
Andre' van Ingelgem
COPYWRITING
Tore Knudsen
PHOTOGRAPHY
G. B Allessandri
AGENCY
Publicis FCB
CLIENT
Norske Shell
ENTRANT LOCATION
Oslo, Norway

NOW, THE WORST
THINGS IN LIFE ARE FREE.
26 / 2
ART DIRECTION
Warren Bott
COPYWRITING
John Sampson
AGENCY
DMB&B New Zealand
CLIENT
NZI Insurance
ENTRANT LOCATION
Auckland, NZ

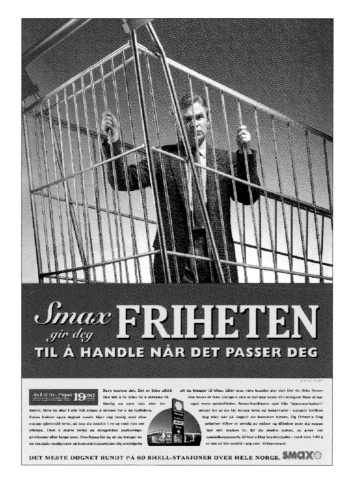

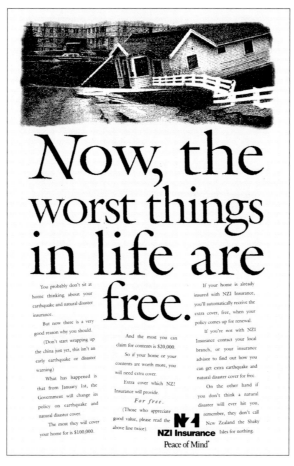

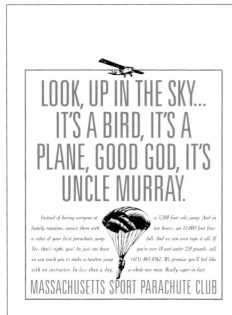

LOOK, UP IN THE SKY...
IT'S A BIRD, IT'S A
PLANE, GOOD GOD, IT'S
UNCLE MURRAY.

Instead of boring everyone at family reunions, amaze them with a video of your first parachute jump. Yes, that's right, you! In just one hour, we can teach you to make a tandem jump with an instructor. In less than a day, a 3,200 foot solo jump. And in ten hours, an 11,000 foot freefall. And we can even tape it all. If you're over 18 and under 220 pounds, call (413) 863-8362. We promise you'll feel like a whole new man. Really super in fact.

MASSACHUSETTS SPORT PARACHUTE CLUB

HOW HARD
CAN SKYDIVING BE?
AFTER ALL, THERE'S ONLY
ONE STEP INVOLVED.

In fact, skydiving is as easy as rolling off a log. Several thousand feet high. But if you want to learn, we can teach you. And stay with you every step of the way. Our licensed jumpmasters can take you on a tandem jump in less than an hour. A 3,200 foot solo jump in a day. Or an 11,000 foot freefall with just ten hours instruction. If you're interested, the first step is simply to call us at (413) 863-8362. The rest is all downhill.

MASSACHUSETTS SPORT PARACHUTE CLUB

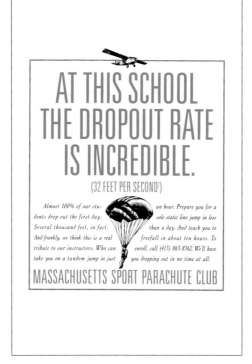

AT THIS SCHOOL
THE DROPOUT RATE
IS INCREDIBLE.
(32 FEET PER SECOND²)

Almost 100% of our students drop out the first day. Several thousand feet, in fact. And frankly, we think this is a real tribute to our instructors. Who can take you on a tandem jump in just an hour. Prepare you for a solo static line jump in less than a day. And teach you to freefall in about ten hours. To enroll, call (413) 863-8362. We'll have you dropping out in no time at all.

MASSACHUSETTS SPORT PARACHUTE CLUB

AT THIS SCHOOL THE DROPOUT RATE IS INCREDIBLE / HOW HARD CAN SKYDIVING BE? / LOOK UP IN THE SKY...
27 / 1

ART DIRECTION
Brian Fandetti
DESIGN
Brian Fandetti
COPYWRITING
Al Lowe
ILLUSTRATION
John Burgoyne
CLIENT
Massachusetts Sport Parachute Club
ENTRANT LOCATION
Boston, MA

AN EGG, A COW, AND A CANDLE
27 / I
ART DIRECTION
Siemen van der Hoek
COPYWRITING
Edward van Tilburg
PHOTOGRAPHY
Martin Woods
AGENCY
N & W/ Leo Burnett
CLIENT
United Airlines
ENTRANT LOCATION
Amsterdam,
Netherlands

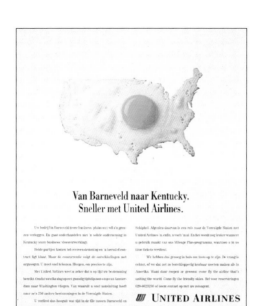

Van Barneveld naar Kentucky.
Sneller met United Airlines.

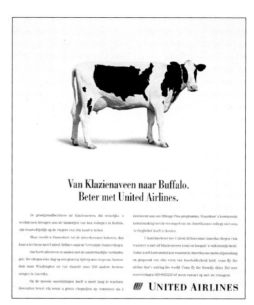

Van Klazienaveen naar Buffalo.
Beter met United Airlines.

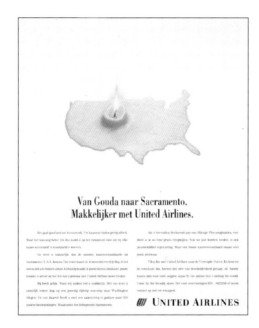

Van Gouda naar Sacramento.
Makkelijker met United Airlines.

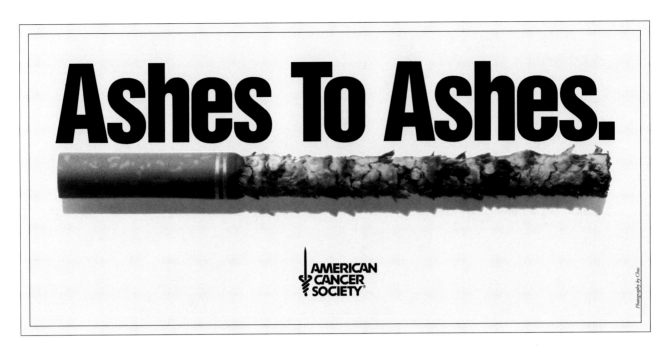

ASHES TO ASHES
28 / 1
ART DIRECTION
Irby Heaton
COPYWRITING
Chris Jacobs
CLIENT
American Cancer
Society
ENTRANT LOCATION
Atlanta, GA

CHRISTMAS WITHOUT
HUNGER
30 / 1
ART DIRECTION
Tomas Lorente
COPYWRITING
Nizan Guanaes
PHOTOGRAPHY
Cassio Vasconcellos
ILLUSTRATION
Brasilio Matsumoto
PRODUCTION
Anelito Nobrega
AGENCY
DM9 Publicidade
CLIENT
Movement of
Citizenhood Against
Misery
ENTRANT LOCATION
Sao Paulo, Brazil

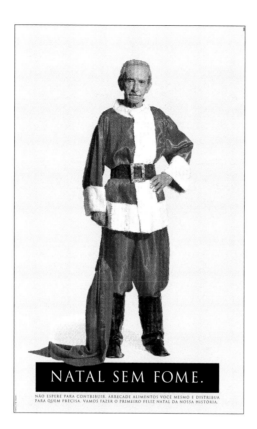

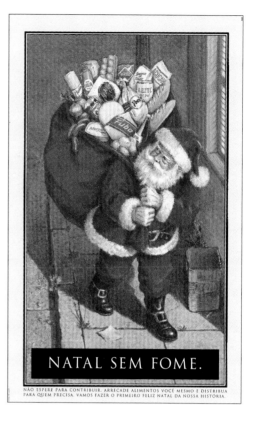

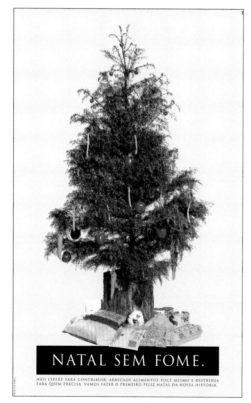

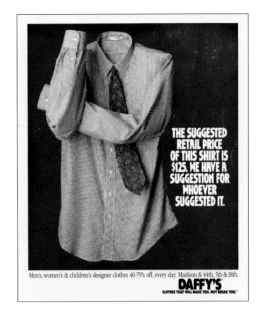

THE SUGGESTED RETAIL PRICE OF THIS SHIRT IS $125. WE HAVE A SUGGESTION FOR WHOEVER SUGGESTED IT.

Men's, women's & children's designer clothes 40-75% off, every day. Madison & 44th, 5th & 18th.

DAFFY'S
CLOTHES THAT WILL MAKE YOU, NOT BREAK YOU.™

HAUTE COUTURE. NOW EASIER TO BUY THAN SAY.

At Daffy's, you'll find high fashion but you won't find high prices. All of our men's, women's & children's fashion & designer clothing is 40-75% off, every day.

DAFFY'S
CLOTHES THAT WILL MAKE YOU, NOT BREAK YOU.™

DESIGNER CLOTHING FOR PEOPLE BORN WITH PLASTIC SPOONS IN THEIR MOUTHS.

You don't need a trust fund to shop at Daffy's. That's because all of our men's, women's and children's fashion and designer clothing is 40-75% off, every day.

DAFFY'S
CLOTHES THAT WILL MAKE YOU, NOT BREAK YOU.™

SUGGESTION
31 / 1
ART DIRECTION
Sal DeVito
COPYWRITING
David Bromberg,
Audrey DeVries
CREATIVE DIRECTION
Sal DeVito
PHOTOGRAPHY
Cailor / Resnick
AGENCY
DeVito / Verdi
CLIENT
Daffy's
ENTRANT LOCATION
New York, NY

HAUTE COUTURE
31 / 2
ART DIRECTION
Pat Sutherland
COPYWRITING
Pat Sutherland,
Tom Gianfagna
CREATIVE DIRECTION
Sal DeVito
AGENCY
DeVito / Verdi
CLIENT
Daffy's
ENTRANT LOCATION
New York, NY

SPOONS
31 / 3
ART DIRECTION
Abi Aron
COPYWRITING
Rob Carducci,
Joel Clement,
Abi Aron
CREATIVE DIRECTION
Sal DeVito
AGENCY
DeVito / Verdi
CLIENT
Daffy's
ENTRANT LOCATION
New York, NY

CACHET
31 / 4
ART DIRECTION
Cheri Soukup
COPYWRITING
Cheri Soukup
CREATIVE DIRECTION
Sal DeVito
AGENCY
DeVito / Verdi
CLIENT
Daffy's
ENTRANT LOCATION
New York, NY

PLANE
31 / 5
ART DIRECTION
Rob Carducci,
Abi Aron
COPYWRITING
Abi Aron,
Rob Carducci
CREATIVE DIRECTION
Sal DeVito
AGENCY
DeVito / Verdi
CLIENT
Daffy's
ENTRANT LOCATION
New York, NY

UNLIMITED
31 / 6
ART DIRECTION
Frank Fusco,
Mark Schruntek
COPYWRITING
Mark Schruntek,
Frank Fusco
CREATIVE DIRECTION
Sal DeVito
AGENCY
DeVito / Verdi
CLIENT
Daffy's
ENTRANT LOCATION
New York, NY

DESIGNER CLOTHES FOR PEOPLE WITH MORE CACHET THAN CASH.

So sashay your cachet into Daffy's for men's, women's & children's fashion & designer clothes 40-75% off, every day. Now open on Manhasset's Miracle Mile.

DAFFY'S
CLOTHES THAT WILL MAKE YOU, NOT BREAK YOU.

EUROPEAN FASHIONS PRICED LIKE THEY FELL OFF THE BACK OF A PLANE.

Men's, women's & children's fashion & designer clothes 40-75% off, every day. Look for a Daffy's opening this fall on Manhasset's Miracle Mile in Long Island.

DAFFY'S
CLOTHES THAT WILL MAKE YOU, NOT BREAK YOU.

DESIGNER CLOTHES 40-75% OFF. FOR AN UNLIMITED TIME ONLY.

It's a once in a lifetime offer that will last a lifetime. At Daffy's, all of our men's, women's & children's fashion & designer clothing is 40-75% off, every day.

DAFFY'S
CLOTHES THAT WILL MAKE YOU, NOT BREAK YOU.

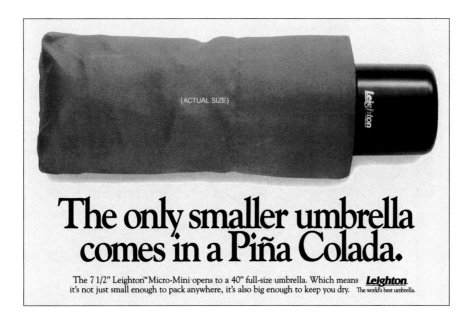

(ACTUAL SIZE)

The only smaller umbrella comes in a Piña Colada.

The 7 1/2" Leighton™ Micro-Mini opens to a 40" full-size umbrella. Which means **Leighton.** it's not just small enough to pack anywhere, it's also big enough to keep you dry. The world's best umbrella.

**THE ONLY SMALLER
UMBRELLA COMES IN A
PINA COLADA**
31 / 7
ART DIRECTION
John Follis
DESIGN
John Follis
COPYWRITING
John Follis
PHOTOGRAPHY
Jeff Wolfson
AGENCY
Follis Advertising
CLIENT
Futai, USA
ENTRANT LOCATION
New York, NY

DR. JEKYLL AND MR. HYDE
31 / 1, 2
ART DIRECTION
Satoji Kashimoto
DESIGN
Takeshi Nakajima
COPYWRITING
Shinji Fujita
ILLUSTRATION
Minoru Tachibana,
Fujio Akatuka,
Ichiro Maeno
STUDIO
Recruit Co. Ltd.
CLIENT
Japan Tobacco, Inc.
ENTRANT LOCATION
Tokyo, Japan

BASICALLY
32 / 17
SILVER
ART DIRECTION
John Doyle
DESIGN
John Doyle, Charles Bischof
COPYWRITING
Ernie Schenck
PHOTOGRAPHY
Sigurgeir Sigurjónsson / Hashi
ILLUSTRATION
Peter Hall
AGENCY
Doyle Advertising and Design Group
CLIENT
AKVA Spring Water
ENTRANT LOCATION
Boston, MA

BALD AND TOOTHLESS
32 / 18
DISTINCTIVE MERIT
ART DIRECTION
Carolyn McGeorge
COPYWRITING
Joe Alexander
PHOTOGRAPHY
Dublin Productions
PRODUCTION
Jenny Schoenherr
AGENCY
The Martin Agency
CLIENT
Healthtex, Inc.
ENTRANT LOCATION
Richmond, VA

WHY DO YOU THINK LIFEGUARDS HAVE BINOCULARS ANYWAY?
32 / 1
ART DIRECTION
Lance Paull
COPYWRITING
Steve Crane
PHOTOGRAPHY
Robert Ammirati
CLIENT
Jantzen
ENTRANT LOCATION
New York, NY

COURAGE
32 / 2
ART DIRECTION
Jim Keane
COPYWRITING
Kerry Casey
PHOTOGRAPHY
Jim Arndt
PRODUCTION
Linda Hines
AGENCY
Carmichael Lynch
CLIENT
Schwinn
ENTRANT LOCATION
Minneapolis, MN

WINFIELD
32 / 3
ART DIRECTION
Randy Hughes
COPYWRITING
Bill Johnson
PHOTOGRAPHY
Shawn Michienzi, Curtis Johnson
PRODUCTION
Jan Miller
AGENCY
Clarity Coverdale Rueff
CLIENT
St. Paul Pioneer Press
ENTRANT LOCATION
Minneapolis, MN

MOTHER MAKES COMBAT
BOOTS
32 / 4
ART DIRECTION
Terry Schneider
DESIGN
Joel Nendel
COPYWRITING
Greg Eiden
PHOTOGRAPHY
Doug Petty
PRODUCTION
Doug Petty
MODEL
Pete Stone
AGENCY
Borders, Perrin
& Norrander
CLIENT
Columbia Sportswear
ENTRANT LOCATION
Portland, OR

IT'S SEEN YOU NAKED /
IT'S HEARD YOU SING
32 / 5
ART DIRECTION
Warren Johnson
COPYWRITING
Tom Gabriel
PHOTOGRAPHY
Shawn Michienzi -
Ripsaw
PRODUCTION
Brenda Clemons
AGENCY
Carmichael Lynch
CLIENT
American Standard
ENTRANT LOCATION
Minneapolis, MN

IT'S EASY TO
COORDINATE OUR
OUTFITS
32 / 6
ART DIRECTION
Carolyn McGeorge,
Jamie Mahoney
COPYWRITING
Joe Alexander,
Raymond McKinney
PHOTOGRAPHY
Dublin Productions
PRODUCTION
Jenny Schoenherr
AGENCY
The Martin Agency
CLIENT
Healthtex, Inc.
ENTRANT LOCATION
Richmond, VA

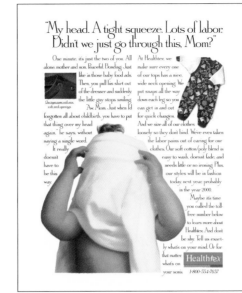

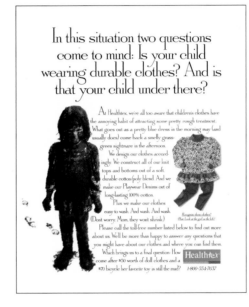

MOST BABY BOTTOMS STINK
32 / 7
ART DIRECTION
Carolyn McGeorge
COPYWRITING
Joe Alexander
PHOTOGRAPHY
Dublin Productions
PRODUCTION
Jenny Schoenherr
AGENCY
The Martin Agency
CLIENT
Healthtex, Inc.
ENTRANT LOCATION
Richmond, VA

MY HEAD
32 / 8
ART DIRECTION
Carolyn McGeorge
COPYWRITING
Joe Alexander
PHOTOGRAPHY
Dublin Productions
PRODUCTION
Jenny Schoenherr
AGENCY
The Martin Agency
CLIENT
Healthtex, Inc.
ENTRANT LOCATION
Richmond, VA

IN THIS SITUATION TWO QUESTIONS COME TO MIND
32 / 9
ART DIRECTION
Jamie Mahoney
COPYWRITING
Raymond McKinney
PHOTOGRAPHY
Dublin Productions
PRODUCTION
Jenny Schoenherr
AGENCY
The Martin Agency
CLIENT
Healthtex, Inc.
ENTRANT LOCATION
Richmond, VA

IT'S TRUE, AS YOU GET
OLDER
32 / 10
ART DIRECTION
Jamie Mahoney,
Carolyn McGeorge
COPYWRITING
Raymond McKinney
PHOTOGRAPHY
Dublin Productions
PRODUCTION
Jenny Schoenherr
AGENCY
The Martin Agency
CLIENT
Healthtex, Inc.
ENTRANT LOCATION
Richmond, VA

BABIES PUT EVERYTHING
IN THEIR MOUTHS
32 / 11
ART DIRECTION
Carolyn McGeorge,
Jelly Helm
COPYWRITING
Joe Alexander
PHOTOGRAPHY
Dublin Productions
PRODUCTION
Jenny Schoenherr
AGENCY
The Martin Agency
CLIENT
Healthtex, Inc.
ENTRANT LOCATION
Richmond, VA

THERE'S ONLY ONE
PROBLEM WITH BUYING
SIZE 3 FOR 3 YEAR OLDS.
BOTH THESE KIDS ARE 3
YEARS OLD
32 / 12
ART DIRECTION
Jamie Mahoney
COPYWRITING
Raymond McKinney
PHOTOGRAPHY
Dublin Productions
PRODUCTION
Jenny Schoenherr
AGENCY
The Martin Agency
CLIENT
Healthtex, Inc.
ENTRANT LOCATION
Richmond, VA

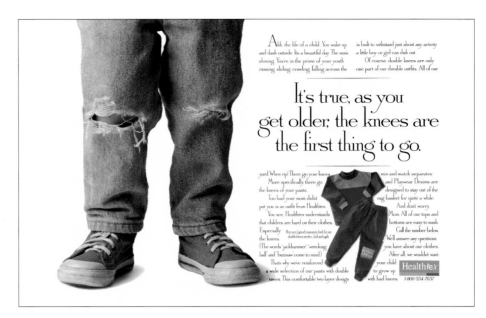

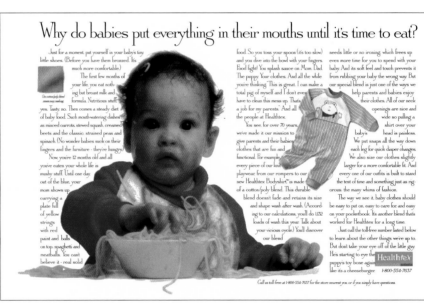

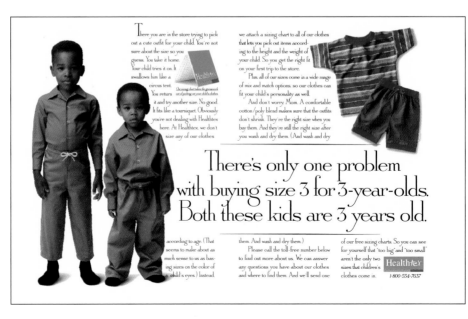

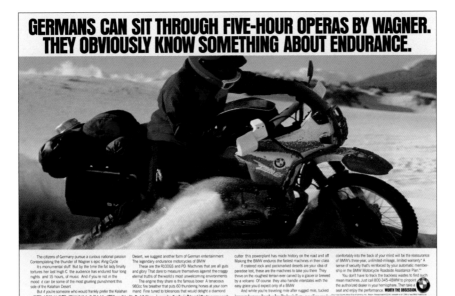

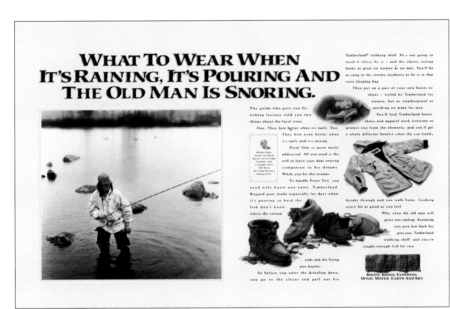

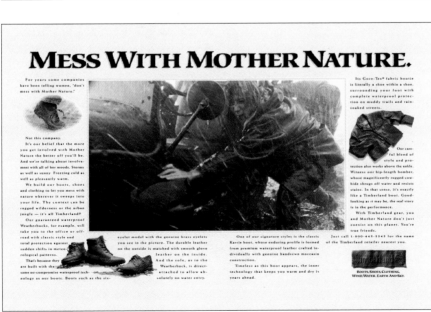

OPERA
32 / 13
ART DIRECTION
Jeroen Bours
COPYWRITING
Carl Walters
CREATIVE DIRECTION
Ron Burkhardt
PHOTOGRAPHY
Michael Moesch
AGENCY
Burkhardt & Christy
Advertising
CLIENT
BMW of North
America / Motorcycles
ENTRANT LOCATION
New York, NY

**BOOTS, SHOES,
CLOTHING, WIND,
WATER, EARTH AND SKY**
32 / 14
ART DIRECTION
Margaret McGovern
COPYWRITING
Paul Silverman
PHOTOGRAPHY
stock
PRODUCTION
John Holt Studio
AGENCY
Mullen
CLIENT
The Timberland
Company
ENTRANT LOCATION
Wenham, MA

**BOOTS, SHOES,
CLOTHING, WIND,
WATER, EARTH**
32 / 15
ART DIRECTION
Margaret McGovern
COPYWRITING
Paul Silverman
PHOTOGRAPHY
stock
PRODUCTION
John Holt Studio
AGENCY
Mullen
CLIENT
The Timberland
Company
ENTRANT LOCATION
Wenham, MA

BOOTS, SHOES WIND,
WATER, EARTH
32 / 16
ART DIRECTION
Margaret McGovern
COPYWRITING
Paul Silverman
PHOTOGRAPHY
John Krakauer,
Product: John Holt
Studio
AGENCY
Mullen
CLIENT
The Timberland
Company
ENTRANT LOCATION
Wenham, MA

CHIMP
32 / 19
ART DIRECTION
Jamie Mahoney
COPYWRITING
Raymond McKinney
PHOTOGRAPHY
Dublin Productions
PRODUCTION
Jenny Schoenherr
AGENCY
The Martin Agency
CLIENT
Healthtex, Inc.
ENTRANT LOCATION
Richmond, VA

HARRY HOUDINI
32 / 20
ART DIRECTION
Carolyn McGeorge
COPYWRITING
Joe Alexander
PHOTOGRAPHY
Dublin Productions
PRODUCTION
Jenny Schoenherr
AGENCY
The Martin Agency
CLIENT
Healthtex, Inc.
ENTRANT LOCATION
Richmond, VA

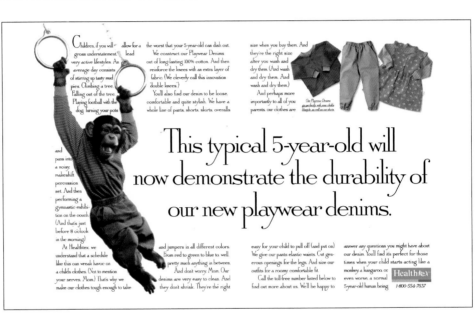

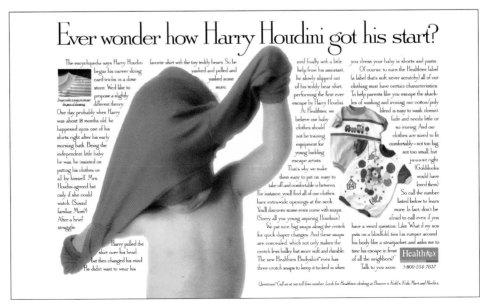

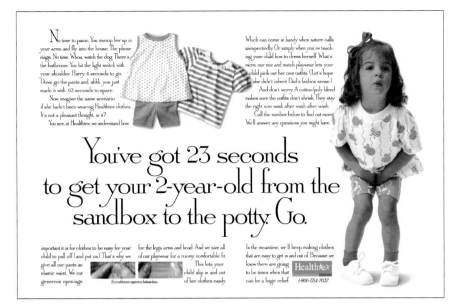

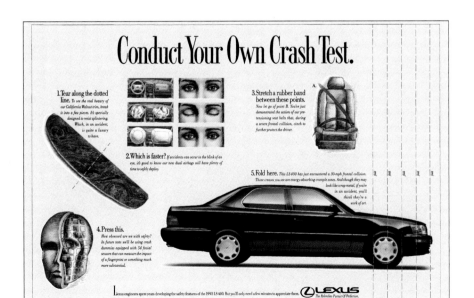

YOU'VE GOT 23 SECONDS
32 / 21
ART DIRECTION
Jamie Mahoney,
Carolyn McGeorge
COPYWRITING
Raymond McKinney
PHOTOGRAPHY
Dublin Productions
PRODUCTION
Jenny Schoenherr
AGENCY
The Martin Agency
CLIENT
Healthtex, Inc.
ENTRANT LOCATION
Richmond, VA

**PRETEND THE WIND IS
BUTTER**
32 / 22
ART DIRECTION
Yvonne Smith
COPYWRITING
Rob Siltanen
PHOTOGRAPHY
Lamb & Hall
AGENCY
Chiat / Day inc.
CLIENT
Nissan Motor Corp.
ENTRANT LOCATION
Venice, CA

**CONDUCT YOUR OWN
CRASH TEST**
32 / 23
ART DIRECTION
John Boone
COPYWRITING
Ron Huey
PHOTOGRAPHY
Michael Ruppert
ILLUSTRATION
Antar Dayal
AGENCY
Team One Advertising
CLIENT
Lexus
ENTRANT LOCATION
El Segundo, CA

FOR THIS PERFORMANCE

the role of the soft drink

will be played by Pepsi.

FOR THIS PERFORMANCE
32 / 18
SILVER
ART DIRECTION
Graham Lee
COPYWRITING
David Crichton,
Brad Monk
AGENCY
J. Walter Thompson
Co. Ltd
CLIENT
Pepsi - Cola Canada
ENTRANT LOCATION
Toronto, Canada

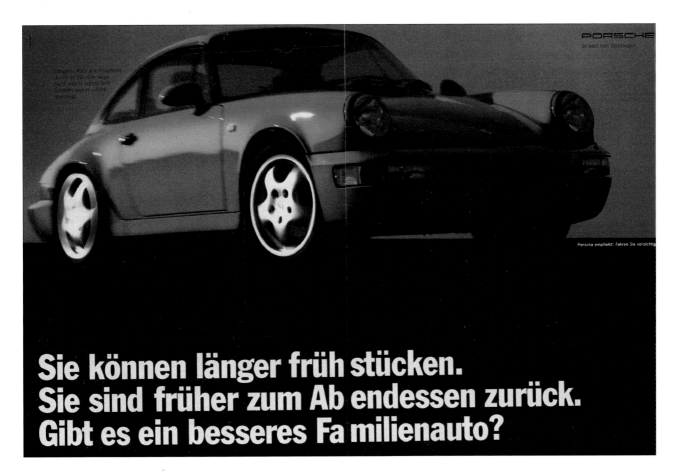

FAMILY CAR
32 / 9
DISTINCTIVE MERIT
ART DIRECTION
Deneke von Weltzien,
Claudia Wriedt
DESIGN
Tina Obladen
COPYWRITING
Mathias Jahn
PHOTOGRAPHY
Uwe Düttmann
AGENCY
Jung v. Matt
CLIENT
Dr. Ing. h.c. F. Porsche
AG
ENTRANT LOCATION
Hamburg, Germany

TENNIS
32 / 1
ART DIRECTION
David Rhodes
COPYWRITING
Angus Tucker
PHOTOGRAPHY
Rick McKechnie
STUDIO
In House
AGENCY
Scali, McCabe,
Sloves (Can) Ltd.
CLIENT
Purolator Courier
ENTRANT LOCATION
Toronto, Canada

**WHEN WAS THE LAST
TIME YOU FELT REALLY
COMFORTABLE WITH
YOUR BODY?**
32 / 2
ART DIRECTION
Mark Denton
COPYWRITING
Chris Palmer
PHOTOGRAPHY
Joyce Tenneson
AGENCY
Simons Palmer
CLIENT
Nike (UK) Ltd.
ENTRANT LOCATION
London, England

**IT'S NOT THE SHAPE YOU
ARE, IT'S THE SHAPE
YOU'RE IN THAT
MATTERS.**
32 / 3
ART DIRECTION
Mark Denton
COPYWRITING
Chris Palmer
PHOTOGRAPHY
Joyce Tenneson
AGENCY
Simons Palmer
CLIENT
Nike (UK) LTD
ENTRANT LOCATION
London, England

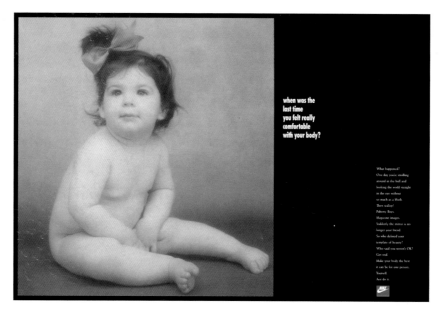

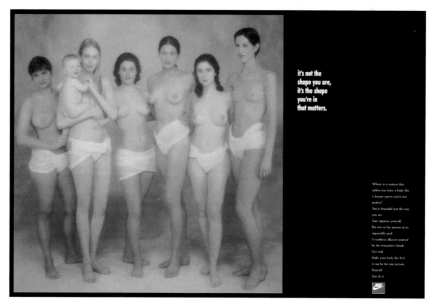

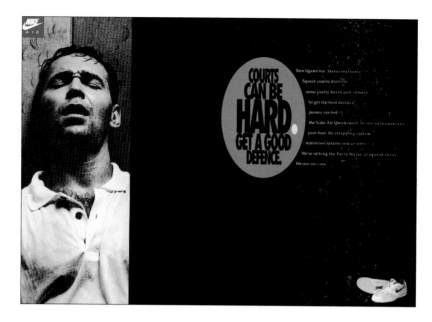

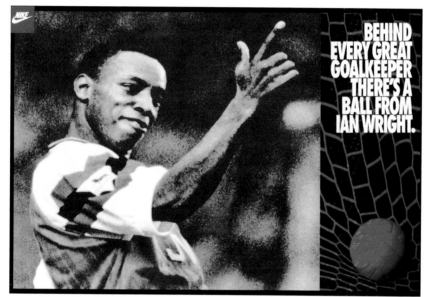

SQUASH
32 / 4
ART DIRECTION
Gary Martin
COPYWRITING
Mark Goodwin
PHOTOGRAPHY
Malcolm Venville
AGENCY
Simons Palmer
CLIENT
Nike (UK) LTD
ENTRANT LOCATION
London, England

IAN WRIGHT
32 / 5
ART DIRECTION
Mark Denton, Gary
Martin
COPYWRITING
Mark Goodwin
AGENCY
Simons Palmer
CLIENT
Nike (UK) LTD
ENTRANT LOCATION
London, England

**ADRENALIN. NOW
AVAILABLE IN A HANDY
TAKE-HOME PACK**
32 / 6
ART DIRECTION
Carl Van Wijk
DESIGN
Carl Van Wijk
COPYWRITING
Mark D'Arcy
PHOTOGRAPHY
Mike Reeves
AGENCY
DMB&B Auckland
CLIENT
Nissan New Zealand
ENTRANT LOCATION
Auckland, NZ

**ONE SHOULD NEVER
ASSUME THAT A TRIP TO
PRINCE EDWARD ISLAND
WILL BE A ROUND TRIP.**
32 / 7
ART DIRECTION
Peter Holmes
COPYWRITING
Randy Diplock
AGENCY
Franklin Dallas
CLIENT
Prince Edward Island
Tourism
ENTRANT LOCATION
Toronto, Canada

MAKE LOVE
32 / 8
ART DIRECTION
Martin Spillman
COPYWRITING
André Benker
AGENCY
Advico, Young
& Rubicam
CLIENT
Lamprecht AG
ENTRANT LOCATION
Zurich, Switzerlan

COSMOS
32 / 10
ART DIRECTION
Enric Aguilera
COPYWRITING
Javi Carro
AGENCY
Delvico Bates
Barcelona
CLIENT
RBA Publishers
ENTRANT LOCATION
Barcelona, Spain

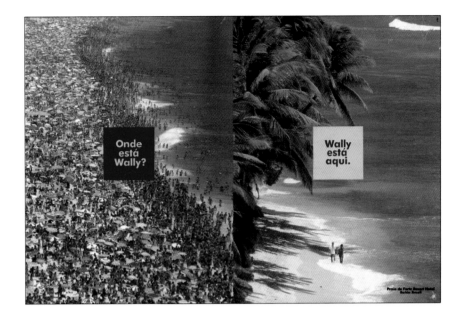

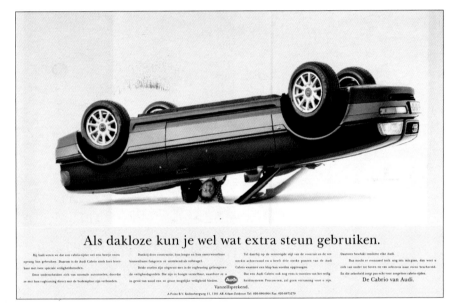

Als dakloze kun je wel wat extra steun gebruiken.

ONDE ESTA' WALLY?
32 / 11
ART DIRECTION
Marcello Serpa
COPYWRITING
Alexandre Gama
PHOTOGRAPHY
Image Bank
PRODUCTION
Anelito Nobrega
AGENCY
DM9 Publicidade
CLIENT
Praia Do Forte Resort Hotel
ENTRANT LOCATION
Sao Paulo, Brazil

CONVERTIBLE
32 / 12
ART DIRECTION
Richard Kuiper
COPYWRITING
Zwier Veldhoen
PHOTOGRAPHY
David Kater
AGENCY
Saatchi & Saatchi Advertising
CLIENT
Audi/Pon's Automobielhandel
ENTRANT LOCATION
Amstelveen, Netherlands

SELDOM MENTIONED
32 / 13
ART DIRECTION
Ken Hoggins
COPYWRITING
Chris O'Shea
PHOTOGRAPHY
Bob Harris
STU2DIO
Mechs
AGENCY
Banks Hoggins O'Shea
CLIENT
Bombay Spirits Co.
ENTRANT LOCATION
London, England

MANUAL. AUTOMATIC
32 / 14
ART DIRECTION
Luciano Zuffo
COPYWRITING
Alexandre Gama
PHOTOGRAPHY
Cassio Vasconcellos
PRODUCTION
Jose Roberto Bezerra
AGENCY
Almap/BBDO
Communicacão Ltda.
CLIENT
COMPUHELP
Distribuidora Ltda.
ENTRANT LOCATION
Sao Paulo, Brazil

IF THEY DIDN'T TASTE SO
GOOD THEY'D BE TOO
TEMPERAMENTAL TO
GROW.
32 / 15
ART DIRECTION
Simon Nickson
DESIGN
Geoff Neilly
COPYWRITING
Rod Dawson
PHOTOGRAPHY
Dave Stewart
CALLIGRAPHY
Alphabet Soup
AGENCY
Primary Contact
CLIENT
English Apples & Pears
ENTRANT LOCATION
London, England

BATH
32 / 16
ART DIRECTION
Michael Miller
COPYWRITING
Shaun Branagan
PHOTOGRAPHY
Simon Harsent
AGENCY
DDB Needham Sydney
CLIENT
Penfolds - Killawarra
Champagne
ENTRANT LOCATION
North Sydney, Australia

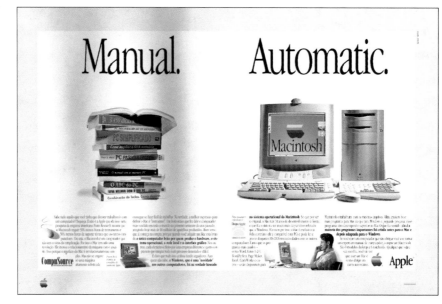

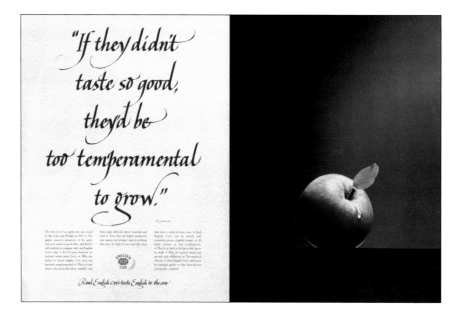

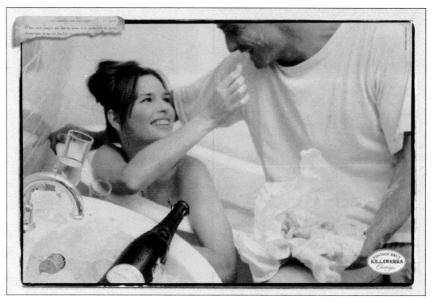

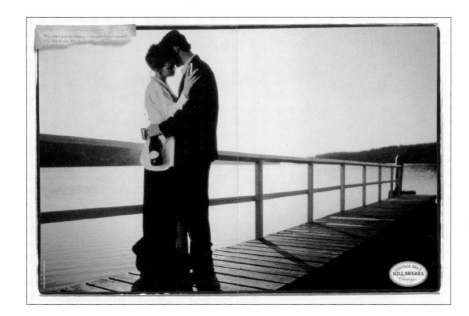

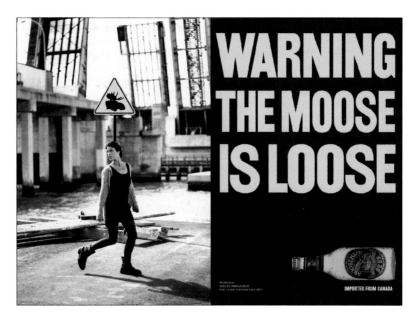

JETTY
32 / 17
ART DIRECTION
Michael Miller
COPYWRITING
Shaun Branagan
PHOTOGRAPHY
Simon Harsent
AGENCY
DDB Needham Sydney
CLIENT
Penfolds Wine Group -
Killawarra Champagne
ENTRANT LOCATION
North Sydney, Australia

**SINCE WE'VE MADE OUR
PEOPLE SHAREHOLDERS
WE NOW MOVE TWO
MORE ITEMS FOR YOU,
HEAVEN AND EARTH.**
32 / 19
ART DIRECTION
Ian Blake
COPYWRITING
Raleen Bagg
PHOTOGRAPHY
Image Bank
AGENCY
Grey Advertising (Pty)
Ltd.
CLIENT
Elliott International
ENTRANT LOCATION
Johannesburg, S.A.

WARNING
32 / 20
ART DIRECTION
Jan Ragnartz
COPYWRITING
Scott Goodson
PHOTOGRAPHY
Peppe Botella
AGENCY
Welinder
CLIENT
Moosehead Breweries
ENTRANT LOCATION
Stockholm, Sweden

WARNING
32 / 21
ART DIRECTION
Jan Ragnartz
COPYWRITING
Scott Goodson
PHOTOGRAPHY
Peppe Botella
AGENCY
Welinder
CLIENT
Moosehead Breweries
ENTRANT LOCATION
Stockholm, Sweden

WARNING
32 / 22
ART DIRECTION
Jan Ragnartz
COPYWRITING
Scott Goodson
PHOTOGRAPHY
Peppe Botella
AGENCY
Welinder
CLIENT
Moosehead Breweries
ENTRANT LOCATION
Stockholm, Sweden

PHOTOFIT
32 / 23
ART DIRECTION
Gary Martin
COPYWRITING
Mark Goodwin,
Gary Martin
PHOTOGRAPHY
Malcolm Venville
AGENCY
Simons Palmer
CLIENT
Nike (UK) LTD
ENTRANT LOCATION
London, England

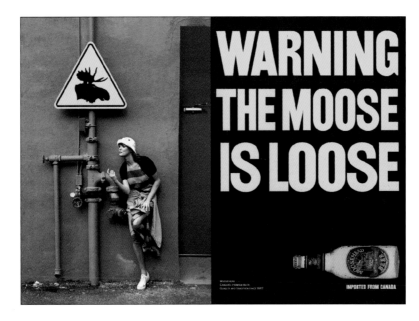
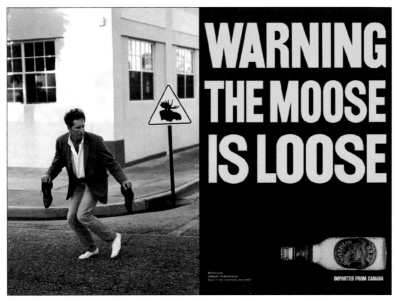
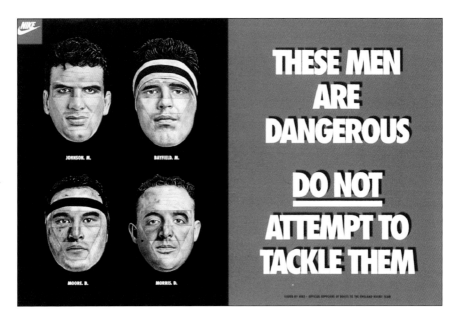

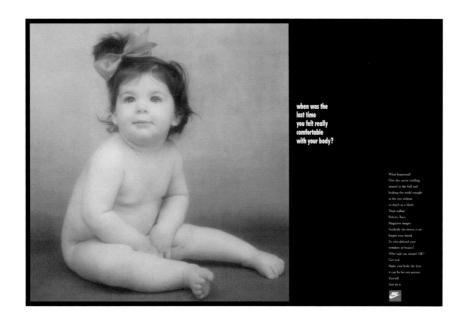

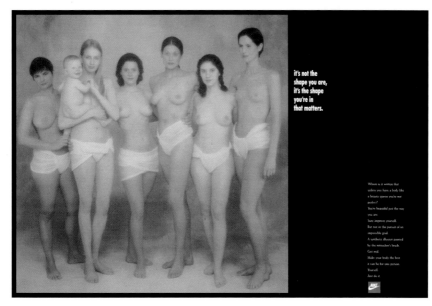

BABY
32 / 24
ART DIRECTION
Mark Denton
COPYWRITING
Chris Palmer
PHOTOGRAPHY
Joyce Tenneson
AGENCY
Simons Palmer
CLIENT
Nike (UK) LTD
ENTRANT LOCATION
London, England

WOMAN
32 / 25
ART DIRECTION
Mark Denton
COPYWRITING
Chris Palmer
PHOTOGRAPHY
Joyce Tenneson
AGENCY
Simons Palmer
CLIENT
Nike (UK) LTD
ENTRANT LOCATION
London, England

SUGGESTION / CHOKING /
VICTIMIZED
33 / 2
SILVER
ART DIRECTION
Sal DeVito,
Audrey DeVries,
Tom Gianfagna,
Pat Sutherland
COPYWRITING
Audrey DeVries,
Pat Sutherland,
Tom Gianfagna,
David Bromberg
PHOTOGRAPHY
Cailor / Resnick
CREATIVE DIRECTION
Sal DeVito
AGENCY
DeVito / Verdi
CLIENT
Daffy's
ENTRANT LOCATION
New York, NY

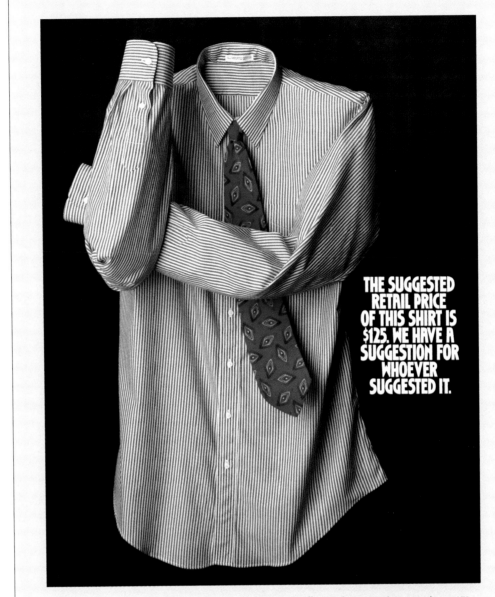

It's easy to coordinate our outfits. This baby, for example, was dressed by her dad.

Next time you drive by a golf course, take a close look at the players. Chances are, you'll see an unco-ordinated guy or two. And we're not talking about their golf swings.

Solids go with prints. And vice versa.

Check out the checks. The her-ringbones. Neons clashing with pastels. Solids smashing into plaids. And most of these dads don't realize they're walking moiré patterns. They just never learned how to mix and match clothes. Which can be a big problem. Especially when it comes time to dress their sons or (gasp!) their little daughters.

That's where Healthtex comes in. Our wide range of solid-colored tops and bottoms go effortlessly with all of our matching prints. Turtlenecks with little flowers, for example, look great with hot pink paperbag pants.

Long-sleeved, blue-and-red striped Healthtex Bodyshirts™ blend easily with red pull-on pants. The combinations are countless. (Like Dad's golf score.) And just like all Healthtex knit playwear, each is made of a soft cotton/poly blend that's easy to wash, doesn't fade and needs little or no ironing. To learn more about our mix-and-match outfits, call us toll-free.

And, Dad, don't be afraid to call yourself. We'll make it fast, so you'll have lots of time to practice your chip-ping. And your putting. And your driving...

Healthtex

1-800-554-7637

MY HEAD / DRESSED BY DAD / MOST BABY BOTTOMS
33 / 3
DISTINCTIVE MERIT
ART DIRECTION
Carolyn McGeorge, Jamie Mahoney
COPYWRITING
Joe Alexander, Raymond McKinney
PHOTOGRAPHY
Dublin Productions
PRODUCTION
Jenny Schoenherr
AGENCY
The Martin Agency
CLIENT
Healthtex, Inc.
ENTRANT LOCATION
Richmond, VA

197

SPAGHETTI BABY / HARRY
HOUDINI / BALD AND
TOOTHLESS
33 / 5

DISTINCTIVE MERIT

ART DIRECTION
Carolyn McGeorge,
Jelly Helm

COPYWRITING
Joe Alexander

PHOTOGRAPHY
Dublin Productions

PRODUCTION
Jenny Schoenherr

AGENCY
The Martin Agency

CLIENT
Healthtex, Inc.

ENTRANT LOCATION
Richmond, VA

When you're bald and toothless, you'd better wear cute clothes.

DESIGNER CLOTHING FOR PEOPLE BORN WITH PLASTIC SPOONS IN THEIR MOUTHS.

You don't need a trust fund to shop at Daffy's. That's because all of our men's, women's and children's fashion and designer clothing is 40-75% off, every day.

DAFFY'S
CLOTHES THAT WILL MAKE YOU, NOT BREAK YOU.

HAUTE COUTURE. NOW EASIER TO BUY THAN SAY.

At Daffy's, you'll find high fashion but you won't find high prices. All of our men's, women's & children's fashion & designer clothing is 40-75% off, every day.

DAFFY'S
CLOTHES THAT WILL MAKE YOU, NOT BREAK YOU.

EUROPEAN FASHIONS PRICED LIKE THEY FELL OFF THE BACK OF A PLANE.

Men's, women's & children's fashion & designer clothes 40-75% off, every day. Look for a Daffy's opening this fall on Manhasset's Miracle Mile in Long Island.

DAFFY'S
CLOTHES THAT WILL MAKE YOU, NOT BREAK YOU.

DESIGNER CLOTHES 40-75% OFF. FOR AN UNLIMITED TIME ONLY.

It's a once in a lifetime offer that will last a lifetime. At Daffy's, all of our men's, women's & children's fashion & designer clothing is 40-75% off, every day.

DAFFY'S
CLOTHES THAT WILL MAKE YOU, NOT BREAK YOU.

DESIGNER CLOTHES FOR PEOPLE WITH MORE CACHET THAN CASH.

So sashay your cachet into Daffy's for men's, women's & children's fashion & designer clothes 40-75% off, every day. Now open on Manhasset's Miracle Mile.

DAFFY'S
CLOTHES THAT WILL MAKE YOU, NOT BREAK YOU.

SPOONS / CACHET / PLANE
33 / 1
ART DIRECTION
Abi Aron,
Rob Carducci,
Pat Sutherland,
Frank Fusco
COPYWRITING
Rob Carducci,
Abi Aron,
Cheri Soukup,
Pat Sutherland,
Joel Clement,
Mark Schruntek,
Tom Gianfagna
CREATIVE DIRECTION
Sal DeVito
AGENCY
DeVito / Verdi
CLIENT
Daffy's
ENTRANT LOCATION
New York, NY

OUR NAME IS MUD/ THERE
ARE TIMES WHEN YOUR
OWN SKIN ISN'T
ENOUGH/ MUD, SKIN,
MESS
33 / 4
ART DIRECTION
Margaret McGovern
COPYWRITING
Paul Silverman
PHOTOGRAPHY
Paul Giraud,
John Krakauer,
Product: Jon Holt
Studio
AGENCY
Mullen
CLIENT
The Timberland
Company
ENTRANT LOCATION
Wenham, MA

OUR NAME IS MUD.

THERE ARE TIMES WHEN YOUR OWN SKIN ISN'T ENOUGH.

MESS WITH MOTHER NATURE.

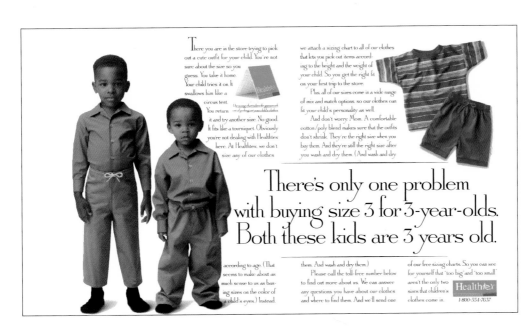

There you are in the store trying to pick out a cute outfit for your child. You're not sure about the size so you guess. You take it home. Your child tries it on. It swallows him like a circus tent. You return it and try another size. No good. It fits like a tourniquet. Obviously you're not dealing with Healthtex here. At Healthtex, we don't size any of our clothes according to age. (That seems to make about as much sense to us as basing sizes on the color of a child's eyes.) Instead,

we attach a sizing chart to all of our clothes that lets you pick out items according to the height and the weight of your child. So you get the right fit on your first trip to the store. Plus all of our sizes come in a wide range of mix and match options, so our clothes can fit your child's personality as well. And don't worry, Mom. A comfortable cotton/poly blend makes sure that the outfits don't shrink. They're the right size when you buy them. And they're still the right size after you wash and dry them. (And wash and dry

them. And wash and dry them.) Please call the toll-free number below to find out more about us. We can answer any questions you have about our clothes and where to find them. And we'll send one of our free sizing charts. So you can see for yourself that "too big" and "too small" aren't the only two sizes that children's clothes come in.

There's only one problem with buying size 3 for 3-year-olds. Both these kids are 3 years old.

Healthtex 1-800-554-7637

JEANS / BOTH KIDS ARE 3 /
23 SECONDS
33 / 6

ART DIRECTION
Jamie Mahoney,
Carolyn McGeorge

COPYWRITING
Raymond McKinney

PHOTOGRAPHY
Dublin Productions

PRODUCTION
Jenny Schoenherr

AGENCY
The Martin Agency

CLIENT
Healthtex, Inc.

ENTRANT LOCATION
Richmond, VA

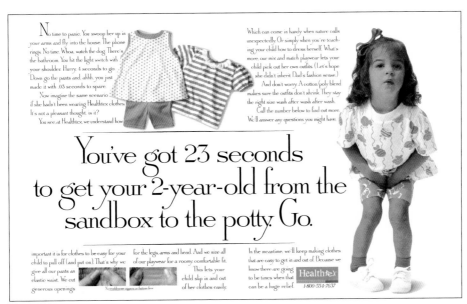

No time to panic. You swoop her up in your arms and fly into the house. The phone rings. No time. Whoa, watch the dog. There's the bathroom. You hit the light switch with your shoulder. Hurry. 4 seconds to go. Down go the pants and, ahhh, you just made it with .03 seconds to spare. Now imagine the same scenario if she hadn't been wearing Healthtex clothes. It's not a pleasant thought, is it? You see, at Healthtex, we understand how

Which can come in handy when nature calls unexpectedly. Or simply when you're teaching your child how to dress herself. What's more, our mix and match playwear lets your child pick out her own outfits. (Let's hope she didn't inherit Dad's fashion sense.) And don't worry. A cotton/poly blend makes sure the outfits don't shrink. They stay the right size wash after wash after wash. Call the number below to find out more. We'll answer any questions you might have.

You've got 23 seconds to get your 2-year-old from the sandbox to the potty. Go.

important it is for clothes to be easy for your child to pull off (and put on). That's why we give all our pants an elastic waist. We cut generous openings for the legs, arms and head. And we size all of our playwear for a roomy, comfortable fit. This lets your child slip in and out of her clothes easily.

In the meantime, we'll keep making clothes that are easy to get in and out of. Because we know there are going to be times when that can be a huge relief.

Healthtex 1-800-554-7637

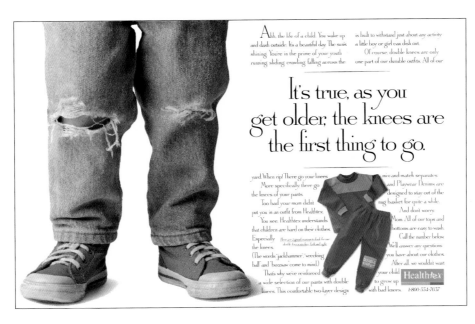

Ahh, the life of a child. You wake up and dash outside. It's a beautiful day. The sun's shining. You're in the prime of your youth running, sliding, crawling, falling across the

is built to withstand just about any activity a little boy or girl can dish out. Of course, double knees are only one part of our durable outfits. All of our

It's true, as you get older, the knees are the first thing to go.

yard. When rip! There go your knees. More specifically, there go the knees of your pants. Too bad your mom didn't put you in an outfit from Healthtex. You see, Healthtex understands that children are hard on their clothes. Especially the knees. (The words "jackhammer," "wrecking ball" and "buzzsaw" come to mind.) That's why we've reinforced a wide selection of our pants with double knees. This comfortable two-layer design

mix-and-match separates and Playwear Denims are designed to stay out of the rag basket for quite a while. And don't worry, Mom. All of our tops and bottoms are easy to wash. Call the number below. We'll answer any questions you have about our clothes. After all, we wouldn't want your child to grow up with bad knees.

Healthtex 1-800-554-7637

MUD GIRL / CHIMP / 48
OUTFITS
33 / 7
ART DIRECTION
Jamie Mahoney
COPYWRITING
Raymond McKinney
PHOTOGRAPHY
Dublin Productions
PRODUCTION
Jenny Schoenherr
AGENCY
The Martin Agency
CLIENT
Healthtex, Inc.
ENTRANT LOCATION
Richmond, VA

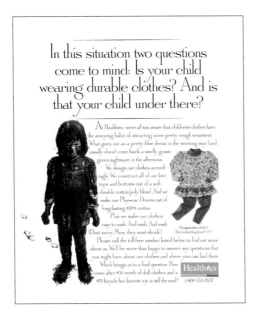

In this situation two questions come to mind: Is your child wearing durable clothes? And is that your child under there?

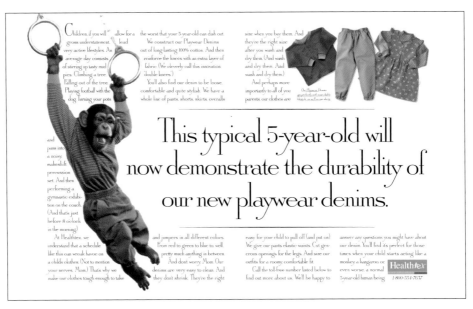

This typical 5-year-old will now demonstrate the durability of our new playwear denims.

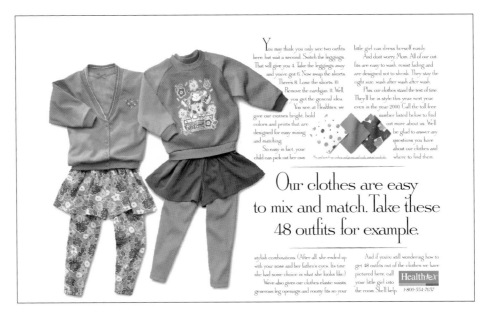

Our clothes are easy to mix and match. Take these 48 outfits for example.

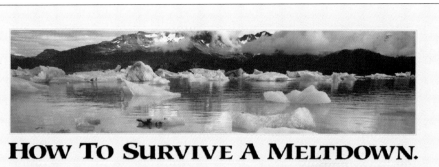

HOW TO SURVIVE A MELTDOWN.

At Timberland, we've spent the past two decades showing people how to survive snowstorms big enough to bury a house.

But what happens when all that snow melts? When cabin fever changes to spring fever? When the frozen rivers yawn, crack, surge and boil, and the sleds give way to canoes?

That's when you take off your Timberland® boots and put on the Timberland Mountain Trainer (TMT) sandal, so rugged it's like a guide boot without the

side panels. Designed for hiking and off-road use, this performance sandal has a multi-directional diamond-cut rubber lug sole and a contoured footbed for support.

Take the TMT sandal, fill in the spaces with full grain leather, and you've got the TMT GTX®, the only true outdoor cross-trainer

available in today's market. It will fend off anything the wilderness or the urban jungle can throw at you.

Since the name inside is Timberland, it's not only waterproof but water-proven. (Take away the Gore-Tex® fabric and you've got the TMT Lean for all those situations that really don't require waterproofing.)

Wear either style with our trekking shell, light in weight but heavy on performance features such

as mesh ventilation, roll-up storm hood and sleeves with an action gusset for unrestricted arm movement.

Anyone who enters the Iditarod® Sled Dog Race knows what Timberland can do with white snow.

Wait till you see what we can do with white water.

BOOTS. SHOES. CLOTHING.
WIND. WATER. EARTH AND SKY.

TIPTOE THROUGH THE TETONS.

We have a short message for everyone who thinks Timberland® only makes gear for conditions of 50° below zero. Take a hike.

Take it in April, May or June. Take it on an August scorcher hot enough to fry your morning omelette. Take it wearing gear so durable and

comfortable it will take miles off mountains.

In unpredictable summer weather, give your feet the extra protection of our waterproof Euro-hiker. Built of premium rough-out leather, this hiker features our exclusive Trail Grip™ rubber sole for extra traction, an SB rubber midsole,

anti-torque inner sole with steel shank, removable orthotic and latex-sealed seams. If you prefer general all-terrain trekking, the boot of choice is our all-leather waterproof Timberland Mountain Trainer (TMT), with

multi-directional diamond-cut rubber lug sole. The technological leader in its category, the TMT introduces the first internal fit system featuring stretch Gore-Tex® fabric. What's more, TMT technology is now available around the country in a classic women's oxford design, for good-looking performance at any altitude.

And for true Timberland protection above shoe level, don't leave home without our lightweight, trekking shell with ventilated mesh front and back pockets, roll-up storm hood, total drawcord system, action armholes and articulated sleeve construction.

Timberland earned its reputation helping mushers hike across 1,049 miles of frozen Alaskan tundra.

Now we're turning our technology towards anyone who hikes anywhere. The Grand Canyon, the Appalachian Trail, the local state park.

We won the Iditarod® Sled Dog Race. Can the Tetons be far behind?

Although the song "Tiptoe through the Tulips" is nearly seventy years old, the Tetons are much older. They originated fifteen million years ago.

BOOTS. SHOES. CLOTHING.
WIND. WATER. EARTH AND SKY.

WHAT TO WEAR WHEN IT'S RAINING, IT'S POURING AND THE OLD MAN IS SNORING.

The guide who gave you fly-fishing lessons told you two things about the local trout.

One. They bite better when it's early. Two. They bite even better when it's early and it's raining.

Point One is quite easily addressed. All you need is the will to leave your dear snoring companion to his dreams. While you hit the streams.

To handle Point Two, you need only know one name. Timberland. Rugged gear made especially for days when it's pouring so hard the fish don't know where the stream

ends and the frying pan begins.

So before you enter the drizzling dawn, you go to the closet and pull out his

Timberland® trekking shell. He's not going to need it where he is – and the classic styling looks as great on women as on men. You'll be as snug in the stormy outdoors as he is in that cozy sleeping bag.

Then put on a pair of your new boots or shoes – styled by Timberland for women, but as weatherproof as anything we make for men.

You'll find Timberland boots, shoes and apparel work overtime to protect you from the elements, and you'll get a whole different benefit when the sun finally

breaks through and you walk home. Looking every bit as good as you feel.

Why, even the old man will greet you smiling. Assuming you give him back his precious Timberland trekking shell, and you've caught enough fish for two.

BOOTS. SHOES. CLOTHING.
WIND. WATER. EARTH AND SKY.

MELTDOWN / TETONS / RAINING / POURING
33 / 8

ART DIRECTION
Margaret McGovern

COPYWRITING
Paul Silverman

PHOTOGRAPHY
David Muench,
Ray Meeks,
Product: John Holt
Studio

AGENCY
Mullen

CLIENT
The Timberland
Company

ENTRANT LOCATION
Wenham, MA

DIET GUARANA
ANTARCTICA
33 / 8
GOLD
ART DIRECTION
Marcello Serpa
COPYWRITING
Nizan Guanaes
PHOTOGRAPHY
Cassio Vasconcellos
PRODUCTION
Anelito Nobrega
AGENCY
DM9 Publicidade
CLIENT
Antarctica (Diet
Guarana)
ENTRANT LOCATION
Sao Paulo, Brazil

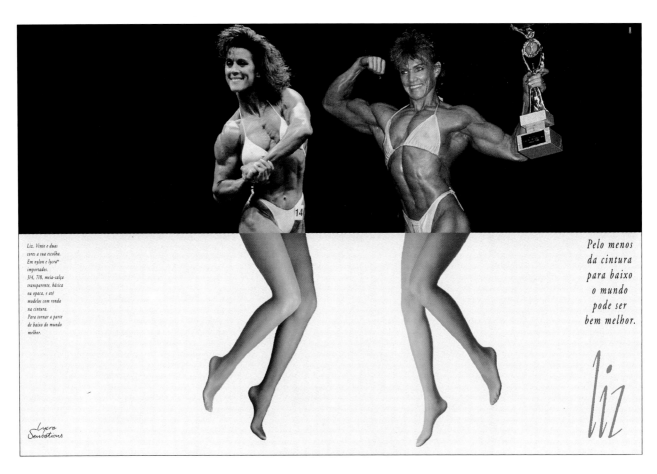

Liz. Vinte e duas cores a sua escolha. Em nylon e lycra® importados. 3/4, 7/8, meia-calça transparente, básica ou opaca, e até modelos com renda na cintura. Para tornar a parte de baixo do mundo melhor.

Pelo menos da cintura para baixo o mundo pode ser bem melhor.

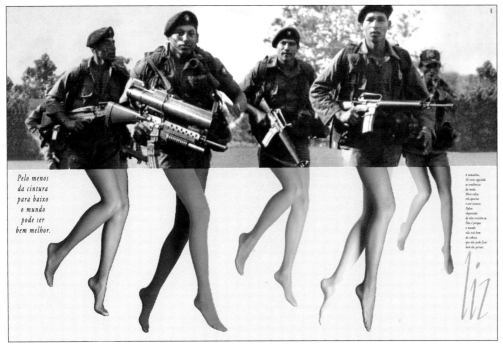

Pelo menos da cintura para baixo o mundo pode ser bem melhor.

THE WORLD CAN LOOK BETTER AT LEAST FROM THE WAIST DOWN
33 / 9
SILVER
ART DIRECTION
Marcello Serpa
COPYWRITING
Alexandre Gama
PHOTOGRAPHY
Cassio Vasconcellos/
Agencia Estado
PRODUCTION
Anelito Nobrega
AGENCY
DM9 Publicidade
CLIENT
CMR
ENTRANT LOCATION
Sao Paulo, Brazil

GIVE US YOUR GERMS /
WE'D LOVE TO CATCH
YOUR GERMS / GERM
WARFARE.
33 / 1
ART DIRECTION
Rob Lawrence,
Elvin Letchford
DESIGN
Rob Lawrence
COPYWRITING
Mike Friskney
CREATIVE DIRECTION
Cotton Stevenson
PHOTOGRAPHY
Tom Szuba
PRODUCTION
June Murray
STUDIO
Herzig Somerville
AGENCY
FCB Canada
CLIENT
Colgate - Palmolive
Canada
ENTRANT LOCATION
Toronto, Canada

Kills all

household

germs

JAVEX BLEACH. BECAUSE IT'S NOT 100% CLEAN
TILL IT'S GERM-FREE.

*TM REG'D COLGATE-PALMOLIVE CANADA INC.

FLOWERS / HITCHCOCK / GUITAR
33 / 2
ART DIRECTION
John Clifford
COPYWRITING
Mark Collis
PHOTOGRAPHY
Graham Ford
STUDIO
Graham Ford
AGENCY
GGT Advertising Ltd.
CLIENT
Taunton - Brody Cider
ENTRANT LOCATION
London, England

WHEN WE SAY, 'TILL
TOMORROW-PROMISE /
AROUND THE WORLD /
THE EARTH IS / HOW TO
SEND A FAX / FOR
BUSINESSMEN
33 / 3
ART DIRECTION
Roberto Cipolla
COPYWRITING
Eugenio Mohallem,
Nizan Guanaes
PHOTOGRAPHY
Freitas / Archive
PRODUCTION
Anelito Nobrega
AGENCY
DM9 Publicidade
CLIENT
DHL
ENTRANT LOCATION
Sao Paulo, Brazil

WHEN WE SAY, 'TIL TOMORROW, WE'RE NOT SAYING GOODBYE. WE'RE MAKING A PROMISE.

Se você fizer uma remessa agora para os Estados Unidos pela DHL, pode ter certeza de uma coisa: até amanhã, neste horário, sua encomenda já vai estar nas mãos do destinatário.

E essa rapidez toda não vale só para os Estados Unidos. A DHL também entrega nas principais cidades do Brasil em até 24 horas. Na Europa em até 48. E no Japão em apenas 72 horas.

A DHL cumpre prazos e promessas porque tem uma estrutura extremamente ágil, sempre pronta para entrar em ação: assim que você telefona, o veículo da DHL que estiver mais perto do seu endereço é acionado por rádio. E num instante ele vai estar na sua porta para retirar a encomenda.

Logo, ela vai estar nas mãos de quem você quiser, em qualquer parte do mundo. Sempre que você tiver muita pressa e pouco prazo, ligue para a DHL. Só não lutamos contra o relógio quando estamos transportando um.

HOW TO SEND A FAX TO ANY PART OF THE WORLD.

Digamos que você está com este problema: mandar um documento muito importante para alguém mais importante ainda.

Essa remessa é tão urgente que já devia estar lá. E esse lá é bem longe. E agora? Agora, tudo o que você tem a fazer é ligar para a DHL, cruzar os braços e recuperar o tempo perdido.

A DHL retira a encomenda da sua mão e entrega nas mãos de quem você quiser, onde essa pessoa estiver, na velocidade da sua pressa. Ou melhor, mais rápido, porque a nossa pressa é maior que a sua.

E o que é longe para você é perto para nós. A DHL tem escritórios em 199 países. Possui 30 mil funcionários treinados, automóveis, helicópteros e nada menos que 190 aviões. Mas isso não importa. O importante é que toda essa estrutura é colocada a sua disposição a partir do momento que você liga para a DHL.

Aliás, se neste exato momento aquele problema imaginário lá de cima for um problema real para você, é só ligar.

Digamos que ele já foi resolvido. A DHL não deixa para amanhã o que pode resolver ontem.

FOR BUSINESSMEN, IT'S AN AMBULANCE.

Bons executivos conseguem se manter calmos mesmo diante das situações mais difíceis. E é claro que ajuda um pouco saber que a DHL existe.

A DHL é capaz de levar uma encomenda urgente a qualquer parte do mundo. E para isso ela tem uma estrutura bem montada e extremamente ágil, pronta para entrar em ação no momento que você telefona: num instante, retiramos a encomenda na sua porta e entregamos nas mãos de quem você quiser, onde essa pessoa estiver, na velocidade da sua pressa. Por exemplo, a DHL entrega nos Estados Unidos em até 24 horas. Na Europa em até 48. E sua remessa só sai das nossas mãos no momento que é entregue nas mãos do destinatário.

Por isso, diante de uma situação de urgência, inadiável, quase desesperadora e com um prazo praticamente impossível de cumprir, você tem duas opções: ligue para a DHL. Ou ligue para a sua mãe.

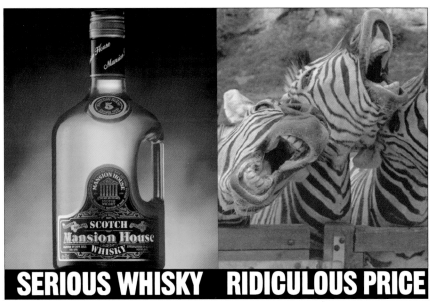

SERIOUS WHISKY /
RIDICULOUS PRICE.
33 / 4

ART DIRECTION
Jos Cornelissen

COPYWRITING
Kristien Veenma

PHOTOGRAPHY
David Kater, stock

AGENCY
Result.

CLIENT
UTO Nederland

ENTRANT LOCATION
Amstelveen,
Netherlands

DREYER'S. NOT DREYER'S
33 / 5
ART DIRECTION
Atsushi Chiba,
Hiroshi Kawasaki,
Michihiko Yanai
DESIGN
Harumi Konuma
COPYWRITING
Akio Shirabe Keiko
Miyahara
PHOTOGRAPHY
Noboru Kumagai
AGENCY
Hakuhodo Inc.
CLIENT
Dreyer's Japan
ENTRANT LOCATION
Tokyo, Japan

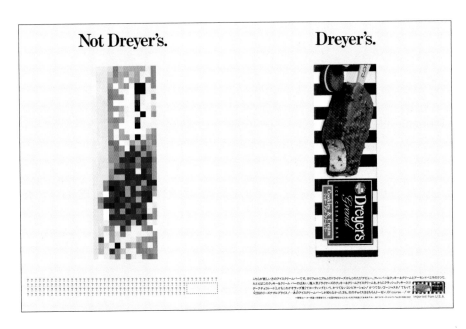

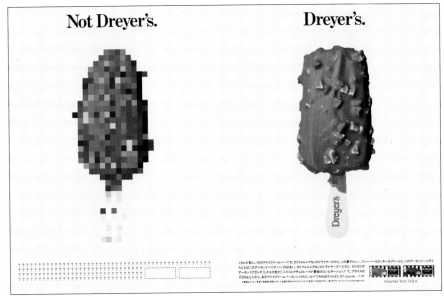

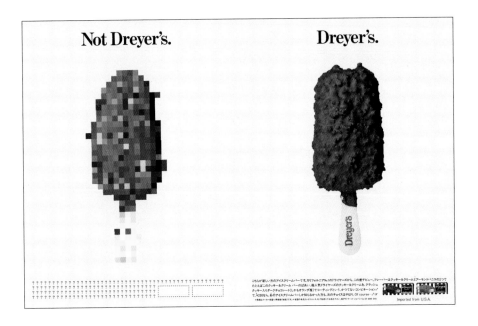

**NOBODY KNOWS
WHEATHER WILD / DO
YOU SEE NOW /
PERISCOPE / PREFER
DESERTED / SEA VIEW /
ESCORTED MEN**
33 / 6
ART DIRECTION
Roberto Cipolla
COPYWRITING
Eugenio Mohallem,
Luiz Toledo
PHOTOGRAPHY
Valerio Trabanco
PRODUCTION
Anelito Nobrega
AGENCY
DM9 Publicidade
CLIENT
CIA Maritima
ENTRANT LOCATION
Sao Paulo, Brazil

DAVID / VAMPIRE / SUMO
33 / 7
ART DIRECTION
Gabi Stoliar
COPYWRITING
Oded Nov
PHOTOGRAPHY
Albi Serfaty,
Bill Robbins
AGENCY
Biletzki Armoni
Yehoshua
CLIENT
Rosh 1 Young
Magazine
ENTRANT LOCATION
Tel Aviv, Israel

**THIS YEAR, 2500 SURFERS
WILL RIDE NEW BOARDS
HAND-SHAPED BY A LEGEND.**

(The rest of you are shit-out-of-luck until next year.)

Becker
Surfboards
MEDIOCRITY SUCKS.
Hermosa Beach
Malibu
Mission Viejo

**TO EVERY POOR, IGNORANT
HODADDY WHO BOUGHT
A BOARD MADE WITH A
SHAPING MACHINE, WE ASK
THE FOLLOWING QUESTION:**

(Isn't it hard walking around with your head stuck in there like that?)

Becker
Surfboards
MEDIOCRITY SUCKS.
Hermosa Beach
Malibu
Mission Viejo
El Toro

**WE STILL SHAPE EACH AND
EVERY BOARD USING THE SAME
MACHINE WE STARTED WITH
THIRTY-TWO YEARS AGO.**

(We call him Phil.)

Becker
Surfboards
MEDIOCRITY SUCKS.
Hermosa Beach
Malibu
Mission Viejo
Lake Forest

MEDIOCRITY SUCKS
33 / 10
ART DIRECTION
Jon Reeder
COPYWRITING
Thomas Binnion,
Jon Reeder
AGENCY
Thomas Binnion
Advertising
CLIENT
Becker Surfboards
ENTRANT LOCATION
Manhattan Beach, USA

FAMILIE / PARTY / WRACK
33 / 11, 12, 13
ART DIRECTION
Ove Gley
DESIGN
Tina Obladen
COPYWRITING
Mathias Jahn
CREATIVE DIRECTION
Hartwig Keunje
PHOTOGRAPHY
Stephan Foersterling,
Felix Lammers
AGENCY
Jung v. Matt
CLIENT
Minolta GmbH
ENTRANT LOCATION
Hamburg, Germany

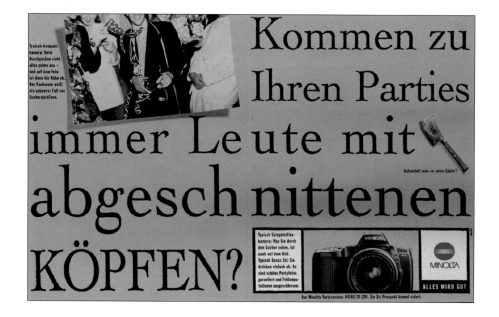

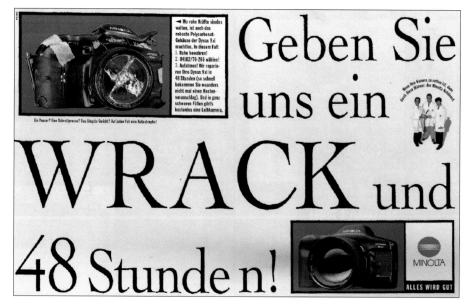

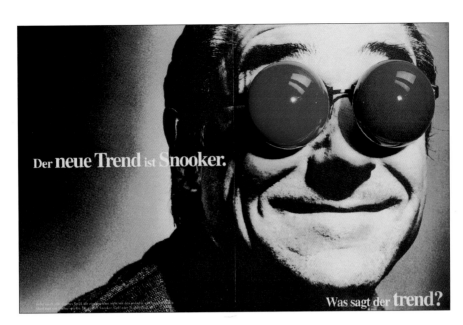

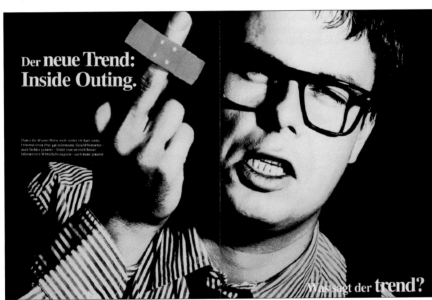

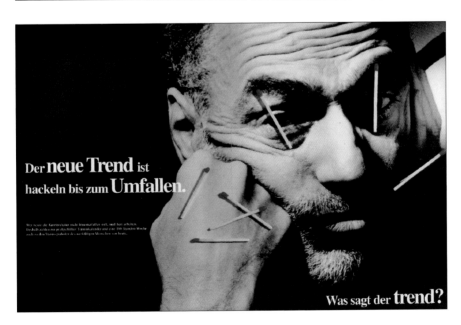

**SNOOKER / INSIDE
OUTING / HACKELN**
33 / 14
ART DIRECTION
Janna Kozeschnik -
Thuer
DESIGN
Karin Kutsam
COPYWRITING
Alexander Rabl
PHOTOGRAPHY
Manfred Klimek,
Oliver Zehner
PRODUCTION
Werner Stupka
AGENCY
Demner & Merlicek
CLIENT
Wirtschafts - Trend -
Verlag
ENTRANT LOCATION
Vienna, Austria

(UNTITLED)
33 / 15
ART DIRECTION
Daniele Cima
COPYWRITING
Enrico Chiarugi
PHOTOGRAPHY
Ivo von Renner,
Gigi Barbieri
ILLUSTRATION
Gianpaolo Amstici
AGENCY
Impact Italia
CLIENT
Legambiente
ENTRANT LOCATION
Milan, Italy

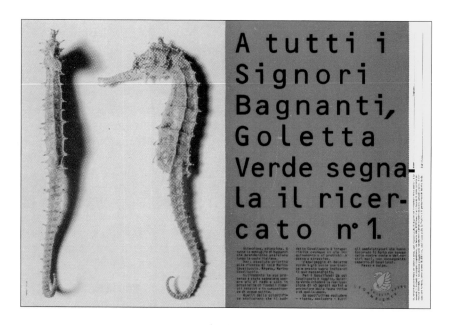

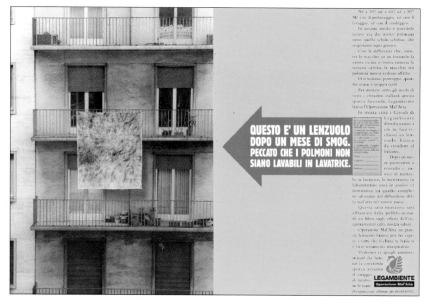

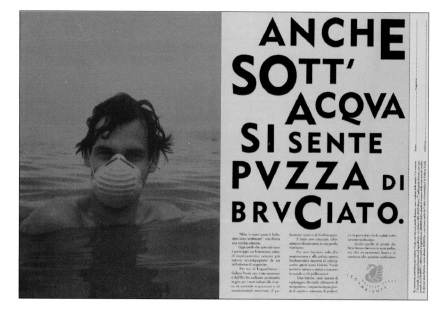

ANGUS MANURE / GAS
MASK
35 / 1

ART DIRECTION
Chuck Finkle

COPYWRITING
Dean Hacohen

PHOTOGRAPHY
Ilan Rubin

AGENCY
Goldsmith / Jeffrey

CLIENT
NYNEX BTB Directory

ENTRANT LOCATION
New York, NY

WEATHER NETWORK /
CRYSTAL BALL
35 / 2
ART DIRECTION
Chuck Finkle
COPYWRITING
Dean Hacohen
PHOTOGRAPHY
Ilan Rubin
AGENCY
Goldsmith / Jeffrey
CLIENT
NYNEX BTB Directory
ENTRANT LOCATION
New York, NY

CARTOON VOICES /
HELIUM
35 / 3
ART DIRECTION
Chuck Finkle
COPYWRITING
Dean Hacohen
PHOTOGRAPHY
Ilan Rubin
AGENCY
Goldsmith / Jeffrey
CLIENT
NYNEX BTB Directory
ENTRANT LOCATION
New York, NY

SUGGESTION
36 / 6
GOLD
ART DIRECTION
Sal DeVito
COPYWRITING
David Bromberg,
Audrey DeVries
CREATIVE DIRECTION
Sal DeVito
PHOTOGRAPHY
Cailor / Resnick
AGENCY
DeVito / Verdi
CLIENT
Daffy's
ENTRANT LOCATION
New York, NY

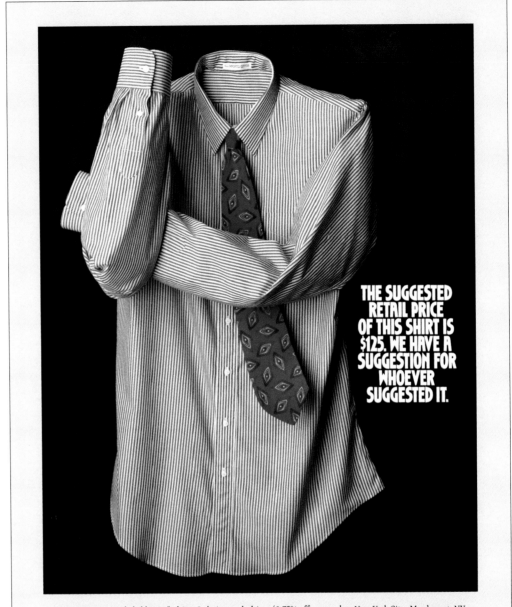

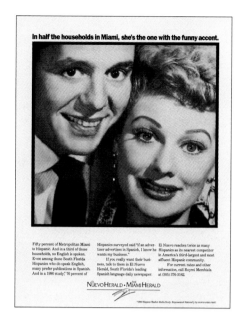

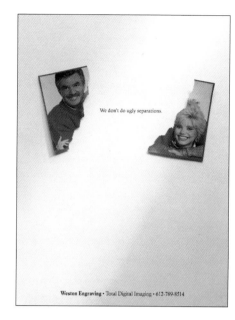

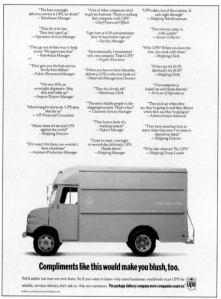

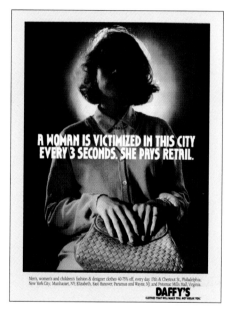

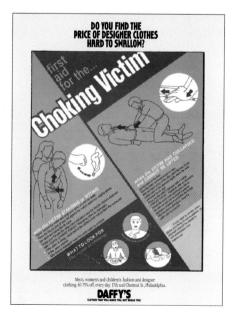

IN HALF THE
HOUSEHOLDS IN MIAMI
36 / 1
ART DIRECTION
Alex Bogusky
COPYWRITING
Chuck Porter
PHOTOGRAPHY
stock
AGENCY
Crispin & Porter
CLIENT
The Miami Herald
ENTRANT LOCATION
Miami, FL

UGLY SEPARATIONS
36 / 2
ART DIRECTION
Wayne Thompson
COPYWRITING
Jan Pettit
PHOTOGRAPHY
Tom Matre
AGENCY
Martin / Williams
CLIENT
Weston Engraving
ENTRANT LOCATION
Minneapolis, MN

COMPLIMENTS LIKE THIS
36 / 3
ART DIRECTION
David Burger
COPYWRITING
David Wojdyla
PHOTOGRAPHY
Lamb & Hall
AGENCY
Ammirati & Puris
CLIENT
UPS
ENTRANT LOCATION
Ridgewood, NJ

VICTIMIZED
36 / 4
ART DIRECTION
Audrey DeVries
CREATIVE DIRECTION
Sal DeVito
COPYWRITING
Audrey DeVries
PHOTOGRAPHY
Cailor / Resnick
AGENCY
DeVito / Verdi
CLIENT
Daffy's
ENTRANT LOCATION
New York, NY

CHOKING
36 / 5
ART DIRECTION
Tom Gianfagna,
Pat Sutherland
COPYWRITING
Pat Sutherland,
Tom Gianfagna
CREATIVE DIRECTION
Sal DeVito
PHOTOGRAPHY
Cailor / Resnick
AGENCY
DeVito / Verdi
CLIENT
Daffy's
ENTRANT LOCATION
New York, NY

SOMETIMES OUR VIEWFINDER
36 / 7
ART DIRECTION
Bill Schwab
COPYWRITING
Tony Gomes
PHOTOGRAPHY
James Nachtwey
AGENCY
Ammirati & Puris Inc.
CLIENT
Nikon
ENTRANT LOCATION
New York, NY

IT'S ALL JUST TALK UNTIL YOU TRY IT
36 / 8
ART DIRECTION
John Vitro
COPYWRITING
John Robertson
PHOTOGRAPHY
Marshall Harrington
ILLUSTRATION
Tom Chung,
Mark Lyon
AGENCY
VITROROBERTSON
CLIENT
Odyssey Sports, Inc
ENTRANT LOCATION
San Diego, CA

YOU'LL NOTICE IN THE HIPPOCRATIC OATH
36 / 9
ART DIRECTION
John Vitro
COPYWRITING
John Robertson
PHOTOGRAPHY
Hank Bensen
AGENCY
Franklin Stoorza
CLIENT
Thermoscan, Inc
ENTRANT LOCATION
San Diego, CA

57- PERCENTAGE OF ECONOMIST READERS
36 / 10
ART DIRECTION
Shalom Auslander,
Mikal Reich
COPYWRITING
Shalom Auslander,
Mikal Reich
PRODUCTION
Valerie Hope
AGENCY
Mad Dogs &
Englishmen
CLIENT
The Economist
ENTRANT LOCATION
New York, NY

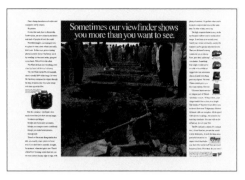

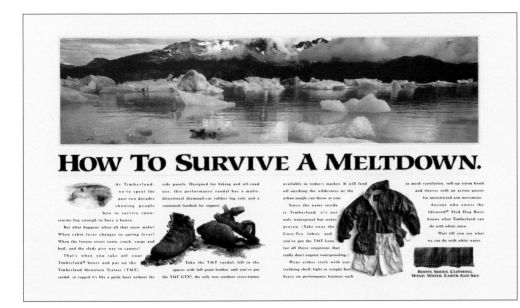

HOW TO SURVIVE A MELTDOWN.

At Timberland, we've spent the past two decades showing people how to survive snow-storms big enough to bury a house.

But what happens when all that snow melts? When cabin fever changes to spring fever? When the frozen rivers yawn, crack, surge and boil, and the sleds give way to canoes?

That's when you take off your Timberland® boots and put on the Timberland Mountain Trainer (TMT) sandal, so rugged it's like a guide boot without the side panels. Designed for hiking and off-road use, this performance sandal has a multi-directional diamond-cut rubber lug sole and a contoured footbed for support.

Take the TMT sandal, fill in the spaces with full grain leather, and you've got the TMT GTX®, the only true outdoor cross-trainer available in today's market. It will fend off anything the wilderness or the urban jungle can throw at you.

Since the name inside is Timberland, it's not only waterproof but water-proven. (Take away the Gore-Tex fabric and you've got the TMT Lean, for all those situations that really don't require waterproofing.)

Wear either style with our trekking shell, light in weight but heavy on performance features such as mesh ventilation, roll-up storm hood and sleeves with an action gusset for unrestricted arm movement.

Anyone who enters the Iditarod® Sled Dog Race knows what Timberland can do with white snow.

Wait till you see what we can do with white water.

BOOTS, SHOES, CLOTHING.
WIND. WATER. EARTH AND SKY.

THERE ARE TIMES WHEN YOUR OWN SKIN ISN'T ENOUGH.

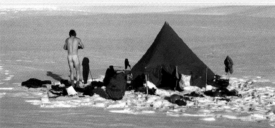

The point of our revealing photo-graph isn't to prove you should cover your butt with clothing when it snows.

It's to dramatize the fact that your skin does some wonderful things to keep you comfortable in extreme conditions. And so does our skin, the incompa-rably protective leathers we use in Timberland® boots, shoes and clothing.

Consider the four pieces of durable Timberland gear pictured in this ad.

Although each has a different use, they share a common founda-tion in the quality of leather used in their construction. Hide that's hand-picked for best results during the water-proofing process. And for natural coloration that weathers hand-somely over time.

As its name suggests, the Iditarod™ Super Boot comes out of our many years of experimental work outfitting mushers who compete in the annual blizzard-whipped 1,049-mile sled dog race stretching from Anchorage to Nome, Alaska.

With the Iditarod as our testing lab, we've proven that the waterproof leathers and 800-gram Thinsulate® insulation in this boot can stand up to anything in North America.

And even though you wouldn't wear our Litchfield Bomber in a sled dog race, it will show you our long-standing ability to make waterproof leather as comfortable in a cloudburst as on a day when there isn't a cloud in the sky.

Likewise, our Weatherbuck Wingtips will take you to the office on a stormy day with feet as dry and warm as if you were wearing the toughest Timberland boots. In fact, the method we use to waterproof these shoes comes directly from our boot-building repertoire. Over twenty years of industry leadership. No shortcuts and no compromises.

Lastly, our name wouldn't be Timberland if our fall offering didn't include a handsewn chukka boot for rugged wear, rain or shine. You get the double comfort of genuine hand-sewn construction plus a waterproof system built around a Gore-Tex® fabric bootie.

It's been a good million years since the skin you were born with was forced to endure the planet's wildest extremes.

Not to worry. Use ours.

For more information about Timberland boots, shoes and cloth-ing, call 1-800-445-5545.

BOOTS, SHOES, CLOTHING.
WIND. WATER. EARTH AND SKY.

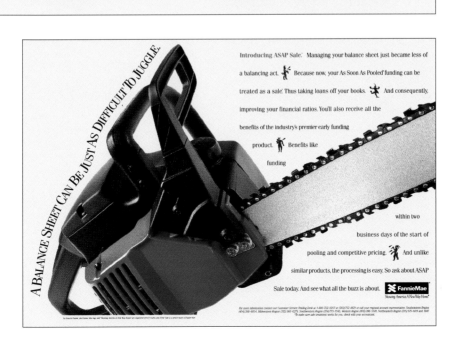

A BALANCE SHEET CAN BE JUST AS DIFFICULT TO JUGGLE.

Introducing ASAP Sale. Managing your balance sheet just became less of a balancing act. Because now, your As Soon As Pooled funding can be treated as a sale. Thus taking loans off your books. And consequently, improving your financial ratios. You'll also receive all the benefits of the industry's premier early funding product. Benefits like funding within two business days of the start of pooling and competitive pricing. And unlike similar products, the processing is easy. So ask about ASAP Sale today. And see what all the buzz is about.

FannieMae
Showing America A New Way Home®

HOW TO SURVIVE A MELTDOWN
36 / 11
ART DIRECTION
Margaret McGovern
COPYWRITING
Paul Silverman
PHOTOGRAPHY
David Muencha, Product: Jon Holt Studio
AGENCY
Mullen
CLIENT
The Timberland Company
ENTRANT LOCATION
Wenham, MA

THERE ARE TIMES
36 / 12
ART DIRECTION
Margaret McGovern
COPYWRITING
Paul Silverman
PHOTOGRAPHY
John Krakauer, Product: John Holt Studio
AGENCY
Mullen
CLIENT
The Timberland Company
ENTRANT LOCATION
Wenham, MA

DIFFICULT TO JUGGLE
36 / 13
ART DIRECTION
Brad Magner
COPYWRITING
Patrick Knoll
PHOTOGRAPHY
Tony Pearce
AGENCY
McKinney & Silver
CLIENT
Fannie Mae
ENTRANT LOCATION
Raleigh, NC

SO WHICH WORM IS MORE DEAD?
36 / 14
ART DIRECTION
Hal Tench
COPYWRITING
John Mahoney
ILLUSTRATION
Ed Lindlof
PRODUCTION
Karen Smith
AGENCY
The Martin Agency
CLIENT
FMC Corporation
ENTRANT LOCATION
Richmond, VA

JUST A REMINDER
36 / 15
ART DIRECTION
Steve St. Clair
COPYWRITING
Steve St. Clair,
Jerry Confino
AGENCY
Lord, Dentsu
& Partners
CLIENT
Agency
ENTRANT LOCATION
New York, NY

AND HE STILL FOUND A WAY
36 / 16
ART DIRECTION
Terre Nichols
COPYWRITING
Andrew Payrton
AGENCY
Lord, Dentsu
& Partners
CLIENT
Time Warner
ENTRANT LOCATION
New York, NY

44 YEARS LATER
36 / 17
ART DIRECTION
Tom Delmundo
DESIGN
Tom Delmundo
COPYWRITING
Kristi Bridges
CREATIVE DIRECTION
Jack Mariucci,
Bob Mackall
PHOTOGRAPHY
stock
CLIENT
Volkswagen
ENTRANT LOCATION
New York, NY

HOW SKY RADIO WORKS
36 / 18
ART DIRECTION
Bob Meagher
COPYWRITING
Joe Alexander
PHOTOGRAPHY
Dublin Productions
PRODUCTION
Karen Smith
AGENCY
The Martin Agency
CLIENT
USA Today Sky Radio
ENTRANT LOCATION
Richmond, VA

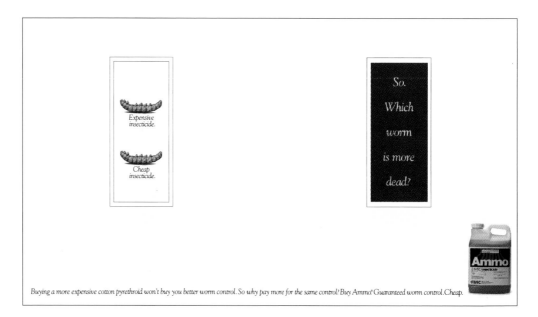

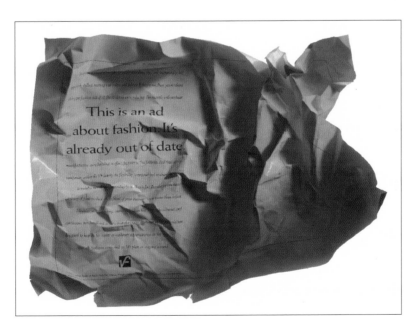

**HAVING TROUBLE
FINDING THE RIGHT JOB?**
36 / 19
ART DIRECTION
Jamie Mahoney
COPYWRITING
Raymond McKinney
PHOTOGRAPHY
Joe Lampi,
Dublin Productions
AGENCY
The Martin Agency
CLIENT
Dick Gerdes
ENTRANT LOCATION
Richmond, VA

**WHAT TO WEAR WHEN
IT'S POURING**
36 / 20
ART DIRECTION
Margaret McGovern
COPYWRITING
Paul Silverman
PHOTOGRAPHY
Ray Meeks,
Product: John Holt
Studio
AGENCY
Mullen
CLIENT
The Timberland
Company
ENTRANT LOCATION
Wenham, MA

**THIS IS AN AD ABOUT
FASHION**
36 / 21
ART DIRECTION
Shari Hindman
COPYWRITING
John Mahoney
PHOTOGRAPHY
Brad Guice
PRODUCTION
Kay Franz
AGENCY
The Martin Agency
CLIENT
VF Corporation
ENTRANT LOCATION
Richmond, VA

CROWD
36 / 22
ART DIRECTION
Grant Richards
COPYWRITING
Todd Tilford
PHOTOGRAPHY
Jay Maisel, Tom Ryan
PRODUCTION
Gail Beckman
AGENCY
The Richards Group
CLIENT
Memorex
ENTRANT LOCATION
Dallas, TX

WORSE, GET LAID OFF...
FRIDAY
36 / 23
ART DIRECTION
Walt Connelly
DESIGN
Walt Connelly,
Mylene Pollock
COPYWRITING
Bruce Richter
PHOTOGRAPHY
Dilip Mehta
AGENCY
Ogilvy & Mather, NY
CLIENT
Time
ENTRANT LOCATION
New York, NY

SOME OF THE BEST NEWS
IN HEADACHE RELIEF
36 / 2
ART DIRECTION
Marcee Ruby
COPYWRITING
David Crichton
PHOTOGRAPHY
Gerry Lee
STUDIO
Westside Studio
AGENCY
J. Walter Thompson
Co. Ltd
CLIENT
Bristol Myers Squibb
Company
ENTRANT LOCATION
Toronto, Canada

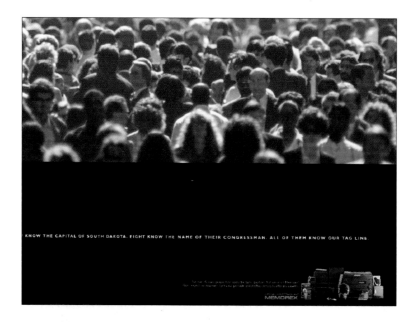

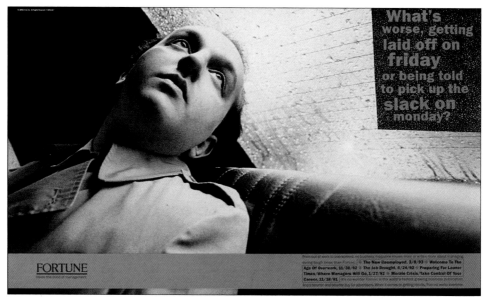

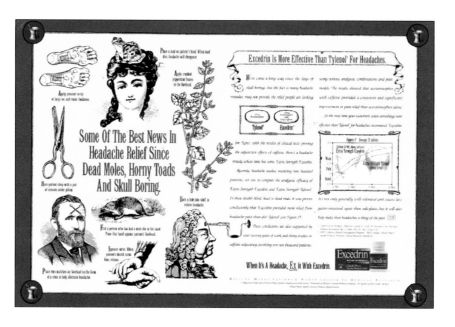

Theory:
the French make
great lovers.

Fact:
the French make
great mustard.

Inspired by the original Dijon recipe. And made with a passion.

French mustard
is a lot like
French romance.
The more
variations you try,
the better it is.

Don't think of it
as an empty jar.
Think of it as
another opportunity
to look
distinguished
at the
supermarket checkout.

THEORY - FACT /
VARIATIONS / EMPTY JAR
37 / 1
ART DIRECTION
Sally Diederichsen
COPYWRITING
Lee Garfinkel
CREATIVE DIRECTION
Lee Garfinkel
AGENCY
Lowe & Partners / SMS
CLIENT
Nabisco - Grey
Poupon
ENTRANT LOCATION
New York, NY

PARTHENON / PUEBLO /
BODIAM
37 / 3
ART DIRECTION
Dane Johnson,
Mark Kuehn
COPYWRITING
Pat Knapp, Tom Rosen
AGENCY
Cramer - Krasselt /
Milwaukee
CLIENT
Johnson Controls
ENTRANT LOCATION
Milwaukee, WI

THE VENTILATION *is fine,* BUT WE'Ɒ WORK ON THE COLD ZONES IN THE LOBBY AND *north-facing* ROOMS.

{ THE PARTHENON, *Athens, Greece* }

BUILDING SECURITY *is quite good, but* WE'Ɒ RECOMMEND SOME *improvements in* DUST FILTRATION.

{ PUEBLO INDIAN DWELLINGS, *Canyon de Chelly, Arizona* }

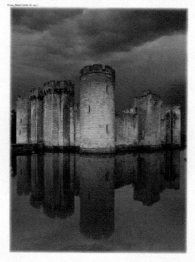

DECENT UPPER FLOOR *temperature balance,* BUT LET'S ADDRESS *humidity problems* IN THE LOWER LEVEL.

{ BODIAM CASTLE, *Sussex, England* }

OUR NAME IS MUD.

To most makers of footwear and apparel, mud is a dirty word.

Not to us. The way we see it, bad weather builds character. And if you've ever seen the character lines in a well-used Timberland® boot, you know what we mean.

What makes our boots (and all Timberland leather gear) age so proudly is the interaction of the elements in all their force with the finest materials the earth can provide.

Take the three pieces of rugged, versatile footwear shown on these pages. One is our signature, the timeless waterproof boot for all-around rugged use. Two is our handsewn Trekker, lined with a Gore-Tex® fabric bootie for waterproof comfort on the trail under any and all conditions.

And three is our well-known Weatherbuck, which combines classic casual shoe

styling with the no-compromise waterproof technology perfected in our boots, an ideal choice for work or weekends.

All three look and feel as great when the mud is flying as when the sun is shining. So does our Iditarod™ 3-in-1 storm coat.

To create it, we spent years working with Alaska's top mushers. And although you may never encounter Yukon-sized precipitation, you'll find its composition ideal for fending off the extremes of turbulence found in much of the North American continent. Specifically, its quilted inner jacket with Primaloft® insulation and nylon shell with waterproof, breathable Gore-Tex laminate.

Wind, rain, mud and slush are a normal part of the world we live in.

It's life — so make sure you dress for the occasion. Just call 1-800-445-5545 for a more complete look at Timberland boots, shoes and clothing.

Here's mud in your eye.

BOOTS, SHOES, CLOTHING.
WIND, WATER, EARTH AND SKY.

THERE ARE TIMES WHEN YOUR OWN SKIN ISN'T ENOUGH.

The point of our revealing photograph isn't to prove you should cover your butt with clothing when it snows.

It's to dramatize the fact that your skin does some wonderful things to keep you comfortable in extreme conditions. And so does our skin, the incomparably protective leathers we use in Timberland® boots, shoes and clothing.

Consider the four pieces of durable Timberland gear pictured in this ad.

Although each has a different use, they share a common foundation in the quality of leather used in their construction. Hide that's hand-picked for best results during the waterproofing process. And for natural coloration that weathers handsomely over time.

As its name suggests, the Iditarod™ Super Boot comes out of our many years of experimental work outfitting mushers who compete in

the annual blizzard-whipped 1,049-mile sled dog race stretching from Anchorage to Nome, Alaska.

With the Iditarod as our testing lab, we've proven that the waterproof leathers and 800-gram Thinsulate® insulation in this boot can stand up to anything in North America.

And even though you wouldn't wear our

Litchfield Bomber in a sled dog race, it will show you our long-standing ability to make waterproof leather as comfortable in a cloudburst as on a day when there isn't a cloud in the sky.

Likewise, our Weatherbuck Wingtips will take you to the office on a stormy day with feet as dry

and warm as if you were wearing the toughest Timberland boots. In fact, the method we use to waterproof these shoes comes directly from our boot-building repertoire. Over twenty years of industry leadership. No shortcuts and no compromises.

Lastly, our name wouldn't be Timberland if our fall offering didn't include a handsewn chukka boot for rugged wear, rain or shine. You get the double comfort of genuine handsewn construction plus a waterproof system built around a Gore-Tex® fabric bootie.

It's been a good million years since the skin you were born with was forced to endure the planet's wildest extremes.

Not to worry. Use ours.

For more information about Timberland boots, shoes and clothing, call 1-800-445-5545.

BOOTS, SHOES, CLOTHING.
WIND, WATER, EARTH AND SKY.

MESS WITH MOTHER NATURE.

For years some companies have been telling women, "don't mess with Mother Nature."

Not this company.

It's our belief that the more you get involved with Mother Nature the better off you'll be. And we're talking about involvement with all of her moods. Stormy as well as sunny. Freezing cold as well as pleasantly warm.

We build our boots, shoes and clothing to let you mess with nature wherever it sweeps into your life. The context can be rugged wilderness or the urban jungle — it's all Timberland.®

Our guaranteed waterproof Weatherbucks, for example, will take you to the office or off-road with classic style and total protection against sudden shifts in meteorological patterns.

That's because they are built with the same no-compromise waterproof technology as our boots. Boots such as the six-

eyelet model with the genuine brass eyelets you see in the picture. The durable leather on the outside is matched with smooth glove leather on the inside. And the sole, as in the Weatherbuck, is directattached to allow absolutely no water entry.

One of our signature styles is the classic Karrie boot, whose enduring profile is formed from premium waterproof leather crafted individually with genuine handsewn moccasin construction.

Timeless as this boot appears, the inner technology that keeps you warm and dry is years ahead.

Its Gore-Tex® fabric bootie is literally a shoe within a shoe, surrounding your foot with complete waterproof protection on muddy trails and rain-soaked streets.

Our careful blend of style and protection also works above the ankle. Witness our hip-length bomber, whose magnificently rugged cowhide shrugs off water and resists stains. In that sense, it's exactly like a Timberland boot. Good-looking as it may be, the real story is in the performance.

With Timberland gear, you and Mother Nature don't just coexist on this planet. You're true friends.

Just call 1-800-445-5545 for the name of the Timberland retailer nearest you.

BOOTS, SHOES, CLOTHING.
WIND, WATER, EARTH AND SKY.

OUR NAME IS MUD / SKIN ISN'T ENOUGH./MESS
37 / 4

ART DIRECTION
Margaret McGovern

COPYWRITING
Paul Silverman

PHOTOGRAPHY
Paul Giraud/Stock,
Product : Jon Holt
Studio

AGENCY
Mullen

CLIENT
The Timberland
Company

ENTRANT LOCATION
Wenham, MA

NBC / 24 YEAR OLD /
TATTOO
37 / 5
ART DIRECTION
Jeff Vogt
TYPOGRAPHIC DESIGN
Graham Clifford
CREATIVE DIRECTION
Ty Montague
PHOTOGRAPHY
Dennis Chalkin,
David Massy
Mark Seliger
PRODUCTION
Vicki Herzog
AGENCY
Chiat / Day New York
CLIENT
MTV Music Television
ENTRANT LOCATION
New York, NY

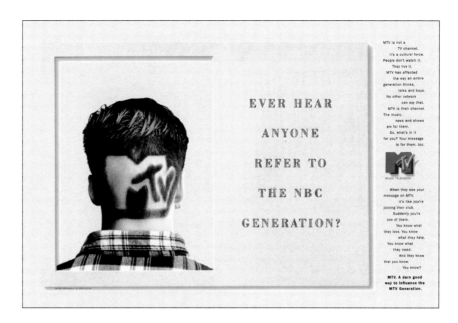

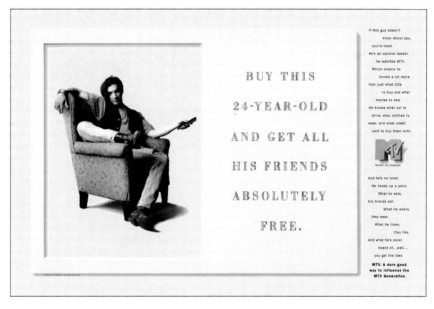

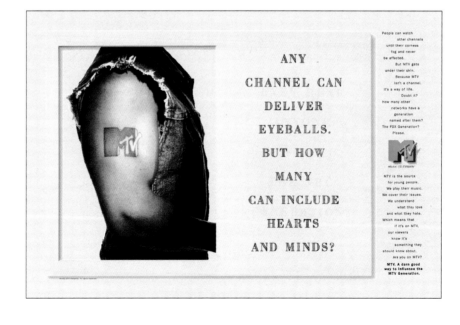

HOW TO SURVIVE A MELTDOWN.

At Timberland, we've spent the past two decades showing people how to survive snow-storms big enough to bury a house. But what happens when all that snow melts? When cabin fever changes to spring fever? When the frozen rivers yawn, crack, surge and boil, and the sleds give way to canoes? That's when you take off your Timberland® boots and put on the Timberland Mountain Trainer (TMT) sandal, so rugged it's like a guide boot without the side panels. Designed for hiking and off-road use, this performance sandal has a multi-directional diamond-cut rubber lug sole and a contoured footbed for support.

Take the TMT sandal, fill in the spaces with full grain leather, and you've got the TMT GTX®, the only true outdoor cross-trainer available in today's market. It will fend off anything the wilderness or the urban jungle can throw at you. Since the name inside is Timberland, it's not only waterproof but water-proven. (Take away the Gore-Tex fabric and you've got the TMT Lean, for all those situations that really don't require waterproofing.) Wear either style with our trekking shell, light in weight but heavy on performance features such as mesh ventilation, roll-up storm hood and sleeves with an action gusset for unrestricted arm movement. Anyone who enters the Iditarod® Sled Dog Race knows what Timberland can do with white snow. Wait till you see what we can do with white water.

BOOTS. SHOES. CLOTHING. WIND, WATER, EARTH AND SKY.

WHAT TO WEAR WHEN IT'S RAINING, IT'S POURING AND THE OLD MAN IS SNORING.

The guide who gave you fly-fishing lessons told you two things about the local trout. One. They bite better when it's early. Two. They bite even better when it's early and it's raining. Point One is quite easily addressed. All you need is the will to leave your dear snoring companion to his dreams. While you hit the streams. To handle Point Two, you need only know one name. Timberland. Rugged gear made especially for days when it's pouring so hard the fish don't know where the stream ends and the frying pan begins.

So before you enter the drizzling dawn, you go to the closet and pull out his Timberland® trekking shell. He's not going to need it where he is – and the classic styling looks as great on women as on men. You'll be as snug in the stormy outdoors as he is in that cozy sleeping bag. Then put on a pair of your new boots or shoes – styled by Timberland for women, but as weatherproof as anything we make for men. You'll find Timberland boots, shoes and apparel work overtime to protect you from the elements, and you'll get a whole different benefit when the sun finally breaks through and you walk home. Looking every bit as good as you feel. Why, even the old man will greet you smiling. Assuming you give him back his precious Timberland trekking shell, and you've caught enough fish for two.

BOOTS. SHOES. CLOTHING. WIND, WATER. EARTH AND SKY.

TIPTOE THROUGH THE TETONS.

We have a short message for everyone who thinks Timberland® only makes gear for conditions of 50° below zero. Take a hike. Take it in April, May or June. Take it on an August scorcher hot enough to fry your morning omelette. Take it wearing gear so durable and comfortable it will take miles off mountains.

In unpredictable summer weather, give your feet the extra protection of our waterproof Euro-hiker. Built of premium rough-out leather, this hiker features our exclusive Trail Grip™ rubber sole for extra traction, an SB rubber midsole, anti-torque innersole with steel shank, removable orthotic and latex-sealed seams. If you prefer general all-terrain trekking, the boot of choice is our all-leather waterproof Timberland Mountain Trainer (TMT), with multi-directional diamond-cut rubber lug sole. The technological leader in its category, the TMT introduces the first internal fit system featuring stretch Gore-Tex® fabric. What's more, TMT technology is now available around the country in a classic women's oxford design, for good-looking per-formance at any altitude.

And for true Timberland protection above shoe level, don't leave home without our lightweight, trekking shell with ventilated mesh front and back pockets, roll-up storm hood, total drawcord system, action armholes and articulated sleeve construction. Timberland earned its reputation helping mushers hike across 1,049 miles of frozen Alaskan tundra.

Now we're turning our technology towards any-one who hikes anywhere. The Grand Canyon. The Appalachian Trail, the local state park. We won the Iditarod® Sled Dog Race. Can the Tetons be far behind?

BOOTS. SHOES. CLOTHING. WIND, WATER, EARTH AND SKY.

SURVIVE A MELTDOWN
/OLD MAN IS SNORING /
TETONS
37 / 6
ART DIRECTION
Margaret McGovern
COPYWRITING
Paul Silverman
PHOTOGRAPHY
David Muench,
Ray Meeks,
Product: John Holt
Studio
AGENCY
Mullen
CLIENT
The Timberland
Company
ENTRANT LOCATION
Wenham, MA

**REPENT/ GOOD
STICK/TRANSLATION**
37 / 7
ART DIRECTION
Wade Koniakowsky
COPYWRITING
Harry Cocciolo
PHOTOGRAPHY
Arthur Meyerson
STUDIO
dGWB
ENTRANT LOCATION
Irvine, CA

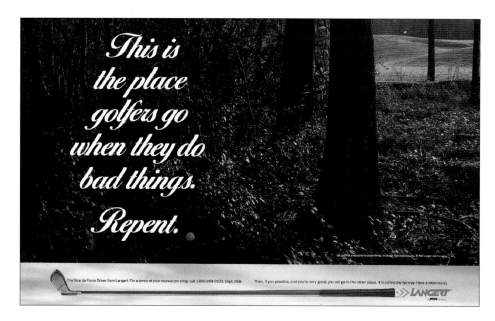

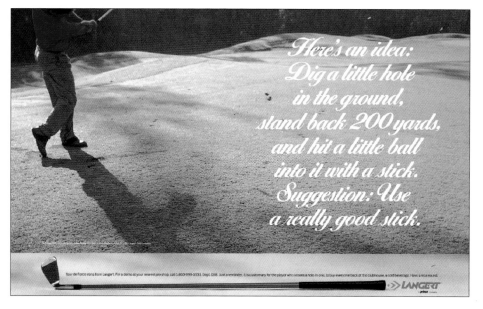

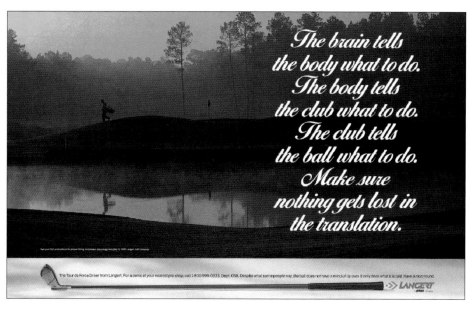

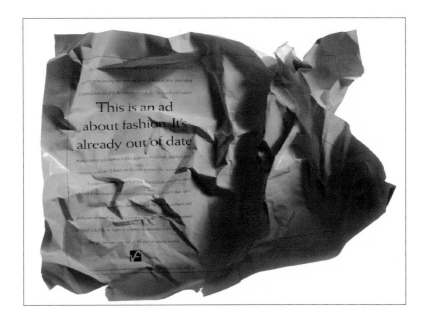

**THIS IS AN AD ABOUT
FASHION / HOW FAST
CAN THIS LITTLE PIGY /
THE RAT RACE**
37 / 9
ART DIRECTION
Shari Hindman
COPYWRITING
John Mahoney
PHOTOGRAPHY
Brad Guice
PRODUCTION
Kay Franz
AGENCY
The Martin Agency
CLIENT
VF Corporation
ENTRANT LOCATION
Richmond, VA

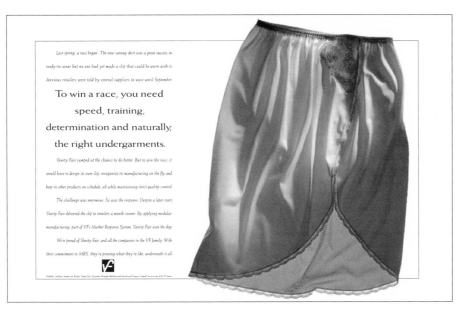

YOUR EYES / WHEN YOU
CONSIDER / IRONICALLY
37 / 10
ART DIRECTION
Rob Rich
COPYWRITING
Mike Sheeham
PHOTOGRAPHY
stock
AGENCY
CGFM
CLIENT
Stevens Roofing
ENTRANT LOCATION
Boston, MA

Your eyes will have a very difficult time picking up the seams on this roof. Fortunately, so will the wind.

Your eyes do not deceive you. What you're looking at is the first black, heat-welded, mechanically-attached, scrim-reinforced rubber roofing system from Stevens. It's called Hi-Tuff/EP.™ Hi-Tuff/EP is a revolutionary rubber membrane that contains no plasticizers, so it weathers exceptionally well. This sheet is specifically designed like all other Stevens Roofing Systems, to be hot-air welded and mechanically attached. So the seams can be made as strong as the membrane itself.

We're talking about aged peel strength values of 25-35 lbs./inch compared to liquid adhesive and tape seams of one to seven pounds. Tear values of 55 pounds versus 10. Breaking strengths of 225 pounds compared to 90 for other common reinforced black rubber membranes.

The result? An extremely durable roofwide sheet of reinforced black rubber without the need for messy seam solvents, adhesives or tapes. One with seams that the wind will find next to impossible to pull apart. Nice to mention a roof that's far more environmentally friendly.

And if that's not news enough, here's the clincher. Stevens Hi-Tuff/EP is manufactured on the most technologically-advanced computer calendering operation in the country, uses tough Stevens fastening systems and specifications, and is installed by professional authorized Hi-Tuff applicators. Meaning you can have the reliability and security of heat-welded seams in a black rubber system for about the same installed cost as a reinforced adhesive-seamed system.

Hi-Tuff/EP comes to you from Stevens, the company that perfected heat-weldable mechanically-attached roofing systems. Over 700 million feet of them. Which is why Hi-Tuff is North America's number one specified heat-weldable roofing system.

So, while you may have a little trouble picking up the seams in the photograph above, you'll certainly have no trouble picking up the phone to find out more about Stevens Hi-Tuff/EP. Just call 1-800/621-ROOF and ask Ann Duffy for additional information or to arrange for a quote on your next roof.

When you consider the conditions we work under, it's no wonder our seams are so strong.

When you think of all the jobs you've had in your life, chances are you recall a few difficult working conditions. Now, stretch your imagination a bit and imagine that you're a roof.

Your seams have to work 24 hours a day, seven days a week, every single day of the year. They have to be able to endure searing heat and freezing cold. Torrential rain and awesome wind storms. Not to mention the occasional 70° day with nothing in sight but blue skies and sunshine.

And they will work, provided you're a Stevens Hi-Tuff/EP™ roof. Because Hi-Tuff/EP starts with a revolutionary, ethylene propylene rubber membrane that contains no plasticizers, so it weathers exceptionally well. It's specifically designed, like all other Stevens roofing systems, to be hot-air welded and mechanically attached. So the seams can be made as strong as the membrane itself.

Seams with aged peel strength values of 25-35 lbs./inch compared to liquid adhesive and tape seams of one to seven pounds. Tear values of 55 pounds versus 10. Breaking strengths of 225 pounds compared to 90 for other common reinforced black rubber membranes.

The result? An extremely durable roofwide sheet of reinforced black rubber without the need for messy seam adhesives, tapes or solvents. One with seams that the wind will find next to impossible to get underneath. Not to mention a roof that's far more environmentally friendly.

Stevens Hi-Tuff/EP is manufactured on the most technologically-advanced computer calendering operation in the country, uses tough Stevens fastening systems and specifications, along with professional authorized Hi-Tuff applicators. Meaning you can have the reliability and security of heat-welded seams in a black rubber system for about the same installed cost as a reinforced adhesive-seamed system.

Hi-Tuff/EP comes from Stevens, the company that perfected heat-weldable mechanically-attached roofing systems. Over 700 million feet of them. Which is why Hi-Tuff is North America's #1 specified heat-weldable roofing system.

Call Ann Duffy at 1-800/621-ROOF, for more information or to arrange for a quote on your next roof.

Ironically, the way to keep your seams from coming apart is to get rid of what holds them together.

What separates the new Stevens Hi-Tuff/EP™ Roofing System from most other black, reinforced rubber systems is actually what keeps it together.

You see, Stevens Hi-Tuff/EP is a truly revolutionary, mechanically-attached, scrim-reinforced, black ethylene propylene rubber membrane whose seams are welded using environmentally-friendly hot air. That eliminates the need for messy seam solvents, adhesives or tapes.

In fact, our seams can be made as strong as the membrane itself. The results? Aged peel strength values of 25-35 pounds per inch compared to one to seven for liquid adhesive and tape seams. Tear values of 55 versus 10 pounds. And breaking strengths of 225 pounds compared to 90 for other common reinforced black rubber systems. A major difference.

And if that's not news enough, here's the clincher. Stevens Hi-Tuff/EP is manufactured on the most technologically-advanced computer calendering operation in the country, uses tough Stevens fastening systems and specifications, and is installed by professional authorized Hi-Tuff applicators. Meaning you can have the reliability and security of heat-welded seams in a black rubber system for about the same installed cost as many competitive reinforced adhesive-seamed systems.

Hi-Tuff/EP comes from Stevens, the company that perfected heat-weldable, mechanically-attached roofing systems. Over 700 million feet of them. Which is why Stevens Hi-Tuff is North America's number one specified heat-weldable roofing system.

We'd like to tell you more about Stevens Hi-Tuff/EP. We promise to use all our hot air on our seams, not on our sales pitch. So for more information or to arrange for a quote from an authorized Hi-Tuff applicator, call Ann Duffy or 1-800/621-ROOF.

MONURIL 2000
37 / 1
ART DIRECTION
Ralph Taubenberger
COPYWRITING
Dr. med.
Frank Antwerpes,
Ralph Taubenberger
PHOTOGRAPHY
Christin Losta
AGENCY
Heye + Partner
CLIENT
Zambon GmbH
ENTRANT LOCATION
Unterhaching, Germany

Even if you can't paint, sing, dance, play or act, you can always write.

Your $25, $50, $100 or $250 membership insures the arts will always have a voice in Virginia. Make your own artistic expression. Simply raise a pen. Write to VFTA, 214 N. Jefferson St., Richmond, Virginia 23220, or call 804-644-ARTS.

 VIRGINIANS FOR THE ARTS

EVEN IF YOU CAN'T PAINT
39 / 8
ART DIRECTION
Margaret Teller
DESIGN
Margaret Teller
COPYWRITING
Jonathan Kaler
PHOTOGRAPHY
Chuck Savage
AGENCY
MSI Advertising
• Marketing
• Public Relations
CLIENT
Virginians for the Arts.
ENTRANT LOCATION
Richmond, VA

FETCHING MACHINE
40 / 2

DISTINCTIVE MERIT

ART DIRECTION
Steve Cardon

DESIGN
Steve Cardon

COPYWRITING
John Kinkead,
Rebecca Bentley–Mila,
Bryan DeYoung

PHOTOGRAPHY
Chip Simons,
Ed Rosenberger

AGENCY
EvansGroup /
Salt Lake City

CLIENT
Humane Society
of Utah

ENTRANT LOCATION
Salt Lake City, UT

BIG & BAD
40 / 3

DISTINCTIVE MERIT

ART DIRECTION
Steve Cardon

DESIGN
Steve Cardon

COPYWRITING
John Kinkead,
Rebecca Bentley–Mila,
Bryan DeYoung

PHOTOGRAPHY
Chip Simons,
Ed Rosenberger

AGENCY
EvansGroup /
Salt Lake City

CLIENT
Humane Society
of Utah

ENTRANT LOCATION
Salt Lake City, UT

238

IMAGINE GETTING A PAPER CUT
FROM THIS PAGE AND BLEEDING TO DEATH.

Even the simple act of leafing through a magazine can be threatening to someone with Hemophilia. If you'd like to know more about this unpredictable disease, write: The Hemophilia Foundation, The SoHo Bldg., 110 Greene St., New York, NY 10012.

National Hemophilia Foundation
Hemophilia. Without your help, there's no stopping it.

PAPER CUT
40 / 1
ART DIRECTION
Ed Parks, Jack Low
DESIGN
Ed Parks, Jack Low
COPYWRITING
Jack Low
AGENCY
McMann & Tate
CLIENT
National Hemophilia
Foundation
ENTRANT LOCATION
Weehawken, NJ

DRINKING PROBLEM.
40 / 1
ART DIRECTION
Laura Ee
COPYWRITING
Tony Ray Pereira
PHOTOGRAPHY
Hon Boon Heng
AGENCY
Leo Burnett Pte Ltd
PUBLICATION
Beverly
CLIENT
Association of Women
for Action and
Research (AWARE)
ENTRANT LOCATION
Singapore

TOUGH TO BEAT.
40 / 2
ART DIRECTION
Laura Ee
COPYWRITING
Tony Ray Pereira
PHOTOGRAPHY
Hon Boon Heng
AGENCY
Leo Burnett Pte Ltd
PUBLICATION
Beverly
CLIENT
Association of Women
for Action and
Research (AWARE)
ENTRANT LOCATION
Singapore

THIS WOMAN HAS A DRINKING PROBLEM.
IT'S 5'10" AND 190 LBS.
Your husband's an alcoholic. He beats you every day. His drinking problem has become yours as well. Fourteen cases of abuse against women were reported in 1981. Today, there are 566. And probably many more go unreported. If you're one of the silent Women in Abusive Relationships (WAR), call any one of the following numbers for help: Association of Women For Action And Research (AWARE) Helpline at 293 1011 or Samaritans Of Singapore at 221 4444. Break the silence. Stop the violence.

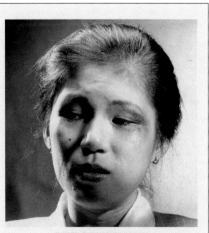

AT WORK, SHE'S TOUGH TO BEAT.
AT HOME, IT'S A DIFFERENT STORY.
Some women come home every day to an abusive husband, not knowing if they'll survive the next battering. Fourteen cases of abuse against women were reported in 1981. Today, there are 566. And probably many more go unreported. If you're one of the silent Women in Abusive Relationships (WAR), call any one of the following numbers for help: Association of Women For Action And Research (AWARE) Helpline at 293 1011 or Samaritans Of Singapore at 221 4444. Break the silence. Stop the violence.

BROKEN HEART.
40 / 3
ART DIRECTION
Laura Ee
COPYWRITING
Tony Ray Pereira
PHOTOGRAPHY
Hon Boon Heng
AGENCY
Leo Burnett Pte Ltd
CLIENT
Association of Women
for Action and
Research (AWARE)
ENTRANT LOCATION
Singapore

REPLY
40 / 4
ART DIRECTION
Enric Aguilera
COPYWRITING
Toni Segarra
CREATIVE DIRECTION
Toni Segarra,
Felix Fdez. de Castro.
PHOTOGRAPHY
Ramon Serrano
AGENCY
Delvico Bates
Barcelona
CLIENT
Spanish Cancer
Association
ENTRANT LOCATION
Barcelona, Spain

KUNDEN MIT WENIG
GELD
40 / 5
ART DIRECTION
Moi Soltek
DESIGN
Christoph Rabanus
COPYWRITING
Oliver Krippahl
PHOTOGRAPHY
Dietmar Henneck
AGENCY
Jung v. Matt
CLIENT
SIXT Autovermietung
ENTRANT LOCATION
Hamburg, Germany

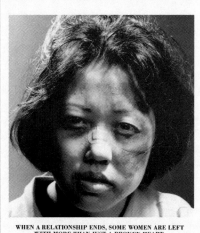

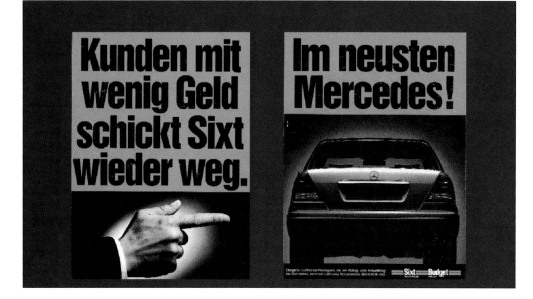

PERSONALS
41 / 1

DISTINCTIVE MERIT

ART DIRECTION
Steve Cardon

DESIGN
Steve Cardon

COPYWRITING
John Kinkead,
Rebecca Bentley–Mila,
Bryan DeYoung

PHOTOGRAPHY
Chip Simons,
Ed Rosenberger

AGENCY
EvansGroup /
Salt Lake City

CLIENT
Humane Society
of Utah

ENTRANT LOCATION
Salt Lake City, UT

DOE MONTANHAS / DOE
HORIZONTES / DOE RIOS /
DOE OCEANOS
41 / 4
SILVER
ART DIRECTION
José Carlos Lollo
COPYWRITING
Nizan Guanaes
PHOTOGRAPHY
Arnaldo Pappalardo,
archives
PRODUCTION
Anelito Nobrega
AGENCY
DM9 Publicidade
CLIENT
Banco De Olhos
(Eye Bank)
ENTRANT LOCATION
Sao Paulo, Brazil

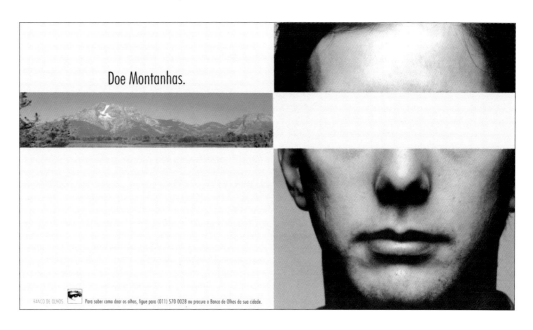

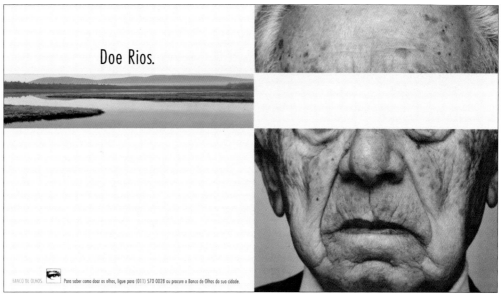

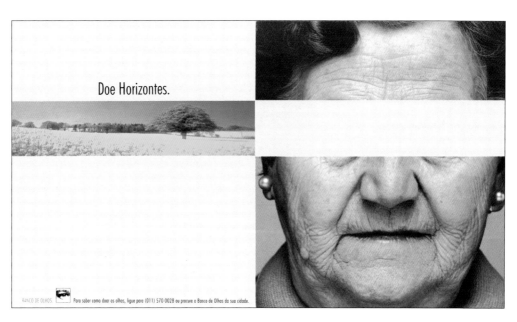

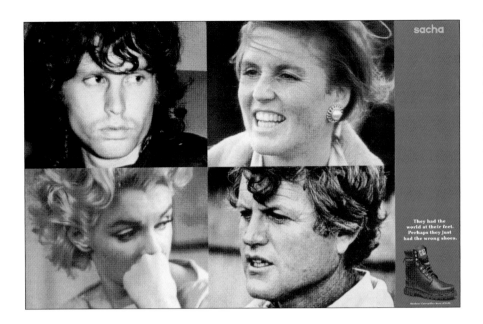

THEY HAD THE WORLD
AT THEIR FEET / IMPROVE
THE APPEARANCE OF
YOUR FEET / BUT WHAT
DO YOU PUT THE
SECOND
41 / 1, 2, 3
ART DIRECTION
Gary Marshall
DESIGN
Gary Marshall
COPYWRITING
Paul Marshall
PHOTOGRAPHY
Mick Beilby
ENTRANT LOCATION
London, England

**OUR COOK WON'T
DISCUSS HIS RECIPES**
43 / 1
DISTINCTIVE MERIT
ART DIRECTION
Taylor Smith
COPYWRITING
Steve Koeneke
CREATIVE DIRECTION
Rich Kohnke
PHOTOGRAPHY
Taylor Smith
PRODUCTION
Jim McDonald
AGENCY
Kohnke Koeneke
CLIENT
Hector's
ENTRANT LOCATION
Milwaukee, WI

YOU WALK PAST
43 / 2
ART DIRECTION
Chad Farmer
COPYWRITING
David Bradley
PHOTOGRAPHY
Loren Haynes
AGENCY
Lambesis
CLIENT
HypeClothing
ENTRANT LOCATION
San Diego, CA

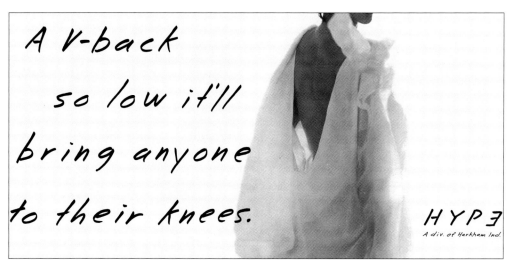

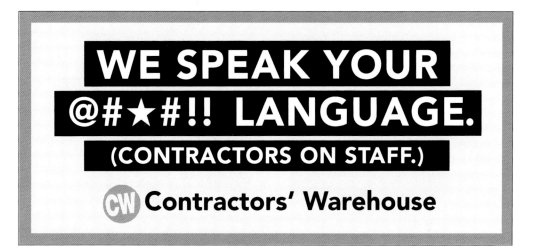

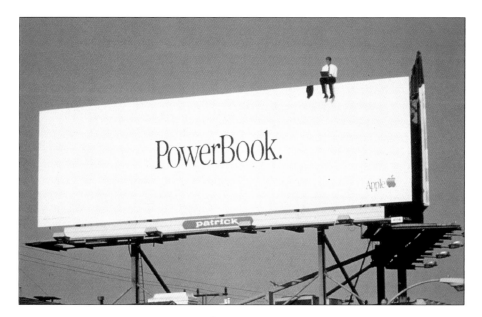

V-BACK
43 / 3
ART DIRECTION
Chad Farmer
COPYWRITING
David Bradley
PHOTOGRAPHY
Loren Haynes
AGENCY
Lambesis
CLIENT
HypeClothing
ENTRANT LOCATION
San Diego, CA

LANGUAGE
43 / 4
ART DIRECTION
Don Carter
DESIGN
Grant Sanders
COPYWRITING
Chris Knopf
PRODUCTION
Barry Bridges
AGENCY
Mintz & Hoke
CLIENT
Contractors
Warehouse
ENTRANT LOCATION
Avon, CT

POWERBOOK
43 / 5
ART DIRECTION
Susan Westre
Seiji Kishi
COPYWRITING
Chris Wall
PRODUCTION
Susan Kassman
AGENCY
BBDO
CLIENT
Apple Computer
ENTRANT LOCATION
Los Angeles, CA

DENTAL FLOSS
43 / 6
ART DIRECTION
Tony Angotti
COPYWRITING
Dion Hughes
AGENCY
Angotti, Thomas
Hedge, Inc.
CLIENT
Molson Breweries, Inc.
ENTRANT LOCATION
New York, NY

GUPPY
43 / 7
ART DIRECTION
Tony Angotti
COPYWRITING
Dion Hughes
AGENCY
Angotti, Thomas
Hedge, Inc.
CLIENT
Molson Breweries, Inc.
ENTRANT LOCATION
New York, NY

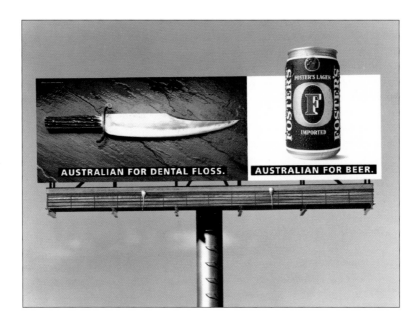

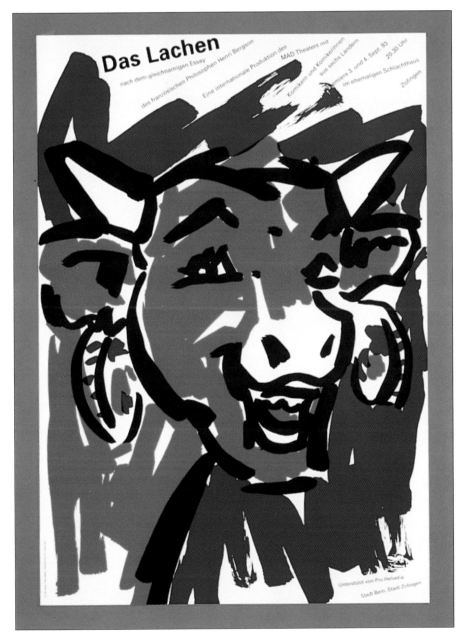

JAZZ FESTIVAL
43 / 1
ART DIRECTION
Niklaus Troxler
DESIGN
Niklaus Troxler
ILLUSTRATION
Niklaus Troxler
CLIENT
Jazz in Willisau
ENTRANT LOCATION
Willisau, Switzerland

BAND
43 / 2
ART DIRECTION
Niklaus Troxler
DESIGN
Niklaus Troxler
ILLUSTRATION
Niklaus Troxler
CLIENT
Jazz in Willisau
ENTRANT LOCATION
Willisau, Switzerland

DAS LACHEN
43 / 3
ART DIRECTION
Niklaus Troxler
DESIGN
Niklaus Troxler
ILLUSTRATION
Niklaus Troxler
CLIENT
Mad Theater, Bern
ENTRANT LOCATION
Willisau, Switzerland

AUSSTELLNING
43 / 4
ART DIRECTION
Niklaus Troxler
DESIGN
Niklaus Troxler
ILLUSTRATION
Niklaus Troxler
CLIENT
Galerie Ars Collect,
Lucerne
ENTRANT LOCATION
Willisau, Switzerland

PLAY THE MUSIC OF JIMI
HENDRIX
43 / 5
ART DIRECTION
Niklaus Troxler
DESIGN
Niklaus Troxler
ILLUSTRATION
Niklaus Troxler
CLIENT
Jazz in Willisau
ENTRANT LOCATION
Willisau, Switzerland

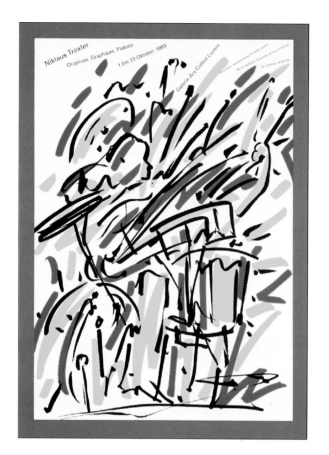

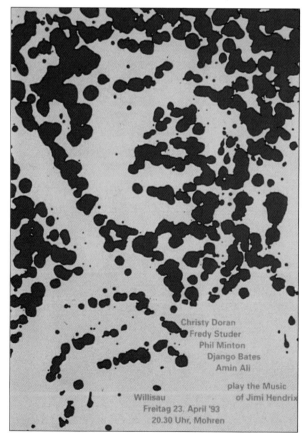

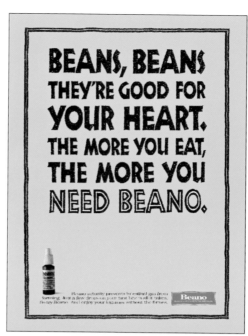

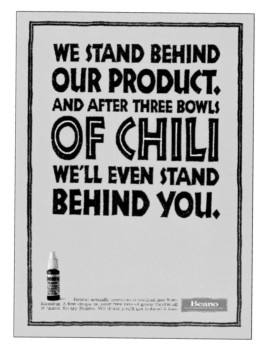

WE STAND ...
44 / 1
DISTINCTIVE MERIT
ART DIRECTION
Mickey Paxton
DESIGN
Mickey Paxton
COPYWRITING
Steve Saari
PHOTOGRAPHY
Bob Jacobs
AGENCY
Houston Effler
& Partners
CLIENT
AKPharma Inc. (Beano)
ENTRANT LOCATION
Boston, MA

**GALOSHES/DENTAL
FLOSS/GUPPY**
44 / 2
ART DIRECTION
Tony Angotti
COPYWRITING
Dion Hughes
AGENCY
Angotti, Thomas
Hedge, Inc.
CLIENT
Molson Breweries,.
U.S.A., Inc.
ENTRANT LOCATION
New York, NY

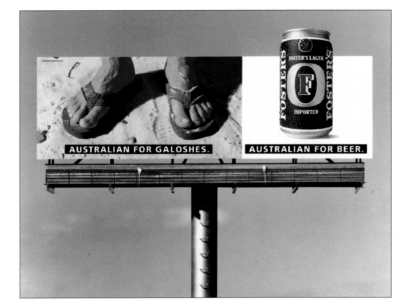

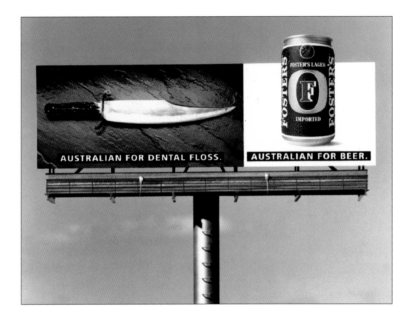

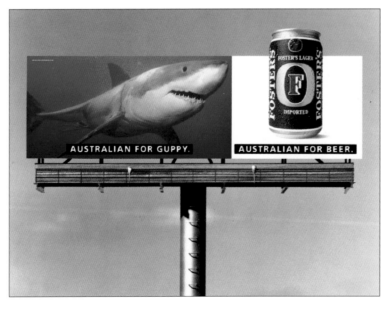

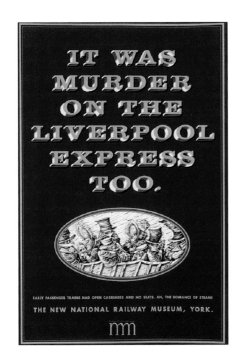

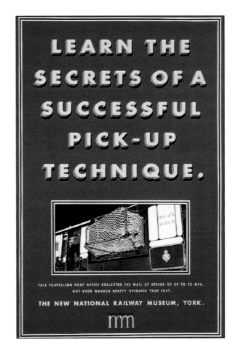

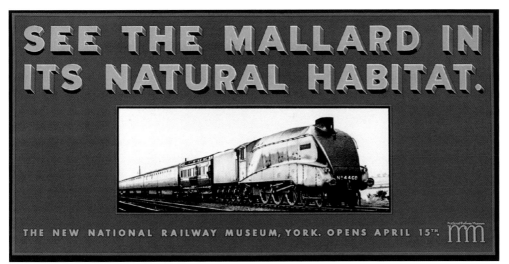

PLATFORMS / MALLARD /
LIVERPOOL EXPRESS .
PICK-UP TECHNIQUE /
RAILWAY WORKER
STUFFED
44 / 1
ART DIRECTION
Andy McKay
COPYWRITING
Tim Riley
ILLUSTRATION
Tony Macsweeny
AGENCY
Simons Palmer
CLIENT
National Railway
Museum
ENTRANT LOCATION
London, England

MOSES
45 / 2
SILVER
ART DIRECTION
Sal DeVito
COPYWRITING
Abi Aron,
Rob Carducci
CREATIVE DIRECTION
Sal DeVito
AGENCY
DeVito / Verdi
CLIENT
Empire Kosher Poultry
ENTRANT LOCATION
New York, NY

WE'RE FASTER THAN YOU
WERE
45 / 4
ART DIRECTION
Andy Azula,
Julie Brendel
COPYWRITING
Bill Milkereit
AGENCY
Loeffler Ketchum
Mountjoy
CLIENT
AAA Bail Bondsmen
ENTRANT LOCATION
Charlotte, NC

WE'RE THERE IN 20
MINUTES OR YOUR NEXT
MEAL IS FREE
45 / 5
ART DIRECTION
Andy Azula,
Julie Brendel
COPYWRITING
Bill Milkereit
AGENCY
Loeffler Ketchum
Mountjoy
CLIENT
AAA Bail Bondsmen
ENTRANT LOCATION
Charlotte, NC

ONLY CHOPIN TAKES
YOU BACK FASTER
45 / 6
ART DIRECTION
Eric Grunlund,
Marc Klein
DESIGN
David George
COPYWRITING
Robert Swartz,
Marc Klein
PHOTOGRAPHY
Eric Gronlund
CLIENT
Lot Polish Airlines
ENTRANT LOCATION
New York, NY

WE'RE FASTER THAN YOU WERE.

Call AAA Bail Bonding for cash in a flash. 728-7478.

WE'RE THERE IN 20 MINUTES OR YOUR NEXT MEAL IS FREE.

Call AAA Bail Bonding for cash in a flash. 728-7478.

ONLY CHOPIN TAKES YOU BACK FASTER.

Nobody flies you to the new Poland faster than LOT Polish Airlines Boeing 767s. The only non-stops to Warsaw.
THE POLISH AIRLINE
LOT

IN THIS CITY, A WOMAN IS VICTIMIZED EVERY 3 SECONDS. SHE PAYS RETAIL.

Designer clothes 40-75% off, every day. New York City, Manhasset, L.I. & New Jersey.

DAFFY'S
CLOTHES THAT WILL MAKE YOU, NOT BREAK YOU.

THE SUGGESTED RETAIL PRICE OF THIS SHIRT IS $125. WE HAVE A SUGGESTION FOR WHOEVER SUGGESTED IT.

Designer clothes 40-75% off, every day. New York City, Manhasset, L.I. & New Jersey.

DAFFY'S
CLOTHES THAT WILL MAKE YOU, NOT BREAK YOU.

MOST LOCAL PAPERS RUN OBITUARIES
OF PROMINENT NEW YORKERS.
BUT NOT WHILE THEY'RE STILL ALIVE.

THE NEW YORK OBSERVER

THE INSIDER'S UNDERGROUND NEWSPAPER ◆ HOME DELIVERY: (212) 755~2400.

VICTIMIZED
45 / 7
ART DIRECTION
Audrey DeVries
COPYWRITING
Audrey DeVries
CREATIVE DIRECTION
Sal DeVito
PHOTOGRAPHY
Cailor / Resnick
AGENCY
DeVito / Verdi
CLIENT
Daffy's
ENTRANT LOCATION
New York, NY

SUGGESTION
45 / 9
ART DIRECTION
Sal DeVito
COPYWRITING
David Bromberg,
Audrey DeVries
CREATIVE DIRECTION
Sal DeVito
PHOTOGRAPHY
Cailor / Resnick
AGENCY
DeVito / Verdi
CLIENT
Daffy's
ENTRANT LOCATION
New York, NY

OBITUARIES
45 / 10
ART DIRECTION
Andrea D'Aquino
COPYWRITING
David Bromberg
PHOTOGRAPHY
Mark Weiss
AGENCY
Weiss, Whitten,
Stagliano Inc.
CLIENT
The New York
Observer
ENTRANT LOCATION
New York, NY

NEARSIGHTED
45 / 11
ART DIRECTION
Bryan Bulison
COPYWRITING
Todd Tilford
PHOTOGRAPHY
Tom Ryan
AGENCY
The Richards Group
CLIENT
Optique
ENTRANT LOCATION
Dallas, TX

POOR VISION
45 / 12
ART DIRECTION
Bryan Bulison
COPYWRITING
Todd Tilford
PHOTOGRAPHY
Tom Ryan
AGENCY
The Richards Group
CLIENT
Optique
ENTRANT LOCATION
Dallas, TX

GRANDFATHER'S VISION
45 / 13
ART DIRECTION
Bryan Bulison
COPYWRITING
Todd Tilford
PHOTOGRAPHY
Tom Ryan
AGENCY
The Richards Group
CLIENT
Optique
ENTRANT LOCATION
Dallas, TX

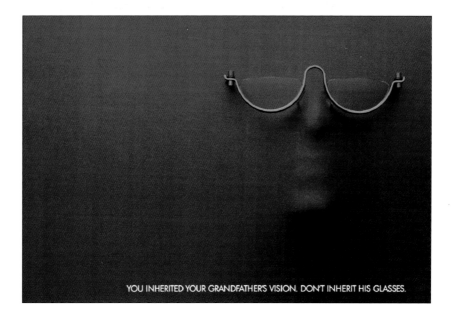

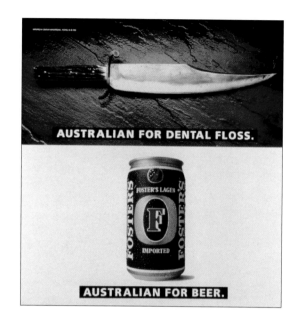

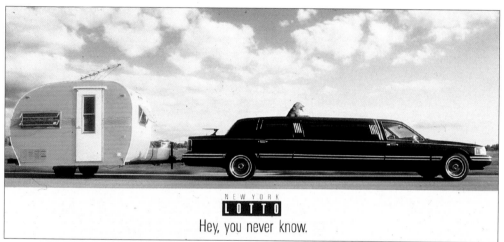

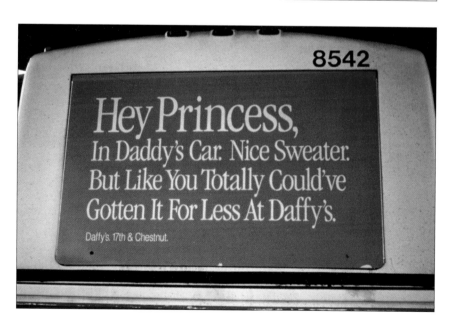

DENTAL FLOSS
45 / 14
ART DIRECTION
Tony Angotti
COPYWRITING
Dion Hughes
AGENCY
Angotti, Thomas
Hedge, Inc.
CLIENT
Molson Breweries,
U.S.A., Inc.
ENTRANT LOCATION
New York, NY

DOG IN LIMO
45 / 15
ART DIRECTION
David Angelo
DESIGN
David Angelo
COPYWRITING
Paul Spencer
CREATIVE DIRECTION
Jack Mariucci,
Bob Mackall
PHOTOGRAPHY
Joe Baraban
CLIENT
New York State
Lottery
ENTRANT LOCATION
New York, NY

PRINCESS
45 / 16
ART DIRECTION
Rob Carducci,
Abi Aron
COPYWRITING
Abi Aron,
Rob Carducci
CREATIVE DIRECTION
Sal DeVito
AGENCY
DeVito / Verdi
CLIENT
Daffy's
ENTRANT LOCATION
New York, NY

JAGUAR
45 / 17
ART DIRECTION
Abi Aron
Rob Carducci
COPYWRITING
Rob Carducci,
Abi Aron
CREATIVE DIRECTION
Sal DeVito
AGENCY
DeVito / Verdi
CLIENT
Daffy's
ENTRANT LOCATION
New York, NY

VOLVO
45 / 18
ART DIRECTION
Rob Carducci,
Abi Aron
COPYWRITING
Abi Aron
Rob Carducci
CREATIVE DIRECTION
Sal DeVito
AGENCY
DeVito / Verdi
CLIENT
Daffy's
ENTRANT LOCATION
New York, NY

BROOKS HERS
45 / 19
ART DIRECTION
Walt Connelly
DESIGN
Walt Connelly
COPYWRITING
Bruce Richter
ILLUSTRATION
Walt Connelly
AGENCY
Ogilvy & Mather, NY
CLIENT
Brooks Brothers
ENTRANT LOCATION
New York, NY

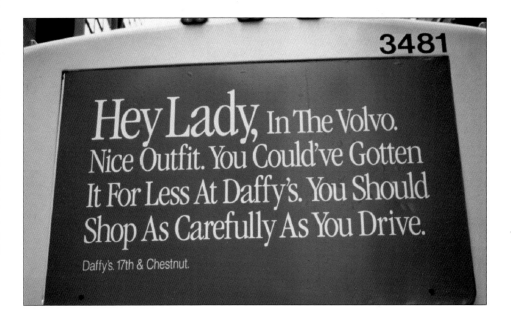

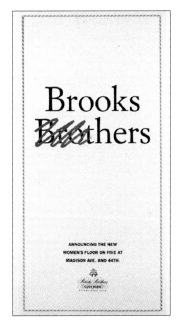

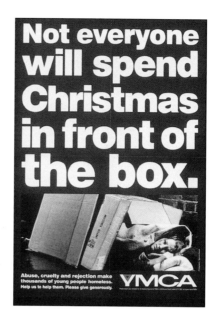

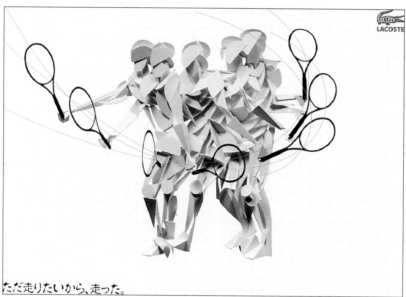

ただ走りたいから、走った。

NOT EVERYONE WILL
SPEND CHRISTMAS
45 / 1
ART DIRECTION
James Spence
COPYWRITING
Caroline Gibson
PHOTOGRAPHY
Spencer Rowell
AGENCY
Impact FCA !
CLIENT
YMCA
ENTRANT LOCATION
London, England

LACOSTE
45 / 2
ART DIRECTION
Masato Ohki
DESIGN
Masato Ohki,
Atsushi Kohgo
COPYWRITING
Rika Enomoto
CREATIVE DIRECTION
Kunitaka Okada
PHOTOGRAPHY
Masato Ohko
SCULPTURE
Masato Ohko
STUDIO
Masato Ohki
Design Room
AGENCY
I & S
CLIENT
Seibu, Dep. Store,
Lacoste
ENTRANT LOCATION
Kawasaki City, Japan

THE SUGGESTED RETAIL PRICE OF THIS SHIRT IS $125. WE HAVE A SUGGESTION FOR WHOEVER SUGGESTED IT.

Designer clothes 40-75% off, every day. New York City, Manhasset, L.I. & New Jersey.

DAFFY'S
CLOTHES THAT WILL MAKE YOU, NOT BREAK YOU.

SUGGESTION / CHOKING /
VICTIMIZED
46 / 4
DISTINCTIVE MERIT
ART DIRECTION
Sal DeVito,
Audrey DeVries,
Tom Gianfagna,
Pat Sutherland
COPYWRITING
Audrey DeVries,
Pat Sutherland,
Tom Gianfagna,
David Bromberg
CREATIVE DIRECTION
Sal DeVito
PHOTOGRAPHY
Cailor / Resnick
AGENCY
DeVito / Verdi
CLIENT
Daffy's
ENTRANT LOCATION
New York, NY

DO YOU FIND THE PRICE OF DESIGNER CLOTHES HARD TO SWALLOW?

Designer clothes 40-75% off, every day. New York City, Manhasset, L.I. & New Jersey.

DAFFY'S
CLOTHES THAT WILL MAKE YOU, NOT BREAK YOU.

On
occasion,
the
words
"Pardon Me"
are used
in
New York.

**Traffic would be moving a lot faster
if those limos up ahead
would quit passing the Grey Poupon.**

ON OCCASION / QUEENS / TRAFFIC
46 / 1

ART DIRECTION
Sally Diederichsen

COPYWRITING
Jennifer Sandbank,
Lesley Stern

CREATIVE DIRECTION
Lee Garfinkel

AGENCY
Lowe & Partners/ SMS

CLIENT
Nabisco -
Grey Poupon

ENTRANT LOCATION
New York, NY

EGGS SLAM 1,2,3
46 / 2
ART DIRECTION
Sal DeVito
COPYWRITING
Sal DeVito
PHOTOGRAPHY
Cailor / Resnick
AGENCY
DeVito / Verdi
CLIENT
Empire Kosher Poultry
ENTRANT LOCATION
New York, NY

The Other Chicken Companies Are Going To Hate This Ad.

Many chickens on the market today are less than perfect. That's because the companies that sell them believe if a chicken is good enough to be approved by the government, it's good enough to be sold to you. At Empire, after a chicken passes government inspections, it has to pass kosher inspections–where many times a chicken is rejected for not being as perfect as we believe a chicken should be. Where can you find an Empire chicken? They're conveniently located at your supermarket and butcher, next to the chickens that are less than perfect.

EMPIRE KOSHER CHICKEN Empire

The Other Chicken Companies Are Going To Hate This Ad.

Many chickens on the market today are less than perfect. That's because the companies that sell them believe if a chicken is good enough to be approved by the government, it's good enough to be sold to you. At Empire, after a chicken passes government inspections, it has to pass kosher inspections–where many times a chicken is rejected for not being as perfect as we believe a chicken should be. Where can you find an Empire chicken? They're conveniently located at your supermarket and butcher, next to the chickens that are less than perfect.

EMPIRE KOSHER CHICKEN Empire

The Other Chicken Companies Are Going To Hate This Ad.

Many chickens on the market today are less than perfect. That's because the companies that sell them believe if a chicken is good enough to be approved by the government, it's good enough to be sold to you. At Empire, after a chicken passes government inspections, it has to pass kosher inspections–where many times a chicken is rejected for not being as perfect as we believe a chicken should be. Where can you find an Empire chicken? They're conveniently located at your supermarket and butcher, next to the chickens that are less than perfect.

EMPIRE KOSHER CHICKEN Empire

WE'LL GET TO YOU BEFORE YOUR CELLMATES DO.

Call AAA Bail Bonding for cash in a flash. 728-7478.

WE'RE THERE IN 20 MINUTES OR YOUR NEXT MEAL IS FREE.

Call AAA Bail Bonding for cash in a flash. 728-7478.

WE'RE FASTER THAN YOU WERE.

Call AAA Bail Bonding for cash in a flash. 728-7478.

CELLMATES / MEAL /
FASTER
46 / 3
ART DIRECTION
Andy Azula,
Julie Brendel
COPYWRITING
Bill Milkereit
AGENCY
Loeffler Ketchum
Mountjoy
CLIENT
AAA Bail Bondsmen
ENTRANT LOCATION
Charlotte, NC

CONTACTS /
NEARSIGHTED / POOR
VISION / GRANDFATHER'S
VISION.
46 / 5
ART DIRECTION
Bryan Bulison
COPYWRITING
Todd Tilford
PHOTOGRAPHY
Tom Ryan
AGENCY
The Richards Group
CLIENT
Optique
ENTRANT LOCATION
Dallas, TX

THEY COULD MAKE CONTACTS OBSOLETE.

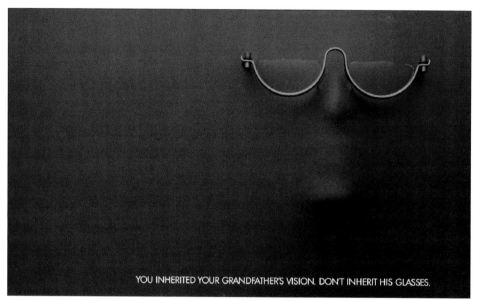

YOU INHERITED YOUR GRANDFATHER'S VISION. DON'T INHERIT HIS GLASSES.

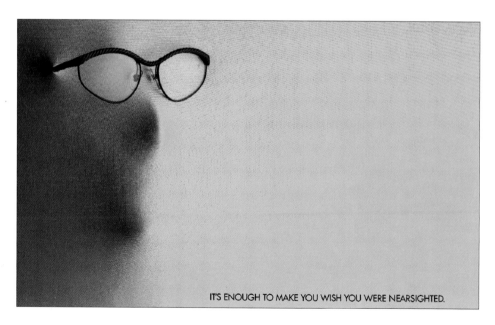

IT'S ENOUGH TO MAKE YOU WISH YOU WERE NEARSIGHTED.

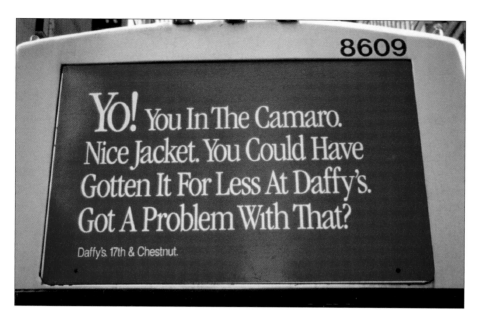

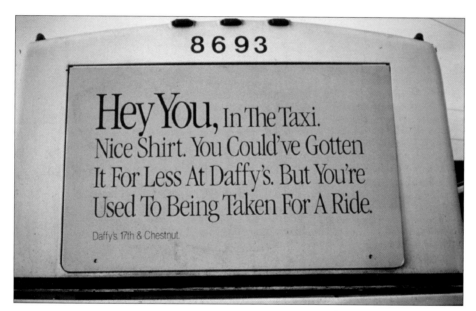

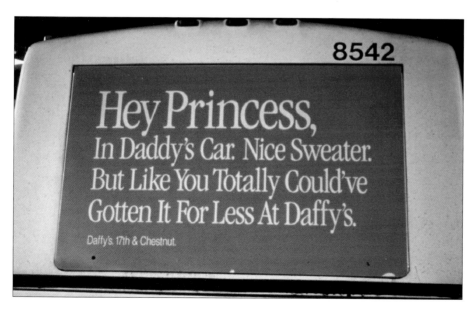

VOLVO / CAMARO / TAXI / PRINCESS / JAGUAR
46 / 6

ART DIRECTION
Abi Aron,
Rob Carducci

COPYWRITING
Rob Carducci,
Abi Aron

CREATIVE DIRECTION
Sal DeVito

AGENCY
DeVito / Verdi

CLIENT
Daffy's

ENTRANT LOCATION
New York, NY

1957
47 / 6
SILVER
ART DIRECTION
John Doyle
DESIGN
John Doyle
COPYWRITING
Ernie Schenck
PHOTOGRAPHY
Library of Congress,
The National Archive,
David Muench and
unknown
ILLUSTRATION
Peter Hall, John Doyle
AGENCY
Doyle Advertising and
Design Group
CLIENT
National Association of
Atomic Veterans
ENTRANT LOCATION
Boston, MA

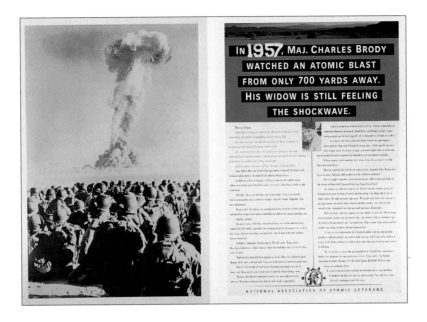

1946
47 / 1
DISTINCTIVE MERIT
ART DIRECTION
John Doyle
DESIGN
John Doyle
COPYWRITING
Ernie Schenck
PHOTOGRAPHY
Library of Congress,
The National Archive
and unknown
ILLUSTRATION
Peter Hall, John Doyle
AGENCY
Doyle Advertising and
Design Group
CLIENT
National Association of
Atomic Veterans
ENTRANT LOCATION
Boston, MA

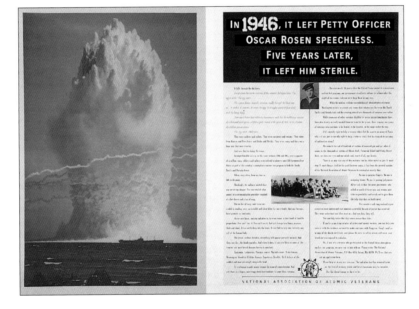

WHEN OUR DOGS CHASE CARS, THEY CHASE PORSCHES.

SHE'S GOT OVER 50,000 MILES BUT STILL RUNS GOOD.

WHEN OUR DOGS CHASE CARS, THEY CHASE PORSCHES
47 / 2
DISTINCTIVE MERIT
ART DIRECTION
Steve Tom
DESIGN
Steve Tom
COPYWRITING
Kara Goodrich
PHOTOGRAPHY
Michael Johnson
AGENCY
Clarke Goward
Advertising
CLIENT
Greyhound Friends, Inc
ENTRANT LOCATION
Boston, MA

SHE'S GOT OVER 50,000 MILES BUT STILL RUNS GOOD
47 / 3
DISTINCTIVE MERIT
ART DIRECTION
Steve Tom
DESIGN
Steve Tom
COPYWRITING
Kara Goodrich
PHOTOGRAPHY
Michael Johnson
AGENCY
Clarke Goward
Advertising
CLIENT
Greyhound Friends, Inc
ENTRANT LOCATION
Boston, MA

YOUR FATHER ALWAYS
WANTED A
PROFESSIONAL ATHLETE
IN THE FAMILY
47 / 4
DISTINCTIVE MERIT
ART DIRECTION
Steve Tom
DESIGN
Steve Tom
COPYWRITING
Kara Goodrich
PHOTOGRAPHY
Michael Johnson
AGENCY
Clarke Goward
Advertising
CLIENT
Greyhound Friends, Inc
ENTRANT LOCATION
Boston, MA

1951
47 / 5
DISTINCTIVE MERIT
ART DIRECTION
John Doyle
DESIGN
John Doyle
COPYWRITING
Ernie Schenck
PHOTOGRAPHY
Library of Congress,
The National Archive,
David Muench and
unknown
ILLUSTRATION
Peter Hall, John Doyle
AGENCY
Doyle Advertising and
Design Group
CLIENT
National Association of
Atomic Veterans
ENTRANT LOCATION
Boston, MA

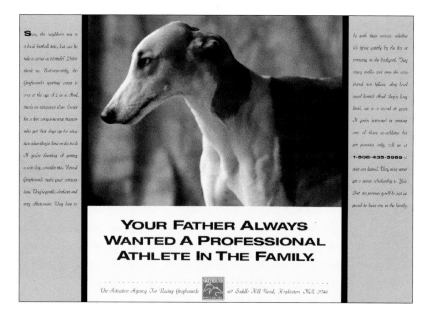

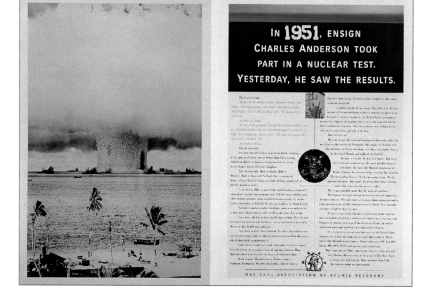

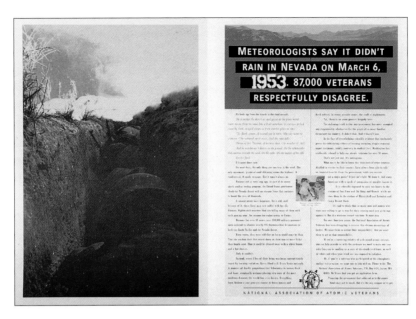

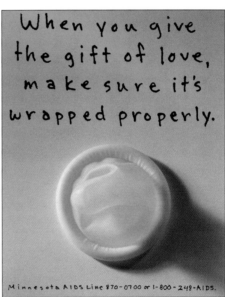

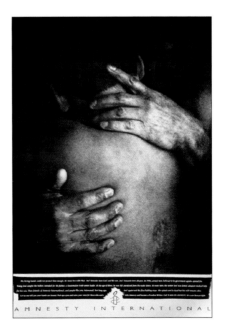

1953
47 / 7
DISTINCTIVE MERIT
ART DIRECTION
John Doyle
DESIGN
John Doyle
COPYWRITING
Ernie Schenck
PHOTOGRAPHY
Library of Congress,
The National Archive,
David Muench and
unknown
ILLUSTRATION
Peter Hall, John Doyle
AGENCY
Doyle Advertising and
Design Group
CLIENT
National Association of
Atomic Veterans
ENTRANT LOCATION
Boston, MA

ROLL ON
47 / 8
ART DIRECTION
Wayne Thompson
COPYWRITING
Tom Kelly
PHOTOGRAPHY
Peter Wong
AGENCY
Martin / Williams
CLIENT
Minnesota Aids Project
ENTRANT LOCATION
Minneapolis, MN

WRAPPED PROPERLY.
47 / 9
ART DIRECTION
Wayne Thompson
COPYWRITING
Tom Kelly
PHOTOGRAPHY
Peter Wong
AGENCY
Martin / Williams
CLIENT
Minnesota Aids Project
ENTRANT LOCATION
Minneapolis, MN

SOTZ
47 / 10
ART DIRECTION
John Doyle
DESIGN
John Doyle
COPYWRITING
Robin Raj
PHOTOGRAPHY
Raymond Meeks
ILLUSTRATION
John Doyle
AGENCY
Doyle Advertising and
Design Group
CLIENT
Amnesty International
ENTRANT LOCATION
Boston, MA

FLAGMAN(ARMS MOVE)
47 / 11
ART DIRECTION
Craig Hadorn
COPYWRITING
Dory Toft
PRODUCTION
Marie Brown
AGENCY
Livingston + Company
CLIENT
Museum of Flight
ENTRANT LOCATION
Seattle, WA

FUNDS ARE DRYING UP
47 / 12
ART DIRECTION
Jim Fortune
COPYWRITING
Tom Townsend
CREATIVE DIRECTION
Jim Fortune,
Tom Townsend
PRODUCTION
Don Greifenkamp
AGENCY
DMB&B / St. Louis
CLIENT
The Salvation Army
ENTRANT LOCATION
St. Louis, MO

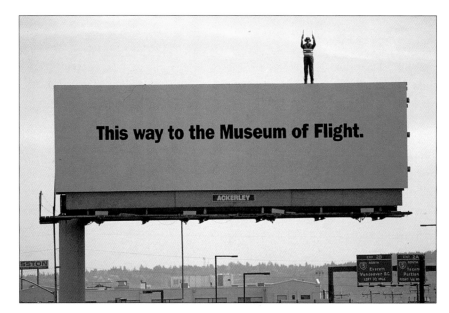

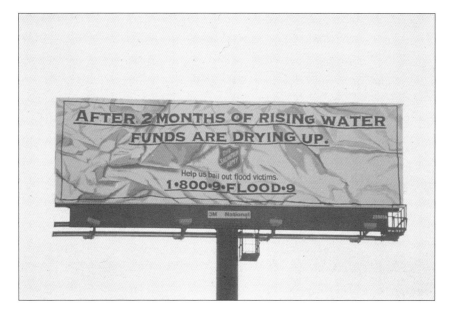

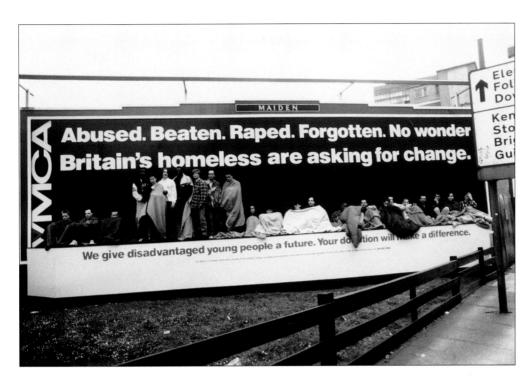

ABUSED. BEATEN. RAPED. FORGOTTEN.
47 / 1
ART DIRECTION
Ian Harding
COPYWRITING
Shaun McIlrath
AGENCY
Impact FCA !
CLIENT
YMCA
ENTRANT LOCATION
London, England

ARE YOU O.K?
47 / 2
ART DIRECTION
Kazuyuki Mori
DESIGN
Kazuyuki Mori
PHOTOGRAPHY
Kunihiro Togawa
DIRECTION
Kazuyuki Mori
CLIENT
Chubu Creators Club
ENTRANT LOCATION
Nagoya, Japan

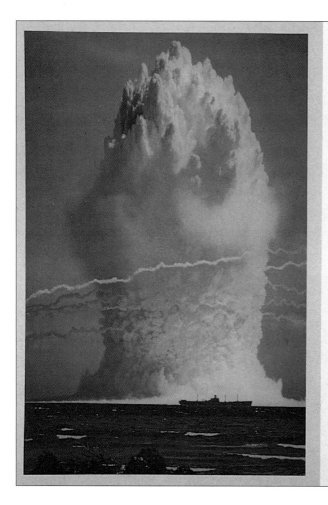

IN **1946**, IT LEFT PETTY OFFICER OSCAR ROSEN SPEECHLESS. FIVE YEARS LATER, IT LEFT HIM STERILE.

NATIONAL ASSOCIATION OF ATOMIC VETERANS

1946 / 1951 / 1953 / 1957

48 / 3

GOLD

ART DIRECTION
John Doyle

DESIGN
John Doyle

COPYWRITING
Ernie Schenck

PHOTOGRAPHY
Library of Congress,
The National Archive,
David Muench and
unknown

ILLUSTRATION
Peter Hall, John Doyle

AGENCY
Doyle Advertising and
Design Group

CLIENT
National Association of
Atomic Veterans

ENTRANT LOCATION
Boston, MA

(continued on next
page)

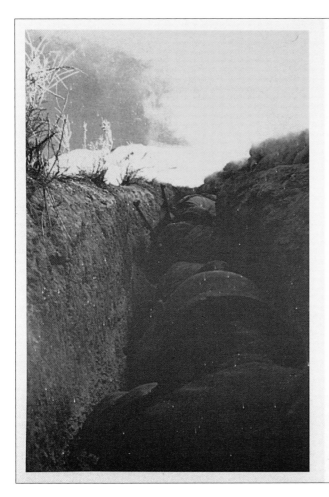

(continued from
previous page)

In **1957**, MAJ. CHARLES BRODY WATCHED AN ATOMIC BLAST FROM ONLY 700 YARDS AWAY. HIS WIDOW IS STILL FEELING THE SHOCKWAVE.

NATIONAL ASSOCIATION OF ATOMIC VETERANS

(continued from
previous page)

LEAVE IT TO THE
TOBACCO INDUSTRY /
CIGARETTE COMPANIES /
THE ONLY THING
48 / I

ART DIRECTION
Dennis Lim

COPYWRITING
Steve Skibba

CREATIVE DIRECTION
Cabell Harris

PHOTOGRAPHY
Tom Nelson

AGENCY
Livingston + Company

CLIENT
California Department
of Health Services

ENTRANT LOCATION
Venice, CA

WE'RE HAVING THE SAME PROBLEM WITH OUR GREYHOUNDS / SHE'S GOT OVER 50,000 MILES / WHEN OUR DOGS CHASE CARS
48 / 2

ART DIRECTION
Steve Tom

DESIGN
Steve Tom

COPYWRITING
Kara Goodrich

PHOTOGRAPHY
Michael Johnson

AGENCY
Clarke Goward
Advertising

CLIENT
Greyhound Friends, Inc

ENTRANT LOCATION
Boston, MA

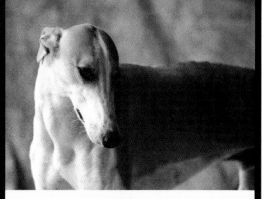

WE'RE HAVING THE SAME PROBLEM WITH OUR GREYHOUNDS THEIR EX-OWNERS DID. THEY JUST DON'T GO FAST ENOUGH.

SHE'S GOT OVER 50,000 MILES BUT STILL RUNS GOOD.

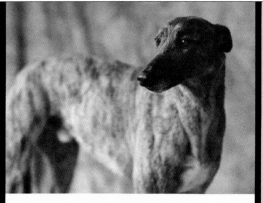

WHEN OUR DOGS CHASE CARS, THEY CHASE PORSCHES.

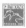

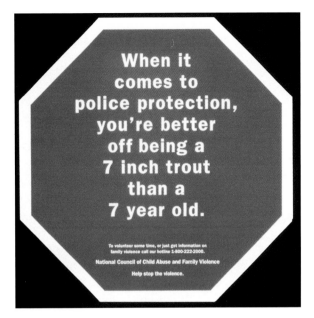

When it comes to police protection, you're better off being a 7 inch trout than a 7 year old.

To volunteer some time, or just get information on family violence call our hotline 1-800-222-2000.
National Council of Child Abuse and Family Violence
Help stop the violence.

7 - INCH TROUT / BABY SEAL / TRAFFIC LAWS
48 / 4
ART DIRECTION
Taras Wayner
COPYWRITING
Taras Wayner
AGENCY
Earle Palmer Brown / Bethesda
CLIENT
National Council on Child Abuse and Family Violence
ENTRANT LOCATION
Bethesda, MD

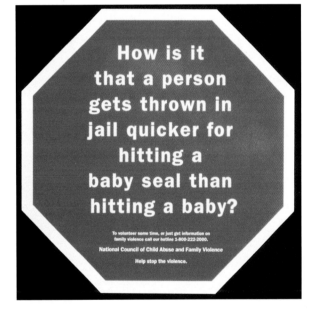

How is it that a person gets thrown in jail quicker for hitting a baby seal than hitting a baby?

To volunteer some time, or just get information on family violence call our hotline 1-800-222-2000.
National Council of Child Abuse and Family Violence
Help stop the violence.

Something's wrong when a person gets in more trouble for violating traffic laws than violating their child.

To volunteer some time, or just get information on family violence call our hotline 1-800-222-2000.
National Council of Child Abuse and Family Violence
Help stop the violence.

277

TILL DEATH / FOR BETTER
/ LOVE, HONOUR
48 / 1
ART DIRECTION
Theseus Chan
COPYWRITING
Jim Aitchison,
Grover Tham
PHOTOGRAPHY
Wee Khim
AGENCY
Euro RSCG Ball
Partnership
CLIENT
Singapore Council of
Women's
Organisations
ENTRANT LOCATION
Singapore

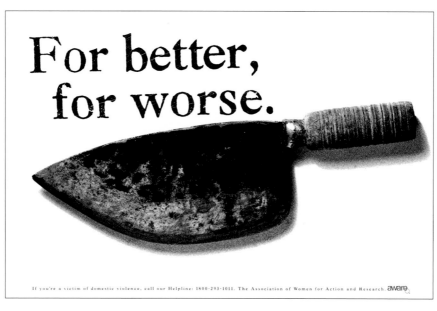

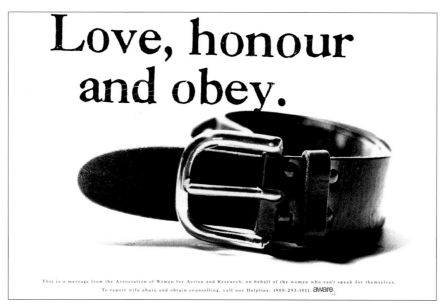

RECYCLE #1 / RECYCLE #2
48 / 2, 3

ART DIRECTION
Akio Okumura

DESIGN
Akio Okumura

STUDIO
Packaging Create Inc.

CLIENT
Japan Graphic
Designers Association
Inc.

ENTRANT LOCATION
Osaka, Japan

PITY
49 / 33
DISTINCTIVE MERIT
ART DIRECTION
Jeff Hopfer
COPYWRITING
Todd Tilford, Vinnie
Chieco
PHOTOGRAPHY
Holly Stewart
PRODUCTION
Gail Beckman
AGENCY
The Richards Group
CLIENT
Tabu Lingerie
ENTRANT LOCATION
Dallas, TX

PITY YOU'LL ONLY BE WEARING IT
FOR A FEW MINUTES.

TABU
LINGERIE

**SEYMOUR CHWAST
RETURNS TO DALLAS**
49 / 1
ART DIRECTION
Seymour Chwast
DESIGN
Seymour Chwast
ILLUSTRATION
Seymour Chwast
CLIENT
Dallas Society of Visual
Communications
ENTRANT LOCATION
New York, NY

CITIZENSHIP
49 / 2
ART DIRECTION
Taylor Smith
CREATIVE DIRECTION
Rich Kohnke
COPYWRITING
Steve Koeneke
PHOTOGRAPHY
Taylor Smith
PRODUCTION
Jim McDonald
AGENCY
Kohnke Koeneke
CLIENT
Hector's
ENTRANT LOCATION
Milwaukee, WI

SHANGHAI
49 / 3
ART DIRECTION
Don Miller
COPYWRITING
Albert Kelly
CREATIVE DIRECTION
Sam Scali
ILLUSTRATION
stock
AGENCY
Lowe & Partners / SMS
CLIENT
South Street Seaport
Museum
ENTRANT LOCATION
New York, NY

THERE ARE TWO THINGS OUR CHEF WON'T DISCUSS. HIS RECIPES AND HIS CITIZENSHIP.

IN THE OLD DAYS they used to shanghai people to get them on a ship. These days we use advertising.

South Street Seaport Museum

KIDS QUIET
49 / 4
ART DIRECTION
Don Miller
COPYWRITING
Albert Kelly
CREATIVE DIRECTION
Sam Scali
AGENCY
Lowe & Partners / SMS
CLIENT
South Street Seaport
Museum
ENTRANT LOCATION
New York, NY

SUBWAY
49 / 5
ART DIRECTION
Don Miller
COPYWRITING
Albert Kelly
CREATIVE DIRECTION
Sam Scali
AGENCY
Lowe & Partners / SMS
CLIENT
South Street Seaport
Museum
ENTRANT LOCATION
New York, NY

SNOWMOBILE
49 / 6
ART DIRECTION
Doug Trapp
COPYWRITING
Christopher Wilson
PHOTOGRAPHY
R. Hamilton Smith
ILLUSTRATION
Brad Palm
AGENCY
Martin / Williams
CLIENT
Target Stores /
Minneapolis. Institute
of Art
ENTRANT LOCATION
Minneapolis, MN

THE SHOW
49 / 7
ART DIRECTION
Doug Trapp
COPYWRITING
Jan Pettit
ILLUSTRATION
Walt Taylor,
Doug Trapp
AGENCY
Martin / Williams
CLIENT
Art Directors /
Copywriters Club
ENTRANT LOCATION
Minneapolis, MN

**CLINTON- GOOD IDEAS
ON WHERE TO START**
49 / 8
ART DIRECTION
Jennifer Ward
COPYWRITING
Larry Lipson
PHOTOGRAPHY
stock
AGENCY
Cramer - Krasselt
CLIENT
Supercuts
ENTRANT LOCATION
Chicago, IL

**PERFECT.EXTENDED
WEATHER FORECAST FOR
THE RICHMOND AREA**
49 / 9
ART DIRECTION
Cliff Sorah
COPYWRITING
Raymond McKinney
AGENCY
The Martin Agency
CLIENT
The Edgar Allan Poe
Museum
ENTRANT LOCATION
Richmond, VA

EARTHTONE
49 / 10
ART DIRECTION
Bob Meagher
COPYWRITING
Joe Alexander
PHOTOGRAPHY
Mark Scott
PRODUCTION
Jenny Schoenherr
AGENCY
The Martin Agency
CLIENT
Wrangler Earthtone
ENTRANT LOCATION
Richmond, VA

HAVING TROUBLE
FINDING THE RIGHT JOB?
49 / 11
ART DIRECTION
Jamie Mahoney
COPYWRITING
Joe Alexander
PHOTOGRAPHY
Joe Lampi, Dublin
Productions
AGENCY
The Martin Agency
CLIENT
Dick Gerdes
ENTRANT LOCATION
Richmond, VA

EVER WONDER WHY
JUNGLES ARE SO LUSH?
49 / 12
ART DIRECTION
John Amicangelo
COPYWRITING
John Amicangelo,
Dan Swanson
PHOTOGRAPHY
Jeff Coolidge
ILLUSTRATION
Suzanne Barnes
ENTRANT LOCATION
Boston, MA

TALK BACK
49 / 13
ART DIRECTION
Anne Taylor
COPYWRITING
Scott Jorgensen
CLIENT
St. Francis Debate
Team
ENTRANT LOCATION
Minneapolis, MN

LAWYERS
49 / 14
ART DIRECTION
Anne Taylor
COPYWRITING
Scott Jorgensen
CLIENT
St. Francis Debate
Team
ENTRANT LOCATION
Minneapolis, MN

CAR KEYS
49 / 15
ART DIRECTION
Anne Taylor
COPYWRITING
Scott Jorgensen
CLIENT
St. Francis Debate
Team
ENTRANT LOCATION
Minneapolis, MN

284

GREAT PRACTICE
FOR MARRIAGE.

In debate you'll learn the skills to communicate persuasively. But that doesn't mean you won't end up sleeping on the couch. Talk to Mr. Keller in LA3 about joining. **ST. FRANCIS DEBATE TEAM**

If our films were any shorter, they'd be photo-graphs.

12TH ASBURY FESTIVAL OF **SHORT** FILMS

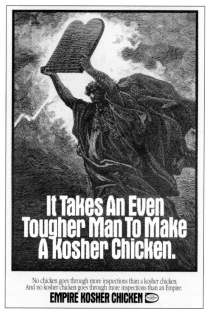

It Takes An Even
Tougher Man To Make
A Kosher Chicken.

No chicken goes through more inspections than a kosher chicken.
And no kosher chicken goes through more inspections than an Empire.
EMPIRE KOSHER CHICKEN

MARRIAGE
49 / 16
ART DIRECTION
Anne Taylor
COPYWRITING
Scott Jorgensen
CLIENT
St. Francis Debate
Team
ENTRANT LOCATION
Minneapolis, MN

PHOTOGRAPHS
49 / 17
ART DIRECTION
Danielle Flagg
COPYWRITING
David Bromberg
AGENCY
Weiss, Whitten,
Stagliano Inc.
CLIENT
Asbury Film Festival
ENTRANT LOCATION
New York, NY

MOSES
49 / 18
ART DIRECTION
Sal DeVito
COPYWRITING
Abi Aron,
Rob Carducci
CREATIVE DIRECTION
Sal DeVito
AGENCY
DeVito / Verdi
CLIENT
Empire Kosher Poultry
ENTRANT LOCATION
New York, NY

**OFFICIAL AIRLINE OF THE
DALLAS COWBOYS.**
49 / 19
ART DIRECTION
Armando Hernandez
COPYWRITING
Tucker Hasler
AGENCY
Temerlin McClain
CLIENT
American Airlines
ENTRANT LOCATION
Irving, TX

AmericanAirlines
Official Airline of the Dallas Cowboys.

BIRDS DO IT
49 / 20
ART DIRECTION
Steve Mitchell
COPYWRITING
Scott Jorgensen
PHOTOGRAPHY
Joe Lampi
CLIENT
Baldwin Sport
Parachute Center
ENTRANT LOCATION
Minneapolis, MN

INSPIRATION
49 / 21
ART DIRECTION
Steve Mitchell
COPYWRITING
Matt Elhardt
CLIENT
The Show Book
ENTRANT LOCATION
Minneapolis, MN

BIBLE
49 / 22
ART DIRECTION
Noam Murro
COPYWRITING
Dean Hacohen
PHOTOGRAPHY
Ilan Rubin
AGENCY
Goldsmith / Jeffrey
CLIENT
El Al Israel Airlines
ENTRANT LOCATION
New York, NY

OUTRUN THIS
49 / 23
ART DIRECTION
Steve Mitchell
COPYWRITING
Doug Adkins
PHOTOGRAPHY
Curtis Johnson
CLIENT
Greyhound Protection
League
ENTRANT LOCATION
Minneapolis, MN

HEAVY BREATHING
49 / 24
ART DIRECTION
John Gellos
COPYWRITING
Joan Wildermuth
ILLUSTRATION
Joe Heiner
AGENCY
Altschiller Reitzfeld
CLIENT
Ferrero
ENTRANT LOCATION
New York, NY

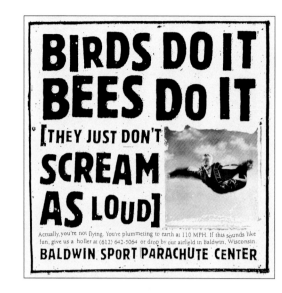

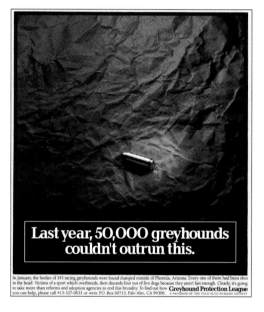

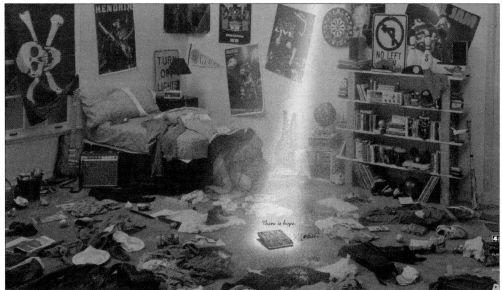

THERE IS HOPE
49 / 25
ART DIRECTION
Rohitash Rao
COPYWRITING
Kathy Hepinstall
PHOTOGRAPHY
Michael Ruppert
AGENCY
Stein Robaire Helm
ENTRANT LOCATION
Los Angeles, CA

NO PROBLEM
49 / 26
ART DIRECTION
Kent Johnson
COPYWRITING
Kent Johnson
AGENCY
The Richards Group
CLIENT
Dana's Dance
Academy
ENTRANT LOCATION
Dallas, TX

LSD
49 / 27
ART DIRECTION
Grant Richards
COPYWRITING
Todd Tilford
PHOTOGRAPHY
Robb Debenport
PRODUCTION
Gail Beckman
AGENCY
The Richards Group
CLIENT
McQueeney Design
ENTRANT LOCATION
Dallas, TX

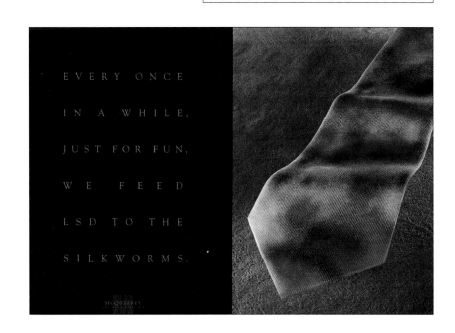

TERRIFIC
49 / 28
ART DIRECTION
Grant Richards
COPYWRITING
Todd Tilford
PHOTOGRAPHY
Robb Debenport
PRODUCTION
Gail Beckman
AGENCY
The Richards Group
CLIENT
McQueeney Design
ENTRANT LOCATION
Dallas, TX

SIGN
49 / 29
ART DIRECTION
Grant Richards
COPYWRITING
Todd Tilford
PHOTOGRAPHY
Robb Debenport
PRODUCTION
Gail Beckman
AGENCY
The Richards Group
CLIENT
McQueeney Design
ENTRANT LOCATION
Dallas, TX

ARMANI
49 / 30
ART DIRECTION
Bryan Burlison
COPYWRITING
Todd Tilford
PHOTOGRAPHY
Richard Reens
PRODUCTION
Gail Beckman
AGENCY
The Richards Group
CLIENT
Harley-Davidson of
North Texas
ENTRANT LOCATION
Dallas, TX

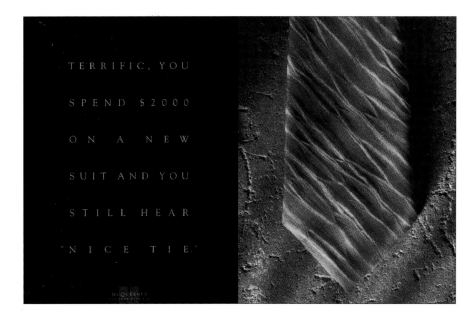

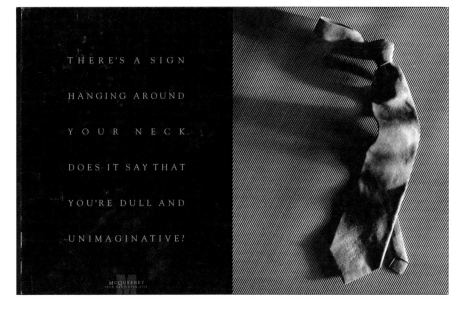

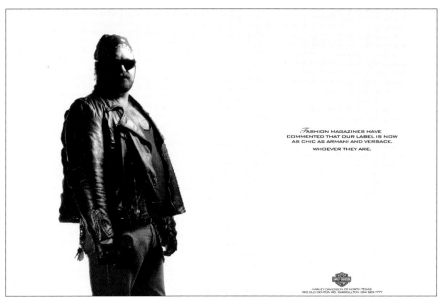

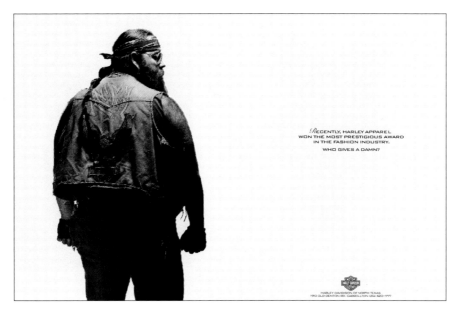

RECENTLY, HARLEY APPAREL
WON THE MOST PRESTIGIOUS AWARD
IN THE FASHION INDUSTRY.

WHO GIVES A DAMN?

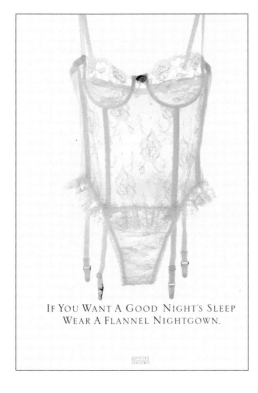

IF YOU WANT A GOOD NIGHT'S SLEEP
WEAR A FLANNEL NIGHTGOWN.

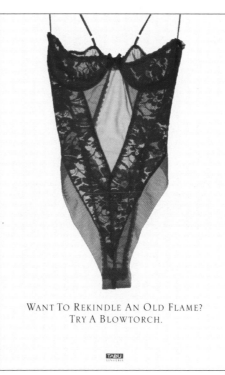

WANT TO REKINDLE AN OLD FLAME?
TRY A BLOWTORCH.

DAMN
49 / 31
ART DIRECTION
Bryan Burlison
COPYWRITING
Todd Tilford
PHOTOGRAPHY
Richard Reens
PRODUCTION
Gail Beckman
AGENCY
The Richards Group
CLIENT
Harley-Davidson of
North Texas
ENTRANT LOCATION
Dallas, TX

FLANNEL
49 / 32
ART DIRECTION
Jeff Hopfer
COPYWRITING
Todd Tilford,
Vinnie Chieco
PHOTOGRAPHY
Holly Stewart
PRODUCTION
Gail Beckman
AGENCY
The Richards Group
CLIENT
Tabu Lingerie
ENTRANT LOCATION
Dallas, TX

BLOWTORCH
49 / 34
ART DIRECTION
Jeff Hopfer
COPYWRITING
Todd Tilford,
Vinnie Chieco
PHOTOGRAPHY
Holly Stewart
PRODUCTION
Gail Beckman
AGENCY
The Richards Group
CLIENT
Tabu Lingerie
ENTRANT LOCATION
Dallas, TX

HEATING BILLS
49 / 35
ART DIRECTION
Jeff Hopfer
COPYWRITING
Todd Tilford,
Vinnie Chieco
PHOTOGRAPHY
Holly Stewart
PRODUCTION
Gail Beckman
AGENCY
The Richards Group
CLIENT
Tabu Lingerie
ENTRANT LOCATION
Dallas, TX

WHEN YOU'RE SLEEPING
49 / 36
ART DIRECTION
Jim Baldwin
COPYWRITING
David Fowler
AGENCY
The Richards Group
CLIENT
Motel 6
ENTRANT LOCATION
Dallas, TX

GUNS
49 / 37
ART DIRECTION
Pat Harris
COPYWRITING
Bruce Gifford
PRODUCTION
Bruce Gifford
AGENCY
Arnold Finnegan Martin
CLIENT
The Corner Coffee
Shop
ENTRANT LOCATION
Richmond, VA

LYLE LOVETT
49 / 38
ART DIRECTION
Pat Harris
COPYWRITING
Bruce Gifford
PRODUCTION
Bruce Gifford
AGENCY
Arnold Finnegan Martin
CLIENT
The Corner Coffee
Shop
ENTRANT LOCATION
Richmond, VA

SING FOR FOOD
49 / 39
ART DIRECTION
Rich Wakefield
DESIGN
Rich Wakefield
COPYWRITING
Bruce Gifford
PHOTOGRAPHY
stock
PRODUCTION
Deborah Burton
CLIENT
The Freedom House
Homeless Shelter
ENTRANT LOCATION
Richmond, VA

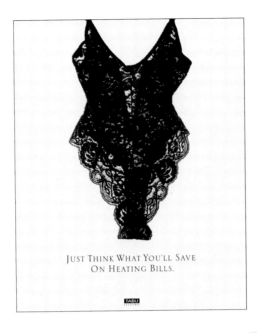

JUST THINK WHAT YOU'LL SAVE
ON HEATING BILLS.

TABU

When you're sleeping, we look
just like those big fancy hotels.
Motel 6

ONE GUN A MONTH? THAT'S ONLY 12 GUNS A YEAR! HOW AM I SUPPOSED TO DEFEND MY HOME WITH ONLY 12 GUNS? AND WHAT HAPPENS WHEN I WANT TO GO HUNTING? MY WIFE WILL BE LEFT AT HOME WITH 6 MEASLY GUNS. AND WHAT ABOUT THE KIDS? WHAT ARE THEY GONNA USE TO DEFEND THEMSELVES? SMURFS? IT DOESN'T MAKE ANY SENSE. AND NOW THEY'RE TALKING ABOUT HAVING A ONE WEEK WAITING PERIOD. WHAT GOOD DOES THAT DO? AFTER A WEEK I'M NOT MAD ANYMORE.

Chill out, man. Have a bagel or somethin'.

JULIA ROBERTS AND LYLE LOVETT? THAT'S WORSE THAN PAULINA AND RIC OCASEK. I MEAN, LOOK AT THE GUY. HAVE YOU SEEN WHAT'S GOING ON WITH THE TOP OF HIS HEAD LATELY? MY FRONT HEDGE LOOKS BETTER MANAGED. SURE HE SINGS GREAT. BUT AT SOME POINT HE'S GONNA STOP SINGIN' AND COME LOOKING FOR SOME LOVIN'. CAN YOU IMAGINE WAKING UP IN THE MORNING TO THAT HAIR AND THOSE GUMS? YEESH. WAKE UP JULIA PRETTY SOON THE SONG'S GONNA END AND YOU'RE GONNA REALIZE THIS GUY HAS NO FLIP SIDE.

Chill out, man. Have a bagel or somethin'.

THE SOUND OF MUSIC

WILL SING FOR FOOD

A SPECIAL SHOWING TO BENEFIT THE HOMELESS.

WHO DIED
49 / 41
ART DIRECTION
Scott Krahn
COPYWRITING
Gary Mueller
PHOTOGRAPHY
Scott Krahn
AGENCY
Birdsall Voss &
Kloppenburg
CLIENT
Gary Mueller
ENTRANT LOCATION
Milwaukee, WI

BAY STREET THEATRE
FESTIVAL 1993 POSTER.
49 / 42
ART DIRECTION
Paul Davis
DESIGN
Paul Davis
ILLUSTRATION
Paul Davis
CLIENT
Bay Street Theatre
ENTRANT LOCATION
New York, NY

RECYCLE
MANUFACTURED BY
PACKAGING CREATE INC.
49 / 1
ART DIRECTION
Akio Okumura
DESIGN
Akio Okumura
STUDIO
Packaging Create Inc.
CLIENT
Packaging Create Inc.
ENTRANT LOCATION
Osaka, Japan

MERRY XMAS
49 / 2
ART DIRECTION
Luke Nola
DESIGN
Luke Nola
COPYWRITING
Warwick Delmonte
PHOTOGRAPHY
David Ogden
CLIENT
Caxton
ENTRANT LOCATION
Auckland, New
Zealand

POSTER DESIGNED TO
PROMOTE THE THIRD
ALBUM FROM MYRNA LOY
49 / 3
ART DIRECTION
Kerstin Vieg
PHOTOGRAPHY
Kerstin Vieg
CLIENT
Normal Records
ENTRANT LOCATION
Koln, Germany

VOICE FROM THE EARTH
49 / 4
ART DIRECTION
Takafumi Kusagaya
DESIGN
Takafumi Kusagaya
COPYWRITING
Takafumi Kusagaya
CLIENT
Voice from the Earth
ENTRANT LOCATION
Tokyo, Japan

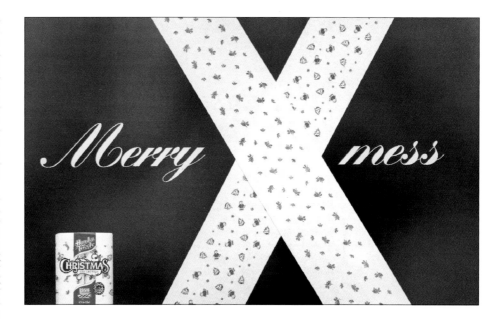

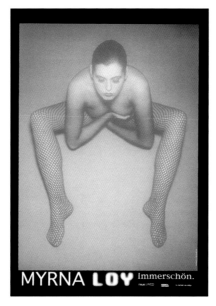

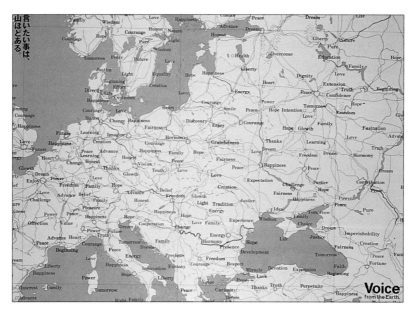

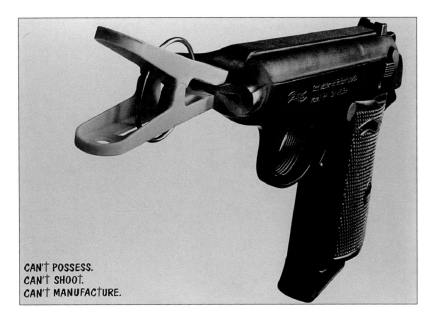

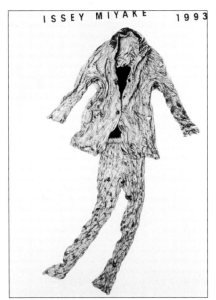

CAN'T POSSESS. CAN'T SHOOT. CAN'T MANUFACTURE.
49 / 5
ART DIRECTION
Jiro Kanahara
DESIGN
Jiro Kanahara
COPYWRITING
Jiro Kanahara
PHOTOGRAPHY
Koji Matsuzawa
ENTRANT LOCATION
Tokyo, Japan

ISSEY MIYAKE 1993
49 / 6
ART DIRECTION
Ikko Tanaka
DESIGN
Ikko Tanaka
PHOTOGRAPHY
Irving Pem
CLIENT
Miyake Design Studio
ENTRANT LOCATION
Tokyo, Japan

IF YOU'RE STILL AWAKE, YOU NEED A SLUMBERLAND MATTRESS.
49 / 7
ART DIRECTION
Kins Lee
DESIGN
Kins Lee
COPYWRITING
Janet Lee
ILLUSTRATION
Hau Theng Hui
PRODUCTION
Wong Fok Loy
ACCOUNT DIRECTION
Jeff Low, Willie Lim
AGENCY
Spider
STUDIO
Spider
CLIENT
Slumberland Inchcape Sdn Bhd
ENTRANT LOCATION
Kuala Lumpur, Malaysia

DANTON
49 / 8
ART DIRECTION
Wieslaw Walkuski
CLIENT
Visual Studio - Warsaw
ENTRANT LOCATION
Warsaw, Poland

KISS
49 / 9
ART DIRECTION
Masutera Aoba
DESIGN
Masaaki Kawaguchi
PHOTOGRAPHY
Masami Hagiwara
CLIENT
Kose Co., LTD
ENTRANT LOCATION
Tokyo, Japan

HIROMICHI NAKANO ' 93
COLLECTION POSTER.
49 / 10
ART DIRECTION
Katsunori Aoki
DESIGN
Katsunori Aoki
PHOTOGRAPHY
Yoshihito Imaizumi
DIRECTION
Hiromichi Nakano
CLIENT
Hiromichi Nakano
Design Office
ENTRANT LOCATION
Tokyo, Japan

Art Not Available

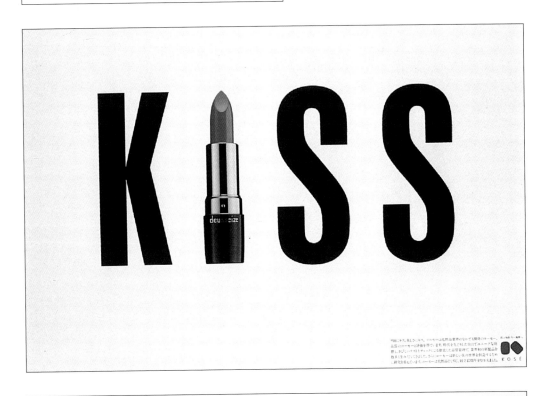

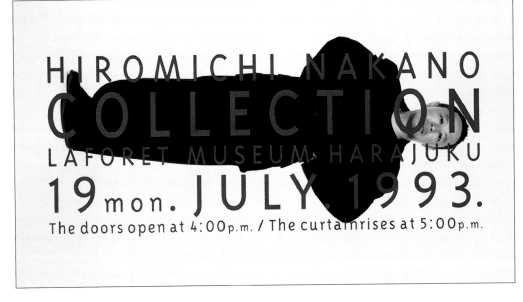

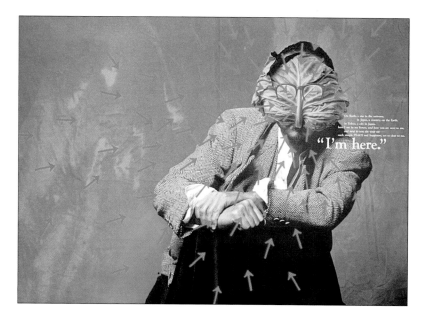

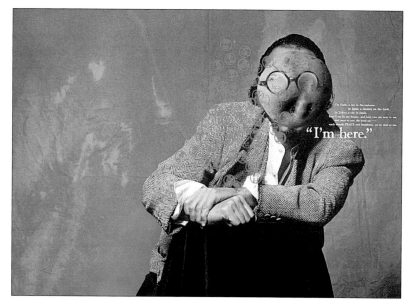

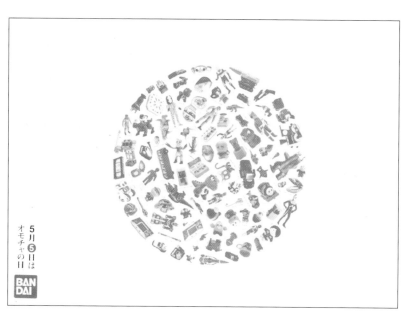

LETTUCE - I'M HERE.
49 / 11
ART DIRECTION
Katsu Asano
DESIGN
Kinue Yonezawa
COPYWRITING
Katsu Asano
PHOTOGRAPHY
Bungo Saito
ILLUSTRATION
Katsu Asano
AGENCY
ASA 100 Company
CLIENT
Japan Graphic
Designers Association
Inc.
ENTRANT LOCATION
Tokyo, Japan

POTATO - I'M HERE.
49 / 12
ART DIRECTION
Katsu Asano
DESIGN
Kinue Yonezawa
COPYWRITING
Katsu Asano
PHOTOGRAPHY
Bungo Saito
ILLUSTRATION
Katsu Asano
AGENCY
ASA 100 Company
CLIENT
Japan Graphic
Designers Association
Inc.
ENTRANT LOCATION
Tokyo, Japan

BAN DAI - TOYS
49 / 13
ART DIRECTION
Tatsuo Ebina,
Motojiro Furuta
DESIGN
Tatsuo Ebina,
Takeshi Goshi
COPYWRITING
Hideki Azuma
PHOTOGRAPHY
Tadashi Tomono
AGENCY
Asatsu Inc.
CLIENT
Bandai Co., LTD.
ENTRANT LOCATION
Tokyo, Japan

BAN DAI - CHILDREN
49 / 14
ART DIRECTION
Tatsuo Ebina,
Motojiro Furuta
DESIGN
Tatsuo Ebina,
Takeshi Goshi
COPYWRITING
Hideki Azuma
PHOTOGRAPHY
Tadashi Tomono
AGENCY
Asatsu Inc.
CLIENT
Bandai Co., LTD.
ENTRANT LOCATION
Tokyo, Japan

IDAY
49 / 15
ART DIRECTION
John Rushworth
DESIGN
John Rushworth,
Nick Finney
PHOTOGRAPHY
The Douglas Brothers
CLIENT
Royal College of Art
ENTRANT LOCATION
London, England

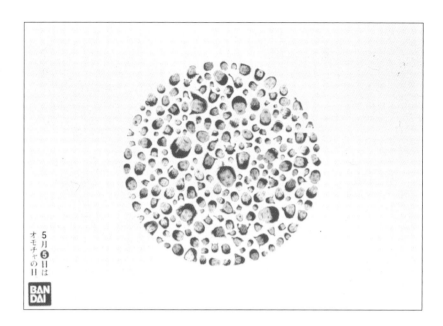

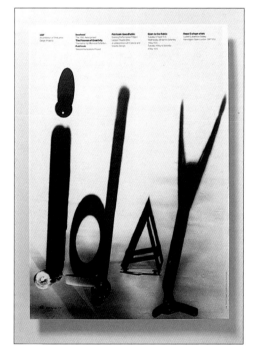

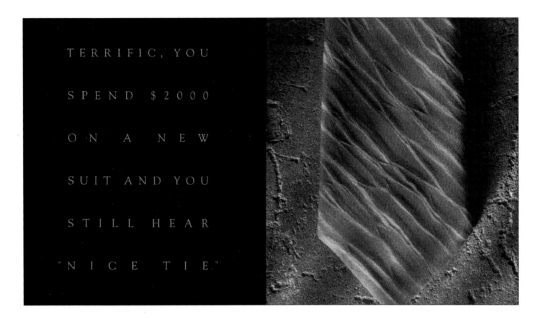

TERRIFIC, YOU SPEND $2000 ON A NEW SUIT AND YOU STILL HEAR "NICE TIE."

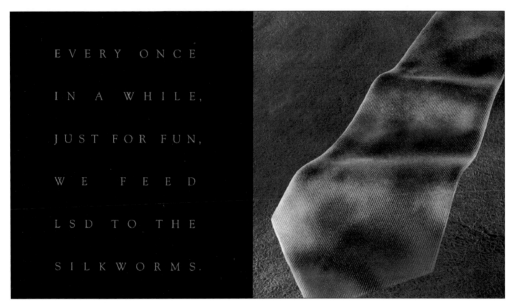

EVERY ONCE IN A WHILE, JUST FOR FUN, WE FEED LSD TO THE SILKWORMS.

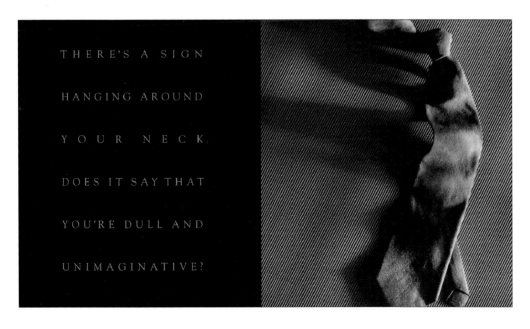

THERE'S A SIGN HANGING AROUND YOUR NECK. DOES IT SAY THAT YOU'RE DULL AND UNIMAGINATIVE?

LSD / SIGN / TERRIFIC
50 / 1
SILVER
ART DIRECTION
Grant Richards
COPYWRITING
Todd Tilford
PHOTOGRAPHY
Robb Debenport
PRODUCTION
Gail Beckman
AGENCY
The Richards Group
CLIENT
McQueeney Design
ENTRANT LOCATION
Dallas, TX

BLOWTORCH / PITY /
FLANNEL
50 / 6
SILVER
ART DIRECTION
Jeff Hopfer
COPYWRITING
Todd Tilford,
Vinnie Chieco
PHOTOGRAPHY
Holly Stewart
PRODUCTION
Gail Beckman
AGENCY
The Richards Group
CLIENT
Tabu Lingerie
ENTRANT LOCATION
Dallas, TX

WANT TO REKINDLE AN OLD FLAME?
TRY A BLOWTORCH.

JUST THINK WHAT YOU'LL SAVE
ON HEATING BILLS.

PITY YOU'LL ONLY BE WEARING IT
FOR A FEW MINUTES.

IF YOU WANT A GOOD NIGHT'S SLEEP
WEAR A FLANNEL NIGHTGOWN.

SHANGHAI / SUBWAY /
KIDS QUIET
50 / 4
DISTINCTIVE MERIT
ART DIRECTION
Don Miller
COPYWRITING
Albert Kelly
CREATIVE DIRECTION
Sam Scali
ILLUSTRATION
stock
AGENCY
Lowe & Partners / SMS
CLIENT
South Street Seaport
Museum
ENTRANT LOCATION
New York, NY

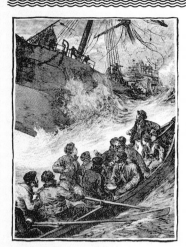

To get here 200 years ago,
people endured long delays
in small spaces, crowded
with nasty people.

But you can take the subway.

THEY ATE ROTTEN AND WEEVILY BREAD, endured sickness and storm and
were frequently butchered by pirates. But considering all there is to see
and do at the South Street Seaport Museum, they figured it was worth the trip.

South Street Seaport Museum

IN THE OLD DAYS they
used to shanghai people
to get them on a ship.
These days we use advertising.

WE STRONGLY ENCOURAGE you to visit the South Street
Seaport Museum, and experience first hand what life was like
150 years ago. Modern-day assault laws, however, prevent us
from hitting you with anything harder than this poster.

South Street Seaport Museum

These should keep
the kids quiet
this weekend.

GOUGE ROUTER SCRIMSHAW KNIFE. Hand saw. Chisel. Large mallet.
Noisy kids? We've got just the tools to keep them quiet. And if they're still rest-
less after the boat-building demonstration, there's always the tour of the plank.

South Street Seaport Museum

Fade Resistant Checotah Shirts.

Our New Jeans And Shirts Come In The Colors Cowboys Love To Wear: Earthtones.

Introducing Shadow Canyon. A whole new line of jeans and shirts in shades inspired by the colors of the West.

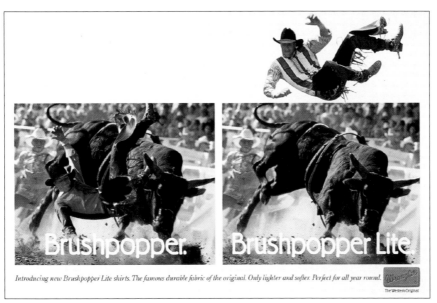

Brushpopper. Brushpopper Lite.

Introducing new Brushpopper Lite shirts. The famous durable fabric of the original. Only lighter and softer. Perfect for all year round.

FADE RESISTANT /
EARTHTONE /
BRUSHPOPPER LITE
50 / 2
ART DIRECTION
Bob Meagher
COPYWRITING
Joe Alexander,
Steve Dolbinski
PHOTOGRAPHY
Mark Scott
AGENCY
The Martin Agency
CLIENT
Wrangler - Campaign
ENTRANT LOCATION
Richmond, VA

301

**SNOW / SNOWMOBILE /
BOUNDARY WATERS**
50 / 3
ART DIRECTION
Doug Trapp
COPYWRITING
Christopher Wilson
PHOTOGRAPHY
Cameron Davidson,
Tom Connors,
R.H. Smith
ILLUSTRATION
Brad Palm
AGENCY
Martin / Williams
CLIENT
Target Stores /
Minneapolis Institute of
Art
ENTRANT LOCATION
Minneapolis, MN

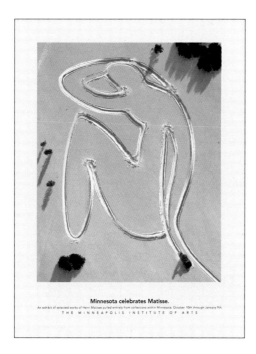

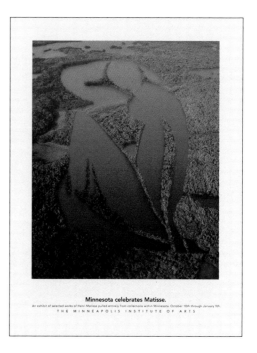

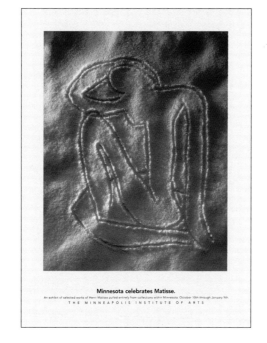

THE FEW, THE PROUD,
THE STUPID / YOU
HAVEN'T EARNED YOUR
WINGS UNTIL ... / IT'S
ONLY DEATH-DEFYING IF
YOU ...
50 / 5
ART DIRECTION
Mike Murray,
Mike Fetrow
COPYWRITING
Doug Adkins
PHOTOGRAPHY
Richard Hamilton
Smith
AGENCY
Hunt Murray
CLIENT
General Aviation
Services
ENTRANT LOCATION
St. Paul, MN

303

ONE GUN A MONTH? THAT'S ONLY 12 GUNS A YEAR! HOW AM I SUPPOSED TO DEFEND MY HOME WITH ONLY 12 GUNS? AND WHAT HAPPENS WHEN I WANT TO GO HUNTING? MY WIFE WILL BE LEFT AT HOME WITH 6 MEASLY GUNS. AND WHAT ABOUT THE KIDS? WHAT ARE THEY GONNA USE TO DEFEND THEMSELVES? SMURFS? IT DOESN'T MAKE ANY SENSE. AND NOW THEY'RE TALKING ABOUT HAVING A ONE WEEK WAITING PERIOD. WHAT GOOD DOES THAT DO? AFTER A WEEK I'M NOT MAD ANYMORE.

Chill out, man. Have a bagel or somethin'.

JULIA ROBERTS AND LYLE LOVETT? THAT'S WORSE THAN PAULINA AND RIC OCASEK. I MEAN, LOOK AT THE GUY. HAVE YOU SEEN WHAT'S GOING ON WITH THE TOP OF HIS HEAD LATELY? MY FRONT HEDGE LOOKS BETTER MANAGED. SURE HE SINGS GREAT. BUT AT SOME POINT HE'S GONNA STOP SINGIN' AND COME LOOKING FOR SOME LOVIN'. CAN YOU IMAGINE WAKING UP IN THE MORNING TO THAT HAIR AND THOSE GUMS? YEESH. WAKE UP JULIA PRETTY SOON THE SONG'S GONNA END AND YOU'RE GONNA REALIZE THIS GUY HAS NO FLIP SIDE.

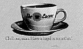

Chill out, man. Have a bagel or somethin'.

WACO? WHY WOULD GOD APPEAR IN WACO? WHAT DO THEY HAVE THAT WE DON'T HAVE? IF ALL THOSE PEOPLE ARE DOWN THERE WAITING FOR A SIGN FROM GOD, THEY BETTER GET COMFORTABLE. I MEAN, IT'S BEEN ALMOST 2000 YEARS SINCE HE SHOWED UP. THEY'VE ONLY BEEN WAITING THREE WEEKS. GET IN LINE, Y'KNOW? AND WHAT ARE THEY GONNA DO IF HE SHOWS UP, ANYWAY? GIVE HIM A BAG OF TRAIL MIX AND TELL HIM TO STAY AWAY FROM THE WINDOW?

Chill out, man. Have a bagel or somethin'.

WACO / GUNS / LYLE LOVETT
50 / 7
ART DIRECTION
Pat Harris
COPYWRITING
Bruce Gifford
PRODUCTION
Bruce Gifford
AGENCY
Arnold Finnegan Martin
CLIENT
The Corner Coffee Shop
ENTRANT LOCATION
Richmond, VA

YOU WAKE UP.
FASTEN YOUR POCKET PROTECTOR.
ADJUST YOUR GLASSES. GO TO SCHOOL.
AND COLLECT LUNCH MONEY FROM
THE CLASS BULLY.

WHAT WOULD LIFE BE LIKE IF YOU KNEW KARATE?

YOUR BOSS HAS BEEN
MAKING PROPOSITIONS AGAIN.
IRONICALLY, HE'S THE ONE
WHO ENDS UP ON HIS BACK.

WHAT WOULD LIFE BE LIKE IF YOU KNEW KARATE?

FOR ONCE, WOULDN'T IT BE
NICE TO STOMP INTO A BIKER BAR,
SADDLE UP TO AN EMPTY STOOL
AND ORDER A SHIRLEY TEMPLE?

WHAT WOULD LIFE BE LIKE IF YOU KNEW KARATE?

WHAT WOULD LIFE BE LIKE
50 / 8
ART DIRECTION
Bruce Bousman
DESIGN
Bruce Bousman
COPYWRITING
Harold Einstein,
Greg Hahn
AGENCY
The Firm
CLIENT
Jun Chong Tae Kwon
Do Center
ENTRANT LOCATION
Agoura, CA

CLEAVER / PIN / SCISSOR /
SAW BLADE
50 / 5
GOLD
ART DIRECTION
Yuji Tokuda
DESIGN
Yuji Tokuda
PHOTOGRAPHY
Takashi Seo, Chno - ku
ILLUSTRATION
Chno - ku
STUDIO
Dentsu Inc.
AGENCY
Dentsu Inc.
CLIENT
Dentsu Cotec Inc.
ENTRANT LOCATION
Tokyo, Japan

YAMAHA POPULAR MUSIC
SCHOOL.
50 / 1, 2
ART DIRECTION
Yohichi Komatsu
DESIGN
Yohichi Komatsu
COPYWRITING
Mizuho Hara
PHOTOGRAPHY
Akihito Kubota
AGENCY
ASATSU Inc.
CLIENT
Yamaha Music
Foundation
ENTRANT LOCATION
Tokyo, Japan

**IF PRINTED WELL,
ANYTHING CAN BECOME
A THING OF BEAUTY**
50 / 3
ART DIRECTION
Martyn Walsh,
Alex Guidetti
COPYWRITING
Martyn Walsh,
David Watkinson
PHOTOGRAPHY
Lionel Oherruaults,
Jonathan Lovekin,
Bill Willcox
AGENCY
Saatchi & Saatchi
Switzerland
CLIENT
IRL Printers
ENTRANT LOCATION
Nyon, Switzerland

IF PRINTED WELL, ANYTHING CAN BECOME A THING OF BEAUTY

PRINTED QUALITY

IF PRINTED WELL, ANYTHING CAN BECOME A THING OF BEAUTY

PRINTED QUALITY

IF PRINTED WELL, ANYTHING CAN BECOME A THING OF BEAUTY

PRINTED QUALITY

IF PRINTED WELL, ANYTHING CAN BECOME A THING OF BEAUTY

PRINTED QUALITY

BAN DAI
50 / 4
ART DIRECTION
Tatsuo Ebina,
Motojiro Furuta
DESIGN
Tatsuo Ebina
COPYWRITING
Hideki Azuma
PHOTOGRAPHY
Tadashi Tomono
DIRECTION
Tatsuo Ebina,
Motojiro Furuta
AGENCY
Asatsu Inc.
CLIENT
Bandai Co., LTD.
ENTRANT LOCATION
Tokyo, Japan

EVERY ONCE

IN A WHILE,

JUST FOR FUN,

WE FEED

LSD TO THE

SILKWORMS.

MCQUEENEY

LSD
51 / 7
GOLD
ART DIRECTION
Grant Richards
COPYWRITING
Todd Tilford
PHOTOGRAPHY
Robb Debenport
PRODUCTION
Gail Beckman
AGENCY
The Richards Group
CLIENT
McQueeney Design
ENTRANT LOCATION
Dallas, TX

FLANNEL
51 / 8
SILVER
ART DIRECTION
Jeff Hopfer
COPYWRITING
Todd Tilford,
Vinnie Chieco
PHOTOGRAPHY
Holly Stewart
PRODUCTION
Gail Beckman
AGENCY
The Richards Group
CLIENT
Tabu Lingerie
ENTRANT LOCATION
Dallas, TX

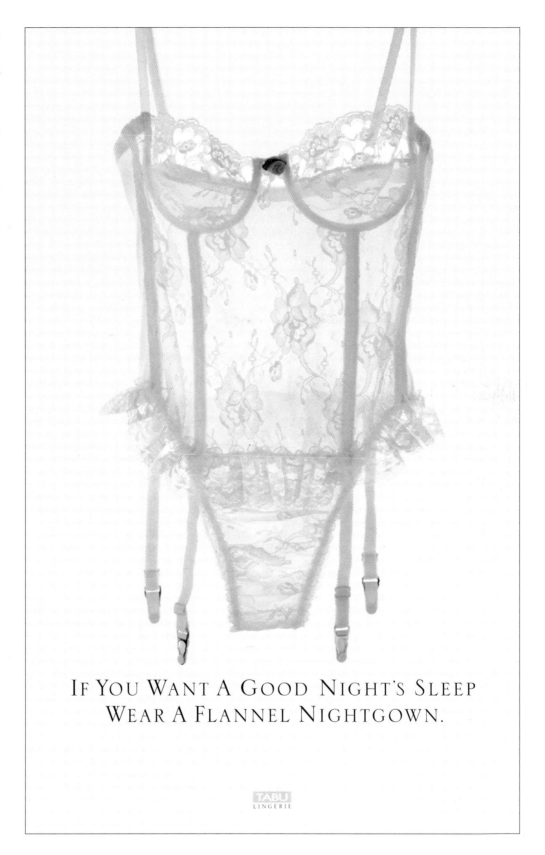

IF YOU WANT A GOOD NIGHT'S SLEEP
WEAR A FLANNEL NIGHTGOWN.

SIGN
51 / 5
DISTINCTIVE MERIT
ART DIRECTION
Grant Richards
COPYWRITING
Todd Tilford
PHOTOGRAPHY
Robb Debenport
PRODUCTION
Gail Beckman
AGENCY
The Richards Group
CLIENT
McQueeney Design
ENTRANT LOCATION
Dallas, TX

TERRIFIC
51 / 6
DISTINCTIVE MERIT
ART DIRECTION
Grant Richards
COPYWRITING
Todd Tilford
PHOTOGRAPHY
Robb Debenport
PRODUCTION
Gail Beckman
AGENCY
The Richards Group
CLIENT
McQueeney Design
ENTRANT LOCATION
Dallas, TX

PITY
51 / 10
DISTINCTIVE MERIT
Jeff Hopfer
COPYWRITING
Todd Tilford,
Vinnie Chieco
PHOTOGRAPHY
Holly Stewart
PRODUCTION
Gail Beckman
AGENCY
The Richards Group
CLIENT
Tabu Lingerie
ENTRANT LOCATION
Dallas, TX

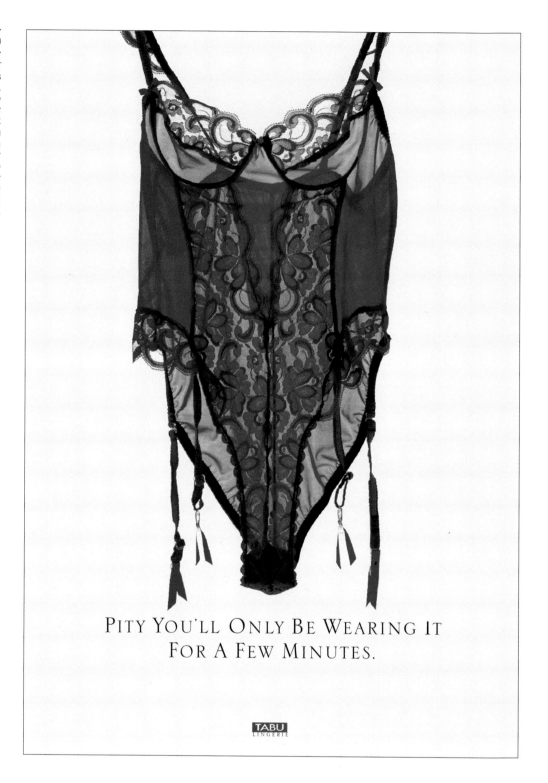

PITY YOU'LL ONLY BE WEARING IT
FOR A FEW MINUTES.

AGENCY CHRISTMAS CARD
51 / 1
ART DIRECTION
Jeff Martin
COPYWRITING
Carey Moore
ILLUSTRATION
Dwayne Coleman
AGENCY
Lewis Advertising / Birmingham
CLIENT
Lewis Advertising
ENTRANT LOCATION
Birmingham, AL

DUDYCHA, SCHIRK & ASSOCIATES (1974 - 1975)
51 / 2
ART DIRECTION
Jamie Mahoney
COPYWRITING
Joe Alexander
PHOTOGRAPHY
Joe Lampi,
Dublin Productions
AGENCY
The Martin Agency
CLIENT
Dick Gerdes
ENTRANT LOCATION
Richmond, VA

DIRECT MAIL – MANURE / MASK
51 / 3
ART DIRECTION
Chuck Finkle
COPYWRITING
Dean Hacohen
PHOTOGRAPHY
Ilan Rubin
AGENCY
Goldsmith / Jeffrey
CLIENT
NYNEX BTB Directory
ENTRANT LOCATION
New York, NY

BLOODY JUDGE
REMINDER
51 / 4
ART DIRECTION
Spencer Till
COPYWRITING
Carey Moore
PHOTOGRAPHY
Michael O'Brien
AGENCY
Lewis Advertising /
Birmingham
CLIENT
Birmingham Ad Club
ENTRANT LOCATION
Birmingham, AL

HEATING BILLS
51 / 9
ART DIRECTION
Jeff Hopfer
COPYWRITING
Todd Tilford,
Vinnie Chieco
PHOTOGRAPHY
Holly Stewart
PRODUCTION
Gail Beckman
AGENCY
The Richards Group
CLIENT
Tabu Lingerie
ENTRANT LOCATION
Dallas, TX

BLOWTORCH
51 / 11
ART DIRECTION
Jeff Hopfer
COPYWRITING
Todd Tilford,
Vinnie Chieco
PHOTOGRAPHY
Holly Stewart
PRODUCTION
Gail Beckman
AGENCY
The Richards Group
CLIENT
Tabu Lingerie
ENTRANT LOCATION
Dallas, TX

A BEDTIME STORY
51 / 1
SILVER
ART DIRECTION
Kins Lee
DESIGN
Kins Lee
COPYWRITING
Janet Lee
LINE DRAWING
Francis Lim, Stan Lee
ACCOUNT DIRECTION
Jeff Low, Willie Lim
STUDIO
Spider
AGENCY
Spider
CLIENT
Slumberland Inchcape
Sdn Bhd
ENTRANT LOCATION
Kuala Lumpur, Malaysia

JUDGE: 1993 ADDY AWARDS

JUST THINK WHAT YOU'LL SAVE
ON HEATING BILLS.

WANT TO REKINDLE AN OLD FLAME?
TRY A BLOWTORCH.

EVERY ONCE

IN A WHILE,

JUST FOR FUN,

WE FEED

LSD TO THE

SILKWORMS.

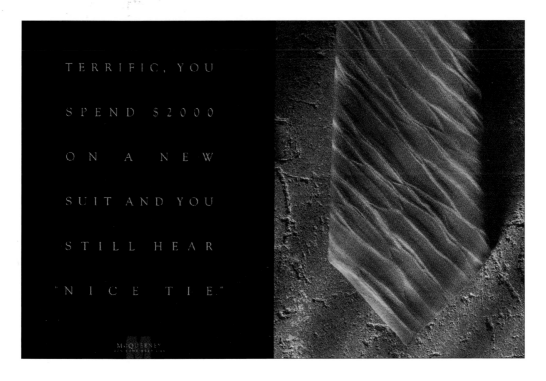

TERRIFIC, YOU

SPEND $2000

ON A NEW

SUIT AND YOU

STILL HEAR

"NICE TIE."

LSD / TERRIFIC / SIGN
52 / 2
GOLD
ART DIRECTION
Grant Richards
COPYWRITING
Todd Tilford
PHOTOGRAPHY
Robb Debenport
AGENCY
The Richards Group
CLIENT
McQueeney Design
ENTRANT LOCATION
Dallas, TX

BLOWTORCH / PITY / FLANNEL
52 / 3
DISTINCTIVE MERIT
ART DIRECTION
Jeff Hopfer
COPYWRITING
Todd Tilford,
Vinnie Chieco
PHOTOGRAPHY
Holly Stewart
PRODUCTION
Gail Beckman
AGENCY
The Richards Group
CLIENT
Tabu Lingerie
ENTRANT LOCATION
Dallas, TX

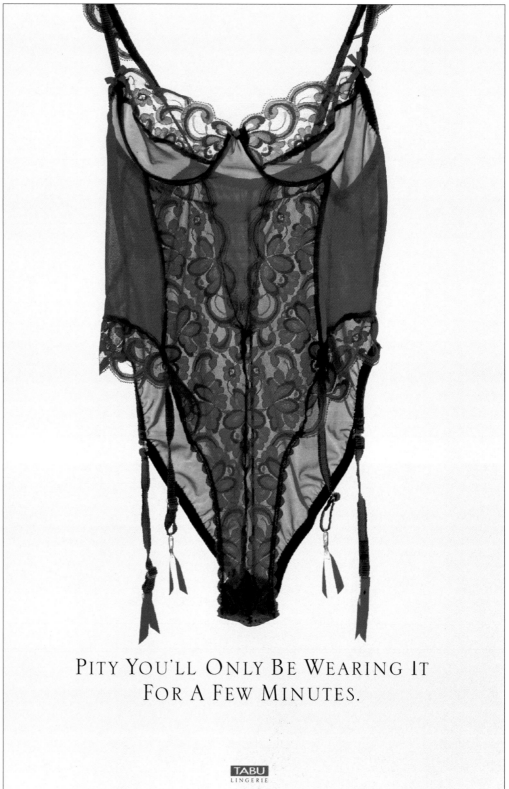

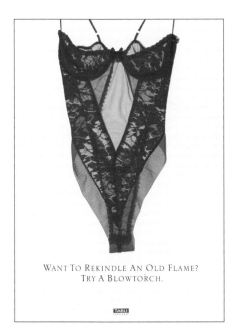

WANT TO REKINDLE AN OLD FLAME?
TRY A BLOWTORCH.

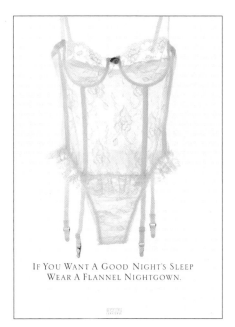

IF YOU WANT A GOOD NIGHT'S SLEEP
WEAR A FLANNEL NIGHTGOWN.

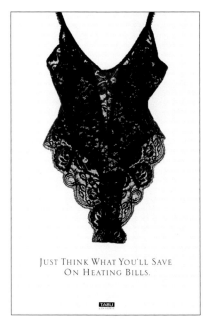

JUST THINK WHAT YOU'LL SAVE
ON HEATING BILLS.

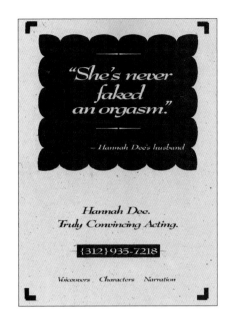
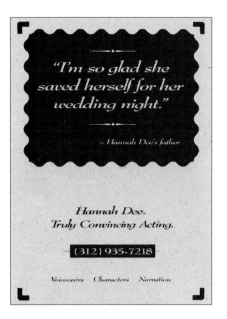
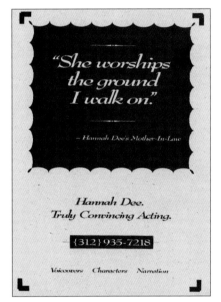

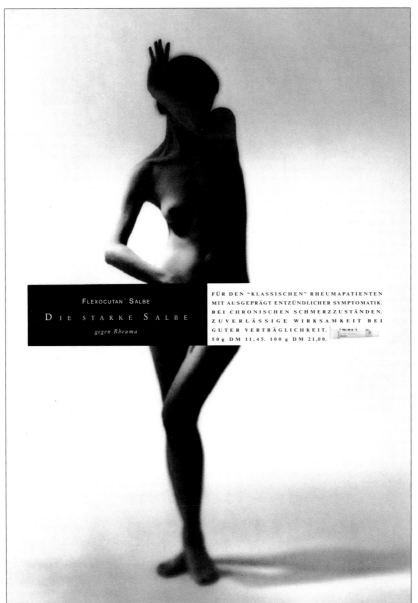

DIE FLEXIBLE- RHEUMA /
THERAPIE / VON DORSCH
52 / 2
ART DIRECTION
Sigi Mayer
DESIGN
Petra Mercker
COPYWRITING
Charlie Frauscher
PHOTOGRAPHY
Mario Katzmair
AGENCY
PHARMA Performance
CLIENT
Dorsch
ENTRANT LOCATION
Munich, Germany

EDITORIAL

K · THE NEW YORK TIMES **OP-ED** FRIDAY, MAY 28, 1993 · A29

Abroad at Home
ANTHONY LEWIS

The Clinton Mystery

BOSTON

What has gone wrong with the Clinton Presidency? Can it be fixed? Or are we headed for another failure that will further erode public faith in the political system?

The questions are being asked — astonishingly so, if you think how early it is. Four months into a new administration, people who voted for Mr. Clinton are wondering whether it can be saved.

Mr. Clinton has just won a big victory with House passage of his budget measure. That will raise morale in a bruised White House. But the doubts will not so easily go away.

It is the little things that hurt, as always in politics — because they are a metaphor for larger worries. How could a man as smart as Bill Clinton tie up the Los Angeles Airport to get a $200 haircut? How could he be so oblivious to public reaction? Is there no one on his staff with the sense and the independence to tell him no?

Oblivious is the word, too, for the handling of the White House travel office affair. Put aside the cronyism charge being made by some in the press. Did no one on the Clinton staff understand how unfair it was to fire long-time employees as suspected wrongdoers without giving them a chance to defend themselves? Or how politic it would look to deny later that they had been fired?

The puzzle about this smart Administration is how it can be so oblivious to reality. And that goes much deeper than the attention-getting incidents of recent weeks.

A clue may lie in Mr. Clinton's campaign last year. It was a campaign of sweeping promises: sweeping and explicit. He did not just utter generalities about making America good again. He said he would end illiteracy within five years, give all Americans health care and pay for it out of cost controls, cut middle-class taxes, reduce the deficit. And so on.

Were those cynical promises by a candidate who knew how hard it would be to carry them out? To the contrary, Bill Clinton was part of a generation that rejected as an excuse the idea that things are hard to fix. It believed the country's problems stemmed from inept leadership, and believed it could solve them if it took over.

There is idealism in that view, but also dangerous naïveté. The President is not a Galahad whose strength is the strength of 10 if his heart is pure. Governing is hard work, the more so in a country whose Constitution divides power so it will be difficult to change things.

The President is the focus of the vast apparatus of modern communications. Americans look to him to solve all their problems. But the demand greatly outpaces the reality of Presidential power.

By all signs Bill Clinton believed in Presidential myth when he took office. He seemed not to understand that it takes to govern: explaining, persuading, making friends, making enemies. Instead he wanted to be loved by everyone: which is not governing.

He has been a surprisingly uncommunicative President. He has talked a great deal: to this or that group just about every day. But he has hardly ever communicated a Big Idea to the public in a way that would sell it, but

What is wrong with this Presidency?

in his economic program.

It is a savage world for presidents these days, as those of us who criticize them ought to recognize.

The press is ravenous, ready to see scandal in a speck of dust. Its self-importance passes belief. Some kind of record may have been set this week, when a New Hampshire television anchor complained about being asked to put some makeup on President Clinton before interviewing him. Lèse-majesté!

The talk show hosts are out there, spewing ignorance and hate. No rumor is too absurd or too invasive to repeat.

The Republican opposition is rigid,

DIALOGUE

The A.D.L. Under Fire

The Jewish community has a right to monitor anti-Semitic groups. We oppose attempts to use the A.D.L.'s deep troubles to build stereotypes of a supposed spy octopus, yet we believe the A.D.L.'s leaders are reaping what they sowed when they lunged to the right in the Reagan-Bush years and became a neo-conservative citadel.

Its Shift to the Right Has Led to Scandal

By Dennis King and Chip Berlet

The Anti-Defamation League of B'nai B'rith is embroiled in a scandal. It results from allegations that a longtime researcher on its payroll in California was illegally given police files as part of an A.D.L. effort not just to monitor bigots but also to watch thousands of other individuals (including the dovish son of the former Israeli Defense Minister Moshe Arens) and hundreds of environmental, civil rights and other social action groups. The researcher, Roy Bullock, has admitted selling intelligence on anti-apartheid groups to South Africa.

The police have raided A.D.L. offices in San Francisco and Los Angeles, and the A.D.L. could face charges of eavesdropping, tax violations and receiving confidential government files. The investigation may develop into a probe of the A.D.L.'s nationwide information-gathering networks. Paul McCloskey, a former Congressman, has filed a class-action invasion-of-privacy lawsuit on behalf of targeted individuals.

Dennis King, who did freelance work for the Anti-Defamation League in the early 1980's, is author of "Lyndon LaRouche and the New American Fascism." Chip Berlet is an editor of Police Misconduct and Civil Rights Law Report, a newsletter.

double standard that attacked many civil rights activists as ideologically suspect while ignoring the bigotry of the A.D.L.'s new right-wing allies. In 1984, the A.D.L. was justified in scolding Jesse Jackson, a Presidential candidate, for overheated criticisms of American Jews and Israel. But it remained silent in 1985 on the appointment of Patrick Buchanan, already a defender of Nazi war criminals, as White House communications director.

The A.D.L. properly urged black politicians to condemn Louis Farrakhan for calling Hitler a "great man" but shrugged off frequent meetings between some of Ronald Reagan's national security staffers and followers of the neo-Nazi Lyndon LaRouche organization. A 54-page A.D.L. report on Mr. LaRouche in 1986 devoted exactly two sentences to these meetings. In 1988, the A.D.L. defended Frederick V. Malek, a George Bush campaign aide who had compiled lists of Jewish-sounding names for the Nixon Administration: he had only carried out orders, the A.D.L. said.

To avoid any such diversion, the A.D.L. said in 1986 that a Louis Harris poll it had commissioned had shown reports of Farm Belt anti-Semitism to be "grossly exaggerated." In fact, the poll revealed shocking anti-Semitism, and the A.D.L. had to back down when the American Jewish Committee disputed its interpretation.

The A.D.L.'s abandonment of serious analysis reached its nadir in 1988, when in an Op-Ed article in The Wall Street Journal, an A.D.L. fact-finder, Mira L. Boland, described white supremacy as a "negligible" force (citing only membership figures, not the influence of supremacists) and suggested that anyone who regarded "violent racism" as a major problem was indulging either in "paranoid fantasy" or subversive propaganda.

Even after David Duke, a former Klansman and neo-Nazi, won 60 percent of the white vote in the Senate race in Louisiana in 1990, the A.D.L. did not attack him as aggressively as it had Jesse

Jackson. Abraham H. Foxman, who became national director of the A.D.L. in 1987, argued that the organization might lose its tax-exempt status if it took a stand on a political candidate — though Jesse Jackson had been attacked by the A.D.L. while he was a candidate.

While Mr. Buchanan was a Presidential candidate in 1992, tapping into Mr. Duke's constituency, the A.D.L. did not oppose him, evidently again relying on its tax-exempt status as an excuse for passivity. After he bowed out, the A.D.L. published a critical analysis of his remarks.

Even the 1991 Crown Heights riots couldn't nudge the A.D.L. into its former activism. A.D.L. leaders, in spite of their professed views of black anti-Semitism as the overriding domestic threat to Jews, issued neutral statements avoiding any mention of anti-Semitism, while Jews were being beaten in the streets. (Mr. Foxman later said this "self-imposed restraint" had been a mistake.)

The A.D.L. will soon face fierce attacks, with the likelihood of further lawsuits in the California scandal. The usual circling-the-wagons defense that has been the chief tactic of the major Jewish organizations won't be convincing. Neither will the predictable defense that rests on the A.D.L.'s prior record of fighting bigotry. In recent years, it has sacrificed principled politics to expediency. For the A.D.L. to recapture the trust it has lost, a full housecleaning is in order. □

It's a Big Lie, Hailed by Anti-Semites

By Abraham H. Foxman

The Big Lie technique is alive and well. Just ask us at the Anti-Defamation League, which has been the target of the Big Lie for months. You may have seen headlines. "The A.D.L. Is Spying On You." "A.D.L. Runs Spy Network Across the Country." "A.D.L. Has Files on Good Americans." "A.D.L. Spies for Zion." "A.D.L. Sells Information to Foreign Governments."

Say something outrageous about someone or some group — something no one would believe. Say it often enough and in time the lie acquires a life of its own. People believe that if a message is heard often there must be some truth to it. It is difficult to fight the Big Lie. Those fighting it appear to protest too much.

There is no choice, however, but to expose the lie for what it is, for its pernicious intent and for its poisonous consequences. We must fight the Big Lie not only for the sake of the A.D.L. but also for that of the Jewish community and others in our society who, too, could suffer from similar attacks.

There is no A.D.L. spy network. There is no selling of information to foreign governments. What there is, is what is right about the A.D.L. — what the A.D.L. has been doing to protect the Jewish community and American society for decades. These so-called revelations are "facts" being created from whole cloth and are innocent activities presented as sinister ones.

One such creation is the charge that the A.D.L. has a spy network.

tivity because it does not exist, and yet time and again we hear the charge that the A.D.L. is spying on good folks. Those who charge us with such activity don't have the vaguest idea what we are about, and at least have the onus of bringing proof to support their charges.

The Big Lie technique takes innocent actions and portrays them as sinister. Such has been the case with the use of the word "files." The "proof" that the A.D.L. is engaged in spying is the very fact that it has files on all kinds of people and organizations. Ironically, the very people making these charges themselves maintain and use such files whether they be journalists, lawyers or academics.

Another aspect of the Big Lie is the notion that in recent years the A.D.L. has taken on on a right-wing perspective that has contributed to its recent difficulties. Absurd. A look at A.D.L. publications and reports from 1990 through 1992 reveals just how absurd: 63 reports exposed groups on the far right, 20 exposed the far left. Similarly, the A.D.L. Law Enforcement Bulletin, published since 1988, contains 68 articles on the right and seven on the left. The Order. The K.K.K. The White Aryan Resistance. David Duke. All right-wing extremists — and all A.D.L. priorities.

Why the Big Lie? On one level it is simply a question of media irresponsibility. But there is likely something else going on in some circles, something more sinister — something requiring more analysis. In a recent A.D.L. public opinion poll on anti-Semitism, one of the most disturbing findings was that more than 30 percent believed Jews have too much power.

There are those who seem to be playing on that anxiety, those willing to exploit this perception about American Jews by portraying the A.D.L. as all-powerful and all-seeing. That is why the Big Lie is an attack in the broadest sense on the community relations and political efforts of the entire Jewish community.

While the motives behind the Big Lie are matters for specu-

On My Mind
A. M. ROSENTHAL

Clinton Voter Stays Glad!

She swooped at me across the banquet room like a lovely bird of passion, glistening with the joy and fulfillment of vengeance.

"Now," she cried in high Republican ecstasy. "Now aren't you sorry you voted for Clinton?"

No, I cry back, do with me what you will, but I am not sorry. I am glad, glad.

I will make up my mind about 1996 in 1996. But right now Clinton voters are ahead of the game. They already have achieved major goals.

For one thing, George Bush is not President. Surely that was a shining objective in voting for Mr. Clinton. They can't take that away from us.

Continuing: The new President gave Americans a wake-up shake by making them think through the deficit — and what they are willing to pay in taxes or benefits to reduce it. And he is giving the U.S. its first national debate on universal health care, decades overdue. If Clinton voters now don't like the details of what they asked for, the right to scream our heads off is right there in the Constitution.

He floundered on Bosnia; he certainly did. But he has managed to keep the country out of a war impossible to win without a heavy commitment of ground troops. Any hands raised for that?

Admittedly, there is a certain dependable regularity to White House pratfalls. If we try hard, maybe we can put down haircuts that close airports and tinkering with the F.B.I. to arrogance, smugness and inexperience in the White House, top down. Perhaps it can be cured by Presidential self-examination and a hug to some aides, one warm, last hug.

But that's enough: of smarmy patience. It ends, replaced by healthy snarls when Mr. Clinton reverses himself or fudges on the single most important goal in American life: racial reconciliation.

We all have our definitions about that but for most Clinton voters it cannot include such things as these:

Racial polarization. Setting black and white politically and legally apart. Making the Justice Department and courts the supervisors of state legislatures, to decide when majority political rule can be set aside for minority interests. Deciding that a black politician elected with white support is not really an "authentic" black politician. Scorning the efforts of the Voting Rights Act to give blacks power within majority politics, not apart from or above it. Creating weighted voting systems that would promote apartness.

But Mr. Clinton, to the grief — the exact word — of Democratic integrationists has nominated Prof. Lani Guinier to head the civil rights wing of the Justice Department. She stands for those things and others destructive of the hope for racial harmony to which they devoted so much of their lives.

The nomination has created such shock among Democrats that she will probably not get Congressional approval. Her name may even be withdrawn.

But questions about how she came to be nominated are as important as she is herself.

This is not some bad after-dinner joke or imperious holding up of air traffic but a matter of deepest national interest and emotion.

How could he have done such a

But what's this about race politics?

thing? The simplest answer is that he agrees with her. Or maybe he does not think it important what his new civil rights chief thinks about civil rights.

Democratic racial integrationists, including people who worked with him to draw up his civil rights policy during the campaign, say neither answer makes sense. They cannot believe it, not about the Bill Clinton who had stood against quotas during the campaign, who went from black church to white church preaching the same message of individual responsibility against racial divisiveness.

What then? Was the nomination promoted by Hillary Clinton? If so

LAWN & GARDEN
53 / 1
ART DIRECTION
Scott Minister
DESIGN
Scott Minister
PHOTOGRAPHY
Kathy Dlabick
EDITING
Pam Coffman
Coordination
Becky Kover,
Shirley McNeely
AGENCY
The Columbus
Dispatch
ENTRANT LOCATION
Columbus, OH

MAKE ROOM
53 / 3
ART DIRECTION
Galie Jean-Louis
DESIGN
Galie Jean-Louis
PHOTOGRAPHY
Amy Guip
ILLUSTRATION
Amy Guip
PUBLICATION
Anchorage Daily News
ENTRANT LOCATION
Anchorage, AK

ARTS ETC.
53 / 4
ART DIRECTION
Sue Dawson
PUBLICATION
The Boston Globe
ENTRANT LOCATION
Boston, MA

BOW WOW WOW
55 / 1
ART DIRECTION
Gary Koepke
PHOTOGRAPHY
Dan Winters
EDITING
Johnathan Van Meter
STUDIO
Koepke International
Ltd.
CLIENT
Time Ventures, Inc.
ENTRANT LOCATION
Magnolia, MA

NOVEMBER 1993
55 / 2
DESIGN
John Plunkett,
Barbara Kuhr
COPYWRITING
Louis Rossetto
PHOTOGRAPHY
Henry Blackham
STUDIO
Plunkett & Kuhr
CLIENT
Wired USA
ENTRANT LOCATION
Park City, UT

**COULD YOU BUILD A
HOUSE WITH THIS?**
55 / 3
ART DIRECTION
Carl Lehmann-Haupt,
Nancy Cohen
EDITING
Susan S. Szenasy
PHOTOGRAPHY
Ilisa Katz
PUBLICATION
Metropolis
PUBLISHER
Horace Havemeyer III
ENTRANT LOCATION
New York, NY

HOME?
55 / 4
ART DIRECTION
Carl Lehmann-Haupt,
Nancy Cohen
EDITING
Susan S. Szenasy
PHOTOGRAPHY
Mara Kurtz
PUBLICATION
Metropolis
PUBLISHER
Horace Havemeyer III
ENTRANT LOCATION
New York, NY

**REDESIGNING THE OVAL
OFFICE**
55 / 5
ART DIRECTION
Carl Lehmann-Haupt,
Nancy Cohen
EDITING
Susan S. Szenasy
PHOTOGRAPHY
Michael Ackerman
PUBLICATION
Metropolis
PUBLISHER
Horace Havemeyer III
ENTRANT LOCATION
New York, NY

THE HOT LIST
56 / 11
DISTINCTIVE MERIT
ART DIRECTION
Fred Woodward
DESIGN
Debra Bishop
PUBLICATION
Rolling Stone Magazine
PUBLISHER
Wenner Media Inc.
ENTRANT LOCATION
New York, NY

THE

HOT

LIST

Popular culture operates on the principle of the eternal return, which is why we are once more confronted with *The Brady Bunch*, Abba and the Hot List. Now, a Hot List can't be all things to everybody. But this year's model does have a few simple goals: to celebrate, to educate and to irritate. We've tried to err on the side of the underdog. We've tried to be politically correct *and* politically incorrect, and if we've pissed off Tipper and Al, so be it. What else? We've tried to capture the sublime and the ridiculous. We've tried to come up with a list that won't embarrass the hell out of us in two years. In order to do all that, we've picked the brains of a few nonresident experts. So. The 1993 Hot List: Because we care enough to share. Because we do it every year. Because we can.

ROLLING STONE, MAY 13TH, 1993 · 61

DAVID LETTERMAN
56 / 12
DISTINCTIVE MERIT
ART DIRECTION
Fred Woodward
DESIGN
Fred Woodward,
Gail Anderson
ILLUSTRATION
Al Hirshfeld
PUBLICATION
Rolling Stone Magazine
PUBLISHER
Wenner Media Inc.
ENTRANT LOCATION
New York, NY

UNTITLED
56 / 21
DISTINCTIVE MERIT
ART DIRECTION
Fred Woodward
DESIGN
Angela Skouras
PHOTOGRAPHY
Mark Seliger
PHOTO DIRECTION
Laurie Kratochvil
PUBLICATION
Rolling Stone Magazine
PUBLISHER
Wenner Media Inc.
ENTRANT LOCATION
New York, NY

**THE TROUBLE WITH
WESLEY**
56 / 1

ART DIRECTION
Gary Koepke

DESIGN
Gary Koepke,
Richard Baker

PHOTOGRAPHY
Dan Winters

EDITING
Johnathan Van Meter

PUBLICATION
The Vibe

CLIENT
Time Ventures, Inc.

ENTRANT LOCATION
Magnolia, MA

IT'S PARTY TIME
56 / 2

ART DIRECTION
Micheal F. Diloia

DESIGN
Tim J. Baldwin

ILLUSTRATION
Anthony Russo

PUBLICATION
Penthouse Letters

PUBLISHER
General Media

ENTRANT LOCATION
New York, NY

DEAD AGAIN?
56 / 3

ART DIRECTION
Gary Koepke

DESIGN
Richard Baker

PHOTOGRAPHY
Merlyn Rosenberg

EDITING
Johnathan Van Meter

STUDIO
Koepke International
Ltd.

PUBLICATION
The Vibe

PUBLISHER
Time Ventures, Inc.

ENTRANT LOCATION
Magnolia, MA

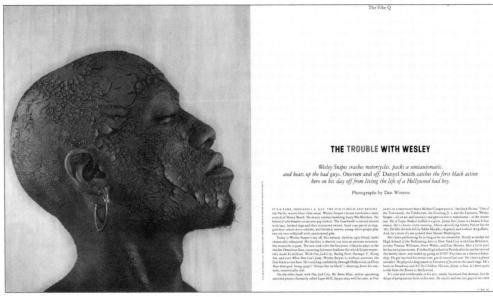

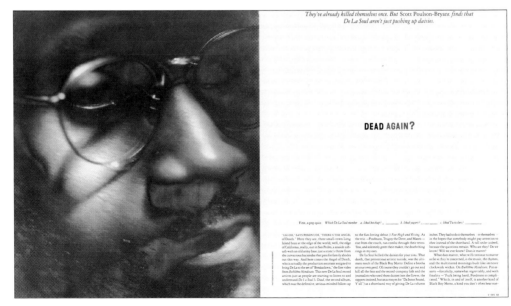

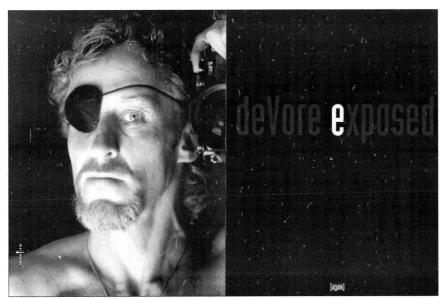

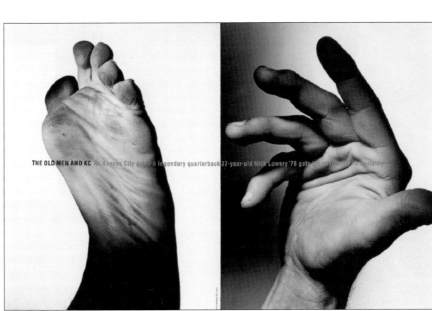

IT'S ALL IN YOUR HEAD
56 / 4
ART DIRECTION
Mark Geer
DESIGN
Mark Geer
COPYWRITING
Charles Bankhead
ILLUSTRATION
John Kleber
STUDIO
Geer Design, Inc.
PUBLICATION
Caring Magazine
PUBLISHER
Memorial Healthcare
System
ENTRANT LOCATION
Houston, TX

DEVORE EXPOSED
56 / 5
ART DIRECTION
Holly Jaffe
DESIGN
Holly Jaffe
COPYWRITING
Ernest Vogliano
PHOTOGRAPHY
Nicolas DeVore III
PUBLICATION
Aspen Aces and Eights
Magazine
PUBLISHER
Aspen Aces and Eights
Inc.
ENTRANT LOCATION
New York, NY

THE OLD MEN AND KC
56 / 6
ART DIRECTION
Scott Menchin
DESIGN
Scott Menchin
PHOTOGRAPHY
Ken Shung
CLIENT
Dartmouth
ENTRANT LOCATION
New York, NY

RITE OF PASSAGE
56 / 7
ART DIRECTION
Mark Geer
DESIGN
Mark Geer
COPYWRITING
Jolynn Rogers
PHOTOGRAPHY
Hans Staartjes
STUDIO
Geer Design, Inc.
PUBLICATION
Caring Magazine
PUBLISHER
Memorial Healthcare
System
ENTRANT LOCATION
Houston, TX

ONE PICTURE
56 / 8
ART DIRECTION
Suzanne Morin
PHOTOGRAPHY
Frans Lanting, Peter
Howe
AGENCY
Minden Pictures
ENTRANT LOCATION
New York, NY

JOINT VENTURES
56 / 9
ART DIRECTION
Mark Geer
DESIGN
Mark Geer
COPYWRITING
Charles Bankhead
ILLUSTRATION
Malcolm Tarlofsky
STUDIO
Geer Design, Inc.
PUBLICATION
Caring Magazine
PUBLISHER
Memorial Healthcare
System
ENTRANT LOCATION
Houston, TX

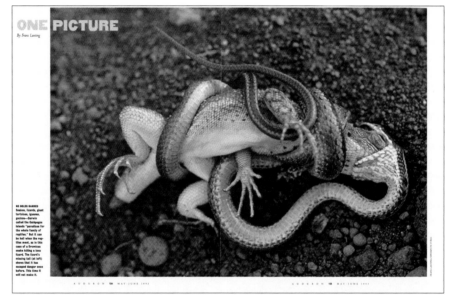

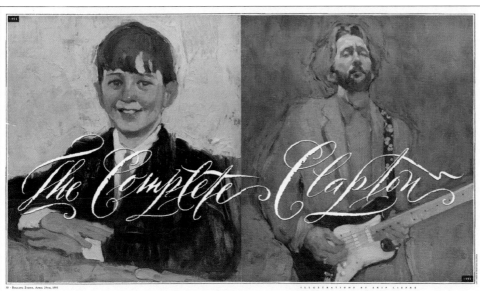

CHAOS HITS WALL STREET
56 / 10
ART DIRECTION
David Armario
DESIGN
James Lambertus
CLIENT
Walt Disney Publishing
ENTRANT LOCATION
Burbank, CA

THE COMPLETE CLAPTON
56 / 13
ART DIRECTION
Fred Woodward
DESIGN
Fred Woodward,
Gail Anderson
ILLUSTRATION
Skip Liepke
PUBLICATION
Rolling Stone Magazine
PUBLISHER
Wenner Media Inc.
ENTRANT LOCATION
New York, NY

BLIND MELON
56 / 14
ART DIRECTION
Fred Woodward
DESIGN
Fred Woodward,
Gail Anderson
PHOTOGRAPHY
Mark Seliger
PHOTO DIRECTION
Laurie Kratochvil
PUBLICATION
Rolling Stone Magazine
PUBLISHER
Wenner Media Inc.
ENTRANT LOCATION
New York, NY

THE MAKING OF THE
SOVIET BOMB
56 / 15
ART DIRECTION
Fred Woodward
DESIGN
Gail Anderson
PHOTOGRAPHY
Matt Mahurin
PUBLICATION
Rolling Stone Magazine
PUBLISHER
Wenner Media Inc.
ENTRANT LOCATION
New York, NY

BEHIND THE FLY
56 / 16
ART DIRECTION
Fred Woodward
DESIGN
Debra Bishop
ILLUSTRATION
Charles Burns
PUBLICATION
Rolling Stone Magazine
PUBLISHER
Wenner Media Inc.
ENTRANT LOCATION
New York, NY

ZOO WORLD ORDER
56 / 17
ART DIRECTION
Fred Woodward
DESIGN
Fred Woodward
COPYWRITING
Wenner Media, Inc.
PHOTO DIRECTION
Laurie Kratochvil
PUBLICATION
Rolling Stone Magazine
PUBLISHER
Wenner Media Inc.
ENTRANT LOCATION
New York, NY

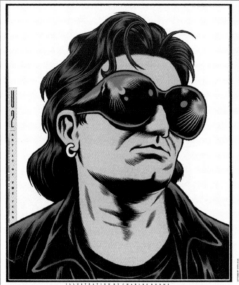

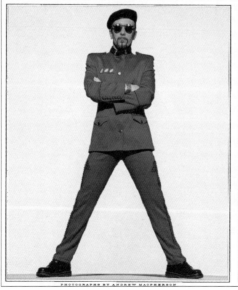

336

THE ROAD TO WELLVILLE
56 / 18
ART DIRECTION
Fred Woodward
DESIGN
Catherine Gilmore-Barnes
ILLUSTRATION
Malcolm Tarlofsky
PUBLICATION
Rolling Stone Magazine
PUBLISHER
Wenner Media Inc.
ENTRANT LOCATION
New York, NY

DAVID GEFFEN
56 / 19
ART DIRECTION
Fred Woodward
DESIGN
Debra Bishop
PHOTOGRAPHY
Herb Ritts
PHOTO DIRECTION
Laurie Kratochvil
PUBLICATION
Rolling Stone Magazine
PUBLISHER
Wenner Media Inc.
ENTRANT LOCATION
New York, NY

ROPIN' THE WHIRLWIND
56 / 20
ART DIRECTION
Fred Woodward
DESIGN
Debra Bishop
PHOTOGRAPHY
Kurt Markus
PHOTO DIRECTION
Laurie Kratochvil
LETTERING
Anita Karl
PUBLICATION
Rolling Stone Magazine
PUBLISHER
Wenner Media Inc.
ENTRANT LOCATION
New York, NY

AN EXPERIMENT IN
TERROR BRANCHING OUT
56 / 22
ART DIRECTION
Donna Bonavita
DESIGN
Donna Bonavita
COPYWRITING
Robert M. Strozier
PHOTOGRAPHY
George Ross
ILLUSTRATION
Sarah Oliphant
PUBLICATION
World
AGENCY
KMPG
Communications
Group
ENTRANT LOCATION
Montvale, NJ

THE OLD MAN
AND THE TEE
56 / 23
ART DIRECTION
D.J. Stout
DESIGN
D.J. Stout,
Nancy McMillen
COPYWRITING
Bud Shrake
PHOTOGRAPHY
Michael O'Brien
PUBLICATION
Texas Monthly
ENTRANT LOCATION
Austin, TX

LIABILITY SQUEEZE
56 / 24
ART DIRECTION
Donna Bonavita
DESIGN
Donna Bonavita
COPYWRITING
Jon C. Madonna
PHOTOGRAPHY
George Ross
PUBLICATION
World
AGENCY
KMPG
Communications
Group
ENTRANT LOCATION
Montvale, NJ

branching
OUT

BY ROBERT M. STROZIER

Ineffective leaders often lose sight of what's going on around them. They get squeezed by the press of administrative matters, narrow thinking, and bureaucratic rigidity. They can't see the forest for the trees—can't see tomorrow's opportunities for today's headaches. As this compendium of CEO profiles and management maxims suggests, however, effective leaders are different. They're able to learn from their experiences and surroundings—and apply what they learn. They keep growing because they give themselves room to grow.

THE OLD MAN AND THE TEE

A year after he paired up with novelist Bud Shrake to produce the best-selling Little Red Book, 89-year-old golf sage Harvey Penick has followed through with a sequel, a video, and other strokes of genius.

by GARY CARTWRIGHT

SQUEEZE

BY JON C. MADONNA

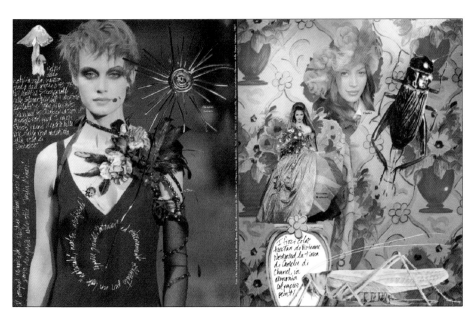

GO EAST
56 / 5
ART DIRECTION
Christian Guth
DESIGN
Barbel Block
ILLUSTRATION
Peter Schmid
PRODUCTION
Anne Wania,
Heidi Salzer
PUBLICATION
! Forbes
ENTRANT LOCATION
Munich, Germany

BLACK? - STRICT OR SEXY
56 / 1
ART DIRECTION
Luca Stoppini
DESIGN
Luca Stoppini
PHOTOGRAPHY
Michel Comte
PUBLICATION
Vogue Italia
ENTRANT LOCATION
Milan, Italy

JARDIN
56 / 2
ART DIRECTION
Luca Stoppini
DESIGN
Luca Stoppini
PHOTOGRAPHY
Alfa Castaldi,
Bruno Rinaldi
PUBLICATION
Vogue Italia
ENTRANT LOCATION
Milan, Italy

BRITISH ECCENTRICS
56 / 3
ART DIRECTION
Luca Stoppini
DESIGN
Luca Stoppini
PUBLICATION
Vogue Italia
ENTRANT LOCATION
Milan, Italy

PERSONAL DIARY
56 / 4
ART DIRECTION
Luca Stoppini
DESIGN
Luca Stoppini
PUBLICATION
Vogue Italia
ENTRANT LOCATION
Milan, Italy

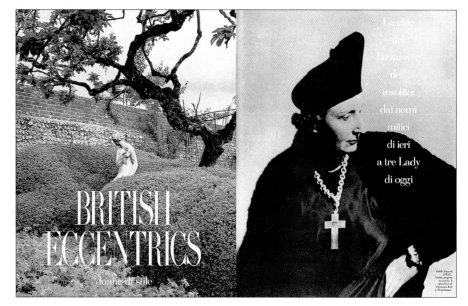

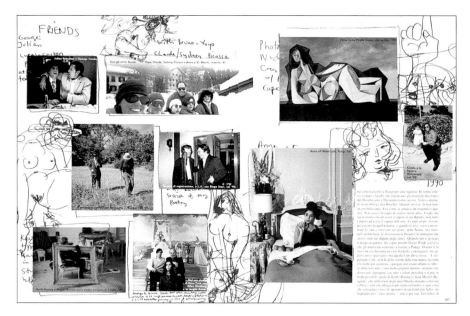

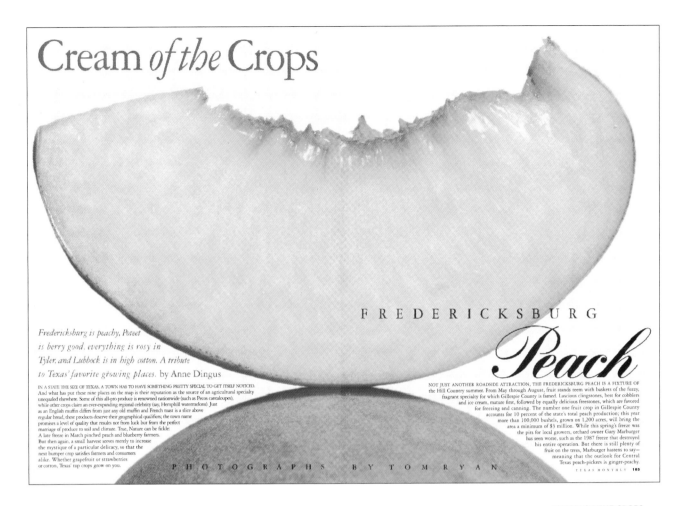

Cream *of the* Crops

FREDERICKSBURG

Peach

Fredericksburg is peachy, Poteet is berry good, everything is rosy in Tyler, and Lubbock is in high cotton. A tribute to Texas' favorite growing places. by Anne Dingus

IN A STATE THE SIZE OF TEXAS, A TOWN HAS TO HAVE SOMETHING PRETTY SPECIAL TO GET ITSELF NOTICED. And what has put these nine places on the map is their reputation as the source of an agricultural specialty unequaled elsewhere. Some of this all-pro produce is renowned nationwide (such as Pecos cantaloupes), while other crops claim an ever-expanding regional celebrity (say, Hemphill watermelons). Just as an English muffin differs from just any old muffin and French toast is a slice above regular bread, these products deserve their geographical qualifiers; the town name promises a level of quality that results not from luck but from the perfect marriage of produce to soil and climate. True, Nature can be fickle: A late freeze in March pinched peach and blueberry farmers. But then again, a small harvest serves merely to increase the mystique of a particular delicacy, so that the next bumper crop satisfies farmers and consumers alike. Whether grapefruit or strawberries or cotton, Texas' top crops grow on you.

NOT JUST ANOTHER ROADSIDE ATTRACTION, THE FREDERICKSBURG PEACH IS A FIXTURE OF the Hill Country summer. From May through August, fruit stands teem with baskets of the fuzzy, fragrant specialty for which Gillespie County is famed. Luscious clingstones, best for cobblers and ice cream, mature first, followed by equally delicious freestones, which are favored for freezing and canning. The number one fruit crop in Gillespie County accounts for 10 percent of the state's total peach production; this year more than 100,000 bushels, grown on 1,200 acres, will bring the area a minimum of $3 million. While this spring's freeze was the pits for local growers, orchard owner Gary Marburger has seen worse, such as the 1987 freeze that destroyed his entire operation. But there is still plenty of fruit on the trees, Marburger hastens to say— meaning that the outlook for Central Texas peach-pickers is ginger-peachy.

PHOTOGRAPHS BY TOM RYAN

TEXAS MONTHLY **103**

CREAM OF THE CROPS
57 / 1

ART DIRECTION
D.J. Stout

DESIGN
D.J. Stout,
Nancy McMillen

COPYWRITING
Anne Dingus

PHOTOGRAPHY
Tom Ryan

PUBLICATION
Texas Monthly

ENTRANT LOCATION
Austin, TX

THE WATERCOLORS OF
JOHN JAMES AUDUBON
57 / 2

ART DIRECTION
Suzanne Morin

DESIGN
Suzanne Morin,
Jonathan B. Foster

COPYWRITING
Linda Pernex

ILLUSTRATION
John James Audubon

ENTRANT LOCATION
New York, NY

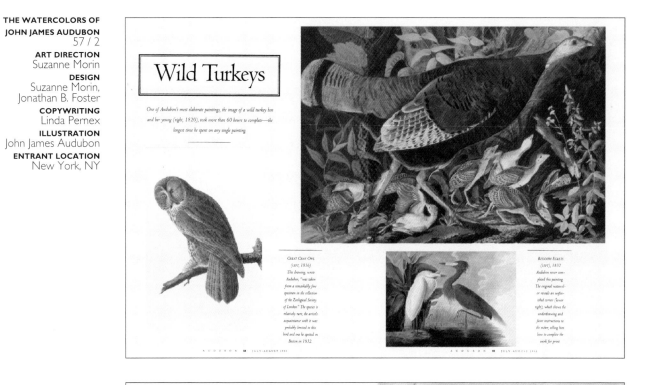

Wild Turkeys

One of Audubon's most elaborate paintings, the image of a wild turkey hen and her young (right, 1826), took more than 60 hours to complete—the longest time he spent on any single painting.

GREAT GRAY OWL (LEFT, 1836) This drawing, wrote Audubon, "was taken from a remarkably fine specimen in the collection of the Zoological Society of London." The species is relatively rare, the artist's acquaintance with it was probably limited to this bird and one he spotted in Boston in 1832.

REDDISH EGRETS (LEFT), 1832 Audubon never completed this painting. The original watercolor reveals an unfinished corner (lower right), which shows the underdrawing and faint instructions to the etcher, telling him how to complete the work for print.

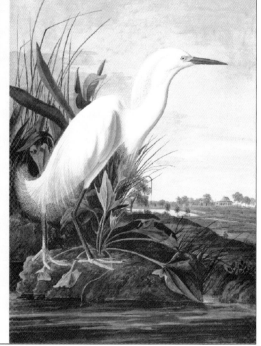

The Watercolors of John James Audubon

FOR MORE THAN 125 YEARS AUDUBON'S WATERCOLORS HAVE BEEN HOUSED AT THE NEW-YORK HISTORICAL SOCIETY. THIS FALL, FOR THE FIRST TIME, 90 PAINTINGS WILL TRAVEL IN AN EXHIBITION THAT OPENS OCTOBER 3 AT WASHINGTON, D.C.'S NATIONAL GALLERY (SEE PAGE 119 FOR OTHER VENUES.) ALSO THIS FALL, VILLARD BOOKS WILL PUBLISH JOHN JAMES AUDUBON: THE WATERCOLORS FOR "THE BIRDS OF AMERICA," BY ANNETTE BLAUGRUND AND THEODORE E. STEBBINS JR., WITH REBA FISHMAN, HOLLY HOTCHNER, AMY R. W. MEYERS, AND CAROLE ANNE SLATKIN. ON THESE EIGHT PAGES, AUDUBON PRESENTS THE FIRST LOOK MOST OF US HAVE EVER HAD AT THE WATERCOLORS.

John James Audubon came to his art the long way around. After crisscrossing the Atlantic as both a child and a young man, launching a series of disastrous business ventures, and finally overcoming the double handicap of ornithological ignorance and juvenile incompetence at the drawing board, Audubon emerged as the supreme painter of birds. The key was to match flame with flame—the burning intensity of his own life with that of his subjects.

"One day, while watching the habits of a pair of Pewees," he wrote, "I looked so intently at their graceful attitudes that a thought struck my mind like a flash of light, that nothing, after all, could ever answer my enthusiastic desires to represent nature, except to copy her in her own way, alive and moving."

To capture a sense of life as it is lived, he became a great walker: Before dawn he was invariably on his way into the woods, alert to the life around him. His skill as a rifleman still brings moments of disquiet to conservationists who have read about how he left carcasses of birds in windrows on remote shores.

Audubon lived at a time when Americans were profligate with their wilderness treasures, which seemed to them infinite. In his essay on passenger pigeons, written in the early 1800s, Audubon noted one of their great migrations, which lasted for three days over Louisville, Kentucky. "The banks of the Ohio were crowded with men and boys, incessantly shooting . . . ," he wrote. "Multitudes were thus destroyed. For a week or more, the population fed on no other flesh than that of Pigeons, and talked of nothing but Pigeons."

Yet Audubon's true genius lay not in the rifle but in his eye. He made up for his lack of scientific education with the ability to see, and to record what he saw on paper. The snowy egret shown at right in its watery habitat is symbolic of a world that he saved for us—a landscape now irrevocably lost, a remnant of frontier America. The spark that animated those birds of another time still glows in Audubon's art.

—*FRANK GRAHAM JR.*

Gyrfalcons

Although the gyrfalcon (right) is occasionally found in the United States, Audubon painted this 1836 work from a single female specimen held in England. The birds are least often seen in their white phase, as painted here. They are very rare; during the Middle Ages, when falcons were commonly used in hunting, only royalty were allowed to use them.

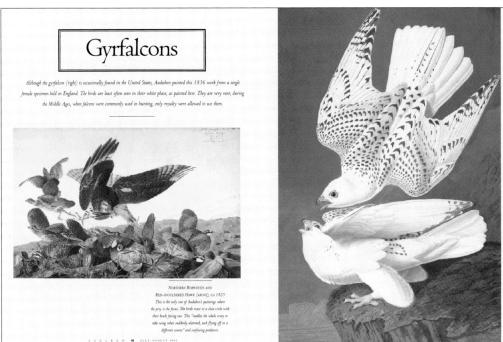

NORTHERN BOBWHITES AND
RED-SHOULDERED HAWK (ABOVE), CA 1825
This is the only one of Audubon's paintings where
the prey is the focus. The birds roost in a close circle with
their heads facing out. This "enables the whole covey to
take wing when suddenly alarmed, each flying off in a
different course" and confusing predators.

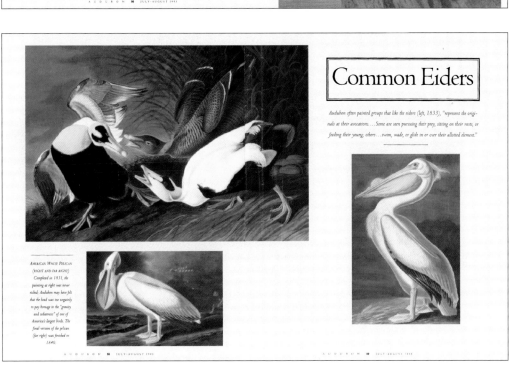

Common Eiders

Audubon often painted groups that like the eiders (left, 1833), "represent the originals at their avocations.... Some are seen pursuing their prey, sitting on their nests, or feeding their young; others...swim, wade, or glide in or over their allotted element."

AMERICAN WHITE PELICAN
(RIGHT AND FAR RIGHT)
Completed in 1831, the
painting at right was never
etched; Audubon may have felt
that the head was too ungainly
to pay homage to the "gravity
and sedateness" of one of
America's largest birds. The
final version of the pelican
(far right) was finished in
1840.

WE WORK
57 / 3
ART DIRECTION
Carl Lehmann-Haupt,
Nancy Cohen
PHOTOGRAPHY
Michael Ackerman
EDITING
Susan Szenasy
PUBLISHER
Horace Havemeyer III
STUDIO
Metropolis Magazine
ENTRANT LOCATION
New York, NY

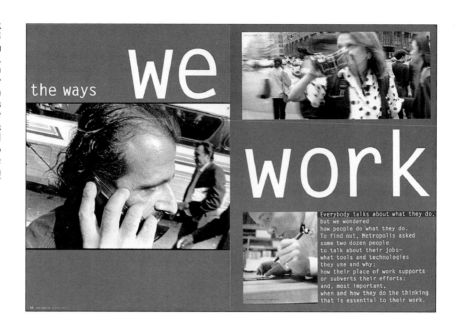

TRAVEL & LEISURE
58 / 1
ART DIRECTION
Lloyd Ziff
DESIGN
Lloyd Ziff
COPYWRITING
Lloyd Ziff (Cover)
PHOTOGRAPHY
Geof Kern (Cover)
PUBLICATION
Travel and Leisure
ENTRANT LOCATION
Brooklyn, NY

WESLEY SNIPES
58 / 2
ART DIRECTION
Gary Koepke
DESIGN
Gary Koepke,
Richard Baker
EDITING
Johnathan Van Meter
STUDIO
Koepke International
Ltd.
PUBLICATION
The Vibe
CLIENT
Time Ventures, Inc.
ENTRANT LOCATION
Magnolia, MA

GEORGE CLINTON
58 / 3
ART DIRECTION
Gary Koepke
DESIGN
Gary Koepke,
Richard Baker
EDITING
Johnathan Van Meter
STUDIO
Koepke International
Ltd.
PUBLICATION
The Vibe
CLIENT
Time Ventures, Inc.
ENTRANT LOCATION
Magnolia, MA

BOW WOW WOW
58 / 4
ART DIRECTION
Gary Koepke
DESIGN
Gary Koepke,
Richard Baker
EDITING
Johnathan Van Meter
PUBLICATION
The Vibe
CLIENT
Time Ventures, Inc.
ENTRANT LOCATION
Magnolia, MA

PREMIERE ISSUE
58 / 5
DESIGN
John Plunkett,
Barbara Kuhr
PHOTOGRAPHY
Neil Selkirk,
Bill Zemanek,
Henrik Kam
ILLUSTRATION
Eric Adigard,
Stewart Cuolitz,
Nick Phillip
STUDIO
Plunkett & Kuhr
PUBLISHER
Wired USA
ENTRANT LOCATION
Park City, UT

JANET JACKSON
58 / 6
ART DIRECTION
Fred Woodward
DESIGN
Fred Woodward,
Gail Anderson,
Catherine Gilmore-
Barnes,
Debra Bishop,
Angela Skouras,
Geraldine Hesslers,
Lee Bearson
PHOTO DIRECTION
Laurie Kratochvil
PUBLICATION
Rolling Stone Magazine
PUBLISHER
Wenner Media Inc.
ENTRANT LOCATION
New York, NY

BLIND MELON
58 / 7
ART DIRECTION
Fred Woodward
DESIGN
Fred Woodward,
Gail Anderson,
Debra Bishop,
Geraldine Hessler
PHOTO DIRECTION
Laurie Kratochvil
PUBLICATION
Rolling Stone Magazine
PUBLISHER
Wenner Media Inc.
ENTRANT LOCATION
New York, NY

THERE'S NO SUCH THING
AS A SIMPLE SUICIDE
58 / 8
ART DIRECTION
Paula Scher,
Janet Froehlich
(NY Times)
DESIGN
Paula Scher, Ron Louie
STUDIO
Pentagram Design
CLIENT
The New York Times
Magazine
ENTRANT LOCATION
New York, NY

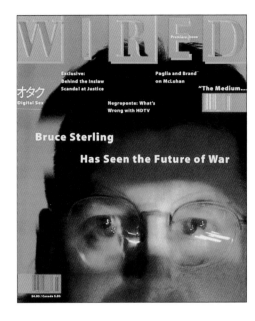

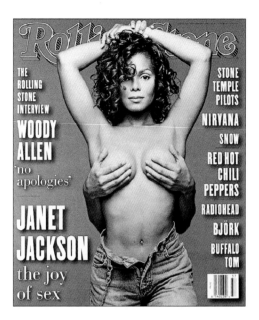

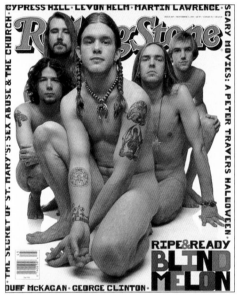

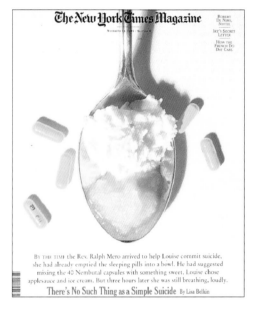

INSTANT
58 / 1
ART DIRECTION
Willi Demel
PHOTOGRAPHY
Klaus Hagmeier
AGENCY
Trust Hanauer Landste
139-141
CLIENT
W &W Cycles
ENTRANT LOCATION
Frankfurt, Germany

UCLA SUMMER SESSIONS
1993
59 / 1
CREATIVE DIRECTION
Inju Sturgeon
DESIGN
Paul Rand (Cover)
STUDIO
UCLA, Summer
Sessions Office
PUBLICATION
UCLA, Summer
Sessions 1994 Catalog
ENTRANT LOCATION
Los Angeles, CA

YOU CAN'T LOOK AWAY
ANYMORE
59 / 2
ART DIRECTION
Janet Froelich
DESIGN
Nancy Harris
PHOTOGRAPHY
Matuschka
PHOTO EDITING
Kathy Ryan,
Sarah Harbutt
PUBLICATION
The New York Times
Magazine
ENTRANT LOCATION
New York, NY

THE MORNING-AFTER PILL
59 / 3
ART DIRECTION
Janet Froelich
PHOTOGRAPHY
Joyce Tenneson
PHOTO EDITING
Kathy Ryan
PUBLICATION
The New York Times
Magazine
ENTRANT LOCATION
New York, NY

U&LC 20.3 COVER
59 / 4
ART DIRECTION
Woody Pirtle,
John Klotnia
DESIGN
John Klotnia,
Ivette Montes de Oca
STUDIO
Pentagram Design
PUBLICATION
Upper & lower case
PUBLISHER
International Typeface
Corporation
ENTRANT LOCATION
New York, NY

HE LIVED. WHO PAYS?
59 / 5
ART DIRECTION
Janet Froelich
DESIGN
Kathi Rota
PHOTOGRAPHY
Keith Carter
PHOTO EDITING
Kathy Ryan
PUBLICATION
The New York Times
Magazine
ENTRANT LOCATION
New York, NY

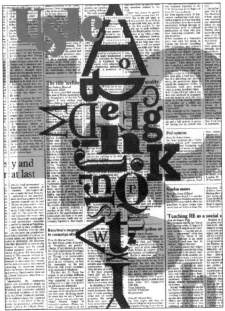

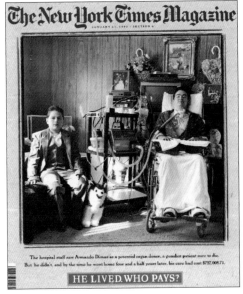

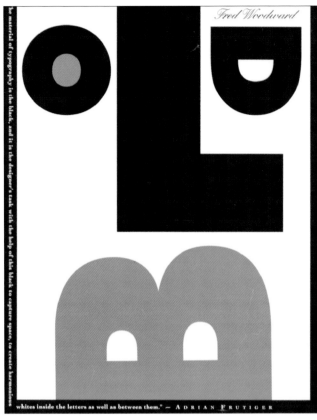

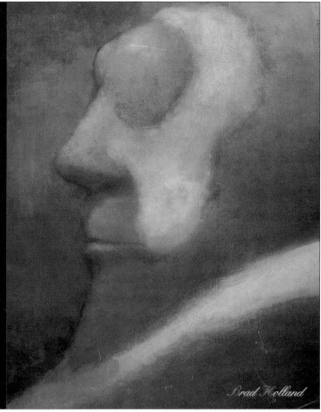

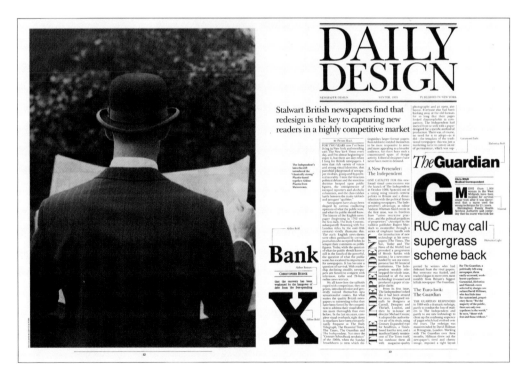

BOLD FACE
60 / 3
DISTINCTIVE MERIT
ART DIRECTION
Jennifer Goland
DESIGN
Fred Woodward
COPYWRITING
Confetti Magazine
ILLUSTRATION
Brad Holland
PUBLICATION
Confetti Magazine
ENTRANT LOCATION
New York, NY

DAILY DESIGN
60 / 1
ART DIRECTION
Woody Pirtle,
John Klotnia
DESIGN
John Klotnia,
Ivette Montes de Oca
PHOTOGRAPHY
Gentl & Hyers
STUDIO
Pentagram Design
PUBLICATION
Upper & lower case
PUBLISHER
International Typeface
Corporation
ENTRANT LOCATION
New York, NY

U&LC SCRAPBOOK X 20
60 / 2

ART DIRECTION
Paul Davis

DESIGN
Lisa Mazur,
Chalkley Calderwood

PRODUCTION
Jane DiBucci

PUBLICATION
U & lc

PUBLISHER
International Typeface
Corporation

ENTRANT LOCATION
New York, NY

**LIVING COLOR: LEAVE IT
ALONE**
60 / 4

ART DIRECTION
Carol Chen

DESIGN
Aimee Macauley

COPYWRITING
Hillary Shell

PHOTOGRAPHY
Amy Guip

PUBLICATION
Hits Magazine

CLIENT
Epic Records /
Living Colour

ENTRANT LOCATION
New York, NY

**ADWEEK: MEDIA
OUTLOOK '94**
60 / 5

ART DIRECTION
Carole Erger-Fass

DESIGN
Blake Taylor

PHOTOGRAPHY
Geoff Kern

PHOTO EDITING
Sabine Meyer

PUBLICATION
Adweek

ENTRANT LOCATION
New York, NY

**MALCOLM X, L'AUTRE
JOURNAL**
60 / 1

ART DIRECTION
Michel Mallard

DESIGN
Michel Mallard

ILLUSTRATION
Jean Michel Basquiat

STUDIO
Michel Mallard, Paris

PUBLICATION
L'Autre Journal

ENTRANT LOCATION
Paris, France

A USER'S GUIDE TO CHOICES, MATS, AND HANGING METHODS

THE RIGHT
FRAME

Anything looks better in a frame. If you
doubt this even for a second, go to the
nearest museum of science or natural his-
tory and see how elegant everyday bugs
look impaled on enameled pins and
mounted inside handsome wooden boxes.
If Cicindela campestris — the lowly
tiger beetle — can look better in a room of

THE RIGHT FRAME
61 / 1
ART DIRECTION
Gael Towey
DESIGN
Eric Pike, Lisa Wagner
COPYWRITING
Sarah Medford
PHOTOGRAPHY
Thibault Jeanson
PUBLICATION
Martha Stewart Living
ENTRANT LOCATION
New York, NY

THIS PAGE: A pressed fig leaf in a copper-
tape frame. OPPOSITE: Photographer John
Dugdale borders his work with an inch-
wide mat covered in ribbon. The brass
ring screwed into the frame top echoes
the shape of the porcelain finback.

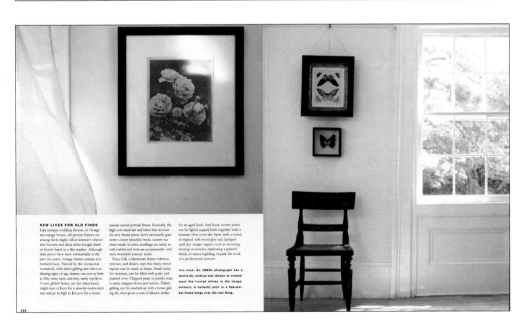

NEW LIVES FOR OLD FINDS
Like antique wedding dresses or vintage
decoupage boxes, old picture frames are
among those highly labor-intensive objects
that become real deals when bought third-
or fourth-hand at a flea market. Although
their prices have risen substantially in the
past ten years, vintage frames remain eco-
nomical buys. Pierced by the occasional
wormhole, with faded gilding and other en-
dearing signs of age, frames can cost as little
as fifty cents each, and they rarely top $500.
A new gilded frame, on the other hand,
might start at $300 for a nine-by-twelve-inch
size and go as high as $20,000 for a monu-

mental carved portrait frame. Ironically, the
high-cost materials and labor that account
for new-frame prices don't necessarily guar-
antee a more beautiful result; current ma-
chine-made wooden moldings are rarely as
well crafted and intricate as nineteenth- and
early-twentieth-century styles.
Tracy Gill, a Manhattan frame collector,
restorer, and dealer, says that many minor
repairs can be made at home. Small nicks,
for instance, can be filled with putty and
painted over. Chipped paint or patchy stain
is easily stripped down and redone. Flaked
gilding can be touched up with a home gild-
ing kit, then given a coat of diluted shellac

for an aged look. And loose corner joints
can be lightly tapped back together with a
hammer (first cover the frame with a towel)
or reglued with wood glue and clamped
until dry. Larger repairs, such as recasting
missing ornaments, replicating a painted
finish, or major regilding, require the work
of a professional restorer.

THIS PAGE: An 1860s photograph has a
twelve-ply archival mat chosen to comple-
ment the ivoried whites in the image.
OPPOSITE: A butterfly print in a flea-mar-
ket frame hangs over the real thing.

114

FASHION: THE LOOK OF
THE NINETIES
61 / 2
ART DIRECTION
Janet Froelich
DESIGN
Gina Davis
PHOTOGRAPHY
Kurt Markus
STYLIST
Polly Hamilton
PUBLICATION
The New York Times
Magazine
ENTRANT LOCATION
New York, NY

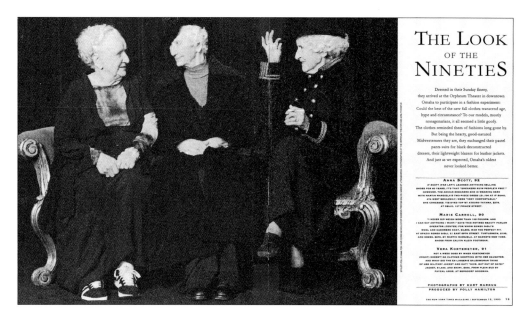

THE LOOK
OF THE
NINETIES

Dressed in their Sunday finery,
they arrived at the Orpheum Theater in downtown
Omaha to participate in a fashion experiment:
Could the best of the new fall clothes transcend age,
hype and circumstance? To our models, mostly
nonagenarians, it all seemed a little goofy.
The clothes reminded them of fashions long gone by.
But being the hearty, good-natured
Midwesterners they are, they exchanged their pastel
pants suits for black deconstructed
dresses, their lightweight blazers for leather jackets.
And just as we expected, Omaha's oldest
never looked better.

ANNA SCOTT, 92

MARIE CARROLL, 90

VERA KORTEMEYER, 91

PHOTOGRAPHS BY KURT MARKUS
PRODUCED BY POLLY HAMILTON

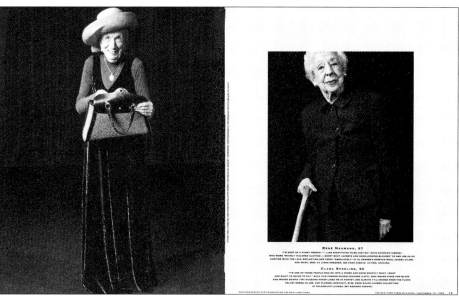

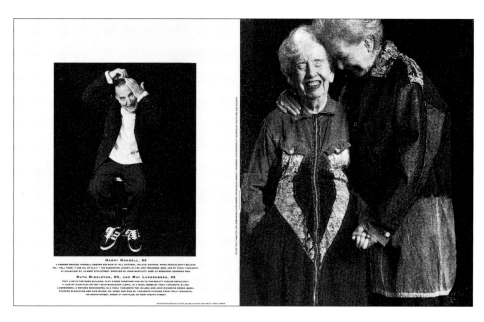

U&LC 20.2 KIDS' BOOKS
YOU CAN ENJOY
61 / 3

ART DIRECTION
Woody Pirtle, John Klotnia

DESIGN
John Klotnia, Ivette Montes de Oca

COPYWRITING
Steven Heller

PHOTOGRAPHY
John Paul Endress

STUDIO
Pentagram Design

PUBLICATION
Upper & lower case

PUBLISHER
International Typeface Corporation

ENTRANT LOCATION
New York, NY

WEISHEIT, DIE IM WINDE
WEHT: FAHREN DER
FANTE
61 / 1
ART DIRECTION
Hans-Georg Pospischil
DESIGN
Peter Breul, Bernadette
Gotthardt
PUBLICATION
Frankfurter Allgemeine
Magazin
ENTRANT LOCATION
Frankfurt, Germany

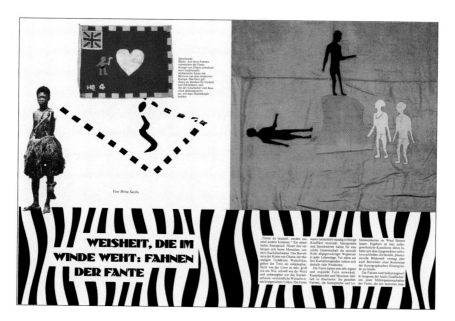

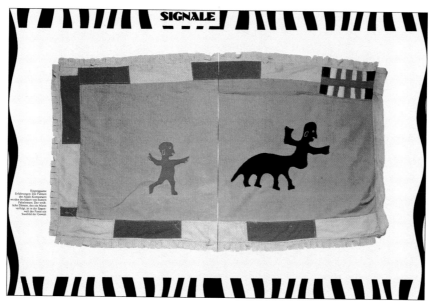

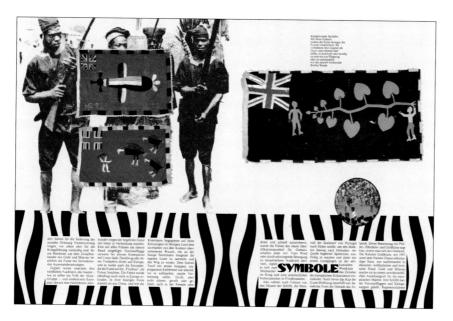

SINN UND FORM:
BADEMODE
61 / 2
ART DIRECTION
Hans-Georg Pospischil
DESIGN
Peter Breul,
Bernadette Gotthardt
PHOTOGRAPHY
Susan Lamér
PUBLICATION
Frankfurter Allgemeine
Magazin
ENTRANT LOCATION
Frankfurt, Germany

MARTHA STEWART
LIVING
62 / 1
ART DIRECTION
Gael Towey
DESIGN
Hannah Milman,
Jennifer Napier,
Lisa Wagner,
Eric A Pike,
David McLean
COPYWRITING
Cathy Horyn,
Barbara Kantrowitz,
Allen Lacy,
Todd Eberla,
Celia Barbour,
Katherine Whiteside
PHOTOGRAPHY
Victoria Pearson,
Grant Peterson,
Davies and Starr,
Dana Gallagher,
William Abranowicz,
Maria Robledo
PUBLICATION
Martha Stewart Living
ENTRANT LOCATION
New York, NY

GRAPHIS 288
62 / 2
ART DIRECTION
B. Martin Pedersen
DESIGN
B. Martin Pedersen
STUDIO
Pedersen Design
PUBLICATION
Graphis
ENTRANT LOCATION
New York, NY

1993 FRENCH DESIGNER
SHOWHOUSE CATALOG
62 / 3
ART DIRECTION
Amy Morton
DESIGN
Amy Morton,
Lucas Deaver
ILLUSTRATION
Lucas Deaver (Cover)
STUDIO
A.M.Graphics /
Charles Patteson
Associates
CLIENT
American Hospital of
Paris Foundation
ENTRANT LOCATION
New York, NY

VIEW ON COLOUR NO. 2
62 / 3
DISTINCTIVE MERIT
ART DIRECTION
Anthon Beeke -Lidewij
Edelkoort
DESIGN
Anthon Beeke
ILLUSTRATION
Joost Swarte, et al
STUDIO
Studio Anthon Beeke
PUBLICATION
View on Colour no. 2
CLIENT
United Publishers, Paris
ENTRANT LOCATION
Amsterdam,
Netherlands

**VOGUE - A BAHIA DE
NIZAN**
62 / 2
ART DIRECTION
Tomás Lorente
COPYWRITING
Nizan Guanaes
PHOTOGRAPHY
Miro
AGENCY
DM9 Publicidade
PUBLICATION
Vogue
ENTRANT LOCATION
São Paulo, Brazil

VIEW ON COLOR NR. 3
62 / 1
ART DIRECTION
Anthon Beeke -
Lidewij Edelkoort
DESIGN
Anthon Beeke
STUDIO
Studio Anthon Beeke
PUBLICATION
Views on Colour No. 3
CLIENT
United Publishers, Paris
ENTRANT LOCATION
Amsterdam,
Netherlands

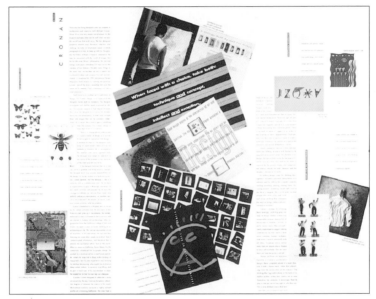

LIVING THE VALUES
63 / 1
ART DIRECTION
Peg Patterson
DESIGN
Caroline Kavanagh
COPYWRITING
Principal
Communications
PHOTOGRAPHY
various
ILLUSTRATION
various
CLIENT
Prudential Home
Mortgage Company
ENTRANT LOCATION
New York, NY

IN THE PUBLIC EYE
63 / 3
ART DIRECTION
Linda Hinrichs
DESIGN
Linda Hinrichs
COPYWRITING
Paolo Poledri
PHOTOGRAPHY
Jock McDonald
ILLUSTRATION
Michael Cronan,
Gerry Reis,
Michael Manwaring,
Michael Vanderbyl
STUDIO
Powell Street Studio
CLIENT
SF MoMA • Arch.
& Design Forum
ENTRANT LOCATION
San Francisco, CA

WORLD TOUR
63 / 2
ART DIRECTION
Gary Koepke
DESIGN
Gary Koepke,
Diddo Ramm
EDITING
Michael Schulze
STUDIO
Koepke International
Ltd.
CLIENT
Dun & Bradstreet
Software
ENTRANT LOCATION
Magnolia, MA

ARTSWORD
63 / 4
ART DIRECTION
Kristin Sommese
DESIGN
Kristin Sommese,
Jim Lilly
EDITING
Al Anderson
PHOTOGRAPHY
Kristin Sommese,
Jim Lilly
STUDIO
Sommese Design
CLIENT
Penn State School
of Visual Arts
ENTRANT LOCATION
State College, PA

GRAND LOUVRE - 10 ANS
DE TRAVAUX
63 / 1
ART DIRECTION
Michael Levin
DESIGN
Andrea Houlton
COPYWRITING
Catherine Bergeron
PHOTOGRAPHY
EPGL Archives
PRODUCTION
EPGL
STUDIO
Michael Levin
CLIENT
Etablissement public
du Grand Louvre
ENTRANT LOCATION
Paris, France

ROUGH
64 / 1
ART DIRECTION
Todd Hart,
Shawn Freeman
DESIGN
Todd Hart,
Shawn Freeman
COPYWRITING
Bill Baldwin
PHOTOGRAPHY
Phil Hollenbeck
ILLUSTRATION
various
PUBLISHER
Dallas Society of Visual
Communications
ENTRANT LOCATION
Dallas, TX

**HERTZ: GOING THE
EXTRA MILE**
65 / 12
DISTINCTIVE MERIT
ART DIRECTION
Christopher Johnson
DESIGN
Jen Sussman
COPYWRITING
Geoffrey Precourt
PHOTOGRAPHY
various
STUDIO
Christopher Johnson
and Associates
AGENCY
International
Management Group
CLIENT
The Hertz Corporation
ENTRANT LOCATION
New York, NY

GRAPHIS LOGOS 2
65 / 1
ART DIRECTION
B. Martin Pedersen
DESIGN
B. Martin Pedersen
STUDIO
Pedersen Design
PUBLICATION
Graphis
ENTRANT LOCATION
New York, NY

JOURNEY: TRAVEL DIARY
OF A DAYDREAMER
65 / 2
ART DIRECTION
Rita Marshall
DESIGN
Rita Marshall
ILLUSTRATION
Guy Billout
STUDIO
Delessert and Marshall
PUBLISHER
Creative Education
ENTRANT LOCATION
Lakeville, CT

ALBUCIUS
65 / 3
ART DIRECTION
Robert Shapazian
DESIGN
Jeffrey Mueller
PHOTO RETOUCHING
Toni Zeto
PUBLISHER
The Lapis Press
ENTRANT LOCATION
Venice, CA

DEFYING GRAVITY: THE MAKING OF NEWTON
65 / 4
ART DIRECTION
Robin Rickabaugh,
Heidi Rickabaugh
DESIGN
Jon Olsen
COPYWRITING
Markos Kounalakis
PHOTOGRAPHY
Doug Menuez
ILLUSTRATION
Jon Olsen
STUDIO
Principia Graphica
PUBLISHER
Beyond Words
Publishing
ENTRANT LOCATION
Portland, OR

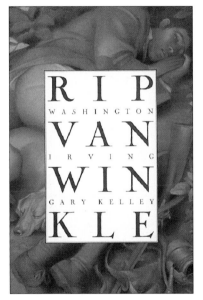

RIP VAN WINKLE
65 / 5
ART DIRECTION
Rita Marshall
DESIGN
Louise Fili
ILLUSTRATION
Gary Kelley
STUDIO
Louise Fili Ltd.
PUBLISHER
Creative Education
ENTRANT LOCATION
New York, NY

SCHOOL OF VISUAL ARTS
1994-1995 CATALOGUE
65 / 6
ART DIRECTION
Kurt Houser
CREATIVE DIRECTION
Silas H. Rhodes
DESIGN
Kurt Houser,
Beverly Perkin
PHOTOGRAPHY
Chris Callis
STUDIO
Visual Art Press, LTD.
ENTRANT LOCATION
New York, NY

**AL HELD: ITALIAN
WATERCOLORS + AN
INTERVIEW + AN ESSAY**
65 / 7
ART DIRECTION
Renate Gokl
DESIGN
Renate Gokl
COPYWRITING
Maarten
Van De Guchte
CLIENT
Krannert Art Museum
ENTRANT LOCATION
Urbana, IL

**MADE IN JAPAN:
TRANSISTOR RADIOS OF
THE 1950'S AND 1960'S**
65 / 8
ART DIRECTION
Maureen Erbe
DESIGN
Maureen Erbe,
Rita A. Sowins
COPYWRITING
Aileen Antonier
PHOTOGRAPHY
Henry Blackham
PUBLISHER
Chronicle Books
ENTRANT LOCATION
Los Angeles, CA

**DUTCH MODERNE:
GRAPHIC DESIGN FROM
DESTIJL TO DECO**
65 / 9
ART DIRECTION
Louise Fili
DESIGN
Louise Fili
AUTHORS
Steven Heller,
Louise Fili
STUDIO
Louise Fili Ltd.
PUBLISHER
Chronicle Books
ENTRANT LOCATION
New York, NY

ITALIAN ART DECO:
GRAPHIC DESIGN
BETWEEN THE WARS
65 / 10
ART DIRECTION
Louise Fili
DESIGN
Louise Fili
AUTHORS
Steven Heller,
Louise Fili
STUDIO
Louise Fili Ltd.
PUBLISHER
Chronicle Books
ENTRANT LOCATION
New York, NY

PAPER PETS
65 / 11
ART DIRECTION
Seymour Chwast,
Samuel Antupit
DESIGN
Seymour Chwast
COPYWRITING
Seymour Chwast
ILLUSTRATION
Seymour Chwast
STUDIO
The Pushpin Group
PUBLISHER
Henry N. Abrams, Inc.
ENTRANT LOCATION
New York, NY

THE HAT BOOK
65 / 13
ART DIRECTION
Leslie Smolan
DESIGN
Leslie Smolan
Jennifer Domer
COPYWRITING
various
PHOTOGRAPHY
Rodney Smith
STUDIO
Carbone Smolan
Associates
PUBLISHER
Nan A. Talese /
Doubleday
ENTRANT LOCATION
New York, NY

JUNKO KOSHINO
65 / 1
SILVER
ART DIRECTION
Katsuhiro Kinoshita
DESIGN
Katsuhiro Kinoshita
CREATIVE DIRECTION
Junko Kishino
PHOTOGRAPHY
Itaru Hirama,
Shigeyuki Morishita,
Masataka Nakano,
Kou Saitoh,
Masahiko Takeda,
Takashi Tsubaki
PUBLISHER
Koshino Junko
Design Office
ENTRANT LOCATION
Tokyo, Japan

JUNKO KOSHINO
65 / 2
DISTINCTIVE MERIT
ART DIRECTION
Katsuhiro Kinoshita
DESIGN
Katsuhiro Kinoshita
CREATIVE DIRECTION
Junko Kishino
PHOTOGRAPHY
Kazumi Kurigami,
Itaru Hirama,
Tadashi Hirose,
Issei Isshiki,
Shigeyuki Morishita,
Masataka Nakano,
Kou Saitoh,
Masahiko Takeda,
Takashi Tsubaki
PUBLISHER
Koshino Junko
Design Office
ENTRANT LOCATION
Tokyo, Japan

HOT FOOD, COOL JAZZ
65 / 4
ART DIRECTION
Andrew Hoyne
DESIGN
Andrew Hoyne
COPYWRITING
Jill Duplex,
Terry Durack
PHOTOGRAPHY
Rob Blackburn
ILLUSTRATION
Simon Goh
MUSIC
various
STUDIO
Andrew Hoyne Design
PUBLISHER
William Heinemann
Australia
ENTRANT LOCATION
Melbourne Victoria,
Australia

TRENDBUCH DER ERSTE
GROSSE DEUTSCHE
TRENDREPORT
65 / 5
ART DIRECTION
Régine Thienhaus
DESIGN
Régine Thienhaus
COPYWRITING
Matthias Horx
ILLUSTRATION
Philip Anderson
PRODUCTION
Büro Hamburg
PUBLISHER
Econ Verlag
ENTRANT LOCATION
Hamburg, Germany

NO. 15 ANNUAL CREATIV
CLUB AUSTRIA
65 / 8
ART DIRECTION
Cordula Alessandri,
Hans Proschofsky
DESIGN
Cordula Alessandri
COPYWRITING
Dieter Weidhofer
PRODUCTION
Martina Berger
PUBLISHER
Creativ Club Austria
ENTRANT LOCATION
Wien, Austria

WABI - SABI - SUKI - THE ESSENCE OF JAPANESE BEAUTY
65 / 3
ART DIRECTION
Ikko Tanaka
DESIGN
Ikko Tanaka
AGENCY
Cosmo Public Relations Corp.
PUBLISHER
Mazda Motor Corporation
ENTRANT LOCATION
Tokyo, Japan

DER ALTE MANN UND DAS MEER - (THE OLD MAN AND THE SEA)
65 / 6
ART DIRECTION
Grit Fischer, Thomas Fradel
DESIGN
Seymour Chwast
ILLUSTRATION
Seymour Chwast
STUDIO
The Pushpin Group, Inc.
PUBLISHER
Buchergilde Gutenberg
ENTRANT LOCATION
New York, NY

I + I = 3
65 / 7
ART DIRECTION
Hans Bockting
DESIGN
Hans Bockting, Will de l'Ecluse
PHOTOGRAPHY
Diana Blok
ILLUSTRATION
various
STUDIO
UNA Amsterdam
PUBLISHER
(Z)OO produkties / UNA
ENTRANT LOCATION
Amsterdam, Netherlands

JILTED
67 / 1
SILVER
ART DIRECTION
Carin Goldberg,
Frank Metz
DESIGN
Carin Goldberg
PHOTOGRAPHY
Man Ray
PUBLISHER
Simon and Schuster
ENTRANT LOCATION
New York, NY

MALA HISTORIA SZTUKI
67 / 2
ART DIRECTION
Jurek Wajdowicz
DESIGN
Jurek Wajdowicz
STUDIO
Emerson, Wajdowicz
Studios, Inc.
PUBLISHER
Science & College
Publishing, Poland
ENTRANT LOCATION
New York, NY

SEX: AN ORAL HISTORY
67 / 2
ART DIRECTION
Melissa Jacoby
DESIGN
Melissa Jacoby
PHOTOGRAPHY
Barnaby Hall
PUBLISHER
Penguin U.S.A.
ENTRANT LOCATION
New York, NY

THE THING HAPPENS:
TEN YEARS OF WRITING
ABOUT THE MOVIES
67 / 3
ART DIRECTION
Krystyna Skalski
DESIGN
Louise Fili
PHOTOGRAPHY
William Duke
PUBLISHER
Grove Press
ENTRANT LOCATION
New York, NY

BONE: A NOVEL
67 / 4
ART DIRECTION
Victor Weaver
DESIGN
Carin Goldberg
PHOTOGRAPHY
Genthe
PUBLISHER
Hyperion
ENTRANT LOCATION
New York, NY

IN EXTREMIS: THE LIFE OF
LAURA RIDING
67 / 5
ART DIRECTION
Krystyna Skalski
DESIGN
Carin Goldberg
PUBLISHER
Grove Press
ENTRANT LOCATION
New York, NY

SYLVIA
67 / 6
ART DIRECTION
Steven Brower
DESIGN
Steven Brower
ILLUSTRATION
Steven Brower
PUBLISHER
Carol Publishing Group
ENTRANT LOCATION
New York, NY

TARANTULA
67 / 7
ART DIRECTION
Henry Sene Yee
DESIGN
Henry Sene Yee
COPYWRITING
Eric Wybenga
PHOTOGRAPHY
Elliott Landy,
Landy Vision
PRODUCTION
Twisne Fan
PUBLISHER
St. Martin's Press
ENTRANT LOCATION
New York, NY

HELLO I MUST BE GOING:
GROUCHO AND HIS
FRIENDS
67 / 8
ART DIRECTION
Steven Brower
DESIGN
Steven Brower
PUBLISHER
Carol Publishing Group
ENTRANT LOCATION
New York, NY

LET ME HEAR YOUR VOICE
67 / 9
DESIGN
Micheal Bierut
STUDIO
Pentagram Design
PUBLISHER
Alfred A. Knopf
ENTRANT LOCATION
New York, NY

JOURNEY'S END
67 / 10
ART DIRECTION
Rosemary Kracke
ILLUSTRATION
Peter Gergely
PUBLISHER
Doubleday Book and
Music Clubs
ENTRANT LOCATION
Highland Falls, NY

FULL MOON OVER
AMERICA
67 / 11
ART DIRECTION
Jackie Merri Meyer
DESIGN
Paula Scher,
Jackie Merri Meyer
ILLUSTRATION
Paula Scher
PUBLISHER
Warner Books
ENTRANT LOCATION
New York, NY

A WRITER'S LIFE: PHILIP
LARKIN
67 / 12
ART DIRECTION
Dorris Janowitz,
Michael Kaye
DESIGN
Louise Fili
STUDIO
Louise Fili Ltd.
PUBLISHER
Farrar Straus Giroux
ENTRANT LOCATION
New York, NY

TURNSTILE FICTION
67 / 13
ART DIRECTION
John Gall
DESIGN
John Gall
PHOTOGRAPHY
John Gall
ENTRANT LOCATION
Hoboken, NJ

LENI RIEFENSTAHL: A
MEMOIR
67 / 14
ART DIRECTION
Michael Accordino
DESIGN
Michael Accordino
COPYWRITING
Jim Fitzgerald
PRODUCTION
Kathy Fink Lovisolo
PUBLISHER
St. Martin's Press
ENTRANT LOCATION
New York, NY

THE WISDOM OF FDR
67 / 15
ART DIRECTION
Steven Brower
DESIGN
Steven Brower
ILLUSTRATION
Steven Brower
PUBLISHER
Carol Publishing Group
ENTRANT LOCATION
New York, NY

THE REVOLUTION FOR 4
SECONDS, PLAYS IN
TOKYO 1982 - 1992
67 / 1
ART DIRECTION
Hitomi Sago
DESIGN
Hitomi Sago
COPYWRITING
Hiroshi Hasebe (Title)
PHOTOGRAPHY
Kazunari Koyama
STUDIO
Hitomi Sago Design
Office Inc.
PUBLISHER
Kawade Shobo
Publishing Co., Ltd.
ENTRANT LOCATION
Tokyo, Japan

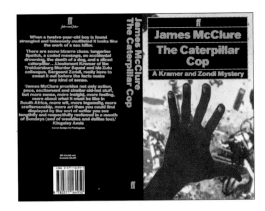

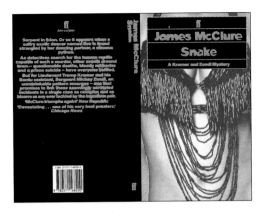

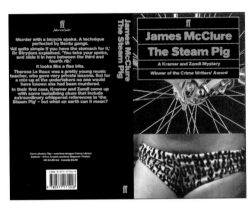

THE CATERPILLAR COP
68 / 1
ART DIRECTION
John McConnell
DESIGN
Kate Emamooden,
Alan Dye,
Jason Godfrey
COLLAGE
J. Godfrey
PUBLISHER
Faber & Faber
ENTRANT LOCATION
London, England

SNAKE
68 / 2
ART DIRECTION
John McConnell
DESIGN
Kate Emamooden,
Alan Dye
PHOTOGRAPHY
Colour Photo Library
PUBLISHER
Faber & Faber
ENTRANT LOCATION
London, England

THE STEAM PIG
68 / 3
ART DIRECTION
John McConnell
DESIGN
Kate Emamooden,
Alan Dye
PHOTOGRAPHY
Images and Magnum
Photo Libraries
PUBLISHER
Faber & Faber
ENTRANT LOCATION
London, England

THE SONG DOG
68 / 4
ART DIRECTION
John McConnell
DESIGN
Kate Emamooden,
Alan Dye,
Jason Godfrey
PHOTOGRAPHY
Photo Library
PUBLISHER
Faber & Faber
ENTRANT LOCATION
London, England

GRAPHIC DESIGN

TRISTAR SHOWEST
MONTAGE
69 / 11
GOLD
ART DIRECTION
Ed Sullivan
DESIGN
Jeff Boortz
PHOTO DIRECTION
Ted Cohen
PRODUCTION
Eric Ladd
STUDIO
TriStar
CLIENT
Aspect Ratio
ENTRANT LOCATION
Hollywood, CA

E! MEMORIAL DAY PROMO
69 / 2
ART DIRECTION
Jill Taffet
DESIGN
Flavio Kampah
COPYWRITING
Bob Taylor
PRODUCTION
Bob Taylor
MUSIC
Drew Neumann,
Kimberlee Carlson
STUDIO
E! Entertainment
Television
CLIENT
E! Entertainment
Television
ENTRANT LOCATION
Los Angeles, CA

E! SWIRL I.D.
69 / 4
ART DIRECTION
Jill Taffet
DESIGN
Mark Osborne
PRODUCTION
Jill Taffet
MUSIC
Drew Neumann,
Kimberlee Carlson
STUDIO
E! Entertainment
Television
CLIENT
E! Entertainment
Television
ENTRANT LOCATION
Los Angeles, CA

A + E MYSTERY MOVIE
69 / 5
ART DIRECTION
Billy Pittard
CREATIVE DIRECTION
Curt Doty
DESIGN
Curt Doty (Logo)
PHOTO DIRECTION
Andrew Turman
PRODUCTION
Dale Everett
DIRECTION
Curt Doty
CLIENT
Artie Scheff, A&E
Network
ENTRANT LOCATION
Hollywood, CA

E! HOWARD AT TEN
PROMO
69 / 7
ART DIRECTION
Jill Taffet
DESIGN
Mark Osborne
COPYWRITING
Kelly Cole
PRODUCTION
Bob Taylor
DIRECTION
Jill Taffet
MUSIC
Kimberlee Carlson
STUDIO
E! Entertainment
Television
CLIENT
E! Entertainment
Television
ENTRANT LOCATION
Los Angeles, CA

NICKELODEON HOME
VIDEO TRAILER
69 / 8
ART DIRECTION
Steve Thomas
DESIGN
Agi Fodor
COPYWRITING
Agi Fodor
PRODUCTION
Agi Fodor
CLIENT
Nickelodeon
Home Video
ENTRANT LOCATION
New York, NY

E! PURE SOAP OPEN
69 / 13
ART DIRECTION
Jill Taffet
DESIGN
Marc Karzen
PRODUCTION
Jill Taffet, Karin Rainey
MUSIC
Drew Neumann,
Kimberlee Carlson
STUDIO
E! Entertainment
Television
CLIENT
E! Entertainment
Television
ENTRANT LOCATION
Los Angeles, CA

THE GOSSIP SHOW OPEN
69 / 16
ART DIRECTION
Jill Taffet
DESIGN
Alice Song, Jill Taffet
PRODUCTION
Jill Taffet, Karin Rainey
MUSIC
Elyse Schiller,
Jim Watson
STUDIO
E! Entertainment
Television
CLIENT
E! Entertainment
Television
ENTRANT LOCATION
Los Angeles, CA

**GOOD MORNING
AMERICA / SUNDAY**
69 / 17
ART DIRECTION
Andy Hann,
Amy Nagasawa
DESIGN
Andy Hann,
Amy Nagasawa
COPYWRITING
Andy Hann,
Amy Nagasawa
ILLUSTRATION
Sally McHenry
PRODUCTION
Nagasawa & Hann
DIRECTION
Nagasawa & Hann
CLIENT
Good Morning
America / Jim Wagner
ENTRANT LOCATION
Los Angeles, CA

ESPN2 SLIGHTLY PROMOS
70 / 1
ART DIRECTION
Flavio Kampah
DESIGN
Flavio Kampah,
David Sparrgrove
COPYWRITING
Phil Delbourgo
(Big Fat TV)
PHOTOGRAPHY
Giorgio Scalli, DP
PRODUCTION
Susan Skoog
DIRECTION
Flavio Kampah
MUSIC
Lino Studio
STUDIO
Kampah Visions
AGENCY
Big Fat TV
CLIENT
ESPN2
ENTRANT LOCATION
Venice, CA

NICKELODEON HOME
VIDEO MUSHFEST
70 / 2

ART DIRECTION
Steve Thomas

DESIGN
Agi Fodor

COPYWRITING
Agi Fodor, Tom Hill

PRODUCTION
Agi Fodor

CLIENT
Nickelodeon Home
Video

ENTRANT LOCATION
New York, NY

INK SPOTS
71 / 13
SILVER
ART DIRECTION
Lin Tipton
CREATIVE DIRECTION
Larry Volpi,
Phillip Halyard
COPYWRITING
Michael Ouweleen
PRODUCTION
Judi Nierman
DIRECTION
Paul Vester
MUSIC
Jeff Wayne Music
(London), John Altman
STUDIO
Angel Studio
CLIENT
Warner - Lambert
ENTRANT LOCATION
New York, N.Y

TIME
71 / 11
ART DIRECTION
Flavio Kampah,
David Sparrgrove
DESIGN
Flavio Kampah,
David Sparrgrove
PHOTOGRAPHY
Giorgio Scalli, DP
PRODUCTION
Gino Campagna
DIRECTION
Pier Luca De Carlo
MUSIC
David Bowie
STUDIO
Kampah Visions
CLIENT
Radius
ENTRANT LOCATION
Venice, CA

MOBIL
72 / 1
ART DIRECTION
Steve Graff
PRODUCTION
Joe Scibetta
DIRECTION
Alex Weil
AGENCY
DDB Needham
Worldwide
CLIENT
Mobil
ENTRANT LOCATION
New York, NY

DISCO DOG / GOSPEL /
CHICKEN / WACKY
74 / 1
ART DIRECTION
Frank &
Caroline Mouris,
Mark Baldo,
Chris Gilligan
DESIGN
Frank &
Caroline Mouris,
Mark Baldo,
Chris Gilligan
ILLUSTRATION
Frank &
Caroline Mouris,
Chris Gilligan,
George McClemmmon
PRODUCTION
Amy Friedman,
Sharon Ngoi
DIRECTION
Frank &
Caroline Mouris,
Chris Gilligan,
Mark Baldo
MUSIC
Baron & Baron /
Red Dog Music
CLIENT
Nickelodeon
ENTRANT LOCATION
New York, NY

UNITED STATES
HOLOCAUST MEMORIAL
MUSEUM
75 / 1
GOLD
ART DIRECTION
Ralph Appelbaum
DESIGN
Christopher Miceli,
James Cathcart,
Victor Colom, Kai Chiu,
Robert Homack,
Shari Berman
CARTOGRAPHY
Paul Pugliese
CLIENT
United States
Holocaust Memorial
Museum
ENTRANT LOCATION
New York, NY

SONY CORPORATION
BUILDING WRAP-AROUND
77 / 1
ART DIRECTION
Mark Burdett
DESIGN
Mark Burdett
PHOTOGRAPHY
Mark Malibrigo,
Jimmy Ienner, Jr.
CLIENT
Sony Corporation
ENTRANT LOCATION
New York, NY

UNTITLED
77 / 1
ART DIRECTION
Asai Yoshiteru
DESIGN
Asai Yoshiteru,
Suzuki Tomoyuki
COPYWRITING
Itoh Hiroyasu
PHOTOGRAPHY
Asai Yoshiteru
STUDIO
Agni Studio Co., Ltd.
CLIENT
Peaceful Uses of
Atomic Energy
ENTRANT LOCATION
Nagoya, Japan

UNTITLED
77 / 2
ART DIRECTION
Asai Yoshiteru
DESIGN
Asai Yoshiteru,
Suzuki Tomoyuki
COPYWRITING
Itoh Hiroyasu
PHOTOGRAPHY
Asai Yoshiteru
STUDIO
Agni Studio Co., Ltd.
CLIENT
Peaceful Uses of
Atomic Energy
ENTRANT LOCATION
Nagoya, Japan

UNTITLED
77 / 3
ART DIRECTION
Asai Yoshiteru
DESIGN
Asai Yoshiteru,
Suzuki Tomoyuki
COPYWRITING
Itoh Hiroyasu
PHOTOGRAPHY
Asai Yoshiteru
STUDIO
Agni Studio Co., Ltd.
CLIENT
Peaceful Uses of
Atomic Energy
ENTRANT LOCATION
Nagoya, Japan

VANISHING POINT
77 / 4
ART DIRECTION
Koji Mizutani
DESIGN
Masashi Yamashita,
Hiroshi Ohmizo
PHOTOGRAPHY
Hibiki Kobayashi
PRODUCTION
Koji Mizutani
DIRECTION
Koji Mizutani
STUDIO
Mizutani Studio
CLIENT
Mizutani Studio
ENTRANT LOCATION
Tokyo, Japan

VANISHING POINT
77 / 5
ART DIRECTION
Koji Mizutani
DESIGN
Masashi Yamashita,
Hiroshi Ohmizo
PHOTOGRAPHY
Hibiki Kobayashi
PRODUCTION
Koji Mizutani
DIRECTION
Koji Mizutani
STUDIO
Mizutani Studio
CLIENT
Mizutani Studio
ENTRANT LOCATION
Tokyo, Japan

VANISHING POINT

CRACKER BARREL OLD
COUNTRY STORE /
ANNUAL REPORT 1993
78 / 7
SILVER
ART DIRECTION
Thomas Ryan
DESIGN
Thomas Ryan
COPYWRITING
John Baeder
PHOTOGRAPHY
McGuire
ILLUSTRATION
Paul Ritscher +
Thomas Ryan
STUDIO
Thomas Ryan Design
AGENCY
Corporate
Communication Inc.
CLIENT
Cracker Barrel Old
Country Store
ENTRANT LOCATION
Nashville, TN

**HARMONY HOLDINGS,
INC. 1992 ANNUAL
REPORT**
78 / 10
DISTINCTIVE MERIT
ART DIRECTION
Jim Berté
DESIGN
Jim Berté
COPYWRITING
Harmony Holdings Inc.
PHOTO MANIPULATION
Jennifer Herzig
CLIENT
Harmony Holdings, Inc.
ENTRANT LOCATION
Marina del Rey, CA

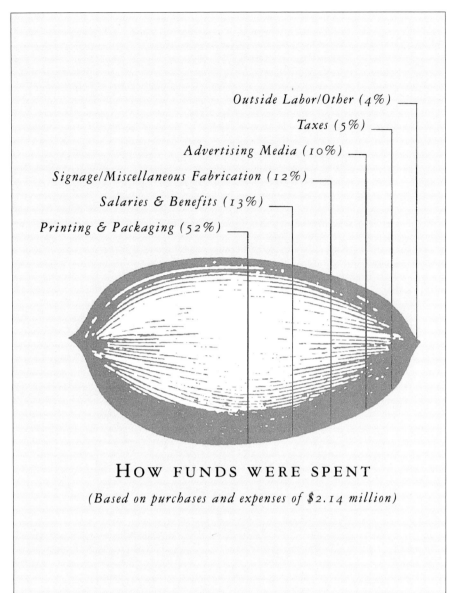

Outside Labor/Other (4%)

Taxes (5%)

Advertising Media (10%)

Signage/Miscellaneous Fabrication (12%)

Salaries & Benefits (13%)

Printing & Packaging (52%)

HOW FUNDS WERE SPENT

(Based on purchases and expenses of $2.14 million)

THE PECAN REPORT 1993
78 / 14
DISTINCTIVE MERIT
ART DIRECTION
Forrest Richardson
DESIGN
Forrest Richardson
COPYWRITING
Forrest Richardson
ILLUSTRATION
Forrest Richardson
STUDIO
Richardson or
Richardson
CLIENT
Richardson or
Richardson
ENTRANT LOCATION
Phoenix, AZ

THE LIMITED, INC. 1992
ANNUAL REPORT
78 / 19
ART DIRECTION
Aubrey Balkind,
Kent Hunter
DESIGN
Robert Wong
COPYWRITING
Robert Minkoff
PHOTOGRAPHY
various
AGENCY
Frankfurt Balkind
Partners
CLIENT
The Limited, Inc.
ENTRANT LOCATION
New York, NY

Questioning is good business. A year ago,

we responded to more than 10,000 questions

from our associates.

Questioning ThinkingActing

The process continues.

The Limited, Inc.
1992 Annual Report

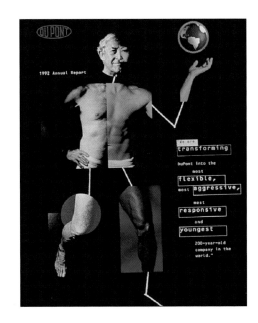

DUPONT 1992 ANNUAL REPORT
78 / 1
CREATIVE DIRECTION
Aubrey Balkind,
Kent Hunter
DESIGN
Kin Yuen
COPYWRITING
Justin Carisio,
Maury Bates
PHOTOGRAPHY
Greg Weiner
ILLUSTRATION
Holland
AGENCY
Frankfurt Balkind
Partners
CLIENT
E. I. Du Pont de
Nemours and
Company
ENTRANT LOCATION
New York, NY

THE EARTH TECHNOLOGY CORPORATION 1992 ANNUAL REPORT
78 / 2
ART DIRECTION
Lana Rigsby
DESIGN
Lana Rigsby,
Troy S. Ford
COPYWRITING
JoAnn Stone
PHOTOGRAPHY
Gary Faye
STUDIO
Rigsby Design, Inc.
CLIENT
The Earth Technology
Corporation
ENTRANT LOCATION
Houston, TX

JUILLIARD ANNUAL REPORT 1991-1992
78 / 3
ART DIRECTION
Karen Salsgiver
DESIGN
Karen Salsgiver,
Cathleen Mitchell
COPYWRITING
Lynne Rutkin
AGENCY
Salsgiver Coveney
Associates Inc.
CLIENT
The Julliard School
ENTRANT LOCATION
Westport, CT

**THE LINCOLN
FOUNDATION - ANNUAL
REPORT 1992**
78 / 4
ART DIRECTION
Carter Weitz
DESIGN
Carter Weitz,
Bob Barney
COPYWRITING
Phil Heckman
PHOTOGRAPHY
David Radler
AGENCY
Bailey Lauerman and
Associates
CLIENT
Lincoln Foundation
ENTRANT LOCATION
Lincoln, NE

**THE GEORGE GUND
FOUNDATION ANNUAL
REPORT 1992**
78 / 5
ART DIRECTION
Mark Schwartz
DESIGN
Michelle Moehler
COPYWRITING
David Bergholz,
Deena Epstein
PHOTOGRAPHY
Judith Joy Ross
PRODUCTION
Mark Schwartz
DIRECTION
Mark Schwartz
STUDIO
Nesnadny + Schwartz
CLIENT
The George Gund
Foundation
ENTRANT LOCATION
Cleveland, OH

**THE ROCKEFELLER
FOUNDATION 1992
ANNUAL REPORT**
78 / 6
ART DIRECTION
Woody Pirtle,
John Klotnia
DESIGN
John Klotnia,
Ivette Montes de Oca
PHOTOGRAPHY
John Paul Endress,
William Whitehurst,
et al
STUDIO
Pentagram Design
CLIENT
Rockefeller Foundation
ENTRANT LOCATION
New York, NY

ARIAD
PHARMACEUTICALS, INC.
1992 ANNUAL REPORT
78 / 8
ART DIRECTION
Susan Hochbaum
DESIGN
Susan Hochbaum,
Woody Pirtle
ILLUSTRATION
Jack Unruh,
Barbara Kelley
(portrait)
STUDIO
Pentagram Design
CLIENT
Ariad Pharmaceuticals
Inc.
ENTRANT LOCATION
New York, NY

SOUTH TEXAS COLLEGE
OF LAW-1993 DEAN'S
REPORT
78 / 9
ART DIRECTION
Mark Geer
DESIGN
Mark Geer,
Heidi Flynn Allen
COPYWRITING
D. Maurer, R. Perrone,
K. Scobee
PHOTOGRAPHY
Beryl Striewski,
Chris Shinn
ILLUSTRATION
Morgan Bomar
STUDIO
Geer Design, Inc.
CLIENT
South Texas College
of Law
ENTRANT LOCATION
Houston, TX

THE VOICE OF VICTIMS -
MOTHERS AGANIST
DRUNK DRIVING 1991-92
ANNUAL REPORT
78 / 11
ART DIRECTION
Bryan L. Peterson
DESIGN
Bryan L. Peterson
COPYWRITING
Marsha Coburn
PHOTOGRAPHY
Gerry Kano
STUDIO
Peterson and Company
CLIENT
Mothers Against Drunk
Driving
ENTRANT LOCATION
Dallas, TX

1993 ANNUAL REPORT -
HERMAN MILLER, INC.
AND SUBSIDIARIES
78 / 12
ART DIRECTION
Stephen Frykholm
DESIGN
Stephen Frykholm,
Yang Kim,
Sara Giovanitti
COPYWRITING
Clark Malcolm
PHOTOGRAPHY
Brad Trent,
Nick Merrick,
Genevieve Hafner
CLIENT
Herman Miller, Inc.
ENTRANT LOCATION
Zeeland, MI

BIG APPLE CIRCUS -
ANNUAL REPORT 1993
78 / 13
ART DIRECTION
Ivan Chermayeff
DESIGN
Cathy Rediehs Schaefer
COPYWRITING
Big Apple Circus
PHOTOGRAPHY
various
CLIENT
Big Apple Circus
ENTRANT LOCATION
New York, NY

THE WORLD IS LISTENING
- VOLUME 1
78 / 15
ART DIRECTION
Neal Ashby
DESIGN
Neal Ashby
COPYWRITING
Fred Guthrie
PHOTOGRAPHY
Barb Kinney
ILLUSTRATION
Dave Plunkert
ENTRANT LOCATION
Washington, DC

NEW YORK CITY
HOUSING DEVELOPMENT
CORPORATION
78 / 16
ART DIRECTION
Anthony Russell
DESIGN
Susan Limoncelli,
Jennifer Wood
PHOTOGRAPHY
Ben Russell
CLIENT
NYC Housing
Development
Corporation
ENTRANT LOCATION
New York, NY

NOT JUST BIRTH
CONTROL
78 / 17
ART DIRECTION
Lois Baron,
Susan Stern,
Ross Whitaker
DESIGN
Susan Stern
COPYWRITING
Lois Baron
PHOTOGRAPHY
Ross Whitaker
CLIENT
Community Family
Planning Council
ENTRANT LOCATION
New York, NY

ICOS CORPORATION 1992
ANNUAL REPORT
78 / 18
ART DIRECTION
John Van Dyke
DESIGN
John Van Dyke,
Ann Kumasaka
COPYWRITING
ICOS Staff
PHOTOGRAPHY
Randy Allbritton,
Jeff Corwin
ILLUSTRATION
Walter Stewart
STUDIO
Van Dyke Company
CLIENT
ICOS Corporation
ENTRANT LOCATION
Seattle, WA

MIGROS BERNE
78 / 3
ART DIRECTION
Atelier Herrmann SGD
(Laupen, Switzerland)
DESIGN
Brigit Herrmann
(Laupen, Switzerland)
COPYWRITING
Fjodor I. Bychanow
(Bijisk, Russia)
PHOTOGRAPHY
Vladimir I. Czerkasow
(Bijisk, Russia)
ILLUSTRATION
Fjodor I. Bychanow,
Atelier Herrmann SGD
PRODUCTION
Mastra Druck,
Schönbühl
DIRECTION
Peter M. Stadelmann,
TRANSLATION
Svetlana Selichova,
(St. Petersburg, Russia),
Olga Pop
(Köniz, Switzerland)
COORDINATION
Thomas E. Bornhauser
(Wohlen, Switzerland)
ENTRANT LOCATION
Schönbühl, Switzerland

CRAFTS COUNCIL
ANNUAL REPORT 1992 / 93,
SERVING THE PUBLIC
78 / 5
ART DIRECTION
John Rushworth
DESIGN
John Rushworth,
Nick Finney
PHOTOGRAPHY
Giles Revell
CLIENT
Crafts Council
ENTRANT LOCATION
London, England

TITLE
78 / 4
ART DIRECTION
Tatsuo Ebina
DESIGN
Tatsuo Ebina
PHOTOGRAPHY
Tadashi Tomono,
Masaaki Miyazawa,
Toru Kinoshita
CLIENT
E. Co., Ltd.
ENTRANT LOCATION
Tokyo, Japan

**VORWERK ANNUAL
REPORT 1992 - TAKE YOUR
TIME**
78 / 12
ART DIRECTION
Hermann Michels
DESIGN
Hermann Michels
COPYWRITING
Manfred Piwinger /
Vorwerk & Co.,
Wolfgang Niehüser
PRODUCTION
Ley & Wiegandt
(Wuppertal)
ENTRANT LOCATION
Wuppertal, Germany

THE VH-1 AWARDS
BOOKLET
79 / 22
SILVER
ART DIRECTION
Cherri Dorr,
Sharon Werner
DESIGN
Sharon Werner,
Amy Quinlivan
COPYWRITING
VH-1 Networks
PHOTOGRAPHY
Paul Irmiter,
Shawn Smith
ILLUSTRATION
Sharon Werner,
Amy Quinlivan
STUDIO
Werner Design
Werks Inc.
CLIENT
VH-1 Networks
ENTRANT LOCATION
New York, NY

**MTV VIDEO MUSIC
AWARDS PROGRAM 1993**
79 / 34
SILVER
ART DIRECTION
Jeffrey Keyton,
Stacy Drummond,
Stephen Byram
DESIGN
Jeffrey Keyton,
Stacy Drummond,
Stephen Byram
COPYWRITING
Karin Henderson
PHOTOGRAPHY
various
ILLUSTRATION
various
ENTRANT LOCATION
New York, NY

THE MUSIC OF JOHNNY
MATHIS - A PERSONAL
COLLECTION
79 / 13
DISTINCTIVE MERIT
ART DIRECTION
Allen Weinberg
PHOTOGRAPHY
Don Hunstein (Cover)
ILLUSTRATION
various
STUDIO
Sony Music
CLIENT
Sony Music
ENTRANT LOCATION
New York, NY

**NOTES OF THE OTTOMAN
LEGACY - WRITTEN IN
THE TIME OF WAR**
79 / 42
DISTINCTIVE MERIT
ART DIRECTION
Michael Gericke,
Paula Scher,
Bill Drenttel
DESIGN
Michael Gericke,
Sharon Harel,
Donna Ching
COPYWRITING
David Rieff
PHOTOGRAPHY
Christopher Morris,
Black Star
MAPS
Hammond Inc.
STUDIO
Pentagram Design
CLIENT
Champion International
ENTRANT LOCATION
New York, NY

A WALK IN THE
MOUNTAINS / PLAIN
CLOTHES
79 / 44
DISTINCTIVE MERIT
ART DIRECTION
Marion English,
Terry Slaughter
DESIGN
Marion English
COPYWRITING
Laura Holmes
PHOTOGRAPHY
Edward Thomas
ILLUSTRATION
Marion English
CLIENT
Plain Clothes
ENTRANT LOCATION
Birmingham, AL

MOHAWK VELLUM:
PERFECTLY ORDINARY
79 / 46
DISTINCTIVE MERIT
ART DIRECTION
Micheal Bierut
DESIGN
Micheal Bierut,
Lisa Cerveny
PHOTOGRAPHY
John Paul Endress
STUDIO
Pentagram Design
CLIENT
Mohawk Paper Mills
ENTRANT LOCATION
New York, NY

**LINOGRAPHICS OFFICIAL
PRICE GUIDE**
79 / 47
DISTINCTIVE MERIT
ART DIRECTION
William Kochi
DESIGN
William Kochi
PHOTOGRAPHY
William Kochi
STUDIO
KODE Associates, Inc.
CLIENT
LinoGraphics
ENTRANT LOCATION
New York, NY

NORTH SEMINARY
79 / 1
ART DIRECTION
Jim Kochevar
DESIGN
Jim Kochevar
COPYWRITING
Jim Kochevar
AGENCY
Big Tuna / Chicago
CLIENT
Champagne Properties
ENTRANT LOCATION
Chicago, IL

**TEN YEARS AND
ROLLING...THE CON-WAY
COMPANIES**
79 / 2
ART DIRECTION
Kit Hinrichs
DESIGN
Mark Selfe
COPYWRITING
client
PHOTOGRAPHY
John Blaustein,
David J. Sam,
Bob Esparza
ILLUSTRATION
Jeffrey West,
Larry McIntire,
John Mattos
STUDIO
Pentagram Design
CLIENT
Consolidated
Freightways, Inc.
ENTRANT LOCATION
San Francisco, CA

**MUSIC CENTER OF LOS
ANGELES COUNTY
EDUCATION BROCHURE**
79 / 3
ART DIRECTION
Maureen Erbe
DESIGN
Maureen Erbe,
Rita A. Sowins
PHOTOGRAPHY
Craig Schwartz
CLIENT
The Music Center of
Los Angeles County
ENTRANT LOCATION
Los Angeles, CA

MUSIC CENTER
UNIFIED FUND
79 / 4
ART DIRECTION
Maureen Erbe
DESIGN
Maureen Erbe,
Rita A. Sowins
PHOTOGRAPHY
various
CLIENT
The Music Center of
Los Angeles County
ENTRANT LOCATION
Los Angeles, CA

LOCALITÀ
79 / 5
ART DIRECTION
Tom Wood,
Susan Howard,
Craig Cutler
DESIGN
Tom Wood
PHOTOGRAPHY
Craig Cutler
STUDIO
Wood Design
CLIENT
Craig Cutler Studio
ENTRANT LOCATION
New York, NY

POPULAR SCIENCE HOME
REMODELING IDEAS '94
79 / 6
ART DIRECTION
Paul Kelly
DESIGN
Monica Gotz
COPYWRITING
Ed Keil
ILLUSTRATION
Monica Gotz
STUDIO
Mc Studio / Times
Mirror Magazines
CLIENT
Popular Science
ENTRANT LOCATION
New York, NY

KNOLL OFFICE CHAIRS
79 / 7
DESIGN DIRECTION
Tom Geismar
DESIGN
Emanuela Frigerio
CLIENT
The Knoll Group
ENTRANT LOCATION
New York, NY

EFFECTIVE ENERGY
79 / 8
ART DIRECTION
Tom Wood
DESIGN
Tom Wood
COPYWRITING
Mary Anne Costello
PHOTOGRAPHY
Jeff Corwin
STUDIO
Wood Design
CLIENT
Louis Dreyfus Energy
ENTRANT LOCATION
New York, NY

FORTY-FIFTH
ANNIVERSARY WESTERN
REGIONAL GREEK
CONFERENCE
(BROCHURE)
79 / 9
ART DIRECTION
John Sayles
DESIGN
John Sayles
COPYWRITING
Wendy Lyons
ILLUSTRATION
John Sayles
STUDIO
Sayles Graphic Design
CLIENT
Western Regional
Greek Conference
ENTRANT LOCATION
Des Moines, IA

**INFORMATION
TECHNOLOGY INC.**
79 / 10
ART DIRECTION
Carter Weitz
DESIGN
Carter Weitz
COPYWRITING
Laura Crawford,
Rich Bailey
PHOTOGRAPHY
Don Farrall
AGENCY
Bailey Lauerman
and Associates
CLIENT
Information
Technology Inc.
ENTRANT LOCATION
Lincoln, NE

**BAILEY LAUERMAN AND
ASSOCIATES - WHAT WE
DO**
79 / 11
ART DIRECTION
Carter Weitz
DESIGN
Carter Weitz
COPYWRITING
Rich Bailey
PHOTOGRAPHY
Jim Krantz
AGENCY
Bailey Lauerman
and Associates
CLIENT
Bailey Lauerman
and Associates
ENTRANT LOCATION
Lincoln, NE

**SIMPSON PAPER
COMPANY - DIMENSIONS -
THE OTHER MUSEUMS**
79 / 12
ART DIRECTION
Richard Poulin
DESIGN
Richard Poulin
COPYWRITING
Maxwell Arnold
PHOTOGRAPHY
various
STUDIO
Richard Poulin
Design Group Inc.
CLIENT
Simpson Paper
Company
ENTRANT LOCATION
New York, NY

SAN ANTONIO: GET A
FEEL FOR IT
79 / 14
ART DIRECTION
John Sayles
DESIGN
John Sayles
COPYWRITING
Wendy Lyons,
Mary Bell
ILLUSTRATION
John Sayles
STUDIO
Sayles Graphic Design
CLIENT
Insurance Conference
Planners Association
ENTRANT LOCATION
Des Moines, IA

FAIRWAY PINES - GOLF
AND COUNTRY CLUB
79 / 16
ART DIRECTION
Peter Richards
DESIGN
Peter Richards
COPYWRITING
Gary Graf
PHOTOGRAPHY
various
AGENCY
McFarland Richards
And Graf
CLIENT
Fairway Pines
ENTRANT LOCATION
Seattle, WA

MARCAM CORPORATION
ENTERPRISE SOLUTION
79 / 17
ART DIRECTION
Ellen Clancy
DESIGN
Tom Riddle
COPYWRITING
Dana Webster
ILLUSTRATION
Steve Lyons
AGENCY
Polese Clancy, Inc.
CLIENT
Marcam Corporation
ENTRANT LOCATION
Boston, MA

WILD SANCTUARY
BROCHURE
79 / 18
ART DIRECTION
Kit Hinrichs
DESIGN
Jackie Foshaug
COPYWRITING
Delphine Hirasuna
PHOTOGRAPHY
Flip Nicklin,
Frans Lanting,
Jim Brandenburg,
Malcolm Kirk
STUDIO
Pentagram Design
CLIENT
Wild Sanctuary
Communications
ENTRANT LOCATION
San Francisco, CA

THE 1993 ONE SHOW
79 / 19
ART DIRECTION
Jeff Griffith
DESIGN
Jeff Griffith,
Anne Marie Scarpa
COPYWRITING
Jeff Griffith, Daniel Russ
PHOTOGRAPHY
various
AGENCY
Griffith Advertising
Design
CLIENT
The One Club
ENTRANT LOCATION
New York, NY

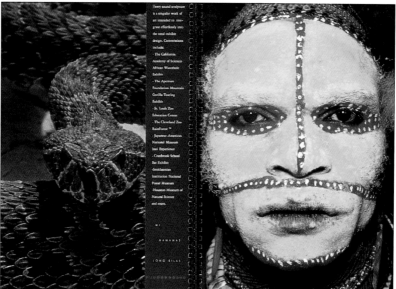

SKALD - JUNE 1993
79 / 20
ART DIRECTION
Kit Hinrichs
DESIGN
Jackie Foshaug
COPYWRITING
Peterson, Skolnick
and Dodge
PHOTOGRAPHY
Barry Robinson,
Harvey Lloyd
ILLUSTRATION
Gary Overacre,
James McMullan,
Dave Stevenson
STUDIO
Pentagram Design
CLIENT
Royal Viking Line
ENTRANT LOCATION
San Francisco, CA

THE VH-1 AWARDS
79 / 21
ART DIRECTION
Cherri Dorr,
Sharon Werner
DESIGN
Sharon Werner,
Amy Quinlivan
COPYWRITING
VH-1 Networks
PHOTOGRAPHY
Paul Irmiter,
Shawn Smith
ILLUSTRATION
Sharon Werner,
Amy Quinlivan
STUDIO
Werner Design Werks
Inc.
CLIENT
VH-1 Networks
ENTRANT LOCATION
Minneapolis, MN

FOX RIVER BOND
79 / 23
ART DIRECTION
John Van Dyke
DESIGN
John Van Dyke,
Ann Kumasaka
COPYWRITING
Tom McCarthy
PHOTOGRAPHY
Terry Heffernan
STUDIO
Van Dyke Company
CLIENT
Fox River Paper
Company
ENTRANT LOCATION
Seattle, WA

**BOSTON BALLET - THIRTY
YEARS**
79 / 24
ART DIRECTION
Vic Ceroli
DESIGN
Mary McGuire
COPYWRITING
Paula Tully
PHOTOGRAPHY
Jerry Berndt
AGENCY
Hill, Holliday, Connors,
Cosmopolous
CLIENT
Boston Ballet
ENTRANT LOCATION
Boston, MA

**HARLEY-DAVIDSON 1994
BROCHURE**
79 / 25
ART DIRECTION
Warren Johnson
COPYWRITING
Jim Nelson
PHOTOGRAPHY
Peggy Day /
Northlight Studios
PRODUCTION
Brenda Clemons
AGENCY
Carmichael Lynch
CLIENT
Harley-Davidson
ENTRANT LOCATION
Minneapolis, MN

**THE KNOLL IDENTITY
GUIDELINES**
79 / 26
ART DIRECTION
Tom Geismar
DESIGN
Cathy Rediehs Schaefer
COPYWRITING
Cathy Rediehs Schaefer
CLIENT
The Knoll Group
ENTRANT LOCATION
New York, NY

CREATING CRANE CREST R BOOK
79 / 27
ART DIRECTION
Steff Geissbuhler
DESIGN
James McKibben
COPYWRITING
Lisa Friedman
PHOTOGRAPHY
Rodney Smith
PRODUCTION
Creating Crane Crest R
CLIENT
Crane & Co.
ENTRANT LOCATION
New York, NY

ALPHA INDUSTRIES INC.-MANUFACTURER FOR THE U.S. MILITARY
79 / 28
ART DIRECTION
Rosemary Conroy
DESIGN
Joe Barsin
COPYWRITING
Tom Daniel
PHOTOGRAPHY
Charles Freeman
AGENCY
Siquis, LTD.
CLIENT
Alpha Industries Inc.
ENTRANT LOCATION
Baltimore, MD

SEEING IS BELIEVING
79 / 29
ART DIRECTION
Barry Shepard
DESIGN
Mike Shanks,
Nathan Joseph
COPYWRITING
Barry Shepard
PHOTOGRAPHY
Rodney Rascona
PRODUCTION
Mary Meek
STUDIO
SHR Perceptual
Management
CLIENT
SHR Perceptual
Management
ENTRANT LOCATION
Scottsdale, AZ

MEREX CORPORATION
79 / 30
ART DIRECTION
Russ Haan,
Dino Paul
DESIGN
Dino Paul,
Brad Smith
COPYWRITING
Russ Haan
STUDIO
After Hours
CLIENT
Merex Corporation
ENTRANT LOCATION
Phoenix, AZ

FOAMEX
79 / 31
ART DIRECTION
Peter Harrison,
Susan Hochbaum
DESIGN
Susan Hochbaum,
Kevin Lauterbach
COPYWRITING
Bruce Duffy
PHOTOGRAPHY
John Madere,
Kenji Toma
STUDIO
Pentagram Design
CLIENT
Foamex
ENTRANT LOCATION
New York, NY

**CORPORATE CITIZEN -
CORPORATE CULTURE -
CORPORATE SOUL -
NEENAH PAPER**
79 / 32
ART DIRECTION
Maxey Andress
DESIGN
Mark Nelson
COPYWRITING
Melissa James
PHOTOGRAPHY
Chas Studion
CLIENT
Neenah Paper
ENTRANT LOCATION
Atlanta, GA

NIPSI
79 / 33
ART DIRECTION
Rick Vaughn,
Daniel Michael Flynn
DESIGN
Daniel Michael Flynn
COPYWRITING
Nathan James
PHOTOGRAPHY
Micheal Barley
STUDIO
Vaughn Wedeen
Creative
CLIENT
National Institutional
Pharmacy Services
ENTRANT LOCATION
Albuquerque, NM

**MASSACHUSETTS
COLLEGE OF ART 1993 /
1995**
79 / 35
ART DIRECTION
Clifford Stoltze
DESIGN
Kyong Choe,
Clifford Stoltze,
Peter Farrell,
Rebecca Fagan
PHOTOGRAPHY
various
ILLUSTRATION
various
STUDIO
Stoltze Design
CLIENT
Massachusetts College
of Art
ENTRANT LOCATION
Boston, MA

**THE P CHRONICLES -
NUMBER 2**
79 / 36
ART DIRECTION
Seymour Chwast
DESIGN
Greg Simpson
COPYWRITING
Steve Heller
PHOTOGRAPHY
Rick Muller
STUDIO
The Pushpin Group
CLIENT
Ivy Hill Corporation
ENTRANT LOCATION
New York, NY

AIGA CONFERENCE GIFT
BOOK
79 / 37
ART DIRECTION
Paul Wharton
DESIGN
Ellen Huber
ILLUSTRATION
J. Otto Siebold
CLIENT
Cross Pointe Paper
Corporation
ENTRANT LOCATION
Minneapolis, MN

PEOPLE IN STEEL
79 / 38
ART DIRECTION
Patrick Short
DESIGN
Patrick Short
COPYWRITING
various
PHOTOGRAPHY
Allen Weiss /
Nomad Short Subjects
STUDIO
BlackBird Creative
CLIENT
DuBose Steel
ENTRANT LOCATION
Raleigh, NC

CATERPILLAR HISTORY
BOOK
79 / 39
ART DIRECTION
Mark Oldach
DESIGN
Don Emery
COPYWRITING
Max Russell
PHOTOGRAPHY
J.B. Spector
and Pick Up
STUDIO
Mark Oldach Design
CLIENT
Caterpillar Inc.
ENTRANT LOCATION
Chicago, IL

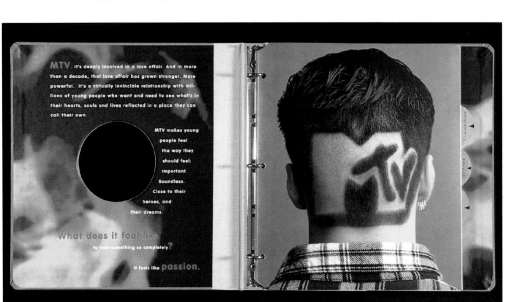

RUST FARMS
79 / 40
ART DIRECTION
Tom Simons
DESIGN
Tom Simons
PHOTOGRAPHY
Harry DeZitter
AGENCY
Partners and Simons
CLIENT
Harry DeZitter
ENTRANT LOCATION
Boston, MA

SIMPSON NEO BROCHURE
79 / 41
ART DIRECTION
Woody Pirtle,
John Klotnia
DESIGN
Woody Pirtle,
John Klotnia,
Ron Louie,
Ivette Montes De Oca
PHOTOGRAPHY
various
ILLUSTRATION
various
CLIENT
Simpson Paper Co.
ENTRANT LOCATION
New York, NY

MTV - MEDIA KIT
79 / 43
ART DIRECTION
Jeffrey Keyton
DESIGN
Pieter Woudt, Alex So
COPYWRITING
Karin Henderson
PHOTOGRAPHY
Mark Seliger
ILLUSTRATION
Pieter Woudt, Alex So
ENTRANT LOCATION
New York, NY

CHOICES
79 / 45
ART DIRECTION
Frank C. Lionetti
DESIGN
Alexandra Boyden,
Laurie Frick
STUDIO
Frank C. Lionetti
Design Inc.
CLIENT
Public Service Electric
and Gas Company
ENTRANT LOCATION
Old Greenwich, CT

FULL CIRCLE: BEYOND
RECYCLING
79 / 48
ART DIRECTION
Paul Wharton
DESIGN
Garin Ispen
COPYWRITING
Words at Work
ILLUSTRATION
Guy Billout
CLIENT
Cross Pointe Paper
Corporation
ENTRANT LOCATION
Minneapolis, MN

PASSPORT TO RUSSIA
79 / 49
ART DIRECTION
Paul Wharton
DESIGN
Paul Wharton
COPYWRITING
Sandra Bucholtz
CLIENT
Cross Pointe Paper
Corporation
ENTRANT LOCATION
Minneapolis, MN

THE MEAD ANNUAL
REPORT SHOW 1993
79 / 50
ART DIRECTION
Joyce Nesnadny,
Mark Schwartz
DESIGN
Joyce Nesnadny,
Brian Lavy,
Michelle Moehler
COPYWRITING
Robert A. Parker
PHOTOGRAPHY
Roman Sapecki
ILLUSTRATION
Nesnadny and
Schwartz, Old Masters
PRODUCTION
Shawn Palmer,
Mark Schwartz
DIRECTION
Shawn Palmer,
Mark Schwartz
STUDIO
Nesnadny + Schwartz
CLIENT
Mead Corporation
ENTRANT LOCATION
Cleveland, OH

PAGENET ANNUAL
REPORT 1992
79 / 51
ART DIRECTION
Douglas May
DESIGN
Douglas May
COPYWRITING
Carol St. George
PHOTOGRAPHY
Will Crocker
ILLUSTRATION
Jan Harrison
STUDIO
May and Co.
CLIENT
Paging Network Inc.
ENTRANT LOCATION
Dallas, TX

BELL & CO. CAPABILITIES
BROCHURE
79 / 52
ART DIRECTION
Joel Suissa, Marci Suissa
DESIGN
Joel Suissa, Marci Suissa
COPYWRITING
Alice Miller
PHOTOGRAPHY
HCP Photography
ILLUSTRATION
George Cuevas
STUDIO
Suissa Design
CLIENT
Evan Bell, Bell and Co.
ENTRANT LOCATION
Miami Beach, FL

**YOU WAKE UP - JUN
CHONG TAE KWON DO
CENTER**
49 / 40
ART DIRECTION
Bruce Bousman
DESIGN
Bruce Bousman
COPYWRITING
Harold Einstein,
Greg Hahn
AGENCY
The Firm
CLIENT
Jun Chong Tae Kwon
Do Center
ENTRANT LOCATION
Agoura, CA

SYZYGY
79 / 53
ART DIRECTION
Matthew L. Doty
DESIGN
Matthew L. Doty
COPYWRITING
Matthew L. Doty
PHOTOGRAPHY
Barbara Strong Doty
ILLUSTRATION
Matthew Doty,
Lili Hertzler
PRODUCTION
Matthew Doty,
Barbara Doty
AGENCY
Strong Productions, Inc.
CLIENT
self promotion
ENTRANT LOCATION
Cedar Rapids, IA

**POTLATCH VINTAGE
REMARQUE - BY OUR
CHILDREN WE WILL
LEARN**
79 / 54
ART DIRECTION
Kevin B. Kuester
DESIGN
Tim Sauer
COPYWRITING
David Forney
PHOTOGRAPHY
Marc Norberg
ILLUSTRATION
Alex Boies
AGENCY
The Kuester Group
CLIENT
Potlatch Corporation
ENTRANT LOCATION
Minneapolis, MN

YOU WAKE UP.
FASTEN YOUR POCKET PROTECTOR.
ADJUST YOUR GLASSES. GO TO SCHOOL.
AND COLLECT LUNCH MONEY FROM
THE CLASS BULLY.

WHAT WOULD LIFE BE LIKE IF YOU KNEW KARATE?

ART NOT AVAILABLE

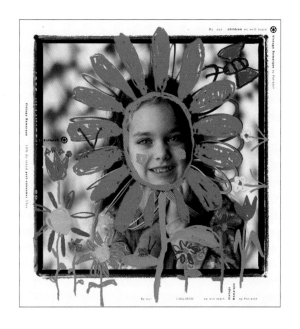

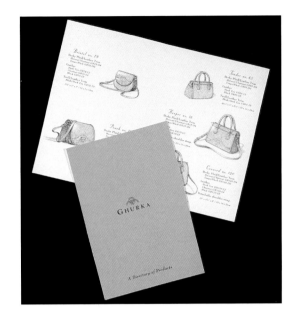

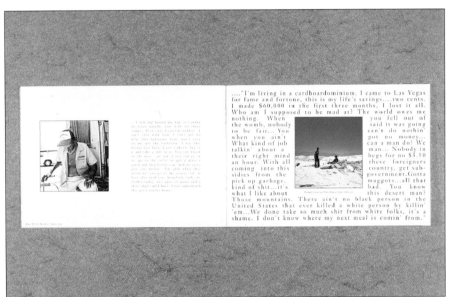

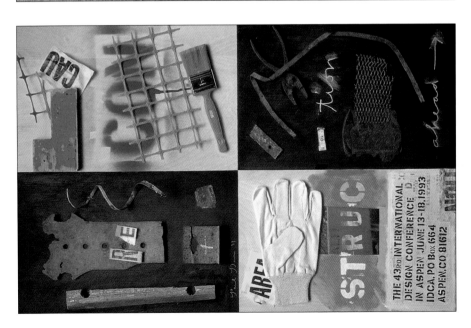

**GHURKA - A DIRECTORY
OF PRODUCTS**
79 / 55
ART DIRECTION
Kimberly Berzack
DESIGN
Kimberly Berzack
ILLUSTRATION
John Finley
AGENCY
Weiss, Whitten,
Stagliano
CLIENT
Ghurka
ENTRANT LOCATION
New York, NY

**ANDREW GARN, BUTLER
INSTITUTE OF AMERICAN
ART / EXHIBITION
BROCHURE**
79 / 56
ART DIRECTION
Andrew Garn,
Kathleen Heike Triem
DESIGN
Andrew Garn,
Kathleen Heike Triem
PHOTOGRAPHY
Andrew Garn
**COMPUTER
ILLUSTRATION**
Benett Beckenstein
CLIENT
Butler Institute of
American Art
ENTRANT LOCATION
New York, NY

**THE 43RD
INTERNATIONAL DESIGN
CONFERENCE IN ASPEN**
79 / 57
ART DIRECTION
Paul Davis
DESIGN
Lisa Mazur
ILLUSTRATION
Paul Davis
CLIENT
International Design
Conference in Aspen
ENTRANT LOCATION
New York, NY

UNIVEL
79 / 58
ART DIRECTION
Gordon Mortensen
DESIGN
Gordon Mortensen
COPYWRITING
Doug Cruickshank
ILLUSTRATION
Chris Gall
STUDIO
Mortensen Design
CLIENT
Univel
ENTRANT LOCATION
Mountain View, CA

JOAN LEINEKE CATERING
BROCHURE
79 / 59
ART DIRECTION
Michael Dunlavey
DESIGN
Kevin Yee
STUDIO
The Dunlavey
Studio, Inc.
CLIENT
Joan Leineke
ENTRANT LOCATION
Sacramento, CA

POTLATCH
QUINTESSENCE- THE
PASSIONATE SURFACE
79 / 60
ART DIRECTION
Kevin B. Kuester
DESIGN
Kevin B. Kuester,
Bob Goebel
COPYWRITING
David Forney
PHOTOGRAPHY
various
ILLUSTRATION
Frank O. Gehry,
Kevin B. Kuester
AGENCY
The Kuester Group
CLIENT
Potlatch Corporation
ENTRANT LOCATION
Minneapolis, MN

CNET (FLIPBOOK)
79 / 61

ART DIRECTION
Michael Gericke

DESIGN
Donna Ching,
Sharon Harel

ILLUSTRATION
Todd Graveline,
Sharon Harel

CLIENT
Cnet, New York, NY

ENTRANT LOCATION
New York, NY

TESTA
79 / 3

ART DIRECTION
Antonella Testa

DESIGN
Antonella Testa

COPYWRITING
Maurizio Sala

AGENCY
In Testa

CLIENT
Armando Testa S.p.A.

ENTRANT LOCATION
Milan, Italy

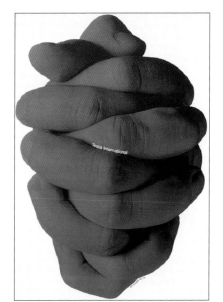

DIBBERN
79 / 2

ART DIRECTION
Sibylle Haase

DESIGN
Regina Spiekermann,
Katja Hirschfelder

COPYWRITING
Evelyn C. Froh

PHOTOGRAPHY
Hans Hansen

ILLUSTRATION
Sibylle Haase

AGENCY
Atelier Haase & Knels

CLIENT
B.T. Dibbern GmbH &
Co. KG

ENTRANT LOCATION
Bremen, Germany

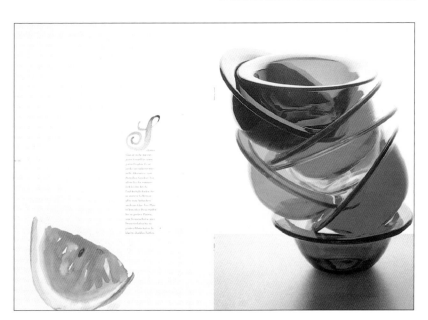

**HABSBURG -
FALL/WINTER: 93 / 94**
79 / 7
ART DIRECTION
Franz Merlicek
DESIGN
Judith Modl
COPYWRITING
Sabine Gruber
PHOTOGRAPHY
Bernhard Angerer
ILLUSTRATION
Jürgen Mick
PRODUCTION
Werner Stupka
AGENCY
Demner & Merlicek
CLIENT
Kleidermanufaktur
Habsburg
ENTRANT LOCATION
Vienna, Austria

**DESIGNERS COMPANY
AGENCY BROCHURE**
79 / 8
ART DIRECTION
Rob Verhaart
DESIGN
Rob Verhaart
COPYWRITING
Poppe Van Pelt
PHOTOGRAPHY
Rainer Leitzgen
AGENCY
Designers Company
CLIENT
Designers Company
ENTRANT LOCATION
Amsterdam,
Netherlands

**POLAROID TYPE 59
POLACOLOR ER**
79 / 6
ART DIRECTION
Gerold Gerdes
DESIGN
Gerold Gerdes
PHOTOGRAPHY
Gerold Gerdes
PRODUCTION
Paivi Hoikkala
AGENCY
Mad Max Ltd
CLIENT
Turku Fair Center Ltd.
ENTRANT LOCATION
Turku, Finland

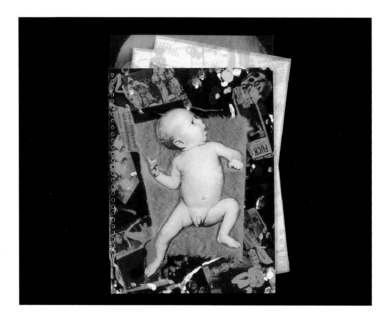

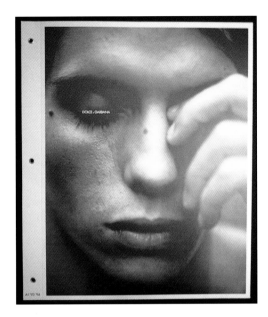

DOLCE & GABBANA
79 / 1
ART DIRECTION
Luca Stoppini
DESIGN
Luca Stoppini
PHOTOGRAPHY
Mario Sorrenti
CLIENT
Dolce & Gabbana
ENTRANT LOCATION
Milan, Italy

**LENNY HENRY - LOUD
TOUR!**
79 / 9
ART DIRECTION
Judi Green
DESIGN
Judi Green, James Bell
COPYWRITING
Lenny Henry
PHOTOGRAPHY
Trevor Leighton
AGENCY
The Green House
CLIENT
Lenny Henry -
Loud Tour!
ENTRANT LOCATION
On - the - Hill, England

**STARKES LAND -
BROCHURE FOR TOURIST
PROMOTION**
79 / 5
ART DIRECTION
Nando Miglio,
Carla Rumler
DESIGN
Nando Miglio,
Carla Rumler
COPYWRITING
Tirol Werbung
PHOTOGRAPHY
Kurt Markus
PRODUCTION
Rauch Druck
CLIENT
Tirol Werbung
ENTRANT LOCATION
Innsbruck, Austria

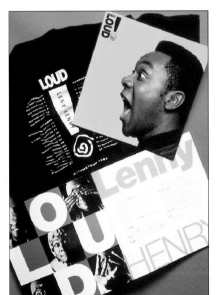

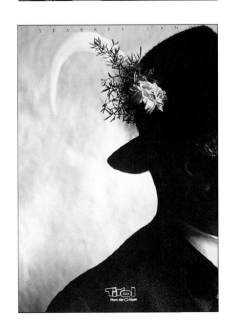

SLOW HAND CO., LTD.
79 / 4

ART DIRECTION
Yoichirou Fujii

DESIGN
Yoichirou Fujii,
Akira Ohtake,
Megumi Yamada,
Yuko Nohara

PHOTOGRAPHY
Harutaka Nodera,
Yoichirou Fujii

ILLUSTRATION
Miyuki Sakai

PRODUCTION
Yoichirou Fujii

STUDIO
Bakery 37.1 Co., Ltd.

CLIENT
Slow Hand Co., Ltd

ENTRANT LOCATION
Tokyo, Japan

NICK AT NITE / MTV
NETWORKS
80 / 2
SILVER
ART DIRECTION
Laurie Kelliher,
Sharon Werner
DESIGN
Sharon Werner
COPYWRITING
Nick at Nite
PHOTOGRAPHY
Nick at Nite
ILLUSTRATION
Sharon Werner
STUDIO
Werner Design Werks
Inc.
CLIENT
Nick at Nite / MTV
Networks
ENTRANT LOCATION
Minneapolis, MN

MONADNOCK I
80 / I
ART DIRECTION
Tom Geismar
DESIGN
Cathy Rediehs Schaefer
COPYWRITING
Cathy Rediehs Schaefer
PHOTOGRAPHY
David Arky
PRODUCTION
Monadnock Brochures
CLIENT
Monadnock Paper Mills
ENTRANT LOCATION
New York, NY

MONADNOCK 2
80 / 3
ART DIRECTION
Tom Geismar
DESIGN
Cathy Rediehs Schaefer
COPYWRITING
Cathy Rediehs Schaefer
PHOTOGRAPHY
David Arky
PRODUCTION
Monadnock Brochures
CLIENT
Monadnock Paper Mills
ENTRANT LOCATION
New York, NY

ICL BY SAZABY
80 / I
ART DIRECTION
Hiroki Kubota,
Takaaki Matsumoto,
NY
DESIGN
Hiroki Kubota
PHOTOGRAPHY
Takahiro Kurokawa
PRODUCTION
SAZABY Design
Centre
CLIENT
SAZABY Inc.
ENTRANT LOCATION
Tokyo, Japan

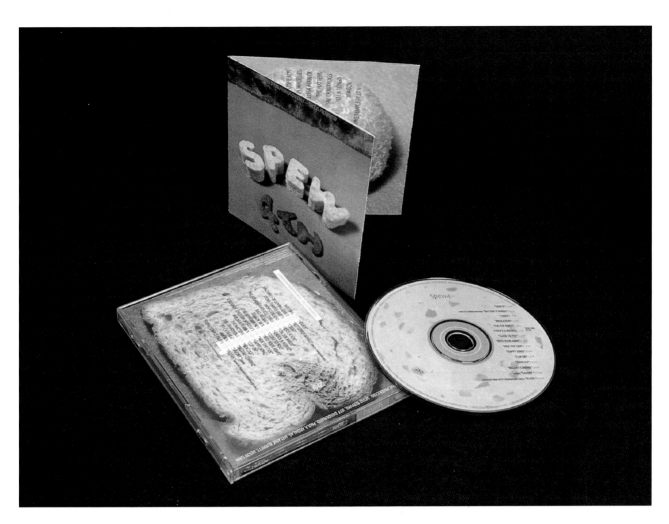

SPEW 4TH
81 / 13
SILVER
ART DIRECTION
Charlie Becker
DESIGN
Charlie Becker
PHOTOGRAPHY
Charlie Becker
ENTRANT LOCATION
New York, NY

**LOS LOBOS - JUST
ANOTHER BAND FROM
EAST L.A. - A COLLECTION**
81 / 9
DISTINCTIVE MERIT
ART DIRECTION
Tom Recchion,
Louie Perez
DESIGN
Tom Recchion,
Louie Perez
PHOTOGRAPHY
Keith Carter,
Fredrik Nilsen
STUDIO
Warner Bros.
Records In-house
Art Department
CLIENT
Warner Bros. / Slash
Records
ENTRANT LOCATION
Burbank, CA

AGATA & VALENTINA
81 / 24
DISTINCTIVE MERIT
ART DIRECTION
Stephen Doyle
DESIGN
Gary Tooth
CLIENT
JAV Foods
ENTRANT LOCATION
New York, NY

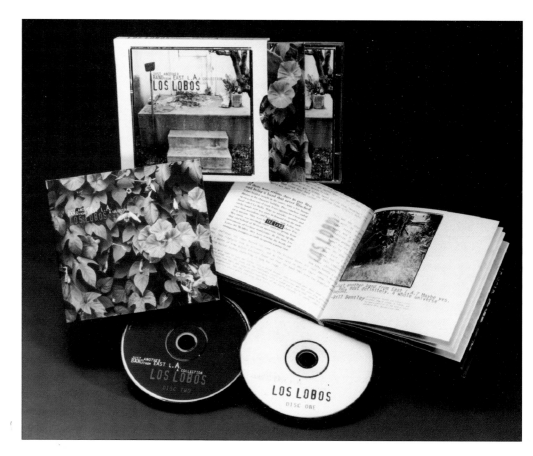

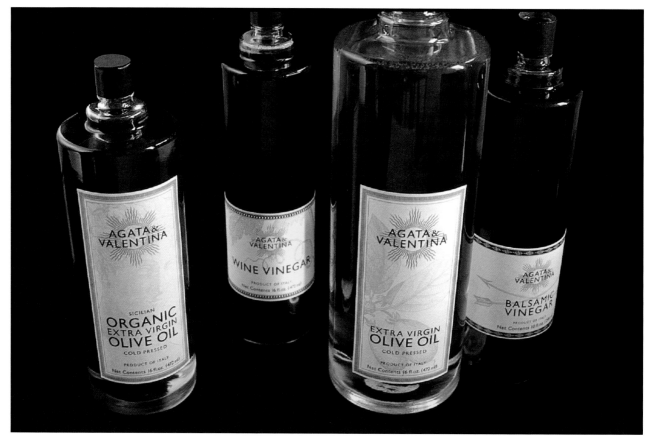

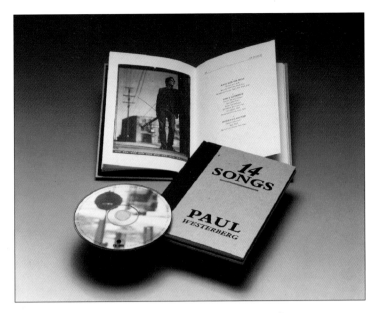

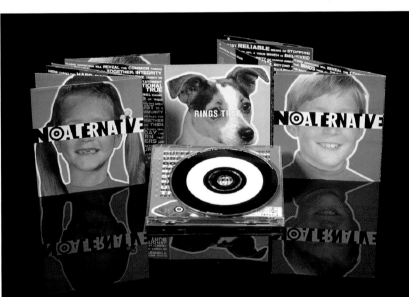

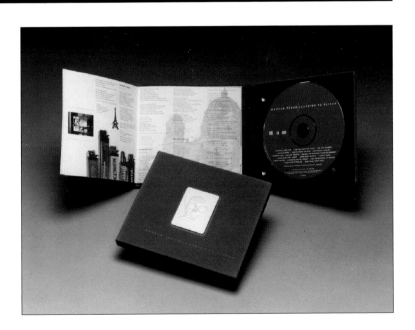

PAUL WESTERBERG 14
SONGS SPECIAL PACKAGE
81 / 1

ART DIRECTION
Kim Champagne,
Jeff Gold

DESIGN
Kim Champagne,
Jean Krikorian,
Paul Westerberg

PHOTOGRAPHY
Frank Ockenfels,
Kim Champagne

STUDIO
Warner Bros. Records
In-House

CLIENT
Sire Record Company

ENTRANT LOCATION
Burbank, CA

NO ALTERNATIVE
81 / 2

ART DIRECTION
Bureau

ENTRANT LOCATION
New York, NY

WARREN ZEVON -
LEARNING TO FLINCH
SPECIAL PACKAGE
81 / 3

ART DIRECTION
Jeri Heiden,
Lyn Bradley

DESIGN
Jeri Heiden, Lyn
Bradley

PHOTOGRAPHY
Willie Gibson,
Warren Zevon,
Duncan Aldrich,
Gloria Boyce,
Victor Bracke

COVER ART
Jimmy Wachtel

STUDIO
Warner Bros.
Records In-House
Art Department

CLIENT
Giant/Reprise Records

ENTRANT LOCATION
Burbank, CA

**DOG SOCIETY - TEST
YOUR OWN EYES**
81 / 5
ART DIRECTION
Larry Freemantle
PHOTOGRAPHY
Hans Neleman
ENTRANT LOCATION
New York, NY

ROY ROGERS & TRIGGER
81 / 6
ART DIRECTION
Tim Hale
DESIGN
Casey McGarr
PHOTOGRAPHY
Rick Brynt
ILLUSTRATION
Casey McGarr
STUDIO
In House Fossil Design
AGENCY
In House
CLIENT
Fossil Watches
ENTRANT LOCATION
Dallas, TX

SCHOLARSHIPS 101
81 / 7
ART DIRECTION
Forrest Richardson,
Debi Young Mees
DESIGN
Forrest and Valerie
Richardson
COPYWRITING
Forrest Richardson
STUDIO
Richardson or
Richardson
CLIENT
Pinnacle Peak Solutions
ENTRANT LOCATION
Phoenix, AZ

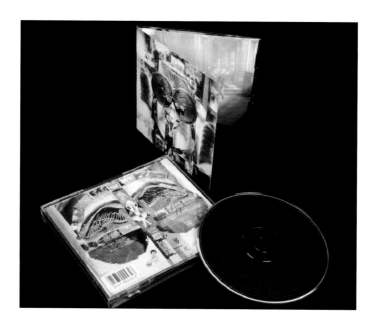

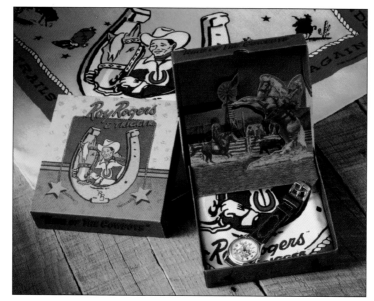

YES - HIGHLIGHTS - THE VERY BEST OF YES
81 / 8
ART DIRECTION
Elizabeth Barrett
ILLUSTRATION
Steven Dana
ENTRANT LOCATION
New York, NY

311 MUSIC CD PACKAGE
81 / 10
ART DIRECTION
Deborah Norcross
DESIGN
Deborah Norcross,
Henk Elenga
PHOTOGRAPHY
Alastair Thain,
Paul Caponigro,
Melodie McDaniel
ILLUSTRATION
Eric Stotic, Henk Elenga
STUDIO
Warner Bros.
Records In-House
Art Department
CLIENT
Capricorn / Warner
Bros. Records
ENTRANT LOCATION
Burbank, CA

MELVINS. HOUDINI.
81 / 11
ART DIRECTION
Valerie Wagner,
Frank Kozik
DESIGN
Valerie Wagner
ILLUSTRATION
Frank Kozik
ENTRANT LOCATION
New York, NY

**VAN HALEN LIVE: RIGHT
HERE, RIGHT NOW. CD
PACKAGE**
81 / 12
ART DIRECTION
Jeri Heiden
DESIGN
Jeri Heiden,
Lyn Bradley
PHOTOGRAPHY
David Graham,
John Halpern,
Samantha Harvey,
Robert Buhl,
Mark Seliger
STUDIO
Warner Bros.
Records In-House
Art Department
CLIENT
Warner Bros. Records
ENTRANT LOCATION
Burbank, CA

**MC LYTE - AIN'T NO
OTHER (CD PACKAGE)**
81 / 14
ART DIRECTION
Lynn Kowalewski
PHOTOGRAPHY
Merlyn Rosenberg
ENTRANT LOCATION
New York, NY

IN-STORE PLAY
81 / 15
ART DIRECTION
Sara Rotman
DESIGN
Sara Rotman
CLIENT
Epic Records
ENTRANT LOCATION
New York, NY

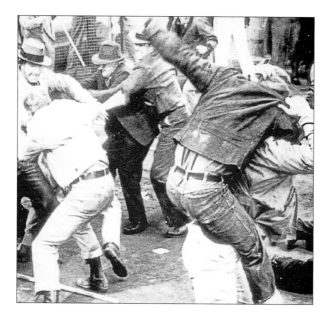

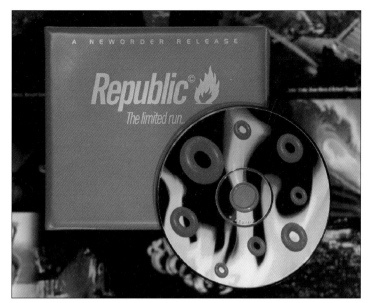

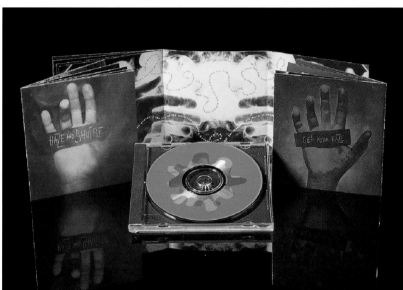

NEW ORDER REPUBLIC -
THE LIMITED RUN...
81 / 16
ART DIRECTION
Jeff Gold, Steven Baker,
Peter Saville
DESIGN
Peter Saville,
Brett Wickens,
Howard Wakefield
STUDIO
Pentagram, London
CLIENT
Warner Bros./ Qwest
Records
ENTRANT LOCATION
Burbank, CA

HAZE AND SHUFFLE - GET
YOUR HAZE
81 / 17
ART DIRECTION
Elisa Keogh,
Susan Mendola
DESIGN
Elisa Keogh
PHOTOGRAPHY
Amy Guipp,
Alison Dyer
ENTRANT LOCATION
New York, NY

MELISSA FERRICK:
SPECIAL PACKAGE
81 / 18
ART DIRECTION
Richard Bates
DESIGN
Sung Lee
PHOTOGRAPHY
Glen Erler
ENTRANT LOCATION
New York, NY

LIVING COLOR - STAIN
81 / 19
ART DIRECTION
Carol Chen
DESIGN
Carol Chen
PHOTOGRAPHY
Amy Guip
CLIENT
Epic Records /
Living Colour
ENTRANT LOCATION
New York, NY

CLUTCH
81 / 20
ART DIRECTION
Frank Gargiulo
PHOTOGRAPHY
Dan Winters
ENTRANT LOCATION
New York, NY

OCTOBER PROJECT
81 / 21
ART DIRECTION
Nicky Lindeman
DESIGN
Nicky Lindeman,
Tracy Boychuck
PHOTOGRAPHY
Andrea Gentyl
CLIENT
Epic Records
ENTRANT LOCATION
New York, NY

NNENNA FREELON - HERITAGE
81 / 22
ART DIRECTION
Stacy Drummond
DESIGN
Stacy Drummond,
Julian Peploe
PHOTOGRAPHY
Christopher Micaud
CLIENT
Columbia Records
ENTRANT LOCATION
New York, NY

BILLY JOEL - SHADES OF GREY
81 / 23
ART DIRECTION
Sara Rotman
DESIGN
Sara Rotman
CLIENT
Columbia Records
ENTRANT LOCATION
New York, NY

SCHOOLLY D - ANOTHER SIGN
81 / 25
ART DIRECTION
Stacy Drummond
DESIGN
Julian Peploe
PHOTOGRAPHY
David Katzenstein
CLIENT
Columbia Records
ENTRANT LOCATION
New York, NY

TEMPO 3.1
81 / 26
DESIGN
Bruce Crocker
COPYWRITING
Grant Sanders
PHOTOGRAPHY
Ricardo Pontes
ILLUSTRATION
Matthew Imperiale
STUDIO
Crocker Inc.
CLIENT
Boston Acoustics
ENTRANT LOCATION
Brookline, MA

JOE HENRY - KINDNESS OF
THE WORLD
81 / 27
ART DIRECTION
Melanie Nissen
DESIGN
Melanie Nissen,
Sung Lee,
Charlie Becker
PHOTOGRAPHY
Melanie Nissen
ENTRANT LOCATION
New York, NY

HOLEPROOF NATURALS
81 / 5
ART DIRECTION
Andrew Hoyne
DESIGN
Andrew Hoyne,
Carolyn Arthur
COPYWRITING
Stephen Boscutti
STUDIO
Andrew Hoyne Design
CLIENT
Holeproof
ENTRANT LOCATION
Melbourne Victoria,
Australia

LOW CALORIE, PUPPY
81 / 8
ART DIRECTION
John Blackburn
DESIGN
John Blackburn
COPYWRITING
John Blackburn
ILLUSTRATION
John Geary
CLIENT
Denes Pet Care
ENTRANT LOCATION
London, England

ENA SEA - ONE
81 / 2
ART DIRECTION
Thomas Sassenbach
DESIGN
Thomas Elsner
PHOTOGRAPHY
Thomas Elsner,
Elke Sezle, Züli Aladag
ENTRANT LOCATION
Munich, Germany

**SLINGER PMS - FAN IN
3 - D**
81 / 6
ART DIRECTION
Jan Lepair
DESIGN
Jan Lepair
AGENCY
Jan Lepair Art
Direction & Design
CLIENT
Drukkerij Slinger bv
ENTRANT LOCATION
HB Bussum,
Netherlands

**PAUL SCHÜTZE - THE
RAPTURE OF METALS**
81 / 3
ART DIRECTION
Jorg Willich
PHOTOGRAPHY
Hanne Triltsch,
Jorg Willich
PRODUCTION
Jorg Willich
CLIENT
SDV - Tontrager
ENTRANT LOCATION
London, England

ZEISS
81 / 11
ART DIRECTION
Mary Lewis
DESIGN
David Beard
AGENCY
Lewis Moberly
CLIENT
Bass
ENTRANT LOCATION
London, England

AMÉ SPARKLING DRINK
81 / 9
ART DIRECTION
Kathy Miller
DESIGN
Kathy Miller
PHOTOGRAPHY
David Gill
CLIENT
AMÉ
ENTRANT LOCATION
London, England

WAITROSE LUXURY NUTS
RANGE
81 / 10
ART DIRECTION
Kathy Miller
DESIGN
Kathy Miller
PHOTOGRAPHY
David Gill
CLIENT
Waitrose
ENTRANT LOCATION
London, England

JOZSEF ATTILA
81 / 1
ART DIRECTION
Peter Nagy & György
Kara
DESIGN
Peter Nagy & György
Kara
PHOTOGRAPHY
archives
PRODUCTION
Helga Hàbetler
STUDIO
PART
CLIENT
Hungarian Broadcasting
Co.
ENTRANT LOCATION
Budapest, Hungary

VERY - PET SHOP BOYS
81 / 4
ART DIRECTION
Daniel Weil
DESIGN
Daniel Weil,
Arthur Collin
PRODUCTION
Pet Shop Boys
CLIENT
EMI Records Ltd.
ENTRANT LOCATION
London, England

JACKY 5
81 / 7
ART DIRECTION
Toshiaki Itoh
DESIGN
Yoshitaka Sasaki
COPYWRITING
Hotaka Ishino
ILLUSTRATION
Mao Yamaguchi
AGENCY
Grafix International
CLIENT
Jewelry Corp.
ENTRANT LOCATION
Tokyo, Japan

ADELPHI WHISKY
82 / 8
SILVER
ART DIRECTION
Graham Scott
DESIGN
Julie Hampton
COPYWRITING
Charlie Maclean
CLIENT
The Adelphi Distillery
Limited
ENTRANT LOCATION
Edinburgh, Scotland

T-SHIRT FOR DAILY USE
82 / 6
ART DIRECTION
Rüdiger Götz, Olaf
Stein
DESIGN
Rüdiger Götz, Olaf
Stein
COPYWRITING
Rüdiger Götz, Olaf
Stein
ILLUSTRATION
Rüdiger Götz
AGENCY
Factor Design
CLIENT
Fontshop Berlin
ENTRANT LOCATION
Hamburg, Germany

TRUSTEAS' CAKE SERIES
82 / 5
ART DIRECTION
Hitomi Sago
DESIGN
Hitomi Sago, Asako
Kaneko
COPYWRITING
Yoko Fujiwara
ILLUSTRATION
Taro Manabe
PRODUCTION
Tei Suzuki
STUDIO
Hitomi Sago Design
Office Inc.
AGENCY
C & S Co., Ltd.
CLIENT
Henri Charpentier Co.,
Ltd.
ENTRANT LOCATION
Tokyo, Japan

TRY ME, VAN LEER
PACKAGING SYSTEMS
82 / 1
ART DIRECTION
Leon Bosboom,
Willem Kroon
DESIGN
Leon Bosboom,
Willem Kroon
PHOTOGRAPHY
Frans Jansen
CLIENT
Van Leer Packaging
Systems
ENTRANT LOCATION
Amsterdam,
Netherlands

447

HARRIS OILS RANGE
82 / 7
ART DIRECTION
Kathy Miller
DESIGN
Kathy Miller
CLIENT
Harris Oils
ENTRANT LOCATION
London, England

ICL BY SAZABY
82 / 2
82 / 3
82 / 4
ART DIRECTION
Takaaki Matsumoto
DESIGN
Yukiko Yamazaki,
Hiroki Kubota
PRODUCTION
SAZABY Design
Centre
CLIENT
SAZABY Inc.
ENTRANT LOCATION
Tokyo, Japan

**THE OFFICIAL
HANDBOOK ON TYING
THE KNOT**
83 / 1
ART DIRECTION
Joel Templin
DESIGN
Joel Templin
COPYWRITING
Lisa Pemrick
PHOTOGRAPHY
Paul Sinkler
ILLUSTRATION
Joel Templin
CALLIGRAPHY
Kara Fellows
STUDIO
Templin Design
ENTRANT LOCATION
Minneapolis, MN

**EARLE PALMER BROWN
CHAIN LETTER**
83 / 2
ART DIRECTION
Randy Freeman
DESIGN
Randy Freeman
COPYWRITING
Kevin Doyle
AGENCY
Earle Palmer Brown /
Richmond
CLIENT
Earle Palmer Brown /
Richmond
ENTRANT LOCATION
Richmond, VA

Dear_____,

This is not a chain Christmas Card. This is a letter that will bring you great holiday luck. Copy this letter and send it to ten of your friends and in turn your holidays will be full of peace and joy.

If you send it off in less than 10 days from the date you received it, you will be the recipient of much good fortune. Consider the small three man agency in Portland, Oregon that received this message of holiday luck for Christmas 1981. They made 10 copies and sent them to friends. Shortly therafter, they got an athletic shoe account that made them famous. (The client will go unnamed but it's initials are NIKE.)

WARNING : If you should choose to ignore this letter, bad luck will follow you all the days of your life! Take for example Fallon McElligot advertising from Minneapolis. A careless Account Executive failed to send on the required copies of this letter. Three days later they hired Bill Westbrook as Creative Director. A move that could possibly be that agency's last.

Don't take that risk, send 10 of your friends this letter and enjoy a holiday season full of cheer, peace, and love or PAY DEARLY NOW AND FOREVER.

HAPPY HOLIDAYS,

**EARLE
PALMER
BROWN
RICHMOND**

Earle Palmer Brown

CATHAY PACIFIC
— CUISINE FROM THE
LAND DOWN UNDER
83 / 1
ART DIRECTION
Byron Jacobs
DESIGN
Byron Jacobs,
Tracy Hoi, Bernard Lau
COPYWRITING
Joanne Watcyn - Jones
STUDIO
PPA Design Limited
CLIENT
Cathay Pacific Airways
ENTRANT LOCATION
Hong Kong

NEUE BESEN KEHREN
GUT!
83 / 2
ART DIRECTION
Volkmar Pötsch
DESIGN
Gabi Lafer
COPYWRITING
Sepp Hartinger
PRODUCTION
Simone Simonitsch,
Johanna Martinger
DIRECTION
Sepp Hartinger
AGENCY
Hartinger Consulting
ENTRANT LOCATION
Leibnitz, Austria

SPIDER SAFETY MATCHES
83 / 3
ART DIRECTION
Kins Lee
DESIGN
Kins Lee
COPYWRITING
Janet Lee
PRODUCTION
Kins Lee, David Lee
STUDIO
Spider
CLIENT
Spider
ENTRANT LOCATION
Kuala Lumpur, Malaysia

THE 1993 DALLAS SHOW
84 / 1

ART DIRECTION
Rex Peteet

DESIGN
Rex Peteet,
Derek Welch

COPYWRITING
Rex Peteet

PHOTOGRAPHY
Phil Hollenbeck

ILLUSTRATION
Rex Peteet,
Derek Welch,
Mike Schroeder

STUDIO
Sibley / Peteet Design

PRINTING
Woods Lithographics

CLIENT
Dallas Society of Visual
Communications

ENTRANT LOCATION
Dallas, TX

PDR / ROYAL - ELECTION DAY / INDEPENDENCE DAY/ LABOR DAY/ CHRISTMAS DAY
84 / 2

ART DIRECTION
Martin Solomon

DESIGN
Martin Solomon,
Alexa Nasal

COPYWRITING
Martin Solomon

PHOTOGRAPHY
Martin Solomon

ILLUSTRATION
Martin Solomon

STUDIO
PDR / Royal

CLIENT
PDR / Royal

ENTRANT LOCATION
New York, NY

AIDS BOWL
84 / 1
ART DIRECTION
Masayuki Shimizu
DESIGN
Masayuki Shimizu &
Shingo Muso
COPYWRITING
Nio Kimura, Kyoko
Mikazuki
ENTRANT LOCATION
Osaka, Japan

BREDA FOTOGRAFICA
84 / 2
ART DIRECTION
Teun Anders,
Ingeborg Blóem
DESIGN
Ingeborg Blóem
PHOTOGRAPHY
Reinoud Klazes
CLIENT
Stichting Breda
Fotografica
ENTRANT LOCATION
Amsterdam,
Netherlands

THE LABORATORY
85 / 2
SILVER
ART DIRECTION
Keizo Matsui,
Yuko Araki
DESIGN
Yuko Araki
PHOTOGRAPHY
Masao Chiba
STUDIO
Keizo Matsui
& Associates
CLIENT
Hundred Design Inc.
ENTRANT LOCATION
Osaka, Japan

ICL BY SAZABY - CLEAR
CALENDAR BLOCKS
85 / 4
SILVER
ART DIRECTION
Hatsuko Kobayashi,
Takaaki Matsumoto,
NY
DESIGN
Hatsuko Kobayashi
PRODUCTION
SAZABY Design
Centre
CLIENT
SAZABY Inc.
ENTRANT LOCATION
Tokyo, Japan

CALENDAR 1994 - TOTO
85 / 3
ART DIRECTION
Kan Akita
DESIGN
Kan Akita,
Masayoshi Kodaira
CLIENT
TOTO, Ltd.
ENTRANT LOCATION
Tokyo, Japan

MON	TUE	WED	THU	FRI	SAT	SUN
28	29	30	31	1	2	3
4	5	6	7	8	9	10
11	12	13	14	15	16	17
18	19	20	21	22	23	24
25	26	27	28	29	30	1
2	3	4	5	6	7	8

4 April

TOTO

INSPIRATION - JAZZ
85 / 1
ART DIRECTION
Per Arnoldi
DESIGN
Per Arnoldi
COPYWRITING
Prof. F. Friedel,
Per Arnoldi
ENTRANT LOCATION
Berg. Gladbach,
Germany

THE *National Media Corporation needed a revitalized visual identity to reflect its growing status as a fully integrated marketer, taking consumer products from concepts to consumers worldwide.*

BYRON PREISS
MULTIMEDIA LOGOS
87 / 6
SILVER
ART DIRECTION
Paula Scher
DESIGN
Paula Scher, Ron Louie
STUDIO
Pentagram Design
CLIENT
Byron Preiss
Multimedia
ENTRANT LOCATION
New York, NY

NATIONAL MEDIA
CORPORATION LOGO
87 / 1
ART DIRECTION
Craig Bernhardt
DESIGN
Ignacio Rodriguez
STUDIO
Bernhardt Fudyma
Design Group
CLIENT
National Media
Corporation
ENTRANT LOCATION
New York, NY

WARNER BROS. ARCHIVES
LOGO
87 / 2
ART DIRECTION
Jeri Heiden,
Michael G. Rey
DESIGN
Greg Lindy
STUDIO
Rey International
CLIENT
Warner Bros. Records
ENTRANT LOCATION
Los Angeles, CA

EDGE - INVERTIBLE
LOGOTYPE FOR INSIDE
EDGE
87 / 3
ART DIRECTION
Bennett Peji
DESIGN
Bennett Peji
COPYWRITING
Tamara Krupchak
ILLUSTRATION
Bennett Peji
STUDIO
Bennett Peji Design
CLIENT
Inside Edge
ENTRANT LOCATION
San Diego, CA

BRAINSTORM INC.
87 / 4
ART DIRECTION
Chuck Johnson
DESIGN
Chuck Johnson
ILLUSTRATION
Chuck Johnson
STUDIO
Brainstorm - Inc.
CLIENT
Brainstorm - Inc.
ENTRANT LOCATION
Dallas, TX

BARD CENTER FOR
GRADUATE STUDIES IN
THE DECORATIVE ARTS
87 / 5
ART DIRECTION
Paula Scher
DESIGN
Paula Scher, Ron Louie
CLIENT
Bard Center for
Graduate Studies in the
Decorative Arts
ENTRANT LOCATION
New York, NY

Invertible Logotype for Inside Edge

Symbol for Fort Worth Opera Wine Auction

FORT WORTH OPERA
WINE AUCTION
87 / 7
ART DIRECTION
Lance Barclay
CREATIVE DIRECTION
Gladys Pinkerton
AGENCY
Paul Lazzaro And
Associates
CLIENT
Fort Worth Opera
ENTRANT LOCATION
Fort Worth, TX

NATHALIE JACOB -
DESIGN INTÉRIEUR
87 / 1
DISTINCTIVE MERIT
ART DIRECTION
Louis Gagnon
DESIGN
Louis Gagnon
STUDIO
Paprika
CLIENT
Nathalie Jacob - Design
Intérieur
ENTRANT LOCATION
Montreal, Canada

HUHNERFARM
87 / 3
DESIGN
Andrea Klausner
ILLUSTRATION
Andrea Klausner
CLIENT
Buttenhauser
Hühnerfarm
STUDIO
Graphic-Design
Andrea Klausner
ENTRANT LOCATION
Vienna, Austria

THE ROYAL PARKS
87 / 2
ART DIRECTION
Richard Moon
DESIGN
Ceri Webber,
Andrew Locke
CLIENT
The Royal Parks,
London
ENTRANT LOCATION
London, England

NATHALIE JACOB DESIGN
INTÉRIEUR
87 / 5
ART DIRECTION
Louis Gagnon
DESIGN
Louis Gagnon
STUDIO
Paprika
CLIENT
Nathalie Jacob Design
Intérieur
ENTRANT LOCATION
Montreal, Canada

COMPANY LOGO
87 / 4
ART DIRECTION
Kins Lee
DESIGN
Kins Lee
PRODUCTION
David Lee
STUDIO
Spider
CLIENT
Spider
ENTRANT LOCATION
Kuala Lumpur, Malaysia

ART NOT AVAILABLE

BASEMAN STATIONERY
88 / 5
SILVER
ART DIRECTION
Todd Waterbury
DESIGN
Todd Waterbury
COPYWRITING
Gary Baseman
ILLUSTRATION
Gary Baseman
STUDIO
Todd Waterbury
CLIENT
Baseman
ENTRANT LOCATION
Portland, OR

ROLLING STONE
FACSIMILE COVER PAGE
88 / 10
SILVER
ART DIRECTION
Fred Woodward
DESIGN
Debra Bishop
ILLUSTRATION
Anita Karl
CLIENT
Wenner Media, Inc.
ENTRANT LOCATION
New York, NY

FACSIMILE

FROM

ROLLING STONE

1290 AVENUE OF THE AMERICAS, NEW YORK, NY 10104-0298

TEL·212·484·1616

Date *199*...

To ...

Company ..

Facsimile № ...

From ..

Facsimile № *Phone №*

Message ..

..

Number of Pages to Follow

WORK ADVERTISING AND CONSULTING SERVICES
88 / 1
DISTINCTIVE MERIT
ART DIRECTION
Cabell Harris
DESIGN
Dan Olson,
Haley Johnson
AGENCY
WORK
CLIENT
WORK
ENTRANT LOCATION
Marina del Rey, CA

ROBIN
88 / 2
DISTINCTIVE MERIT
ART DIRECTION
Charles Shields
DESIGN
Charles Shields
ILLUSTRATION
Charles Shields
STUDIO
Shields Design
CLIENT
Robin Hassett
Photography
ENTRANT LOCATION
Fresno, CA

THE END
88 / 3
ART DIRECTION
Scott Wadler
DESIGN
Karl Cantarella
AGENCY
MTV Network
Creative Services
ENTRANT LOCATION
New York, NY

**NEW CENTURY SCHOOLS
- COLE F. WALKER**
88 / 4
ART DIRECTION
Bart Cleveland
DESIGN
Bart Cleveland
ILLUSTRATION
Bart Cleveland
PRODUCTION
Mary Dahm
AGENCY
Hughes Advertising
(Atlanta)
CLIENT
New Century Schools
ENTRANT LOCATION
Atlanta, GA

**FLORI HENDRON DESIGN
STATIONERY SYSTEM**
88 / 6
ART DIRECTION
Maureen Erbe
DESIGN
Maureen Erbe,
Rita A. Sowins
CLIENT
Flori Hendron Design
ENTRANT LOCATION
Los Angeles, CA

EASY - STATIONERY
88 / 7
ART DIRECTION
Scott Wadler
DESIGN
Timorse
AGENCY
MTV Networks
Creative Services
ENTRANT LOCATION
New York, NY

AFTER HOURS CREATIVE
AND RUSS HAAN / WRITER
88 / 8
ART DIRECTION
Dino Paul, Russ Haan
DESIGN
Dino Paul
PHOTOGRAPHY
Kevin Cruff
STUDIO
After Hours
CLIENT
After Hours
ENTRANT LOCATION
Phoenix, AZ

CHRISTOPHER CONERLY -
ART DIRECTION
88 / 9
ART DIRECTION
Christopher Conerly
DESIGN
Christopher Conerly
PHOTOGRAPHY
Dave Shafer
RETOUCHING
Danny Strickland
CLIENT
Christopher Conerly
ENTRANT LOCATION
Atlanta, GA

PLENTY - CREATIVE TRADING
88 / 5
ART DIRECTION
Koeweiden - Postma
DESIGN
Eric Hesen
PHOTOGRAPHY
Koeweiden - Postma
CLIENT
Gemme Veel / Plenty
ENTRANT LOCATION
Amsterdam,
Netherlands

STARLITE DANCE
88 / 2
ART DIRECTION
Mary Lewis
DESIGN
Bryan Clark
AGENCY
Lewis Moberly
CLIENT
Starlite Dance
ENTRANT LOCATION
London, England

TARZAN
88 / 1
ART DIRECTION
Daniel Fortin
DESIGN
Chi Sing George Fok
PHOTOGRAPHY
Adrien Duey
CLIENT
Tarzan Comm.
Graphique Inc.
ENTRANT LOCATION
Montréal - Qué,
Canada

BIJ - VOORBEELD
88 / 3
ART DIRECTION
Will de l'Ecluse
DESIGN
Will de l'Ecluse
STUDIO
UNA Amsterdam
CLIENT
Bij - voorbeeld
ENTRANT LOCATION
Amsterdam,
Netherlands

VORMEVINGSINSTITUUT
88 / 4
ART DIRECTION
Will de l'Ecluse
DESIGN
Will de l'Ecluse,
Hans Bockting,
Harm Hoogland
STUDIO
UNA Amsterdam
CLIENT
Vormgevingsinstituut-
The Netherlands
Design Institute
ENTRANT LOCATION
Amsterdam,
Netherlands

BENEFIT LAUNCH
89 / 1

SILVER

ART DIRECTION
Stephen Doyle

DESIGN
Mats Hakansson

STUDIO
Drenttel Doyle
Partners

AGENCY
Drenttel Doyle
Partners

CLIENT
Champion International
Corp.

ENTRANT LOCATION
New York, NY

SOHO PICTURES
89 / 4
DISTINCTIVE MERIT
ART DIRECTION
Carol Bokuniewicz
DESIGNER
Carol Bokuniewkz
CLIENT
Soho Pictures
ENTRANT LOCATION
New York, NY

NICK AT NITE
89 / 2
ART DIRECTION
Laurie Kelliher
DESIGN
Sharon Werner
COPYWRITING
Bill Burnett
ILLUSTRATION
Sharon Werner
PRODUCTION
Mark Materowski
DIRECTION
Lisa Judson
CLIENT
Nick at Nite
ENTRANT LOCATION
New York, NY

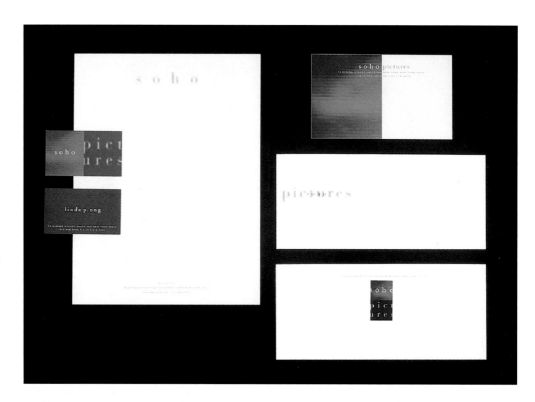

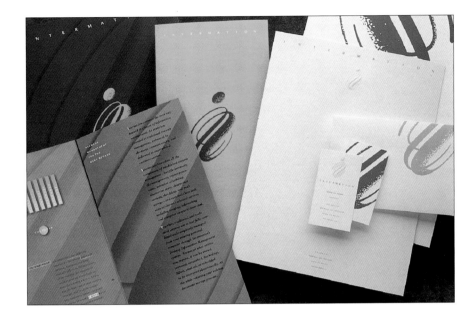

INTERMATION
MARKETING MATERIALS
89 / 3
ART DIRECTION
Jack Anderson
DESIGN
Jack Anderson,
Leo Raymundo,
Julia LaPine,
Jill Bustamante
COPYWRITING
Bill Rozier
ILLUSTRATION
Julia LaPine
STUDIO
Hornall Anderson
Design Works
CLIENT
Intermation
ENTRANT LOCATION
Seattle, WA

COUNCIL OF FASHION
DESIGNERS OF AMERICA
89 / 5
ART DIRECTION
Michael Bierut
DESIGN
Michael Bierut,
Agnethe Glatved,
Esther Bridavsky
PHOTOGRAPHY
Roxanne Lowitt
STUDIO
Pentagram Design
CLIENT
Council of Fashion
Designers of America
ENTRANT LOCATION
New York, NY

INDOCHINE 1929
89 / 2
ART DIRECTION
Lilian Tang
DESIGN
Lilian Tang, Chau So
Hing, Stephen Yeung,
Andy Lee
CLIENT
ELITECONCEPTS
ENTRANT LOCATION
Hong Kong

POMPEJI
WIEDERENTDECKT
89 / 1
ART DIRECTION
Helmut Rottke
DESIGN
Nicole Elsenbach,
Ulrike Kleine
COPYWRITING
W. Reinhold
PHOTOGRAPHY
archives
AGENCY
Rottke Werbung
CLIENT
IBM Deutschland,
Stuttgart
ENTRANT LOCATION
Düsseldorf, GFR

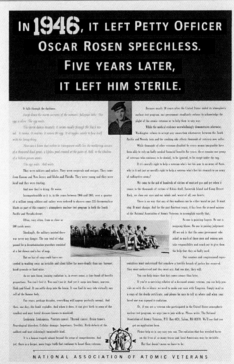

THE CARE BOOK
90 / 2
SILVER
ART DIRECTION
Andres Fehr,
Lucio Zago
DESIGN
Andres Fehr,
Lucio Zago
COPYWRITING
St. Clare's Hospital and
Health Center
PRODUCTION
ZOF, Inc. Visual
Communications
AGENCY
ZOF, Inc. Visual
Communications
CLIENT
St. Clare's Hospital and
The Spellman Center
ENTRANT LOCATION
New York, NY

1946
90 /1
ART DIRECTION
John Doyle
DESIGN
John Doyle
COPYWRITING
Ernie Schenck
PHOTOGRAPHY
Library of Congress,
The National Archive,
and unknown
ILLUSTRATION
Peter Hall, John Doyle
AGENCY
Doyle Advertising and
Design Group
CLIENT
National Association of
Atomic Veterans
ENTRANT LOCATION
Boston, MA

1951
90 / 2

ART DIRECTION
John Doyle

DESIGN
John Doyle

COPYWRITING
Ernie Schenck

PHOTOGRAPHY
Library of Congress,
The National Archive,
David Muench,
unknown

ILLUSTRATION
Peter Hall, John Doyle

AGENCY
Doyle Advertising and
Design Group

CLIENT
National Association of
Atomic Veterans

ENTRANT LOCATION
Boston, MA

TOGETHER ENSEMBLE
1994
90 / 1

ART DIRECTION
Steven Fortier (Fortier
Design Group)

DESIGN
Mario Lecuyer

ILLUSTRATION
From competition -
schools across Canada

CLIENT
Canadian International
Development Agency

ENTRANT LOCATION
Ottawa, Canada

NICKELODEON - PLAN IT
FOR THE PLANET,
AFFILIATE KIT
91 / 1

ART DIRECTION
Laurie Kelliher

DESIGN
Michelle Willems

COPYWRITING
David Goldenberg

ILLUSTRATION
Julie Wilson

PRODUCTION
Laura Hunter

DIRECTION
Lisa Judson

CLIENT
Nickelodeon (School)

ENTRANT LOCATION
New York, NY

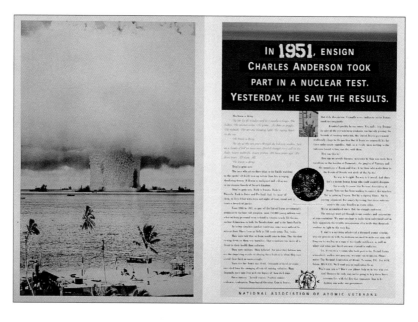

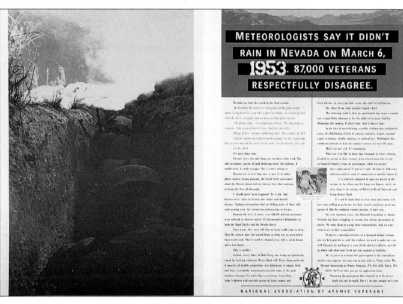

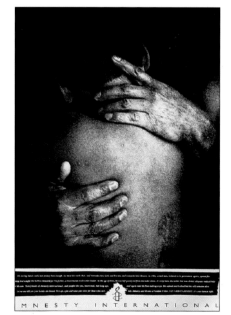

NICKELODEON - PLAN IT FOR THE PLANET, SCHOOL KIT
91 / 1

ART DIRECTION
Laurie Kelliner

DESIGN
Michelle Willems

COPYWRITING
David Goldenberg

ILLUSTRATION
Julie Wilson

PRODUCTION
Laura Hunter

DIRECTION
Lisa Judson

CLIENT
Nickelodeon

ENTRANT LOCATION
New York, NY

NATIONAL ASSOCIATION OF ATOMIC VETERANS
91 / 2

ART DIRECTION
John Doyle

DESIGN
John Doyle

COPYWRITING
Ernie Schenck

PHOTOGRAPHY
Library of Congress,
The National Archive,
David Muench,
unknown

ILLUSTRATION
Peter Hall, John Doyle

AGENCY
Doyle Advertising and
Design Group

CLIENT
National Association of
Atomic Veterans

ENTRANT LOCATION
Boston, MA

AMNESTY INTERNATIONAL
91 / 3

ART DIRECTION
John Doyle

DESIGN
John Doyle

COPYWRITING
Robin Raj

PHOTOGRAPHY
Raymond Meeks,
Annie Leibovitz,
Nadav Kander,
Matt Mahurin,
Eric Meola

ILLUSTRATION
John Doyle

AGENCY
Doyle Advertising and
Design Group

CLIENT
Amnesty International

ENTRANT LOCATION
Boston, MA

HANG MAN
92 / 12
GOLD
ART DIRECTION
James Victore
DESIGN
James Victore
COPYWRITING
Kica Matos
STUDIO
Victore Design Works
CLIENT
NAACP
ENTRANT LOCATION
New York, NY

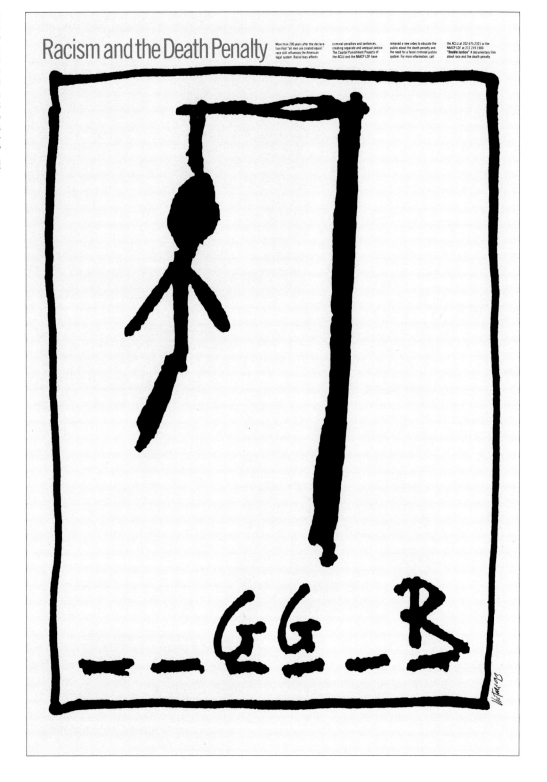

474

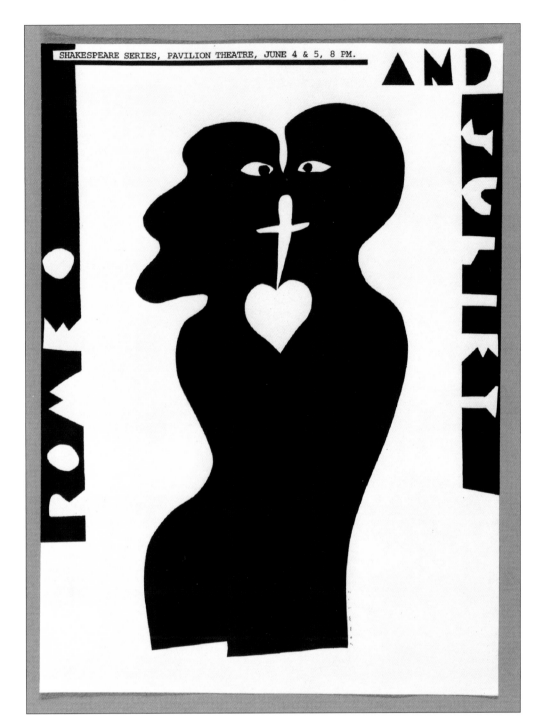

ROMEO AND JULIET
92 / 19
SILVER
ART DIRECTION
Lanny Sommese
DESIGN
Lanny Sommese
ILLUSTRATION
Lanny Sommese
STUDIO
Sommese Design
CLIENT
Penn. State
Department of Theatre
ENTRANT LOCATION
State College, PA

BLACK IS UGLY

All his life he believed all the lies white men had told him. He believed that black was ugly and a punishment from God, (although he could not guess what his sin must have been.) So he spent his entire life being cold when white men were warm. And he was hungry when white men were fed. It seemed to him to be the natural order of things, (although he could not guess why he should be punished.) And when I told him, it was not true, he would not believe me. It was too late.

DUANE MICHALS SPEAKS HIS MIND TO THE DALLAS SOCIETY OF VISUAL COMMUNICATIONS, DECEMBER 2, 1992, DALLAS, TEXAS

BLACK IS UGLY
92 / 3
DISTINCTIVE MERIT
ART DIRECTION
Shawn Freeman,
Todd Hart
DESIGN
Shawn Freeman
COPYWRITING
Duane Michals
PHOTOGRAPHY
Duane Michals
CLIENT
Dallas Society of Visual
Communications
ENTRANT LOCATION
Dallas, TX

STANLEY BLACK
PORTRAIT POSTER
92 / 1
ART DIRECTION
Todd Waterbury
DESIGN
Todd Waterbury
COPYWRITING
Todd Waterbury
ILLUSTRATION
Todd Waterbury
STUDIO
Todd Waterbury
CLIENT
Stanley Bach
ENTRANT LOCATION
Portland, OR

OZ NE : HARP
92 / 2
ART DIRECTION
Douglas G. Harp
DESIGN
Douglas G. Harp,
Susan C. Harp,
Linda E. Wagner
COPYWRITING
Douglas G. Harp
PHOTOGRAPHY
Douglas G. Harp
STUDIO
Harp and Company
CLIENT
Harp and Company
ENTRANT LOCATION
Big Flats, NY

WALLFLOWER
92 / 4
ART DIRECTION
McRay Magleby
DESIGN
McRay Magleby
COPYWRITING
Norman Darais
SILKSCREENING
Rory Robinson
ILLUSTRATION
McRay Magleby
STUDIO
BYU Graphics
CLIENT
Brigham Young
University
ENTRANT LOCATION
Provo, UT

A B C D E F G H I J K
ELEMENO P Q R S T U V W
X Y Z: WE ARE ALL-LIKE IT
OR NOT-TYPESETTERS
NOW.
92 / 5
ART DIRECTION
Dino Paul
DESIGN
Bob Dahlquist
COPYWRITING
Bob Dahlquist
STUDIO
After Hours
AGENCY
After Hours
ENTRANT LOCATION
Phoenix, AZ

477

LOVELACE DUKE CITY MARATHON
92 / 6
ART DIRECTION
Rick Vaughn
DESIGN
Rick Vaughn
ILLUSTRATION
Rick Vaughn
STUDIO
Vaughn Wedeen Creative
CLIENT
Duke City Marathon
ENTRANT LOCATION
Albuquerque, NM

THE COLOR OF CHANGE
92 / 7
ART DIRECTION
Stacy Drummond
DESIGN
Stacy Drummond
COPYWRITING
Kim Greene
CLIENT
Columbia Records
ENTRANT LOCATION
New York, NY

EARTH DAY 1993
92 / 8
ART DIRECTION
McRay Magleby
DESIGN
McRay Magleby
COPYWRITING
Norman Darais
SILKSCREENING
Rory Robinson
ILLUSTRATION
McRay Magleby
STUDIO
BYU Graphics
CLIENT
Brigham Young University
ENTRANT LOCATION
Provo, Utah

C POSTER
92 / 9
ART DIRECTION
Paula Scher
DESIGN
Seymour Chwast
COPYWRITING
Seymour Chwast
STUDIO
Pentagram
CLIENT
Ambassador Arts
ENTRANT LOCATION
New York, NY

MTV NETWORKS - PLAN IT
FOR THE PLANET
92 / 10
ART DIRECTION
Laurie Kelliner
DESIGN
Michelle Willems
COPYWRITING
David Goldenberg
ILLUSTRATION
Julie Wilson
PRODUCTION
Lisa Judson
ENTRANT LOCATION
New York, NY

MODERN DOG PROJECT
SEATTLE
92 / 11
ART DIRECTION
Robynne Raye,
Dan Ripley
DESIGN
Robynne Raye
COPYWRITING
Robynne Raye
ILLUSTRATION
Robynne Raye
STUDIO
Modern Dog
CLIENT
NAMES project Seattle
ENTRANT LOCATION
Seattle, WA

RACISM
92 / 13
ART DIRECTION
James Victore
DESIGN
James Victore
STUDIO
Victore Design Works
ENTRANT LOCATION
New York, NY

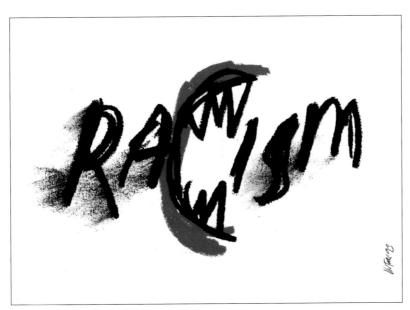

4
92 / 14
ART DIRECTION
Sharon Werner,
Amy Quinlivan
DESIGN
Amy Quinlivan,
Sharon Werner
COPYWRITING
Amie Valentine
PHOTOGRAPHY
Michael Crouser
AGENCY
Amy Quinlivan Design,
Werner Design
Werks Inc.
CLIENT
Quinlivan, Werner,
Great Faces Inc.,
Print Craft Inc.
ENTRANT LOCATION
Minneapolis, MN

AMBASSADOR ARTS P
92 / 15
ART DIRECTION
Paula Scher
DESIGN
Paula Scher
STUDIO
Pentagram Design
CLIENT
Ambassador Arts /
Champion International
Inc.
ENTRANT LOCATION
New York, NY

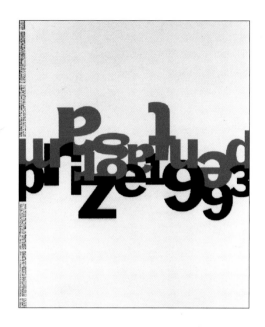

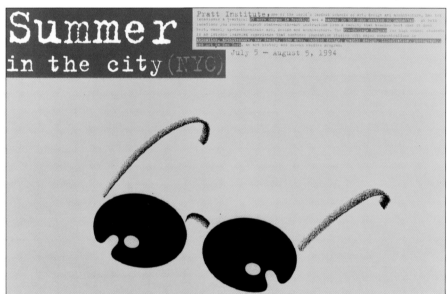

PENTAGRAM PRIZE 1993
POSTER
92 / 16
ART DIRECTION
John Klotnia,
James Biber
DESIGN
John Klotnia
COPYWRITING
Sarah Haun
STUDIO
Pentagram Design
CLIENT
Pentagram Design
ENTRANT LOCATION
New York, NY

PRATT INSTITUTE,
SUMMER IN THE CITY
92 / 17
ART DIRECTION
Michael McGinn
DESIGN
Michael McGinn
ILLUSTRATION
Michael McGinn
AGENCY
Designframe Inc.
CLIENT
Pratt Institute
ENTRANT LOCATION
New York, NY

ICI, MARK YOUR
CALENDARS
92 / 18
ART DIRECTION
Michael McGinn
DESIGN
Michael McGinn
AGENCY
Designframe Inc.
CLIENT
ICI
ENTRANT LOCATION
New York, NY

TYPE DIRECTORS -
TRANSPARENT
92 / 28
DISTINCTIVE MERIT
ART DIRECTION
Katrin Schmitt -Tegge,
Andrea Krause
DIRECTION
Professor Helfried
Hagenberg
CLIENT
Fachhochschule
Düsseldorf
ENTRANT LOCATION
Düsseldorf, Germany

INDEPENDENT WOMEN
FOUNDATION -
KONGRESS
92 / 4
STUDIO
Feuchtenberger
CLIENT
Independent Women
Foundation
ENTRANT LOCATION
Berlin, FRG

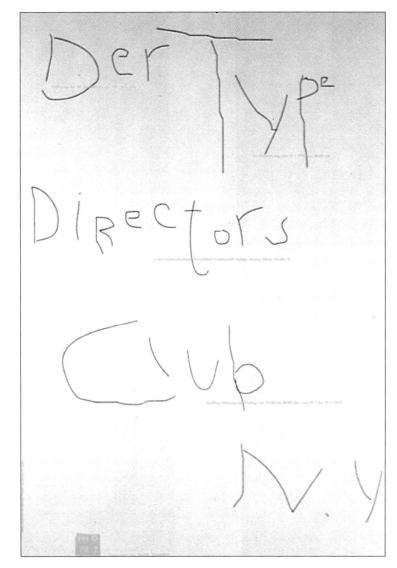

Art Not Available

Art Not Available

Art Not Available

ANGRY HOUSEWIVES
92 / 18
STUDIO
Feuchtenberger
CLIENT
Kunstgriffe. V,
ENTRANT LOCATION
Berlin, FRG

BE A TIGER
92 / 19
STUDIO
Feuchtenberger
CLIENT
Thalia Theatre
ENTRANT LOCATION
Berlin, FRG

MIZUNO PROMOTIONAL
POSTER
92 / 10
ART DIRECTION
Fumio Kawamoto
DESIGN
Fumio Kawamoto
COPYWRITING
Julian Holmes
PHOTOGRAPHY
Izumi Shimada
CLIENT
Mizuno Corporation
ENTRANT LOCATION
Osaka, Japan

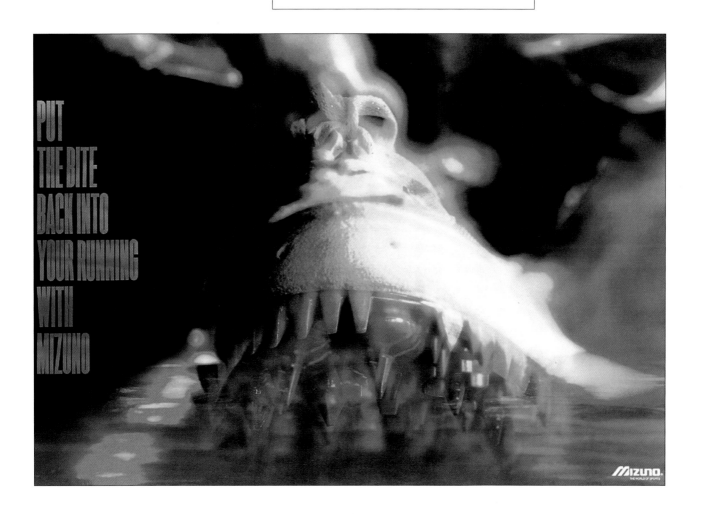

POSTER EXHIBITION 1993 /
ANGEL
92 / 1
ART DIRECTION
Iku Akiyama
DESIGN
Iku Akiyama
ILLUSTRATION
Iku Akiyama
CLIENT
Japan Graphic
Designers Association
ENTRANT LOCATION
Tokyo, Japan

POSTER FOR
IMAGINATION OF
LETTERS
92 / 12
ART DIRECTION
Iku Akiyama
DESIGN
Iku Akiyama
ILLUSTRATION
Iku Akiyama
CLIENT
Morisawa & Company
Ltd.
ENTRANT LOCATION
Tokyo, Japan

THE 31ST AICA SEMINAR
IN CONTEMPORARY
ARCHITECTURE
92 / 8
ART DIRECTION
Kan Akita
DESIGN
Kan Akita,
Masayoshi Kodaira
AGENCY
Kenposha
CLIENT
Aica Kogyo Co., Ltd.
ENTRANT LOCATION
Tokyo, Japan

ART TODAY 1993
92 / 13
ART DIRECTION
Kan Akita
DESIGN
Kan Akita,
Masayoshi Kodaira
AGENCY
I & S Corporation
CLIENT
Sezon Museum of
Modern Art
ENTRANT LOCATION
Tokyo, Japan

1993 TAKENAKA DESIGN
TOKYO
92 / 20
ART DIRECTION
Kan Akita
DESIGN
Kan Akita,
Masayoshi Kodaira
COMPUTER GRAPHICS
Shinichiro Tomioka
AGENCY
Takenaka Corporation
CLIENT
Takenaka Corporation
ENTRANT LOCATION
Tokyo, Japan

EIGHT GRAPHIC
DESIGNERS FROM HONG
KONG
92 / 33
ART DIRECTION
Freeman Lau Siu Hong
DESIGN
Freeman Lau Siu Hong
PHOTOGRAPHY
C. K. Wong
CLIENT
GGG Gallery
ENTRANT LOCATION
Hong Kong

LOPFLAPSLACK.LING.
92 / 21
ART DIRECTION
Tobias Strebl,
Sandra Lütze
DIRECTION
Professor Helfried
Hagenberg
CLIENT
Fachhochschule
Düsseldorf
ENTRANT LOCATION
Düsseldorf, Germany

COMPANY NAME:
92 / 29
ART DIRECTION
Katrin Schmitt-Tegge,
Andrea Krause
DIRECTION
Professor Helfried
Hagenberg
CLIENT
Fachhochschule
Düsseldorf
ENTRANT LOCATION
Düsseldorf, Germany

FINGERPRINTS
92 / 26
ART DIRECTION
Kayoko Yamasaki
DESIGN
Kayoko Yamasaki
COPYWRITING
Kayoko Yamasaki
ENTRANT LOCATION
Nagasaki - Shi,
Nagasaki, Japan

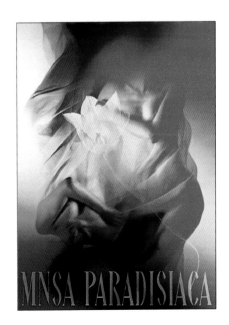

IZUMIOTSU CITY ORIAM MUSEUM
92 / 27
ART DIRECTION
Ken Miki
PRODUCTION
Takuya Kihara
DESIGN
Ken Miki,
Shigeyuki Sakaida
CLIENT
Izumiotsu City Oriam
Museum
ENTRANT LOCATION
Osaka, Japan

I'M HERE (TREE WITH DIFFERENT NAMES OF COUNTRIES)
92 / 9
ART DIRECTION
Masato Ohki
DESIGN
Masato Ohki,
Atsushi Kohgo
PHOTOGRAPHY
Masato Ohki
SCULPTOR
Masato Ohki
STUDIO
Masato Ohki Design
Room
CLIENT
JAGDA
ENTRANT LOCATION
Kawasaki - City, Japan

MINSA PARADISIACA
92 / 7
ART DIRECTION
Mieko Misawa
DESIGN
Mieko Misawa
PHOTOGRAPHY
Ryoji Fukuchi
ENTRANT LOCATION
Tokyo, Japan

MARKUS LINDER - PIANO
MAN
92 / 2
ART DIRECTION
Peter Felder
DESIGN
Peter Felder
COPYWRITING
Peter Felder,
Markus Linder
PHOTOGRAPHY
Herbert Rauch
STUDIO
Felder Grafik Design
CLIENT
Markus Linder -
Piano Man
ENTRANT LOCATION
Rankweil, Austria

CHRYSLER BLDG....
92 / 30
ART DIRECTION
Sakamoto Hiroki
DESIGN
Sakamoto Hiroki
COMPUTER GRAPHICS
Ohide Akiyoshi
CLIENT
JAGDA
ENTRANT LOCATION
Utsunomiya, Japan

OVERZEESE VISIES
92 / 6
ART DIRECTION
Gert Dumbar
DESIGN
Robert Nakata
PHOTOGRAPHY
Lex Van Pieterson
AGENCY
Studio Dumbar
CLIENT
Zeebelt Theatre
ENTRANT LOCATION
The Hague,
Netherlands

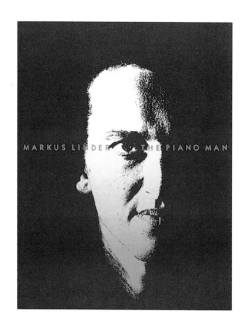

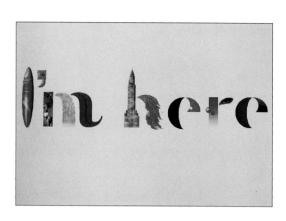

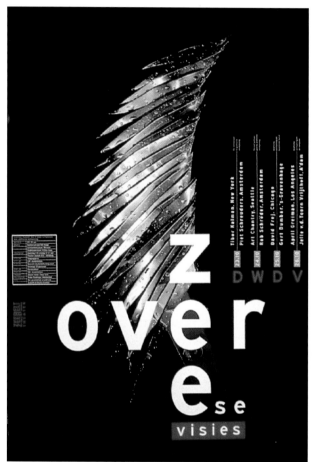

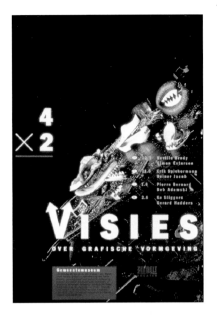

4 X 2 VISIES OVER
GRAFISCHE VORMGEVING
92 / 24
ART DIRECTION
Gert Dumbar
DESIGN
Gert Dumbar,
Robert Nakata
PHOTOGRAPHY
Lex Van Pieterson
AGENCY
Studio Dumbar
CLIENT
Zeebelt Theatre
ENTRANT LOCATION
The Hague,
Netherlands

CHAIR / AIDS
92 / 22
ART DIRECTION
Takashi Akiyama
DESIGN
Takashi Akiyama
ILLUSTRATION
Takashi Akiyama
CLIENT
Ritsemeikan University
ENTRANT LOCATION
Tokyo, Japan

AIDS / CONDOM -
RUNNING
92 / 23
ART DIRECTION
Takashi Akiyama
DESIGN
Takashi Akiyama
ILLUSTRATION
Takashi Akiyama
CLIENT
SEIYU
ENTRANT LOCATION
Tokyo, Japan

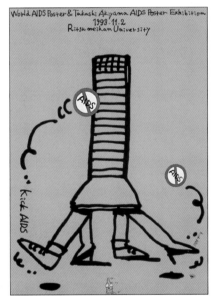

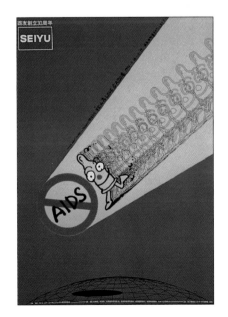

489

I'M HERE (WORLD)
92 / 32
ART DIRECTION
Takashi Akiyama
DESIGN
Takashi Akiyama
ILLUSTRATION
Takashi Akiyama
CLIENT
Japan Graphic
Designers Association
Inc.
ENTRANT LOCATION
Tokyo, Japan

AIDS < LOVE
92 / 3
ART DIRECTION
Takashi Sekiguchi
DESIGN
Takashi Sekiguchi
ILLUSTRATION
Takashi Sekiguchi
CLIENT
Takashi Sekiguchi
ENTRANT LOCATION
Yokohama, Japan

LOVE > AIDS
92 / 17
ART DIRECTION
Takashi Sekiguchi
DESIGN
Takashi Sekiguchi
ILLUSTRATION
Takashi Sekiguchi
CLIENT
Takashi Sekiguchi
ENTRANT LOCATION
Yokohama, Japan

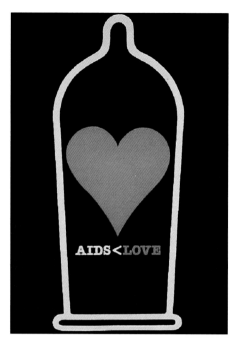

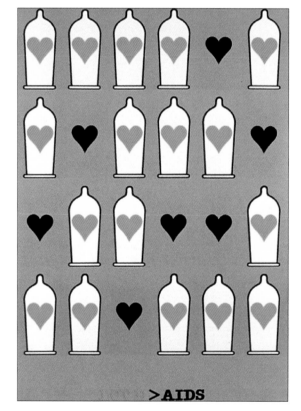

FINE ART
92 / 11
ART DIRECTION
Mark Hurst
DESIGN
Mark Hurst
CLIENT
Manchester
Metropolitan University
Faculty of Art + Design
ENTRANT LOCATION
Manchester, England

THE CALLIGRAPHY OF
TOSHIKAZU MIYAZAKI...
92 / 5
ART DIRECTION
Toshikazu Miyazaki
DESIGN
Toshikazu Miyazaki
CALLIGRAPHY
Toshikazu Miyazaki
CLIENT
Toshikazu Miyazaki
ENTRANT LOCATION
Osaka, Japan

THE CALLIGRAPHY OF
TOSHIKAZU MIYAZAKI...
92 / 14
ART DIRECTION
Toshikazu Miyazaki
DESIGN
Toshikazu Miyazaki
CALLIGRAPHY
Toshikazu Miyazaki
CLIENT
Toshikazu Miyazaki
ENTRANT LOCATION
Osaka, Japan

THE CALLIGRAPHY OF
TOSHIKAZU MIYAZAKI...
92 / 15
ART DIRECTION
Toshikazu Miyazaki
DESIGN
Toshikazu Miyazaki
CALLIGRAPHY
Toshikazu Miyazaki
CLIENT
Toshikazu Miyazaki
ENTRANT LOCATION
Osaka, Japan

POST EARLY
92 / 16
DESIGN
Lynn Trickett,
Brian Webb
ILLUSTRATION
Pat Keely,
FHK Henrion, Caswell
AGENCY
Trickett & Webb
CLIENT
Camberwell Press
ENTRANT LOCATION
London, England

SIXTY YEARS OF SERVICE
92 / 25
DESIGN
Lynn Trickett,
Brian Webb,
Steve Edwards
AGENCY
Trickett & Webb
CLIENT
London Transport
ENTRANT LOCATION
London, England

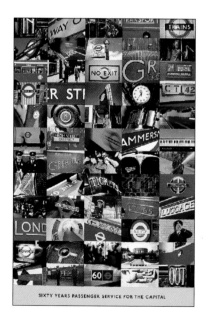

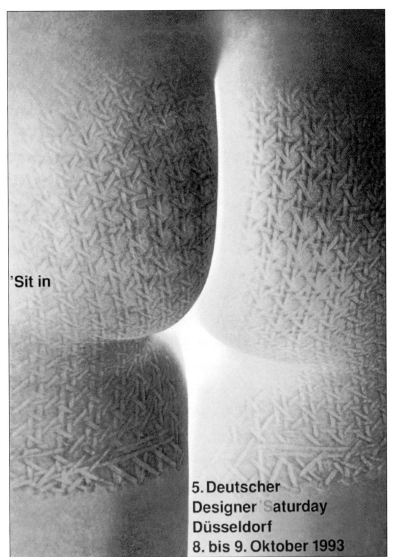

'SIT IN
92 / 31
ART DIRECTION
Uwe Loesch
COPYWRITING
Uwe Loesch
PHOTOGRAPHY
Manuela Egner
STUDIO
Arbeitsgemeinschaft für
visuelle und verbale
Kommunikation,
Düsseldorf
CLIENT
Design Zentrum
Nordrhein Westfalen
ENTRANT LOCATION
Düsseldorf

ENDANGERED SERIES
93 / 1
SILVER
ART DIRECTION
Lanny Sommese
DESIGN
Lanny Sommese
ILLUSTRATION
Lanny Sommese
STUDIO
Sommese Design
CLIENT
Penn State Institute for
Arts and Humanistic
Studies
ENTRANT LOCATION
State College, PA

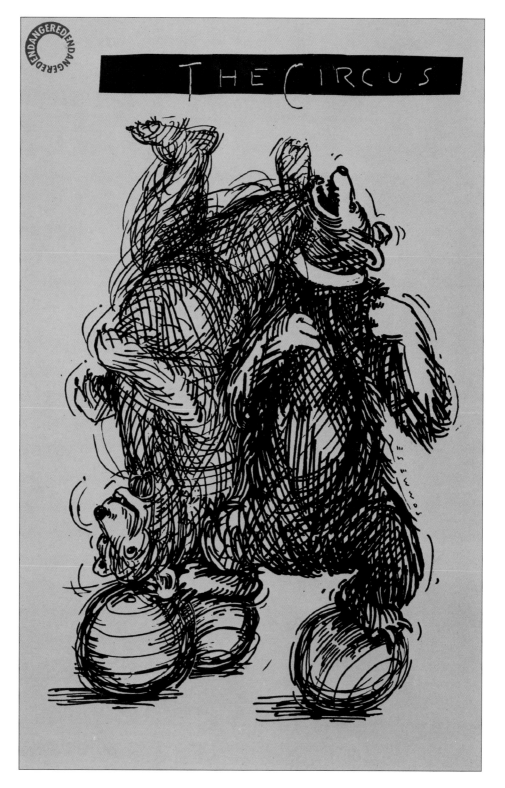

BE ALIVE (25 PIECES)
· 93 / 6
GOLD
ART DIRECTION
Zempaku Suzuki
DESIGN
Zempaku Suzuki,
Norio Nishikawa
COPYWRITING
Michiaki Taguchi,
Nob Ogasawara
PHOTOGRAPHY
Toshaki Takeuchi,
Keizo Tanaka
OBJECT CREATION
Daini Biwako Gakuen,
Hospital for Severely
Disabled Persons
STUDIO
B · BI Studio Inc.
CLIENT
B · BI Studio Inc.
ENTRANT LOCATION
Tokyo, Japan

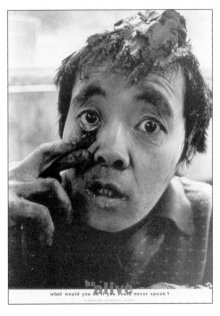

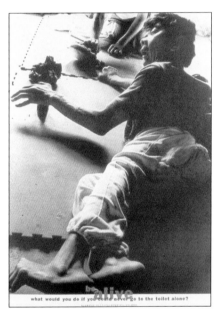

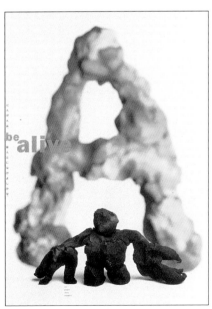

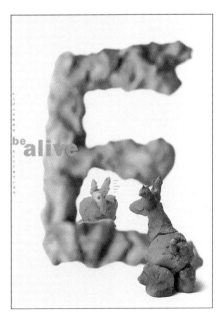

STOP
93 / 8
SILVER
ART DIRECTION
Lex Drewinski
DESIGN
Lex Drewinski
STUDIO
Lex Drewinski
CLIENT
Friedenshaus, Berlin
ENTRANT LOCATION
Berlin, Germany

I NEVER WANTED TO BE A
DRIFTER.
93 / 2
DISTINCTIVE MERIT
ART DIRECTION
Osamu Fukushima
DESIGN
Osamu Fukushima
COPYWRITING
Bob Ward
PHOTOGRAPHY
Mitsuru Mizutani
CLIENT
Japan Graphic
Designers Association
ENTRANT LOCATION
Tokyo, Japan

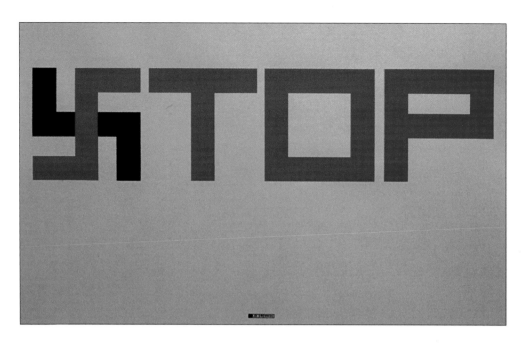

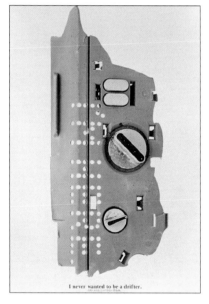

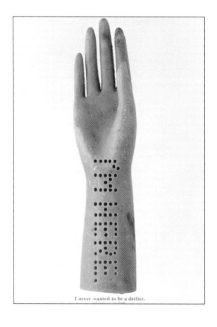

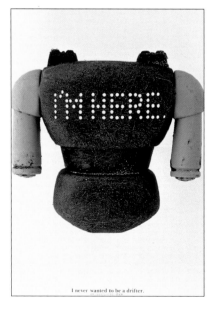

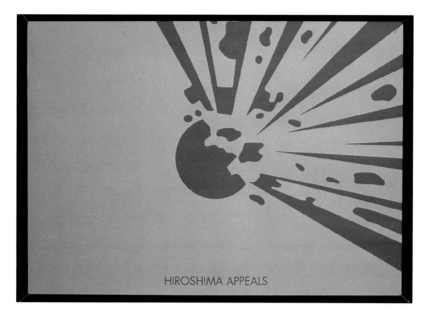

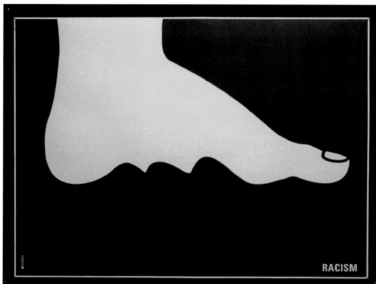

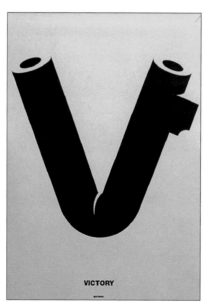

HIROSHIMA APPEALS
93 / 1
ART DIRECTION
Lex Drewinski
DESIGN
Lex Drewinski
STUDIO
Lex Drewinski
CLIENT
Friedenshaus, Berlin
ENTRANT LOCATION
Berlin, Germany

RACISM
93 / 7
ART DIRECTION
Lex Drewinski
DESIGN
Lex Drewinski
STUDIO
Lex Drewinski
CLIENT
Friedenshaus, Berlin
ENTRANT LOCATION
Berlin, Germany

GERMANIA 2000?
93 / 9
ART DIRECTION
Lex Drewinski
DESIGN
Lex Drewinski
STUDIO
Lex Drewinski
CLIENT
Friedenshaus, Berlin
ENTRANT LOCATION
Berlin, Germany

VICTORY
93 / 10
ART DIRECTION
Lex Drewinski
DESIGN
Lex Drewinski
STUDIO
Lex Drewinski
CLIENT
Friedenshaus, Berlin
ENTRANT LOCATION
Berlin, Germany

FOREST (BONSAI TREES)
93 / 3
ART DIRECTION
Takashi Sekiguchi
DESIGN
Takashi Sekiguchi
ILLUSTRATION
Takashi Sekiguchi
CLIENT
Takashi Sekiguchi
ENTRANT LOCATION
Yokohama, Japan

FOREST (T.V. TREES)
93 / 4
ART DIRECTION
Takashi Sekiguchi
DESIGN
Takashi Sekiguchi
ILLUSTRATION
Takashi Sekiguchi
CLIENT
Takashi Sekiguchi
ENTRANT LOCATION
Yokohama, Japan

FOREST (TREES)
93 / 5
ART DIRECTION
Takashi Sekiguchi
DESIGN
Takashi Sekiguchi
ILLUSTRATION
Takashi Sekiguchi
CLIENT
Takashi Sekiguchi
ENTRANT LOCATION
Yokohama, Japan

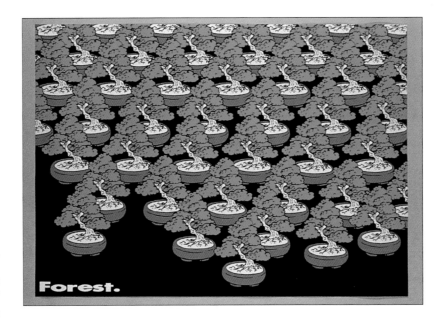

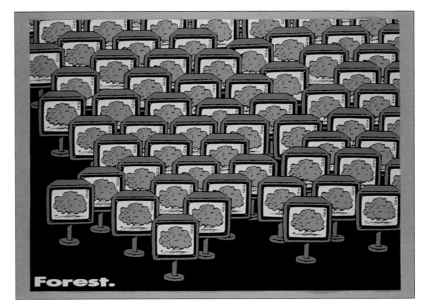

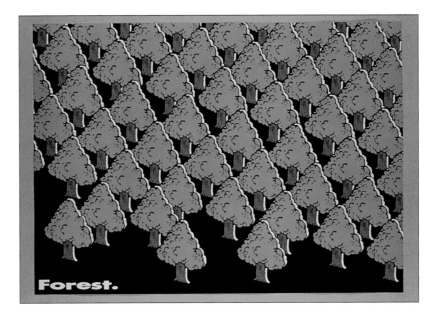

U&LC - ISSUE 20.2
94 / 9
DISTINCTIVE MERIT
ART DIRECTION
Woody Pirtle,
John Klotnia
DESIGN
John Klotnia,
Ivette Montes de Oca
STUDIO
Pentagram Design
PUBLICATION
Upper & lower case
CLIENT
International Typeface
Corporation
ENTRANT LOCATION
New York, NY

JEFF CORWIN -
PHOTOGRAPHY
PROMOTION
94 / 1
ART DIRECTION
John Van Dyke,
DESIGN
John Van Dyke,
Ann Kumasaka
COPYWRITING
Tom McCarthy
PHOTOGRAPHY
Jeff Corwin
STUDIO
Van Dyke Company
CLIENT
Jeff Corwin
ENTRANT LOCATION
Seattle, WA

JEFF CORWIN -
PHOTOGRAPHY
PROMOTION
94 / 1
ART DIRECTION
John Van Dyke
DESIGN
John Van Dyke,
Ann Kumasaka
COPYWRITING
Tom McCarthy
PHOTOGRAPHY
Jeff Corwin
STUDIO
Van Dyke Company
CLIENT
Jeff Corwin
ENTRANT LOCATION
Seattle, WA

VIRTUAL REALITY
MACHINE
94 / 2
ART DIRECTION
Tim Hale
DESIGN
Drew M. Denoyer
COPYWRITING
Drew M. Denoyer
PHOTOGRAPHY
Rick Bryant
ILLUSTRATION
Drew M. Denoyer
STUDIO
In-House
CLIENT
Fossil Watches
ENTRANT LOCATION
Dallas, TX

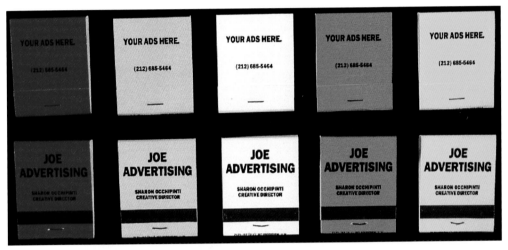

THIS IS A T-SHIRT
94 / 3
ART DIRECTION
kp, Bill Ainsworth
DESIGN
kp
COPYWRITING
Sheperd Simmons
CREATIVE DIRECTION
Michael H. Thompson,
Trace Hallowell
ILLUSTRATION
kp
AGENCY
Thompson and
Company
CLIENT
Thompson and
Company
ENTRANT LOCATION
Memphis, TN

JOE ADVERTISING
94 / 4
ART DIRECTION
Sharon Occhipinti
CREATIVE DIRECTION
Sharon Occhipinti
COPYWRITING
Mark Jespersen
AGENCY
Joe Advertising
CLIENT
Joe Advertising
ENTRANT LOCATION
Wilton, CT

**L'ENFANCE DE LA
CUISINE**
94 / 5
ART DIRECTION
Michael Bierut
DESIGN
Michael Bierut,
Agnethe Glatved
ILLUSTRATION
Eve Chwast
CLIENT
Pentagram Design
ENTRANT LOCATION
New York, NY

BIG BANG FLIP BOOK
94 / 6
ART DIRECTION
Andrzej Olejniczak
DESIGN
Inhi Clara Kim,
Andrzej Olejniczak
ENTRANT LOCATION
New York, NY

**THAT DOG IS ALWAYS
SENSATIONAL**
94 / 7
ART DIRECTION
Robynne Raye,
Vittorio Costarella
DESIGN
Robynne Raye,
Vittorio Costarella,
Michael Strassburger
COPYWRITING
Robynne Raye
STUDIO
Modern Dog
CLIENT
Modern Dog
ENTRANT LOCATION
Seattle, WA

GRUBMAN. CARS.
94 / 8
ART DIRECTION
Steve Liska
DESIGN
Sarah Faust, Steve Liska
PHOTOGRAPHY
Steve Grubman
STUDIO
Liska and Associates
Inc.
CLIENT
Steve Grubman
ENTRANT LOCATION
Chicago, IL

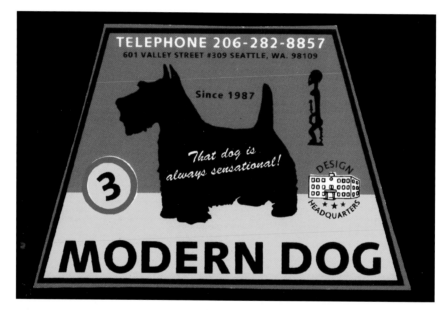

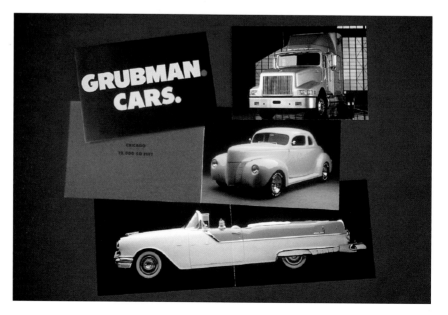

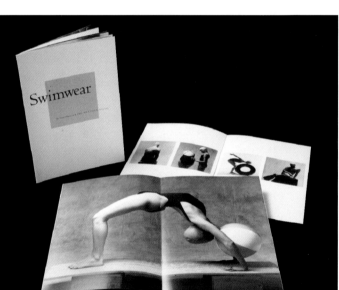

U&LC 20.3
94 / 10

ART DIRECTION
Woody Pirtle,
John Klotnia

DESIGN
John Klotnia, Ivette
Montes de Oca

STUDIO
Pentagram Design

PUBLICATION
Upper & lower case

CLIENT
International Typeface
Corporation

ENTRANT LOCATION
New York, NY

SWIMWEAR
94 / 11

ART DIRECTION
Michael Konetzka

DESIGN
Michael Konetzka

COPYWRITING
Lise Metzger

PHOTOGRAPHY
Lise Metzger

CLIENT
Lise Metzger
Photography

ENTRANT LOCATION
Washington, DC

CLEAR SKY WARNING.
94 / 6

DISTINCTIVE MERIT
ART DIRECTION
Keiichi Hirai

DESIGN
Keiichi Hirai

COPYWRITING
Isao Nakaigawa

AGENCY
ASATSU Inc.

ENTRANT LOCATION
Tokyo, Japan

DRUCKBILDER
94 / 5
ART DIRECTION
Michael Rösch,
Norbert Gabrysch
DESIGN
Irmgard Janssen,
Karin Dohle
COPYWRITING
Edna Thömer
PHOTOGRAPHY
Ute Karen Seggelke
PRODUCTION
Gebr. Klingenberg
GmbH
DIRECTION
Rolf Merker
AGENCY
wir kommunikative
Werbung GmbH
CLIENT
Gebr. Klingenberg
GmbH
ENTRANT LOCATION
Berlin, Germany

ANDREW HOYNE DESIGN
94 / 7
ART DIRECTION
Andrew Hoyne
DESIGN
Andrew Hoyne,
Carolyn Arthur
ILLUSTRATION
Andrew Hoyne
STUDIO
Andrew Hoyne Design
CLIENT
Andrew Hoyne Design
ENTRANT LOCATION
Melbourne Victoria,
Australia

ATELIER HASSE & KNELS
94 / 3
ART DIRECTION
Fritz & Sibylle Haase
DESIGN
Katja Hirschfelder,
Regina Spiekermann
COPYWRITING
Johannes Jeltsch,
Hamburg
AGENCY
Atelier Haase & Knels
CLIENT
Atelier Haase & Knels
ENTRANT LOCATION
Bremen, Germany

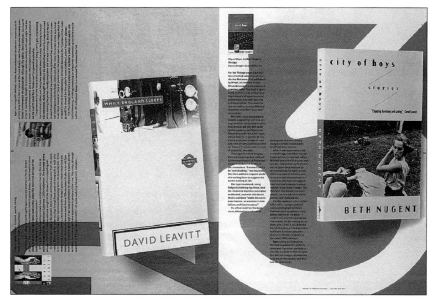

ALSO AVAILABLE IN OTHER COLOURS
94 / 1
ART DIRECTION
George Hardie
DESIGN
George Hardie
ILLUSTRATION
George Hardie
CLIENT
University of Brighton
ENTRANT LOCATION
Westbourne - Hants,
England

U&LC 20.2
94 / 2
ART DIRECTION
Woody Pirtle,
John Klotnia
DESIGN
John Klotnia,
Ivette Montes de Oca
STUDIO
Pentagram Design
CLIENT
International Typeface
Corporation
ENTRANT LOCATION
New York, NY

SEASON'S GREETINGS - POSTCARD
94 / 4
ART DIRECTION
Peter Brenoe
DESIGN
Koichi Yamamoto
COPYWRITING
Elizabeth Oswald,
Naka Fukuda
PHOTOGRAPHY
Junai Nakagawa
CLIENT
T.Y.A. Inc.
ENTRANT LOCATION
Shiruya, Japan

FOR ANYONE WHO
NEEDS A
PHOTOGRAPHER....
95 / 1
ART DIRECTION
Neal Ashby
DESIGN
Neal Ashby
COPYWRITING
Neal Ashby,
Stuart Miller
PHOTOGRAPHY
Barry Myers
CLIENT
Barry Myers,
Photographer
ENTRANT LOCATION
Annapolis, M.D.

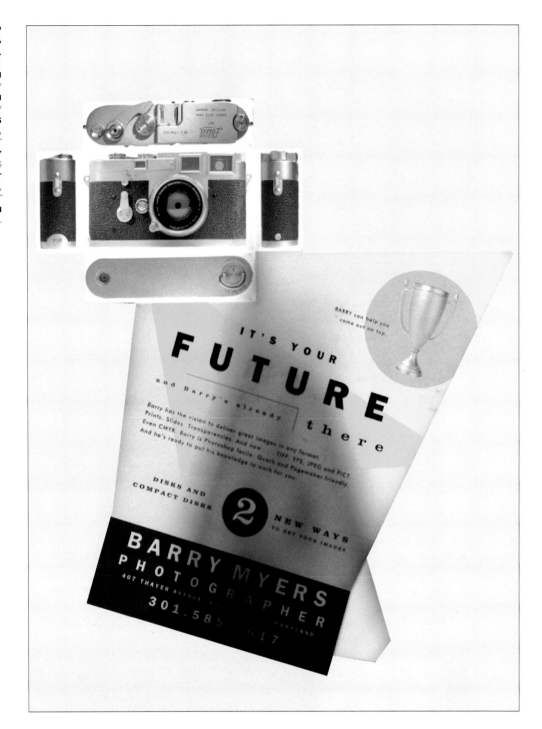

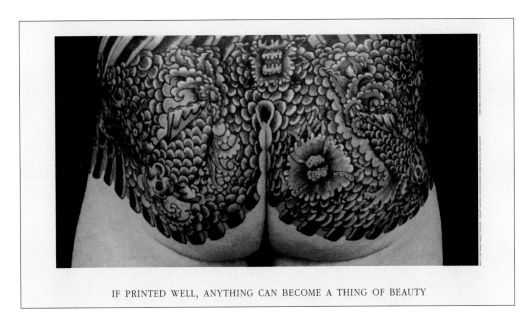

IF PRINTED WELL, ANYTHING CAN BECOME A THING OF BEAUTY

IF PRINTED WELL,
ANYTHING CAN BECOME
A THING OF BEAUTY
95 / 1
ART DIRECTION
Martyn Walsh,
Alex Guidetti
COPYWRITING
Martyn Walsh,
David Watkinson
PHOTOGRAPHY
Lionel Oherruaults,
Jonathan Lovekin,
Bill Willcox
AGENCY
Saatchi & Saatchi
Switzerland
CLIENT
IRL Printers
ENTRANT LOCATION
Nyon, Switzerland

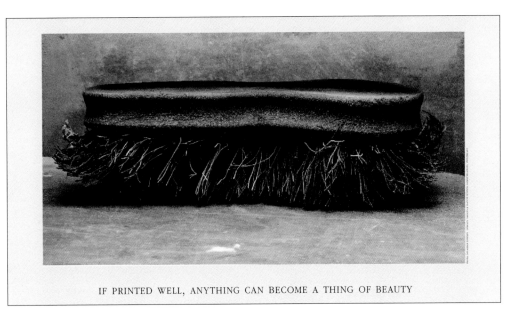

IF PRINTED WELL, ANYTHING CAN BECOME A THING OF BEAUTY

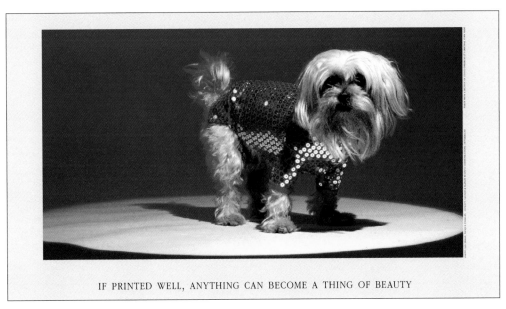

IF PRINTED WELL, ANYTHING CAN BECOME A THING OF BEAUTY

PHOTOGRAPHY & ILLUSTRATION

AMNESTY
INTERNATIONAL / SOTZ
96 / 1
ART DIRECTION
John Doyle
DESIGN
John Doyle
COPYWRITING
Robin Raj
PHOTOGRAPHY
Raymond Meeks
ILLUSTRATION
John Doyle
AGENCY
Doyle Advertising and
Design Group
CLIENT
Amnesty International
ENTRANT LOCATION
Boston, MA

AMNESTY
INTERNATIONAL /
YUZANA
96 / 2
ART DIRECTION
John Doyle
DESIGN
John Doyle
COPYWRITING
Robin Raj
PHOTOGRAPHY
Matt Mahurin
ILLUSTRATION
John Doyle
AGENCY
Doyle Advertising and
Design Group
CLIENT
Amnesty International
ENTRANT LOCATION
Boston, MA

AMNESTY
INTERNATIONAL / FATIMA
96 / 3
ART DIRECTION
John Doyle
DESIGN
John Doyle
COPYWRITING
Robin Raj
PHOTOGRAPHY
Nadav Kander
ILLUSTRATION
John Doyle
AGENCY
Doyle Advertising and
Design Group
CLIENT
Amnesty International
ENTRANT LOCATION
Boston, MA

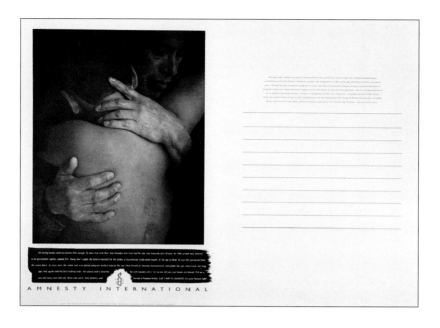

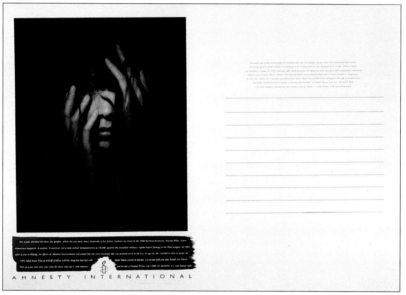

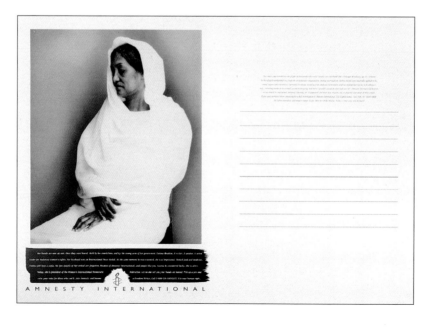

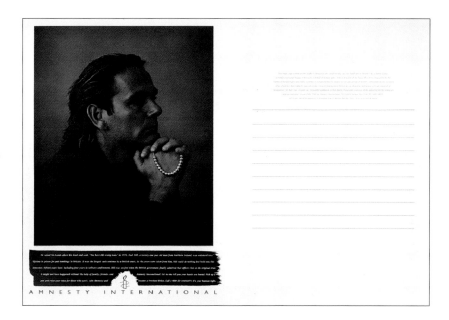

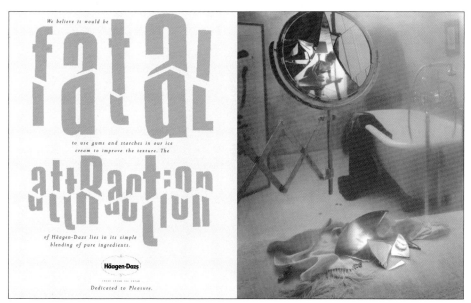

AMNESTY INTERNATIONAL / HILL
96 / 4
ART DIRECTION
John Doyle
DESIGN
John Doyle
COPYWRITING
Robin Raj
PHOTOGRAPHY
Annie Leibovitz
ILLUSTRATION
John Doyle
AGENCY
Doyle Advertising and Design Group
CLIENT
Amnesty International
ENTRANT LOCATION
Boston, MA

FATAL ATTRACTION - HÄAGEN DAZS
96 / 2
ART DIRECTION
Martin Galton, Rooney Carruthers
COPYWRITING
Will Awdry, Larry Barker
PHOTOGRAPHY
Andreas Heumann
AGENCY
Bartle, Bogle, Hegarty, London
CLIENT
Häagen Dazs
ENTRANT LOCATION
London, England

LET'S HOPE, THIS IS NOT BERLIN!
96 / 1
ART DIRECTION
Martin Schmid
PHOTOGRAPHY
Thomas Herbrich
MODELMAKING
Thomas Herbrich
AGENCY
Springer & Jacoby, Hamburg
CLIENT
Information Center Concrete
ENTRANT LOCATION
Düsseldorf, Germany

LET'S HOPE, IT IS CONCRETE!
96 / 3
ART DIRECTION
Martin Schmid
PHOTOGRAPHY
Thomas Herbrich
MODELMAKING
Gerry Judah, London
AGENCY
Springer & Jacoby, Hamburg
CLIENT
Information Center Concrete
ENTRANT LOCATION
Düsseldorf, Germany

BURNED OBJECTS - SELF–PROMOTION BOOK
97 / 25
SILVER
ART DIRECTION
Stephen Wilkes
DESIGN
Steve Liska
PHOTOGRAPHY
Stephen Wilkes
CLIENT
Stephen Wilkes
ENTRANT LOCATION
New York, NY

AMNESTY INTERNATIONAL / MEEKS, LEIBOVITZ, KANDER, MAHURIN
97 / 1
ART DIRECTION
John Doyle
DESIGN
John Doyle
COPYWRITING
Robin Raj
PHOTOGRAPHY
Raymond Meeks,
Annie Leibovitz,
Nadv Kander,
Matt Mahurin
ILLUSTRATION
John Doyle
AGENCY
Doyle Advertising and Design Group
CLIENT
Amnesty International
ENTRANT LOCATION
Boston, MA

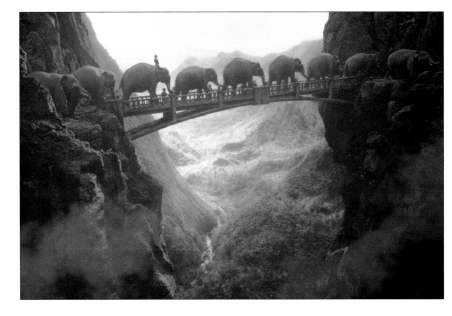

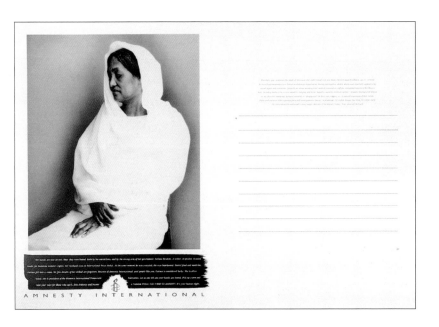

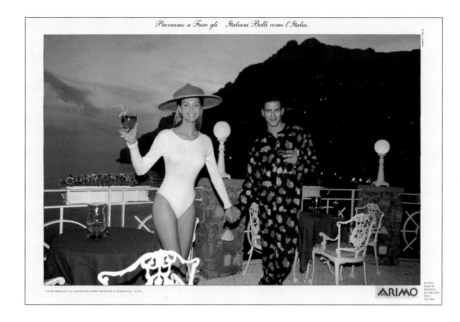

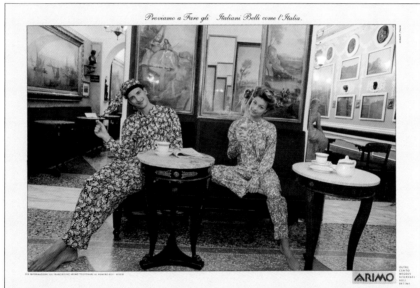

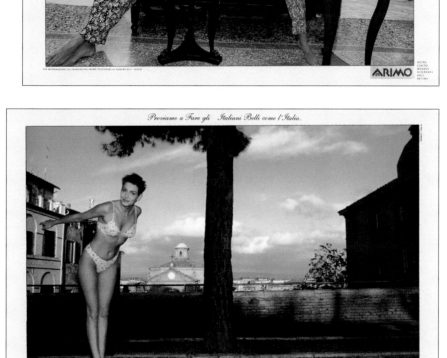

MAN AND WOMAN WITH DRINKS
97 / 1
ART DIRECTION
Daniele Cima
PHOTOGRAPHY
Ivo von Renner
AGENCY
IMPACT Italy
PUBLICATION
National Print Italy
CLIENT
ARIMO
ENTRANT LOCATION
Hamburg, Germany

MAN AND WOMAN IN PYJAMAS
97 / 2
ART DIRECTION
Daniele Cima
PHOTOGRAPHY
Ivo von Renner
AGENCY
IMPACT Italy
PUBLICATION
National Print Italy
CLIENT
ARIMO
ENTRANT LOCATION
Hamburg, Germany

WOMAN IN BIKINI
97 / 3
ART DIRECTION
Daniele Cima
PHOTOGRAPHY
Ivo von Renner
AGENCY
IMPACT Italy
PUBLICATION
National Print Italy
CLIENT
ARIMO
ENTRANT LOCATION
Hamburg, Germany

MAN AND WOMAN IN
BATHING SUITS
97 / 4
ART DIRECTION
Daniele Cima
PHOTOGRAPHY
Ivo von Renner
AGENCY
IMPACT Italy
PUBLICATION
National Print Italy
CLIENT
ARIMO
ENTRANT LOCATION
Hamburg, Germany

MAN AND WOMAN IN
JUMPERS
97 / 5
ART DIRECTION
Daniele Cima
PHOTOGRAPHY
Ivo von Renner
AGENCY
IMPACT Italy
PUBLICATION
National Print Italy
CLIENT
ARIMO
ENTRANT LOCATION
Hamburg, Germany

LEVI'S - (BY THE DOCK)
97 / 6
ART DIRECTION
Stefano Colombo
COPYWRITING
Alessandro Canale
PHOTOGRAPHY
Peter Lavery
AGENCY
McCann - Erickson
Italiana
CLIENT
Levi Strauss Italia
ENTRANT LOCATION
Milan, Italy

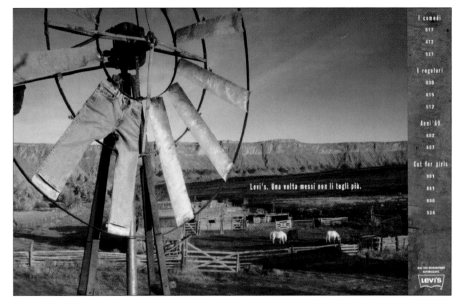

**LEVI'S - PUT ON ONCE,
EVER TO BE TAKEN OFF.
(BY THE TRAIN)**
97 / 7
ART DIRECTION
Stefano Colombo
COPYWRITING
Alessandro Canale
PHOTOGRAPHY
Peter Lavery
AGENCY
McCann - Erickson
Italiana
CLIENT
Levi Strauss Italia
ENTRANT LOCATION
Milan, Italy

**LEVI'S - PUT ON ONCE,
EVER TO BE TAKEN OFF.
(BY THE FARM)**
97 / 8
ART DIRECTION
Stefano Colombo
COPYWRITING
Alessandro Canale
PHOTOGRAPHY
Peter Lavery
AGENCY
McCann - Erickson
Italiana
CLIENT
Levi Strauss Italia
ENTRANT LOCATION
Milan, Italy

**ELLE DECORATION
(NO. 15)**
97 / 9
ART DIRECTION
Manfred Manke,
Munich
PHOTOGRAPHY
Steve Keller
PUBLICATION
Elle Decoration
CLIENT
Mercantile for Kosta
Boda
ENTRANT LOCATION
Moosburg, Germany

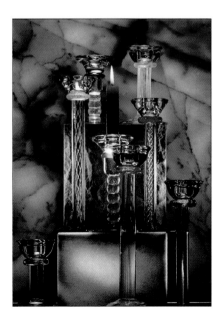

**YOU CAN'T LOOK AWAY
ANYMORE**
98 / 4
SILVER
ART DIRECTION
Janet Froelich
DESIGN
Nancy Harris
PHOTOGRAPHY
Matuschka
PHOTO EDITING
Kathy Ryan,
Sarah Harbutt
PUBLICATION
The New York Times
Magazine
ENTRANT LOCATION
New York, NY

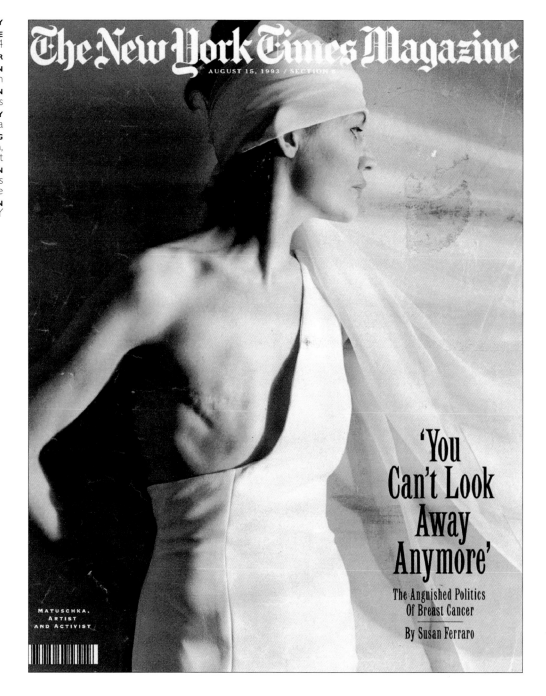

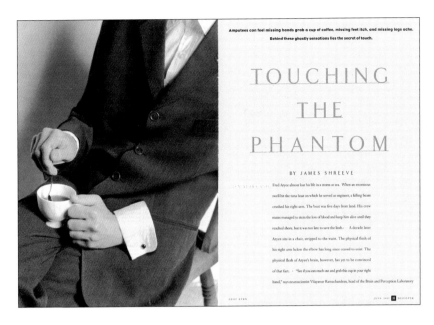

TOUCHING THE PHANTOM
98 / 1
ART DIRECTION
David Armario
DESIGN
James Lambertus
PHOTOGRAPHY
Geof Kern
PUBLISHER
Walt Disney Publishing
ENTRANT LOCATION
Burbank, CA

DANAMANIA!
98 / 2
ART DIRECTION
Fred Woodward
DESIGN
Fred Woodward
PHOTOGRAPHY
Mark Seliger
PHOTO DIRECTION
Laurie Kratochvil
PUBLICATION
Rolling Stone Magazine
PUBLISHER
Wenner Media Inc.
ENTRANT LOCATION
New York, NY

**A LASTING IMPRESSION /
CURTIS MAYFIELD**
98 / 3
ART DIRECTION
Fred Woodward
DESIGN
Fred Woodward,
Gail Anderson
PHOTOGRAPHY
Mark Seliger
PHOTO DIRECTION
Laurie Kratochvil
PUBLICATION
Rolling Stone Magazine
PUBLISHER
Wenner Media Inc.
ENTRANT LOCATION
New York, NY

HE LIVED. WHO PAYS?
98 / 5

ART DIRECTION
Janet Froelich

PHOTOGRAPHY
Keith Carter

PHOTO EDITING
Kathy Ryan

PUBLICATION
The New York Times
Magazine

ENTRANT LOCATION
New York, NY

THE SEDUCTION OF
PETER JAY RUDGE
98 / 6

ART DIRECTION
Fred Woodward

DESIGN
Gail Anderson

PHOTOGRAPHY
Dan Winters

PHOTO DIRECTION
Laurie Kratochvil

PUBLICATION
Rolling Stone Magazine

PUBLISHER
Wenner Music Inc.

ENTRANT LOCATION
New York, NY

IN THE REALM OF THE
CHEMICAL
98 / 7

ART DIRECTION
David Armario

DESIGN
David Armario

PHOTOGRAPHY
Geof Kern

PUBLISHER
Walt Disney Publishing

ENTRANT LOCATION
Burbank, CA

**THE SEDUCTION OF
PETER JAY RUDGE**
98 / 8
ART DIRECTION
Fred Woodward
DESIGN
Gail Anderson
PHOTOGRAPHY
Dan Winters
PHOTO DIRECTION
Laurie Kratochvil
PUBLICATION
Rolling Stone Magazine
PUBLISHER
Wenner Media Inc.
ENTRANT LOCATION
New York, NY

THE PARASOL EFFECT
98 / 9
ART DIRECTION
David Armario
DESIGN
James Lambertus
PHOTOGRAPHY
Chick Rice
PUBLISHER
Walt Disney Publishing
ENTRANT LOCATION
Burbank, CA

JERRY GARCIA
98 / 10
ART DIRECTION
Fred Woodward
DESIGN
Fred Woodward
PHOTOGRAPHY
Mark Seliger
PHOTO DIRECTION
Laurie Kratochvil
PUBLICATION
Rolling Stone Magazine
PUBLISHER
Wenner Media Inc.
ENTRANT LOCATION
New York, NY

**IMAGE OF AMAZON RIVER
WITH TWO CANOES AND
WOODEN SHACK**
98 / 12
DESIGN
Donna Bonavita
PHOTOGRAPHY
Arthur Meyerson
AGENCY
In-House
PUBLICATION
World Magazine
PUBLISHER
KPMG Peat Marwick
ENTRANT LOCATION
Houston, TX

HATE THY NEIGHBOR
98 / 13
ART DIRECTION
Patricia Bradbury
DESIGN
Doris Downes - Jewett
PHOTOGRAPHY
Patrick Robert,
Les Stone
ENTRANT LOCATION
New York, NY

**IF THE OTHER PLANETS
TRACE RIPPLES ON A
POND, PLUTO IS A FISH...**
98 / 14
ART DIRECTION
David Armario
DESIGN
David Armario
PHOTOGRAPHY
Dan Winters
PUBLISHER
Walt Disney Publishing
ENTRANT LOCATION
Burbank, CA

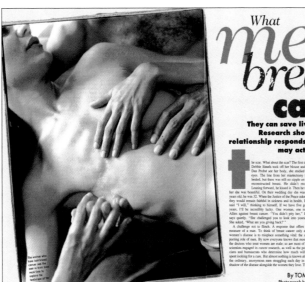

What *men* can do about *breast* cancer

**They can save lives. Literally.
Research shows that how the man in a
relationship responds to the woman's illness
may actually extend her life.**

he scar. What about the scar? The first time Debbie Simels took off her blouse and let Dan Probst see her body, she studied his eyes. The line from her mastectomy had healed, but there was still an ripple on her reconstructed breast. He didn't recoil. Leaning forward, he kissed it. Then he told her she was beautiful. On their wedding day she was 30 years old; he was 32. When the Justice of the Peace asked if they would remain faithful in sickness and in health, Dan said "I will," thinking to himself, If we have five good years, I'll be incredibly lucky. One woman, one man. Allies against breast cancer. "You didn't pity her," Dan says quietly. "She challenged you to look into yourself. She asked, 'What are you giving back?'"

A challenge not to flinch. A response that offers the measure of a man. To think of breast cancer only as a women's disease is to misplace something vital: the supporting role of men. By now everyone knows that most of the doctors who treat women are male; so are most of the scientists engaged in cancer research, as well as the politicians and bureaucrats who determine how much will be spent looking for a cure. But almost nothing is known about the ordinary, anonymous men struggling each day in the shadow of the disease alongside the women they love. They

know the answers to tormenting questions: Have I lost my femininity? Does he still desire me? Will he show me his true feelings or simply clam up? Research suggests that the quality of support received by the woman can improve and perhaps even extend her life. If that is true, the choice of the right partner may even shape how long she lives.

A man who shrinks from breast cancer is a loser. Debbie Simels chose someone made of better stuff. She had a quick mind and a brilliant smile; she worked as an occupational therapist for a small state hospital in Pocasset, Massachusetts. What she really wanted, she told Dan, was to live in be "a crotchety old Cape Cod woman." He was a Wisconsin farm boy, tall thin, imperturbable, trained as a psychologist—and looking for a job. The hiring committee that Debbie served on chose him to be the hospital's chief psychologist.

During Dan's first week on the new job, Debbie mentioned that she had discovered a lump in her breast and was going to have a biopsy. Although breast cancer is not common among young women, the lump turned out to be malignant. She had a mastectomy. Three months after the operation, on Valentine's Day, 1984, Dan asked her for their first date. "She was still on chemotherapy," he recalls. When he proposed 15 months later during a Celtics basketball game, she accepted. "She set a

BY TOM MATHEWS
Photograph by STEWART FEREBEE

AMERICAN ORIGINALS

HOW I BECAME A SHADOW

FICTION BY JAMES PURDY

HOW I BECAME A SHADOW, HOW I LIVE IN THE DEFILE OF MOUNTAINS, AND HOW I LOST MY COCK.
BY PABLO RANGEL.
GONZAGO IS TO BLAME. HE SAID, "THAT ROOSTER IS TOO GOOD FOR A PET. HE BELONGS IN THE COCKFIGHT. YOU GIVE HIM TO ME, YOU OWE ME FAVORS. I AM YOUR COUSIN. GIVE HIM UP."
"NEVER, GONZAGO," I REPLIED. "NUNCA. I RAISED THE LITTLE FELLOW FROM ALMOST AN EGG. I NEVER RENDER HIM TO YOU, PRIMO."
"SHUT YOUR MOUTH THAT FLIES ARE ALWAYS CRAWLING IN. SHUT UP, YOU WHELP, WHEN I COMMAND. THAT COCK IS TOO GOOD FOR A PET. HEAR ME. YOU WILL GIVE HIM UP, AND WE WILL BOTH MAKE MONEY. YOU BELLYACHE, YOU SAY YOU ARE ALWAYS BROKE, AND THEN WHEN THE CHANCE COMES TO MAKE SOMETHING YOU

PHOTOGRAPH BY DAVID MICHAEL KENNEDY

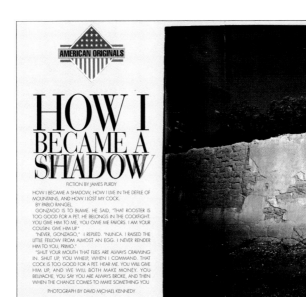

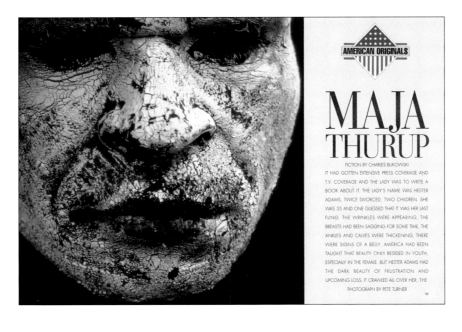

AMERICAN ORIGINALS

MAJA THURUP

FICTION BY CHARLES BUKOWSKI

IT HAD GOTTEN EXTENSIVE PRESS COVERAGE AND T.V. COVERAGE AND THE LADY WAS TO WRITE A BOOK ABOUT IT. THE LADY'S NAME WAS HESTER ADAMS, TWICE DIVORCED, TWO CHILDREN. SHE WAS 35 AND ONE GUESSED THAT IT WAS HER LAST FLING. THE WRINKLES WERE APPEARING, THE BREASTS HAD BEEN SAGGING FOR SOME TIME, THE ANKLES AND CALVES WERE THICKENING, THERE WERE SIGNS OF A BELLY. AMERICA HAD BEEN TAUGHT THAT BEAUTY ONLY RESIDED IN YOUTH, ESPECIALLY IN THE FEMALE. BUT HESTER ADAMS HAD THE DARK BEAUTY OF FRUSTRATION AND UPCOMING LOSS; IT CRAWLED ALL OVER HER, THE

PHOTOGRAPH BY PETE TURNER

SOME KIND OF HERO
98 / 18
ART DIRECTION
Pamela Berry
DESIGN
Pamela Berry
COPYWRITING
Pamela Berry
PHOTOGRAPHY
Mark Seliger
PHOTO EDITING
Jennifer Crandall,
Rachel Knepfer
ILLUSTRATION
Mark Seliger
ENTRANT LOCATION
New York, NY

**FOREVER YOUNG: NEIL
YOUNG**
98 / 19
ART DIRECTION
Fred Woodward
DESIGN
Fred Woodward
PHOTOGRAPHY
Mark Seliger
PHOTO DIRECTION
Laurie Kratochvil
PUBLICATION
Rolling Stone Magazine
PUBLISHER
Wenner Media Inc.
ENTRANT LOCATION
New York, NY

CORN
98 / 20
ART DIRECTION
Gael Towey
DESIGN
Anne Johnson,
Hannah Milman
COPYWRITING
Celia Barbour
PHOTOGRAPHY
John Dugdale
PUBLICATION
Martha Stewart Living
ENTRANT LOCATION
New York, NY

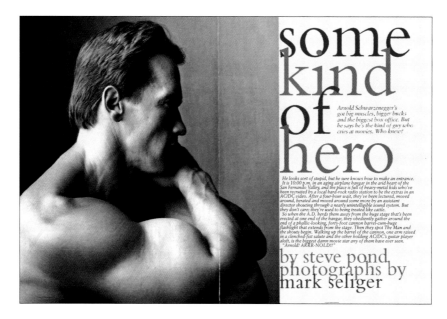

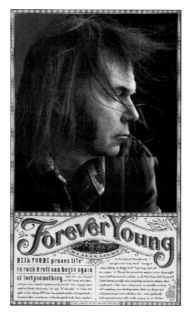

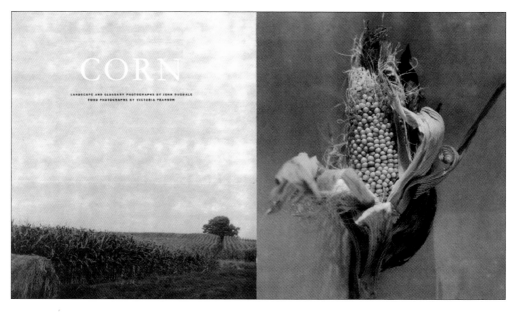

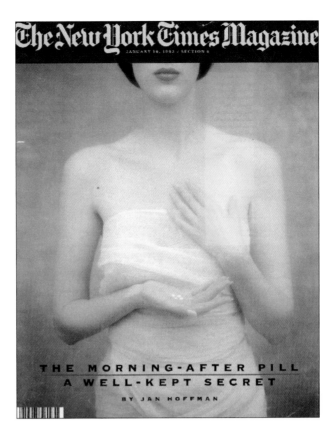

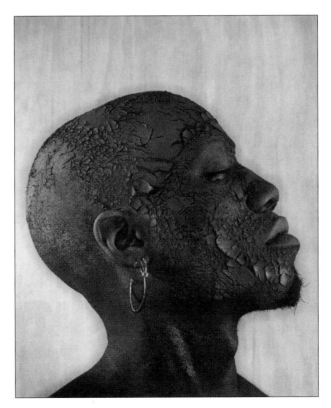

THE MORNING - AFTER PILL, A WELL KEPT SECRET
98 / 21
ART DIRECTION
Janet Froelich
PHOTOGRAPHY
Joyce Tenneson
PHOTO EDITING
Kathy Ryan
PUBLICATION
The New York Times Magazine
ENTRANT LOCATION
New York, NY

WESLEY SNIPES - PORTRAITS
98 / 22
ART DIRECTION
Gary Koepke
PHOTOGRAPHY
Dan Winters
PHOTO EDITING
George Pitts
STUDIO
Koepke International LTD.
PUBLISHER
Time Venture Inc.,
ENTRANT LOCATION
Magnolia, MA

THE LOOK OF THE
NINETIES
99 / 10
GOLD
ART DIRECTION
Janet Froelich
DESIGN
Petra Mercker
PHOTOGRAPHY
Kurt Markus
STYLING
Polly Hamilton
PUBLICATION
The New York Times
Magazine
ENTRANT LOCATION
New York, NY

A PORTFOLIO BY
SEBASTIAO SALGADO
99 / 1
99 / 2
ART DIRECTION
Fred Woodward
DESIGN
Catherine Gilmore-
Barnes
PHOTOGRAPHY
Sebastiao Salgado
PHOTO DIRECTION
Laurie Kratochvil
PUBLICATION
Rolling Stone Magazine
PUBLISHER
Wenner Media Inc.
ENTRANT LOCATION
New York, NY

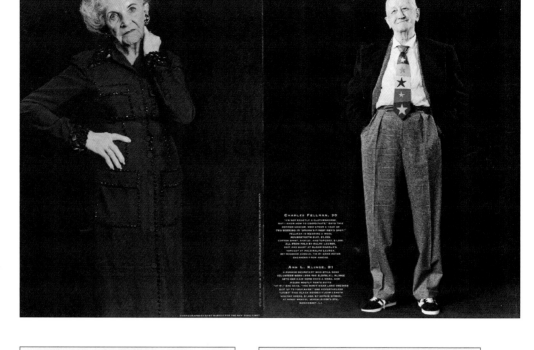

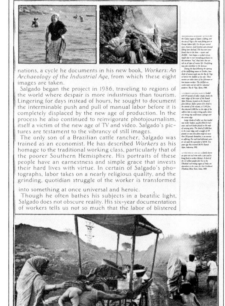

nations, a cycle he documents in his new book, *Workers: An Archaeology of the Industrial Age*, from which these eight images are taken.

Salgado began the project in 1986, traveling to regions of the world where despair is more industrious than tourism. Lingering for days instead of hours, he sought to document the interminable push and pull of manual labor before it is completely displaced by the new age of production. In the process he also continued to reinvigorate photojournalism, itself a victim of the new age of TV and video. Salgado's pictures are testament to the vibrancy of still images.

The only son of a Brazilian cattle rancher, Salgado was trained as an economist. He has described *Workers* as his homage to the traditional working class, particularly that of the poorer Southern Hemisphere. His portraits of these people have an earnestness and simple grace that invests their hard lives with virtue. In certain of Salgado's photographs, labor takes on a nearly religious quality, and the grinding, quotidian struggle of the worker is transformed

into something at once universal and heroic.

Though he often bathes his subjects in a beatific light, Salgado does not obscure reality. His six-year documentation of workers tells us not so much that the labor of blistered

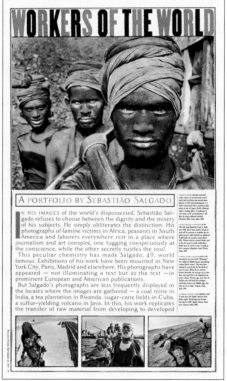

WORKERS OF THE WORLD

A PORTFOLIO BY SEBASTIÃO SALGADO

IN HIS IMAGES of the world's dispossessed, Sebastião Salgado refuses to choose between the dignity and the misery of his subjects. He simply obliterates the distinction. His photographs of famine victims in Africa, peasants in South America and laborers everywhere rest in a place where journalism and art conspire, one tugging conspicuously at the conscience, while the other secretly rustles the soul.

This peculiar chemistry has made Salgado, 49, world famous. Exhibitions of his work have been mounted in New York City, Paris, Madrid and elsewhere. His photographs have appeared — not illuminating a text but *as* the text — in prominent European and American publications.

But Salgado's photographs are less frequently displayed in the locales where the images are gathered — a coal mine in India, a tea plantation in Rwanda, sugar-cane fields in Cuba, a sulfur-yielding volcano in Java. In this, his work replicates the transfer of raw material from developing to developed

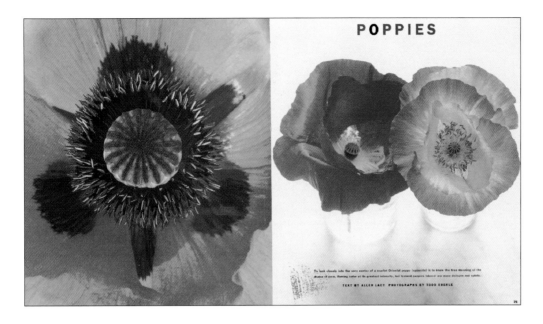

POPPIES

To look closely into the very center of a scarlet Oriental poppy (papaver) is to know the true meaning of the drama of pure, flaming color at its greatest intensity, but to tend poppies takes — are more delicate and subtle.

TEXT BY ALLEN LACY PHOTOGRAPHS BY TODD EBERLE

'A rebirth of the Cossacks is also a rebirth of Russia, because we live everywhere.'
— Ivan Zhukov, a young Cossack in Krasnodar

HARD SELL

A training manual in being liked.
TEXT BY DIANE KEATON

POPPIES
99 / 3
ART DIRECTION
Gael Towey
DESIGN
Anne Johnson,
Jennifer Waveric,
Lisa Wagner
COPYWRITING
Allen Lacy
PHOTOGRAPHY
Todd Eberle
PUBLICATION
Martha Stewart Living
ENTRANT LOCATION
New York, NY

**THE SOUND OF COSSACK
THUNDER (A PHOTO
ESSAY BY ELLEN BINDER)**
99 / 4
ART DIRECTION
Janet Froelich
DESIGN
Gina Davis
COPYWRITING
Ellen Binder
PHOTO EDITING
Kathy Ryan
PUBLICATION
The New York Times
Magazine
ENTRANT LOCATION
New York, NY

THE HARD SELL
99 / 5
ART DIRECTION
Janet Froelich
DESIGN
Richard Baker
COPYWRITING
Kathy Ryan
AUTHOR
Diane Keaton
PUBLICATION
The New York Times
Magazine
ENTRANT LOCATION
New York, NY

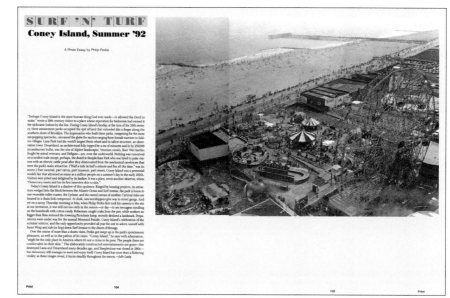

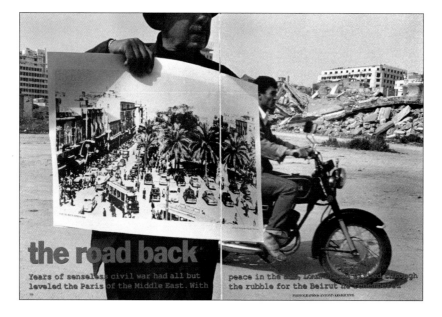

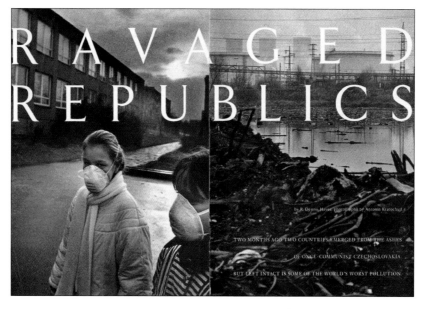

VIBE
99 / 9
ART DIRECTION
Gary Koepke
PHOTOGRAPHY
Christian Witkin
PHOTO.EDITING
George Pitts
STUDIO
Koepke International
LTD.
PUBLISHER
Time Ventures, Inc.
ENTRANT LOCATION
Magnolia, MA

BADETEMPEL
99 / 1
ART DIRECTION
Sophie Bleifuss
DESIGN
Sophie Bleifuss
COPYWRITING
Hans - Eberhard Hess,
Dirk Meyhöfer
PHOTOGRAPHY
Dieter Leistner
PRODUCTION
Verlag Ernst & Sohn
PUBLICATION
Badetempel
ENTRANT LOCATION
Mainz

THE HIGH COST OF LIVING
100 / 1
ART DIRECTION
Janet Froelich
PHOTOGRAPHY
Keith Carter
PHOTO EDITING
Kathy Ryan
PUBLICATION
The New York Times Magazine
ENTRANT LOCATION
New York, NY

THE DEATH OF EROS
100 / 2
ART DIRECTION
Janet Froelich
DESIGN
Kathi Rota
PHOTOGRAPHY
Amy Guip
PUBLICATION
The New York Times Magazine
ENTRANT LOCATION
New York, NY

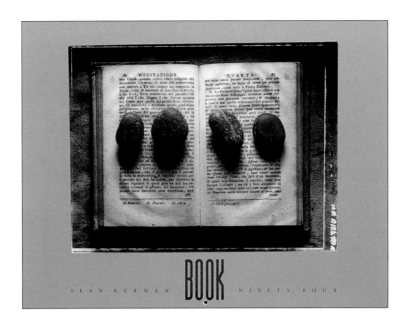

BOOK CALENDAR 1994
101 / 1
ART DIRECTION
Sean Kernan
DESIGN
Sean Kernan
COPYWRITING
Sean Kernan
PHOTOGRAPHY
Sean Kernan
CLIENT
Sean Kernan, Inc.,
ENTRANT LOCATION
Stony Creek, CT

**WOMAN WITH PONYTAIL,
WOMAN WITH HAT,
WOMAN WITH COLLAR**
101 / 1, 2, 3
ART DIRECTION
Hartwig Klappert
DESIGN
Octanorm
PHOTOGRAPHY
Hartwig Klappert
CLIENT
Octanorm
ENTRANT LOCATION
Berlin, Germany

**POOL, FORKS WITH
SPAGHETTI, SHOES WITH
TOE**
101 / 4, 5, 6
ART DIRECTION
Hartwig Klappert
DESIGN
Noth and Hauer
PHOTOGRAPHY
Hartwig Klappert
CLIENT
Huber Gruppe /
Printing Inks
ENTRANT LOCATION
Berlin, Germany

UNTITLED
102 / 1
ILLUSTRATION
Brad Holland
AGENCY
J. Walter Thompson
CLIENT
Ansaldo
ENTRANT LOCATION
New York, NY

UNITED NATIONS STAMPS
103 / 1
ART DIRECTION
Rocco Callari
DESIGN
Braldt Bralds, Rocco
Callari
ILLUSTRATION
Braldt Bralds
DIRECTION
Tony Fouracre
STUDIO
United Nations Postal
Administration
CLIENT
United Nations Postal
Administration
ENTRANT LOCATION
Washington, DC

**AIDS IS NOT A DEATH
SENTENCE**
104 / 5
ART DIRECTION
Dwayne Flinchum
DESIGN
Dwayne Flinchum
ILLUSTRATION
Marshall Arisman
ENTRANT LOCATION
New York, NY

**THE WHITE COLLAR
BLUES**
104 / 6
ART DIRECTION
Richard Baker,
Kelly Doe
DESIGN
Kelly Doe
ILLUSTRATION
Scott Menchin
CLIENT
The Washington Post
ENTRANT LOCATION
New York, NY

FREE YOUR MIND
104 / 7
ART DIRECTION
Jeffrey Keyton
ILLUSTRATION
Paul Davis
CLIENT
MTV - MTV Creative
Services
ENTRANT LOCATION
New York, NY

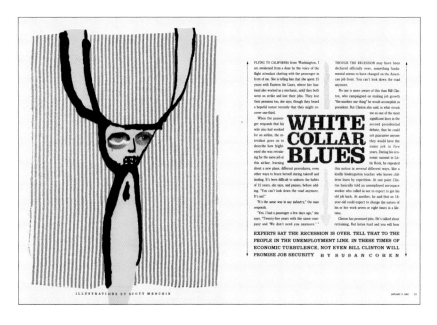

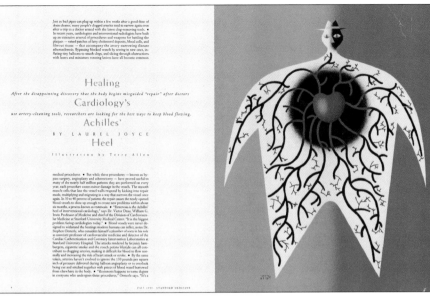

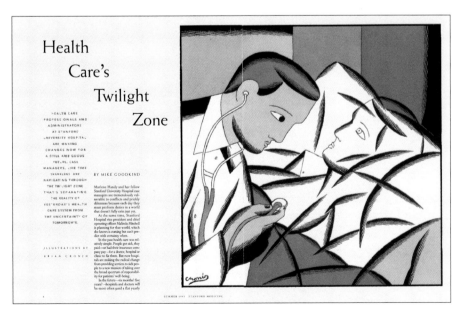

**HEALING CARDIOLOGY'S
ACHILLES' HEEL**
104 / 8
ART DIRECTION
David Armario
DESIGN
David Armario
ILLUSTRATION
Terry Allen
PUBLICATION
Stanford Medicine
ENTRANT LOCATION
Burbank, CA

CHRISTIAN NORTHEAST
104 / 9
ART DIRECTION
Pamela Berry
PHOTO EDITING
Jenifer Crandall
ILLUSTRATION
Christian Northeast
ENTRANT LOCATION
New York, NY

**HEALTH CARE'S
TWILIGHT ZONE**
104 / 10
ART DIRECTION
David Armario
DESIGN
David Armario
ILLUSTRATION
Brian Cronin
PUBLICATION
Stanford Medicine
ENTRANT LOCATION
Burbank, CA

MAD MAXWELL
104 / 11
ART DIRECTION
Dwayne Flintcham
DESIGN
Penthouse
COPYWRITING
Dwayne Flintcham
ILLUSTRATION
Brad Holland
PUBLICATION
Penthouse
ENTRANT LOCATION
New York, NY

SEX AND THE FEMALE
AGENDA
104 / 12
ART DIRECTION
David Armario
DESIGN
James Lambertus
ILLUSTRATION
Anita Kunz
CLIENT
Walt Disney Publishing
ENTRANT LOCATION
Burbank, CA

UNTITLED
104 / 13
ART DIRECTION
Dan Barron
ILLUSTRATION
Brad Holland
PUBLICATION
Art Direction Magazine
ENTRANT LOCATION
New York, NY

FAITH NO MORE
104 / 14
ART DIRECTION
Kelly Doe,
Richard Baker
DESIGN
Kelly Doe
ILLUSTRATION
Scott Menchin
CLIENT
The Washington Post
ENTRANT LOCATION
New York, NY

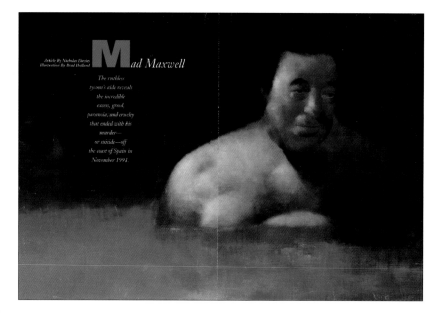

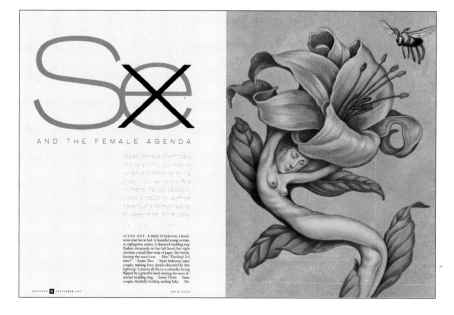

SCANNING THE DIAL
104 / 15
ART DIRECTION
Judy Garlan
ILLUSTRATION
Seymour Chwast
STUDIO
The Pushpin Group, Inc.
CLIENT
The Atlantic Monthly
ENTRANT LOCATION
New York, NY

SOME LIKE IT HOT/SOME LIKE IT COLD
104 / 16
ART DIRECTION
Michael Valenti
ILLUSTRATION
Seymour Chwast
STUDIO
The Pushpin Group, Inc.
CLIENT
The New York Times
ENTRANT LOCATION
New York, NY

FINDING FAULT
TOLERANCE
104 / 17
ART DIRECTION
Frank C. Lionetti
DESIGN
Alexandra Boyden
COPYWRITING
Mari Ryan
ILLUSTRATION
Guy Billout
STUDIO
Frank C. Lionetti Design Inc.
CLIENT
ENTEX Information Services
ENTRANT LOCATION
Old Greenwich, CT

Confessions
of a Plant
Inspector

Three journeys

in quest of

South American

flower power

Illustrations by

Blair Drawson

As a world-class botanist (*Homo sapiens botanicus*), Douglas C. Daly necessarily spends months on the road, far from his office at the New York Botanical Garden, where he's called "Curator of Amazonian Botany." In the course of 26 expeditions to South America—adding up to three years so far—Daly has not only mastered his specialty, the study of *Burseraceae* (a family of aromatic tropical trees), but also rooted out some 40 plant species previously unknown to science. Fortunately, you needn't be a scientist to appreciate Daly's travels. He also writes in splendid English, distilling his adventures with a wry eye for irony and detail. Below are Daly bulletins on three South American journeys that most readers may be happy they missed.

BECAUSE
children's emergencies are
different
from adults', but not smaller,
Stanford
hospital's emergency room
physicians
work closely with a specially
trained
team *from* Lucile Packard
Children's
Hospital

NOT SO

Little

EMERGENCIES

BY MARGO SCHNEIDMAN
Illustrations By Mark Ulricksen

They're Back! Once considered under control, some mighty microbes are making a frightening comeback.

By Rosanne Spector

ILLUSTRATIONS BY JORDIN ISIP

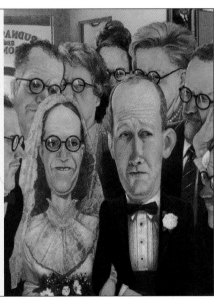

MARRYING
INTO THE
BUSINESS

Make the Most of Your New Working Relationship
By Barbara B. Buchholz and Margaret Crane

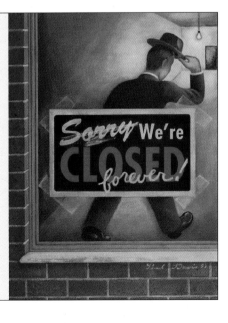

THROWING
IN THE
TOWEL

Preparing Your Firm — and Yourself — When It's Time to Close Up Shop • By Rollene Saal

THEY'RE BACK!
104 / 21

ART DIRECTION
David Armario

DESIGN
David Armario

ILLUSTRATION
Jordin Isip

PUBLICATION
Stanford Medicine

ENTRANT LOCATION
Burbank, CA

MARRYING INTO THE BUSINESS
104 / 22

ART DIRECTION
Will Hopkins,
Mary K. Baumann

DESIGN
Will Hopkins

COPYWRITING
Barbara B. Buchholz,
Magaret Crane

ILLUSTRATION
C. F. Payne

STUDIO
Hopkins / Baumann

PUBLICATION
Your Company

CLIENT
American Express
Publishing Corporation

ENTRANT LOCATION
New York, NY

THROWING IN THE TOWEL
104 / 23

ART DIRECTION
Will Hopkins,
Mary K. Baumann

DESIGN
Angela Esposito

COPYWRITING
Rollene Saal

ILLUSTRATION
Paul Davis

STUDIO
Hopkins / Baumann

PUBLICATION
Your Company

CLIENT
American Express
Publishing Corporation

ENTRANT LOCATION
New York, NY

BEHIND THE FLY
105 / 2
SILVER
ART DIRECTION
Fred Woodward
DESIGN
Debra Bishop
ILLUSTRATION
Charles Burns
CLIENT
Wenner Media, Inc.
ENTRANT LOCATION
New York, NY

THE TWO JACKS
105 / 4
DISTINCTIVE MERIT
ART DIRECTION
Fred Woodward
ILLUSTRATION
C.F. Payne
PUBLICATION
Rolling Stone Magazine
CLIENT
Wenner Media Inc.
ENTRANT LOCATION
New York, NY

ZOOROPA, MON AMOUR
105 / 3
ART DIRECTION
Fred Woodward
ILLUSTRATION
Mark Ryden
PUBLICATION
Rolling Stone Magazine
CLIENT
Wenner Media Inc.
ENTRANT LOCATION
New York, NY

**THE BULGARIAN
CONNECTION**
105 / 1
ART DIRECTION
David Armario
DESIGN
James Lambertus
ILLUSTRATION
Jonathon Rosen
CLIENT
Walt Disney Publishing
ENTRANT LOCATION
Burbank, CA

THE REAL ACTION HERO
105 / 5
ART DIRECTION
Fred Woodward
ILLUSTRATION
Edmund Guy
PUBLICATION
Rolling Stone Magazine
CLIENT
Wenner Media Inc.
ENTRANT LOCATION
New York, NY

THE BOYS OF SUMMER
105 / 6
ART DIRECTION
Fred Woodward
ILLUSTRATION
David Cowles
PUBLICATION
Rolling Stone Magazine
CLIENT
Wenner Media Inc.
ENTRANT LOCATION
New York, NY

DAVID LETTERMAN
105 / 7
ART DIRECTION
Fred Woodward
DESIGN
Fred Woodward,
Gail Anderson
ILLUSTRATION
Al Hirschfeld
PUBLICATION
Rolling Stone Magazine
CLIENT
Wenner Media Inc.
ENTRANT LOCATION
New York, NY

IRON JOHN
105 / 8
ART DIRECTION
Kerry Tremain
ILLUSTRATION
Brad Holland
PUBLICATION
Mother Jones
ENTRANT LOCATION
New York, NY

Iron John: a lover's tale

by Véronique Vienne

FOR EVERYONE ON EARTH there was once a pregnant mother. We all tend to forget this. To remind myself, I sometimes squint when I am in a crowd. I imagine her everywhere—waddling, patient, awkward, moving carefully because she cannot see her feet. As if to prepare herself, she looks, and feels, like a big baby. ▪ That woman (she was so much younger then) will always be your mother, and you will always be her child. She will always think that she knows what is best for you. ▪ It is to the rallying cry of "Mommy, leave me alone!" that the men's movement is organizing itself. A grass roots phenomenon, it encourages men to meet by themselves to experience their quintessential maleness. Robert Bly, one of the most important voices in the movement, is largely responsible for its childlike, let's-go-hide-in-our-tree-house strategy. He argues that in order to discover their true identities, men must free themselves from the influence of women, particularly their mothers. ▪ To help them do this, Bly takes frustrated sons back to their "natural" habitat—the woods. But these happy campers can never escape altogether: instead of Mother, they now have to deal with Mother Nature. And Mother Nature does not cook dinner or do the dishes.

Paintings by Brad Holland

I am the angry mother. If you venture into the woods, young men, beware of the woman who is looking for her son and wants to take him back.

ENERGIE ALTERNATIVE
105 / 1
ILLUSTRATION
Brad Holland
AGENCY
J. Walter Thompson
CLIENT
Ansaldo
ENTRANT LOCATION
New York, NY

FREE YOUR MIND
107 / 1
DISTINCTIVE MERIT
ART DIRECTION
Jeffrey Keyton,
Stacy Drummond,
Stephen Bryan
DESIGN
Jeffrey Keyton,
Stacy Drummond,
Stephen Bryan
ILLUSTRATION
various
ENTRANT LOCATION
New York, NY

1993 was a very pivotal year in the advertising and design industry.

The last five years saw us wondering where it was all going: new technologies, old business, corporate identity; big agencies, small agencies, new agencies, layoffs, freelancing, consultants—it stunned many of us.

However, in 1993 it started to resolve itself, even if we don't quite know what to call it yet.

Technology has impacted greatly on business and sparked new ways of working creatively. Advertising agencies read the handwriting in the sky and have begun to restructure the way they do business. The design community, after years of pondering where the work went, recognizes new opportunities surfacing. There is work and the attitude is positive.

If the industry was due for an overhaul, these times have forced us to re-evaluate what we are about. Out of confusing times come reforms and reinventions.

The award-winning work in this book contains come brilliant and traditional work, and work that not only is brilliant but explores new territory.

If creativity seems to have been in hibernation in the recent past, the best work done in 1993 points to its reawakening.

—Allan Beaver
President, ADC

ADC PUBLICATIONS PRESIDENT'S STATEMENT

In Ray Bradbury's *Fahrenheit 451*, the government decided that the only reading material worth printing was comic books; the only media worth televising was interactive shopping and gameshows; the only entertainment was virtual reality pronography. Well, that's not a bad assessment of the present since it's a 1950s view of the future.

In the past year alone, magazines and newspaper op-ed pages have been bemoaning the death of the book. The main complaint is that books no longer have content; that they're purely commercial ventures.

When you look at the ADC Annual, however, you see more than commerce, or non-existent content. Inside of these pages you see inspiration. You'll find a source of current "events" in the advertising, editorial, design, and video industries. You'll learn what the worldwide community of communicators are thinking and doing with traditional and non-traditional concepts. You'll feel something only a book can give you: the sense that you are experiencing a new world that's available right at your fingertips, with or without computer literacy. The work you see in these pages is the output of people who come from all ends of the computer spectrum. What they have in common is that they're the best at what they do, regardless of how they do it.

This Annual was produced with the best that computer technology has provided us in scanning, pagination, and output, in the hands a of classically trained typographer who is just as excited about the past as he is the future. We hope you will enjoy this memorable, permanent record of a moment in time.

—Anistatia R. Miller
President, ADC Publications, Inc.

VCEF SCHOLARSHIP FUND

The VCEF: Recognizing and Rewarding Talent in a Meaningful Way

They say money is the root of all evil. But it's a lifesaver for talented young men and women whose dreams are bigger than their means.

I'm pleased to report that in the past year our Visual Communicators Educational Fund (VECF) made $21,000 available to students eager to follow careers in the advertising and communications fields.

By year's end, thirty-four high school students were surprised and delighted to share this unexpected tuition windfall.

Selection of the student was made by a number of the outstanding art institutions in the new York metropolitan area.

These include Cooper Union College, Fashion Institute of Technology, New York Technical Institute, Parsons School of Design, Pratt Institute (Brooklyn & Manhattan) and School of Visual Arts.

I thank each of these fine schools for their enthusiastic support and cooperation.

The entire tuition awards process, and its exciting culmination, should be extremely gratifying to every ADC member.

Because every ADC member is a member of VCEF.

That, more than aything else, is the point of the message.

It's my hope:

• That a;; ADC members will view the VCEF as an opportunity to give back to this business a little of what it has given to us. An opportunity to enhance the club's image by recognizing tomorrow's art talent as well as today's art achievement.

• That all ADC memebrs will encourage their school or colleges to institute permanent graduaiton awards for deserving high school seniors.

• That all ADC members will work with their companies and, where possible, with other compaies to establish college level summer internships. Foote, Cone & Belding has made this an ongoing commitment.

• That all ADC members who are financially able will consider a monetary contribution to the VCEF, and seek a matching contribution from their companies.

I hope I'm not hoping for too much. But let us, in the words of Leo Burnett: "Reach for the Stars."

In closing, I mustn't forget to thank the members of the VCEF for a year of extraordinary effort. The inconvenient evening meetings, the endless phone calls, the countless faxes.

It was well worth it.

—David Davidian
President, VCEF

Cooper Union
Day Gleeson, chairperson
Christian Luis
Kathryn Poteet
Stephanie Reyer

New York City Technical College
Joel Mason, chairperson
Michael Nicolini
Ronald Sequeira, Jr.
Alix Val
Larissa Yerastova

Fashion Institute of Technology
Ruby Friedland, chairperson
Leslie Baker
John Brandinelli
Suzan Hasselbach
Su Matthews
Johanna Sulit
Jessica Venegas

Parson
Al Greenberg, chairperson
Debora Berardi
Laura Berkowitz
Claudia D'Argenio
Pilar Emanuel
David Harley
Laura Herzberg
David Irvin
Eun Mi Koh
Ricardo Jo
Andy Lau
Kyongsill Lee
Lichael Morales
Eun Seon Yeo

School of Visual Arts
Richard Wilde, chairperson
Doron Edut
Habg Jun
Sasha Shor
Reiko Sugitani

Native New Yorker **Martin Solomon** studied communication art at New York State University and Pratt Institute. In his early career, he was an art director at William Douglas McAdams, BBDO, and Doyle Dane Bernbach advertising agencies. He is creative director of his own design firm Martin Solomon Company, which he established in 1961.

Solomon is a member of the Type Directors Club and was chairperson of "TDC 35." He currently serves on the Art Directors Club of New York's Executive Board. His work has won recognition from the Art Directors Clubs of New York, New Jersey, Chicago, and Los Angeles; the Type Directors Club of New York; and the AIGA. His many awards and honors include the ANDY, Mead Paper's Creativity on Paper and Show of Shows awards, Society of Illustrators, *Print* Magazine Regional Design, and Desi. In 1982 he was presented with the Outstanding Alumni Silver Pen Award by New York State University, and in 1990 he received the Benjamin Franklin Fellowship Award.

His work has been featured in international exhibitions including two shows in Tokyo, Japan: "INTERSECT 89" and "The 4th Exhibition of the International Designers 1994." His work has also been catalogued in the permanent collection of the Museum für Kunst und Gewebe in Hamburg, Germany.

Solomon currently teaches typography and design in Parsons School of Design NYC, Fashion Institute of Technology, and the graduate program at Marywood College in Pennsylvania. He lectures at major universities including Syracuse University, Rutgers University and Universidad Politecnica in Spain. He has been a guest speaker at the Type Directors Club, Art Directors Clubs, numerous New Jersey advertising agencies and professional organizations. He is on the Advisory Board of the New York City Technical College of the City University of New York and *TipoGrafica* Magazine, a journal of communication design and typography published in Buenos Aires, Argentina.

Solomon was selected by *Print Magazine* to be guest editor and contributor to their special issue "Typography Today" (Nov./Dec. 1986). He is a feature writer for *TipoGraphica*. He has also written for *Graphis, Design Issue,* and *Step by Step* magazines. A retrospective of Solomon's work was recently featured in two German publications *novum gebrauschsgraphil* and *PAGE;* and in the Brazilian publication *Design Interiores.* Solomon was curator of the exhibition "Reflections of Letterpress Typography," at The Cooper Union School's The Herb Lubalin Study Center in 1992. A graphic design, painting and drawing retrospective of his work was exhibited in 1993 at the von Oertzen Gallery in Frankfurt, Germany. Solomon's book, *The Art of Typography,* published by Art Direction Book Company is in its second printing.

Jim Wasserman began his publishing career in 1973 with Samuel Weiser Publishers. He discovered a love for design while creating his first book jacket, typeset in hot metal. He helped develop Weiser's in-house production department, utilizing then state-of-the-art technology — punched paper tape fed to a Linotron typesetter.

He founded Studio 31 in 1977, offering full service book production and graphic design. In 1983, Studio 31 began serious work with typography, driving a Linotron 202 via modem from a Kaypro II. In 1987 an in-house 202 was acquired, driven by sophisticated composition software running on a PC. Currently Studio 31 is using and enjoying the Macintosh platform.

In addition to graphic design and production, Jim's interests include religion and mythology. Author, editor and producer of numerous articles and collections in the field, in 1992 he wrote and designed *Art and Symbols of the Occult* (Inner Traditions, Rochester). In 1993 he edited and wrote an extensive introduction to *Aleister Crowley and the Practice of the Magical Diary* (New Falcon Publications, Phoenix). He is currently writing *Inside Secret Societies* for New Falcon, scheduled for Fall 1995.

In 1994, Jim experienced the fulfillment of a lifelong dream. Chronicle Books published his full-color version of *The Egyptian Book of the Dead,* which features a facsimile reproduction of a magnificent papyrus, with integrated English translation. Modern technology and painstaking book design were combined to reclaim an artistic and philosophic masterpiece of antiquity.

Jim is married and lives in New York City with his wife and two children.

ADC STAFF AND BOARD

ADC MEMBERS

UNITED STATES

Lawrence Aarons
Donald Adamec
Tina Adamek
Gaylord Adams
Steven Adams
Patricia Addiss
Jim Adelman
Peter Adler
Charles S. Adorney
Dennis Ahlgrim
Mirza Alikhani
Heidi Flynn Allen
Jack Anderson
Joseph Anderson
Susan Andreasen
Gennaro Andreozzi
Laurie Angel-Sadis
Rick Angeloni
Al Anthony
Phyllis Aragaki
David Armario
Lawrence A. Armour
Stephanie Arnold
Herman Aronson
Rochelle L. Arthur
Tadashi Asano

Jeff Babitz
Robert O. Bach
Ronald Bacsa
Arati S. Badrinath
Charles H. Baer
Priscilla Baer
Ronald Ballister
Ray Barber
Floyd Barker
Richard M. Baron
Christine Barrett
Elizabeth A. Barrett
Don Barron
Robert Barthelmes
Gladys Barton
Nancy Bauch
Mary K. Baumann
Clifford J. Beaven
Allan Beaver
Arthur Beckman
Lois Bender
Ephram Benguiat
Edward J. Bennet
Laurence Key Benson
Bill Berenter
John Berg
Danielle Berger
Matt Berman
Walter L. Bernard
Peter Bertolami
Frank Bertulis
Robert Best
Barbara Binzen
Janet Blank
Peter J. Blank
Robert Blattner

Robert H. Blend
Bruce Bloch
David S. Block
Karen M. Bloom
Arnold Blumberg
Edward Boches
Robert Bode
Sharon Bodenschatz
Donna Bonavita
George Warren Booth
Jean Bourges
Harold A. Bowman
Doug Boyd
Evelyn M. Brady
Simeon Braguin
Fred J. Brauer
Al Braverman
Michael Brent
Lynn Dreese Breslin
William P. Brockmeier
Ed Brodsky
Ruth Brody
Sam Brody
Adrienne Brooks
Leslie Brooks
Steven Brower
George Brown
Mark Delane Brown
Robert Bruce
Bruno E.Brugnatelli
Gary Brumberg
Alice Bryce-Clark
William Buckley
Ron Burkhardt
Bonnie Butler
Peter Bynum

Bill Cadge
Albert J. Calzetta
Bryan G. Canniff
James Caporimo
James Cardillo
Bob Carew
Thomas Carnase
Roy Carruthers
Ralph Casado
Emmett Cassell
Angelo Castelli
Diana Catherines
Bob Cato
C. Edward Cerullo
Mitchel Chalek
Alan Chalfin
Jean Chambers
Andrew Chang
Anthony Chaplinsky, Jr.
Jack C. Chen
John Cherry
Shirley E. Chetter
Alan Christie
Stanley Church
Seymour Chwast
Herbert H. Clark
Bud Clarke

James V.Clarke
Thomas F. Clemente
Mahlon Cline
Joel Cohen
Peter Cohen
Michael Coll
Elaine Crawford Conner
Catherine Connors
David A. Cooper
Lee Corey
Eva Costabel
Sheldon Cotler
Susan Cotler-Block
Ron Couture
Jac Coverdale
Phyllis Richmond Cox
Robert Cox
James Edward Craig
Meg Crane
Susan J.Crane
Gregory Crossley
Bob Crozier
Leslie Cullen
Christine Curry
Ethel R.Cutler
Gregory F. Cutshaw

David Davidian
Steven Davidson
David R. Davis
Paul B. Davis
Phillip Davis
Randi B. Davis
Theodore M. Davis
Bill Decorso
Robert Defrin
Tony Degregorio
Joe Del Sorbo
Erick Demartino
Jerry Demoney
Thomas Derderan
David Deutsch
Frank Devito
Charles Dickinson
Charles Dicomo
John Dignam
Dennis Divincenzo
Charles Dixon
Shelley Doppelt
Louis Dorfsman
Marc Dorian
Kay Elizabeth
Matthew Drace
Rina Drucker
Ann Dubiel
Donald H. Duffy

Heidi K.Eckman
Bernard Eckstein
Peter Edgar
Geoffrey T. Edwards
Antonie Eichenberg
Zeneth Eidel

Nina Eisenman
Stanley Eisenman
Robert Eisner
Judith Ellis
Jack Endewelt
David Epstein
Lee Epstein
Shirley Ericson
Suren Ermoyen

Ellen Factor
Joseph Fama
Rose Farber
Gene Fedele
Gene Federico
Michael Fenga
John Ferrell
Kristin Filson
Len Fink
Lou Fiorentino
Blanche Fiorenza
Gonzalo Firpo
Carl Fischer
PatriciaFletcher
Donald P. Flock
John Fraioli
Stephen O. Frankfurt
Richard Franklin
Bill Freeland
Christina Freyss
Ruby Miye Friedland
Beverly Friedman
Michael K. Frith
Oren Frost
Aaron Fuchs
Neil Fujita
Leonard W. Fury

Mark A. Gable
Raymond Gaeta
Robert Gage
Rosemarie Galioto
Danielle Gallo
Lynne Garell
Gene Garlanda
Bert Garner
Joel Garrick
Joseph T. Gauss
Alberto Gavasci
Steff Geissbuhler
Charles Gennarelli
Gerald J. Genova
Jeffrey E. George
Robert J. George
Vida Geranmayeh
Michael Germarkian
John Geryak
Carl Gessman
Victor Gialleonardo
Kurt Gibson
Frank C.Ginsberg
Sara Giovanitti
Milton Glaser

Maureen R. Gleason
Eric Gluckman
Marc Gobe
Tama Alexandrine Goen
Manfred Goettel
Bill Gold
Irwin Goldberg
Gary Goldsmith
Roz Golfarb
Joanne Goodfellow
Lee Goodman
Jean Govoni
Roy Grace
Diana Graham
Al Greenberg
Adam Greiss
Jack Griffin
Jeffrey Griffith
Erika Groeschel
Glen P. Groglio
Phillip Growick
Susan Grube
Raisa Grubshteyn
Ira Alan Grunther
Nelson Gruppo
Kimberly Guerre
Silvano Guidone
S. Rollins Guild

Robert Hack
Kurt Haiman
Everett Halvorsen
Shoichiro Hama
Edward Hamilton
Frances M. Hamilton
Lauren J. Hammond
David Haney
Cabell Harris
Alan Hartwell
Barry Hassel
Amy Heit
Steven Heller
William Hendricks
Randall Hensley
Robert S. Herald
Maureen Herche
Susan Herr
Jannike Hess
Chris Hill
Peter Hirsch
Charles Hively
Jitsuo Hoashi
Gordon Hochhalter
Harvey Hoffenberg
Marilyn Hoffner
Steve Horn
Julia L. Horowitz
William David Houser
Paul Howard
Debra Morton Hoyt
Jud Hurd
Brian Hutter

Henry Isdith
Skip K. Ishii

Harry Jacobs
Lee Ann Jaffee
John E. Jamison
Andrzej Janerka
Patricia Jerina
Paul Jervis
Shaun Johnston
Joanne Jubert

Nicki Kalish
Kiyoshi Kanai
Walter Kaprielian
Paul Kaufman
Brian M. Kelly
Alice Kenny
Nancy Kent
Myron W. Kenzer
Jana Khalifa
Ronald Kiel
Ellen Sue Kier
BokyoungKim
Hyeson Kim
Hedy Klein
Judith Klein
Andrew Kner
Henry O. Knoepfler
Ray Komai
Kati Korpijaakko
Oscar Krauss
Johannes Krempl
Anna Kurz

Howard La Marca
Anthony La Petri
Christine Lan
Beverly Schrager Laise
Abril Lamarque
Joseph O. Landi
Hope Langson
Michael Lanotte
Lisa A. Larochelle
Lawrence Larstanna
Kenneth H. Lavey
Marie Christine Lawrence
Sal Lazzarotti
Lee Le Van
Steven W. Lebeck
Michael A. Lebron
Edwin Lee
Lee Levan
Richard Levenson
Shawn Levesque
Peter Levine
Rick Levine
Alexander Liberman
Susan Llewellyn
George Lois
Henry R.Loomis
George Lott

Alfred Lowry
Ruth Lubell
John Lucci
Diane Luger
Larry Lurin
Robert W. Lyon, Jr.
Michael J. Lyons

Richard Macfarlane
David H.Macinnes
Samuel Magdoff
Lou Magnani
Anthony Mancino
Pamela G. Manser
Jean Marcellino
Eric Marcus
David R. Margolis
Jack Mariucci
Andrea Marquez
Joel Mason
Marce Mayhew
Joan Mazzeo
Michael Mazzeo
Stephen J. McErlain
William Mccaffery
Nick Mcgreevy
Fernando Medina
Scott A.Mednick
Nancy A. Meher
Barney Melsky
Lyle Metzdorf
Jackie Merri Meyer
Thomas A. Miano
Eugene Milbauer
Anistatia R. Miller
Lawrence Miller
John Milligan
Wendell Minor
Michael Miranda
Leonard Mizerek
Clement Mok
Joseph Montebello
Ken Montone
Richard Moore
Paul Moran
Katherine Moreno-
Sanchez
Minoru Morita
Leonard Morris
William R. Morrison
Amy Morton
Thomas Morton
Louie Moses
Tobias Moss
Dale Moyer
Robert Mueller
Virginia Murphy-Hamill
Timothy J. Musios
Ralph J. Mutter

Daniel Nelson
Barbara Nessim
Mary Ann Nichols

Raymond Nichols
Joseph Nissen
Michael Nix
Evelyn C. Noether
Barbara J. Norman
George Noszagh
David November

Frank O'Blak
Lisa O'Donnell
Hugh O'Neill
Bill Oberlander
Sharon Occipinti
John Okladek
Nina Ovryn
Bernard S. Owett

Onofrio Paccione
Robert Paganucci
John A. Palancio
Jane Palecek
Tony Palladino
Brad Pallas
Jeff Pappalardo
James Park
Jacques Parker
Kathleen Pascoe
Joanne Pateman
Art Paul
Alan Peckolick
B. Martin Pedersen
Patrick Peduto
Pierre Pepin
Harold A. Perry
Roberta Perry
Victoria I. Peslak
John Peter
Christos Peterson
Robert Petrocelli
Chris Petrone
Theodore D. Pettus
Steward Phelps
Allan Philiba
James Philips
Alma Phipps
Michael Pilla
Ernest Pioppo
Peter Pioppo
Robert Pliskin
Richard Portner
Louis Portuesi
Frances Posen
Anthony Pozsonyi
Robert Procida

Michael Quackenbush
Charles W. Queener
Elissa Querze
KathleenQuinn Fable

Paul Rand

Samuel Reed
Sheldon Reed
Deck P. Reeks
Herbert Reinke
Harris Reitman
Robert Reitzfeld
Joseph Leslie Renaud
Ladan Rezaei
David Rhodes
Ruthann Richert
Edward C. Ricotta
Barbara Rietschel
Roxy Rifkin
Elizabeth T. Riley
Arthur Ritter
Valerie Ritter
Karen Ritter-Mayer
Barbara B. Roberts
Kenneth Roberts
Bennett Robinson
Harry Rocker
Harlow Rockwell
Susan Rohall
Andy Romano
Bobbi Rosenthal
Charles Rosner
Andrew Ross
Mark Ross
Peter Ross
Richard J. Ross
Suzanna M. Rossiello
Arnold Roston
Tom Roth
Alan Rowe
Mort Rubenstein
Randee Rubin
Thomas P. Ruis
Henry N. Russell
Albert Russo
Deborah Russo
Don Ruther
Thomas Ruzicka

Joseph Sachs
Stewart Sacklow
Moriyoshi Saito
Robert Saks
Peter Saladino
Richard M. Salcer
Robert Salpeter
James Salser
Ina Saltz
George Samerjan
Anthony Santore
Audrey Satterwhite
Hans Sauer
John Sayles
David J. Saylor
Sam Scali
Ernie Scarfone
Roland Schenk
Paula Scher
Glen Scheuer
Klaus F. Schmidt

Joyce Schnaufer
Eileen Hedy Schultz
Adriane Schwartz
Victor Scocozza
Julie Scwartzman
Alexis Seabrook
William Seabrook, III
Amy Sears
J. J. Sedelmaier
Leslie Segal
Rebecca Segerstrom-
Sato
Sheldon Seidler
Tod Seisser
John Sellers
John L. Sellers
Alexander Shear
Maxim Shukov
Jerry Siano
Louis Silverstein
Robert Simmons
Milt Simpson
Leslie Singer
Leonard Sirowitz
Lucy Sisman
Jack Skolnik
Carol Lynn Smith
Robert S. Smith
Sheila Smith
Edward Sobel
Andrew Sokol
Daryl Solomon
Martin Solomon
Mark Solsburg
Harold Sosnow
Isaac Stackell
Nancy Stamatopoulos
Hilda Stanger
Shelly Laroche
Mindy Phelps Stanton
Karsten Stapelfeldt
Robert Steigelman
Karl Steinbrenner
Vera Steiner
Barrie Stern
Gerald Stewart
Bernard Stone
Otto Storch
Lizabeth Storrs
Ilene Strizver
William Strosahl
Shunsaku Sugiura
Pamela Sullivan
Sharon Sullivan
Pat Suth
David Sutton
Ken Sweeny
Leslie A. Sweet

Jo Ann Tansman
Vincent Taschetti
Melcon Tashian
William Taubin
Jack Tauss

Mark Tekushan
Nell Thalasinos
BradburyThompson
Robert Todd
Toni Toland
Ben Tomita
Shinichiro Tora
John C. Towners
Victor Trasoff
Joanne Trovato
Susan B. Trowbridge
Joseph P. Tully

Clare Ultimo
Frank Urrutia

George Vasquez
Barbara Vaughn Davis
Haydee N. Verdia
Jeanne Viggiano
Massimo Vignelli
Amy Vischio
Frank A. Vitale
Thomas Vogel
David L. Vogler
Maria Laurenzi
Barbara Von Schreiber
Cal Vornberger
Thuy Vuong

Dorothy Wachtenheim
Jurek Wajdowicz
Joseph O. Wallace
Michael Wallin
John W. Warner
Kenneth Wasserman
Laurence Waxberg
Denise A. Weber
Jessica Weber
Peter Weber
Art Weithas
Daphne Wiedling
Gail Wiggin
Richard Wilde
Rodney C. Williams
Rupert Witalis
Ross Wittenburg
Henry Wolf
Jay Michael Wolf
Robert H. Wong
Laura Woods
Laura E.Woods
Elizabeth G. Woodson

Ira Yoffe
Zen Yonkovig
Frank Young

Bill Zabowski
Carmile S. Zaino

Ulla Zang
Elaine Zeitsoff
Mikael T. Zielinski
Bernie Zlotnick
Lisa A. Zollinger
Richard J. Zuzzolo
Alan Zwiebel

ARGENTINA
Daniel Verdino

AUSTRALIA
Katheryn Davidian
Ron Kambourian

AUSTRIA
Mariusz Jan Demner
Helmut Klein
Lois Lammerhvber
Franz Merlicek

BELGIUM
Julien Behaeghel

BERMUDA
Paul Smith

BRAZIL
Oswaldo Miranda
Fransesc Petit
Adeir Rampazzo

CANADA
Rob Davidson
Claude Dumoulin
Larry Toplin

DENMARK
Dres Simon

GERMANY
Rainer Arke
Mario Baier
Leistnev Dioter
Frank Gross
Reiner Hebe
Claus Koch
Olaf Leu
Friederike Mojen
Lothar Nebl
Stephan Platt
Hans-Georg Pospischill
Samy J. Tood

GREECE
Vangelis Konstantinidis

HONG KONG
Eddy Cheung
Tommy Li Wing Chuen
Byron Jacobs

INDIA
Brendan Pereira

ISRAEL
Dan Reisinger

ITALY
Silvano Guidone
Gerardo Pavone

JAPAN
Masuteru Aoba
Hiroyuki Aotani
Katsumi Asaba
Yuji Baba
Peter Brenoe Shuwa
Tekunobu Fukushima
Osamu Furumura
Akio Hirai
Ken Ichihashi
Yasuyuki Ito
Michio Iwaki
Toshio Iwata
Takahisa Kamijyo
Hideyuki Kaneko
Mitsuo Katsui
Fumio Kawamoto
Ryohei Kojima
Mitsuhiko Kotani
Kazuki Maeda
Keizo Matsui
Takaharu Matsumoto
Takao Matsumoto
Shin Matsunaga
Iwao Matsuura
Kuniaki Miyasaka
Junichi Morimoto
Keisuke Nagatomo
Michio Nakahara
Yasuharu Nakahara
Nakoto Nakamura
Yoshimi Oba
Yoshitomo Ohama
Toshiyuki Ohashi
Kyoji Ohkura
Motoaki Okuizumi
Akio Okumura
Shigeshi Omori
Yasuo Suzuki
Yutaka Takahama
MasakazuTanabe
Ikko Tanaka

Ben Tomita
Yusaku Tomoeda
Michihiro Usami
Norio Vejo
Masato Watanabe
Yoshiko Watanabe
Akihiro H. Yamamato
Yoji Yamamoto
Takeo Yao

KOREA
Ki Young Chae
Joon Chung
Joy Chung
Kwang Soo Han
Jung Hak Jang
Yeong-Joon Kang
Chul Han Kim
Doo Hwang Kim
Duk Kyu Kim
Een Seok Kim
Hae Kyung Kim
Hyun Kim
Kyang Kyu Kim
Hyun Chang Kwon
Joe Chul Lee
Nack Mi Paik
Dong Hee Park
Seung Soon Park
Woo Duk Park
Sang-Chol Rhee

MALAYSIA
Peter Wong

MEXICO
Felix Beltran
Luis Efren Ramirez

MONACO
Amedeo M. Turello

THE NETHERLANDS
Pieter Brattiga
Walter Van Lotringen

THE PHILIPPINES
Emily A. Abrera

PORTUGAL
Eduardo Aires

PUERTO RICO
Dennis Lopez

SINGAPORE
Chiet-Hsuen

SPAIN
Jose M. Trias

SWITZERLAND
Bilal Dallenbach
Moritz Jaggi
Dominique Schuetz
Bundi Stephan
Hans G. Syz
Philipp Welti

UNITED KINGDOM
Jim Baker
Celia Stothard